A
History of
**Far Eastern
Art**

Sherman E. Lee

DIRECTOR EMERITUS, THE CLEVELAND
MUSEUM OF ART

A History of
Far
Eastern
Art

FOURTH EDITION

PRENTICE-HALL, INC.
Englewood Cliffs, New Jersey
and
HARRY N. ABRAMS, INC.
New York

Fourth Edition 1982

EDITOR: Naomi Noble Richard

DESIGNER: Dirk Luykx

Library of Congress Cataloging in Publication Data
Lee, Sherman E.
 A history of Far Eastern art.
 Bibliography: p.
 Includes index.
 1. Art, Far Eastern. I. Title.
N7336. L43 1982 709'.5 81–3603
ISBN 0–13–390138–6 AACR2

Published in 1982 by HARRY N. ABRAMS, INCORPORATED, New York
Printed and bound in Japan

CONTENTS

PART THREE

THE RISE OF NATIONAL INDIAN AND INDONESIAN STYLES

PART FOUR

CHINESE AND JAPANESE NATIONAL STYLES
AND THE INTERPLAY OF CHINESE AND JAPANESE ART

PREFACE

If one began the study of Oriental art in the 1930s, as the author did, one often heard the query still current among students in the 1960s: Where can I find a general survey of the art of Eastern Asia? What book can be recommended to the art major in college, or to the interested layman who is aware of the Orient but unable or unwilling to plow through the ever more forbidding number of general works— studies of the art of China, or India, or Japan? Books in each of these categories may include numerous references to the arts of other Asian countries, but only as incidentals. The main relationships become lost in the forests of national interest and book space requirements. Even more frustrating are those general works that cater to the minority interest in the "mystery" of the East, or to the guilty conscience of those who deplore the West's assumedly materialistic attitudes. These introductions are legion and can be countered only by reference to such an obscure and specialized source as "Chinese Civilization in Liberal Education" (in *Proceedings of a Conference at the University of Chicago*, Chicago, 1959), in which Dr. Alexander C. Soper III has written the sanest and most telling, if curt and fragmentary, account of the place of Chinese art in the liberal arts.

A general introduction to Far Eastern art, although it is apt to be doomed by the results of new research and wider knowledge, has been badly needed; the usefulness and succession of comparable surveys of Western art have underscored this lack in regard to the art of the Orient. Interest alone demands a launching pad, however unstable, to the higher reaches of specialized knowledge; and scholarship needs occasional broad panoramas to modify or correct, thus automatically providing the grounds for new locations of the framework or new directions for the vehicle. It is, in my opinion, more important for the layman or beginning art historian first to know the place of great Indian sculpture or Chinese painting in the art of the Far East, and of the world, than to begin studying these contributions merely as documents of the national history or the religion of their respective areas.

But the works of art in their own contexts indicate their outer relationships only too clearly. The international flavor of classic Buddhist art, in India, Java, Central Asia, China, or Japan—is apparent in its forms, just as the national character of later Cambodian art is as clear as that of certain so-called derivative phases of Japanese art. Again, a broad view, especially of style, is of the greatest importance in recognizing that the art of the Orient, like that of the Occident, is not a special, unique, and isolated manifestation. Related art forms appear on an international stage as often as isolated national styles develop on a contracted geographic stage. Seen in this light, without romantic mystery as well as without the paraphernalia of esoteric scholarship, the art of Eastern Asia seems to me more readily understandable, more sympathetic, more human. We can never see a Chinese work of art as a Chinese does; much less can we hope to know it as it was in its own time. On the other hand, we should not, unless for some really valid reason, violate the context of the work of art. But here are thousands of still meaningful and pleasurable works of art, part of our world heritage—and we should not permit them to be withheld from us by philologists, swamis, or would-be Zen Buddhists. What are they? How are

they to be related to each other? What do they mean to us as well as to their makers? These are proper questions for a general study.

So far no one student has commanded the disciplines necessary to present such a broad survey in really satisfactory form. Since the Second World War the fields of Oriental history, political science, economics, and art have burgeoned, but it is unlikely that such paragons of learning could be forthcoming soon. Any effort inevitably will have numerous shortcomings, some of them perhaps fatal; but, if the effort is worth a try, then at least some of these shortcomings should be faced and either controlled or baldly admitted. The present work makes no pretense to provide more than the briefest historical or religious background to the works of art. In many cases the subject matter, when it is of a particularly esoteric nature, has been slighted or ignored. But questions of style, of visual organization, of aesthetic flavor or comparison, have been emphasized. Since the one really unique and unforgettable quality of a work of art is its visual appearance, and since as Focillon said, the artist's "special privilege is to imagine, to recollect, to think, and to feel in forms," it seemed only logical to me that forms should be the principal concern of the book. Furthermore such matters interest me more than others.

There is one other aspect of Far Eastern art that has not been limited in the present work. Numerous media were used by the Oriental artist. It is quite impossible to know Chinese art without knowing such so-called minor arts as ceramics and jade. Lacquer is very important in Japan. In India, architecture, per se, is of more limited interest than in Japan. This study presents the various *styles* of Far Eastern art in the media used by the artists in the most creative way. Thus, there is much on Indian sculpture but little on Indian ceramics. Contrariwise, late Chinese ceramics are emphasized while late Chinese sculpture is conspicuous by its well-deserved absence. The same selectivity is applied to the choice of styles for discussion. Though conservative modes are of considerable interest as foils or points of depature for more progressive styles, their persistence beyond a certain point can only be called ossification, and one can indulge in the satisfaction of dropping the vestigial remainder; thus the slighting of the Kano school in Japan or of the court-academy painters of the Ming and Qing dynasties.

Other omissions and weaknesses are less deliberate. They involve the shortcomings of the author's acquaintance with some of the many and complex areas of Far Eastern art. The sections on Javanese art, the art of the steppes, or on Mughal painting fall into this category. Recent excavations on the Chinese mainland are numerous, excellent, and fruitful sources for future knowledge. But still, I feel that the present effort is worth the making; this is not an encyclopedia, a complete history, or a handbook of iconography, but an *introduction* to the creative art of Eastern Asia.

The plan of the book is simple. It begins with the early East Asian cultures, Neolithic and Bronze Age, with special emphasis on the Indus Valley civilization that is related to the other ancient urban river cultures of Mesopotamia and Egypt, and the great bronze culture of early China. This section is followed by a study of the rise of Buddhist art in India and of its influence throughout eastern Asia. The following sections trace the rise of "national" art styles in India, Southeast Asia, Indonesia, and East Asia. The latter section, with major emphasis on China and Japan, stresses the alternating national and international character of art East Asian. The modern art of the East is omitted on the grounds that its creative side is more a part of worldwide internationalism than of the tradition of art presented in this volume.

Further reading for those so inclined is suggested by a general bibliography and by a specific list of significant sources for each chapter.

The author is much indebted to the various persons who helped in gathering photographs and information, and with the burdensome task of typing, proofreading, and compilation. Particular acknowledgment should go to Mrs. Margaret Fairbanks Marcus for her patient and critical reading of the draft; Dr. Thomas Munro, Mr. Edward B. Henning, and Mr. Milton S. Fox all read the manuscript and offered excellent advice, which was usually heeded; Mr. Wai-kam Ho was most instructive with regard to early Chinese material. My book owes a great deal to the diligence and expert craftsmanship of Mr. Philip Grushkin, Mrs. Susan A. Grode, and Miss Harriet Squire, of the Abrams staff. Mrs. Nancy Wu Stafstrom, Mrs. Susan Berry, and Mrs. Margarita Drummond bore the brunt of preparing the list of illustrations and arranging for photographs, while Miss Louise G. Schroeder was responsible for the equally onerous task of typing and retyping. I am particularly indebted to Messrs. Junkichi Mayuyama, Inosuke Setsu, and Manshichi Sakamoto for most of the Japanese photographs, while Dr. J. E. van Lohuizen, Dr. Benjamin Rowland, and Mr. S. E. Tewari were most kind and helpful with certain rather difficult Indian material. To these, and many others unnamed, the author proffers humble and sincere thanks. Finally, and by no means least, he is grateful to his wife, who endured his late hours and by no means unexpressed frustrations with the work in progress.

S.E.L.

PREFACE TO THE FOURTH EDITION

The remarkable achievements of the archaeologists of the People's Republic of China in the last two decades alone required that the Neolithic, Bronze, and Iron Age sections of this book be completely reconsidered. The substance of these scientific excavations is remarkable and significant; some of the finds, however, particularly from the post-Han periods, although exciting as new material, have not seriously altered our present understanding of later Chinese art. The early sections of this book have been completely reworked. The later sections have been selectively modified, particularly those clearly requiring second thoughts about the development of Chinese painting.

I have kept to two basic ideas for this text—one, general; the other, particular. The consideration of East Asia as a patchwork of national units still seems to me inadequate, and a balanced approach recognizing international movements as well as national ones has been maintained. And I have continued to emphasize illustrations of works in Western collections where such material is comparable in quality and importance with that to be found in the Orient. This gives the majority of readers the possibility

sometime of seeing the original works—a consummation much to be desired, for reproductions have been, are, and will be deceptive paths to understanding.

I must particularly acknowledge the contribution made by the editor, Naomi Richard, who has taken exacting care with the accuracy and clarity of exposition and captions and the improved synthesis of introductory background sections. She demanded precision and conciseness with exemplary patience and good humor and has made the revisions both germane and readable. The publisher has been patient and reasonably compliant. What more could one ask, except that the reader find this book more useful and more accurate than the previous one. Though I have personal misgivings at the adoption of *pinyin* romanization of Chinese words instead of the previously used Wade-Giles system, the now widespread use of the former method carried the argument of the modernists. At least an effort at correlation of the two systems has been made in the index. I have found this useful in understanding my own text.

S.E.L.

A COMPARATIVE TIME CHART FOR FAR EASTERN ART

INDIA SOUTHEAST ASIA

	INDIA	THAILAND	CAMBODIA	INDONESIA (JAVA)
3500				
3000	NEOLITHIC	NEOLITHIC		
2500				
2000	INDUS VALLEY CIVILIZATION			
1500	*Aryan Invasions*			NEOLITHIC
1400	BRONZE AGE			
1300				
1200				
1100	VEDIC AGE			
1000			NEOLITHIC	NEOLITHIC
900		BAN CHIENG CULTURE		
800	IRON AGE			
700				
642				
600	SAISUNAGA-NANDA PERIOD		NEOLITHIC	
500				
400				
322	MAURYA PERIOD			
300			BRONZE AGE	BRONZE AGE
200			*under South Chinese influence in Northern Indo-China "Dong Son" Culture*	*under South Chinese influence*
185	SUNGA PERIOD			
100				
72				
70	ANDHRA PERIOD			
0				
100	KUSHAN PERIOD			IRON AGE
200			PRE-ANGKOR PERIOD	
300				CENTRAL JAVA
320				
400	GUPTA PERIOD		FU-NAN	
500			*EARLY KHMER STYLE*	
600			CHEN-LA	
647		DVARAVATI PERIOD		
700	MEDIEVAL PERIOD	HINDU-JAVANESE STYLE		SRIVIJAYA AND SAILENDRA KINGDOMS
800			KOULEN — 802	HINDU CENTRAL JAVA
900			FIRST ANGKOR PERIOD — 877	
1000			— 1002	EAST JAVANESE PERIOD
1022		CAMBODIAN DOMINANCE	SECOND ANGKOR PERIOD	
1100				
1200			— 1201	SINGASARI
1250	*Sultanate of Delhi*	SUKHODAYA PERIOD	THAI DOMINANCE	MAJAPAHIT
1310				
1336				
1378	VIJAYA-NAGAR PERIOD		*Sack of Angkor* — 1437	
1400		AYUDHYA PERIOD		
1500				WAYANG STYLE / ISLAMIC STYLE
1526		MUGHAL DYNASTY		
1600	*RAJPUT STYLE*			
1646	MADURA PERIOD			
1756				
1767				
1900				

Matching colors across the chart indicate cultural continuities across geographical and political boundaries.

CHINA	KOREA	JAPAN	THE WEST
NEOLITHIC *Painted Pottery Culture* / *Black Pottery Culture*			**NEOLITHIC** *Early Mesopotamian Culture and Egyptian Old Kingdom*
BRONZE AGE —1766			**BRONZE AGE** *New Kingdom in Egypt*
AO PERIOD			
[SH]ANG DYNASTY			
ANYANG PERIOD —1045	**NEOLITHIC**		**IRON AGE**
[EARL]Y ZHOU [PE]RIOD / WESTERN ZHOU DYNASTY		**NEOLITHIC**	*Assyrian Empire*
[MI]DDLE [ZH]OU [P]ERIOD —722			*Rise of Greek Art*
EASTERN ZHOU DYNASTY — *Spring and Autumn Annals* —481 / [L]ATE [ZH]OU [PE]RIOD — *Warring States* —221		**JOMON PERIOD**	*Alexander the Great*
QIN DYNASTY —206	**BRONZE AGE**	**BRONZE-IRON AGE**	
WESTERN HAN DYNASTY —9 / 25	**IRON AGE** —108 / —57	**YAYOI PERIOD**	*Roman Art of The Early Empire*
EASTERN HAN DYNASTY —220	**NAKNANG PERIOD** —313		
[TH]REE KINGDOMS-[SI]X DYNASTIES —589	**THREE KINGDOMS PERIOD**	**KOFUN PERIOD** (*Haniwa Culture*) —552	*Early Byzantine Art*
SUI DYNASTY 581 —618		ASUKA (SUIKO) PERIOD —645	
[T]ANG DYNASTY	**UNIFIED SILLA KINGDOM** —668	**NARA PERIOD** —794	*Charlemagne*
		JOGAN PERIOD —897	
FIVE DYNASTIES —907 / —960	—935 / 918	**HEIAN PERIOD** / FUJIWARA PERIOD —1185	*Romanesque Art*
NORTHERN SONG DYNASTY —1127	**KORYO KINGDOM**		*Gothic Art*
SOUTHERN SONG DYNASTY —1279		KAMAKURA PERIOD —1333	
[Y]UAN DYNASTY —1368	—1392	NAMBOKUCHO PERIOD —1392	*Renaissance*
[M]ING DYNASTY	**YI (LI) DYNASTY**	ASHIKAGA (MUROMACHI) PERIOD —1573	
—1644		MOMOYAMA PERIOD —1615	*Baroque* / *Rococo*
[Q]ING DYNASTY —1912	—1910	TOKUGAWA (EDO) PERIOD —1868	*Impressionism and Post-Impressionism*

CHRONOLOGICAL TABLES

INDIAN ART

Pre-Buddhist Period Early times–c. 322 B.C.

 Indus Valley Civilization c. 2500–c. 1500 B.C.

 Aryan Invasions c. 2000–c. 1500 B.C.

 Saisunaga-Nanda Period 642–322 B.C.

Period of Buddhist Dominance c. 322 B.C.–
 after A.D. 600

 Maurya (Asoka) Period 322–185 B.C.

 Sunga Period 185–72 B.C.

 Andhra Period c. 70 B.C.–3rd century A.D.

 (Satavahana Dynasty 220 B.C.–A.D. 236)

 Kushan Period (including Gandhara)
 c. A.D. 50–320

 Gupta Period (including Harsha) A.D. 320–647

Medieval Period c. A.D. 600–c. 1200

 Pallava Period (south) c. A.D. 500–c. 750

 First Chalukyan Period (central Indian) A.D. 550–
 753

 Rashtrakutan Period A.D. 753–c. 900

 Pala and Sena Periods (Bengal) c. A.D. 730–c. 1197

 Medieval Kingdoms of Rajputana
 and the Deccan (north) c. A.D. 900–c. 1190

 Chola Period (south) Mid-9th century A.D.–1310

Later Medieval Period A.D. 1200–1756

 Sultanate of Delhi (north)
 c. A.D. 1200–14th century

 Vijayanagar Period (south) A.D. 1336–1646

 Madura Period (south) A.D. 1646–c. 1900

 Mughal Dynasty A.D. 1526–1756

 Rajput Style (north) c. A.D. 1500–c. 1900

SOUTHEAST ASIAN AND INDONESIAN ART

THAILAND

Ban Chieng Culture c. 2000–c. 700 B.C.

Dvaravati Period (Indian influence) 6th–
 10th century A.D.

 Hindu-Javanese Style c. A.D. 700–c. 1000

Cambodian Dominance A.D. 1022–c. 1250

Sukhodaya Period c. A.D. 1250–1378

Ayudhya Period A.D. 1378–1767

 Ayudhya and Lopburi Schools

CAMBODIA

Pre-Angkor Period (Early Khmer; Indian influence)

 "Fu-nan" ?–c. A.D. 600

 "Chen-la" c. A.D. 600–802

 Koulen (Transitional Period) A.D. 802–877

First Angkor Period A.D. 877–1002

Second Angkor Period A.D. 1002–1201

Sack of Angkor A.D. 1437

JAVA

Central Java 7th and 8th centuries A.D.

Srivijaya and Sailendra Dominance from
 Sumatra c. A.D. 750–c. 850

Hindu Central Java c. A.D. 850–c. 930

East Javanese Period c. A.D. 930–1478

Muhammadan Conquest 15th and 16th centuries A.D.

Wayang (Native) Style 15th century A.D. to date

CHINESE ART

Shang Dynasty 1766–1045 B.C.

 Capital at Ao 1766–1300 B.C.

 Capital at Anyang 1300–1045 B.C.

Zhou Dynasty 1045–256 B.C.

 Western Zhou Dynasty 1045–771 B.C.

 Eastern Zhou Dynasty 771–256 B.C.

 Period of Spring and
 Autumn Annals 722–481 B.C.

 Period of Warring States 481–221 B.C.

 Stylistic dating of Zhou Period:

 Early Zhou Period 1045–c. 900 B.C.

 Middle Zhou Period c. 900–c. 600 B.C.

 Late Zhou Period c. 600–222 B.C.

Qin Dynasty 221–206 B.C.

Han Dynasty 206 B.C.–A.D. 220

 Western Han Dynasty 206 B.C.–A.D. 9

 Eastern Han Dynasty A.D. 25–220

Six Dynasties A.D. 220–589

 Northern Dynasties A.D. 317–581

 Northern Wei Dynasty A.D. 386–535

 Northern Qi Dynasty A.D. 550–577

 Southern Dynasties A.D. 420–589

Sui Dynasty A.D. 581–618

Tang Dynasty A.D. 618–907

Five Dynasties A.D. 907–960

Liao Kingdom (in Manchuria) A.D. 936–1125

Song Dynasty A.D. 960–1279

 Northern Song Dynasty A.D. 960–1127

 Southern Song Dynasty A.D. 1127–1279

Yuan Dynasty A.D. 1280–1368

Ming Dynasty A.D. 1368–1644

 Stylistically significant reigns:

 Yong Le A.D. 1403–1424

 Xuan De A.D. 1426–1435

 Cheng Hua A.D. 1465–1487

 Zheng De A.D. 1506–1521

 Jia Jing A.D. 1522–1566

 Wan Li A.D. 1573–1619

Qing Dynasty A.D. 1644–1912

 Stylistically significant reigns:

 Kang Xi A.D. 1662–1722

 Yong Zheng A.D. 1723–1735

 Qian Long A.D. 1736–1795

 Jia Qing A.D. 1796–1820

KOREAN ART

Neolithic, Bronze, Iron Ages c. 6000 B.C.–A.D. 300

Naknang (Han Chinese Dominance) 108 B.C.–A.D. 313

Three Kingdoms 57 B.C.–A.D. 668

 Koguryo Dynasty 37 B.C.–A.D. 668

 Paekche Dynasty 18 B.C.–A.D. 663

 Old Silla Dynasty 57 B.C.–A.D. 668

Unified Silla Kingdom A.D. 668–935

Koryo Period A.D. 918–1392

Yi (Li) Dynasty A.D. 1392–1910

JAPANESE ART

Archaeological Age Early times–A.D. 552

 Jomon Period Early times–200 B.C.

 Yayoi Period 200 B.C.–A.D. 200

 Kofun Period (Haniwa Culture) A.D. 200–552

Asuka (Suiko) Period A.D. 552–645

Nara Period A.D. 645–794

 Early Nara (Hakuho) Period A.D. 645–710

 Late Nara (Tempyo) Period A.D. 710–794

Heian Period A.D. 794–1185

 Early Heian (Jogan) Period A.D. 794–897

 Late Heian (Fujiwara) Period A.D. 897–1185

Kamakura Period A.D. 1185–1333

Nambokucho Period (Northern
and Southern Courts) A.D. 1333–1392

Ashikaga (Muromachi) Period A.D. 1392–1573

Momoyama Period A.D. 1573–1615

Tokugawa (Edo) Period A.D. 1615–1868

 Early Tokugawa Period A.D. 1615–1716

 Late Tokugawa Period A.D. 1716–1868

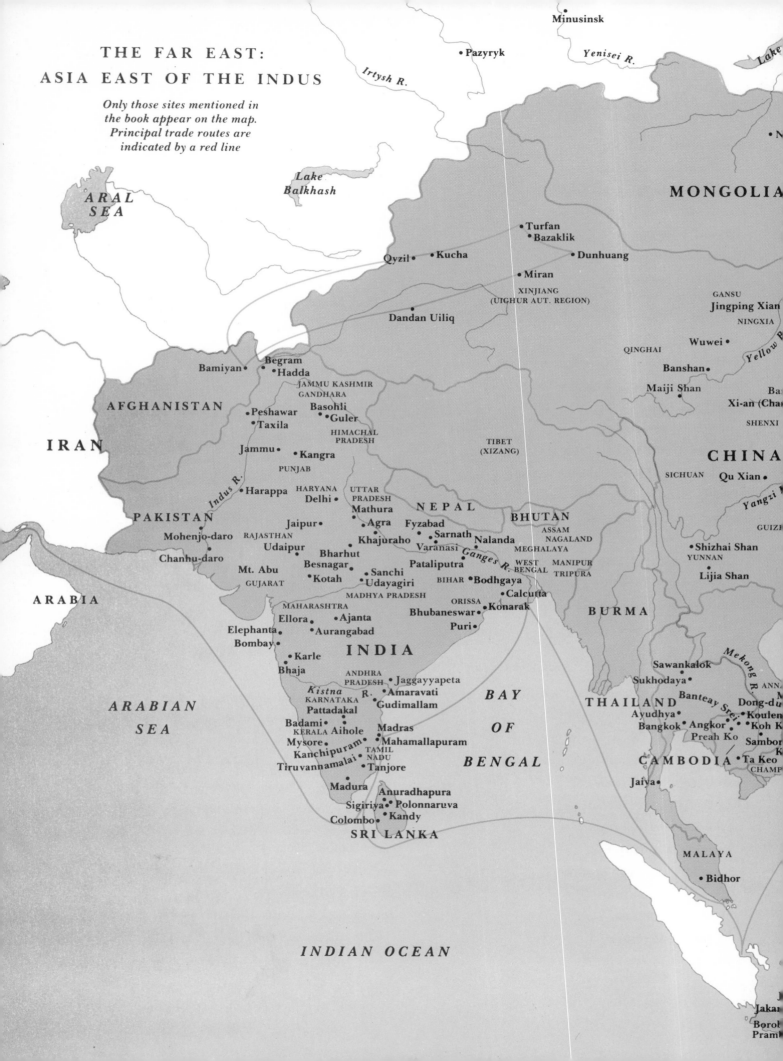

THE FAR EAST:
ASIA EAST OF THE INDUS

*Only those sites mentioned in
the book appear on the map.
Principal trade routes are
indicated by a red line*

Minusinsk

• Pazyryk

Irtysh R.

Yenisei R.

Lake

MONGOLIA

*ARAL
SEA*

*Lake
Balkhash*

• Turfan
• Bazaklik

• Dunhuang

Qyzil • • Kucha

• Miran

GANSU
Jingping Xian

XINJIANG
(UIGHUR AUT. REGION)

NINGXIA

• Dandan Uiliq

QINGHAI

Wuwei

Yellow R.

Banshan •

Bamiyan • • **Begram**
• **Hadda**

JAMMU KASHMIR
GANDHARA

Maiji Shan •

Ba
Xi-an (Cha

AFGHANISTAN

• Peshawar
• Taxila

Basohli
• **Guler**

HIMACHAL
PRADESH

TIBET
(XIZANG)

SHENXI

CHINA

IRAN

Jammu • • **Kangra**

PUNJAB

SICHUAN

Qu Xian •

Yangzi R.

• Harappa

HARYANA
Delhi •

UTTAR
PRADESH

NEPAL

BHUTAN

ASSAM
NAGALAND

GUIZH

PAKISTAN

Jaipur •

Mathura •

Fyzabad •

MEGHALAYA

• **Shizhai Shan**

Mohenjo-daro •

RAJASTHAN

• Agra

• **Sarnath**
Varanasi • **Nalanda**

Ganges R.

WEST
BENGAL

MANIPUR
TRIPURA

YUNNAN

Chanhu-daro •

Udaipur •

Khajuraho •

Bharhut •

Pataliputra •

BIHAR • **Bodhgaya**

• Lijia Shan

Mt. Abu •

Besnagar •
• Kotah

• Sanchi
• Udayagiri

• **Calcutta**

ORISSA

• Konarak

ARABIA

MADHYA PRADESH

Bhubaneswar •

Puri •

BURMA

MAHARASHTRA

Ellora •

• Ajanta

Elephanta •
Bombay •

• Aurangabad

INDIA

Mekong R.

Sawankalok •

• Karle

Sukhodaya •

ANN

Bhaja •

ANDHRA
PRADESH

THAILAND

Banteay Srei

Dong-du

*ARABIAN
SEA*

*Kistna
R.*

• Jaggayyapeta

• Amaravati
Gudimallam

*BAY

OF

BENGAL*

Ayudhya •
Bangkok •

Koulen
Angkor •

• Koh K

KARNATAKA

Pattadakal •

Preah Ko •

Sambor

Badami •

Aihole

Madras •

CAMBODIA

Ta Keo

Mysore •

• Mahamallapuram

K

Kanchipuram •

TAMIL
NADU

Jaiya •

CHAMP

Tiruvannamalai •

• Tanjore

Madura •

• Anuradhapura

Sigiriya • • Polonnaruva

Colombo • • Kandy

SRI LANKA

MALAYA

• Bidhor

INDIAN OCEAN

Jakar

Borob
Pram

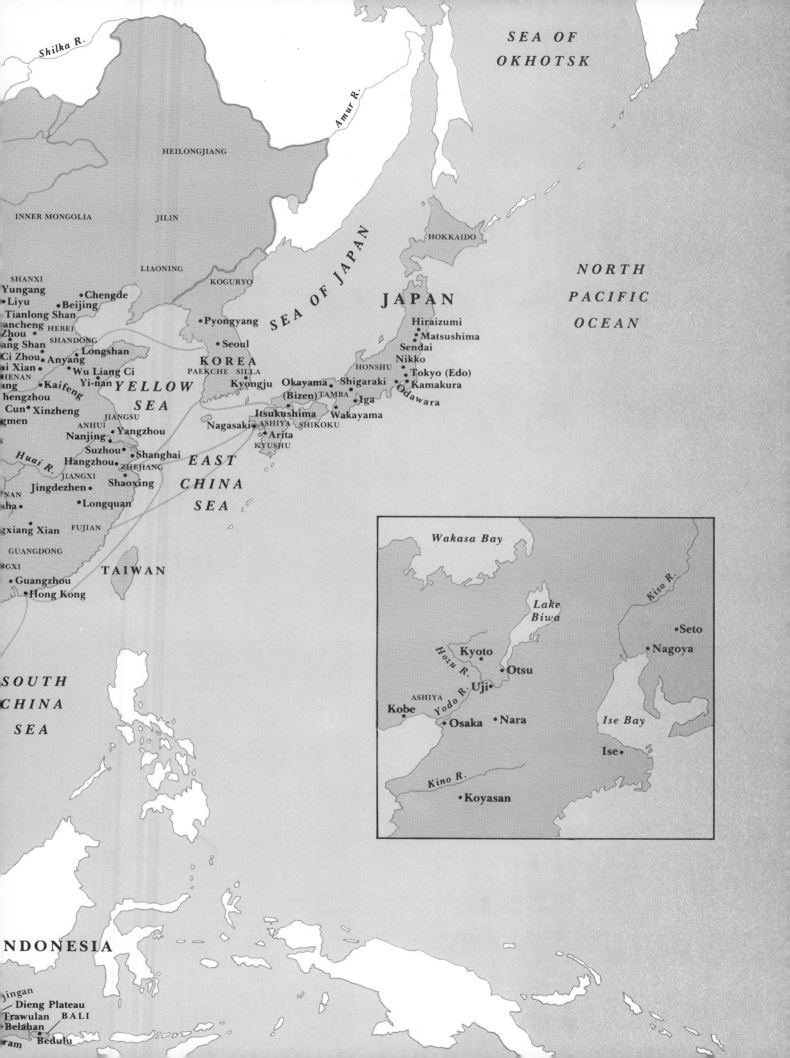

CHINESE

The letters of the *pinyin* and Wade-Giles romanizations approximate in pronunciation the italicized letters in the words in the "equivalent" column.

pinyin	Wade-Giles	equivalent	pinyin	Wade-Giles	equivalent
f	f	*f*ee	eng	eng	su*ng*
h	h	between *h*ot and I*ch* (German)	i	i	between d*i*n and d*ea*n, except after *s, ss, sz, sh, ch, ch', zh*
l	l	*l*ad			
m	m	*m*ight	(s)i	(ss)u	hidd*e*n
n	n	*n*o	(sh)i,	(sh)ih,	
r	j	between *r*ust and *j*eune (French)	(ch)i,	(ch')ih,	*bur*r
s	s, ss, sz	*s*eat	(zh)i	(ch)ih	
x	hs	between *s*eat and *sh*eet	ia	ia	*y*acht
w	w	*w*alk	ian	ien	between *y*en and *yan*k
b	p	*b*ought	iang	iang	*h*e + *ang*
p	p'	*p*ie	iao	iao	*yow*l
d	t	*d*ot	ie	ieh	*y*en
t	t'	s*t*arling	in	in	between *i*n and d*ea*n
g	k	*g*old	ing	ing	si*ng*
k	k'	*c*ut	iong	iung	*jung* (German)
c	ts', tz'	po*ts*	iu	iu	between *you* and L*eo*
z	ts, tz	pa*ds*	o	o	*o*ff
j*	ch	*g*in	ong	ung	*jung* (German)
zh*	ch	*j*olt	ou	ou	s*ew*
q*	ch'	*ch*eap	ou	u	s*ew*, after *y*
ch*	ch'	*ch*alk	u	u	t*oo*
sh	sh	*sh*oe	u	ü	d*u* (French), after *j, q, y, x*
y	y	*y*oung	ua	ua	*wa*nt
a	a	h*a*rd	uai	uai	*wi*ne
ai	ai	p*ie*	uan	uan	*wa*nt
an	an	*wa*nt, except after *y*	uan	üan	d*u* (French) + *yan*k, after *j, q, y, x*
yan	yen	between *y*en and *yan*k			
ang	ang	*Ang*st (German)	uang	uang	*wan* + si*ng*
ao	ao	cl*ou*d	ui	ui, uei	w*eigh*
e	e	between tak*e*n and d*u*n	ue	ueh	d*u* (French) + y*et*
e	e	*o*ff, after *h, k, k'*	un	un	between *un*der and *Ow*en
ei	ei	*eigh*t	uo	o, uo	t*ow*ard

* *Pinyin j* and *zh, q* and *ch* are not distinguished in Wade-Giles transcription but differ in pronunciation: *j* and *q* are "dry" sounds, pronounced with tongue flattened against the upper palate; *zh* and *ch* are "wet," spoken with the tip of the tongue curled up to touch the upper palate.

INDIAN LANGUAGES (mostly SANSKRIT)

Vowels in general are pronounced as in Italian; short *a* is pronounced as *a* in "*A*merica," never as *a* in "m*a*n." *G* is always hard, as in "*g*o." *C* is pronounced as in "*ch*urch," *s* as in "*sh*ip," *h* as in "lo*ch*"; *kh* and *gh* in Persian words (e.g., "Mu*gh*al") are pronounced somewhat like "lo*ch*." In Indian languages, *h* following another consonant (e.g., B*h*utesar, An*dh*ra, *Kh*ajuraho) should be distinctly sounded. Other consonants are pronounced approximately as in English. Diacritical marks appear only in the index.

JAPANESE

Vowels in general are pronounced as in Italian. Consonants in general are pronounced as in English. *G* is always hard, as in "*g*o." Two vowels in sequence are always pronounced separately (never as a diphthong):

Taira: f*a*ther + b*ee*n
Koetsu: *ough*t + *e*nd

Macrons, which appear only in the index, indicate that the vowel is to be held somewhat longer: Onjō.
In general, all syllables receive equal stress.

NOTE TO THE READER

Those works are *in situ* for which no museum or collection is named in the captions. Measurements are not given for objects that are inherently large (architecture, architectural sculpture, gardens, temple sites). Dates in the captions are based on documentary evidence, unless preceded by "c." Inclusive period dates are listed in the Comparative Time Chart and Chronological Tables at the beginning of the book. A list of photographic credits for the illustrations appears at the end of the book. The notes, indicated by superior numbers in the text, appear in a separate section preceding the Bibliography. All diacritical marks are omitted from the text and appear in the Index.

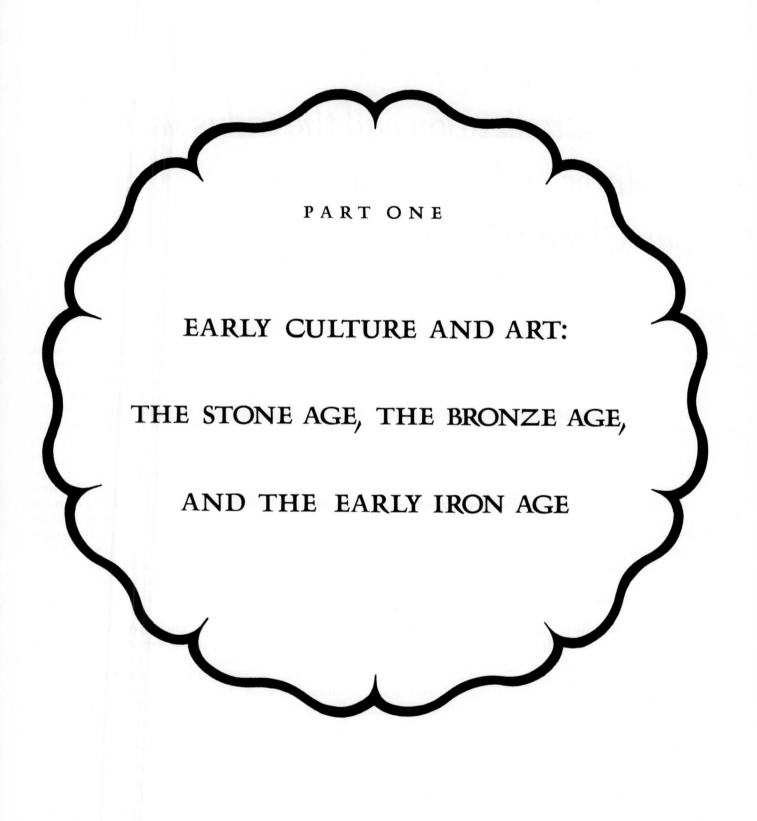

PART ONE

EARLY CULTURE AND ART:

THE STONE AGE, THE BRONZE AGE,

AND THE EARLY IRON AGE

1

Urban Civilization and the Indus Valley; Neolithic and Pre-Shang China; Ban Chieng Culture

Many books on Oriental art have adopted the now classic opening statement, "Asia is one," with which Okakura Kakuzo began his book, *The Ideals of the East.* The statement is far from true. Asia is not even one continent geographically; and the idea that the cultures of Asia are one, that there exists such a thing, for example, as the "Oriental mind," or that all the peoples of these regions are united by a highly developed metaphysical approach to life, is false. In his many writings Ananda Coomaraswamy developed with great insistence the view that Chinese, Japanese, and Indian artists all worked within a single metaphysical framework. This attitude is understandable, even though it is biased. Asian countries, remote from far Western centers of culture and evolving in isolation from all but superficial contacts with them, were ravished by adventurers who represented only an unfortunate aspect of the Western world. Such intrusions made Asians particularly aware of their traditional ideals. They forgot the discrepancies, the contrasts, and the multiple factors that were also a part of their heritage and spoke only of what they treasured most and liked to believe was their unique contribution, in contrast to the assumed aggressive materialism of the West. Such error is all too human and is present in Christian attitudes toward "savages," in Muslim opinion of the Hindu, or in the peculiar serenity of the Chinese, who called their country the Middle Kingdom, believing that it was the center of the universe.

This book does not accept these attitudes, and begins with the idea that Asia is not one, but many.

It is a collection of peoples, of geographic areas, and, finally, of cultures. Each has its own assumptions, its own views and uses of art. There are, of course, influences and counter-influences; there are interweaving patterns derived from religion, from the migrations of peoples, and from the effects of trade and commerce. We are, then, confronted in Asia with many different entities. It is impossible, for example, to speak even of Chinese art as if there were one "mystique" behind the whole. We have to speak of Chinese art of the Bronze Age and of Chinese art in the more sophisticated periods of the Tang and Song dynasties. We shall see those Japanese arts that are partially derived from Chinese art; but then we must examine even more carefully those arts that are uniquely Japanese and radically different, not only in appearance but in motivation, from those of China.

With this approach in mind, we can survey the arts of the countries of eastern Asia: India and Nearer India—that is, Nepal and Sri Lanka; Farther India—that is, Cambodia and Thailand; and Indonesia—that is, Java and Sumatra; and China, Korea, and Japan. We include Central Asia insofar as it was a passageway between India and East Asia and a means of transmitting certain influences from the Western world to the Far East.

Asian art begins with the emergence of man as a species in both Java and China. The earliest Hominidae developed a half million or more years ago, and the first evidences of human, purposeful effort are the rude stone choppers found in the dwelling areas of Java, Lantian, and Beijing (Pe-

king) man. These Early Stone Age artifacts are the first in a series of stone implements that progresses through Mesolithic flaked hatchets, points, and flaked scrapers to the honed and polished stone implements and beads of Neolithic origin. The investigation of Stone Age man in Asia is still in its beginnings; and until the undoubtedly numerous remains from India, Central Asia, China, and Indonesia are found, studied, and related, a general summary would be meaningless. The last decade alone has seen a great proliferation of material remains from all areas of China, materially altering previous prehistorical studies and conclusions.

But the great transition that really begins the story of art for us in Asia is that same transition that begins the story of developed civilized art everywhere in the world: the transition from a nomadic, food-seeking, hunting culture to a village and finally to an urban, food-storing, surplus-using culture. This evolution did not occur in China until perhaps 2000 B.C., and in the Indus Valley of northwest India perhaps just before 2200 B.C. With this change we enter also into the realm of complex art forms.

INDUS VALLEY CIVILIZATION

In the Indus valley Indian and English excavators found an extraordinary culture, one of the most recent discoveries of a major civilization. In the early 1920s the excavations were haphazardly conducted, and the importance of the site was not realized until Sir John Marshall dug at Mohenjo-daro and at the second city, Harappa. The culture, sometimes called the Mohenjo-daro or Harappa culture, is now most often referred to as the Indus Valley civilization. In the early 1930s, to the excitement of the archaeological world, remarkable finds were made, and excavations interrupted by World War II are now continuing. Here was a full-bloom urban culture comparable in extent and quality to those of Mesopotamia and Egypt. The fragments of script remaining have not as yet been surely deciphered, and we are only now beginning to learn an appreciable amount about the life of these cities.

An aerial view of the excavations at Mohenjo-daro reveals that subsidiary buildings and structures were axially oriented with relation to certain main streets, indicating that the city was highly organized politically and socially and not just an agglomeration of dwellings along a road or river (*fig. 1*). Not only was its plan an orderly one; it had a highly developed irrigation and sewage system as well. There were numerous buildings of some size, such as the so-called Great Bath. What this structure was used for we do not know, but there have been some fascinating speculations. Some have suggested that the inhabitants of Mohenjo-daro kept crocodiles or other aquatic animals in the pool; others guess that it was a place where wealthier citizens bathed. In any event, it was a sizable public structure with a most elaborate drainage system to keep the water fresh. Cubicles and rooms around the tank were

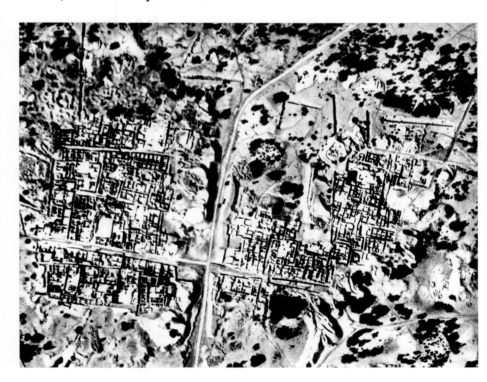

1. *Mohenjo-daro, India.* Aerial view. Indus Valley culture

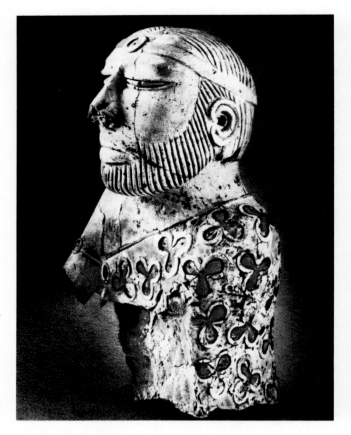

2. *High Priest.* Limestone, height 7". Mohenjo-daro, India. Indus Valley culture. National Museum, New Delhi

3. *Nude male torso.* Red sandstone, height 3 3/4". Harappa, India. Indus Valley culture. National Museum, New Delhi

perhaps intended for use by priests or bathers. The Great Bath was a large and important structure implying a socially and technically advanced society.

In the early years of the excavations, fortifications and citadels seemed conspicuously absent at both Mohenjo-daro and Harappa. Utopian idealists were tempted to hope that they had found the perfect society, composed of a peace-loving people, war-riorless and classless—a prototype of the ideal state. But in 1946 Sir Mortimer Wheeler began to excavate at Harappa and found the citadel. He studied a large and previously ignored mound, cut across it very carefully, and found the fortress. Here the military rulers of the Indus Valley had lived and here, as their piled-up bodies suggest, they had met their end, probably at the hands of Aryan invaders, about 1500 B.C. Indus Valley culture was at its peak from about 2200 to 1800 B.C., and sometime between 2000 and 1500 B.C. waves of Aryan invasions utterly destroyed it.

Numerous important works of art were found at both Mohenjo-daro and Harappa. The fine-grained limestone bust of a man, approximately seven inches in height, has traces of color on the trefoil pattern of the robe (*fig. 2*). The type of representation is of interest because it appears to be related to some of the early Sumerian figures, particularly those found

at Tello and Ur. The figure, a formal, dignified, sculptural achievement, calls to mind a deity, priest, or important official, and is therefore referred to as "High Priest." The suggestion has been made that the downcast eyes portray a yoga disciple of con-templation, but this hardly seems likely. It is a formal and hieratic sculpture. This is of interest, as two radically different types of sculpture are found in the Indus Valley: one, this formal type, and the other a highly naturalistic, "organic" type. The latter style can be seen in the red sandstone torso from Harappa, about four inches high (*fig. 3*). Some skeptics deny that this sculpture is of the period and believe it represents a considerably later style, of perhaps the second or first century B.C. The consensus, however, is that the figure does date from the Indus Valley period, and this is not difficult to believe in view of other objects that have been found. The Harappa figure is suavely modeled, with a tendency toward what we shall call organic style; that is, the forms seem natural and living, soft and flowing, rather than crystalline and angular in structure as are some inorganic forms. It shows intelligent study of the human body—what it looks like and how it works—and that study has been appropriately expressed in the material. This con-cept of organic sculptural style is particularly signif-icant in later Indian sculpture. No one has satis-

factorily explained the curious circular drill impressions in the shoulders. Perhaps they were meant for the attachment of movable arms; or, less likely, they are symbolic markings. Only two stone figures of this organic type were found; the other is in a dancing pose.

In early Egyptian and Mesopotamian art, artists apparently disregarded or lacked interest in the way the body looks and moves, and attempted to make it timeless and static, frozen in space. This Indus type, however, seems much more of the moment, more immediate in the reaction of the artist to the subject and in the communication of that reaction to the spectator. The whole effect is rather like the feeling of surprising immediacy one receives from Magdalenian painting of bison, deer, or antelope. The Indus Valley sculptor seems to have breathed the shape and form of the human body into stone, even causing it to appear soft. To what extent this organic style is influenced by clay modeling it is impossible to say, but some such influence seems likely.

The work that provides a link between the organic and the more formal, hieratic styles of the Indus Valley culture is a copper figure of a dancing girl from Mohenjo-daro (*fig. 4*). The excavation reports indicate quite clearly that it was found with Indus Valley pottery and other materials. Further, the head, particularly the way in which the eyes and the nose are modeled, recalls the limestone "High Priest" of figure 2. But in the modeling of the back and the side one sees the same organic style as is found in the red sandstone torso of figure 3. This sculpture was certainly influenced by clay modeling, for of course the figure had to be modeled in clay or wax before it could have been cast in bronze. The elaborate asymmetrical hairdo much resembles those found in later Indian sculpture, and the use of bangles and the nudity of the figure are also in keeping with later Indian practice. The type and pose of the little dancer may be related to clay fertility images, such as those found throughout the ancient Near East. A considerable point has been made of the Negroid features of the dancing girl, which seem to confirm the theories of certain ethnologists on the movements of ethnic strains in India. She may represent one of the Negroid peoples still found in south India, where they presumably migrated when forced out of northwest India by the Aryan invasions of about 1500 B.C. or slightly earlier.

The usual implements of an early culture—all kinds of bangles, beads, toys for children, copper knives and spindles, all the impedimenta of the kind that pile up in one's attic—were found in the Indus

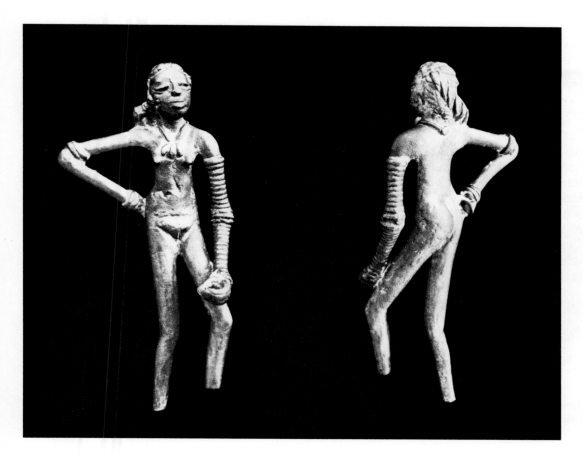

4. *Dancing girl.* Copper, height 4 1/4". Mohenjo-daro, India. Indus Valley culture. National Museum, New Delhi

excavations. Among them are extraordinary large storage jars with painted designs of birds and animals in an organic style, which seem to be related to even earlier Neolithic potteries of the region (*fig. 5*). The geometric patterns in these designs seem to be derived from plant life.

The most distinctive creations of the Indus Valley artist are the stamp seals, found in considerable quantity and inscribed with legends in the still undeciphered Indus Valley script. They are carved in fine-grained steatite, and most of them are in the form of rectangular stamps rather than in the cylindrical shape characteristic of Mesopotamian seals. Carved in intaglio, the designs on Indus Valley seals often have an animal as their principal subject. A few have figures, alone or with animals. One famous seal displays a seated figure in a yogi-like pose (*fig. 6*), and another presents a combat between a cow-headed female and a tiger. But the characteristic seals are those depicting bulls, mostly bulls with big humps (*fig. 7*). In subject matter one or two of the seals showing combat scenes are like those found in Mesopotamian sites. Stylistically, however, they differ. The seals of the Mesopotamian region tend either to be geometric, as in the very earliest examples, or to move in the direction of a highly stylized expression that cleverly uses drilling and incision to give an effect of movement and a degree of naturalism. On the other hand, the Indus

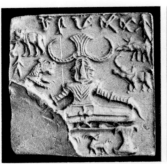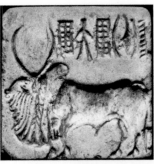

6. (above left) *Square stamp seal*. Design: Siva, with inscription. White steatite, width 1 3/8″. Mohenjo-daro, India. Indus Valley culture. National Museum, New Delhi

7. (above right) *Square stamp seal*. Design: Two-horned bull with inscription. Steatite, width 1 1/4″. India. Indus Valley culture. Cleveland Museum of Art

Valley seals are painstakingly and fully modeled, with sleek outlines and very few traces of the tool or technique. The Indus carver tended to obliterate the evidences of technique in order to achieve a stylized but naturalistic effect, while the Mesopotamian artist seemed to delight in playing with tool marks. The Mohenjo-daro seals are midway between the organic figures and the hieratic figures of the "High Priest" type.

Indus Valley seals also provide us with a means of correlation with the early cultures of Mesopotamia, and allow us to date the Indus Valley civilization with some certainty. Seals of the Indus type have been found in Mesopotamia in Akkadian sites at levels that allow us to arrive at dates for the Indus Valley civilization of at least as early as 2500 to 1500 B.C. The Indus Valley culture does not appear to be as old as the Mesopotamian culture or the Egyptian "river culture," and may well have received stimuli from these, but it is still one of the four great river-cradles of civilization: the Nile, the Tigris-Euphrates, the Indus, and the Yellow River, to the last of which we now turn.

NEOLITHIC AND PRE-SHANG CHINA

Till recently the Xia and Shang dynasties were considered mythical, but continuing excavations in the People's Republic of China have revealed more and more of their existence and of the accompanying development of bronze technology. These excavations have also established a firm and complex picture of Neolithic China. They have steadily confirmed our growing understanding that Chinese

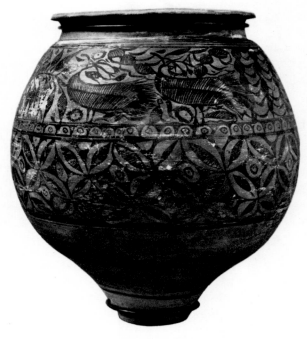

5. *Storage jar*. Earthenware, height 20 3/4″. Chanhu-daro, India. Indus Valley culture. Museum of Fine Arts, Boston

culture was largely developed in what is still the heartland of China—Henan, Shenxi, and Shanxi provinces. The hard information provided by archaeology has now made questions of the priority of Painted Pottery or Black Pottery culture, the absolute dates of early Neolithic culture, far less speculative and more certain. One basic fact remains. The various native contributions and the now far more hypothetical and remote foreign contributions provided the catalytic unity necessary to produce the great Bronze Age of China.

Although we still can discern two major Neolithic cultures in the Yellow River heartland—the Painted Pottery culture with its relatives in the western plateau and the Black Pottery culture with its extensions to the east in Shandong and Zhejiang— the priority of Painted Pottery culture is clearly established. Further, its origins are not to be found in the northwest, thus maintaining the possibility of influences from the far West, but in the heartland itself. This area, known to the Chinese as *zhong yuan,* or central plain, has always been the center of the "Middle Kingdom." A possible third Neolithic culture in the near south, but with painted pottery and stone tools related to Yangshao and Longshan respectively, has been found in Jiangsu, notably at Qingliangang.

The type-site (site that sums up the characteristics of a culture) of the earliest and most important Chinese Neolithic culture is Banpo, discovered in 1953 in an eastern suburb of modern Xi-an, which was once the great Tang dynasty capital, Changan. Here, at a protected bend in the Wei River, an extensive village dating at least to the fifth millennium B.C. was founded and intermittently developed by the early Chinese. Their painted pottery (*fig. 8*) provided the prototypes for the pervasive decorated earthenware vessels from Gansu (*colorplate 1, p. 49*), Shenxi, and Shanxi, called Yangshao ware after the later (c. 2500 B.C.) site of that name to the east in Henan. This earliest Neolithic culture is characterized by mostly circular pit-dwellings, a mixed hunting-herding-farming economy, red-bodied painted pottery, the elementary use of jade, and the beginnings of a sign, or at least a numbering, system. These are elements of some significance in later Chinese culture.

Some of the most beautiful of Neolithic painted vessels are those associated with the Banshan burials discovered by Andersson in Gansu in the 1920s. Though their designs are comparable to those of the Anau region near the Black Sea, they now seem more logically to be a development from the earlier painted ceramics of Banpo and Yangshao. The large funerary urn in the Seattle Art Museum is a characteristic Banshan vessel. Sometimes these painted

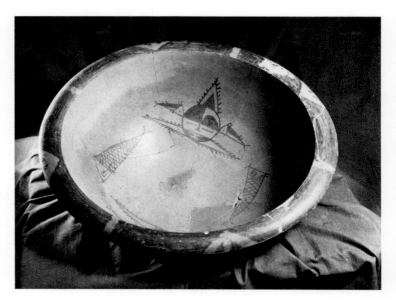

8. *Bowl.* Painted Pottery, red earthenware with black slip decoration; height 7", diameter 15". Banpo, Shenxi, China. Neolithic period, Yangshao culture, c. 4000 B.C. Banpo Museum

potteries have very interesting combinations of geometric and naturalistic designs, the naturalism usually veiled by presentation in a geometric guise. On many urns there are simplified representations of cowrie shells, which have been found in the sites of the Yangshao culture. In many parts of the world the cowrie has been used as money and worn as an amulet because of the magical properties attributed to it, especially those associated with birth and fertility. The combination of the death pattern with one of birth and fertility may be yet another expression of the desire for life after death or, at the very least, for continuity in the social order.

The shapes of the painted pots are always full-blown, and their walls are of very thin red clay. They are usually made by coiling and later by a slow turntable, but wheel-thrown pots are typical of thin Longshan ware and some late Yangshao work from Dahe Cun, Henan. The fundamental method, however, was coiling, building the rolled clay in coils and forming shapes by means of pads and fingers.

The type-site of the second and later Neolithic culture of the plains is Chengziyai, and the culture revealed there is called Longshan. One of the attributes of this plains culture is the use of pounded earth for dwellings and defense walls; it is to be noted that the later Shang people also used pounded earth. Another is the use of a very thin, black pottery. It is perhaps the finest Neolithic pottery made, so thin it reminds one of "egg-shell" porcelain

despite the fact that it is earthenware (*fig. 9*). The elegant shapes seem characteristic of the Longshan culture. A third attribute is the practice of divination by means of a crack pattern produced by the application of a hot point to scraped bone. Though the later Shang peoples substituted the underside, or plastron, of a tortoise for the bone, their purpose was the same: consultation with ancestors by divination. This is a most important link between the Longshan and the later Shang dynastic caltures.

Gray pottery, much of it cord-marked, has been found at most of these Neolithic sites and was used for normal utilitarian purposes. It continues into the Shang dynasty as a useful ware for the common people, while the fine painted and thin black wares are replaced by objects produced by a more sophisticated technology—that of bronze casting. But many of the pottery shapes are continued in the new medium.

One of the most significant of these is the *li* tripod, found in both Neolithic cultures (*fig. 10*). Its appearance suggests that it is the result of making three vases with pointed bottoms and leaning them

9. *Beaker*. Black Pottery, thin biscuit; height 6 1/4″. Weifang, Shandong, China. Neolithic period, Longshan culture, c. 2000 B.C.

together. From this may have developed the tripod with hollow legs, which allowed the heat of the fire the greatest access to the contents of the tripod. The solid-leg tripod was also made, perhaps slightly later. Since the tripod is one of the most important bronze shapes of the Shang dynasty, the *li* demonstrates a definite continuity from Chinese Neolithic culture into that of the Shang Bronze Age.

We also have a few interesting sculptures in stone and jade. They have appeared on the market as a result of "clandestine" excavations or grave robbings, and there is good reason to believe them to be Neolithic, although this is only speculation. Perhaps the most interesting of these is in the Nelson Gallery–Atkins Museum, in Kansas City. It is only about four inches long, an unpolished jade lump that has been formed very simply, following the original boulder shape, into the representation of a bird, with indications of wings and head and with a circular pit for the eye—very simple, very stylized, yet monumental despite its small size (*fig. 11*). Recent excavations in China have revealed more developed jade techniques, notably the invention of the rectangular prism with cylindrical hole later known as the *zong* (*fig. 36*). These artifacts are also distinguished by carefully incised patterns of parallel links and hollow-drilled circular elements that prefigure early Shang jade technique and decoration.

The sequence of these pottery cultures, very important for our knowledge of chronology, has been established in the Anyang region, the type-site for later Shang dynasty culture, notably at Hougang and Houjiazhuang. At the bottom level, which is the earliest of excavated areas, was the Painted Pottery culture, followed, in ascending order, by the Black Pottery culture and the pervasive gray pottery of the central region. Carbon 14 dating has confirmed the stratigraphic evidence and provided beginning dates of at least 5000 B.C. for Yangshao and at least 2000 B.C. for Longshan. So the Neolithic sequence is Yangshao, Longshan, followed by the coalescence of these Chinese cultures in the Shang levels; none of the Neolithic pottery cultures made large-scale or systematic use of metal, and the developed use of metal is the most characteristic feature of Shang culture.

BAN CHIENG

Recent discoveries at Ban Chieng in Thailand have revealed an early Bronze Age culture that must have been prevalent in an area comprising at least present-day northern Thailand and Cambodia. Painted pottery with unusual designs unrelated to those of China or any nearby culture was executed

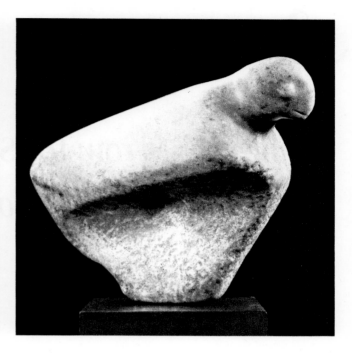

10. *Li tripod*. Earthenware, height 6″. Anyang, Henan, China. Late Chinese Neolithic type. Buffalo Society of Natural Sciences

11. *Bird*. Jade, height 4 1/8″. Chinese Neolithic period. Nelson Gallery–Atkins Museum, Kansas City. Nelson Fund

first in incised and red-painted gray wares and later in red or brown slip on buff earthenware covered with a cream slip. Numerous bronze implements and vessels have also been found, with geometric patterns based on whorls and parallel linear designs. These are dimly related to some slightly later bronzes found in south China. The luxury use of iron as a supplement to bronze ornament in the middle phase of Ban Chieng is a remarkable occurrence that awaits future study.

Various dates, some of them influenced by wishful thinking, have been proposed for this Ban Chieng material, but the earliest Neolithic artifacts date to 3500 B.C., with a classic Bronze Age coeval with China's at 2000–1600 B.C., and with Neolithic painted survivals as late as 600 B.C. All of this is a startling development and one that is still in the process of exploration, evaluation, and future publication by archaeologists from Thailand and the University of Pennsylvania.

2

Chinese Art from the Shang Through the Middle Zhou Period

DISCOVERING CHINA'S BRONZE AGE

The historic texts from the Zhou dynasty onward record in great detail the sequence of Shang and Zhou kings as well as a less certain record of an even earlier Xia dynasty. In the nineteenth century Western interest in China's history brought Western skepticism to bear on these records, which were dismissed as only legendary. In the late nineteenth and early twentieth centuries numerous chance finds were made, in the "wastes of Yin" at Anyang in Henan, of marked and inscribed animal bones and tortoise plastrons (the lower shell). The inscriptions were in pictographs related to developed Chinese characters, and the markings were burns and cracks resembling those found somewhat later on similar materials from the Longshan sites of east China. The finds from Henan were thought by some to be forgeries, by others to be "dragon bones" useful for medicinal purposes, and by a few to be meaningful if puzzling relics from China's distant past. At the same time bronze vessels were clandestinely excavated from the same area, and these were collected and described as "Zhou" relics. In 1928 controlled excavations were begun by the Academia Sinica at Anyang in Henan, and bronzes, inscribed bones and plastrons, jades, stone sculptures, and ceramics were found in royal tombs and in settlement areas. The authenticity of the oracle bones was established and with them the historic existence of the Shang dynasty with its last capital—Yin—at Anyang. These excavations continued through 1937, and such magnificent works were found as those illustrated in figures

16 and 24. Other materials were excavated in clandestine diggings and appeared on the world art market.

Scholars grappled with the wealth of new material and, thanks to Bernhard Karlgren, who first demonstrated the distinctions between Shang and Zhou,

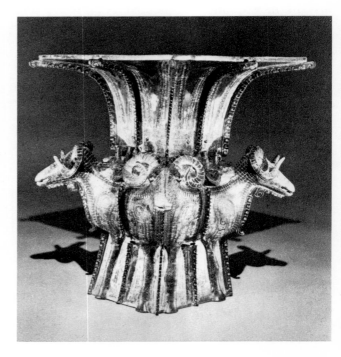

12. *Four-ram fang zun.* Ceremonial wine vessel; bronze, height 23". Ningxiang Xian, Hunan, China. Shang dynasty, Anyang period (c. 1300–1045 B.C.). Historical Museum, Beijing

and Max Loehr, who presented a chronological bronze sequence anticipating an early and middle Shang culture prior to that of Anyang, a Shang dynasty reaching back to the mid-second millennium was recognized. But the weight and extent of confirmation for these hypotheses was astonishing. The archaeologists of the People's Republic of China have accomplished a continuing series of excavations and many salvage finds throughout China. These have not only confirmed a sequence for Shang dynasty materials from before 1600 B.C., but have all but confirmed the historic existence of the Xia dynasty (traditionally 2205–1766 B.C.) and an emerging bronze culture at an even earlier if still uncertain date. The more distant horizon has not only been enlarged chronologically but geographically, for Neolithic and Shang sites have now been encountered as far north as Baode (Shanxi) and in eastern China as well as in the area immediately below the Yangzi River, particularly in Hunan Province (*fig. 12*). This geographic extension of our knowledge of Shang culture and art has greatly increased the complexity of the archaeological picture and is additional confirmation of what must now be quite clear—that the development of decorated pottery and bronze technology was an indigenous Chinese process, accompanying the development of a distinctive language, already anticipated as early as Neolithic Banpo.

SHANG

The accepted sequence of Bronze Age cultures for pre-Shang and Shang is described in terms of the following type-sites:

Erlitou (central Henan): before 1600 B.C. and perhaps equivalent to the first Shang capital, Bo

Erligang 1 and 2 (southeast corner of Zhengzhou, Henan): 1600–1300 B.C. and probably equivalent to the second Shang capital, Ao or Xiao (*figs. 14 and 20*)

Anyang (northern Henan): after 1300–1045 B.C. and the last or seventh Shang capital, Yin (*figs. 15–19, 21, 23–28*)

If the Xia are still somewhat problematical, the Shang are not. Who were they? Certainly the evidence now is overwhelming that they were native Chinese, people of the Central Plain culture and inheritors of the combined wealth of knowledge and inventions of the two dominant Neolithic cultures, Yangshao and Longshan. At their dominant location in the central plain they created the most highly

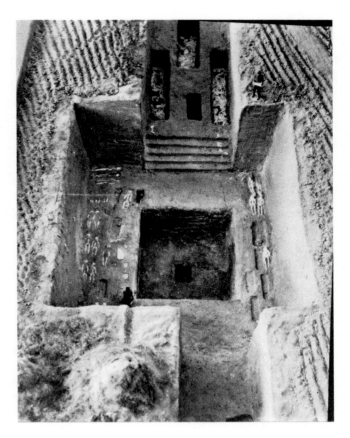

13. *Royal tomb*. Wuguan Cun, Anyang, Henan, China. Shang dynasty

developed bronze technology of the ancient world. Like the Longshan, they practiced divination by applying a heated tool to tortoise plastrons and used pounded earth for building and wall foundations. The shapes of Shang bronzes and ceramics are heavily indebted to the two Neolithic cultures. Elements of their writing and iconography are related to the Yangshao culture, as is the continued use of the *li* tripod. But the invention and development of a written language, the creation of a complex bronze technology with an accompanying refinement of ceramic processes, and the organization of a warlike civilization relying on horse-drawn chariots to control the living and large chamber burials (*fig. 13*) with accompanying human sacrifice to propitiate the dead mark the emergence and dominance of the Shang dynasty.

Although we know increasingly more about the material culture of the Shang, we know far too little about their religion and the extraordinary vocabulary of animal designs dominating their artifacts of jade, stone, wood, and bronze. There is little doubt that these ornaments have meaning and symbolic value, but the nature of this fabulous bestiary is still unknown despite contorted efforts to explain it by

reference to the moon or a phallic deep structure. We do know the questions asked on the oracle bones, for the script is clearly an early but still well-developed form of classical Chinese. These questions indicate a belief in an overlord we can equate with a supreme deity, as well as in various spirits. There was probably a shamanic cult with an important and active priestly class that included the rulers. The oracle bone questions are primarily concerned with the hunt, war, and agriculture: Will the chase tomorrow be successful? Will the forthcoming battle be won? Will this season's crops flourish? We cannot yet know the meanings of what is obviously a complicated symbolism, but we can reasonably assume a highly developed animism combined with a concept of a supreme deity, a belief in magic, and a belief in control by propitiation through the sacrifice of animals and humans. The interpretation of the king's dreams, including visions of ghosts and spirits, plays a part in the oracle bone texts. Let us consider Shang funerary architecture, sculpture, ceramics, and jade, with examples largely from their final and most developed phase, the art of Anyang. A map (p. 29) shows the principal sites: Zhengzhou, probably the second capital; Anyang, the last; and the more recently discovered and outlying sites as far as Ningxiang in Hunan.

Anyang, from about 1300 B.C., was the center of Shang ritual culture. Humble burials have been found there as well as royal, but the number, size, and magnificence of the royal burials, compared

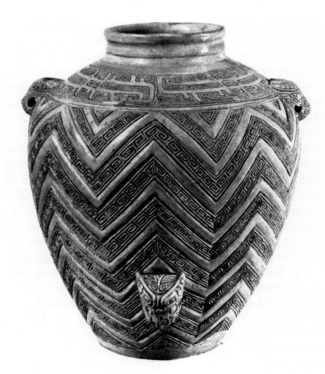

15. *Vessel*. White earthenware with impressed decoration, height 13″. China. Shang dynasty. Freer Gallery of Art, Smithsonian Institution, Washington, D.C.

even with the earlier burials at Zhengzhou, seem to give a special significance to the tombs of Yin. Figure 13, an aerial view of the tomb of Fu Hao, consort of Wu Ding, the twelfth ruler of Shang, conveys some sense of the enormous size of the Anyang tombs—and Fu Hao's, over thirteen by eighteen feet, was by no means the largest. Some were over sixty feet deep. The floor level of Fu Hao's shaft-grave housed the royal corpse and most of the utensils and implements buried with her. Below the corpse was a small pit holding the remains of six sacrificed dogs, and along the perimeters lay the skeletons of sixteen humans. The tomb of Fu Hao is the only undisturbed royal Shang tomb yet excavated, and its wealth is a sure indication of what other discovered tombs once contained: over 440 bronzes, including 200 vessels; nearly 600 jade, stone, and bone carvings (*fig. 18*); and some 7,000 cowrie shells, which, as in so many areas of East Asia and the Pacific, were the coin of the realm.

The riches of this tomb bespeak the extent to which other tombs were looted from Song dynasty times until today. Grave robbers used long copper or bronze probes to locate the salable metal objects they sought and then dug them out, in the process damaging or destroying their archaeological contexts.

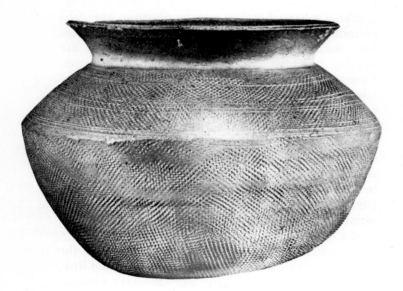

14. *Guan jar*. Proto-stoneware, height 6 1/8″, diameter 8 3/8″. Probably Zhengzhou, Henan, China. Shang dynasty, sixteenth–fifteenth century B.C. Nelson Gallery–Atkins Museum, Kansas City. Nelson Fund

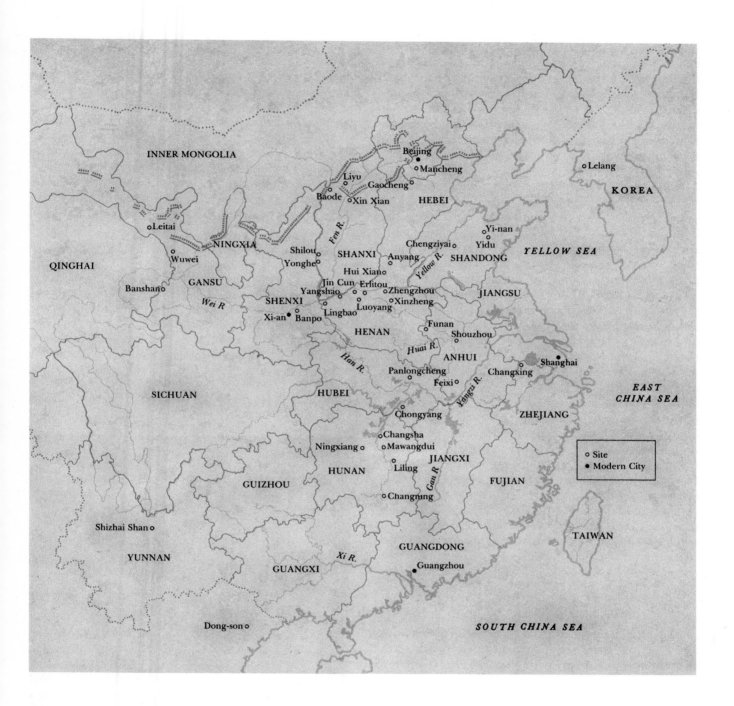

We know, mostly from the evidence of imprints in the soil, that decorated wood architectural members were in use, but we have little else to tell us of Shang architecture. Tentative reconstructions of post-and-lintel structures, with gabled, thatched roofs, standing on raised foundation platforms of pounded earth, suggest a simple bay system of architecture anticipating later developments in both China and Japan.

Coarse gray pottery for everyday use was found in the more ordinary living areas. But the extraordinary discovery of high-fired and glazed stoneware at Zhengzhou (*fig. 14*) pushes the horizon of Chinese porcelain development back over one thousand years, from 400 B.C. to before 1400 B.C. Nearly complete pots and shards have been found in unchallengeable archaeological contexts. The resemblance of these pieces to the much later developments in celadon is remarkable and is probably due to technical discoveries associated with bronze foundry practices and to the presence of suitable clay. The iron glaze appears to be ash-induced and intentional. Still a third type of ceramic is known from Anyang, a white pottery of fine white and chalky clay (*fig. 15*), fired at low temperatures and covered with

impressed and carved designs imitating those on developed Shang bronzes. The usual patterns are a fret interlock or squared spirals with superimposed bands or handles embodying animal masks or designs. Bovine masks in high relief were applied to the surface of the jar in the Freer Gallery. Though numerous shards and incomplete pieces of the white ware have been found, intact examples are extremely rare.

Another innovation of the Shang dynasty is stone sculpture in the round or in high relief, usually of white marble with decoration derived from the dominant bronzes (*fig. 16*). To judge from the mortises on the back of the owl and its companion tiger, these sculptures were used architecturally, as supports either for columns or for platforms of wood. The designs are carefully but strongly cut and show the same rigorous development of the enigmatic symbolic language of snake, mask, cloud-pattern, and dragon. The combination of elegant and refined detail with powerful silhouette contributes to the awesome effect of these beasts with gaping mouths or fierce beaks.

These large sculptures are far less numerous, however, than the small-scale representations of the Shang vocabulary of images in jade amulets and/or ornaments. Regardless of our interpretations of their meaning, these representations are our clearest clues to recognition of the individual elements of the language of Shang ornament. Here one can see the conformation of single units: fish, swallow, owl, man, tiger, elephant. And we can also see their elementary combinations and metamorphoses, less complex and subtle here than in the bronzes. The use of jade was not new; we have mentioned its appearance in Neolithic contexts. But the late Shang technique and repertory in this medium far transcend their predecessors. The simplicity of Neolithic shapes is carried on in long jade blades, necessarily sawed from a reasonably large boulder and then polished to their final shape, often with the addition of incised or, more rarely, thread-relief decoration of the most subtle type (*fig. 17*). Such a jade would have served no useful purpose, since jade is brittle and cannot withstand any sharp and severe impact. Rather we should see such an elegant jade as a ritual replica of usable bronze weapons.

The greatest number of these late Shang jades are representations of animals and, more rarely, humans, often in the round. The large number of jades from the tomb of Fu Hao includes representations of a proto-*feng-huang,* dragons, and birds, separately and combined, and elephants, hawks, and human figures, one of them with a birdlike tail (*fig. 18*). The metamorphic intention can also be clearly seen in a composite head of a feline with large, sharp teeth,

elephant's trunk, and bovine horns. The three elements are smoothly unified within less than two inches of jade (*fig. 19*). It may seem surprising to find an elephant's trunk represented in north China, but a skeleton of the beast was found at Anyang, and even more exotic forms—whale and rhinoceros, for example—indicate the presence of a royal menagerie or park as a fitting adjunct to the Shang royal court. Though elephants may have ranged as far north as Henan at this time, the bronze figure of an Indian rhinoceros at the Asian Art Museum in San Francisco supports the probability of the existence of a royal zoo.

SHANG BRONZES

Although the development of art in the Shang dynasty must have involved all media, bronze was the major vehicle of cultural expression, and this fact, together with the deterioration and loss of the more ephemeral wood, ivory, textile, and lacquer, causes

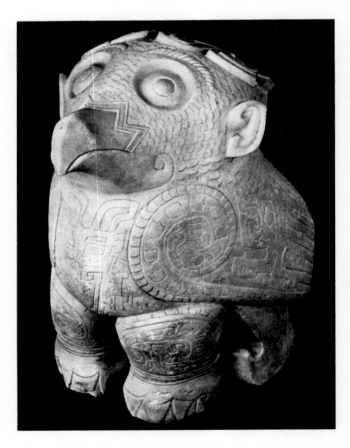

16. *Owl.* Marble, height 17 3/4″. Tomb 1001, Houjiazhuang cemetery site, Anyang, Henan, China. Shang dynasty. Academia Sinica, Taibei

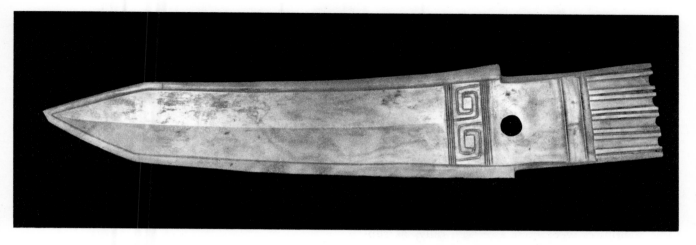

17. *Blade.* White jade, length 17 5/8″. China. Shang dynasty. Collection Ernest Erickson, New York

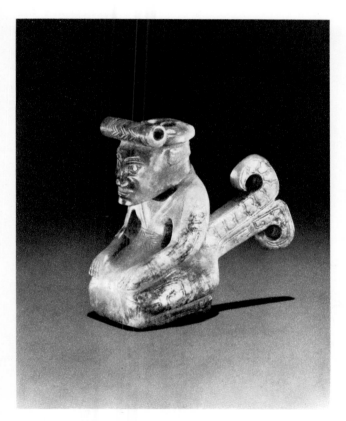

18. *Figurine.* Jade, height 2 3/4″. Tomb of Fu Hao, Anyang, Henan, China. Shang dynasty, Anyang period (c. 1300–c. 1045 B.C.). Institute of Archaeology, Beijing

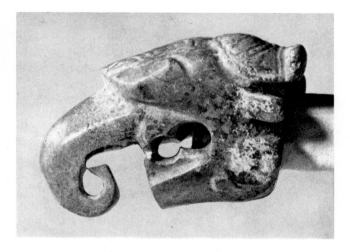

19. *Tiger-Elephant.* Jade, length 1 5/8″. China. Shang dynasty. Cleveland Museum of Art

the artistic evidence for sequential order to be overwhelmingly documented by bronze. Claims that pierced copper pendants or axes have been found at Longshan Neolithic sites remain to be fully proved, but there is little question that an indigenous bronze

technology producing both weapons and utensils is datable at least to early Shang (c. 1600 B.C.) and very likely to Xia (c. 2000 B.C.). A few bronze vessels, including examples of the relatively complex *jue* type (related to the three-legged vessels shown fourth from the left in figure 22), have been found at Erlitou in the first documented phase of Shang culture. These thin-walled vessels are the immediate prototypes for the even more impressive vessels from the earliest phase (Erligang 1) at Ao (Zhengzhou), including the *li he* from the Asian Art Museum of San Francisco (*fig. 20*). The characteristics of these earliest vessels include thin walls, possibly derived from still earlier but as yet unknown sheet copper types; thread-relief ornament, as one might expect from a design first incised on molds in imitation of incised ceramic

20. *Li he*. Ceremonial wine vessel; bronze, height 9″. China. Shang dynasty, sixteenth–fourteenth century B.C. Asian Art Museum, San Francisco

20–A. *Jue*. Ceremonial wine vessel; bronze, height 9 1/8″. Reportedly from Liulige, Henan, China. Early Shang dynasty. Seattle Art Museum

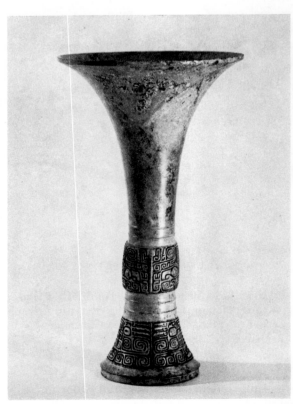

20–B. *Gu*. Ceremonial wine vessel; bronze, height 10 1/2″. China. Middle Shang dynasty. Cleveland Museum of Art

techniques; close relationships to Black Pottery Longshan prototypes, expressed in the large, tapering, hollow legs. The ornament is abstract, like that on Neolithic ceramics, but with clear hints of an underlying mask or dragon design.

Weapons such as the ax and dagger also reveal part of the development of bronze technology and animal representation. The earliest knives are relatively simple, though some of the more elaborate examples from late Shang, related to Siberian knives of the Andronovo (1750–1300 B.C.) and Karasuk (1300–700 B.C. or later) periods, have handles ending in horse, deer, or ibex heads. But the axes of middle and late Shang (*fig. 21*) are purely Chinese—awesome and terrible weapons accompanying the ritual sacrifices revealed in the royal tombs *(fig. 13)*. The decoration of the ax in figure 21 combines two elements usually seen singly, the *tao-tie*, which in modern Chinese means "ogre mask" or "glutton mask," and the *kui* dragon, a single-legged creature with horns, fangs, teeth, and usually a gaping mouth. The term *tao-tie* was applied to the Bronze Age motif by Chinese connoisseurs and scholars of a much later time, and the misnomer has stuck, though the mask may represent many different animals—bull, tiger, or deer, among others, or a composite of some or all of these. From the ax in figure 21 some kind of feline, perhaps a tiger, resembling, as has often been pointed out, masks in the much later carvings of the American Indians of the Northwest coast, looks straight out at the spectator. The face is depicted as if divided down the center, with the two sides of the head spread out to the front plane, so that one sees two side views from the front. The result is a rectangular pattern with staring eyes and bared fangs. From the evidence of hundreds of decapitated human figures buried at Anyang we may conclude that axes of this size and type were used for human sacrifice.

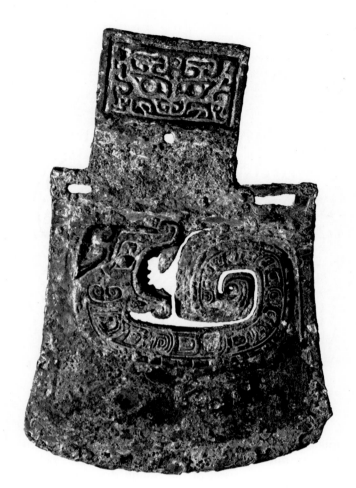

21. *Ax*. Bronze, width 5 1/2″. China. Shang dynasty. Cleveland Museum of Art

Before we look at individual bronze vessels, let us examine a drawing indicating the probable derivation of some of their shapes (*fig. 22*). The drawing includes only five of the large number of known shapes and variations. But these are the significant and common types most closely related to the cera-

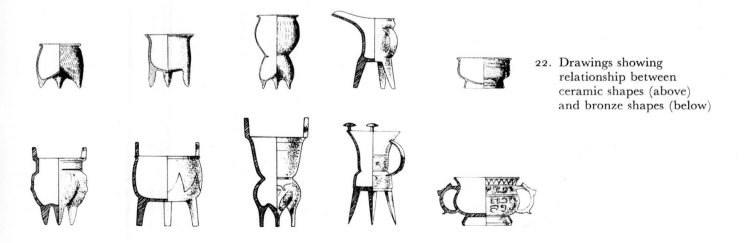

22. Drawings showing relationship between ceramic shapes (above) and bronze shapes (below)

33

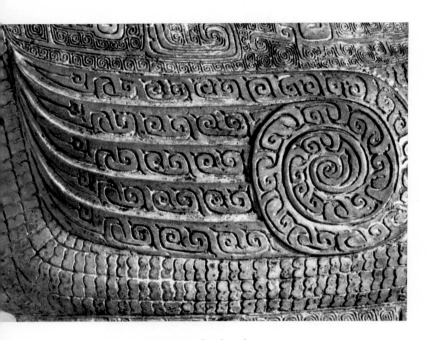

23. *Guang.* Detail of colorplate 2

mic shapes of early Neolithic China. At the top right is a ceramic type found in the plains culture; below is a bronze *gui* vessel of the Shang dynasty. At top left is the hollow-legged *li* tripod, with the solid-legged *ding* tripod immediately to its right. Below them are their bronze analogues. The *xian* steamer and the handled *jia* display the same continuity, as do other vessels, but many unprecedented shapes appear in middle and late Shang, indicating the inventiveness of the bronze caster under the stimulus of an increasing demand for luxury products.

The stylistic development of bronze vessels, from Erlitou through Erligang (Zhengzhou) 1 and 2 and early to late Anyang, largely corresponds to Max Loehr's perspicacious division of Shang art into five phases. The first (*fig. 20*) consists of simply shaped, thin-walled vessels decorated with narrow bands of thin relief lines, with the decoration carved into the same ceramic piece-molds that shaped the vessels. The second comprises thicker-walled vessels made in more complicated piece-molds, their narrow bands of decoration now composed of wider, ribbon-like intaglio lines forming embryo *tao-tie* and *kui* dragons (*fig. 20-A*). The third shows a more complex and "dense" adaptation of style II (*fig. 20-B*). The fourth (*colorplate 2, fig. 23*), first appearing at Anyang, displays great technical and stylistic innovation: The piece-molds that form the thick-walled, tautly shaped vessels are themselves shaped around model cores having both incised and applied low relief, and the major, animal, motifs are clearly differentiated from a closely packed and delicate

squared-spiral ground, the so-called *lei wen,* or thunder pattern. The vessels of the fifth (*figs. 24-27*) and final phase, at Anyang and elsewhere in the now extensive Shang realm, exhibit markedly high relief, the ornament projecting into space, and are made from extremely complex piece-molds formed on models.

In all of this we must emphasize the exclusive use of the piece-mold technique, uniquely Chinese in the Bronze Age and developed to a point of virtuosity unknown in any other culture. Bronze casting in Central Asia, the Near East, and the Mediterranean was dependent upon the lost-wax process, a technique whereby molten bronze replaces a wax model inside a solid clay casing. The Chinese method was both more complex technically and more demanding of visual imagination, comparable to jade carving in its difficulty and in the skill and patience it required. Lost-wax methods were not used in China until their importation from the West at the beginning of the late Zhou period, at first probably in the manufacture of objects in precious metals.

The piece-mold technique required first the making of an exact clay model of the bronze vessel to be. When it had hardened, units of soft clay were pressed against it, taking on the negative impress of both its shape and its carved decoration. These could be "touched up" by carving or the application of additional relief, or both, then fired to become the units of the mold. The surface of the model was then shaved down to become the core of the mold; the walls of the bronze vessel would exactly equal in thickness this layer that had been shaved from the model. The core was locked into place by spacers within the assembled piece-mold, which was held together by mortises and tenons. The use of fine rather than coarse clay made sharp detail possible and also reduced the likelihood of casting flaws produced by bubbling. One can imagine the complexity of the assembled mold used to cast such a complicated and large piece as that shown in figure 12.

Where do the elements of developed Shang bronze shapes and decoration come from? The most persuasive theory is that of Li Chi, who conducted the early excavations at Anyang. Li believes that the bronzes derive, at least in part, from lacquer-painted wooden prototypes, whose fragmentary remains show designs precisely like those on the bronzes and suggest certain bronze shapes, notably the *fang ding* (square *ding*; *fig. 25*), the square *yi*, and the famous bronze drum in the Sumitomo Collection (*fig. 24*), once unique but now matched by a slightly earlier example found in 1977 at the southern site of Chongyang in Hubei Province. The Sumitomo drum was cast as one unit, save for the removable lid. Its cen-

tral decorative motif is a human being with a winged headdress; below that is a mask with two eyes in profile view. On the lid are two birds and an ogre mask. The meaning of the symbols is not known to us. The ends of the bronze are cast to simulate crocodile hide, suggesting derivation from an earlier wooden drum with crocodile-skin drumheads.

The *ding,* in Li Chi's hypothesis, is convincing evidence of the derivation of bronze vessels from wooden ones (*fig. 25*). It is a four-square vessel, as if made of boards of wood, with painted decoration, peglike legs, and loop handles on the sides. The decoration, in figure 25, is easy to read and unusual. On each side of the vessel the main mask is a deer head, framed above and below with a band of little dragon-like monsters. On the long sides of the vessel the masks are flanked by two hook-beaked birds, perhaps owls, on either side. This tremendous specimen, over two feet square, was excavated at Anyang.

The Sumitomo Collection provides us with another extraordinary bronze, for which there is no prototype among Neolithic shapes—a very complicated vessel in the form of a bear or a tiger squatting on its haunches, with its tail used as a third support, and surmounted by a deer on its head (*fig. 26*). The

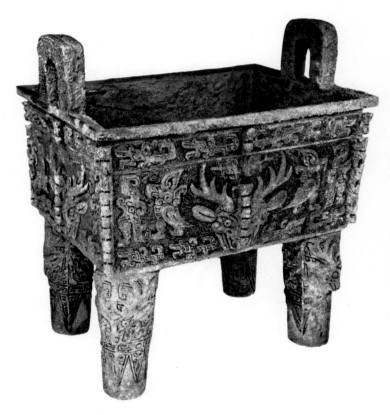

25. *Fang ding.* Ceremonial food vessel; bronze, height 24 1/2″. Tomb 1004, Houjiazhuang, Anyang, Henan, China. Shang dynasty, Anyang period (c. 1300–1045 B.C.). Academia Sinica, Taibei

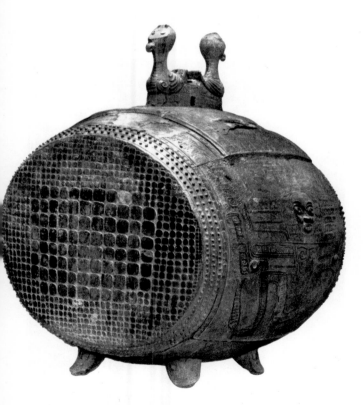

24. *Drum.* Bronze, height 31 3/8″. China. Shang dynasty, Anyang period (c. 1300–1045 B.C.). Sumitomo Collection, Kyoto

bail-like handle is composed of serpents and capped where it joins the vessel with the head of a boarlike animal. The *kui* dragon is a prominent part of the animal's side decoration. On its legs are snake forms and on its flanks even clearer indications of the snake in a diamond-backed form. Clutched in the forelegs and maw of the beast is the figure of a man with his head turned sideways. Whether this is a representation of the perils of the hunt or whether it is a representation, as Hentze and Waterbury believe, of the eclipsing sun as devourer, depends largely on one's disposition to believe in the universality of these myths. But there is no precedent for a vessel such as this. It is a Shang invention and embodies the principal elements that make up the Shang bronze style—the combination of many animals in one form, the metamorphosis of one animal into another, the desire to cover the whole vessel with a complex design, and the tendency toward powerful, sculptural forms that in later Shang bronzes tend to project into space.

We have illustrated many vessels to show a variety of shapes and a wide range of decoration. The *li ding,* or three-legged *ding* (*fig. 27*), is a classic Shang form. The design, a mask surmounted by a band

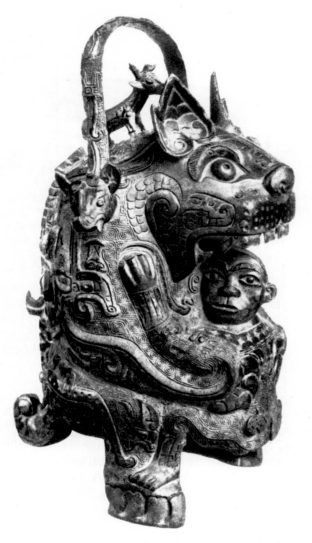

their mild acid weakened the incrustations, which then fell off when tapped with a hammer. The process was repeated until the design began to appear. Originally, of course, the vessels were a lustrous coppery bronze or silver color, some with inlays of a black pigment-like substance.

A *guang* in the Freer Gallery embodies Shang concepts of metamorphosis beautifully (*colorplate 2, p. 50*). A tiger-like cover changes at the back into the mask of an owl with eyes, ear tufts, and beak. Modern symbol seekers would prefer the bird to be a pheasant, symbol of the sun, but it has been ornithologically identified as an owl. The back of the vessel resembles a spoon-billed bird. The artist has combined three presumably incompatible elements—an owl, some other kind of bird, and a tiger—into one functional design. The neck of the second bird provides the handle by which one tilts the vessel and pours when the cover is removed. The ground of the vessel is elaborately developed with a pattern of squared spirals, sometimes called the thunder pattern. This provides a texture against which the low relief and the large design elements stand out. The casting is extraordinary for the precision and care required to cast the small thunder-pattern motifs in intaglio (*fig. 23*). The walls of the spirals are quite perpendicular; the bottoms of the tiny channels are

26. *You in form of bear (?) swallowing man.* Ceremonial wine vessel; bronze, height 12 7/8″. China. Shang dynasty. Sumitomo Collection, Kyoto

containing four of the ubiquitous dragon-like monsters, is repeated three times. Each mask is centered, not about the legs of the vessel, but about an intermediary flange, with the four dragons confronted, two by two, on either side of the flange. The whole design is actually a symmetrical pattern exactly duplicated on each side of the flange. On the vessel's tubular legs is the cicada, a design found many times in jade.

A word about patina may be in order at this point. The beautiful greens and blues of the Chinese bronzes are completely accidental, the product of many centuries' burial in the earth and not the intention of the artist. The colors result from various oxides produced by the action of salts in the earth. Many bronzes, coming out of the ground, look like nothing so much as large, encrusted oysters. In the old days they were laboriously cleaned by the "excavator" or the dealer. Peaches were applied to the outside, and

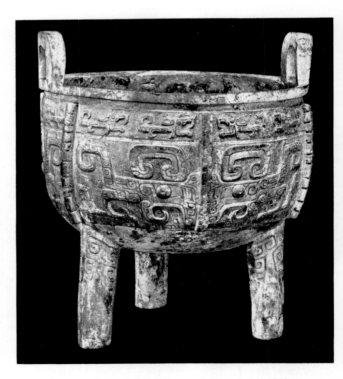

27. *Ding.* Ceremonial food vessel; bronze, height 9 1/2″. Shang dynasty. Seattle Art Museum

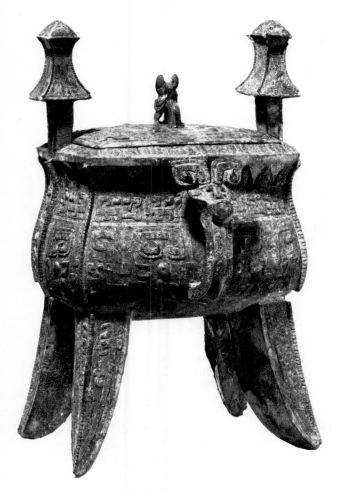

28. *Jia*. Ceremonial wine vessel; bronze, height
16 1/8″. China. Shang dynasty. Freer Gallery of
Art, Smithsonian Institution, Washington, D.C.

perfect grooves. The metal fills in the forms completely; very little plugging was done.

A tripod vessel, the *jue,* was apparently used, according to Yetts, for heating liquids to extremely high temperatures; its three legs were probably set directly in the fire so that the heat could reach the bowl. When the contents were sufficiently hot, it was lifted by the two posts at the top and tilted by the projecting point so the liquid would run out the spout opposite. A larger vessel, three- or four-legged, lacking the spout and projecting point of the *jue,* is the *jia.* The four-legged example *(fang jia)* shown in figure 28, also in the Freer Gallery, is perhaps the most magnificent one known. The decoration keeps closely to the surface, so that the profile appears to be self-contained. The casting is refined and perfect. Its lid is surmounted by a bird, perhaps an owl.

A frequent shape among the Shang bronzes is the tall, trumpet-like *gu,* related to earlier pottery shapes of Neolithic times. Still another, called the *yi,* is used by Li Chi to demonstrate his theory of bronze derivation from wood, the shape of the *yi* being derived from that of a simple wooden house.

Loehr shows in his stylistic sequence that Shang bronze style appears to develop from a rather tightly controlled decoration kept within the contour of the vessel toward a more baroque surface bristling with decoration that appears to project into space. The shift from the Shang to the early Zhou style is to be seen in several vessels securely dated by their inscriptions. Most early Shang bronzes have no inscription, or at most a single character, such as a clan name. Later in the Shang dynasty two-, three-, and four-character inscriptions ·appear; by the time of the transition to Zhou there are long inscriptions, some of more than four hundred characters. A four-legged *ding (fang ding)* in the Nelson Gallery–Atkins Museum *(fig. 29)* bears an inscription of three characters, allowing us to date it to the very beginning the Zhou dynasty in the reign of King Cheng, which began seven years after the fall of Shang. It shows many elements of transitional style: The form of the vessel has now expanded into space, with flanges, mask, legs, and horns projecting in high relief. Even the handles, so tightly contained in the Shang *ding* *(figs. 25, 27),* are now crowned with horned animals, cast so that they project far beyond the outlines of the vessel.

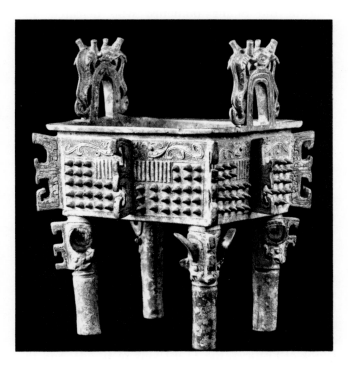

29. *Fang ding*. Ceremonial food vessel; bronze,
inscribed with name of King Cheng, height 11″.
China. Early Zhou period. Nelson Gallery–
Atkins Museum, Kansas City

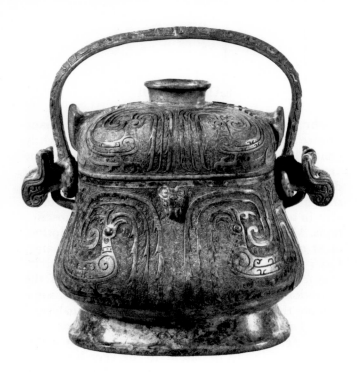

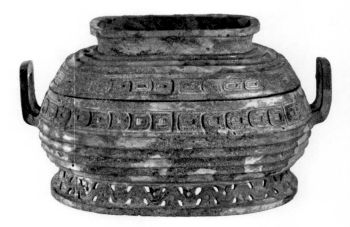

30. *You.* Ceremonial wine vessel; bronze, height 9″. China. Early Zhou period. Freer Gallery of Art, Smithsonian Institution, Washington, D.C.

31. *Gui.* Ceremonial food vessel; bronze, length 12 1/2″. China. Middle Zhou period. Minneapolis Institute of Art. Pillsbury Collection

In the transition to the early Zhou period certain shapes, like the *yi, jue, jia,* and *gu,* simply disappear. The sudden disappearance of these shapes, together with radical changes in the profiles of others, suggests a new society with markedly changed demands. The new people, the Zhou, were a hitherto tributary state west of the Shang domains, who defeated and annexed the Shang. Under Zhou rule hunting decreased, and society was characterized by feudal control of organized agriculture. Recent extraordinary finds of richly inscribed bronze vessels provide us with strikingly exact information about the time of the Zhou conquest at Yin. A *gui* inscription begins, "Wu Wang vanquished Shang, it was in the morning, on the day *jia zi* . . . "[1] —which time Nivison has correlated with the morning of January 15, 1045 B.C. It is significant that such an important bronze vessel was treasured for more than two centuries before it was buried, within other and later Western Zhou vessels, at Lintong in Shenxi, not far from the Zhou capital near present-day Xi-an.

The Zhou rulers formulated, or were later credited with having formulated, the principles of societal relationships both domestic and political that endured for thousands of years as the foundations of traditional Chinese culture. These formulations are recorded in the great classics: the *Yi jing* [Canon of changes], the *Shi jing* [Book of odes], the *Shu jing* [Book of history], the *Li ji* [Book of ritual], and the *Chun chiu* [Spring and autumn annals]. The period also saw a gradual change in religious attitudes. Animistic elements declined, and first mention was clearly made of the concepts of heaven and earth.

The already existing ancestor cult moved toward maturity. In general Zhou China was experiencing a process common in the development of early cultures: a change from a mixed agricultural-hunting society to an organized urban and feudal agricultural state, with the accompanying gradual change from animism to more abstract forms and concepts of religion.

With all these innovations, the Zhou did not obliterate the Shang or their culture. Rather, they absorbed much of Shang culture, adapting it to their own purposes, as evidenced by the continuity of bronze technique and the survival of many Shang bronze shapes and decorative techniques. With varying fortunes, the empire of feudal states they established endured almost a thousand years (c. 1045–256 B.C.). Artistically this time span divides into three major phases: early Zhou (c. 1045–c. 900 B.C.), middle Zhou (c. 900–c. 600 B.C.), and late Zhou (c. 600–221 B.C.), the last phase mostly encompassing the periods the Chinese call Spring and Autumn Annals (722–481 B.C.) and Warring States (481–221 B.C.)

Among the bronzes, early Zhou style is in general a continuation of the Shang, with omission of some shapes and variation in others. With middle Zhou comes a radical change in style and an apparent decline in technique. In the late Zhou period begins a renaissance of the decorative innovation and technical finesse, the flamboyance and intricate detail, characteristic of Shang bronzes.

Let us first look at a typical early Zhou vessel. The *you* shape (*fig. 30*) existed in the late Shang period.

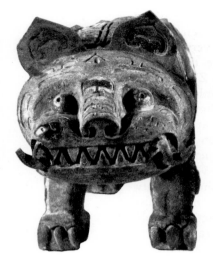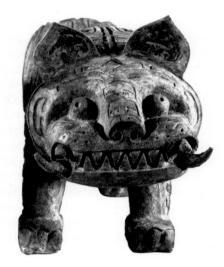

32. (right) *Pair of tigers*. Bronze, length 29 5/8″. China. Middle Zhou period. Freer Gallery of Art, Smithsonian Institution, Washington, D.C.

33. (below) *Tiger*. Side view of one of pair, fig. 32

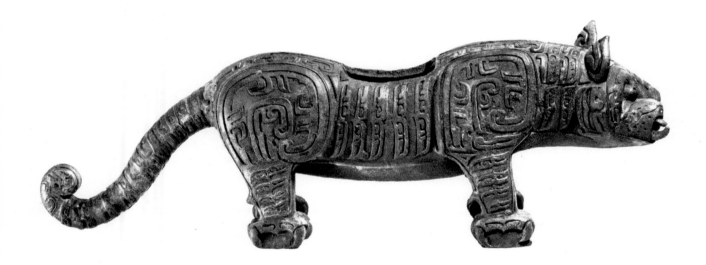

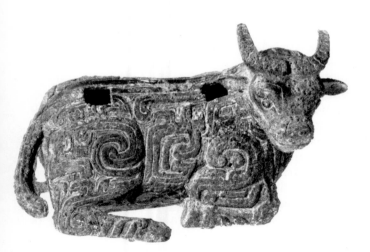

34. *Buffalo*. Bronze, length 8 1/8″. China. Middle Zhou period. Minneapolis Institute of Art. Pillsbury Collection

It is a covered pail and was evidently much in demand. The decoration of the main body of this vessel is particularly interesting, especially the two birds with flamboyantly upswept tails. This motif of the bird with upswept tail appears to be an early Zhou invention. In this vessel it replaces the more characteristic mask of the Shang dynasty. The masks are now small and confined to knobs in the middle of the sides and at the ends of the handle. There is also a slight loss in technical facility, the details being less crisp than formerly.

MIDDLE ZHOU

The first major change from Shang modes occurs, not during the early Zhou period, which saw the

continuation of Shang artistic practices, but at the beginning of the middle Zhou period, when a series of new vessel shapes with a new and very limited ornamentation appears (*fig. 31*). Where the Shang shapes seem vibrant and those of early Zhou either flamboyant or carefully balanced, the middle Zhou vessels seem ponderous and squat. They hug the ground; if we may judge weight by appearance, they appear very heavy. Their decoration assists this change. Some vessels have none and achieve aesthetic variety with the plain surface of the vessel or by horizontal grooving, which emphasizes their weighty and close-to-earth qualities. Even the masks disappear from the handles, which are treated as simple rings. The total form is extremely austere.

A pair of bronze tigers demonstrates what happens to animal forms and their decoration in the middle Zhou period (*figs. 32, 33*). Clearly they are tigers, but the conformation of backs, bellies, and legs renders them earthbound and static compared with Shang representations of the beast. The decoration has lost its metamorphic character; it is consistent and all of a piece; the profusion of animal forms is gone. The whole representation is logical, unified, and naturalistic in point of view. The two tigers were probably architectural members, as there are openings in their backs and they are far too heavy and clumsy to have been used as vessels. Perhaps they were supports for the pillars of a throne or canopy.

Bronze animals in the round first appear, generally, in middle Zhou. A few naturalistic animal vessels date from the Shang dynasty, but from the middle Zhou period comes one of the first representations of an animal without an obvious functional purpose. The buffalo in figure 34 may have been an image, an aid to worship, or an aid to ritual as a representation of sacrifice. But above all it is a sculp-

36. *Zong.* Jade, height 8 1/2″. China. Middle Zhou period. Freer Gallery of Art, Smithsonian Institution, Washington, D.C.

ture in the round and looks more naturalistic, more "real," than do the Shang buffalo. And, though it has lost the vitality of Shang technical dexterity, it possesses greater unity.

In jade too the changes are clearly perceptible. Shapes become simpler. Shang types continue but new ones emerge as well, such as the white jade fish in the Cleveland Museum, which is simple and severe, recalling a Neolithic style (*fig. 35*). The middle Zhou period witnessed the proliferation of some extreme simplifications of geometric shape, such as that found in the *zong,* a tube with a rectangular outer conformation (*fig. 36*). This shape occurs in Neolithic contexts, but its meaning and use still escape us; it is traditionally described in the old Chinese texts as the symbol of earth. Bernhard Karlgren, the Swedish sinologist, believed that the *zong* was originally a casing for a phallic symbol, but the relative abundance of *zong* and extreme scarcity of phallic symbols in jade or any other material cast doubt on his theory. *Zong* are first used on a large scale in the middle Zhou period. The simple decorative development of the shape also begins then, in keeping with the characteristic attempts of the

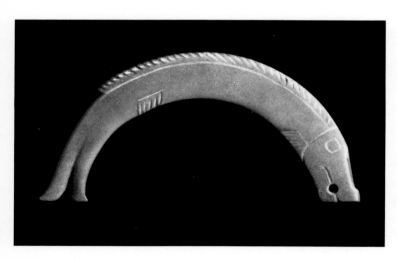

35. *Fish.* Jade, width 3 1/2″. China. Early Zhou period. Cleveland Museum of Art

40

period toward unification and simplification of total form. The counterpart to the *zong* is the *bi* ring, by now designated a symbol of heaven—a large disk with a center hole that is usually one-third the total diameter of the disk. Large circles of jade had existed from Neolithic times, but the shapes were not precise, nor were they fully codified until probably the middle Zhou period.

One small but unusual and aesthetically most important group of jades (*fig. 37*) can now be placed at the end of the middle Zhou period. Artists developed themes and variations on grinning, fanged humanoid masks with elaborate winged headdresses, some modeled in subtle relief, others defined by one of the most difficult of jade techniques, thread relief. Efforts have been made to date these heterodox works to pre-Anyang Shang, but recent excavations of the tomb of Marquis Yi of Zeng (dated to 433 B.C.), in Hubei Province, have discovered a painted wooden chest with what I take to be late middle Zhou bronze design elements. Conspicuous in the decoration of the chest are standing figures with faces and headdresses congruent with those so formidably represented in the jade ornaments. The jades cannot be much earlier than the fixed date of the chest. This would restore them to the dating originally proposed by Salmony—the late middle Zhou period.

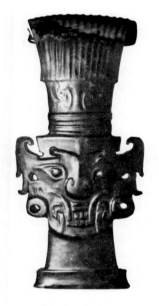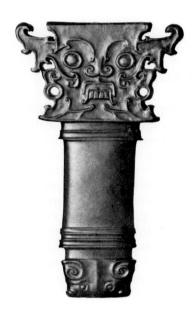

37. *Masks.* Jade, (left) height 3″, (right) height 3 1/8″. China. Late middle Zhou period. National Collection of Fine Arts, Smithsonian Institution, Washington, D.C.

3

The Late Zhou Period

THE BACKGROUND

One of the most fascinating periods of Chinese art history is the late Zhou period, sometimes called late Eastern Zhou, roughly contemporary with the historical periods called Spring and Autumn Annals and Warring States. It was a time of troubles and simultaneously of great intellectual and artistic ferment and growth. The Zhou feudal system was breaking up into a welter of shifting alliances and increasingly frequent and violent wars between competing baronies. The old rituals and philosophical traditions were changing. A mutual leavening of high and low intellectual traditions was taking place. More people were becoming familiar with writing and higher culture. Civilization was expanding, and south China came more and more into the high cultural orbit.

The two main streams of Chinese philosophy date from this time. Confucius was born in 551 B.C. Daoism first appears in a work called the *Dao de jing* [Book of the Way and its power], attributed to one Lao Zi (Old Master), supposedly contemporary with or somewhat later than Confucius. Confucianism is explicitly nonmetaphysical and humanistic: The question it addresses is how best to live in the world, and its answer is a system of political and familial relationships and a code of ethics for regulation of the system. It is a conservative and hierarchical system but also a remarkably evenhanded balance between extremes of optimism and pessimim, based as it is on the assumptions that human excellence is a matter of right conduct and that right conduct can be learned by some. Daoism ignores human society to ask what

the natural world is, and to answer that it is the visible manifestation of the Dao, the Way—the "uncarved block" that contains within itself the matter and form of every physical phenomenon. On this answer Daoism bases its central teaching: that one must live in intuitive harmony with the Dao. For the breakdown of the social order in the Warring States period, Confucianism offered remedies, while Daoism offered escape. Humanistic Confucianism and mystical, pantheistic Daoism did not flourish in isolation; later Chinese dubbed the proliferation of late Zhou philosophers "the Hundred Schools." Among them, Mo Di (born c. 500 B.C.) taught a thoroughgoing pacifist utilitarianism as a corollary of universal love, and the Legalists, whose philosophy informed and justified the totalitarian Qin dynasty (221–206 B.C.), preached a royal absolutism governing through strict laws and harsh punishments.

Of the many late Zhou archaeological sites, we will list only some of the more important ones in more or less chronological order: Xinzheng (Henan), Liyu (Shanxi), Jin Cun (Henan), Hui Xian (Henan), and Changsha (Hunan). The first four are northern sites and are to be dated approximately as follows: Xinzheng, seventh–sixth century B.C.; Liyu, sixth–fifth century B.C.; Jin Cun and Hui Xian, fifth–third century B.C. Changsha is the most important site now known in the south. The material being excavated there dates from the fifth century to the Han dynasty (206 B.C.–A.D. 220) and provides an ever clearer picture of the culture of the Chu state, the dominant political entity of the south in the late Zhou period and one of the most innovative cultures of the time in material techniques and imaginative

figural subject matter and symbolism. Hui Xian in north Henan is a recent excavation of the People's Republic, comparable in some of its materials to Jin Cun. Late Zhou thus affords us more known sites over a wider geographic range than any preceding period, including numerous vessels in a mixed Chinese and Southeast Asian (Dong Son) style from the Guangxi area above present-day Vietnam.

There is also a much greater variety of material, because the late Zhou period witnessed a marked expansion of Chinese techniques and knowledge of raw materials. Undoubtedly, some of this expansion was under stimulus from the West, as is indicated by the influence of the later Animal style and the importation of glass beads from the Mediterranean region.

38. *Tattooed man.* Front and back views. Tomb 2, Pazyryk, near Minusinsk, U.S.S.R. Sixth–fifth century B.C. The Hermitage, Leningrad

ANIMAL STYLE

New animal motifs and ways of representing them appear with increasing frequency during the late Zhou period from the fifth century B.C. "Animal style" is a term coined by Rostovtzeff to describe the stylized representation in relief or in the round of animals in profile, most often with legs drawn up under them or standing proudly erect in an almost heraldic pose. Another aspect of this style is the depiction of parts of animals, heads and haunches, as if representing dismembered ritual sacrifices. These works are often combined with geometric decor—spiral, fret, or interlace—and are usually ornaments rather than independent objects: horse trappings, finials, and other portable trimmings associated with the characteristically nomadic cultures of eastern Russia, Siberia, and Manchuria. We have seen some influence of the Animal style on Shang knife handles, but connections between China and the northern nomadic cultures do not now appear to have been extensive till early in the late Zhou period. In Siberia Russian archaeologists have established a well-defined cultural sequence: Afanasieva (c. 2000 B.C.), Andronovo (1750–1300 B.C.), and Karasuk (1300–700 B.C. or later). The Shang animal-headed knife handles are related to Andronovo and early Karasuk examples, but it is the later manifestations of Siberian Animal style that have the most distinct effect on Chinese art. Some of these later elements are to be found in the most interesting of all late Karasuk sites—Pazyryk, where influences to and from China are to be found.

The rich material from Pazyryk is kept at the Hermitage museum in Leningrad and includes the body of a tattooed man, which had been preserved by the deep-freeze environment at twenty feet or more beneath the tundra (*fig. 38*). The torso, minus head and left hand, was tattooed with an allover

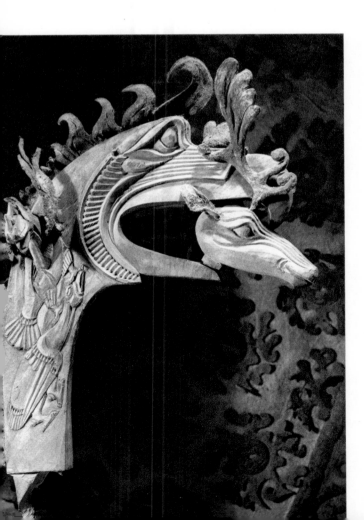

39. *Head of Griffin-Dragon.* Wood and leather, length of head approx. 12″. Pazyryk, near Minusinsk, U.S.S.R. Fifth–fourth century B.C. The Hermitage, Leningrad

40. *Zhong* (clapperless bell). Bronze, height 26 1/8".
China. Late Zhou period. Freer Gallery of Art,
Smithsonian Institution, Washington, D.C.

pattern of Animal style designs. One animal is
metamorphosed into another—a lion becomes a
bird, or a lion's tail ends in a bird's head. The artist
figuratively dismembers the animals, using parts to
stand for wholes. Many of the motifs are comparable
to those in figure 42 from north China. The wood
and leather griffin-dragon from Pazyryk (*fig. 39*) is
markedly similar to the bronze dragon head from
Jin Cun (*fig. 44*). Indeed, the whole development
of naturalistic animal decoration in the late Zhou
period reflects a now considerable understanding
of the Animal style.

BRONZES

Some late Zhou bronzes are composed of cryptic
and awesome symbols, intricately interwoven;
other late Zhou bronzes achieve an equal complexity
that may be well described as playful, elegant,
even consciously aesthetic. Confucius may have
deplored the luxury common in the Warring
States, but the style patronized by the rulers em-
phasized a rich variety of materials—bronze,
gold, silver, jade, lacquer, and silk. Musical ritual
and performance were a peculiarly important aspect
of late Zhou society. Upright, massive bells are
known from both north and south as early as the
Shang dynasty, but in later times the number re-
quired for a performance multiplied and the shapes

were increasingly refined. Sets have been found, in
Henan and as far west as Sichuan, matched to
produce a sonorous and slow-paced recital. The
subtle oval cross section was carefully calculated so
that single bells could produce two tones, depending
upon the part struck. Bosses were enlarged to ensure
an even tone and became the location of complex
decorative motifs such as coiled snakes (*fig. 40*). In
figure 40 the handle for suspension is made up of
paired dragons or birds, while below the three bands
of bosses is a revival of the Shang *tao-tie*, here treated
playfully and decoratively. Parts of these *tao-tie*, in
turn, develop into other animals such as snakes or
birds, reintroducing the idea of metamorphosis. The
flat, spiral ground of Shang is also revived, but with
a singular modification—the "late Zhou hook," a
spiral with a tightly raised curl at its termination,
projecting from the surface of the vessel or bell. The
motif is omnipresent in relief on bronze and jade.

Still another innovation of the period was the use
of inlays of precious metal in bronzes. We have men-
tioned the use of black pigment as inlay in the Shang
dynasty bronzes, but in the late Zhou period silver,
gold, white bronze (an early type of specular metal),
and even glass are being used as inlays. A particularly
fine example is in the Minneapolis Institute of Art—
a three-legged *ding* with a typical late Zhou profile,
completely modified from that of Shang or early
Zhou (*fig. 41*). The *ding* is now rounded, and the legs

41. *Inlaid ding.* Bronze inlaid with gold and silver,
diameter 7 1/8". Jin Cun, Henan, China. Late
Zhou period. Minneapolis Institute of Art.
Pillsbury Collection

42. *Finial*. Bronze inlaid with gold, silver, and white bronze; height 5 1/4". Jin Cun, Henan, China. Late Zhou period. Cleveland Museum of Art

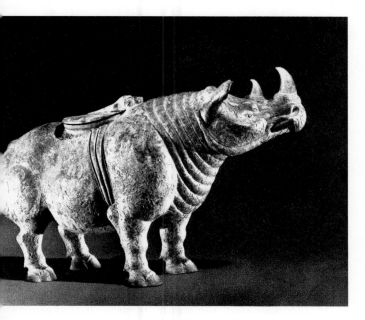

43. *Rhinoceros zun*. Bronze with traces of gold inlay and black glass eyes; original inlay presumably gold and silver; height 13 3/8". Xingping Xian, Shenxi, China. Late Eastern Zhou–Western Han dynasty. Historical Museum, Beijing

feathers curling under the dragon's chin, is a small bird tearing with its beak at the top of the dragon's snout. The subject combines animal combat and metamorphosis, in a manner characteristic of late Zhou revival and innovation. The bird motif is repeated in flat, ribbon-like relief at the base of the dragon's head. Though only about six inches long, the finial is extremely complex in its organization, full of that peculiarly delicate, closely curling movement and rhythm characteristic of late Zhou style. It is elaborately inlaid with silver, gold, and some white bronze, with some of the inlays designed to imitate dotted glass beads.

Sculptured Figures

In addition to innovations in material and technique, the period saw the rapid development of sculpture in the round, especially of animal subjects. The bronze rhinoceros (*fig. 43*), found in Shenxi Province, is the most well observed and richly decorated of late Zhou sculptures. The animal is depicted far more knowingly, if less massively, than his Shang ancestor in the Asian Art Museum of San Francisco. At the same time the decoration has become playful, with a tendency to conscious elegance. The decorative rendering of the hide must have been particularly sumptuous; the brocade-like pattern is still clear, but only a small amount of gold from the original inlay has survived. The gilded bronze dragon head in figure 44 reveals sophistication in the handling of new processes such as gilding, and imagination in formulating a convincing dragon type that becomes, on the whole, standard from this time on. The late Zhou artist combined imagination and realism to produce a unified style.

Animal figures had been seen before, but sculpture

conform to the softer structure of the vessel proper. The whole shape is roughly spherical. The grooves characteristic of middle Zhou vessels are maintained but not used repetitively. This *ding* is especially important for the six dragons inlaid in gold on its cover, which is designed to be used also as a plate when stood on the three legs in the shape of reclining rams in high relief. The body of the vessel is decorated with an abstract pattern of interlocking triangles, further embellished with typical late Zhou hooks. One of the most beautiful of all late Zhou objects is a finial in the shape of a dragon biting and being bitten by a bird (*fig. 42*). It is an extraordinary *tour de force*. The long head of the dragon dominates the composition, but sitting on the dragon's lower jaw, clutching it with its talons and with its tail

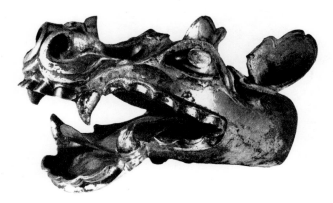

44. *Head of dragon*. Gilt bronze overlaid with silver foil, length 10". Jin Cun, Henan, China. Late Zhou period. Freer Gallery of Art, Smithsonian Institution, Washington, D.C.

45. *Boy on a toad*. Bronze, height 4″. China. Late Zhou period. Ernest Erickson Collection, New York

47. *Interlocked* T *and dragon mirror*. Bronze, diameter approx. 7″. China. Late Zhou period. Museum of Fine Arts, Boston

46. *Wrestlers*. Bronze, height 6 3/8″. China. Late Zhou period. Collection unknown

in the round of the human form was extremely rare before late Zhou. At first figures were used on the lids of vessels, as parts of fittings, or as lamp bearers; later in the period they appear in the full round, perhaps as pure sculpture. The bronze figure of a dancing boy on a toad is most extraordinary, especially in the way that the figure is projected almost spirally into space (*fig. 45*). One of the most interesting sculptures, if only for its ingenuity, is the group of two wrestlers, of unknown provenance, formerly in the collection of Captain E. G. Spencer-Churchill (*fig. 46*). The two figures are identical but oriented in opposite directions, their hands joined as if executing a *pas de deux*. This interest in two figures complexly related is entirely new.

Mirrors

Thousands of bronze mirrors of numerous types are known from late Zhou, following at least one example from the Shang dynasty and several from middle Zhou. The reflecting side, naturally, was polished; the design occupied the mirror back. Mirrors were often buried with the dead, sometimes suspended over the body with the polished side down, thus simulating the sun and making the mirror a cosmic symbol. Figure 47 shows a classic late Zhou mirror back, with a repeated dragon pattern on a ground of interlocked Ts. The stylish, dashing dragons in bandlike relief—three of them around a

central lug—are ancestors of many of the later dragons of Chinese painting. Surely the dragons and interlocked Ts are symbolic as well as decorative, but we are uncertain of their meaning in this context. Certain of the symbols on other mirrors are more explicit than these.

A second mirror, reportedly from Jin Cun, Henan, is the most elaborate late Zhou specimen known (*colorplate 3, p. 51*). Of particular interest is its utterly refined inlay, composed partly of little dottings of gold and silver. The figure on horseback brandishes a short sword like the Scythian *akinakes*, originating in Central Asia and used both in China and in the Mediterranean world. The warrior is attacking a tiger, shown completely in dotted and linear inlay, while the horse and rider are rendered partly in this technique and partly in larger areas of silver inlay. Here, for the first time, we have encountered Chinese pictorial art. Note that the horse and rider are in three-quarter view, revealing considerable interest in foreshortening and action and clearly indicating a growing skill in handling human and animal forms in movement and space.

JADE

The late Zhou style found a rich and sympathetic material in jade. It is no exaggeration to say that the jades of the late Zhou period are the finest ever made, aesthetically as well as technically. Even during the Qian Long reign, by popular opinion

49. *Tiger plaque*. Jade, length 5 7/8″. Jin Cun, Henan, China. Late Zhou period. Freer Gallery of Art, Smithsonian Institution, Washington, D.C.

50. *Interlaced dragon plaque (mask)*. Jade, width 2 7/8″. Changsha, Hunan, China. Late Zhou period. Cleveland Museum of Art

48. *Huang pendant*. Jade, length 8″. Hui Xian, Henan, China. Eastern Zhou dynasty, late sixth–fifth century B.C. Historical Museum, Beijing

the zenith of elaborate jades, the late Zhou jade workers were not surpassed. Jade was the most precious of all materials to the Chinese, and the elaborate, complex, and playful designs they imposed on it resulted in wonderful works of art.

Let us look first at a *huang*, a segment of a disk (*fig. 48*). One can see that a double dragon shape binds the whole together with hooked and scaled bodies. The surface reveals a major and a minor motif, interwoven in a delicate, curling relief, with some incising for the even finer details of eyes and scales. A plaque in the Freer Gallery represents a feline creature whose body is covered with classic examples of the late Zhou hook, which is as characteristic of jade plaques as it is of bronzes (*fig. 49*). The honey-colored dragon plaque, probably from Changsha, Hunan, presents an example of visual double meaning typical of much late Zhou art (*fig. 50*). The solid areas make a pattern of dragons interwoven with birds turned upside down, while the voids present a widely grinning ogre mask. Such an

extremely sophisticated sculptural double entendre vivifies, perhaps, Confucius's concern about luxury-loving courts in the late Zhou period.

CERAMICS

In the turbulence of late Zhou times, not only were new styles and motifs created, but large numbers of new techniques and new materials were introduced. For the first time pottery figurines are used as occasional substitutes for the actual animals and objects previously interred with the deceased. At a grave site in Hui Xian in northern Henan, where dozens of chariots and horses were excavated, animal and human figurines of the same time were also found, some of gray and others of almost black pottery, executed in a lively and naturalistic style. The realistic figures of dogs, pigs, and other domestic animals look almost as if they had been cast from miniature animals.

The usual ceramic vessels were also produced—some gray pottery and, in the more provincial areas, painted red earthenware pots of Neolithic type. Some of these were so convincingly Neolithic that Andersson mistakenly dated one group to about 3000 B.C., whereas they more correctly date from about 500 B.C. In the outlying areas, then, Neolithic techniques continue into the late Zhou and even into the Han dynasty.

But there was also a revival and real development of the Shang invention of stoneware with ash-iron glaze. Isolated examples from early and middle Zhou sites are known; but the widespread appearance, particularly in the south, of this stoneware occurs in late Zhou. The pot in figure 51 is very high-fired stoneware with a gray body burnt brown on the exterior where exposed to the flame. It has vestigial lug handles and a shape resembling that of a bronze *jian*. The shiny olive substance on the shoulder and side is glaze. It seems probable that such a glaze became more common as potters learned to heat kilns to higher temperatures. Ash from the fire, settling by accident on the surface of the pots, would act as a flux, causing the silica in the surface layer of the clay to melt and thus producing spots of natural glaze. Upon this discovery the potters began purposely to agitate the fire so as to force a heavy deposit of ashes onto the upper surfaces of the pots. This more concentrated flux acted on more of the surface silica and thus formed a glaze. We base this hypothetical reconstruction on the fact that the glaze on these early wares is found mainly on the upper surfaces of the vessel. Later potters developed techniques of either dipping the pot into an actual glaze mix or covering the vessel with ash so that a glaze would coat the whole surface.

WOOD AND LACQUER

In addition to glazed ceramics we have, for the first time, actual remnants of worked wood—not simply imprints in the earth like those found at Anyang. The first discovery of these woods was accidental. In the early 1930s workers digging roadbeds for railroad lines at Changsha in Hunan uncovered tombs containing astounding objects

51. *Jar.* "Protoporcelain," Shou Zhou type; diameter 12 1/8". Anhui, China. Late Zhou period. Museum of Eastern Art, Oxford

Colorplate 1. *Burial urn.* Painted Pottery, hard-fired earthenware; height 14 1/8″.
Banshan, Gansu, China. Neolithic period, c. 2200 B.C. Seattle Art Museum

Colorplate 2. *Guang*. Ceremonial vessel; bronze, length 12 1/4″. China. Shang dynasty,
Anyang period, c. 1300–1045 B.C. Freer Gallery of Art, Smithsonian Institution,
Washington, D.C.

Colorplate 3. *Mirror*. Bronze inlaid with gold and silver, diameter 7 5/8″. Jin Cun, Henan, China. Late Zhou period. M. Hosokawa Collection, Tokyo

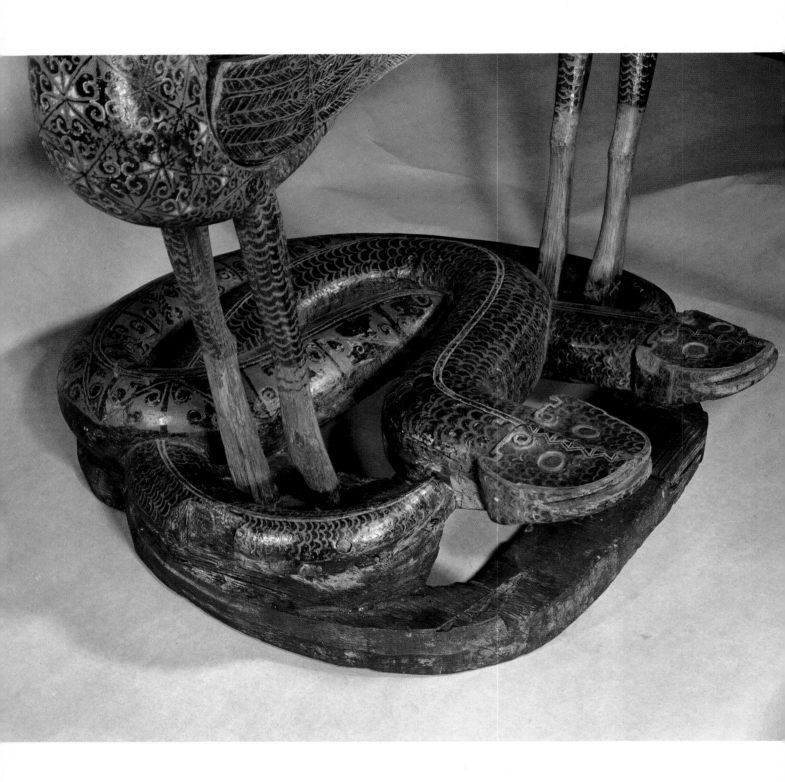

Colorplate 4. *Cranes and Serpents*. Detail of fig. 52

heretofore unknown in Chinese art. Many of these objects had been preserved in almost perfect condition by the constant dampness of the earth. It is change of humidity or temperature that damages such objects; where temperatures and humidity are constant, however extreme, objects are often well preserved. From ancient Egypt, with its very dry and hot climate, we have well-preserved objects of wood and other fragile and perishable materials. Constant extreme humidity has the same preservative effect. At Changsha objects of wood, bamboo, lacquer, and even cloth were preserved intact in the damp tombs. Some of the numerous artifacts recently excavated at this site include bamboo strips with notations in archaic script; an intricately carved wood panel coated with a layer of brown lacquer; and figures, perhaps burial substitutes or possibly images used in shamanistic practices, carved of wood in a curious doll-like fashion and painted with lacquer.

The uses of lacquer and the techniques of working it were also innovations of the late Zhou period, probably originating in the south. One of the most remarkable of all the objects excavated at Changsha was found in 1934 and is in the Cleveland Museum of Art (*fig. 52*). This very large composition, called *Cranes and Serpents*, is the earliest extant Chinese wood sculpture, and one of the greatest. It is covered with designs painted in lacquer, imitating inlaid bronze designs. There is some disagreement as to how these birds and snakes were originally grouped. It was reported by the dealer who sold the piece that remnants of a wooden drum had been found with it, suggesting that the birds and snakes may have formed a drum stand, with the drum suspended from the necks of the birds as they stood back to back. Against this supposition it is argued that the arrangement seems highly unfunctional, for two such slender necks would snap if a drum suspended between them were hit. But excavations at Xinyang in southern Henan have recovered remains of a smaller lacquered wood drum stand with paired birds back to back standing on two felines. The parallel, despite the geographical separation, is too

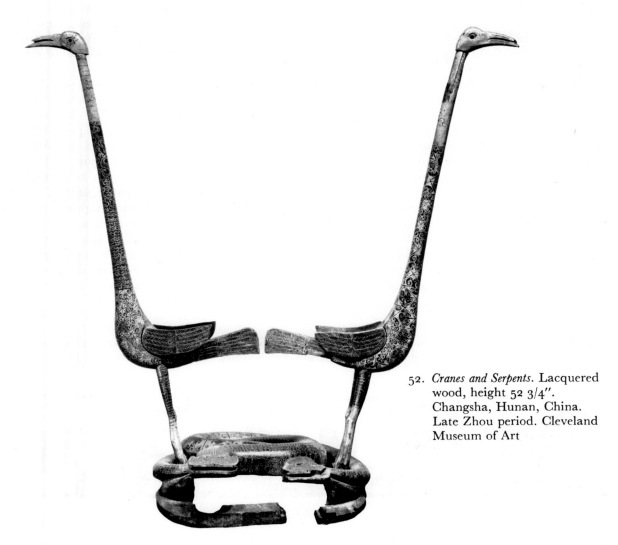

52. *Cranes and Serpents*. Lacquered wood, height 52 3/4".
Changsha, Hunan, China.
Late Zhou period. Cleveland Museum of Art

53

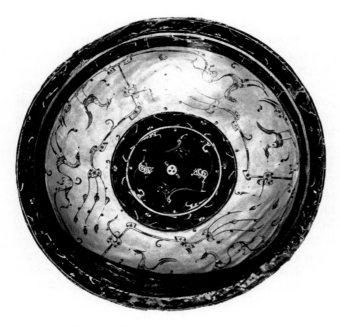

bination of red, yellow, black, and very dark blue, producing a rich and complex effect.

A more characteristic lacquered object is the remarkably well preserved bowl from Changsha, now in the Seattle Art Museum (*fig. 53*). It is made of a very light wood covered with a fine cloth to prevent warping. Over the cloth lacquer was applied in two colors only—red and black—forming a design of dragons, birds, and banners repeated three times around the cavetto, with a semiabstract design of dancing bears and bird forms in the center. All of these lacquered vessels with intricate designs display extremely lively and highly abstract treatments of natural forms, as if the painter had already begun to use line for expressive purposes alone, as was characteristic of later Chinese painting.

53. *Bowl*. Lacquered wood, diameter 10″. Changsha, Hunan, China. Late Zhou period. Seattle Art Museum

THE BEGINNINGS OF BRUSH PAINTING

From the late Zhou period come the beginnings of brush painting, later to be so highly developed in China, which exploited the ability of the flexible brush to produce thick and thin lines and to represent movement by means of those lines. Only recently have a few fragments of this early painting come to light. The earliest examples were rather tentative paintings such as an illustrated text on silk found at Changsha (now in the Metropolitan Museum of Art), an herbal-bestiary with representations of various plants and fantastic animals, including a three-headed man. It was probably made for a shaman and is not much of a painting, being rather stiff and crude, obviously just a "cookbook" page and not to be looked upon as a great work of art.

telling to ignore, particularly in view of our increased understanding of the homogeneity of Chinese culture as far back even as the Shang dynasty. A close examination of the Cleveland birds indicates that they are hybrids—eyed peacock feathers, cranelike profile—perhaps early versions of the *feng-huang*. Their bodies are of one piece of wood; tail feathers and wings (fashioned from flat boards), heads and legs, are all made separately and attached. A detailed front view of the snakes shows the same design found on inlaid bronze tools and vessels (*colorplate 4, p. 52*). The two snakes are differentiated; one has a completely geometric pattern, the other a pattern simulating scales. Perhaps an early manifestation of the male and female principles of *yang* and *yin* is expressed in the paired serpents. The color scheme of the lacquer is not the common one of red and black, but a com-

But we do have recently excavated paintings from Changsha that bespeak a highly developed painting technique. Among them is a faintly preserved ink painting on silk depicting a lady with a phoenix and a dragon. Another example is a design on a lacquered vessel called a *lian*, a cylindrical covered box (*fig. 54*). The design on this box has been schematically

54. *Lian*. (The design has been "unrolled," showing it as a continuous band.) Painted lacquer, height approx. 6″. Changsha, Hunan, China. End of late Zhou period, fourth–third century B.C. Provincial Museum, China

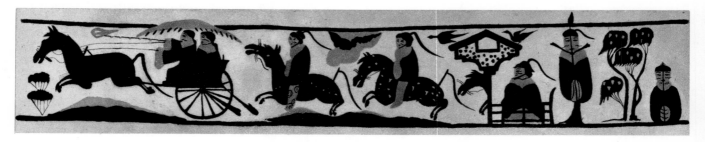

extended in the illustration to reveal the whole. On the left, moving over a small hill, is a two-wheeled chariot drawn by a single horse, followed by two riders, one on a white horse, the other on a green one. This scene of action is followed by one of repose: Here are trees, one in flower; two seated men, one in a small enclosure; and a man in an odd hat who stands facing the observer. Above and below these are designs painted in imitation of inlaid bronze. The representation of the horse at a flying gallop, derived from the Animal style, is extremely lively. The skillful but simple representation of the tree shows a level of brushwork indicating many years of prior development.

The Cleveland Museum of Art has two rare and exquisite painted low reliefs executed on clam shells (*colorplate 5, p. 117*). They are reputed to have been found in north China, and this seems most likely. After cleaning and restoration two scenes were revealed. The first shell shows the chase. A two-man, two-wheeled chariot drawn by four horses is pursuing a deerlike animal and a tiger. Below, a similar chariot is following a deer, with two little dogs, resembling dachshunds, running beside it. The other shell depicts the sequel to the first scene. The now stationary four-horse chariot is seen head-

56. *Hunt scenes.* Detail of fig. 55

on, with two men still in it. Two men have appeared on foot, having dismounted from the other chariot, and are approaching a doe. One holds a long spear and one a knife. Two arrows are lodged in the doe's hindquarters. Below, one of the hunting dogs is chasing deer, while two bristling boars run nearby. Cleaning and restoration revealed an indication of landscape: two kinds of trees, one with three branches and one a stump with a protruding branch. Close to the latter is a halberd, thrust into the ground while the owner deals with the stricken doe. One can also make out, on each of the shells, a pole staff with three trailing pennons. This was a type of clan banner and can be seen also on the lacquer bowl in figure 53. A front view of a quadriga is most extraordinary in so relatively archaic a stage of painting. Here are late Zhou, Qin, or early Han paintings revealing an advanced stage of accomplishment, showing a psychologically unified scene, involving actual events and spectators observing them. They are so unified in composition within the area of the shells that we have not stiff, geometric, static diagrams, but lively pictures, vivid representations with a brilliant use of silhouette.

The hunt is also a characteristic subject of some bronze vessels of the late Zhou period. Often it is less pictorially handled, as on vessels with panels of rather geometric, static hunting scenes in low relief silhouette (*figs. 55, 56*). But on an inlaid bronze tube in the Tokyo Art School, dating from the early Han dynasty, is as dynamic a hunt as that on the shells (*fig. 57*). The drawing in figure 58, made from the tube, shows in black that part of the design which is gold inlay. Some of the elements we have already seen: the running tiger, the horse at the

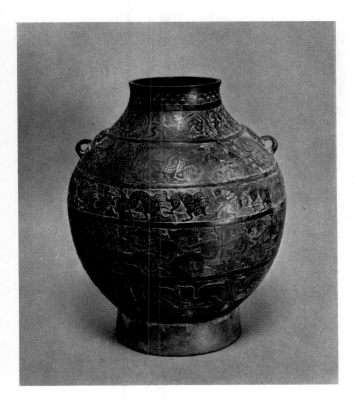

55. *Hu.* Bronze, height 10″. China. Eastern Zhou dynasty, Warring States period. Cleveland Museum of Art

flying gallop, the archer. But there is greater wealth of detail: undulating hills, the bear and the boar, the peacock preening his tail—a landscape filled with varied representations of animals and birds, full of life but in the interweaving, curling style characteristic of the late Zhou period.

Although we are concerned in this book with the visual arts, it should be noted that music, valued by Confucius above all other arts, the dance, and poetry all reached high levels of attainment in these years.

57. *Tube* (shown in three sections). Bronze inlaid with gold, length approx. 8″. China. Early Western Han dynasty. Tokyo Art School

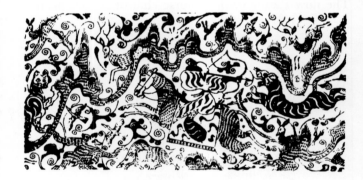

58. *Drawing of inlaid gold design on fig. 57*

The Growth and Expansion of Early Chinese Culture Through the Han Dynasty; Korea and Japan

The Chinese call themselves Sons of Han, the dynasty that saw the establishment of a Chinese world empire. The first empire had in fact been created by the state of Qin, in modern Shenxi Province, which emerged as winner-take-all from over a century of endemic intrigue and warfare among the Warring States. In 221 B.C., when Chu fell and Qi surrendered, King Zheng declared himself Shi Huang Di, First Emperor, of China. Before his death in 210 B.C. he had begun the Great Wall and a network of roads, standardized the script, coinage, and weights and measures, and created the type of centralized bureaucratic regime that has governed China ever since. But he slaughtered his opponents, persecuted Confucians, and ruled with such punitive harshness that his empire crumbled in rebellion and defection less than four years after his death. By 202 B.C. the peasant Liu Bang, victor in the ensuing power struggle, was Emperor Gao Zu of the Han dynasty. Gao Zu was able to take over, stabilize, and enlarge what Shi Huang Di had put together. China's borders were extended from Vietnam in the south through Korea in the north, and from the China Sea deep into Central Asia.

QIN

The discovery in early 1974 of but a distant and small part of the burials surrounding the giant tumulus-tomb of Qin Shi Huang Di excites the imagination and gives a hint of the concentrated power and megalomania of the First Emperor. Originally over six hundred feet high, the man-made hill dominates

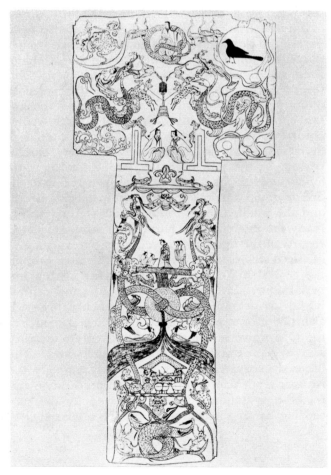

59. *Drawing of Painted Banner, from Tomb of Dai Hou Fu-Ren.* Original: silk, length 80 3/4″. Mawangdui, Hunan, China. Western Han dynasty, c. 180 B.C. Historical Museum, Beijing (?)

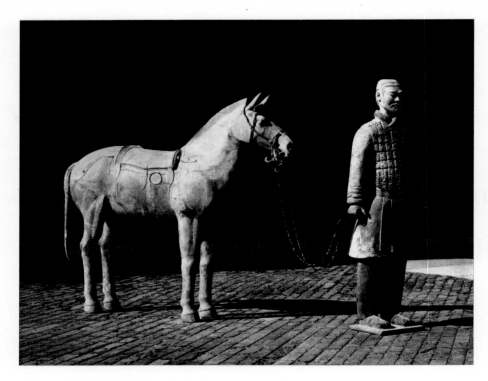

60. *Cavalryman and saddle horse from earthenware army of First Emperor of Qin.* Height of man 5′ 10 1/2″. Lintong, Shenxi, China. C. 210 B.C. Shenxi Provincial Museum

the plain west of Mount Li near Xi-an. Almost half a mile from the hill well-diggers chanced on a part of the clay army and attendants buried around the central tomb mound. At least seven thousand life-sized clay figures of warriors and horses (*fig. 60*), together with wooden chariots, were discovered in military formation, symbolically guarding the approaches to the tomb. Originally richly polychromed, the figures now reveal their material of fired gray clay, modeled with the same careful realism as the much smaller late Zhou figurines found at Hui Xian. The various provincial headdresses of the warriors are depicted in specific detail, and the small, closely coupled horses stand stiffly, ready for mounting or harnessing. More recently, reports of the finding of a veritable bureaucracy of life-sized scribes suggest that the whole area around the central hill contains a clay replica of the imperial court. Literary sources describe the central burial as furnished with an unbelievably rich assortment of tomb furniture, including a model of the Qin universe complete with rivers in mercury and a representation of the constellations. The lifesized excavated figures definitively embody the realistic tendencies of preceding sculptural style and establish a standard hardly achieved by the succeeding tomb sculptures of the Han dynasty.

HAN

The Han empire may be said to have established Chinese cultural patterns until modern times. In art and thought contributions of the late Zhou period

were consolidated. Regional differences, particularly between north and south, continued, but within a more unified cultural and political framework. Scholars reconstituted Confucianism, adapting it to contemporary concerns. Daoism, interpreted by court magicians, degenerated into a fabric of myth, miracle, and magic, and Confucians and Daoists competed for the favor of the throne. China in the late Zhou period had not been totally isolated, but the Han empire was in contact with India, Southeast Asia, Central Asia, and the Mediterranean world. North China was urbane and civilized, while the south still preserved much of the exotic lore and primitive practices of its non-Han inhabitants.

Han Architecture

The tomb-architectural tradition was maintained, though large mounds were used for the first time in imperial or noble burials. Subterranean tombs also continued into the Han dynasty; some of the finest objects of the period have been excavated from such tombs in Korea and in the south, especially at Changsha in Hunan.

We have no actual remains of Han architecture, but enough clay models used as burial substitutes have survived on which to establish a fairly clear picture. One such model house (*fig. 61*), very large (about four feet high), is of gray clay covered with white slip painted with red pigments, and there are other examples of the type, some with a green lead glaze. They show us the post-and-lintel structures with tile roofs that have been built in China until the present day. The considerable weight of the roof

in most Chinese buildings is not borne by the walls, but is distributed down through the bracketing system to stout posts or columns. The walls proper are simply screens of clay on bamboo matting strung between the columns beneath the lintels. The basic unit of the system is the bay, that is, the single cube of space formed by the four columns with their lintels. The size of the bay is determined by the length of the lintels, which can be no longer than the tree trunk from which they are made—a maximum of forty to sixty feet. The building can be made bigger, then, only by adding more bays. The palace is simply such a building, made up of a number of the the highest and largest possible bays put together. Decoration was important and was achieved with inlays of metal, precious stone, and jade, or with colorful paint and lacquer. The literary descriptions of Han palaces reveal them to be extremely rich and sumptuous.

Town Planning

We also know something of the general layout of Han cities, whose arrangement became traditional. The city as a whole was geometrically oriented to the four cardinal directions. The emperor or (in provincial towns) the emperor's representative occupied the area north of the center of the city, which was sited, wherever possible, so that north of center was also the highest ground. Everything was oriented to the central authority, and the city became, in a sense, an imperial diagram of the universe, with the emperor taking the place of the sun at the center. The strict geometry of the plan echoes the jade shapes that symbolized heaven and earth, and the almost geometric social order advocated by Confucianism. Such an order was carried over into city planning. The informal, organic growth to be seen in a Japanese medieval town did not occur in Chinese cities, although it might in small provincial villages.

The tower, as seen in the clay models, was im-

portant not only as a means of guarding cities, but as one of the principal aids to hunting. It was used like a shooting box by archers who shot at birds attracted to it by bait. With the development of Buddhism, towers, now called pagodas, took numerous forms, their many roof lines influenced perhaps by King Kanishka's great stupa near Peshawar in northern India, with its thirteen-storied superstructure.

Han Painting

In Han painting the innovations and forward-looking styles of the late Zhou period continue and mature. Two major styles are distinguishable, and a third, now becoming clear, may have to be taken into account. The formal, official style is rather stiff, geometric, almost hieratic, and stresses silhouette. The second, painterly, style has already been seen in the lacquer bowl (*fig. 53*) and the painted shells (*colorplate 5*) of the late Zhou period.

61. *Tomb model: house.* Painted earthenware, height 52″. China. Han dynasty. Nelson Gallery–Atkins Museum, Kansas City. Nelson Fund

The excavation in 1971 of the tomb of the Marquise of Dai, near Changsha at Mawangdui in Hunan, has uncovered major original examples of Western Han painting. The tomb contained numerous well-preserved examples of early Han decorated lacquer utensils, a painted wooden sarcophagus (*fig. 62*; one of three ornate, nested coffins), and a number of textiles of various weaves (*fig. 63*), as well as the intact, well-fed corpse of the marquise. The silk banner found draping the inner coffin (*fig. 59, colorplate 6*) is accomplished in technique and complex in design. The formal and balanced composition depicts the three world levels: the sky above with its mythical inhabitants—sun crow, moon toad, and celestial dragons; the earth in the middle with the marquise and her women attendants; and the nether regions with a burial grouping of ritual vessels and male (mourner?) figures, supported on serpentine beasts and earth spirits. In style the figures resemble those on the painted basket from Lolang in Korea (*figs. 64, 65*), with silhouettes similarly outlined in rapid linear brushstrokes and a similar palette emphasizing red and yellow with accents of green and blue. This precious hanging painting gives us some inkling of the appearance of the large palace murals mentioned in Han literature.

The painted banner, however, is one of the very

63. *Embroidered silk fabric*. Three-color cloud pattern on plain terra-cotta-colored ground. Tomb of the Marquise of Dai, Mawangdui, Changsha, Hunan, China. Western Han dynasty, c. 180 B.C.

few Han paintings to survive. For the most part, stylistic developments in painting must be inferred from relief carving and lacquer painting. Usually one studies stone reliefs from rubbings, which are taken by laying a thin layer of damp mulberry paper on the stone and pressing it into the crevices and carved areas. It is then lightly rubbed or tapped with an ink bag. The resulting "rubbing" can be reversed through a photographic process to achieve a black-on-white impression not unlike the original painting prototypes.

The formal style is epitomized by the famous reliefs at the Wu Liang Ci, the Wu family mausoleum in Shandong, called by the name of one of its occupants, Wu Liang, and dated about A.D. 147–51. Here the background has been cut away to create the all-important silhouette in extremely low relief, the design is formal and static, the figures are carefully placed and spaced. Figure 66 shows two quite separate scenes: Below, a procession of chariots, mounted men, and footmen moves to the left; over the heavy line that divides the two scenes and serves as ground line for the one above, guests arrive at a

62. *Sarcophagus of the Marquise of Dai*. Detail of outer coffin (of three); lacquered wood with polychrome designs of fantastic animals amid clouds; length approx. 8 1/2'. Mawangdui, Changsha, Hunan, China. Western Han dynasty, c. 180 B.C.

64. (left) *Scenes of Paragons of Filial Piety, from Painted lacquer basket.* Length 15 3/8". Lolang, Korea. Eastern Han dynasty. Central Historical Museum, Pyongyang

65. (below) Detail of fig. 64

66. *Rubbing of stone relief.* Height approx. 36". Wu Liang Ci (Wu family shrines), Jiaxiang, Shandong, China. Eastern Han dynasty, c. A.D. 147–51

hall where an entertainment is taking place, while outside an archer shoots at birds flying around the mythical tree of the sun. The tree has a stylized, almost late Zhou form, including the use of natural leaf forms as a decorative pattern and a trunk bent into an almost perfect late Zhou hook. Except for some overlapping—one of the most primitive ways of suggesting space—there is no indication of depth in this scene; everything is treated as if on one plane. Elsewhere at Wu Liang Ci depth is most crudely indicated, simply by placing one object or figure higher than another, with no indication of connection between foreground and background. In addition, almost no figures are shown in three-quarter view. The whole effect is archaic.

The breed of horses that appears for the first time in these reliefs seems to have come from Central Asia. We read much about the excursions of the Han military into Central Asia for the express purpose of collecting horses—presumably these short-bodied, heavy-barreled specimens with large nostrils—from the nomadic peoples of that region.

Admirable later examples of the official style, with some influence of the freer painterly tradition of the south, are found in the tomb at Yi-nan, also in Shandong, dating from the late second or early third century A.D. These stone reliefs may well indicate the nature of the Han palace murals and the degree of maturity attained by the Han artist in composition (fig. 67). Judging from these and other reliefs and from certain painted tiles, the human figure is handled with some ease and understanding and placed within a recognizable space.

One can see from the Yi-nan tombs that one important concept was already established by the third century A.D., and that is the use of organized space and of a systematic convention to indicate depth (fig. 68). All systems of perspective, however natural or "real," are nevertheless artificial. There are many of them, and the Yi-nan carvings are one early Chinese example. The diagonal tables lead back into a shallow space terminated by racks of hanging bells and musical jades. In the foreground, in the space defined by the slanting diagonal platform, are the musicians, ranged in echelon. The individual figures, though shown in three-quarter view, are stiff silhouettes, and the whole effect is formal, as is much Chinese figure painting of the immediately succeeding periods of Six Dynasties and Tang. One can imagine a palace room decorated with balanced murals of banquet or hunting scenes containing carefully arranged and perfectly symmetrical perspectives.

The famous painted basket from the Chinese colony at Lolang in Korea is in the same formal, official style (figs. 64, 65). Lolang must have been a most important Han outpost, for many wonderful lacquers were found there in water-saturated, wood-lined subterranean tombs. The wicker basket with a lid is the most extraordinary of all the finds. The outside of the cover and the high interior sides over which the lid fits are painted with scenes of filial piety (fig. 65). It is interesting to find so appropriate a combination of official style and Confucian subject—a perfect meeting of form and content. We see somewhat the same handling of figures as in the tomb at Wu Liang Ci, though here the effect is more fluid and lively because we are looking at actual painting, even if in lacquer. Most of the figures are silhouette-like, a few are in three-quarter view, and nearly all are isolated with little overlapping. All occupy the same ground line, so there is no indication of depth. They appear, however, lively and animated. The inscriptions indicate the names of these paragons of filial piety, so we have again the full flavor of an official moralistic attitude. Above and below, the borders show a degenerated version of inlaid designs of gold and silver in bronze harking back to the late Zhou style.

In contrast to this official, formal style, and sometimes found alongside it, is a painterly style. Some lacquers from Lolang and Changsha have most lively and suggestive renderings of movement in subjects consisting largely of mythical beings, dragons, and rabbits (fig. 62). These figures seem to rush across the space, in part apparently propelled by the long lines behind and beneath, which suggest speed. This impression is also created in part by the brushwork, which is not calm and measured but extremely rapid and spontaneous. Here we have a treatment that seems to be applied particularly to themes involving everyday subjects or animals.

Painting on silk, of course, antedated the Han dynasty; there are late Zhou examples from Changsha, Hunan. But the invention of paper in A.D. 105 must have been a great stimulus to the development of brushwork, for paper is the most suitable ground for that most flexible of all writing implements, the Chinese brush. On the famous painted tiles in the Boston Museum are numerous scenes, but one in particular shows what mastery of the brush had been achieved by the middle of the Han dynasty (fig. 69). The speed and flexibility of the brush are expressed in the line, and the brushstroke has become a means of defining character. The three-quarter view is skillfully used. The whole attitude and pose of each figure conveys something of the psychology of the person portrayed: the patient listener, the rather pompous talker, and the decorous and patient man waiting to get a word in edgewise. Notice too the skillful handling of the figure in three-quarter back view, who appears to be turning to the left within

67. (above) *Rubbing of stone relief.* Yi-nan, Shandong, China. Western Han dynasty, late second–early third century A.D.

68. (right) Detail of fig. 67

the shallow space. At the same time the placement of the figures in space is primitive. They all appear to be on the same ground line, and no setting is indicated. But great progress toward the use of the brush in a typically Chinese manner for figure painting can be seen here. From this to the famous scroll *Admonitions of the Instructress*, the earliest extant great Chinese painting, is no great distance.

A third type of painting can now be presumed from the evidence of some extraordinary molded relief tiles excavated from tombs in Sichuan Province in west China. One such tile, divided horizontally, shows two scenes: Above, a stream full of ducks, fish, and lotuses winds into the distance, while two hunters on the bank shoot at flying ducks; below,

69. *Painted tile* (section). Polychrome painting on earthenware hollow tiles, height 7 1/2″, width 94 5/8″. China. First century A.D. Museum of Fine Arts, Boston

five men harvest grain while a sixth brings lunch (*fig. 70*). The depiction is lively and naturalistic, not unlike the scenes on the painted shells, in contrast to the static style of the stone reliefs at Wu Liang Ci and Yi-nan. Recession in space is confidently indicated by the diminishing size of animals and plants, by the spit of land extending diagonally behind the hunters, and by the harvesters in echelon. We may reasonably assume that some Han painters shared this organized and intuitive feeling for space and for the naturalistic handling of human and animal figures.

The close similarity between Han painting and pictorial decoration in stone is clearly attested by two tombs excavated in 1960–61 in Mi Xian, southwest of Zhengzhou in central Henan Province. One is decorated entirely with carving and incising, the other with painted murals, both in advanced late Han pictorial style. Our rudimentary conceptions of Han painting will undoubtedly undergo revision as more such material becomes known.

Han Sculpture

Though small earthenware burial figurines have survived in great numbers, large formal sculptural monuments are exceedingly rare. Those we do have are in several different styles, but on the whole the extant material is dominated by a certain powerful if slightly crude naturalism, with occasional memories of the late Animal style. The combat motif at the tomb of He Qubing recalls Shang motifs and the Animal style. The sculpture of a horse with an incidental figure of a man at this tomb is solidly contained within the stone block (*fig. 71*). The direct realism of the horses from Shi Huang Di's tomb is modified here by more formal considerations. The horse, though in the round, is blocklike, and the stone is not cut away beneath. The ribs of the man and the muscles of the horse's legs are indicated by grooving rather than by modeling in relief. The head with the heavy cheek crescent is a characteristic Chinese rendering, even more noticeable later on. At the same tomb, in a carving in relatively low relief on the surface of a large boulder, a bear wrestles with a large ogre-like man with extraordinarily prominent incisors. As the shape of the horse follows the contours of the original four-square block, this figure follows the natural form of the original boulder. Such relative limitation—or better, such respect for the original material—is characteristic of most archaic sculpture.

The development of sculpture, from a lack of desire to interfere with the stone to a growing virtuosity that delights in cutting into the block, is characteristic of most Western as well as Oriental sculptural styles.

The funeral pillar of the provincial governor Shen is a stone imitation of a tower with a tile roof (*fig. 72*). Under the roof are stone renderings of architectural bracketing and of scenes of combat: a nude warrior with a bow shooting at an oxlike animal, while being pursued in turn by a dragon; and a running figure with flying birds. The scenes occur on the surface of the architectural details: A monkey hangs under the bracketing, the dragon cuts across the architrave. The sculpture has burst the bounds of the simulated architecture.

This vigorous and precocious naturalism has its epitome in the bronze figurines representing an equine entourage found in the tomb of a governor-general Zhang at Wuwei in Gansu, also of the second century A.D. (*fig. 73*). In our knowledge of Eastern Han sculpture, their realism of pose and movement is new and sophisticated. The swallow depicted beneath the rear right hoof of the galloping horse

70. *Rubbing of earthenware tile*. Height 16 1/2″. Chengdu, Sichuan, China. Han dynasty. Richard Rudolph Collection, California

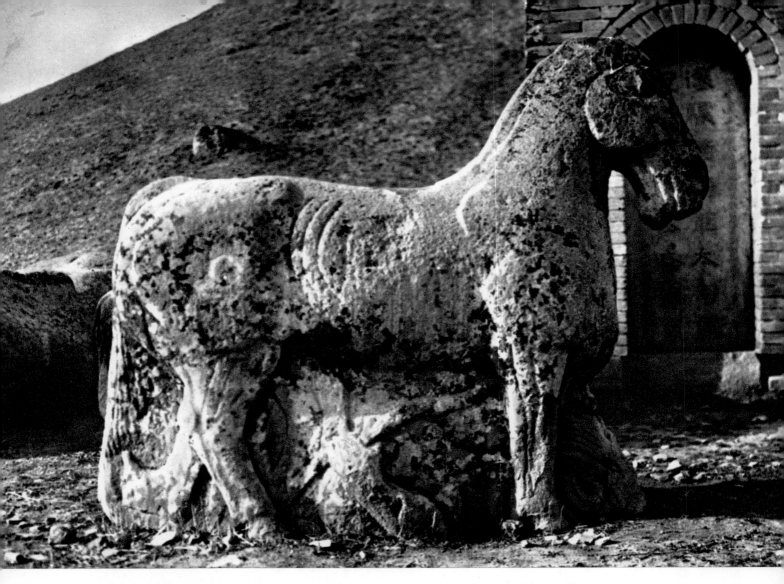

71. *Horse*. Stone, height 74″, length 75″. Xingping Xian, Shenxi, China. Western Han dynasty, c. 117 B.C. Shenxi Provincial Museum

may refer to the name of the steed—the Chinese having a penchant for the poetic naming of the spirited horses they so much admired.

Far to the southwest a unique group of bronze objects and sculptures was found between 1955 and 1960 at Shizhai Shan, not far from Kunming in Yunnan Province. Here from about the fourth century B.C. a provincial kingdom called Dian flourished, ethnically distinct from Han China, to which it became subject in 109 B.C. The bronze figures of animals and humans are sleekly and naturalistically modeled and cast by the lost-wax process in a manner that owes something to the Animal style of Central Asia and that may well have relationships with the bronze artifacts of the Dong Son culture of Southeast Asia. The bronze ritual object (*fig. 74*) is one of the most surprising objects yet found in the continuing excavations in China. The inventiveness of the composition—the arbitrarily hollowed major figure of the bull, its smaller counterpart in the interstice, and the vigorously attacking feline with parallel

incised lines of decoration—creates an almost surrealistic modern effect. Human figure groups from Shizhai Shan are also remarkable for their complexity and naturalism, but with an overall look that suggests both Chinese and Indian elements.

Han Tomb Figurines

The seated mastiff in the Musée Cernuschi is one of thousands of appealing animals in the Han ceramic menagerie of tomb figurines (*fig. 75*). Some are of clay alone, others of gray clay with a covering of white slip, and still others have an olive or deep green lead glaze that deteriorates on burial and becomes iridescent, an effect treasured by collectors and museums. The mastiff in gray clay with white slip decoration is admirable for its knowing naturalism. Sculptors of these figures knew animals so thoroughly—pigs, chickens, and other favorite subjects—that they produced them in a rough-and-ready naturalistic style with no thought of formal

66

decorative development. Tomb figurines give us a glimpse of Han culture and are some of the best documents of the life of the folk.

Han Metalwork

The discovery in 1968 of the rupestrial tombs of Prince Liu Sheng (d. 113 B.C.) and his wife, Princess Dou Wan, at Mancheng in Hebei, about eighty-seven miles southwest of Beijing, added a wealth of material to previously known significant Han metalwork. Their grave goods were an even more spectacular find than those of Fu Hao from Shang dynasty Anyang. In addition to the two now famous but aesthetically unrewarding jade burial suits,

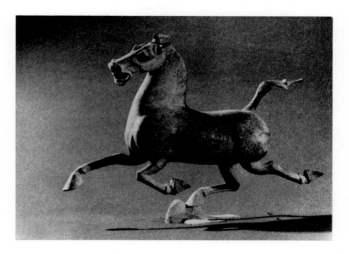

73. *Flying horse.* Bronze, height 13 1/2″. Wuwei, Gansu, China. Eastern Han dynasty, second century A.D. Historical Museum, Beijing (?)

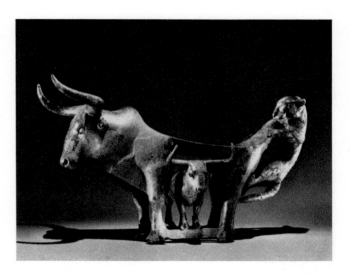

74. *Ritual object in form of two bulls and a tiger.* Bronze, height 16 7/8″. Lijia Shan, Yunnan, China. Western Han dynasty, third–second century B.C. Yunnan Provincial Museum

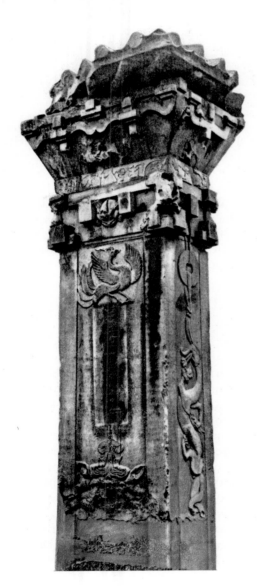

72. *Funeral pillar of Governor Shen.* Stone, height 8′ 9″. Qu Xian, Sichuan, China. Eastern Han dynasty, second century A.D.

almost three thousand objects in various materials were found, including some of the most beautiful and elaborate metalwork, proof conclusive of the continuation of late Zhou technology and inventiveness into the early Han period. The gilt bronze lamp bearer (*fig. 76*) is not only an ingenious device—the lamp has a sliding door to control the amount and direction of light, and the smoke is vented to the rear via the servant's hollow sleeve—but also a convincing representation of a kneeling and offering figure. The realism of pose and garment owes much

to the innovations of late Zhou and of Qin. The gold-inlaid bronze censer (*fig. 77*) with its pierced lid of mountains inhabited by birds, animals, and huntsmen surely embodies an aristocratic taste for elegant technique, sophisticated representation, and knowing symbolism.

Mirrors too continue to be well cast, and the designs of the backs show new creativity. One, called the TLV type because of the apparent Ts, Ls, and Vs in the pattern, usually dates from Western Han and is an adaptation of a sundial design, thus making the back of the mirror into a cosmic symbol. All of the design elements—the mountain in the middle, the four directions, and the Ts, Ls, and Vs—are related to solar orientation, and the mirror, a source of light and insight, is a figurative sun. The fantastic animals of the four directions are portrayed in thread relief. Characteristic of Eastern Han are mirrors on which the cosmic diagram is treated more naturalistically. Some were cast in stone molds, a method largely limited to the Eastern Han period. Instead of the sundial design, a frieze of symbolic

76. *Lamp in form of a young girl.* Gilt bronze, height 18 7/8". Tomb of Dou Wan, Mancheng, Hebei, China. Western Han dynasty, late second century B.C. Hebei Provincial Museum

animals or figures might be depicted in the official, formal style. In figure 78 the decoration consists of the deities of east and west, Dong Wang Gong and Xi Wang Mu, respectively. It too is a cosmic symbol, but its design may derive from scroll painting.

Han Ceramic Vessels

Han ceramic vessels served for daily use and as grave goods. The latter were most often lead glazed, an effect that appears to be an importation from the Mediterranean world. One of the most characteristic forms of lead-glazed burial pottery is the "hill jar," a cylinder on three bear-shaped legs, with a cover representing the magic mountain, the axis of the universe. The Chinese have always had great reverence for mountains, and mountains become the dominant element in Chinese landscape painting, called mountain-and-water pictures. On the hill jar cover the waves of the world-sea lap at the base of the world-mountain. The bodies of such jars often show a frieze of animal combat or hunting scenes coupled with representations of Daoist sage-wanderers. These are executed in a style already seen on late Zhou bronzes. A rarer type of burial ceramic is covered with white slip and painted designs, closely related to the kind of painting on the painted tiles in figure 69.

75. *Tomb figurine: mastiff.* Earthenware, height approx. 11". China. Han dynasty. Musée Cernuschi, Paris

For daily use, iron-glazed stoneware—the origin of later Chinese ceramics—continued to be developed and refined. Han potters learned to cover the whole pot with a uniform and rather thick olive-colored iron glaze. This olive-colored ware was produced in south China, not far from present-day Shanghai, and is called Yue ware (*fig. 79*). It is an important name. Yue, the first of the classic Chinese wares, approached excellence toward the end of the Han dynasty and continued to be made from Han until early Song times—from the second through the tenth century A.D. It was the ancestor of the celadon tradition.

77. (above) *Censer*. Bronze with gold inlay, height 10 1/4″. Tomb of Liu Sheng, Mancheng, Hebei, China. Western Han dynasty, c. 113 B.C. Hebei Provincial Museum

78. (right) *Mirror*. Bronze, diameter 8 1/4″. China. Eastern Han dynasty, dated to A.D. 174. Freer Gallery of Art, Smithsonian Institution, Washington, D.C.

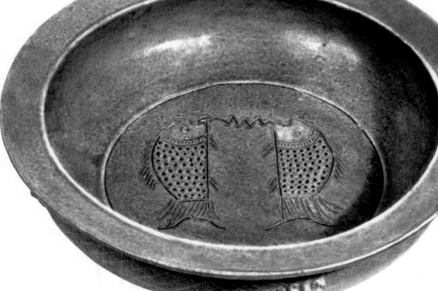

79. *Basin*. Yue ware, with incised fish decor in center; diameter 13 1/4″. Shaoxing, Zhejiang, China. Eastern Han dynasty or early Six Dynasties. Percival David Foundation of Chinese Art, London

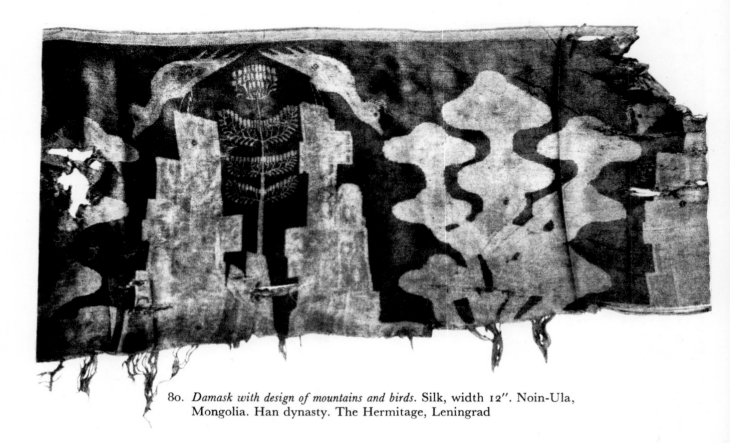

80. *Damask with design of mountains and birds.* Silk, width 12″. Noin-Ula, Mongolia. Han dynasty. The Hermitage, Leningrad

Han Textiles

We will examine only two samples of the textile arts, simply to know that they existed, and on a very high level. Sir Aurel Stein, Peter K. Kozlov, and others found remnants of textiles in Central Asia. Some, such as the one illustrated in figure 80, have stylized designs of mountains, trees, and birds. In this silk damask the two mountains are constructed in a rather geometric, stepped pyramid fashion, and the trees look like enlarged mushrooms. A bird sits on each mountain, on either side of the central tree motif, making a balanced, formal design—a distant ancestor of the great landscape tradition of later Chinese painting. Other complex weaves and embroideries have been found, many with allover patterns of hooks or interlocked diamonds recalling the bronze designs of the late Zhou period (*fig. 63*).

KOREA

One must mention at this point the importance of Korea at various stages in the development of East Asian art. As a peninsula situated between China and Japan, Korea was a major transmitter of cultural influences from the mainland to the islands, but it also was an originator at various times—most notably in the later Bronze Age and again of the styles and iconography associated with Buddhist art.

To secure China's borders, Korea was brought into the empire, largely during the reign of Emperor Wu Di (140–87 B.C.). This gifted people had long profited by contact with China's older culture. Korean arts of the Bronze Age owe much to Chinese influence. The centers of Lolang (Naknang, in Korean) and Tafang (Tapang), flourishing in Han times, had been settled long since by Chinese who emigrated there. Indeed, many of the objects found at Lolang, like the painted lacquer basket in figure 64, were certainly imported from China.

Just before the Kofun culture flourished in Japan, Korea was the setting of a remarkable royal culture under the Three Kingdoms of Silla, Koguryo, and Paekche (first century B.C.–seventh century A.D.). Korean gold work during this time was the most accomplished and spectacular in East Asia. Gold crowns with sheet, twisted, and granulated ornamentation (*fig. 81*) are unique products from royal tombs. Their basic structure, representing geometricized trees and relatively realistic antler forms, evokes shamanistic practices of the Siberian area, but their additional ornaments of comma-shaped jade and quartz beads are certainly the inspiration for the *magatama* ornaments from Japanese Kofun tombs. Gray stoneware vessels from Silla tombs, in

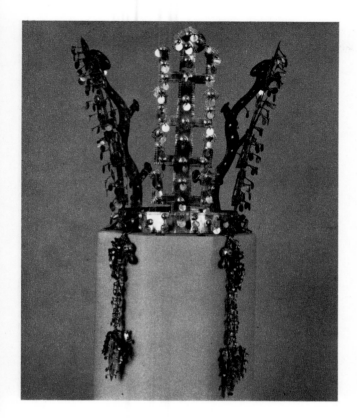

81. *Crown with pendants.* Gold and glass, height 10 1/2".
Gold Bell tomb, Kyongju, Korea. National
Museum of Korea, Seoul

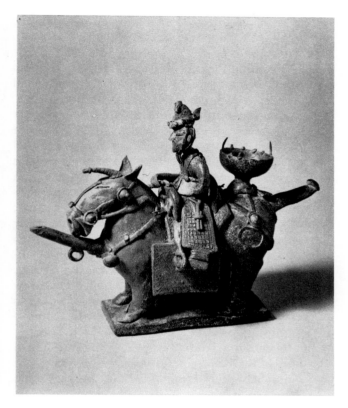

82. *Vessel in shape of a warrior on horseback.* Ash-glazed
gray stoneware, height 9 1/4". Gold Bell tomb,
Kyongju, Korea. National Museum of Korea,
Seoul

83. *Vessel.* Earthenware, approx. 12". Japan. Middle
Jomon period, 3000–2000 B.C. Tsunan-machi
Board of Education, Niigata Prefecture

utilitarian and symbolic figurative shapes, are re-
markable for their individuality and their anticipa-
tion of the later Korean ceramic tradition (*fig. 82*).

JAPAN

Neolithic artifacts, particularly pottery, of the pre–
Bronze Age cultures of Japan are truly impressive.
The Jomon phase, named for the cord pattern found
on pottery vessels, had endured from at least 3500
B.C. to as late as 200 B.C. and appears related to
the Neolithic phase in Manchuria. Early Jomon
pots adhere to simple corded decoration, but by
the middle of the third millennium decoration in
extremely high relief was achieved, to somewhat
fantastic effect (*fig. 83*). Such pots appear to be
growing before our eyes, their bizarre ornament
expanding into space. Later Jomon vessels have more
tightly organized surfaces but still retain something
of that corded, knotted effect so characteristic of this
pottery. Jomon figurines were made concurrently
with the vessels and with the same curious knotted
and corded decoration. Many are female figurines
whose characteristics emphasize fertility, and this

71

agrees with the implications of the numerous stone phallic objects from the middle Jomon period (*fig. 84*).

The Neolithic Jomon culture was succeeded by an age termed "bronze-iron" by Kidder, for bronze and iron appeared in Japan at virtually the same time. Its most characteristic culture is called Yayoi, after the Tokyo neighborhood where its typically plain but refined and sometimes incised pottery was found (*fig. 85*). The cultural development of these peoples seems from archaeological investigation to have been stimulated by invaders from Korea bringing advanced agricultural techniques and bronze-casting; with them came many bronze objects, including mirrors in Han style from China. Profiting by such advanced skills, the Yayoi peoples, or perhaps neighboring clans, cast bronze bells called *dotaku* (*fig. 86*). These are imposing in shape, and some have low relief decoration of houses, boats, animals, or scenes of everyday life—hunting, fishing, and cultivating—in an amusing, primitive "stick-figure" style.

But the most intriguing arts of pre-Buddhist Japan are those of the Kofun, or protohistoric, period, the age of ancient burial mounds and bronze tomb

85. *Yayoi jar*. Earthenware, height approx. 10". Japan. Prehistoric period. Tokyo National Museum

furnishings, ranging in date perhaps from the third to the sixth century A.D. This period saw the rise of the imperial Yamato clan, for whom most of the great burial mounds were made. It was a time of immense activity, when the Japanese seized eagerly on the arts brought from the mainland but at the same time produced clay sculptures called *haniwa*, completely native in style and radically different from mainland burial figurines.

Characteristic of the later Japanese Bronze Age are large mound-tombs. An aerial view of the tomb of the emperor Nintoku not far from Osaka reveals a great keyhole-shaped mound or tumulus surrounded by three moats, the whole originally occupying a space almost half a mile long (*fig. 87*). Many objects of jasper, glass, jade, and gilt bronze are found in tombs of this type, including the well-known *magatama*, comma-shaped beads derived from Korea, often made of highly polished jade of jewel quality.

The architecture of the protohistoric period is far advanced over the Neolithic circular pit dwellings characteristic of the Jomon and early Yayoi phases. It contains much that we now consider typically Japanese, particularly the subtle but direct use of unpainted and undecorated wood, thatch or shingle roofing, wooden piles or columns to raise the

84. *Jomon figurine*. Earthenware, height 10". Japan. Prehistoric period. Tokyo National Museum

structure, and a sympathetic adaptation of the architecture to the natural environment. Several existing Shinto shrines are traditionally associated with the protohistoric period, notably those at Izumo and Ise. Though periodically—and ritually—rebuilt, these two seem to be reasonably authentic documents of the early building styles. Izumo Shrine is the more "primitive" of the two; it is entered on the short side and incorporates the casual asymmetry of a peasant dwelling (*fig. 88*). One cannot but remark on the similarity of these buildings to those still used in Indonesia, notably by the Batak of Sumatra.

The more balanced arrangement of the three buildings of the inner area at Ise, as well as the central entrance on the long side of the main building, suggests an awareness of Korean or Chinese architecture on the part of the Japanese builder of the later protohistoric period. The magnificent setting in the Ise forest dominates the shrine, which seems an integral part of its surroundings. The later Japanese penchant for cloaking sophistication in unpretentious plainness, so evident in the arts of Zen and in the tea ceremony, finds precedent in the simple, rustic buildings at Izumo and Ise.

Haniwa, meaning literally "circle of clay," were sometimes simply clay cylinders placed around a grave mound or tumulus to strengthen the sides of the mound and prevent earth washouts. Never used as furnishings within the tomb, they were placed tightly together, one against the other, like a picket fence around the grave mound. Some with a head at the top may represent the survival of a primitive type. But the *haniwa* that interest us are rather highly developed. The base remains cylindrical, but

86. (above) *Dotaku.* Bronze, height 16 1/2″. Japan. Yayoi period. Tokyo National Museum

87. (right) *Tomb of Emperor Nintoku.* Near Osaka, Japan. Aerial view. Fifth century A.D.

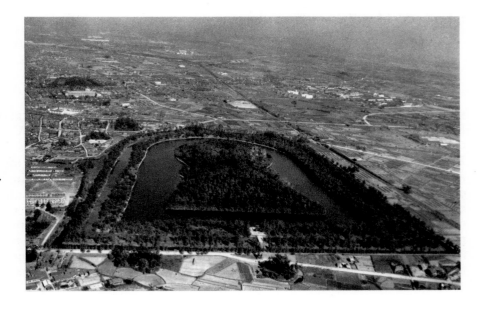

88. *Shrine*. Izumo, Japan

89. (above) *Haniwa: warrior in armor*. Earthenware, height 25″. Japan. Third–sixth century A.D. Negishi Collection, Saitama

90. (left) *Haniwa: horse*. Earthenware, length 26″. Japan. Third–sixth century A.D. Cleveland Museum of Art

set on the base are many lively subjects: human figures singing in chorus, warriors in armor, coy ladies, animals, birds, and even houses (*fig. 89*). Like the Han dynasty figurines, which they do not at all resemble, the *haniwa* give us some idea of the early life of Japan. The technique of the *haniwa* maker was designed to emphasize the material, to use clay so that the object seems to derive from it. The material dominates the concept: tubes of clay, ribbons of clay, slabs of clay. In Chinese tomb figurines, on the other hand, the artist tends to dominate the material. In this difference we find one of the two fundamental distinctions between Japanese and Chinese art. A *haniwa* horse (*fig. 90*) is totally unlike a Chinese horse. The modeling of the head, like that of a toy horse, shows no indication of a cheekbone, no interest in the structure of the eyes or the nostrils. Rather, marks are placed here and there: this is a nose, this is an eye; but the mark is dictated by the nature of the material. To contemporary artists, the *haniwa* figures, with their bold, geometrical, simplified shapes, and their respectful use of clay, are among the most interesting of ancient sculptures.

PART TWO

INTERNATIONAL INFLUENCE

OF BUDDHIST ART

5

Early Buddhist Art in India

From the period between the destruction of the Indus Valley civilization and about the fourth century B.C. almost no significant objects remain, leaving a gap in our knowledge of Indian culture and art. But during these centuries a city architecture developed; the distinctive forms of palaces and dwellings, shrines and temples, are known to us from their representations in early sculptural reliefs at Bhaja, Bharhut, and Sanchi. Aside from their foundations these early structures were largely of wood and have disappeared. There undoubtedly was sculpture too, probably of wood and clay, as well as painting on perishable grounds. The literature of these centuries, the philosophical *Upanishads* and the great epic poems, the *Mahabharata* and the *Ramayana*, gives us much evidence of ideals, values, customs, rites, and ways of life. But of objects we have very few until the rise of Buddhism and its eventual adoption as a state religion by the emperor Asoka, which generated a considerable production of sculpture.

The Buddha's traditional dates are c. 563–c. 483 B.C. We know that he was a prince, probably from the region of Nepal, and that in his lifetime he was a great teacher of ethics. We do not know that he claimed religious leadership or attempted to form a religious order. But his world was undergoing rapid and violent political and social change, and in the resulting instability and uncertainty Buddha's teachings must have become a source of great moral strength to the people who knew him. His relationship to earlier Indian thought, Brahmanism, was that of a reformer rather than a revolutionary. He attempted to modify, reinterpret, and revivify the teachings laid down in the earlier religious texts. He preached a very simple message: that the world

was fundamentally illusory, impermanent, and painful, and that the only way of fulfillment was to escape from the Wheel of Existence, an escape to be accomplished through nonattachment, meditation, and good works. This message is contained in the historic Sermon of the Buddha in the Deer Park at Benares, which corresponds in Buddhist tradition to the Christian Sermon on the Mount:

There is a middle path, a path which opens the eyes and bestows understanding, which leads to peace of mind, to the higher wisdom, to full enlightenment. What is that middle path? Verily it is this noble eightfold path; that is to say: Right views; Right aspirations; Right speech; Right conduct; Right livelihood; Right effort; Right mindfulness; Right contemplation.

This is the truth concerning suffering. Birth is attended with pain, decay is painful, disease is painful, death is painful, union with the unpleasant is painful, separation from the pleasant is painful. These six aggregates which spring from attachment are painful.

This is the truth concerning the origin of suffering. It is that thirst accompanied by starving after a gratification or success in this life, or the craving for a future life.

This is the truth concerning the destruction of suffering. It is the destruction of this very thirst, the harboring no longer of this thirst.

And now this knowledge and this insight has arisen within me. Immovable is the emancipation of my heart. This is my last existence. There will now be no rebirth for me.[2]

Despite his idea that the world was a passing thing, he taught moral behavior, kindness, and love as means of coping with the problems of the world.

The development of Buddhist thought after Buddha's death is the story of a faith that commanded a powerful following with extraordinary rapidity. Soon after his death orders were formed for both men and women, although there was great discussion whether there should be an order of nuns. The events in the Buddha's life were codified. Eight were chosen as being of particular importance: the story of his supernatural Birth from the side of his mother, Queen Maya; the story of his Renunciation of the princely life after encounters with a beggar, a sick man, a corpse, and an ascetic; his Meditation in the forest; his Assault by Mara, the demon of evil, in an attempt to force him to abandon his meditations; his final Enlightenment underneath the *bodhi* tree; the Preaching of the message of enlightenment at Benares; the great Miracle of Sravasti; and finally the *Parinirvana*, not a death, but an end to further reincarnation: he has become the Buddha. This "primitive" Buddhism is maintained in what is called the Lesser Vehicle (Hinayana), and is still the religion practiced in Sri Lanka, Burma, and Thailand. Mahayana, or the Greater Vehicle, developed after the time of Christ; it was a complex philosophical and ritualistic system that related what was until then a minor sect to the whole scheme and tradition of Indian thought. Buddhism, like Christianity, is a proselytizing religion, and it spread rapidly—thanks in great measure to the conversion of the Maurya (central Indian) emperor Asoka and the Kushan (northwest Indian) emperor Kanishka—through Central Asia to China and Japan and across the Indian Ocean to Cambodia and Indonesia. The majority of the later works of Indian Buddhist art and those outside of India are products of the Mahayana faith; Hinayana is the Buddhism of the earlier Indian monuments and those of Sri Lanka, Burma, and Thailand.

Contemporary with the Buddha was another teacher, Mahavira (c. 548–c. 476 B.C.), who also preached a reformed faith, quite comparable to Buddhism with certain major exceptions. These are, notably, a concept of a soul and free will not encompassed by Buddhism and an extreme dualism of spirit and body that the Buddha did not acknowledge. Like Buddhism, this faith, called Jainism, developed into a complex theological system with esoteric overtones and complexities hardly thought of by its founder. The sculptural monuments left to us by Jainism are almost as important as those of Buddhism, particularly in the Kushan art of Mathura. But Buddhism became the great evangelical faith of Asia and consequently is the religion that has

excited the imaginations of countless Orientals and Westerners.

Little is known of art just before the earliest productions of the Buddhist artist. Various forest cults, perhaps stemming from the Dravidian fertility cults of the Indus Valley civilization, must have used shrines and images, but these are now lost except for one or two isolated sculptures and literary references. The coming of Alexander the Great to the Indus River in 327 B.C. had little effect on India, which would not receive the impact of the Mediterranean world till the time of imperial Rome.

MAURYA ART

The earliest Buddhist monuments extant were produced in the Maurya period (322–185 B.C.), notably works ordered by the emperor Asoka (reigned c. 273–232 B.C.), who was himself converted and adopted the Buddhist Law of Piety as the law of his lands. To commemorate his conversion and to expand the teaching of the faith he ordered many stone memorial columns to be set up at points associated with important events of the Buddha's life. These monoliths reveal the influence of Persia, in a smooth aristocratic style that had little influence on later Indian art. Made of beautiful cream-colored *chunar* sandstone, they were of considerable size. Great shafts with the edicts of Asoka engraved near their bases were crowned by an animal or animals on a bell-shaped capital recalling those of the Achaemenid empire of Darius and Xerxes. The capitals were highly polished by a process requiring considerable technical skill. This too is thought to reflect the official and hieratic style of Achaemenid sculpture and has been called the "Maurya polish"; but many have questioned the accuracy of this designation, since the technique could reasonably have continued beyond that period. The best preserved of these great columns is the one excavated at Sarnath and now kept at the museum there (*fig. 91*). Most of the columns have fallen, and the capitals have consequently been moved to museums. The Sarnath capital is surmounted by a plinth with four animals and four wheels in relief which, in turn, is surmounted by four lions back to back. The lions themselves are remarkably like those of Persepolis and Susa, in Persia. The stylization of the face, particularly of the nose and whiskers on the upper part of the jaw, the rather careful rhythm and neat barbering of the mane, the representation of the forelegs by long, sinewy indentations and, especially, the stylization of the claws, separated by deep clefts, and the slightly hunched posture of the animals— all these are elements to be found in the representa-

tions of lions at Persepolis. The representations on the plinth are more unusual. The horse, the best preserved of the four figures in relief, has that sympathetic naturalism we have learned to expect from the Indian sculptor. Despite the stylization of the mane, the treatment of its body and legs shows a much less decorative intention than does the treatment of the lion above.

The subject matter is of great symbolic import

91. *Lion capital*. Polished *chunar* sandstone, height 84″. Asoka column, Sarnath, India. Maurya period, c. 274–237 B.C. Museum of Archaeology, Sarnath

because the lion is the symbol of royalty, and the Buddha, described in the texts as the lion of the Sakya clan, was himself of royal blood. The wheels on the plinth are symbols of the Buddha's Law, and later representations of the Buddha show his hands in the motion of teaching or turning the Wheel, symbolic of his preaching the Sermon at Benares, where he "set the Wheel of the Law in motion." But the other representations are more difficult to explain. The animals represented may perhaps be those associated with the four directions, or they may symbolize lesser deities of the Hindu pantheon as it existed at that time. The horse, in particular, is associated with Surya, the sun god who travels across the sky in a chariot as Apollo, the Greek sun god, did. The Brahmany bull, which in the illustration can just barely be seen on the right of the plinth, is associated with the great god Siva, one of the two most important male deities of the later Hindu pantheon. It has been suggested that the animals on the base represent such non-Buddhist deities at the service of the Buddha. The capital from Rampurva has, in addition to the now familiar bell-shaped capital, a plinth decorated with water flowers and plants, motifs that become extremely important in later Buddhist art. The plinth is surmounted by a bull whose body is carved in the round but whose legs emerge from the block, for the functional reason that the legs alone could not have supported the weight of the stone body (*fig. 92*). This treatment does, strangely enough, recall certain Hittite and Persian versions of the bull, which treat the area below the stomach as a block, on which the genitalia are shown in relief. But the style of the animal itself has none of the awesome and overpowering quality of works from the ancient Near East; rather it has a certain quiet simplicity and gentleness characteristic of later Indian representation of animals.

At the same time that works were being produced under imperial patronage in an official style with traces of Persian influence, other sculptures were produced that have no precedents in the arts of the ancient Near East. They appear to be representations of nature deities, yakshas (male) or yakshis (female). Whether these images were placed at Buddhist sites and connected with Buddhist ritual it is at present impossible to say. The two key monuments of this native style are the Parkham yaksha (*fig. 93*), in the museum at Mathura, and the Besnagar yakshi (*fig. 94*), in the museum at Calcutta. Figure 93 is one of the most interesting and exciting of all pictures of Indian sculpture, for it shows the Parkham yaksha as it once may have stood, in the midst of a village and not within the protective walls of a museum. In the days of the king Bimbisara, a contemporary

of the Buddha, says a Tibetan source, ". . . one of the gate-keepers of Vaisali had died and been born again among demons. . . . He said, 'As I have been born again among demons, confer on me the position of a yaksha and hang a bell around my neck.' So they caused a yaksha statue to be prepared and hung a bell round its neck. Then they set it up in the gatehouse, provided with oblations and garlands along with dance and song and to the sound of musical instruments." One can sense something of the monumental grandeur of these early images. The large figure is of cream sandstone, now badly eroded. It is architectonic, frontally organized, massive in its proportions and, in a sense, held within the block of stone. One might also say that it is contained in a tree trunk, because it is likely that most of the native style sculpture of the period preceding the rise of Buddhist stone sculpture was in wood. The Parkham yaksha and the Besnagar yakshi may well be translations into stone of a tradition of monumental wood sculpture carved from great tree trunks. The relaxation of the yaksha's left knee makes us wish we had some earlier work for comparison, because the bend naturally recalls the relaxation of the knee seen in archaic Greek sculpture. It is a first tentative gesture toward a more informal, less rigid treatment of the figure. The yaksha's paunch, or potbelly, is a constant feature of yaksha iconography, seen especially in Kubera, god of wealth and chief of all yakshas, and in the elephant-god Ganesha, a yaksha type.

The date of the Parkham yaksha is a much-debated subject. There is a present tendency on the part of some scholars to place it later than the previously accepted date within the Maurya period. It has now been suggested by W. Spink that it is a work of the Shunga period, some hundred years later. He points to such details as the heavy necklace as characteristic of Shunga forms. At one side of the figure in the illustration is a little stone piece of much later date. This relief of two figures was set up alongside the big yaksha as part of the village cosmology as late as the ninth or tenth century A.D., or even later. At the time of its discovery by an outsider who came to the village, the yaksha was included in daily ritual worship.

Again, we are fortunate to have a photograph showing the Besnagar yakshi outside the walls of the museum, a tall and powerful figure slightly smaller than the Parkham yaksha, rather sadly damaged but with the same general conformation as the yaksha. The left knee is very slightly bent, less so than in the Parkham yaksha, but the proportions of the figure are equally monumental. The tremendous development of the breasts, the relatively small waist, and the large hips show one of the fundamental Indian representational modes. The female form must suggest its functions of life-bearing, life-giving, and loving. The exact date of the Besnagar yakshi is as open to argument as that of the Parkham yaksha. There are certain similarities—particularly in the headdress, the necklace, and the treatment of the girdle and skirt—to works as late as the first century yakshis at Sanchi. The weathered condition of both the Parkham yaksha and the Besnagar yakshi adds decades to their appearance and increases the archaic effect.

In contrast to these monumental works in stone, which may be continuations of a wood-carving tradition, we must now consider an example of work in earthenware, because the influence of earthenware technique on Indian sculpture is of the utmost

92. *Bull capital.* Polished *chunar* sandstone, height 8'9". India. Maurya period, c. 274–237 B.C. National Museum, New Delhi

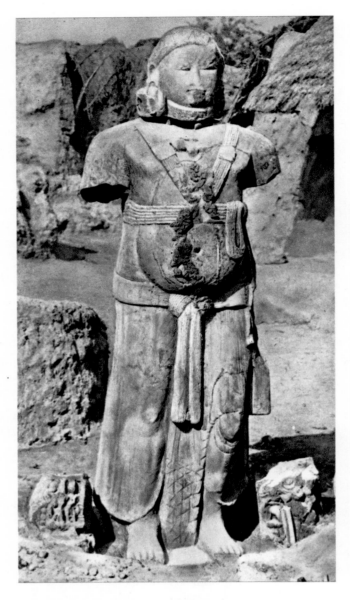

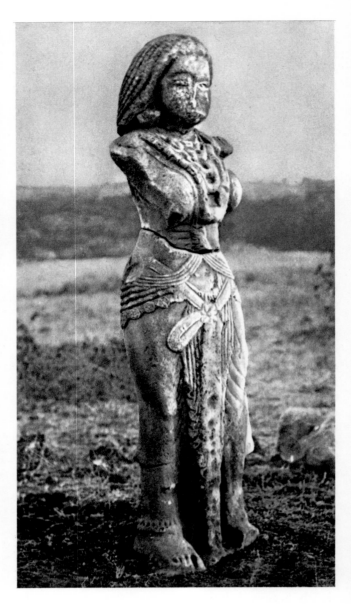

93. *Yaksha*. Sandstone, height 8′ 8″. Parkham, India. Late Maurya period, second century B.C. Museum of Archaeology, Mathura

94. *Yakshi*. Sandstone, height 79″. Besnagar, India. Late Maurya period, second century B.C. Indian Museum, Calcutta

importance (*fig. 95*). Many of the earlier earthenwares come from excavations near Sarnath and Benares on the Ganges, as well as from other sites in north central India where archaeological strata indicate a Maurya date. This female figurine is far more sophisticated than the Parkham yaksha and the Besnagar yakshi. Though the pose is frontal, the treatment of the skirt, the face, and the elaborate headdress contributes a mood of freedom and gaiety. She has a lightness and a plastic quality, something of the softness of clay, that is extraordinarily pleasing. It seems probable that in the Maurya period three different styles flourished: an official one, associated with the court; a native, forest-cult style, rather rigid and archaic, for images of titular deities of trees, streams, or villages; and an emerging style of

sophisticated sculpture, largely lost to us except for the terra-cottas, which was perhaps an urban product somewhere between the court style and the cult style. Certainly this extremely knowing young lady, with her panniered skirts, breathes an air different from either the animal capitals of Asoka or the Parkham yaksha.

BHAJA AND BHARHUT

The Maurya dynasts were followed by the Shungas, a family reigning in north central India from 185 to 72 B.C. Now there is more material more surely dated, and the beginning of an elaborate development of Buddhist sculpture. The first important

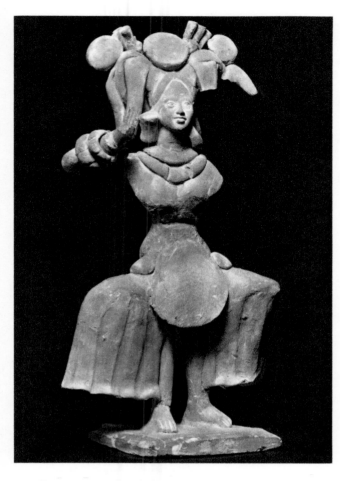

95. *Female figure.* Earthenware, height 11 1/4″.
Pataliputra, Bihar, India. Maurya period, c. 200
B.C. Patna Museum, Bihar

Shunga site is the *chaitya* hall (nave church) and the *vihara* (the refectory and cells of the clergy) at Bhaja. Bhaja is a Buddhist monument, but the sculpture presents the Vedic deities of sun and storm, gods of the pre-Hindu religious environment in which Buddhism developed. One can see from the general plan of the *chaitya* hall why from the early nineteenth century it was called the Buddhist cathedral (*fig. 96*). There is a central nave, two side aisles, an ambulatory at the back, and a high, vaulted ceiling. Although this designation is visually apt, it is materially and functionally misleading. This *chaitya* hall and many others are carved out of living rock, but their prototypes were wood structures whose arched roofs were formed of boughs bent in a curve, lashed to upright beams, and thatched. The focus of the nave is a monument, the stupa, that looks like the Indian burial mound. The stupa, commemorating the *Parinirvana*, or most exalted condition, of the Buddha, is here a symbol of the Buddha and his teaching, and is the focus of the naves of nearly all remaining *chaitya* halls. The facade of the Bhaja *chaitya* hall is also carved to simulate wood construction, looking almost as if the *chaitya* hall were surrounded by a heavenly city of arched pavilions, long railings, and grilled windows. One can make out on one side the head, earrings, breasts, waist, and hips of a large yakshi. There were two such yakshis at Bhaja, good examples of the early use of fertility deities to glorify the Buddha. These were very quickly absorbed into the current of Buddhism, and we find extraordinarily sensuous sculptures on

96. *Exterior of chaitya hall.*
Bhaja, India. Late
Shunga period, c.
first century B.C.

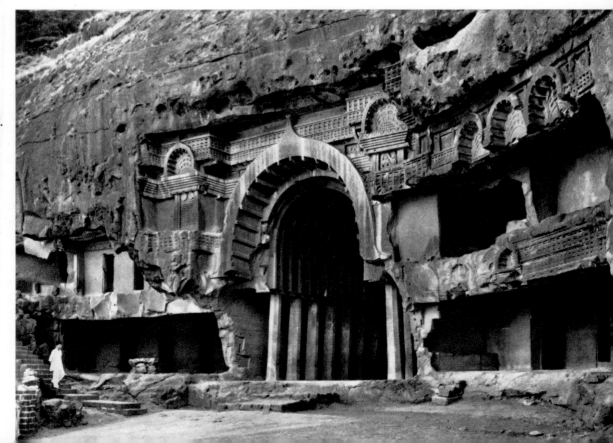

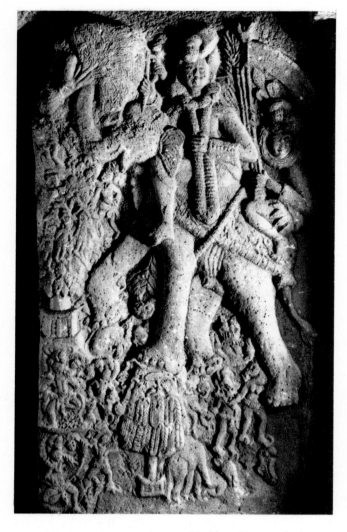

97. *Indra over the court of an earthly king*. Stone relief, height approx. 60″. Bhaja, India. Late Shunga period, c. first century B.C.

both Buddhist and Jain monuments. There is both a low and a high intellectual tradition, and the one cannot live without the other. One of the best demonstrations of this is in the iconography of early Buddhist art.

The *vihara* are small cells for monks, and at Bhaja they are carved into the cliff that flanks the *chaitya* hall to the east. One of the farther ones has a porch on which are carved in low relief some extremely interesting non-Buddhist subjects (*fig. 97*). These represent Vedic deities: Surya, the sun god, in his chariot, and Indra, bringer of storms, thunder, lightning, and rain, riding on his animal-vehicle, an elephant who uproots trees and tramples the ground. Below are people worshiping at sacred trees, while nearby and slightly higher others flee in terror of the storm. In the lowest register, at left, a music-and-dance performance is in progress before a ruler seated in the posture of royal ease. The style of this relief, with the mounted deity and the escort behind him who holds his symbols, is distinctively archaic, notably in the stiff shoulders and frontal pos-

ture of the deity. At the same time, the escort, the elephant, and the figures below display an active and free style, emphasizing curvilinear structure, with one form flowing smoothly into the other, rather like the Maurya earthenware. Bhaja is dated variously, from the end of the second century B.C. to the very beginning of the first, but the second century B.C. seems preferable. Significantly, there is no representation of the Buddha, nor are there, aside from the stupa, any symbols of the Buddha.

The second great monument of the Shunga period is a construction; it is not carved from the living rock. This is the now largely destroyed stupa of Bharhut, of the late second or early first century B.C. The sculptures from Bharhut were found in the fields but have now been removed to the Indian Museum in Calcutta. All that remains of the stupa are a part of the great railing, one of the gates (*torana*), and other fragments (*fig. 98*). In America some of these may be seen at the Freer Gallery in Washington, at the Museum of Fine Arts in Boston, and at the Cleveland Museum of Art. Bharhut is a good example of the imitation of wood construction in stone. Obviously a tower gate of this type, with several cross-lintels, is more appropriately constructed in wood than in stone. The advantage of stone is in its considerably greater permanence. The gates of cities or palaces were very much like this gate, except that they were constructed of wood. Bharhut is the first classic example of the use of aniconic (noniconic) symbolism, so called since it does not represent the figure of the Buddha; the symbols, in a sense, invoke his presence. Bharhut also exemplifies the incorporation of the male and female fertility deities, here better preserved than at Bhaja, into the service of Buddhism.

The form of the stupa was very simple: a burial mound surrounded by a railing of great height. The railing was divided vertically and horizontally, and at each junction between the vertical and horizontal members was a lotus wheel or a medallion in relief representing busts of "donors" and aniconic scenes from the life of the Buddha. The coping above has a lotus-vegetation motif, while the gate pillars proper repeat the motif of the Maurya bell column, with lions supporting the upper architraves of the *torana*, which in turn is crowned by the Wheel, symbolic of the Buddha's Law. A detail of the sculpture on the stupa reveals characteristics we might well associate with wood carving. In this representation of the dream of Queen Maya, the mother of the Buddha dreams of a white elephant, symbolic of the coming of the Buddha to her womb (*fig. 99*). The scene, with its tilted perspective and the seated attendants seen from behind, is stiffly represented, simplified in a manner not like stone carving but like

98. *Gateway and railing of stupa*. Stone, height of gateway approx. 20'. Bharhut, India. Shunga period, early first century B.C. Indian Museum, Calcutta

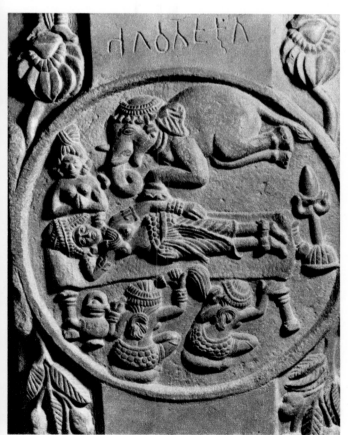

99. *Dream of Queen Maya*. Pillar medallion on stupa railing, height 19". Detail of fig. 98

carved wood. Other scenes from the life of the Buddha are shown, as are numerous jatakas (tales of previous incarnations of the Buddha) and representations of vegetal and water symbols such as the *makara*, which is half fish, half crocodile. A characteristic motif at Bharhut is the lotus medallion enclosing the bust in relief of a turbaned male. At the corner column of each of the *toranas* at Bharhut were representations in relatively high relief of male and female deities, yakshas and yakshis. Several among the yakshis are incorporated into the woman-and-tree motif, a favorite, auspicious, and frequent one in Indian art. The yakshi, Chulakoka Devata, holds the branch of a blossoming mango tree with one hand and twines the opposite arm and leg around its trunk (*fig. 100*). The subject illustrates a familiar Indian belief that the touch of a beautiful woman's foot will bring a tree into flower, a ritual embrace still practiced in south India. The yakshis of Bharhut are singularly wide-eyed and confident, their gestures explicit and naive, the first of a long series of female figures that represent Indian sculpture at its best.

THE ANDHRA PERIOD: SANCHI, AMARAVATI, AND KARLE

The Satavahana dynasty (220 B.C.–A.D. 236) ruled over the Andhra region of central and southern

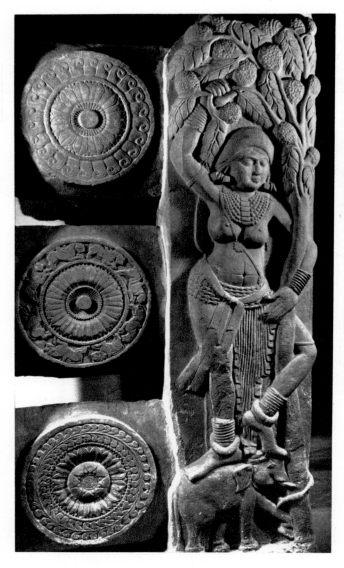

100. *Chulakoka yakshi.* Pillar relief of stupa; red sandstone, height 84″. Bharhut, India. Shunga period, early first century B.C. Indian Museum, Calcutta

India. Consequently its arts include monuments that vary in style. One, the greatest monument of the early Andhra period in central India, is Sanchi. The other prime monument of the period is the group of stupas in south India, the most famous being Amaravati. The stupa of Amaravati was constructed over a considerable length of time, from as early as the first century A.D. until after the fall of the Andhras in the third century A.D. Most of the remaining sculpture from Amaravati is of the third and fourth centuries A.D. Sanchi, on the other hand, is primarily important for its sculptures of the second and first centuries B.C. and is the type-site for the early Andhra period.

Sanchi stands on a hill rising out of the plain just north of the Deccan Plateau, not far from Bhopal. On the hill are three stupas: stupa 1 is the "Great Stupa"; stupa 2 is the earliest in date, about 110

B.C., and also has a few sculptures of late Shunga date; stupa 3 is a smaller monument of the late first century B.C. and the first century A.D. Stupas may have enclosed relics of the Buddha, and great ones were erected at various holy places in India, such as hills and confluences of streams. Generally speaking, they all followed the same plan: a mound of earth faced with stone, covered with white stucco, partly gilded, and surmounted by a three-part umbrella symbolizing the three aspects of Buddhism— the Buddha, the Buddha's Law, and the monastic Order. The umbrella was usually surrounded by a small railing at the very top of the stupa. This may reflect the old idea of the sacred tree with a protective railing, such as those we saw in the Bhaja reliefs. Around the mound proper a path was laid out so that the pilgrim to the holy spot could make a ritual clockwise circumambulation of the stupa, walking the Path of Life around the World Mountain. This path around the stupa was enclosed by a railing pierced by gates at each of the four directions. The railing and the four gates provided the occasions for rich sculptural decoration. The stupa, like so much Indian architecture, is not so much a constructed, space-enclosing edifice as it is a sculpture, a large, solid mass designed to be looked at and to be used as an image or diagram of the cosmos.

The Great Stupa at Sanchi was erected over a period of time (*fig. 101*). The illustration shows it as it exists today, after the Archaeological Survey of India achieved a careful and respectful restoration. The site is now beautifully planted and is one of the most lovely in all of India. The body of the stupa proper was constructed of brick and rubble faced with gilded white stucco. There is a massive Mauryan rail around the base, and a path above that level, on the stupa proper, with a railing of the Shunga period. There are four gateways, all masterworks of early Andhra sculptors. We should recall that there are other Shunga relics at Sanchi, largely on stupa 2, down the hill from stupa 1. But any beginner studies Sanchi for the Great Stupa, whose famous gateway is that on the east. The stone of the Andhra gates is ivory white and gleams in the sunlight against the rubble-and-brick base of the stupa behind, contrasting with the deep brown and green of the rubble and moss where the stupa has been eroded and not restored. We have mentioned that the sculptural style of Bharhut was influenced by work in wood. From an inscription on one of the gates at Sanchi we have further evidence for the derivation of sculpture in stone from work in other materials. It speaks of one group of carvings as being a gift of the ivory carvers of Videsha, a village not far from Sanchi. Some of these sculptures may well display a translation of work in ivory into a stone style.

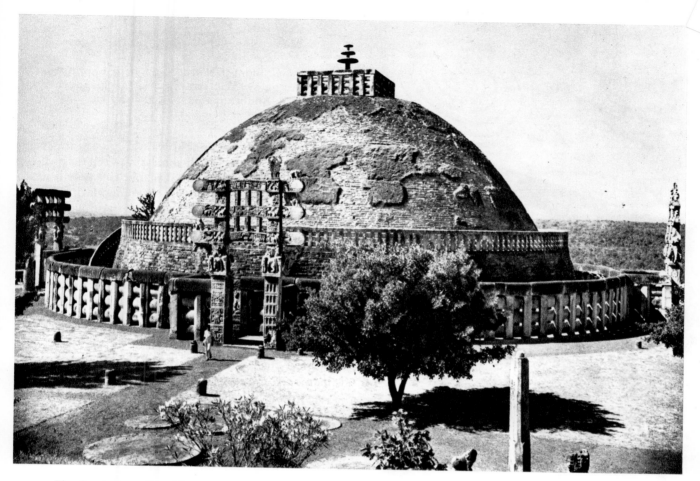

101. *The Great Stupa.* Sanchi, India. Shunga and early Andhra periods, third century B.C.–early first century A.D.

The four gateways, or *toranas*, comprise identical elements: Each has two major posts or columns crowned by three architraves (*fig. 102*). On the topmost architrave are *trishulas*, symbols of the Buddhist triad. The *trishulas* are supported by lotus Wheels of the Law, and the three architraves are elaborately carved with jatakas, charming folk tales with homely morals in which the Buddha is sometimes a human being, sometimes incarnate as an animal. They provide an engrossing picture of forest culture and lore. The capitals that crown the posts, just below the level of the architraves, resemble those we shall see at Karle and are composed of four elephants with riders going counterclockwise around the column. The sculptured stories on the architraves are confined to the space between the extensions of the main pillars, while the parts outside these show single scenes from the life of the Buddha or previous lives of the Buddha, or symbols associated with Buddhism. The lower parts of the main pillars have representations of scenes from the lives of the Buddha on three sides, and their interior faces are carved with large guardian figures of yakshas and yakshis. It is significant that, as at Bharhut, the Buddha is not represented in figural form. The symbolism is still aniconic, and the Buddha is rep-

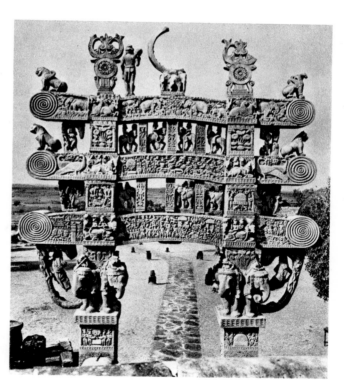

102. *North gate of the Great Stupa.* First century B.C. Detail of fig. 101

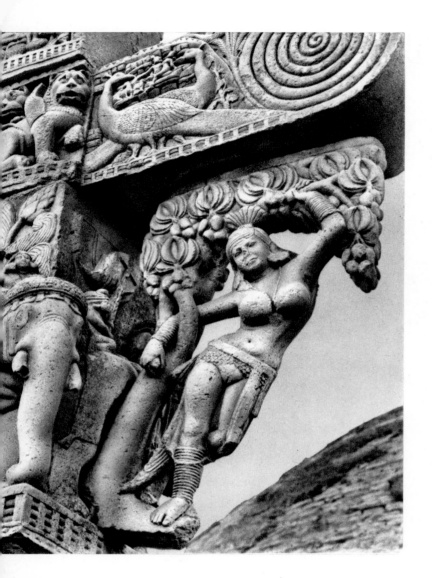

103. *Yakshi*. Bracket figure; stone, height approx. 60".
East gate of the Great Stupa, Sanchi, India.
Early Andhra period, first century B.C.

The body of the Sanchi yakshi pivots in space, though the figure is still somewhat archaic in being largely confined to a frontal plane. Her pose is much more complex, contrasting the angularity of the balancing arms with the curving and voluptuous movements of the body. One sees more use of open space. The sculptor is beginning to cut away the stone to silhouette the figure against open air. Although functionally the figure does not support anything, being an imitation of wooden construction, it is at the same time a decorative sculpture and a simulated architectural bracket. The heavy shape of the tree is squared off at the top and developed as a right angle, and the thrust of the body appears to support the architrave above. On Buddhist monuments the supportive function of yakshas and yakshis was primarily religious, not architectural. The lesser folk, the illiterate, the great mass of people who but dimly understood the teachings of the Buddha, could be comforted when they saw the local tutelary deities, male and female, welcoming them to the austere and abstract stupa.

A fine and completely illustrated book has been written by Sir John Marshall on the sculpture at Sanchi, showing its wealth of detail in the many panels with their narrative content. Our illustrated panel is a good example of a jataka scene; its treatment of the subject illustrates the stage reached by narrative art in the early Andhra period (*fig. 104*). A single panel is framed below by a railing and at the sides by a scrolling vine pattern of grapes that gives lush, rich movement to the edges, expressive of the vegetative forces of life. These enclose a picture plane crowded with figures, in effect a map of an enclosure packed with people. A river runs diagonally from top center to bottom right, thus preserving a maplike view of a landscape whose details we see in side view. The trees of the landscape are shown in their most characteristic shape, the silhouette, and hills and rocks are presented in profile. The human and animal figures are shown more or less frontally but on a ground line, almost as if they were a separate composition within the landscape. The representations are individually accomplished and subtle—the figures are at ease, the representations of monkeys and their movements are highly convincing, even groups of figures seen from the same point of view are credibly rendered. Only the overall organization of these units reveals a lingering archaic approach.

The story told here is that of the Buddha when he was king of the monkeys. In this incarnation the

resented by a wheel, footprints, a throne, or some other symbol.

The yakshi brackets on the gates are of particular importance for their sculptural quality. The most famous one, principally because it is almost perfectly preserved, is the figure on the east gateway, dating from about 90 to 80 B.C. (*fig. 103*). The fertility goddess is posed rather like the yakshi of Bharhut, one hand grasping the bough of a tree and the other arm entwined between two branches. Her left heel is against the base of the tree trunk, giving the ritual blow in the traditional marriage rite of the maiden and the tree, a motif we meet here for the second and by no means last time. The Sanchi yakshi, however, is of a different cast from her sister at Bharhut. She is only slightly later in date but has progressed considerably in technical and compositional development. She is no longer simply a relief on the face of a pillar, standing woodenly, implacably looking out at the observer with an almost Byzantine iconic stare.

Buddha-to-be had as enemy and rival his wicked brother, Devadatta. The monkeys were attacked by archers of the king of Benares, and the Buddha-to-be stretched his huge simian frame from one side of a river to the other so that the monkeys could flee to safety across his body. But the last to cross was Devadatta, who thrust his foot down as he passed over and broke his brother's back. The king had the Buddha-to-be bathed, rubbed with oil, clothed in yellow, and brought before him. "You made yourself a bridge for them to pass over. What are you to them, monkey, and what are they to you?" The dying monkey replied, "I, King, am lord of these bough beasts . . . and weal have I brought to them over whom governance was mine . . . as all kings should." Thereafter the king of Benares ruled righteously and came at last to the Bright World. The story is typical in showing the future Buddha as a royal figure; he is usually a king or prince among men or animals. Further, as a bodhisattva (Buddha-to-be; one capable of Buddhahood who renounces it to do acts of salvation for others), he offers himself again and again as a sacrifice in order to save his fellow beings.

The composition has much in common with some Early Christian ivories—in the "feel" of the medium, the way the figures are carved, and the way they are composed. This bears out the inscription concerning the Videsha ivory carvers. It is an art vibrant with life, full and abundant. It is a style for those who like their art rich and crowded.

Another important early monument is the Great Chaitya Hall at Karle, previously dated rather too early (*fig. 105*). We now know from inscriptions on this *chaitya* hall that Karle was made between about A.D. 100 and 120 and is therefore an accomplishment of the mid-Andhra period, or rather of a minor kingdom related to Andhra. A general exterior view of Karle is not as impressive as that of nearby Bhaja, because at Karle much of the exterior stonework, including a screen over the opening, has remained. This obstructs the view of the *chaitya* hall proper; further, a modern Hindu shrine has been erected in the court, which also tends to block the view. The hall at Karle is cut into a mountain some hundred miles southeast of Bombay, at the top of the Western Ghats which lead from the low-lying coastal plain up to the Deccan Plateau. The area is rather barren, looking not unlike certain sections of Utah and Colorado, with great vistas across the tableland and

with mountains or buttes (ghats) rising directly from the plateau.

The idea of the cave excavated in the mountain appears especially characteristic of India and, through Indian influence, of the eastern part of the Asian mainland. In India the *chaitya* hall and the *vihara* are often cut into living rock. In Central Asia we find cuttings in the clay cliffs. In China there are a great number of Buddhist cave-temples; in Japan the motif occurs hardly at all. Some very interesting psychological and aesthetic problems are raised by the cave complex. Unquestionably the Indian genius is primarily sculptural, and a sculptural quality extends as well to Indian architecture. The Indian does not conceive of architecture primarily as an enclosure of space. He conceives of it as a mass to be modeled, to be formed, and to be looked at and sensed as a sculpture. Perhaps, then, the practice of carving in living rock is understandable. It is possible that primal ideas of fertility are involved, of penetrating the womb of the mountain, or of attaining security in the womb.

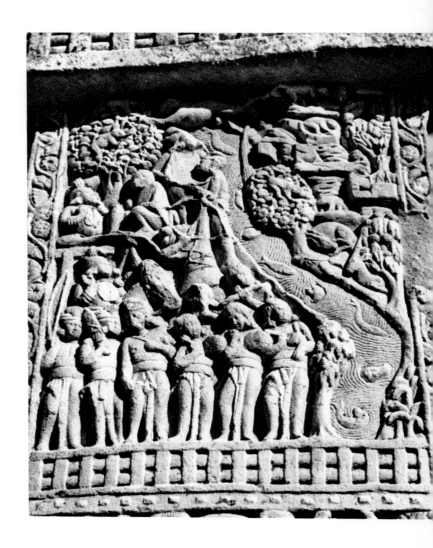

104. *Monkey jataka*. Relief carving; stone, height approx. 30". Upper part of south pillar, west gate of the Great Stupa, Sanchi, India. Early Andhra period, first century B.C.

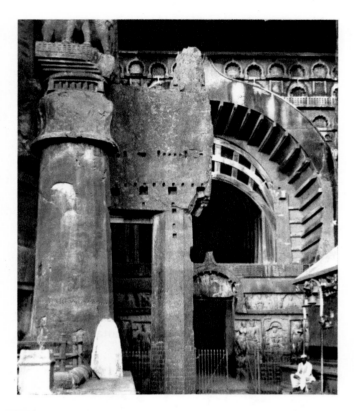

105. *Chaitya hall*. Karle, India. General view. Andhra period, early second century A.D.

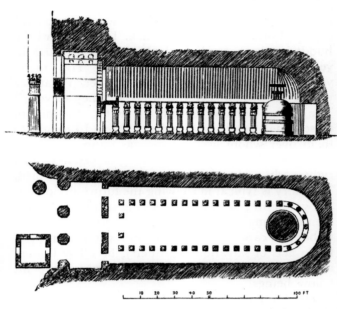

106. *Plan and cross section of the chaitya hall*. Karle, India

The *chaitya* halls at Bhaja and Karle, carved in living rock, serve us as models of the great freestanding *chaitya* halls, the earlier ones built of wood and the later ones of brick and stone, which are now totally lost or ruinous. These exceptional structures are a true interior architecture, intended to house a congregation and made so that worshipers could perform a ritual circumambulation of the stupa at the inner end of the nave. The plan of Karle gives some clue to their arrangement (*fig. 106*). On the Karle plan we note a porch, a narthex or inner porch, and a threefold entrance—one into each of the side aisles and a main entrance into the nave proper. The nave is a simple, long space defined by the columns which extend around the far side of the stupa to make an ambulatory (*fig. 107*). There are no chapels built out to the sides as one finds in medieval Western churches. The elevation shows the developed column type, with "vase" base and bell capitals. By the light from the great horseshoe arch of the facade one can make out the form of the stupa at the end of the nave, and of the vault above, which is an imitation of wood and thatch construction. The main nave at Karle is most impressive, reaching a lofty height of forty-five feet. The vase bases are probably derived from earlier

wood construction, which required columns to be placed in ceramic vases to keep out wood-devouring insects. The bell-shaped capitals of Karle, undoubtedly derived from the Asoka columns, are surmounted by elephants and riders as at Sanchi. But here there are just two riders on each beast, facing out so that they are oriented only to the nave. The stone at Karle is a hard gray blue granitic type, and the whole effect is somberly majestic, in contrast to the severity of Bhaja, where the columns, perfectly plain prismatic shafts with no capital or base, rise directly from the floor and move directly into the vault. At Karle we find much more elaborate figural forms, richly sculptured. The space of the interior at Karle seems to be more flexible, more flowing, than the comparatively static space we sense at Bhaja.

Only superlatives are adequate to describe the sculpture of the great period we now enter. The narthex screen at Karle is sculptured on the exterior with panels containing large-scale male and female figures somewhat questionably called "donors" (*fig. 108*). There are many other panels with routine Buddhist images ranging from the fourth century A.D. to the sixth or seventh century A.D.; but the only work that concerns us here is that of the first

century A.D.—the donors. They are of noble type, but we know not whether they are actually donors or loving couples (*mithuna*). Seldom in the history of art have male and female forms been conceived on so large and abundant a scale, with sheer physical health seeming to brim from them in an ever flowing stream. The quality of *prana*, or breath, which we must mention now and again in connection with Indian sculpture, is obviously present in these figures. Perhaps for the first time we sense that intake of breath when the dancer comes to the climax of his performance, when he comes to the pose that strikes the final note, a pose prepared by a sudden inhalation that arches the chest and achieves perfection with the fullest expanse of the body. Breath and dance are very important in determining the look of Indian sculpture, the stance and the representation of the body. We can imagine the

Indian sculptor studying closely not only performances but rehearsals of the various royal and princely dance companies. From the study of such long and elaborately developed bodily exercise to the heroically posed figures carved in stone is a logical development.

The donors at Karle, more than life-size, are in their youthful prime, and their attire is princely. The male wears a turban and a twisted girdle about his hips; the female wears heavy earrings and a pearl girdle and is draped from the waist down with very light cloth. We are overwhelmingly aware of the masculinity of the male—broad shoulders and chest, narrow hips, virile stance—and equally so of the femininity of the female, with her large breasts and hips and small waist. At Karle we have, perhaps for the first time, the perfectly controlled expression of this Indian ideal and the masterly representation

107. *Nave of the chaitya hall.* Karle, India

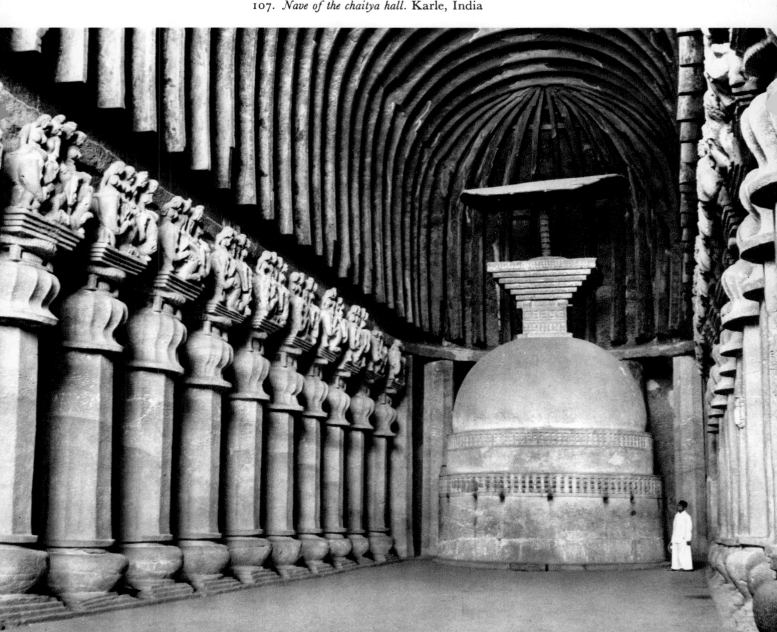

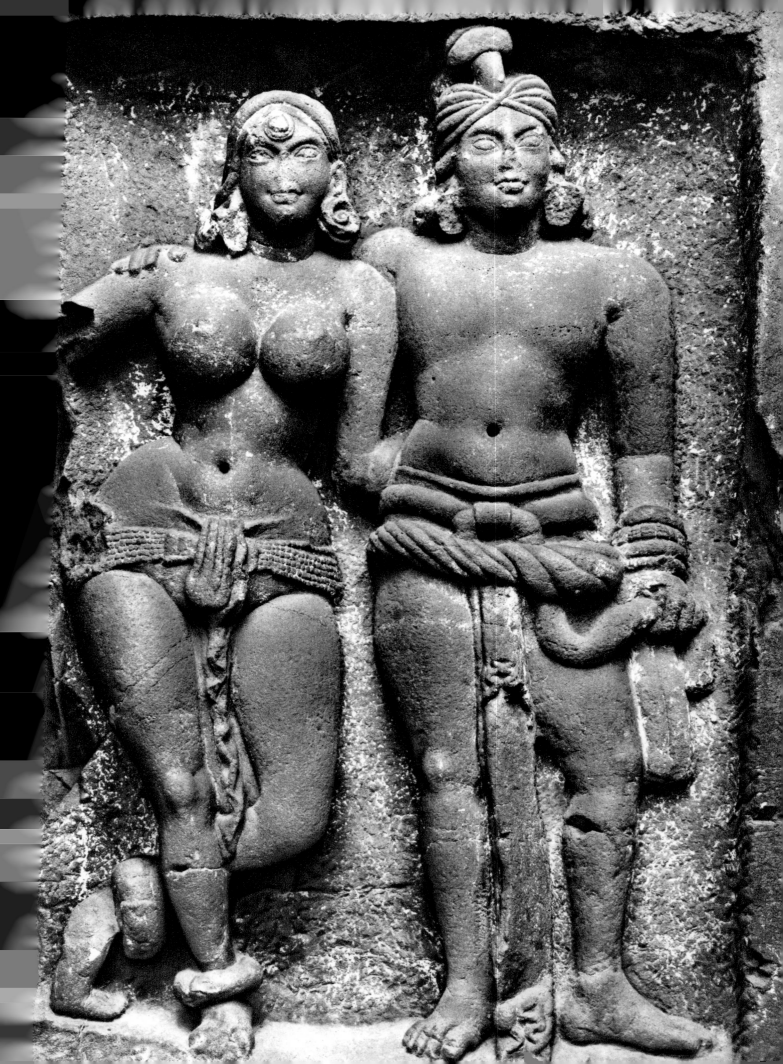

108. (opposite) *Couple*. Stone. Facade of the *chaitya* hall, Karle, India. Andhra period, early second century A.D.

of male and female figures that continues almost without fail up to the tenth and eleventh centuries.

The donors are in fairly high relief and are not too crowded in their assigned space. Though the lintel is close above their heads, it serves to magnify the scale of the figures. If there were any real space above them, they would appear smaller. Instead, they thrust upward, almost supporting the lintel above. The easy postures show no trace of the angularity seen in the arms of the Sanchi yakshi. With the Chulakoka yakshi from Bharhut and the bracket yakshi from Sanchi, the donors at Karle stand chronologically third among the greatest monuments of early Indian figural sculpture.

We now move south to examine the remains of a series of stupas. These are of high quality, and greatly influenced artistic style in south India in post-Buddhist times, when Hinduism became dominant. This development was already under way by the fifth century. South India includes the region around the Kistna River, inland from the sea some three or four hundred miles. The stupa of Amaravati is the type-site for this region, which contains two other well-known stupas: Nagarjunakonda and Jaggayyapeta. The stupas were built under the Satavahana dynasty, which ruled also in north central India and produced the Great Stupa at Sanchi. The dynasty endured much longer in the south than in the north, consequently leaving remains there ranging in date from the first century B.C. to the third century A.D. The most important works from Amaravati are in the Government Museum in Madras and in the British Museum. In general the style of Amaravati can be characterized as more organic and dynamic than anything we have seen before. In contrast to the somewhat geometric character of the more or less contemporary Kushan work in the north, a softer and more flowing manner seemed to flourish in the south. Surely it is no coincidence that the more flowing manner is characteristic of the native Andhra dynasty, as the more geometric is typical of the foreign Kushans.

All three of the Great Stupas in the Kistna region are largely ruined. In the nineteenth century they were threatened with complete destruction. Until the English stopped the demolition of the sculptures, they were burned for lime or used in other structures. But we are able to reconstruct the appearance of the stupa at Amaravati (and, by inference, those at Nagarjunakonda and Jaggayyapeta) from reliefs showing the stupa as it appeared in its final form. The most perfectly preserved of the

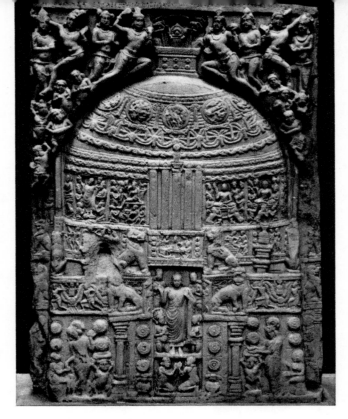

109. *Slab depicting stupa at Amaravati*. Marble, height 74". India. Late Andhra period, late second century A.D. Government Museum, Madras

representations of the Great Stupa of Amaravati is on a slab from one of the later railings, of perhaps the third century A.D., which shows us a great mound faced with brick or stone and finished with stucco (*fig. 109*). From the frontal representation on the slab we can infer a series of large reliefs around the base of the drum and the upper balustrade, punctuated by a curious five-columned tower at each entrance. These correspond to the *torana* at Sanchi but have a completely different shape. Finally there is a very high exterior railing with a profusion of lotus rosettes, and with reliefs of yakshas bearing the lotus Garland of Life around the top register. The entrances also have lions atop pillars, with an architrave going back to the gate, thus making a kind of porch or enclosure leading to the stupa. At the focus of these entrances there are sculptured slabs with both aniconic and iconic representations of the Buddha. The usual symbols are often used to represent the activities of the Buddha—the Wheel of the Law for the Sermon, Footprints for the Presence, etc. Atop the stupa is a railing around the tree, here symbolized by a double parasol on either side of a central shaft.

From this slab one can see that the style has little in common with the Kushan style of the north. Here all forms are curvilinear and flowing, with the exception of architectural members. The angels above, with their bent legs and arms, are treated in a relatively flexible manner. At the side of another

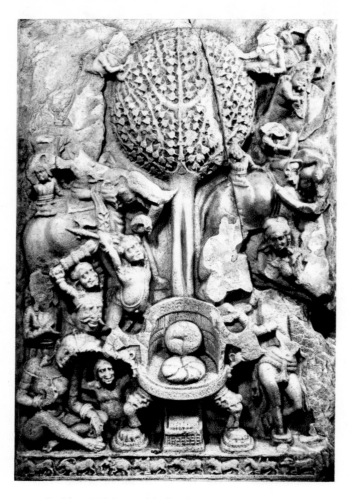

110. *Cushioned throne, with the Assault of Mara* (detail). Relief slab; gray marble, height 69 3/4". School of Amaravati, late Andhra period, late second century A.D. Musée Guimet, Paris

wheel of dominion, his horse and elephant, his light-giving jewel, his wife, his steward or treasurer, and his minister or general.

A text later than the relief, the *Prabhandhacintamani* of Merutunga, describes the scene: "O King! When the cloud of your hand had begun its auspicious ascent in the ten quarters of the heavens, and was raining the nectar flood of gold, with the splendour of the trembling golden bracelet flickering like lightning" The style here is comparable to that at Bharhut, except for certain local characteristics, such as the greatly elongated and rather angular and wooden figures. The prince's costume, too, with its great beaded necklace, heavy rolls of drapery at the waist, and large asymmetric turban, is like costumes at Bharhut and stupa 2 at Sanchi.

The later style at Amaravati is a culmination of the tendencies of the Andhra school and is perhaps best exemplified in the well-known roundel from the railing, showing the Buddha taming the maddened elephant (*fig. 112*). The representation tells the story of the beast by the method of continuous narration, showing it first (on the left) trampling and dashing

fine slab we see aniconic imagery used again, in the form of the cushioned Throne (*fig. 110*), with four attendants worshiping the symbols of the Buddha. The upper frieze displays an actual representation of the Buddha, seated in the lotus pose with a halo behind him, tempted by the daughters of Mara. Here, together on one slab, we have the Buddha image, which may, independent of its development in the north, have come into use at Amaravati by the third century A.D., and the older, aniconic, symbolism. Two reliefs illustrate the early and the late styles of Amaravati. Four stylistic divisions are usually recognized, but in a more general way we can distinguish an early and a late style. The famous slab from Jaggayyapeta, in the museum in Madras, dates from the very beginning of the Andhra period, perhaps to the first century B.C. (*fig. 111*). It shows a subject often connected with Buddhism—a *chakravartin*, or prince, for the Buddha was a *chakravartin*. The tall figure stretches his right hand toward clouds from which falls a rain of square coins. He is surrounded by the Seven Treasures, his

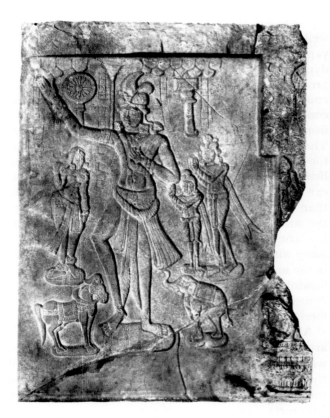

111. *Chakravartin, or universal king.* Marble, height 51". Fragment of paneling from stupa at Jaggayyapeta, India. Andhra period, c. first century B.C. Government Museum, Madras

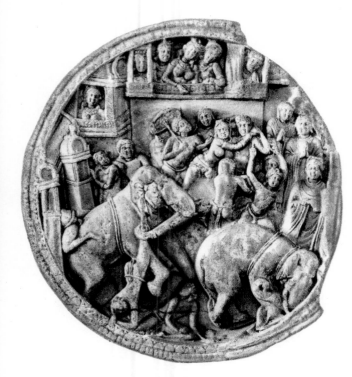

112. *Buddha taming the maddened elephant.* Marble, height 35″. Railing medallion from stupa at Amaravati, India. Andhra period, late second century A.D. Government Museum, Madras

people to death, then (on the right) kneeling and bowing its head before the Buddha. In many ways this is the most advanced piece of sculpture to date, from the standpoint of complexity, handling of space, and representation of the human figure. Despite the method of continuous narration, the scene has visual unity. There is also a fairly successful attempt to indicate a shallow stage or setting for the drama, with the architectural details of a city gate at the left and buildings at the back from which people peer out of windows above the balustrades. There is a sophisticated treatment of scale, in part owing to the inescapable fact that the elephant is large and the figures small. The diminution of the most distant figures in comparison with the nearest ones is clearly shown. The psychological unity of the whole scene is carried into units within the total representation, as in the little group where a woman shies away from the elephant and is calmed by the person behind her. The whole composition probably shows the influence of the painting being done at this time in the caves at Ajanta. The tremendous naturalism, which ranges from an occasional pathetic figure to violent activity or calm inspection, is quite extraordinary. There is, aside from the architecture and one or two of the elephant's halters, hardly a straight line in the composition; everywhere there are slightly twisting or undulating curves and fully rounded shapes. There are no flat planes; everything is

treated in an organic and sensuous way. It is a style that will greatly influence the development of south Indian Hindu sculpture in the Pallava period (c. A.D. 500–c. 750).

STYLES OF THE KUSHAN PERIOD

The Buddha image was developed in the north under a non-Indian dynasty, the Kushan, established in northwest and north central India by an eastern Iranian people of Central Asian origin. We can see something of the impact of these Kushan rulers on Indian sculpture in two very important effigies, the first of King Kanishka (reigned c. A.D. 120–62; *fig. 113*), the second of the preceding king, Vima Kadphises (*fig. 114*). Both effigies are now in the Mathura Museum of Archaeology. The un-Indian appearance of these images comes as something of a surprise. It must be remembered that they were made after the time of Sanchi and the "donor" figures at Karle. Certain elements in their stark, geometric, and abstract style can be attributed to the Scythian type costume of the ruling Kushans. They wore padded boots and a heavy cloak covering the whole body, often seen in Chinese paintings of the barbarians of Central Asia. Still, we may well ask why they continued to have their effigies made in this costume if it were not because the stark geometry of its outlines appealed to them enough to be translated into permanent representation in stone. It certainly is true that these sculptures have a completely different flavor from what we have seen developing in the organic Indian style. The line of the cloak is drawn as if laid out with a straightedge, and there is great emphasis on the repeat patterns of the long mace and the cloak edge. The statue of Vima Kadphises is less well preserved, but we can see geometric elements in it that correspond to those in the statue of Kanishka.

Whether at Mathura or Gandhara, it is under the Kushan dynasty that the first representation of the Buddha appears. It is significant that these icons are almost the only works we have, aside from certain transitional Buddha images, that show this rather harsh style. Most of the sculpture produced in the Kushan period follows the organic development we have seen from Bharhut to Sanchi. Either the ruling class was not sufficiently large or sufficiently dominant artistically to impose a foreign style upon the Indians, or the style was very quickly absorbed, just as the ruling class itself was absorbed into the great Indian mass. It is important to stress the difference between these sculptures and the native Indian tradition, because it is of some interest in relation to the development of the Buddha image

113. *Kanishka*. Red sandstone, height 64″. Mathura, India. Kushan period, c. A.D. 128 or 144. Museum of Archaeology, Mathura

114. *Vima Kadphises*. Red sandstone, height 82″. Mathura, India. Dated the sixth year of Kanishka's reign, A.D. 134 or 150. Museum of Archaeology, Mathura

type, which seems to show an outside influence that must be accounted for.

As evidence that the development of the organic tradition of Indian sculpture continued unhindered despite the Kushans, we can point to three of the best-preserved and most beautiful of the Mathura red sandstone figures, from Bhutesar (*fig. 115*). They embody perhaps an even more frank and unabashed nudity than do the figures at Karle. They are in higher relief, and great emphasis is placed on the organic and flowing character of the female body. This character is modified somewhat by emphasis on rigid linear forms, particularly in the jewelry and lines of drapery; but in general these figures carry on the great voluptuousness of the sculptures at Karle. They are fragments from a railing enclosing a Buddhist or a Jain monument, but either religion hardly envisaged in its dogma even the decorative use of such fertility deities as these, probably modeled on court ladies of the time. Some wash their hair, some look at themselves in mirrors, most are clad in elaborate jewels, wide coin belts, huge earrings, and anklets. The lengths of trans-

parent cloth that form their skirts are gathered in loops at the hips. The poses use the motif of the flexed leg, some with the sacred tree, others without. All three of these female deities stand upon dwarflike yakshas symbolizing earthly powers. These corpulent figures are shown elsewhere with vegetal motifs issuing from their mouths to make part of a great scroll pattern. They are vegetative forces, the lords of life, but here subdued by fertility deities. The upper register of these pillars is marked by a miniature railing. Above are narrative scenes, usually of amorous couples. In the Kushan art of Mathura there is a growing tendency to leave the background as a flat, open area, allowing figures to stand out in high relief against a simple ground and achieving an uncrowded and monumental style. In the Bhutesar figures the face is stylized, with a certain geometric handling of the modeling and representation, perhaps influenced by the Kushan official portrait style.

Most of the stone sculptures of north central India from the Kushan period are made of what is called Mathura or Fathepur Sikri sandstone, common to the region south of Delhi where the great

94

quarries are found. It is a smooth-grained red sandstone with some imperfections in the form of creamy white spots or streaks. Images of such stone were apparently made in the Mathura region and exported, because they are found widely distributed over the whole area of north central India, including such great centers as Sarnath, until the late Gupta period, when cream (*chunar*) sandstone became more popular.

In addition to the yakshi motif used on the railings, we find decorative motifs, the lotus Stem of Life and the lotus itself. A more limited range of subject matter survives than that found in the earlier monuments, and this is not suprising, as Mathura, the holy city that Ptolemy called "Mathura of the gods," was razed to the ground by Mahmud of Ghazni in the eleventh century. Aniconic representation, in which jataka narratives provided great variety, was abandoned, and iconic representation, with the Buddha image as the primary subject, became rather repetitious. Narrative elements began to disappear, replaced nearly always by a single human figure, whether the Buddha, yakshi, yaksha, or bodhisattva, standing erect or, more rarely, seated.

The question of the origin of the Buddha image has been overargued, in part because national sensitivities were at stake. The earliest major publication on the subject is by A. Foucher, the French scholar who wrote in the early twentieth century on the art of Gandhara and the development of the Buddha image. It was his thesis that the Buddha image was developed in Gandhara under the influence of Hellenistic art, particularly of the Apollo image. Against this, at a time of growing Indian national awareness, the Indian scholar Ananda K. Coomaraswamy, late curator of the Indian collections at the Museum of Fine Arts, Boston, published his thesis on the Indian origin of the Buddha image. Coomaraswamy gives a very thorough and convincing argument for an Indian origin evolving from the yaksha image, as convincing as Foucher's argument for a classical origin. Both were right. There is no question that the Buddha image developed in the Kushan period, and that it has both Indian and classical elements. Which came precisely first is a matter of the chicken or the egg, and is conditional on several reign-dated objects that can be dated three or four different ways, depending upon the particular calendar chosen. This highly technical problem need not detain us here; it is significant, however, that the development of the Buddha image occurred under the foreign Kushan dynasty, impelled by the growing elaboration of Buddhism and the concomitant need for icons. Furthermore Buddhism undoubtedly had to compete with a growing Hinduism, a highly figural religion with numerous images of deities.

115. *Yakshi*. Railing pillar; red sandstone, height 55″. Bhutesar, Mathura, India. Kushan period, second century A.D. Indian Museum, Calcutta

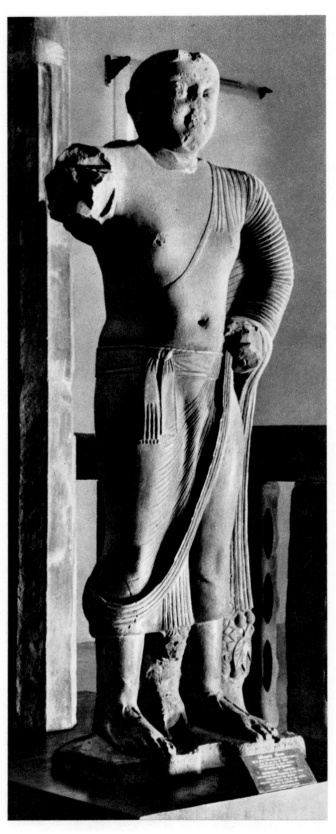

The rapid development of Roman influence on the art of Gandhara, at the northwest frontier of the Kushan empire, may have stimulated the imagery of Buddha in human form. Foucher thought the classical influence was Hellenistic, but it is clear that the main influence on Gandharan art is that of Rome at the time of Trajan and later.

The inscription on the image of the *Bodhisattva of Friar Bala* says that it is the gift of that monk and that it was made, again depending upon computations of reign period, somewhat after A.D. 100 (*fig. 116*). The inscription declares the image to be a bodhisattva—a potential Buddha—but for all intents and purposes it is a Buddha image. We see it here in order to compare it with the king effigies of Kanishka and Vima Kadphises. A strong geometric character is to be seen in the shoulders of these early Buddha images, which are much more square than in the figures at Karle; in the emphasis on linear pattern in the drapery and the very straight, rigid line of the textile borders; in the profile of the legs; and, if the face were well preserved, in the very sharp linear handling of eyes and mouth. They are almost more abstract than the aniconic symbols of Tree, Wheel, or Footprint and seem more forbidding, more awesome, more remote than these. The lion at the feet of the Friar Bala image refers to the Buddha as the lion among men and testifies to his royal origin. Behind this sculpture originally stood a tall prismatic column capped by an impressive stone parasol, another symbol of royalty, some ten feet in diameter and carved with signs of the zodiac and symbols of the celestial mansions (*fig. 117*). Thus the parasol interior is a representation of the universe, and the Buddha is Lord of the sun and the universe. The complete image must have been tremendously awe-inspiring. There is enough relationship to the yakshas at Bharhut and Sanchi to say that it is not chiefly a foreign invention, but at the same time one can see that there is something different here, something more abstract, more universal. The rigid frontality of the figure outdoes that of the Parkham yaksha some three centuries earlier. There is no slight bend of the body, no bend of the knee; but such developments were to come.

A Hindu image may suggest how the likenesses of native deities may have helped in the formation of the Buddha image, and also point out the slight differences in style between them (*fig. 118*). This is a sculpture of Siva from Gudimallam, dating from the Kushan period, probably in the first century A.D. None but a Hindu may see it, for it is still used in temple worship. The earliest known and clearly identified stone representation of that deity, it shows Siva both in figural form and in the form of his principal symbol, the *lingam,* standing, like the fertility

116. *Bodhisattva of Friar Bala.* Red sandstone, height 97 1/2". Mathura, India. Kushan period, A.D. 131 or 147. Museum of Archaeology, Sarnath

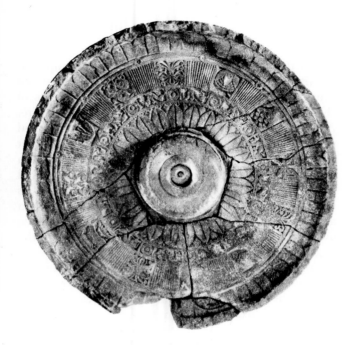

117. *Parasol, from Bodhisattva of Friar Bala* (fig. 116).
Red sandstone, diameter 10'

the body, the strongly arched eyebrows, and the linear pattern of the hair. The image still has a rather un-Indian look when compared with most Indian sculpture. The Buddha's hand forms one of the *mudras*—hand gestures with specific meanings, in a prescribed and carefully organized system. The *mudras* are extremely important in the language of the dance and of images, defining the particu-

goddesses from Mathura, on a dwarf yaksha. The surface is shiny because the figure is daily anointed with oil. The Kushan geometry of the almond-like eyes is notable, but the formation of the torso, chest, and stomach is very different from that of the Kushan Buddha. The whole image is somewhat more organic, more naturalistic than a comparable Buddhist image in a similar pose. Perhaps the influence of images like these, and the more popularly appealing yakshas and fertility deities, led to the development of the Buddha image.

The standing image was not to be the major type. The standard Buddha image was the seated one, usually shown either in meditation or preaching the First Sermon. In the museum at Mathura is a remarkably well preserved seated Buddha image in the form of a stela, a sculptured figure backed by a mass of stone that is slightly rounded to contain a representation of the sacred tree (*fig. 119*). The Buddha is seated in meditation beneath the tree, with a parasol-like halo symbolizing the sun behind his head. He sits in the traditional meditative pose of the yogi and bears the signs of the Buddha: the *urna*, or tuft of hair between the eyes; the *kaparda*, or snail, later to be transformed into the *ushnisha*, or protuberance of wisdom; and the lotus signs on the soles of the feet. The long earlobes record the Buddha's renunciation of his princely status by removing his jewels, including the heavy earrings that had lengthened forever the lobes of his ears, and assuming the austere garb of a monk. One sees again the somewhat geometric treatment of the drapery, the smooth arch at the termination of the drapery on the legs, the emphasis on the linearity of the drapery below

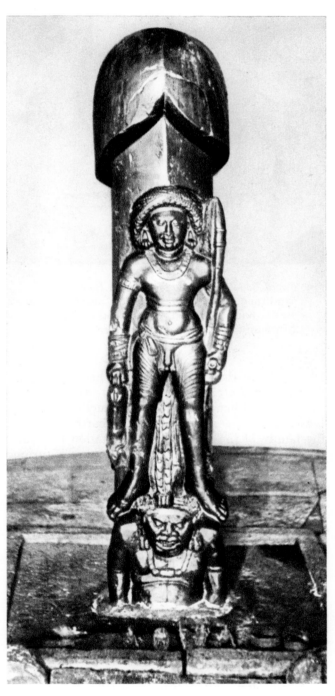

118. *Parasuramesvara lingam.* Polished sandstone, height 60″. Gudimallam, India. First century A.D.

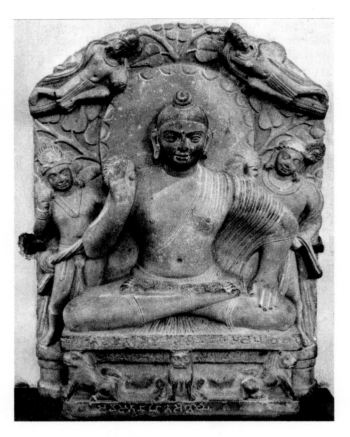

119. *Seated Buddha on lion throne beneath Bo tree.* Red
sandstone, height 27 1/4". Katra mound, Mathura,
India. Kushan period, mid-second century A.D.
Museum of Archaeology, Mathura

less of its iconographic meaning, in sheer sculptural
quality it is one of the greatest productions of the
Kushan period and one of the finest statements of
the masculine ideal in early Indian sculpture.
Although the subject may derive from a classical
source, the treatment of it, the proportions of chest
and waist, and the heaviness of the legs are all Indian
qualities rather than classical. It should be noted
that the subtle modeling of the human figure, its
relation to the lion, and the interweaving of forms in
a single sculptural composition show a great advance
over the sculpture just preceding the end of the
second century, the date of this combat scene.

Jain sculptures, particularly those of *tirthankaras*
(finders of the Ford, or Way) are in the very same
style as the Buddha images, and in most cases cannot
be distinguished from them except by the lozenge
shape on the chest, the mark of the *tirthankara.* A few
Hindu subjects are found as well, notably Krishna
lifting Mount Govardhan, but they too are in the
same style as the Buddhist sculptures.

Gandhara

The second dominant style of the Kushan period is
that of the Gandhara region, in the area of present-

lar aspect of deity represented. There are many
different *mudras;* this one, *abhaya mudra,* means
"fear not." Other gestures include touching the earth
(*bhumisparsa mudra*), or calling the earth to witness
the failure of the assault and temptation by Mara,
the deity of sin incarnate; and the gesture of turning
the Wheel of the Law (*dharmacakra mudra*). The
Buddha is attended by figures recalling yaksha types,
one holding a fly whisk (*chauri*), the symbol of
royalty. Still, the Buddha image is not yet fully
developed by this time in the second century A.D.
Such details as the treatment of the hair have not
achieved their standard form.

In addition to Buddha images of this type, the
Kushan period also produced a few works of more
narrative character. Two of the most famous and
interesting are shown here (*figs. 120, 121*). One
is a convivial scene recalling the bacchanalian
depictions found on Roman pottery or Roman
reliefs showing the potbellied Silenus. The second is a
sculpture often called *Hercules and the Nemean Lion,*
again reminiscent of a classical scene. It represents a
man struggling with a lion beneath a tree. Regard-

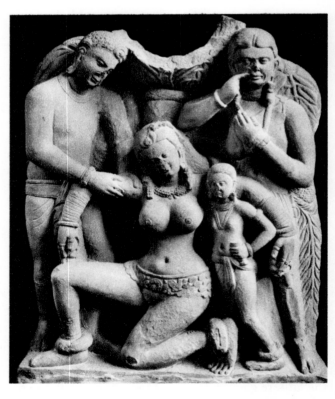

120. *"Bacchanalian" scene.* Red sandstone, height 21 7/8".
Mathura, India. Kushan period, second century
A.D. Museum of Archaeology, Mathura

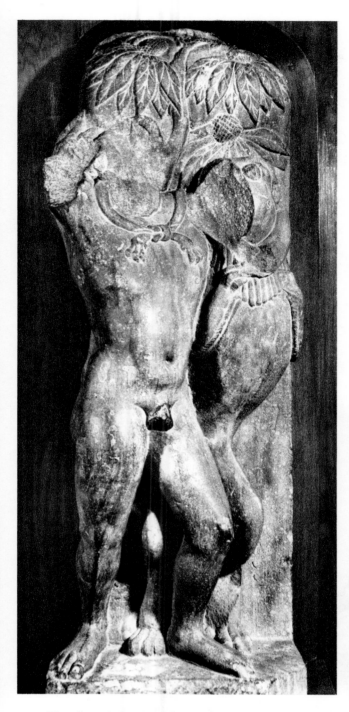

studies, it is more properly described as Romano-Buddhist. The influences came, not from Greece or the Hellenistic world, but from Rome and Roman styles of the late first and the second centuries A.D.

Important as evidence of Roman inspiration at this time are two small reliquary caskets, one, the Kanishka reliquary, with an inscription giving a reign date (*fig. 122*), the other, the Bimaran reliquary, named for the place where it was found (*fig. 123*). To determine the date and nature of this Western inspiration, we must know, in Western calendrical terms, the date of the first year of Kanishka's reign. But since there were at least three different methods of dating available to northern Indians at that time, there are various exact but rather different dates assigned to this casket. It is now generally believed to be a work of the second quarter of the second century A.D. Foucher wished to put it back to the year A.D. 78 and so establish the early presence of classical influence. There is no question that the

121. *Hercules and the Nemean Lion.* Red sandstone, height 29 1/2″. Mathura, India. Kushan period, late second century A.D. Indian Museum, Calcutta

day Afghanistan, Pakistan, and Kashmir. As we have seen, this region bordered directly on some of the post-Alexandrian and later kingdoms of Western origin and so had numerous contacts with the Mediterranean world. The art of Gandhara has been much admired by the Western world, and the reason is not hard to find. For persons accustomed to the classical tradition it was the most palatable art that India produced. It was called Greco-Buddhist art; but now, thanks to B. Rowland's and H. Buchthal's

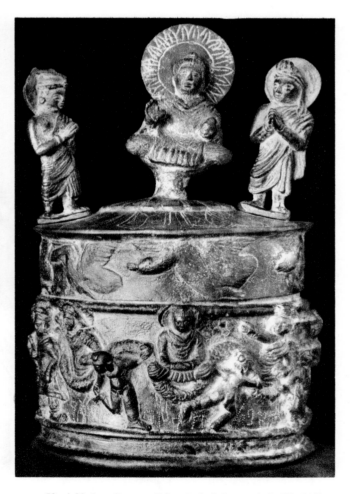

122. *Kanishka's reliquary.* Metal, height 7 3/4″. Shah-ji-ki-Dheri, near Peshawar, Pakistan. Kushan period, A.D. 128 or 144. Archaeological Museum, Peshawar

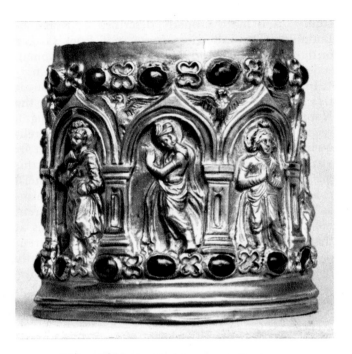

123. *Reliquary*. Gold, height 2 3/4". Bimaran, Afghanistan. Early third century A.D. British Museum, London

124. *Birth of Buddha* (fragment). Stone pedestal, length 20 1/2". Gandhara region. Late second–early third century A.D. Art Institute of Chicago

reliquary of King Kanishka shows definite classical influences, as the little bands of erotes or cupids in garlands are taken directly from classical pottery and sculpture. But the presence of the Buddha image, and its type, confirm the second century date. We might even date the reign of Kanishka from the style of these figures rather than try to argue their date from the various calendars in use at the time. The Bimaran reliquary, a precious object of gold, provides evidence that fully confirms Roman rather than Greek or Hellenistic influence. This is the motif called by scholars of Early Christian art the *homme arcade*, a repetition of figures in arched niches found especially in Early Christian sarcophagi from Asia Minor, most notably in the famous sarcophagus with the figures of Christ and his disciples in the Archaeological Museum at Istanbul. As the *homme arcade* is a motif of the late first or the second century A.D., the date as well as the source is confirmed.

The characteristic art of Gandhara is executed in two major media: stone—a gray blue or gray black schist—and stucco. Most of the early sculpture is carved in stone; no sculpture in stucco is known from the first, second, and perhaps the third centuries A.D. A typical schist carving is the relief representing the Birth of the Buddha (*fig. 124*). Classical art is above all figural and the gods are represented in human form, so it was natural that in the art of Gandhara, influenced by Roman work, Buddhist

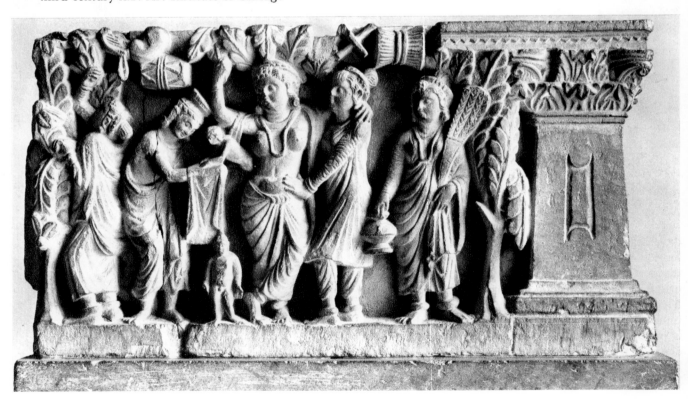

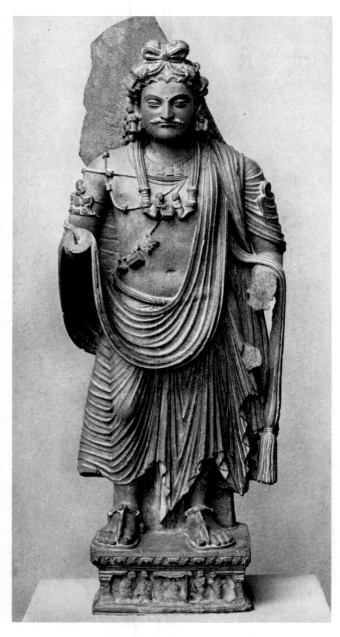

style fascinated André Malraux, as did that of late Roman coins, because in them he saw the birth of a new style out of the degeneration of an older one.

Perhaps the most notable Gandhara creations are schist images of mustachioed bodhisattvas with faces like that of an Apollo, heavy jewelry of the classical type, and boldly organized, rather geometric draperies (*fig. 125*). Below this figure is a scene from the life of the Buddha. In such images the Gandharan style is increasingly less indebted to Rome, and the northwest Indian sculptor is more on his own.

The other aspect of Gandharan style is found in stucco figures. One must succumb to the charm and technical virtuosity of these plastic images. The

125. *Standing bodhisattva*. Stone, height 43″. Gandhara region

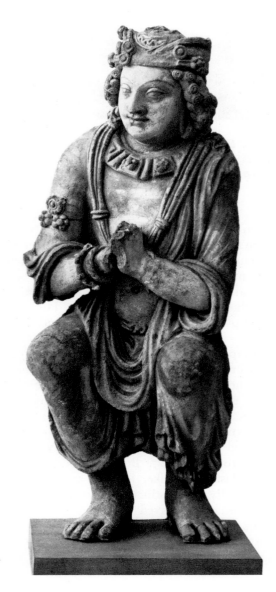

deities were so represented. No Gandharan aniconic sculptural representations of the Buddha are known. Thus in figure 124 we see a Roman matron miraculously producing the Buddha from her left side as she holds the sacred tree. The pose—the hands pulling down the bough and the heel against the trunk—is in the Indian tradition, but not so the Apollo and barbarian types, or the stereotyped drapery derived from that carved on Roman sarcophagi. In general this is a "degenerated" Roman style and is of particular interest to historians of classical art and to students of provincial transformations of style. The

126. *Adoring attendant*. Stucco, height 21 1/2″. Hadda, Afghanistan. Fifth–sixth century A.D. Cleveland Museum of Art

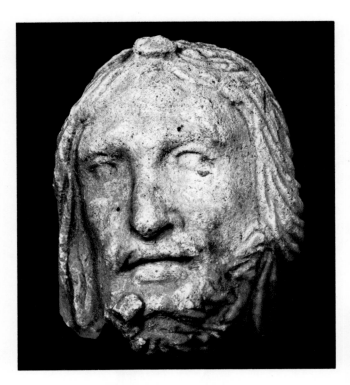

127. *Head of bearded ascetic.* Stucco, height 4 3/8".
Hadda, Afghanistan. Fifth–sixth century A.D.
Musée Guimet, Paris

attempting to force the Buddha to abandon his meditations (*fig. 128*). The fluid bend of his body bespeaks the touch of one who knows the use and handling of clay. The forms are no longer even semigeometric, and the texture of the drapery, produced by scratching the surface of the clay, is sketchy and evanescent in style. The various Gandharan sites from which the stuccos come range in date from the fourth century to as late as the eighth and ninth. The fluid style associated with stucco spread all over the northwest and is comparable in quality and motivation to that of the terra-cottas of north central and central India. It is the great contribution of the Gandharan style to the history of Indian sculpture, however fascinating the hybrid work in stone may be.

production of stone sculpture in Gandhara tends to end by the third or fourth century and the later work to be executed in stucco, as the native Indian genius for plastic and fluid forms reasserts itself. Combining stylistic traits familiar from stone sculpture with Gupta influences from Kashmir, the later Gandharan sculptor created in stucco unified and original works (*fig. 126*). There are, to be sure, traces of classical shapes influenced by Kushan geometry: the arched eyebrows, the sharpness of outlines about the eye, and the modeling of the forms of the cheek. The figure of a bearded man is a classical type and reminds one of works influenced by the school of Skopas, particularly in the psychological overtones of the knitted eyebrows which form a heavy shadow under the brows (*fig. 127*) But the modeling of the mouth is plastic, claylike, formed as one's hand, working directly and instinctively, would achieve it, not in a manner conceived before cutting into the stone. One of the most famous Gandharan stuccos, in the Musée Guimet in Paris, is a representation of a demon, perhaps one of the followers of Mara

128. *Demon.* Stucco, height 11 1/2". Hadda,
Afghanistan. Fifth–sixth century A.D. Musée
Guimet, Paris

The International Gupta Style

GUPTA INDIA

In A.D. 320, when, after the breakup of the Kushan empire, northern India was divided into a number of petty kingdoms, the king of a small principality, probably Chandragupta, possibly his son Samudragupta, established the Gupta dynasty. The kingdom strengthened so that Samudragupta was able to subdue the states around him and achieve imperial status for his dynasty. A succession of able warriors and gifted rulers blessed with long reigns brought peace and prosperity to a vital area in north India extending from coast to coast. The Chinese pilgrim Fa-Xian, who visited India between 405 and 411, was immensely impressed with the generous and efficient government of the Guptas and with the magnificent cities, fine hospitals, and seats of learning in their domains. He writes of the contentment of the people, the general prosperity, and says that "the surprising influence of religion can not be described." Although the Guptas were Hindus, they contributed to the support of both Buddhism and Jainism, and it is recorded that one of the last great rulers, Kumaragupta I (reigned c. A.D. 415–55), built a monastery at the famous Buddhist center of Nalanda.

It was a time of cultural expansion and colonization, which saw the influence of Indian art and ideas extending into Central Asia, China, Southeast Asia, and Indonesia. Bodhidharma, the famous priest, traveled to China. It is very possible that the poet Kalidasa was attached to the court of Chandragupta II (reigned A.D. 376–414). His great drama *The Little Clay Cart,* written in this era, gives a vivid picture of life in the city of Ujjain, where it is believed the later Guptas often held court. The visual arts, especially sculpture and painting, reflect the secure and leisurely atmosphere of the time. It was indeed a classic, golden age. These were, however, the last great days of Indian Buddhist art, except for the Pala and Sena schools of Bengal. As Hinduism displaced Buddhism in India, the future of the art, like that of the faith, moved eastward.

Few freestanding Buddhist structures survive, among them a *chaitya* hall of brick at Chezarla and a notable small fifth century shrine at Sanchi (temple 17), which stands near the Great Stupa. Temple 17 is a simple cell, like an early Greek temple, in which the shrine could be approached through a porch supported by stone columns (*fig. 129*). Behind this temple is a taller structure, temple 18, one of the very few constructed *chaitya* halls remaining in India. All that is left of it are some of the great columns and parts of the architrave. The outline of the foundations is no different from the plan of the early rock-cut *chaitya* halls. One must distinguish between the *chaitya* hall and the cell. The latter ultimately became dominant because a Hindu worshiper moves forward to confront the deity alone, while in Buddhist worship there was much group adoration, often by circumambulation of the stupa. Therefore the Buddhist *chaitya* hall was the most elaborate form of interior architecture known in India until the coming of the Muslims, and the example at Sanchi is as full a statement as this form ever achieved in Buddhist art. The other remaining architectural monuments of the Gupta period are

129. *Temple no. 17.* Stone. Sanchi, India. Gupta period, fifth century A.D.

largely monastery complexes, the most extensive being the one at Sarnath, which covers about a square mile and comprises many similar single-cell units grouped around a variety of courts.

Mathura and Sarnath

Gupta sculpture, the classic artistic expression of Buddhism in India, established the standard type of the Buddha image. This was exported in two main directions—to Southeast Asia and Indonesia, and through Central Asia to East Asia. To think of the Buddha image is to visualize the Gupta type or its derivatives. There are two major geographic styles in Gupta sculpture, with many secondary styles and geographic variations of minor importance. One, the style of Mathura, represents a softened and leavened continuation of the harsh Kushan style; the other is the manner of the region of Sarnath, where the Buddha preached his First Sermon. Sculptures from the Mathura region are made of a moderately fine red sandstone, which can be worked in some detail but not to ultimate refinement. The sculpture of the Sarnath region is of a cream-colored sandstone, the same sandstone used by the Mauryans for their columns and capitals, and capable of being worked to a high degree of detail and finish.

In the National Museum at New Delhi is a red sandstone standing image of the Buddha, which comes from Mathura about the early fourth cen-

tury A.D., with stylistic remnants of Kushan geometry in the drapery and the markedly columnar type of leg (*fig. 130*). Also carried over from the Kushan style are the wide shoulders and large chest, quite different from Sarnath images, and the rigid frontality, almost more than in such early, pre-Buddhist images as the Parkham yaksha. The crisply geometric Kushan style is also evident in the eyelids, eyebrows, mouth, and neck lines, which are not free curves but carefully controlled geometric arcs that look almost as if they had been laid out with a compass. But the roundness and softness of modeling of the face and neck are quite different from the more extroverted and powerful modeling of the Kushans. The overall quality of this new and classic expression of the Buddha is one of serenity and compassion. This quality differs from that of all preceding images and can be attributed to an extraordinary combination of individual characteristics of previous sculptures. The downcast eyes, so important for the concept of the image, may well derive from Gandharan art; the supple and quiescent smoothness of the body surely owes much to the native organic tradition. The perfect fusion of all these physical traits with the now fully evolved concept of Buddhahood was responsible for the image's overwhelming success and its wide influence for over a millennium.

The source for the "string-type" drapery on this image, also found on Chinese and Japanese images, is much debated. Does it come from the Gandhara school, or is it Kushan work from Mathura? There seems to be no question that it appears in the third century A.D., on transitional images whose drapery is sometimes indicated as if by a series of strings arranged in careful parallel arcs on the surface of a nude body. Images from the sixth century and later display a softening of the style and a growing freedom in the treatment of details.

In the fourth century A.D. images of the Mathura school begin to lose popularity, and most images of later date are in other material than red sandstone. Curiously, however, many of the cream sandstone sculptures at Sarnath were covered with red pigment to look like the red Mathura sandstone, perhaps because of the particularly holy traditions of the earlier images.

The most famous and most copied of all the Buddha images of the period is the fifth century *chunar* sandstone image in the Museum of Archaeology at Sarnath, representing the Buddha turning the Wheel of the Law in the Deer Park at Sarnath, a suburb of Benares and a great Buddhist center (*fig. 131*). The image presents the Buddha seated in the pose of the yogi ascetic, the soles of his feet up, his hands in the *dharmacakra mudra*, the turning of the

Wheel of the Law. He is frontally oriented, seated on a cushion, with drapery carefully fluted to suggest a lotus medallion. Beneath the cushion on the plinth of the throne is an aniconic representation, the Wheel of the Law seen from the front, a piece of virtuosity on the part of the sophisticated sculptor. The Deer Park is indicated by two deer, now damaged, on either side of the Wheel, flanked by six disciples in attitudes of adoration. The Buddha's throne is decorated with lions of a fantastic winged type, called leogryphs, who serve to indicate the lion throne of royalty. Behind his head and centered on the *urna*, the tuft between the eyes, is the halo, the sun wheel, indicating the universal nature of the deity, clothed in the sun. The halo is decorated with a border of aquatic motifs, principally lotuses, recalling the ancient fertility and vegetative symbols associated with yakshas and yakshis. On either side,

130. *Standing Buddha.* Red sandstone, height 63″. Mathura, India. Gupta period, fourth century A.D. National Museum, New Delhi

131. *The First Sermon.* Stela; *chunar* sandstone, height 63″. Sarnath, India. Gupta period, fifth century A.D. Museum of Archaeology, Sarnath

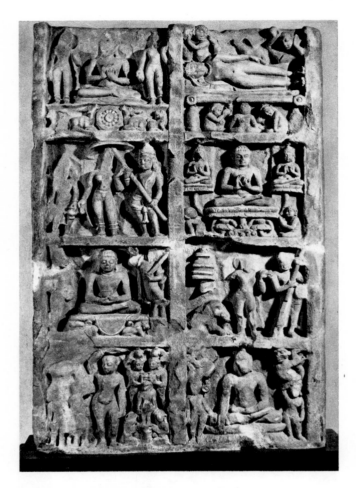

132. *Eight scenes from Buddha's life.* Stela; *chunar* sandstone, height 37″. Sarnath, India. Gupta period, late fifth–sixth century A.D. Museum of Archaeology, Sarnath

the sides of main panels or, more often, in the predella panels, show more advanced styles, with an adventurous handling of space, posture, and gesture.

The language of poetry and prose exerted great influence on Indian sculpture and painting. Religious texts, drama, and poetry are full of metaphor and hyperbole—the hero's brow is like the arc of a bow, his neck like a conch shell; the pendent arm of Maya, mother of the Buddha, hangs like the trunk of an elephant; the curl of the lips is like that of a reflex bow. It is such comparisons that the sculptor and painter translate from the literary figure into curves derived from geometry or volumes idealized from the more irregular forms of nature.

After various classic image types were established there was a consequent loss of variety of subject matter. The rich iconography of the jataka tales at Sanchi, the donors, jatakas, and other subjects at Bharhut, the wealth of representational material on the Great Stupa at Amaravati, became but memories. In some of the stelae at Sarnath that show the developed Buddha image in scenes from the life of the Buddha, we begin to sense an impoverishment of imagination and subject. This is particularly true in the Mahayana material, where images are repeated for their own sake and ultimately reach their most elaborate forms in the Buddhism of Nepal and Tibet, with frightfully complicated and seemingly endless systems of quantities and manifestations. One of the most famous stelae, at the Sarnath museum, represents the eight most important scenes from the life of the Buddha (*fig. 132*): from the upper left downward, Buddha Turning the Wheel of the Law, an unidentified scene, the Temptation of Mara, the Birth of the Buddha with Queen Maya Holding the Bo Tree, the Buddha Calling the Earth to Witness, the Buddha Taming the Maddened Elephant, the Great Miracle of Sravasti, and the *Parinirvana* of the Buddha. Despite all the possibilities of this rich subject matter, there is an almost boring repetition of established motifs. Seated or standing, the various figures look very much alike; because of repetition the forms have degenerated. The images are squat, devoid of the grace and proportion of the great seated image of the Buddha preaching. What is gained in the simplicity of each image and its clarity against a plain background is lost in the bareness of the almost nonexistent narrative description.

Ajanta

The type-site for later Gupta art, but a site with material ranging in date from the first century B.C. to the eighth and ninth centuries A.D., is Ajanta. Only there do we have any considerable remains of the great Gupta and early Medieval school of wall

like angels in Italian Renaissance painting, are two flying angels who rush joyfully in to praise the Buddha. This image is not as taut or as architectonic as the image from Mathura. The treatment of the hands with their elegant but rather limp fingers, the narrow chest and shoulders, the face with its softer outline and double reflex curves instead of simple geometric curves, the foliage motifs, all combine to give the impression of a softer and more organic style. At the same time the frontal symmetry of the image and its precision of gesture tend to add an architectonic frame to the organic detail. The result is a style with its own characteristic traits, quite unlike the almost frenzied energy and movement of Hindu images of slightly later date. The flying and gesturing angel at the upper right is much freer than the main image. In this respect the stela resembles Italian altarpieces, in which the principal figures of the large panels follow rigid, iconic modes of earlier years, while the secondary figures, either tucked in

painting. Painting at Ajanta shows complete mastery and wide range, but the sculpture, largely of the later Gupta period, reveals a considerable decline from the work produced in the fifth century. Ajanta is located in the northern part of the Deccan, not far east of Sanchi (*fig. 133*). The caves are situated on the horseshoe bend of a stream in a somewhat desolate and wild region. Even today it is the haunt of panthers and other wild animals. It was probably chosen as a religious site because of its relative isolation. It was a refuge as well as a place of pilgrimage; and the proportion of the number of monks' cells to places of worship tends to confirm this. The caves at Ajanta are numbered from 1 to 29 and are carved from the living rock. They represent not only great physical effort but a vast expenditure of funds and demonstrate that even at this late date the Buddhist church was still able to produce a major work. The largest *chaitya* (cave 10) dates from the first century B.C. at the latest, though most of the *viharas* (monks'

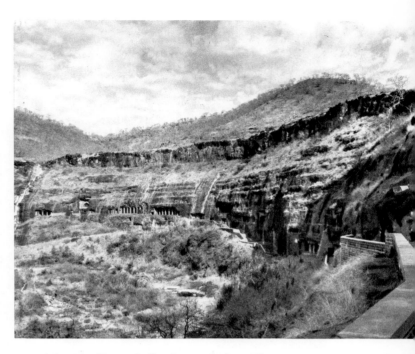

133. (above) *Ajanta, India.* General view. First century B.C.–ninth century A.D.

134. (left) *Chaitya facade.* Cave 19, Ajanta, India. Gupta period, first half of sixth century A.D.

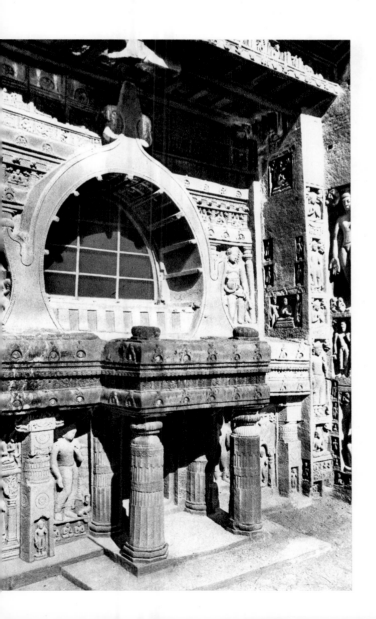

living quarters) appear to date from the sixth and seventh centuries A.D.

There are few architectural problems posed at Ajanta. Being carved from the living rock, the caves are really sculptures modeled on constructed *viharas* or *chaitya* halls. It is likely that at this relatively late stage, in cave 19 of the sixth century, for example (*fig. 134*), these are more free sculptural inventions than accurate models of constructed halls. By this time artisans were so used to working in the living rock and had so many precedents that they were able to indulge in reasonably free inventions. It is doubtful, for example, that the elaborate sculptured facade and interior of cave 19 was duplicated in a constructed *chaitya* hall. This "architecture" is really sculpture. In cave 19 the ornate facade has a small porch flanked by monotonously repeated images of the Buddha and a few guardian kings. The character of the *chaitya* hall as a great opening into the hill is denied by the embellishment of the porch, and so we are confronted with a cutting that does not as fully express the design of the interior as do earlier rock-cut *chaitya* halls.

The interior of cave 26 shows the great elaboration characteristic of later *chaitya* halls (*fig. 135*). The columns are treated with bands of carved, spiraling devices; the capitals are highly developed too, and the friezes above are ornately carved with repetitive

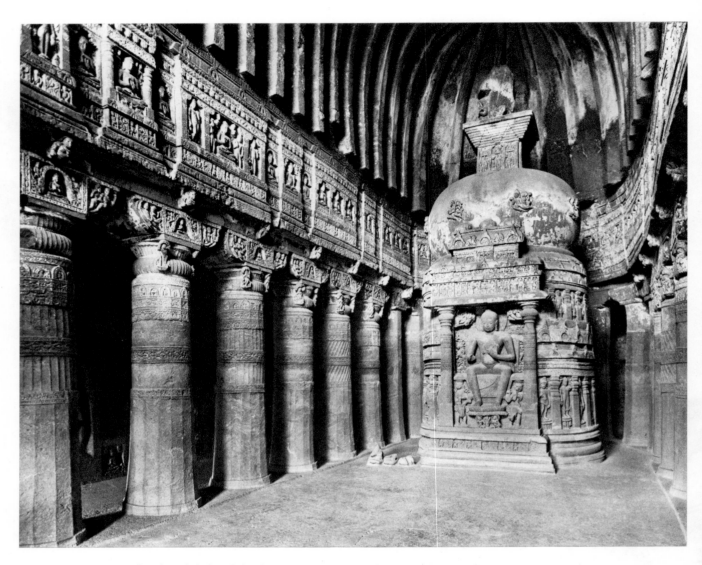

135. *Interior of chaitya hall.* Cave 26, Ajanta, India. Post-Gupta period, c. A.D. 600–642

images. The stupa itself is no longer simply the representation of a burial mound but is placed on a high drum carved with images of the Buddha, the principal one being that of the Buddha seated Western style and turning the Wheel of the Law. The interior was heavily polychromed and must have had a rich, jeweled effect. The tendencies toward a detailed and more pictorial treatment of the interior are not unexpected, for painting is the great art of Ajanta.

The *viharas,* or monks' quarters, which one would have expected to be simple, lonely, and devoid of ornament, are as elaborate as the *chaitya* halls themselves. Cave 17 has a low ceiling and an interior court surrounded by cells—that is, a communal living and cooking area surrounded by sleeping quarters (*fig. 136*). The main axis culminates in a cell with an image of the Buddha for communal or individual worship. On the ceiling are paintings of Buddha images and decorative designs of lotus flowers and fantastic animals. The interior is encrusted with color on the carved columns and on every available flat surface. One significant detail creeps into the later Gupta style, to become especially characteristic of Indian Medieval art. (*Medieval* is used as a general term for the period of Indian art between the decline of the Guptas, about A.D. 600, and the foundation of the great Mughal empire in 1526; see page 175 ff.) Standing or flying figures of different sizes—dwarfs, yakshas, yakshis, and angels—are inserted in the corners of the capitals almost at random, as if the sculptor were at play (*fig. 137*). In these figures we sometimes find great movement and vigor, a freer spirit, and less monotony than in the rather repetitive main images. They are asymmetric in arrangement, and some are so located on the capitals that they

almost deny the character of the architecture. This sculptural representation of movement or flight on the surface of the architecture indicates the direction in which Indian sculpture is moving at this time.

In addition to these architectural sculptures, a few of the finest of the exterior carvings at Ajanta can be considered purely as sculptures. Some are to be found at the sides of the porches leading to the *chaitya* halls or the *viharas*. One sculptor seems to have found a challenge worthy of his skill in the subject, not of a Buddha or bodhisattva or any deity of the main Buddhist hierarchy, but of a *naga* king and queen (*fig. 138*). The *naga* king, a serpent deity with a hood of seven cobras behind him, is attended by his queen, with a single hood, and a figure holding a fly whisk symbolic of the royal nature of the *naga*. This delightful composition depicts the king in the posture called "royal ease," with one knee up, seated next to his queen. The contrast between the elaborate jewelry of the king's headdress and the deep shadow caused by the *naga* hood is aesthetically extremely effective. The composition, with its subtle placement of the attendant in the shadow of the pillar, is a representation of husband and wife, male and female, in the best tradition of great Indian sculpture. The sculptor depicts the drapery of the king and the queen as falling over the block forms in a simple incised pattern, with little ripples lightly cut into the surface to indicate drapery folds. Further, he achieves the ultimate of sophistication by carving rocks in the living rock, producing an aesthetic double-entendre.

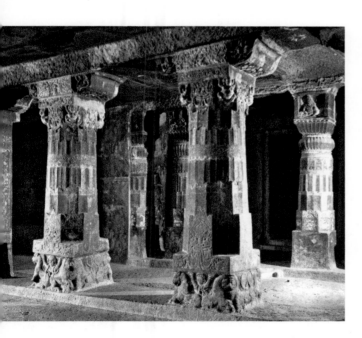

136. *Columns before the central shrine.* Cave 17, Ajanta, India. Gupta period, c. A.D. 470–80

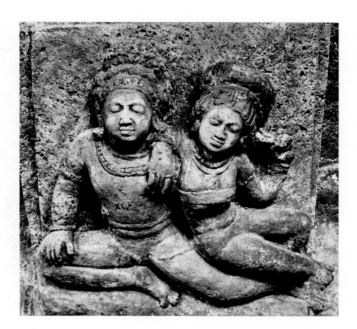

137. *Apsarases.* Bracket figures, cave 16, Ajanta, India. Gupta period, c. A.D. 470–80

This effect is influenced by painting, for characteristic ways of indicating rock forms in the paintings of Ajanta are repeated here: a rather geometric series of interlocked steps.

The major art of Ajanta is painting, and it is only because of the relative isolation of the site (long known only to local villagers) that it is preserved at all. The paintings, executed from the first century B.C. to the seventh century A.D., lasted until the nineteenth century in relatively good condition; their discovery was justly heralded as one of the great artistic finds of all time. But more open exposure to weather, and especially the treatment of early twentieth century restorers, has hurt them, and they are probably in less good condition today. The early *chaitya* hall number 10 boasts remnants of painting from the first century B.C.—an Andhra fresco, of the same period as Sanchi, representing a jataka tale and revealing a surprisingly advanced stage of pictorial development (*fig. 139*). The illustration is but a drawing from the fresco; the now shadowy painting is an amazing production. The figures are not just drawn in outline but are modeled in light and shade, in a way similar to the Roman and Pompeian frescoes. The general color scheme of the figures is brown, but the modeling of the heads and the emotions expressed in the faces indicate a control of advanced means of painting and of convincing methods of representing psychological states that is not to be found in the sculptures, which may well have been produced by a lower hierarchy of artists. The painters seem to have been far ahead of their com-

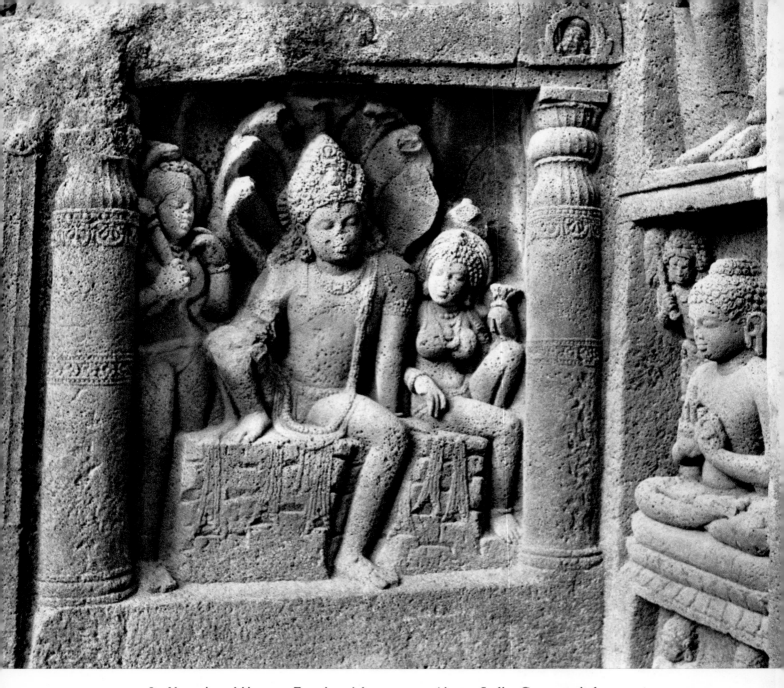

138. *Nagaraja and his queen.* Exterior niche, cave 19, Ajanta, India. Gupta period, c. A.D. 500–550

patriots in other fields. The composition is a much more convincing representation of numerous related figures in space than can be found in the jataka tales carved in stone at Sanchi. The fresco is not only better in quality but in development and complexity and in the artists' ability to solve problems of space and individual representation.

In addition to the fragments from the early Andhra period there are many frescoes whose precise dates are much argued but whose sequence is generally agreed upon. The murals of cave 2, with Buddhist devotees coming to a shrine door (*fig. 140*), are of a radically different type from those in caves 1 and 17. The cave 2 group must be dated as middle Gupta, that is, about the fourth and fifth centuries

A.D. The figures are placed in a definitely indicated space bounded in front by a ground line with small dwarfs (*ganas*) moving in procession and behind by curious geometric rock forms. On this shallow stage space is indicated by movement from below to above, and at the same time by overlapping. The placement of the figures in the limited space is simple, recalling the plain backgrounds of the Gupta sculptures. There is no great turmoil, activity, or movement except among the *ganas* in the lower right-hand corner. The modeling of the individual figures is accomplished by light and shade and is handled much differently from the modeling in slightly later frescoes. Here it occurs at the very edges of the contour: The arms, legs, and bodies are treated

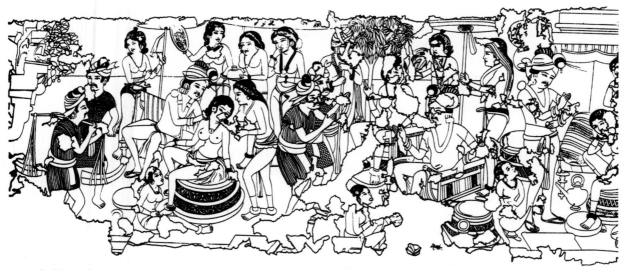

139. *Saddanta jataka: the queen fainting at the sight of the tusks.* Drawing of fresco. Cave 10, Ajanta, India. Andhra period, first century B.C.

140. *Sculptured figure of Hariti and a portion of the fresco.* Cave 2, Ajanta, India. Gupta period, C. A.D. 500–550

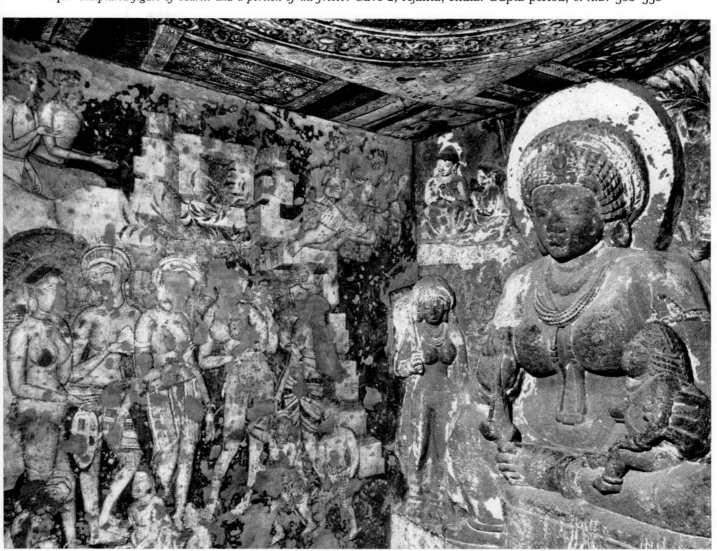

as tubes, the breasts as mounds, with large areas of flat light color edged by darker color. The closest visual analogy is that of a photographic negative, with its forced contrasts of light and dark. The result is a curious but rather solid and simple effect. These figures with large light areas and sharp modeling at the edges are clearly differentiated one from the other, in contrast to later styles.

The developed late Gupta style of the sixth century is most characteristically seen in the porch of cave 17, an entrance to a *vihara* (*colorplate 7, p. 119*). Above the door and to the left is a scene, set in a forest or parklike exterior, of a prince and a princess in a palace. The general color scheme of this painting, in contrast to the rather quiet reds and soft blues of the paintings in cave 4, is almost hot: oranges, rather sharp blues, yellows, and greens with a warm orange tinge. The representation of the figures is quite dif- ferent from the middle Gupta style. There is little modeling, and in the female figure and one or two others there is greater emphasis on linear detail. But above all the composition is more intricate, with greater overlapping and compression of figures than in the noble and stately style of the earlier murals. This complexity is supported by the profusion of the jungle background. Indications of space are also more accomplished, with a stagelike palace setting rendered in a free perspective not based upon a rigid geometric scheme. We say "free" since there are many inconsistencies in the treatment of the perspective. It is used practically rather than logically. At the same time early figure conventions going back as far as Sanchi, such as the large heads looming at the windows, are carried on. The procession with parasols, moving out to the left, reveals a greater use of overlapping than before. These figures are

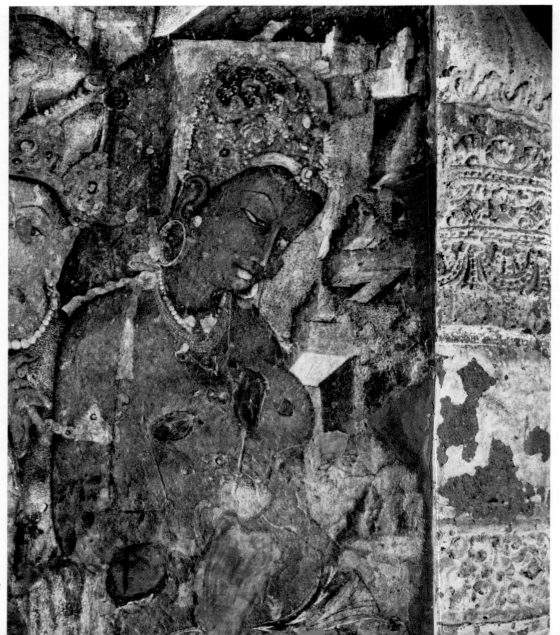

141. *The black princess*. Fresco. Cave 1, Ajanta, India. Post-Gupta period, c. A.D. 600–650

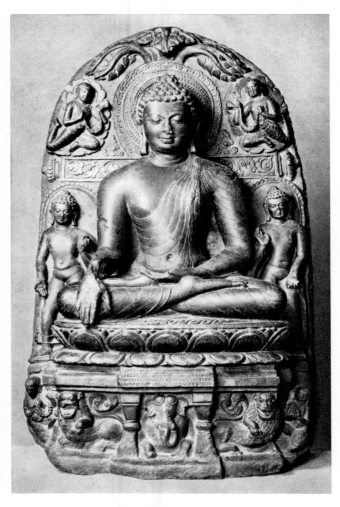

142. *Buddha showing earth-touching mudra.* Black chlorite, height 37". Bengal, India. Pala period, ninth century A.D. Cleveland Museum of Art

from dark to medium dark except for the narrow highlights. The richness of the figure does not depend upon the modeling of the interior surfaces of the figure proper, but upon the adornment of those surfaces with ropes of pearls, headdress, and other jewelry. The loving exaggeration of the lower lip harks back to pure Gupta style. The heavily arching eyebrows and the reverse curve of the eyes are formulas dear to the Gupta sculptor and painter. The warmth of the color is largely a falsification, resulting from the varnish used by restorers of the late nineteenth and early twentieth centuries. We can see something of the method of painting in this detail. The roughened stone was covered with a mixture of chaff and hair bound with plaster to produce a surface on which the underdrawing and then the final painting could be executed on the still slightly damp plaster.

The most famous figure at Ajanta is in cave 1 and has been often described as the "beautiful bodhisattva" (*colorplate 8, p. 120*). It is located at one side of a cell entrance and represents Padmapani holding a blue lotus. The figure is much destroyed from the waist down, but the noble torso and especially the head, with its beautiful countenance and downcast eyes, express that compassion and humility which is the great achievement of Buddhist art. Let it be added, though, that not all the figures at Ajanta are noble types. We find in some details figures that are grotesque and ugly, and others, including merchants, drawn from everyday life, representing the Gupta world as observed by its painters. A brief treatment of the Ajanta caves gives no idea of the complexity and richness of the subject matter, or of the variety of aesthetic techniques to be found at this great site.

BUDDHIST STYLE BEYOND INDIA

Ajanta is perhaps the last great monument of the principal Buddhist style of India. While Buddhism expanded to Southeast Asia and to the northwest and Central Asia, as shown by such splendid images as the Gupta style standing Buddha from Kashmir (*fig. 143*), in India the faith was maintained in strength only in the northeast, particularly the region of Bengal. The two important dynasties of the region are the Pala and Sena, spanning about A.D. 730 to about 1197, by which time the Muhammadan invasion had smashed the Sena rulers. The great achievement of the art of Bengal was to preserve the Gupta formula with considerable quality over a long period, and to transmit it to Nepal, Tibet, Burma, Thailand, and Indonesia. This is not to say that the artists of Bengal did not produce

crowded, but there is little indication of depth by the archaic means of putting one figure above another. The whole emotional and psychological effect is one of sensuous movement, breathing something of that warmth found in the Indian air, reinforced by the supple grace of the bodies. Judging from the remnants of Roman painting and the evidence they give for Greek painting, the paintings of Ajanta represent a greater achievement in narrative art, if perhaps one less rational in perspective or developed in representing deep space.

One detail of a charming princess in cave 1 epitomizes the last painting style of Ajanta, that of the early medieval period in the seventh century (*fig. 141*). It is from a jataka and gives some idea of the emotional and visual impact of the original. The detail reveals the difference between the modeling of this figure and that of the firm and noble middle Gupta figures of cave 2. Here there are no large areas of light color but a gentle modulation

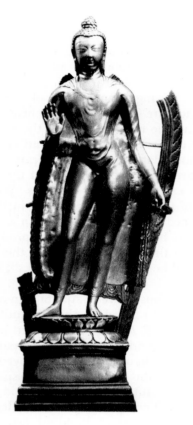

143. *Standing Buddha*. Brass, height 38 5/8". Kashmir, India. Early eighth century A.D. Later Tibetan inscription of Lha-tsun Nagaraja. Cleveland Museum of Art

remarkably new, but the earth is not kind to the particular alloy used by the Bengal artist, with the result that the excavated pieces are severely encrusted. These metal sculptures, their undeniable variations and elaborations notwithstanding, depend on the Gupta style for their character and conformation.

Nepal and Tibet

We can see this more clearly in an illustration of a standard type that preserves and develops this style in Nepal. The standing bodhisattva Padmapani (*fig. 144*) is made of copper alloy and gilded. Its flowing silhouette and rounded forms are much like those we saw in the late Gupta painting at Ajanta. What has changed is the scale, for most of these images from the Himalayas seem more jewel-like, more miniature

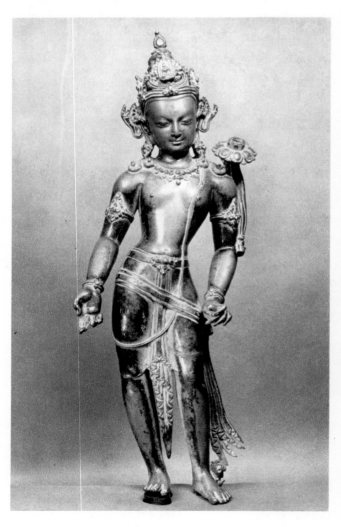

masterpieces in their own right. One of the greatest achievements of the Pala artist, a representation of the Buddha in the earth-touching pose, made of the characteristic black chlorite stone of the region, shows the style at its best (*fig. 142*). Even in this noble and massive black stone the treatment of details of the halo, of the throne, and of the small figures below is so metallic that it would be difficult indeed to say from the photograph whether the image was made of metal or stone.

The tendency in Pala sculpture, exaggerated in the Sena period, was toward a detailed, metallic style in working this hard, very fine-grained black stone. And so we are not surprised also to find numbers of small bronzes and images of gilt-bronze, silver, and gold from the region. These were exported in some quantity. Indeed, they are found today throughout Farther India and Indonesia, and became the models for the native sculptors, especially the Javanese, in their first attempts to represent the Buddha image. The metal images usually turn up either from excavations or by chance export from monasteries in Tibet or Nepal. In the latter circumstance they are in excellent condition and look

144. *Bodhisattva Padmapani*. Bronze, height 24 3/8". Nepal. C. twelfth century A.D. Cleveland Museum of Art

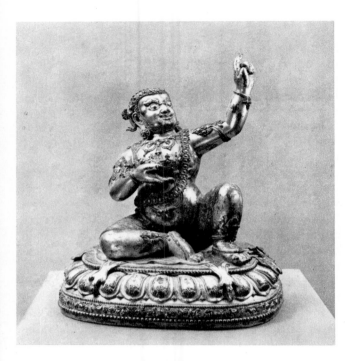

145. *Mahasiddha Virupa.* Gilt bronze, height 17″. China. Ming dynasty, mark and reign of Yong Le (A.D. 1403–24). Cleveland Museum of Art

in character, lapidary continuations of the Gupta tradition. The use of semiprecious stones in numerous details of jewelry, undoubtedly derived from earlier Indian practice now lost, complements small-scale art. Nepal was thoroughly Mahayana and, later, Tantric in its Buddhist faith. Tantric Buddhist systems emphasized complex preparation for initiation, yoga practices under strict discipline of the *guru,* or teacher, and the equal importance of the female principle as the Shakti, or energy, of the male deity. Images with several arms and heads are commonly found. In these the delicate casting and accomplished gilding technique fortify the often miniature size and hyperrefined detail. When one thinks, for example, of the flowing organic forms of modern sculptors such as Lipchitz or Roszak and then observes the Nepalese images with their fluid grace and metallic expansion into space by means of projections and apertures, one senses a true aesthetic achievement.

The Tantric art of Nepal is forced to greater extremes in the sculptural art associated with Lamaism in Tibet. Western Tibet was much indebted to Kashmir for its initial artistic expression, while central Tibet looked more to Nepal and, so long as Buddhism endured there, to northeast India. Added to this, after formal contacts with China from the fourteenth century on, was a strong Chinese influence on metal-casting techniques and on painting

styles. The often frenzied and deliberately fearsome later art of Tibet (*fig. 145*) parallels Japanese Esoteric Buddhist art in these respects (*figs. 393, 430*) and has attracted increasing attention with the emigration to India and the West of both clergy and ritual sculpture and objects after the annexation of Tibet by China in 1951.

No large-scale painting remains from the Pala or Sena dynasties. But Bengalese manuscript illuminations preserve something of the Gupta and early medieval style of Ajanta in painting. The rare manuscripts are painted on long strips of palm leaf, usually with much text and few illustrations, and were the means by which the Gupta painting style, with its concepts of figure and space representation, was transmitted to Nepal and Tibet. A detail of a manuscript from Bengal shows some modeling around the edges of the body, the use of landscape setting, and a simple indication of space by placing an object above to indicate that it is behind (*colorplate 9, p. 121, above*). In another detail from this manuscript are the same curious geometric rock forms that we saw at Ajanta. Here the representation is of a Buddhist ascetic, raising his hand in blessing of an antelope standing before a palm tree. The rich color effect is unlike the rather soft, subdued color of Ajanta.

A second manuscript, of Nepalese origin, based on the style of Bengal manuscripts exported to Nepal, has been dated to A.D. 1111, some fifty to one hundred years later than the first (*colorplate 9, p. 121, below*). It shows a greater sophistication, particularly in the handling of line. The modeling, in either color or shade, is almost flat. Indications of contour or of movement are given by exterior lines. In this manuscript we have representations of deities only, existing in the timeless setting of their own halos. There are no scenes representing landscapes, interiors, or any setting in space. It is a more iconic, hieratic art, fully dominated by the iconography of Mahayana Buddhism but, like the bronzes, full of grace and linear sinuosity in the figures.

Though large-scale early paintings from northeast India are currently unknown, there exist some impressive and sizable works from Nepal and Tibet. Many of these are *tankas,* icons in hanging scroll format, displaying the same style found in the illuminated manuscripts writ large (*fig. 146*). Their warm coloration, emphasizing red, yellow, and orange, with minor notes of blue and green, and the religious intensity expressed by concentration of facial expression, combined with compelling repetitive rhythms, are distinctive and provide the foundations for later Himalayan *tankas.* Chinese styles based on late Song, Yuan, and early Ming Buddhist painting provide a second Tibetan mode after the fourteenth century.

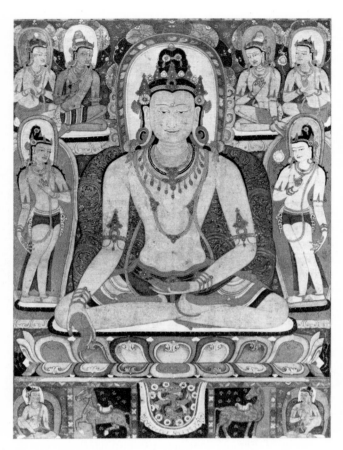

146. *A Tathagata Buddha*. Tanka; watercolors on cloth, height 36 1/2″. Nepal or Tibet. Thirteenth–fourteenth century A.D. Los Angeles County Museum of Art. From the Nasli and Alice Heeramaneck Collection

Sri Lanka

Sri Lanka (Ceylon) is at an extreme geographic remove from Nepal, and its Buddhist art is a contrast to that of Bengal, Nepal, and Tibet. For its Buddhism is Hinayana, espousing a relatively simple and evangelical form of Buddhism and recognizing only the Buddha Sakyamuni—that is, the "historic" Buddha. Thus Hinayana lacks the complicated iconography, the delight in numbers, and the complexity characteristic of the Mahayana school. The style of Sri Lanka is historically important, since it was exported by sea to such regions as Burma and Thailand, where even today the Hinayana sects are dominant, while Cambodia, Java, China, and Japan received and were dominated by Mahayana doctrines.

The early Buddhist art of Sri Lanka is much influenced by the southern school of Amaravati; and so in the famous moon stones—stepping slabs leading to platforms at Anuradhapura—we find the same style as in the casing slabs from Amaravati (*fig. 147*). They are in the form of half-wheels, with concentric bands of representations of the sacred goose (*hamsa*), lions, horses, elephants, and bulls on the exterior rim, which is treated like a lotus Wheel of the Law. Under the austere doctrines of Hinayana Buddhism, early Sinhalese artists produced one image in particular that ranks among the greatest known representations of the Buddha (*fig. 148*). Dating from perhaps the sixth

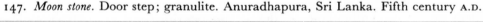

147. *Moon stone*. Door step; granulite. Anuradhapura, Sri Lanka. Fifth century A.D.

Colorplate 5. *Painted shells with hunting scenes:* (above) *The hunt;* (below) *The kill.* Width 3 1/2″.
China. Late Zhou or early Han dynasty. Cleveland Museum of Art

Colorplate 6. *Detail of Painted Banner, from Tomb of Dai Hou Fu-ren.*
Mawangdui, Hunan, China. See fig. 59

Colorplate 7. *Visvantara jataka: palace scene.* Fresco. Porch of cave 17, Ajanta, India. C. A.D. 500

Colorplate 8. (following page) *The "beautiful bodhisattva" Padmapani.* Fresco.
Cave 1, Ajanta, India. C. A.D. 600

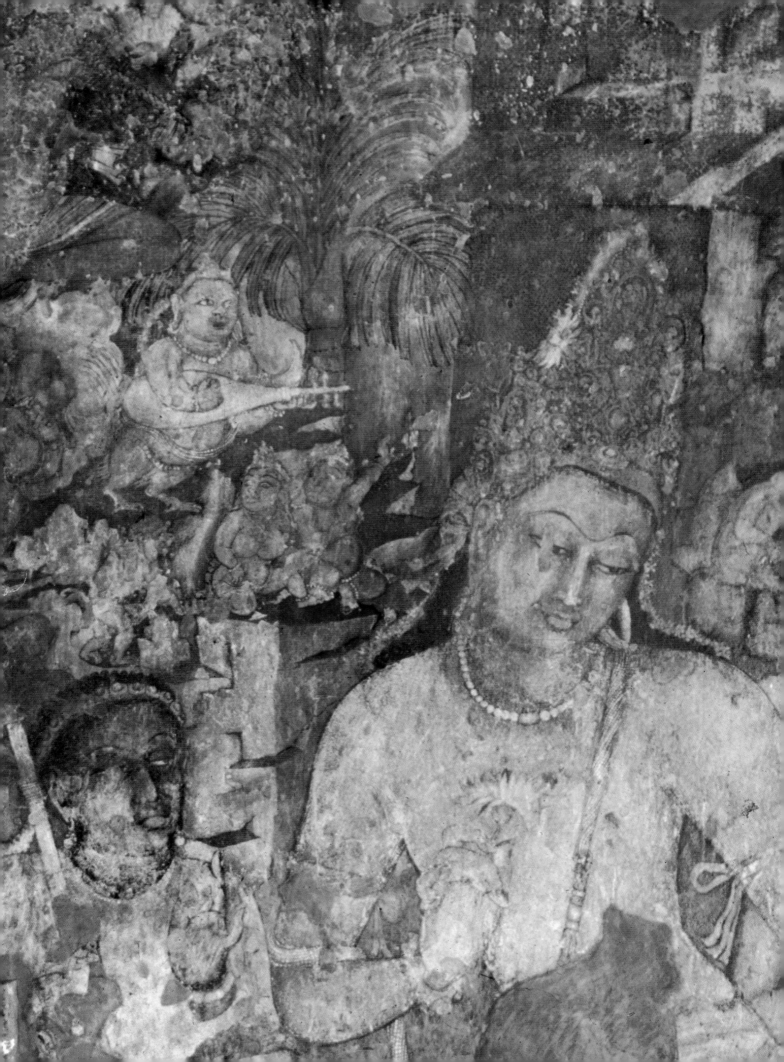

Colorplate 9. (above): *Two scenes from the Gandavyuha*. Illuminated palm-leaf manuscript, height 1 5/8″.
Bengal. Eleventh–twelfth century A.D. Cleveland Museum of Art
(below): *Cover and one leaf of Astasahasrika Prajnaparamita*. Illuminated palm-leaf manuscript, height 2 3/8″.
Nepal. A.D. 1111. Cleveland Museum of Art

 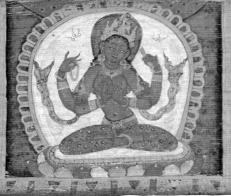

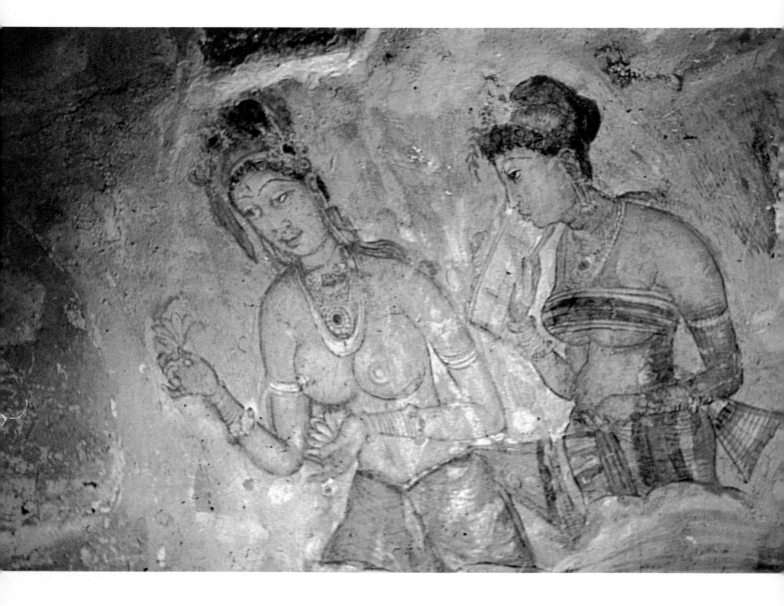

Colorplate 10. *Apsarases*. Fresco. Sigiriya, Sri Lanka. C. A.D. 479–97

Colorplate 11. (opposite) *Shukongojin* (Skt.: Vajrapani). Guardian figure; painted clay, height 68 1/2″.
Sangatsu-do of Todai-ji, Nara, Japan. Nara period, mid-eighth century A.D.

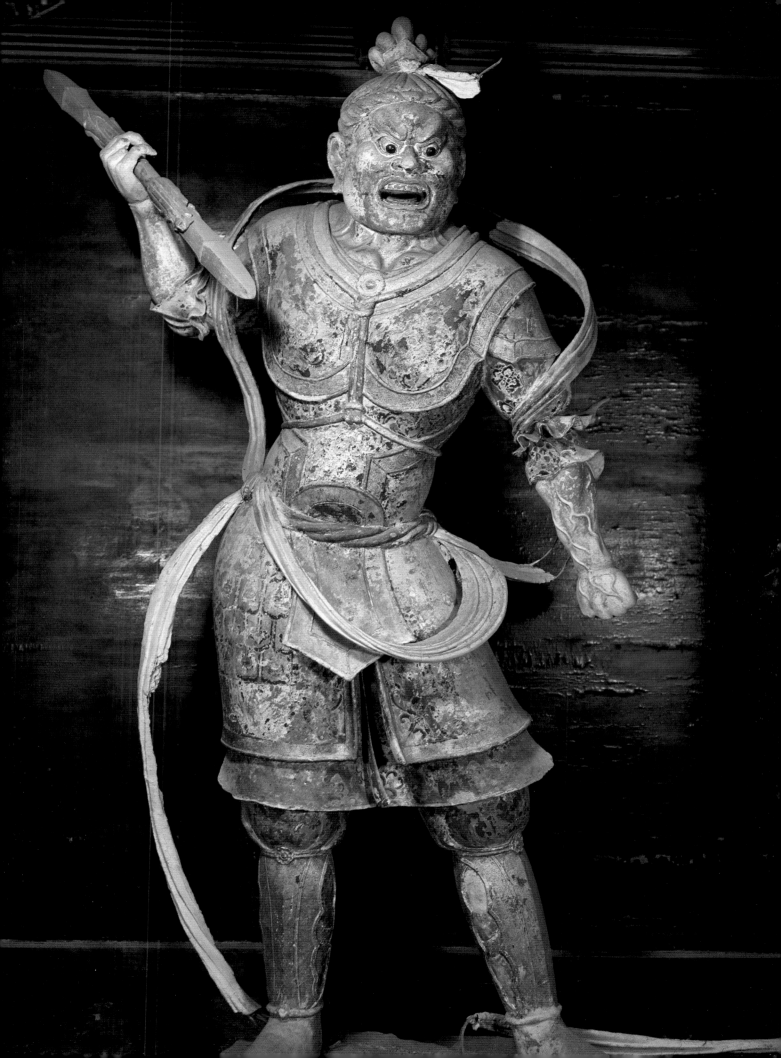

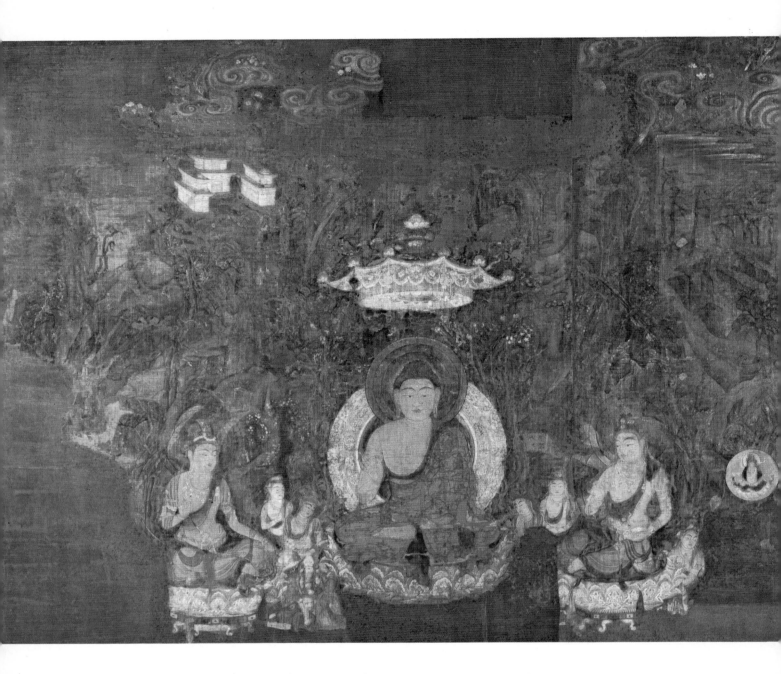

Colorplate 12. *Hokke Mandala*. Color on hemp cloth, width 59″.
Nara period, late eighth century A.D. Museum of Fine Arts, Boston

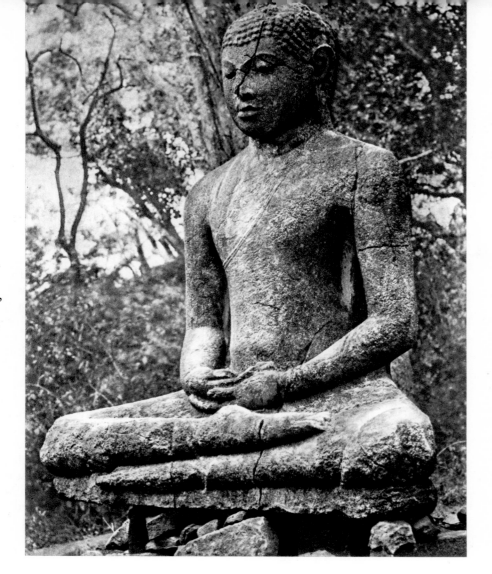

148. *Seated Buddha*. Dolomite, height 79″. Anuradhapura, Sri Lanka. Sixth–seventh century A.D.

century A.D., the image owes to Gupta formulas its simplicity, pose, and treatment of the curled hair. But the austerity or rationality of the image and the corresponding lack of the sensuous qualities to be found in any Gupta sculpture indicate its Sinhalese origin and give it a surpassing quality. The head has none of the rather shallow prettiness to be found in some Gupta sculpture, but has a facial breadth achieved by the expansion of the cheekbones and of the powerful jaw. The enlargement of the ears adds to the scale of the head and allows it to crown in proper proportion the large and imposing body. Some of the mystery of this figure derives from its being badly weatherbeaten. To like this great image for such a reason is to succumb to the "driftwood" school of sculpture and to confirm the taste of those who prefer their bronzes encrusted, their sculptures well worn, and their paintings well rubbed.

Remains of Gupta style painting are found in Sri Lanka on the great rock of Sigiriya, which was used as a fortress retreat from A.D. 511 to 529 by the parricide King Kassapa. A long cleft in the side of the cliff contains a fresco procession of heavenly nymphs (*apsarases*), the lower parts of their opulent bodies obscured by conventionalized clouds (*colorplate 10, p. 122*). Their general style is similar to that of the fifth century fresco in cave 2 at Ajanta, but their distinctive orange and pale green color scheme and the somewhat exaggerated sensuality of the representation is unusual—perhaps somewhat provincial. These graceful and easily moving ladies may well, however, be characteristic of secular painting in the Gupta period. The lack of a landscape or architectural setting emphasizes the erotic appeal of the *apsarases*. One could expect royally commissioned palace decorations to be motivated by a sensuous materialism in contrast to the combination of sacred and profane found in purely religious painting.

The same sensuous appeal is found in the somewhat later Pattini Devi in the British Museum (*fig. 149*). It is a bronze image of more than ordinary size and clearly based upon some elements of Gupta style. At the same time it has an absolutely individual and unique character. Observe the tense roundness of the breasts and of the face, the sensuous and flowing quality of the fingers and the hands, and at

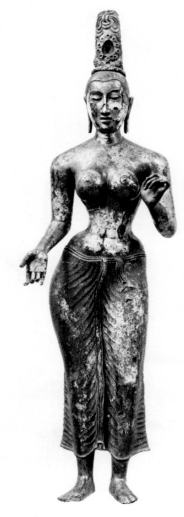

149. *Pattini Devi*. Gilt copper, height 57". Eastern Sri Lanka. Seventh–tenth century A.D. British Museum, London

the same time the emphasis upon the underlying structure of the hips and their relationship to the waist. This depiction of underlying structure is rare; it seems to be the product of an artist or studio working in an individual and free manner, neither anticipated nor repeated. The tall, very narrow headdress is an integral part of the total effect. Crowning the full and voluptuous body with this thin, tall tower gives an added height and elegance. The drapery is not handled either as a linear pattern or as a mass but in character with the modeling of the body, being just slightly modeled, with no sharp ridges or lines but rather with undulations that move along the thighs. A masterpiece such as this places the art of Sri Lanka near the top of any Oriental hierarchy of excellence.

South India continued to dominate the arts of Sri Lanka and from time to time extended its influence to political control. Some seventh century sculptures near Anuradhapura are almost indistinguishable from the Hindu sculptures of the Pallava period at Mahamallapuram (*fig. 150*), and Hindu metal sculptures of pure south Indian type have been found in quantity in northern Sri Lanka.

The last significant productions of the island are the large stone stupas, temples, and sculptures at Polonnaruva dating from the twelfth century. These Hinayana Buddhist images are noteworthy for their size. The colossal scene at the Gal *vihara* of the disciple Ananda mourning at the *Parinirvana* of the Buddha is cut into the living rock and is based on a combination of earlier Sinhalese and Gupta sculptural formulas but shows little interest in the sensuous grace of the latter style (*fig. 151*). All the shapes and details seem purified and, it must be added, mechanized to a point where their appeal is primarily intellectual. We are fascinated in following the patient logic of the sculptor despite its exclusion of the warm, living qualities of the Medieval mainland styles. Such images are of great importance in the development of Thai art, for the Hinayana faith was common to both Thailand and Sri Lanka, and the latter played elder brother to the major Hinayana country of Farther India.

Thailand

The two major influences on the Buddhist art of Farther India and Indonesia came from Sri Lanka and Bengal. Since Sri Lanka continued to be primarily Hinayana in its faith, its influence was largely confined to those farther countries of the same belief, notably Burma and Thailand. Bengal, by virtue of proximity and its status as a prime pilgrimage center, also shaped the art of Burma and Thailand, and was the dominant influence on figural art in Malaya and Java before the rise of national styles there. With few exceptions, however, the earliest sculptural influence in all of these regions was the Gupta image, whether earthenware, stone, or metal. The style of each region began with this type of image, and the gradual achievement of distinctive regional styles was largely the work of the local culture, leavened by subsequent exposure to the formulas of Bengal or Sri Lanka.

The first significant art of Thailand was sculpture, and it remained the favorite form of religious expression. The early peoples of southern Thailand were predominantly Mon from Burma, with some Thai elements from southwest China (Yunnan) and perhaps Tibet. Their Dvaravati kingdom lasted from at least the sixth to the tenth century, when the

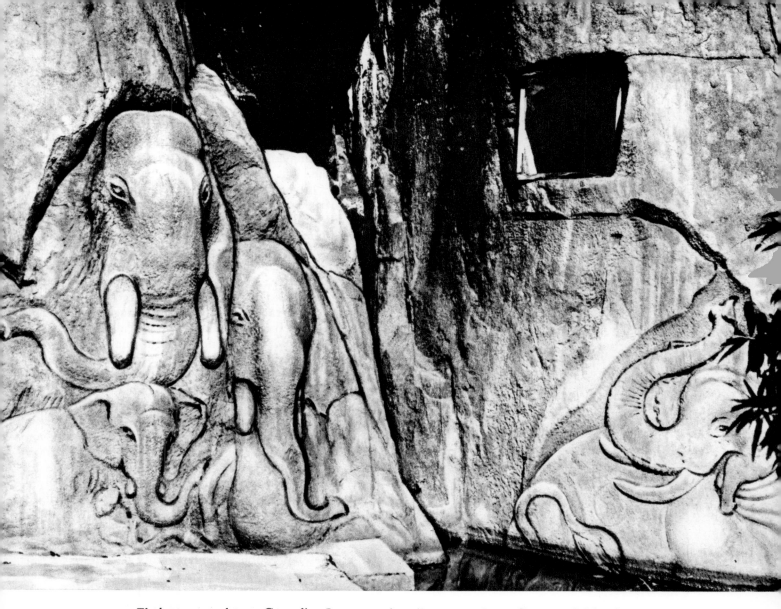

150. *Elephants among lotuses*. Granulite. Insurumuniya *vihara*, near Anuradhapura, Sri Lanka. Probably seventh century A.D.

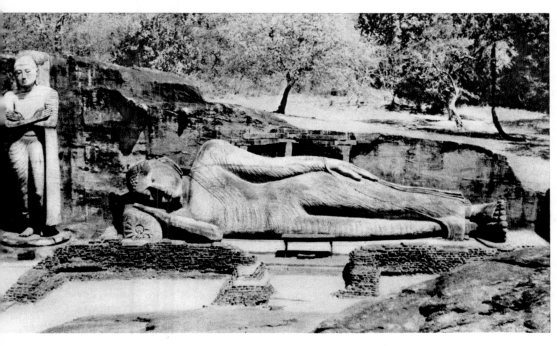

151. *Ananda attending the Parinirvana of the Buddha*. Granulite, height nearly 23'. Gal *vihara*, near Polonnaruva, Sri Lanka. Twelfth century A.D.

127

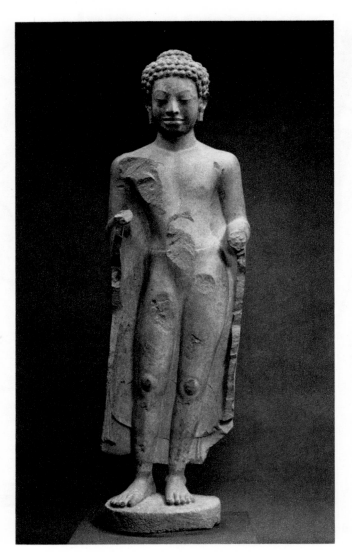

152. *Buddha*. Stone, height 53 1/4″. Thailand. Mon-
Dvaravati period, c. seventh century A.D.
Cleveland Museum of Art

rising power of Mahayana and Hindu Cambodia
reduced Thailand virtually to a cultural province
with its center at Lopburi, producing works little
different from those of the dominant Khmers. The
Mon-Dvaravati style of circa A.D. 600–800, whether
on a large scale in stone (*fig. 152*) or in smaller bronzes
(*fig. 153*), is a consistent rendering of the Gupta
manner of Sarnath, with its smooth, clinging drapery
without folds and its subtle, flowing transitions from
one shape to another. But much of the sensuousness
and plasticity of the Indian technique is lost or
ignored in favor of a greater emphasis on more
austere profiles anticipating the great simplicity and
stylization of the classic Thai style of the fourteenth
century. Another deviation from the Gupta way lies
in the greater attention to linear detail, particularly
about the features of the face. Double outlines around

the eyes and mouth hint at coming decorative quali-
ties based on severe stylization. The emphasis on
simplicity is in keeping with the growing importance
of Hinayana Buddhist culture in Thailand at this
time.

One unusual find from Jaiya, now in the National
Museum of Bangkok, is a notable exception to the
prevailing simplicity of Mon art (*fig. 154*). This
bronze torso of a bodhisattva is clearly the product
of a different tradition and attests to the wide influ-
ence of the great Srivijaya empire of Java, Sumatra,
and Malaya. Here the complex jewelry, the metallic
impression, the momentary and melting expression
of the attractive face, and the exaggerated hip-shot
pose derive from the earliest Pala traditions of
Bengal. But this was not to be the line of development
for Thailand after the decline, beginning about 1220,
of Cambodian control.

A new native kingdom expanded from the north,
and the Thai peoples established a capital at Sukho-
daya in central Thailand. The nearby kilns of
Sawankalok produced quantities of stoneware, and
by the fourteenth century the production of Buddhist
images, principally of metal, approximately equaled
the ceramic output. The enthusiasm and vitality of
the Hinayana rulers and monks seemed inexhaus-
tible. Except for images of the *U-Thong* type, made in
southern Thailand after the expulsion of the Khmers,
it was as if the Cambodian phase had never been.
The elaboration and masculinity of Khmer art was
gone, and in its place came the typical and highest
expression of Thai sculpture imagery, the bronzes of
the early Sukhodaya school. Though painting
certainly existed—witness the evidences from the
engraved stones of the Wat Si Jum at Sukhodaya—
the images of stucco and metal are more numerous.

Various traditions went into the making of these
"high-classic" images—A. B. Griswold's term. The
old Mon-Gupta style was surely not forgotten and
was probably preserved in a few particularly holy
metal or stone images. The simpler Pala Buddha
images, especially those in meditating or earth-
touching poses like the Cleveland stela, were known
to monks and travelers through large examples and
through the smaller ex-votos carried home from
Nalanda as souvenirs. Sri Lanka was an especially
important source, and tradition as well as history
attests to the close connections between the two
countries. After all, Sri Lanka was the fount of
Hinayana Buddhism, and one particularly holy Thai
image type is called "the Sinhalese Buddha," a form
probably embodied in the fine image in Boston, with
its distinctive nose, full cheeks, and limited linear
emphasis about the eyes and mouth (*fig. 155*).
Another important source was the Hinayana scrip-
ture, with its metaphorical descriptions of the various

aspects of the Buddha figure—the golden skin, parrot-beak nose, petal-like fingers—and the signs of his godhood—flame, lotus, wheel, and curls "like the stings of scorpions." Priority for the emergence of the typical Thai Buddha image is variously given to Sukhodaya or to Chieng Sen in the north. The images from the latter region are remarkably close to some Pala sculptures. If they are earlier than the products of Sukhodaya they are nevertheless less unified, less creative manifestations of still unabsorbed influences; if later, they are somewhat provincial manifestations of a Pala revival based on reverence for the images at the great temple at Bodhgaya, scene of the Buddha's meditation.

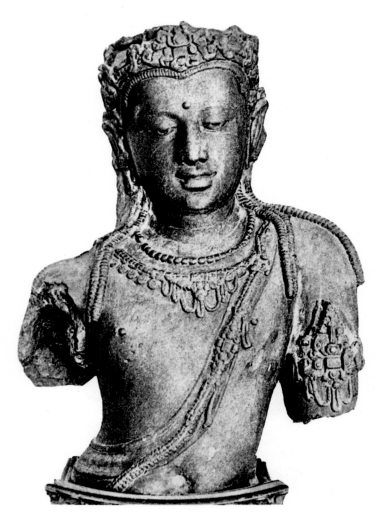

154. *Bodhisattva torso*. Bronze, height 24 3/4". Jaiya, Thailand. Eighth–ninth century A.D., Srivijaya style. National Museum, Bangkok

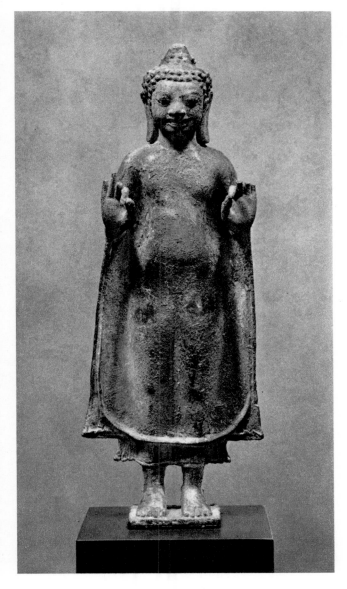

153. *Standing Buddha*. Bronze, height 8 1/4". Thailand. Dvaravati period, seventh century A.D., Mon-Gupta style. Cleveland Museum of Art

The fusion of the various source elements in the Sukhodaya style is complete (*fig. 156*). No clear trace of origin remains in this new and original image type. The influences disappear as if exorcised by fire, and the resulting diamond-sharp configuration recalls the abstraction of geometry. The dangers inherent in such a thorough stylization of linear elements and complete simplification of forms are many—coldness, rigidity, and emptiness are a few, and these soon appear—but at the moment of perfect balance in the fourteenth century the result seems a perfect expression of Hinayana simplicity and asceticism.

The seated images are the most numerous, but one particular Sukhodaya creation deserves special mention—the walking Buddha (*fig. 157*). Conceived as a representation of Buddha Sakyamuni (*see page 116*) as missionary, the image appears particularly unnatural at first glance, but here especially one must remember such literary similes as "arms like the hanging trunk of an elephant." The superhuman

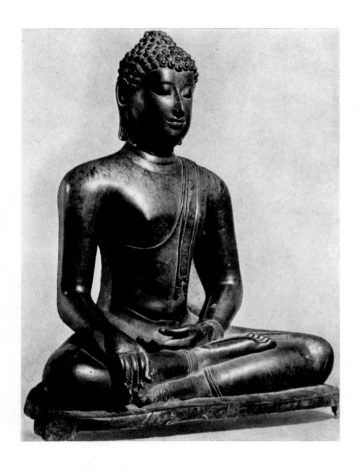

155. (left) *Seated Buddha.* Bronze, height approx. 30″. Thailand. Fourteenth–fifteenth century A.D., Sinhalese type. Museum of Fine Arts, Boston

156. (below left) *Buddha calling the earth to witness.* Bronze, height 37 3/8″. Thailand. Fourteenth century A.D., Sukhodaya high style. Collection H.R.H. Prince Chalermbol Yugala, Bangkok

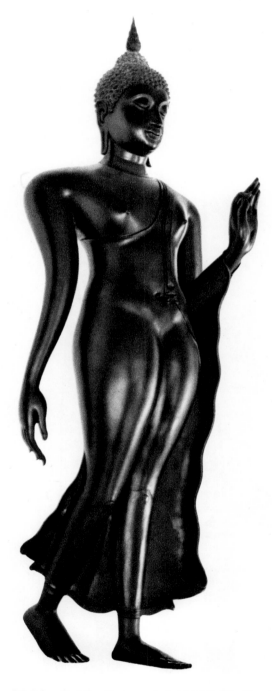

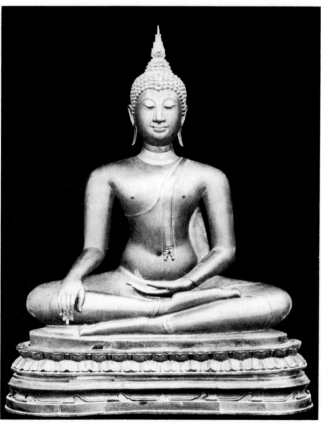

157. *Walking Buddha.* Bronze, height 88″. Thailand. Fourteenth century A.D., Sukhodaya style. Monastery of the Fifth King, Bangkok

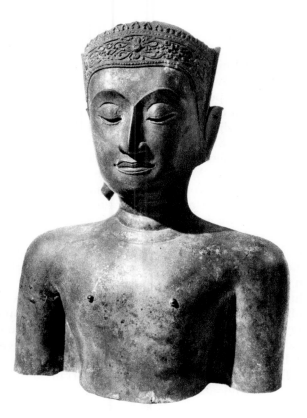

158. *Crowned Buddha torso.* Bronze, height approx. 22″.
Thailand. Sixteenth–seventeenth century A.D.,
Ayudhya type. Whereabouts unknown

ease of the gliding pace is matched by the exquisitely estimated reflex curves of the fingers and the impeccably calculated undulating edge of the drapery falling from the left arm. "All passion spent" is here succeeded by the sculptor's poised, ecstatic vision.

Because of the great strength of Hinayana Buddhism among the Thais during and after the fourteenth century, the tendency to repeat particularly successful sacred images was impossible to resist. A continuous stream of such images poured from the sculptors' foundries in northern, central, and southern Thailand. Minor variations were invented and quickly exhausted. In the north a Chieng Sen "lion type" is chiefly distinguished by a lotus-bud *ushnisha* on the skull in place of the flame used by the sculptors of Sukhodaya and by the lotus pose being accomplished with the soles of both feet on the same level rather than, tailor-fashion, one leg above the other. If this is a giant among minor variations, the aesthetic monotony of the immense production is evident.

One later, southern, variation bears the name of Ayudhya, the Thai capital from about A.D. 1378 until 1767 (*fig. 158*). In these images of the sixteenth century and later, ornament, whether of crowns or heavily jeweled garments, is the attempted means of rejuvenating the exhausted formula. In a few restrained images a decorative and elegant effect is

achieved, but the inner life of the lines of brows, nose, and mouth is largely gone, and a growing superficial prettiness remains. Small wonder that some modern interior decorators find fragments of these images attractive as a means of achieving an acceptable "Oriental flavor." A glance back to the Mon-Dvaravati images and particularly to those of Sukhodaya clearly reveals the unique contribution of the Thai to the international world of Buddhist art.

Indonesia

The principal vehicle by which Mahayana Buddhist imagery was transmitted to Indonesia was the Gupta and post-Gupta art of Bengal. We must imagine the monks and traders of India and Indonesia traveling to and from their homelands. We know from inscriptions that the traders, devout Buddhists as well as sharp businessmen, commissioned works of art in the great centers, particularly in Bengal. Indonesians

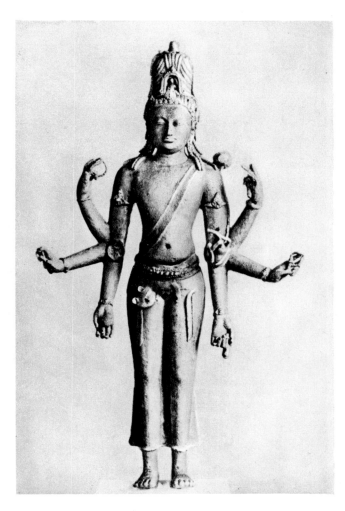

159. *Padmapani.* Bronze. Bidhor, Malaysia. Sixth–seventh century A.D. Perak Museum, Malaysia

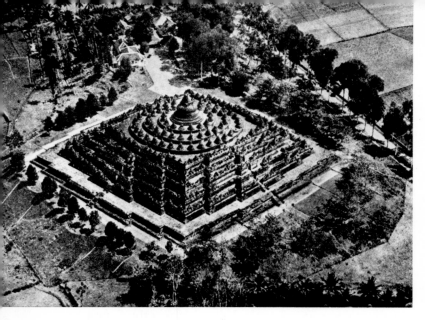

160. *Borobudur, Java.* Aerial view. Late eighth century A.D.

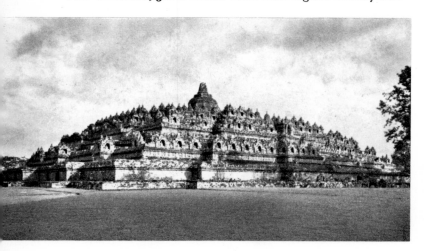

161. *Borobudur*

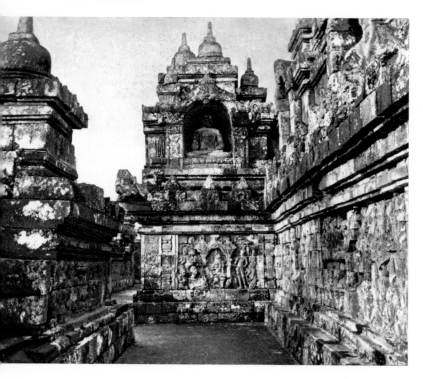

even built temples in Bengal as an act of homage or memorial. Lively commerce brought about great movement of people and of images. Historically, the introduction of Buddhism to Indonesia is associated with the Srivijaya empire, whose capital was not on Java but on Sumatra. Some of the greatest of the early Indonesian metal images have been found on Sumatra and in Malaysia. Despite the unusual find in Celebes of a bronze Buddha image in Amaravati style of the third or fourth century, the pure early Srivijaya style is based almost completely on the Gupta style as transmitted through the early bronzes of Nalanda. An image such as this Padmapani (Lotus-bearer) from Malaysia can well be described in terms applicable to Gupta style (*fig. 159*). The fluidity of the figure is extraordinary and reveals the influence of clay technique. From such beginnings the Javanese developed a great style of their own and created one of the most significant monuments of Buddhist art.

The supreme example of Buddhist art in Southeast Asia and Indonesia is certainly the Great Stupa of Borobudur, situated on the central Dieng Plateau of Java (*fig. 160*). The monument, carefully preserved and restored by Dutch archaeologists and being restored again today, is a fantastic microcosm, reproducing the universe as it was known and imagined in Mahayana Buddhist theology. It dates from about A.D. 800 and apparently was built in a relatively short period of time—a colossal achievement. It is approximately 408 feet long on each side and some 105 feet high. There are in all more than ten miles of relief sculpture. For many years arguments raged as to the precise nature and meaning of the monument, but Paul Mus's book resolved all doubts. Borobudur is a stupa; the profile is that of a hemisphere crowned by a smaller stupa (*fig. 161*). The monument is oriented to the four directions and arranged vertically in accordance with Mahayana cosmogony. Originally below ground level, but now visible, are reliefs representing the doctrine of karma, the cycle of birth and rebirth, of striving and nonrelease on the Wheel of Life. The lower exposed levels of the monument have reliefs with the previous lives of the Buddha, beginning on the lowest level with the jatakas, moving into the life of the Buddha on the next higher level, and then reaching higher into the Mahayana hierarchies of heaven. One proceeds from low to high, from the base to the pure. When one reaches the top of the rectangular part of the monument, one leaves lower regions which, however divine, are less so than the perfect figure of the circle

162. *View of the corridors from the first gallery of the west facade, Borobudur*

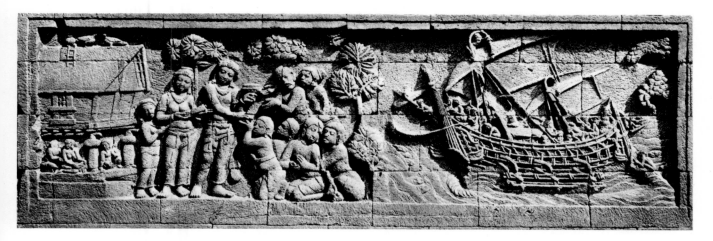

163. *Hiru lands in Hiruka.* Lava stone, width 9′. Bas-relief no. 86, first gallery of Borobudur, Java. Late eighth century A.D.

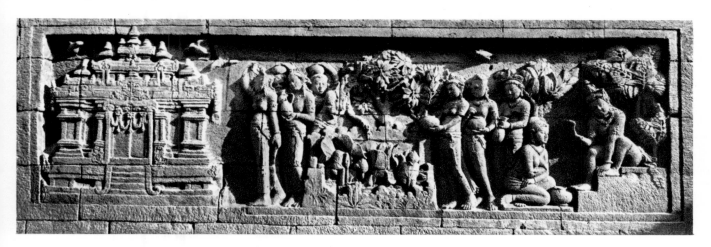

164. *Prince Suddana and his ladies drawing water from the lotus pond near the palace.* Lava stone, width 9′. Bas-relief no. 16, first gallery of Borobudur, Java. Late eighth century A.D.

which forms the three repeated terraces of the upper levels, crowned by a stupa. In each of the lower niches facing the four directions is a Buddha image appropriate to that direction, while each of the miniature stupas on the terraces contains a Buddha image in the preaching *mudra*. The central, closed, stupa also contained a Buddha image, which B. Rowland equates with the god-king himself. This expresses a phenomenon also found in Hindu art in Cambodia: the cult of the *devaraja*, the god-king, in this case the Buddha on earth. Borobudur is, then, a magic monument, an attempt to reconstruct the universe on a small scale. The interior is rubble faced with carved volcanic lava stones. The pilgrim enters the magical structure and performs the rite of circum-ambulation, which figuratively recreates his previous lives and foreshadows his future lives. While pursuing his pilgrimage, he sees reliefs of the previous lives of the Buddha, the life of the Buddha, and the various heavens.

The corridors that surround the monument are open to the sky; there are no interior corridors (*fig. 162*). The reproductions give some idea of the wealth of sculptural representations on both sides of the corridors. These reliefs are obviously influenced by Gupta style in their concept of figural representation. On the other hand, the narrative content is much richer than anything to be seen in the Gupta reliefs of India; and it is this aspect that seems particularly attuned to the native spirit. The development of later Javanese art is in the direction of a narrative style, even of a dramatic-caricature style, and will be considered when we come to the Hindu art of Java. Here, then, is pictorial representation, in a framed picture-relief with numerous figures and with a firm concept of spatial setting (*figs. 163, 164*). This may

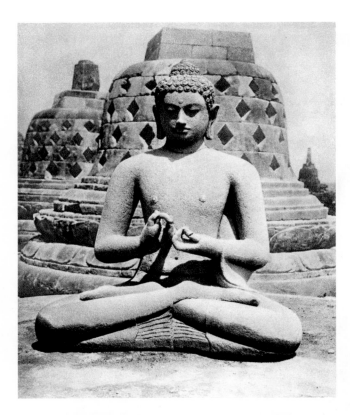

165. *Dhyani Buddha.* Lava stone. Borobudur, Java. Late eighth century A.D.

practiced by the Thai image makers of the Hinayana tradition, the Javanese style with its Mahayana background is less decorative and sleek and has more of the substance of religious fervor. The Buddha image of the central stupa of the terrace, though unfinished, is comparable in style to the others and, as we have seen, is considered to represent the *deva-raja*, the god-king.

Although later developments of Javanese art are largely Hindu, some Buddhist images date from this period of sculptural elaboration. The most notable of these is the often shown freestanding stela

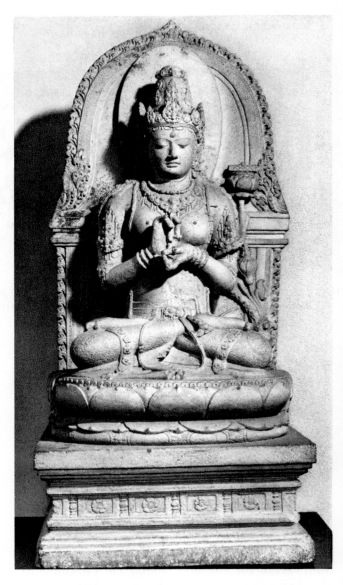

166. *Queen Dedes as Prajnaparamita.* Andesite, height 49 1/2″. Chandi Singasari, Java. Early thirteenth century A.D. Rijksmuseum voor Volkerkunde, Leiden

be limited, shallow, and sometimes with odd juxtapositions, such as the ship apparently on the same plane as the figures on land, but in general the landscape settings and the overlapping of figures display a remarkably advanced complexity. The reliefs are also a great treasure house of information on the mores of the day. We find, for example, representations of early Indonesian houses like the primitive Dyak houses still to be seen today.

The serene reaches of the upper terraces with their many perforated stupas take us to the highest and most abstract levels of the Buddhist hierarchy. The seventy-two images contained within the stupas echo this clean and severe atmosphere (*fig. 165,* which has been removed from within the stupa). Derived from such Gupta prototypes as the famous preaching Buddha of Sarnath, these Buddhas seem even more chaste, with intellectual overtones in keeping with their almost geometric environment. Straight lines are more in evidence, particularly in the profiles of shoulders, arms, and legs. One form moves smoothly into another with no perceptible transitions. The usually benign, gracious, and appealing countenance of the Buddha seems more severe, concentrating on an unpeopled world, or rather on a heaven filled with multiplications of his own image. In contrast to the type of simplification

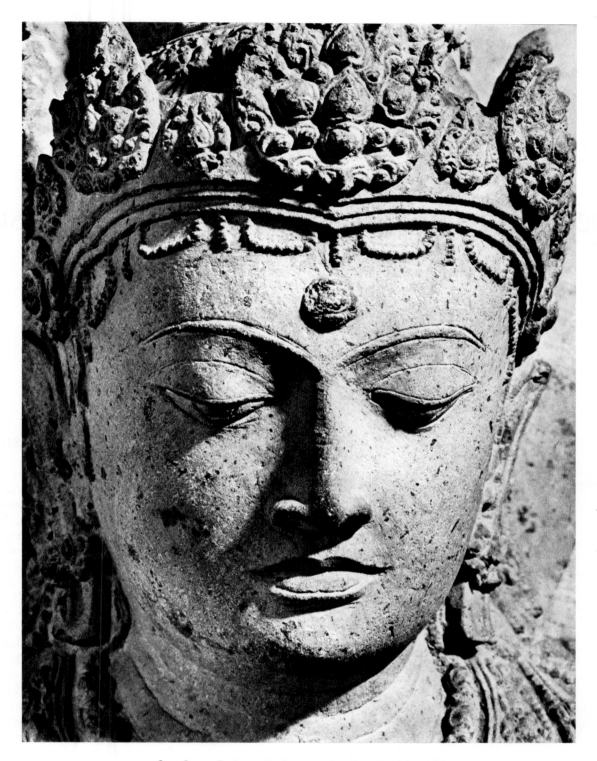

167. *Queen Dedes as Prajnaparamita*. Detail of fig. 166

of Queen Dedes (?; c. A.D. 1220) as Prajnaparamita, the goddess of transcendental wisdom (*figs. 166, 167*). The face and the nude parts of the torso show a smoother and ultrarefined continuation of the style seen at Borobudur, but the elaboration of the jewelry, costume, and throne back reveals the influence of metalwork, particularly of those Javanese wax-cast bronzes that depend for their effect upon the complication of numerous details achieved by the repetition of curling or droplike motifs. Something of the serenity and intellectuality of the earlier Javanese styles is preserved in the ramrod straightness of the torso and the clean, simple, straight lines of the lower part of the throne. These qualities, so appropriate for Buddhist art, are but a small part of later Javanese art, largely dominated by the vigorous development of a native pictorial style under Hindu religious inspiration. Again we witness the end of a Buddhist tradition in South Asia well before its decline in East Asia.

7

The Expansion of Buddhist Art to East Asia

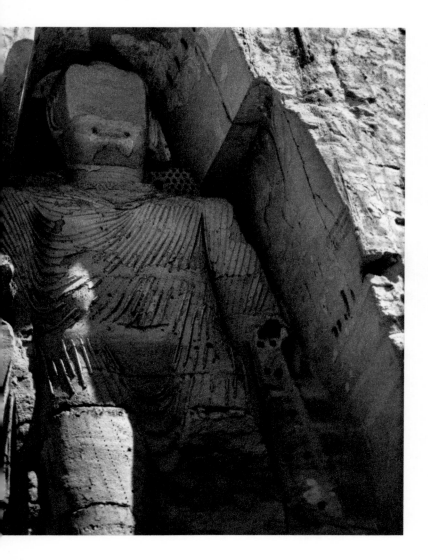

168. *Colossal Buddha.* Stone, height 175'. Bamiyan, Afghanistan. Fourth–fifth century A.D.

BUDDHIST ART IN CENTRAL ASIA

Indian style and Buddhist iconography were transmitted eastward not only by sea and land as far as Indonesia, but also by land over the mountain passes and through Central Asia to China, Korea, and Japan. Central Asia was a flourishing region of oases and some agricultural development as well as a pasture and hunting ground for nomads. The means of Buddhist expansion was the already existing network of three principal routes by which trade, especially in silk, was carried on between China, India, the Near East, and the Western world. The western terminus of these routes was near Bamiyan, outside northwest India, a trade and pilgrimage center under the political rule of an Iranian dynasty, where an Indo-European language was principally spoken. East of Bamiyan there were centers at Qyzil, Kucha, Miran, Turfan, Bazaklik, and numerous others. The eastern terminus of the routes was Dunhuang in the far northwest corner of China.

The principal mediums that concern us here are sculpture and painting, particularly painting in a fresco technique on mixed clay and plaster walls, in caves cut into the earth cliffs or river banks. Four major stylistic elements coexist in this Central Asian region—a Romano-Buddhist style, a Sasanian style based on that of the Persian Sasanian dynasty, a mixed Indo-Iranian or Central Asian style, and

finally a Chinese style representing a later influence moving in the opposite direction. We cannot overemphasize the importance of the Central Asian styles of painting in the development of Buddhist painting in China and Japan. They were the principal vehicles by which the iconography of Buddhism was transported. The many stylistic elements took hold for a time in China—permanent hold on Buddhist icons made for the temples, but only a temporary hold on sophisticated Chinese painting, which very quickly absorbed the Central Asian and Indian elements and reworked them into a native idiom that was then exported back to Central Asia.

The most extraordinary object at Bamiyan is the colossal Buddha (*fig. 168*), remarked upon by all who saw it, including Xuan-Zang. The impact of the Bamiyan Buddha upon travelers caused its iconography and style to be transported back to China, both in the minds of those who saw it and in the form of small "souvenir" objects. It is a stiff rendering of a standing Buddha with "string" drapery and a face of a rather rigid northwest Indian type, judging from the terribly damaged remains. But the rhythmic geometry of the drapery, derived in part from Gupta and Gandharan elements, provided a prototype for numerous images, large and small, made in China and Japan. The huge figure dominates the human figures of the pilgrims who pass by it. The niche is shaped as a body halo (*mandorla*), and with the usual halo behind the head produces a double halo much copied in China and Japan, even in remote cliff carvings that recreated Bamiyan abroad.

Inside the upper arch, over the main halo of the smaller, 120-foot-high image at Bamiyan, one can see the remnants of a fresco symbolizing the sun or the vault of heaven over the Buddha (*fig. 169*). The figure may be identified as Surya, the Hindu sun god, or Apollo, or, most likely, Mithra, the Persian sun deity. The solar deity, clothed body and head in the sun, drives a chariot drawn by horses and attended by winged angels. The angels are of two types. The two in human form, with symmetrical spreading wings that fall from shoulder to knee, are certainly derived from Persian and Mediterranean prototypes. The others appear to be *kinnaris,* deriving ultimately from Greek harpies, winged figures with birds' feet and the bodies and heads of human beings. These heavenly attendants are executed in a decorative and flat style, more in keeping with the Persian tradition than with the Indian style of Ajanta, which was carried into Central Asia as well.

The principal site where the Romano-Buddhist type appears is Miran. The style is particularly evident in a painted frieze of human figures bearing garlands (*fig. 170*). Their faces look like Fayum portraits of Coptic Egypt and are treated in late classical

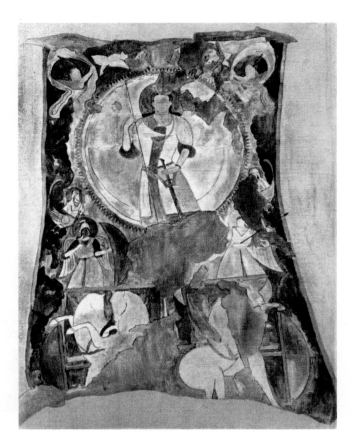

169. *Sun god.* Copy of fresco. Bamiyan, Afghanistan. Fourth–fifth century A.D.

style, with wide, staring, almost Byzantine eyes. The motif of the garland bearer is also of classical origin. These frescoes bear the signature Tita (Titus?), perhaps an itinerant painter from the late Roman Empire.

The third Central Asian style is a mixture of Indian and Iranian elements, with the most important sites located at Kucha, Qyzil, and Dandan Uiliq. The illustration from Dandan Uiliq shows a remarkably well preserved fresco depicting seated figures in priests' robes and a yakshi bathing in water between lotuses, with a large measure of Indian influence apparent in her voluptuous outlines (*fig. 171*). Still, the nose is rather sharper and the eyes slant much more than is customary in purely Indian painting. The whole effect is eclectic, but unified to a degree justifying a Central Asian designation. The dryad at Dandan Uiliq happens to be the most striking and aesthetically interesting of the numerous examples of the style and is of interest also because this is probably the farthest eastward extension of the nude female motif. The subject never appealed to the Chinese and Japanese except in offhand, informal sketches or as illustrations for erotic literature.

The Central Asian style makes much use of a

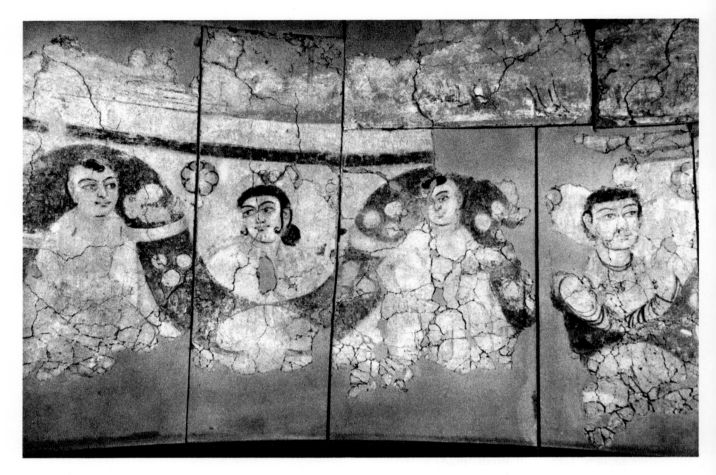

170. *Garland bearers*. Fresco, height approx. 48″. Dado of shrine, Miran, Xinjiang, China. Late third century A.D. Museum of Central Asian Antiquities, New Delhi

"web" technique, the word being used to describe a netlike pattern that unites the composition. This stylistic peculiarity is typical of paintings from Qyzil. The representation of the cremation of the body of the Buddha, an event following the *Parinirvana* and found in later elaborations of Buddhist iconography, shows flames rising above the raised top of the coffin and the Buddha reposing peacefully within (*fig. 172*). There are some traces of Indian style modeling in the slight shadow around the face, which gives a modest illusion of volume. At the same time the small eyes, tiny mouth, and high, pointed eyebrows are characteristic of Iranian style. One can even see some traces of Roman or Mediterranean style in some of the bearded disciples and guardian figures, who remind us of the various river and sea deities shown on Gandharan reliefs (*fig. 173*). But the distinctive color scheme owes little to Iran, India, or China: orange mixed with blues and malachite greens, and shading done in red on benign figures and in blue or black on guardian figures or demons.

171. *Yakshi*. Fresco. Dandan Uiliq, Xinjiang, China. Fifth–sixth century A.D. Destroyed

The schematization of anatomy in fingers, folds of the neck, and peculiar facial types suggests a distinctive Central Asian style. Frescoes of this type were executed by artisans of the region, and since frescoes cannot travel but artists can, it must have been these men, moving according to the demands of the monasteries on the pilgrimage routes, who spread these styles through Central Asia to China and Japan.

Unless we think of the Crusades, we cannot imagine the religious enthusiasm that motivated the burgeoning of these shrines along the pilgrimage and trade routes. Yet it was not a mass movement like the Crusades, but a succession of individuals or small groups who made the pilgrimage to see the homeland of the Buddha. A great many Chinese and Japanese went to India; and of course Indian priests and Central Asian traders visited China. Most people in the modern West, with their motorcars, trains, and planes, seem to think that "travel" is a Western word and that few people ever went anywhere until the automobile was invented. But the volume of travel in the ancient world was extraordinary. Remember the Roman trading station on the eastern coast of India or the one discovered in Thailand; consider

that the most beautiful ivory of Andhra type was discovered in Pompeii, and that one of the finest late Zhou bronzes was recently excavated in Rome. Travel was a normal function in ancient society, and certainly so for monks and pilgrims and for those active in trade.

The Chinese influence in Central Asia is slightly later in date than most of the material just discussed. It is an interesting example of a cultural phenomenon that might be called "backfire." We find the influence of Indian Buddhist art and of Iranian painting style amalgamated in Central Asia, moving to China, producing an impact there, and developing a varied iconography in a new Chinese style, which then, following the imperial ambitions of the Tang state, moved westward back along the same routes into Central Asia. For this phenomenon the most characteristic site is Bazaklik. Here a tenth century "donor" displays an almost pure Chinese style (*fig. 174*). The headdress is of Chinese type; the peculiar facial proportion, with the long nose, round chin, and conventionalized ears, is as purely Chinese as is the flowing linear base of the design.

The eastern focus of the trade and pilgrimage

172. *Cremation of the Buddha.* Fresco. Qyzil, Xinjiang, China. Sixth century A.D. Museum für Völkerkunde, Berlin

173. *Mahakasyapa, from a Parinirvana.* Fresco, length 27 1/2″. The Greatest Cave, Qyzil, Xinjiang, China. Sixth century A.D. Museum für Völkerkunde, Berlin

174. *Donor.* Fresco. Bazaklik, Xinjiang, China. Eighth–tenth century A.D. Museum of Central Asian Antiquities, New Delhi

routes was Dunhuang, the great staging center in the far northwest reaches of China. Here, in hundreds of caves—hence the appellation "Caves of the Thousand Buddhas"—are sculptured clay figures, frescoes, libraries of scrolls, manuscripts, and banners. In this Chinese outpost one finds a fusion of Central Asian elements with an extended range of Chinese styles from the fifth century to almost modern times, in a myriad of examples often well preserved by the dry, desert-like air. This rich trove is a happy hunting ground for the scholar and provides many clues to now lost sculptures and paintings from China's great urban centers. Some of this material will be mentioned in later considerations of Chinese and Japanese figural and landscape art, but only when no surviving sophisticated examples are available. The Dunhuang material, though rich and varied, is most likely provincial in character and gives only tantalizing glimpses of the mainstream of East Asian art. Its very primitiveness, though appealing to modern Western critics, would be unacceptable to the highest standards of traditional Chinese critical judgment.

BUDDHIST ART IN CHINA: PRE-TANG STYLES

It is traditional and fairly well established that Buddhism was introduced into China before A.D. 65. But according to Chinese records, by the third century A.D. there were only five thousand Buddhists in all of north and south China. So we cannot imagine that Buddhism conquered all by the merit of its doctrine or the force of an enthusiastic native mass movement. Rather we must associate the rise of Buddhism in China particularly with the Central Asian Tartars who, by the fifth century A.D., succeeded in establishing control over much of north China. The rulers of the Toba people who achieved this control called themselves the Northern Wei dynasty (A.D. 386–535). Fervent Buddhists, they were fortunate that the faith was an effective means of extending social and political control over the native Chinese population. It must not be assumed that this was done easily, for we have records of Buddhist success before A.D. 440, of the accession of a new ruler and his persecution of Buddhism in A.D. 446, then of the succession of yet another ruler, who reestablished Buddhism, and of its consequent flourishing expansion. Certainly it is true that by A.D. 450 Buddhism was a great force in north China, and that it expanded rapidly from that time on, though it did not achieve even a moderate degree of power in south China until later.

In China Buddhism became the great patron of the arts during the Six Dynasties period, a name traditionally given to the period (A.D. 220–589)

between the Han and the Sui dynasties. In Chinese Buddhist art we can witness over this period a consistent development from an eclectic mixture of Central Asian and Chinese styles to a fully realized Chinese style, which was to become a second international style of Buddhist art culminating in the style of the Tang dynasty (A.D. 618–907). Like the Gupta International style, it spread beyond national boundaries to become dominant over a larger geographic area, including principally China, Korea, and Japan. The precursors of the Tang style are numerous and difficult to follow. They have been placed for purposes of clarity in three main pigeonholes which, like all such arbitrary compartments, convey only an imperfect outline of the real process. The development was by no means so simple. But in general one can speak of an Archaic style, lasting until about A.D. 495, whose type-site is the great cave-temples at Yungang (Cloud Hill, near Datong in Shanxi); an Elongated style, which lasted from about A.D. 495 until the middle of the sixth century, whose type-site is a second cave complex at Longmen (Dragon Gate, near Luoyang in Henan); followed, in turn, by a Columnar style, particularly associated with the Northern Qi dynasty of A.D. 550–77, with a principal type-site at Xiangtangshan (Resounding Hall Mountain, partly in Hebei, partly in Henan). These three major styles of the Six Dynasties period were succeeded by a synthesized style at the time the country was unified, politically and socially, by the short-lived Sui dynasty (A.D. 581–618), which in turn was succeeded by the long and splendid Tang dynasty.

175. *Colossal Buddha*. Stone, height 45'. Cave 20, Yungang, Shanxi, China. Second half of fifth century A.D.

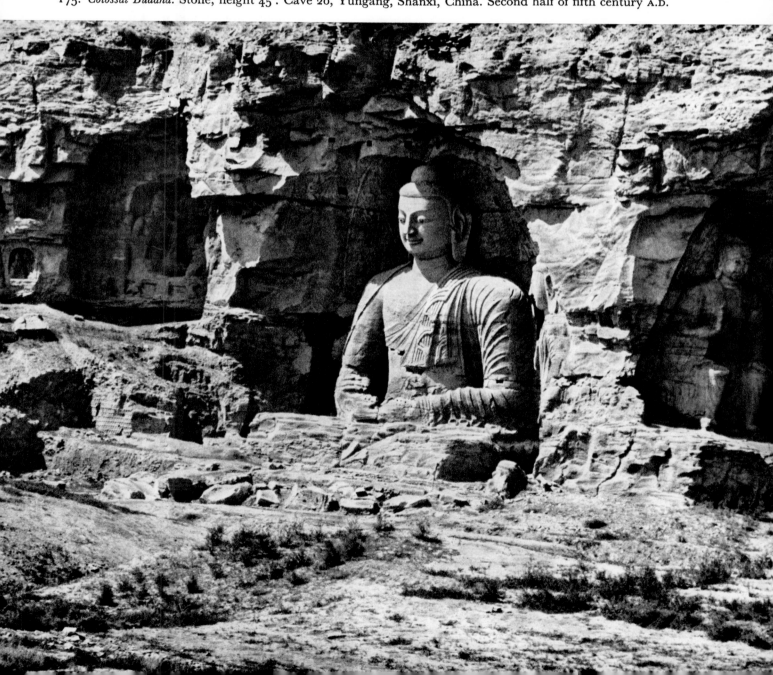

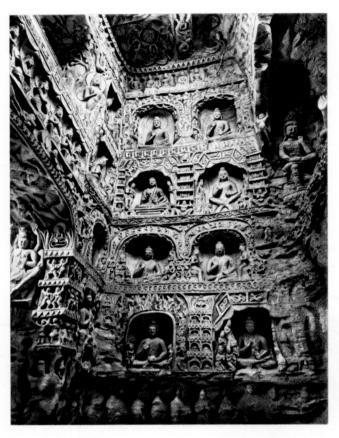

176. *Porch of cave 7.* Yungang, near Datong, Shanxi, China. Second half of fifth century A.D.

These great sculptural styles are figural and represent a new departure for the Chinese genius. The Chinese had carved only some few figures before the rise of Buddhism, but the imagery and iconography of Buddhism were dominantly Indian and consequently teemed with figures. Mahayana Buddhism was certainly a major stimulus for Chinese achievement in figure sculpture.

The term "Six Dynasties" hardly describes the period A.D. 220–589. It was a time of political convulsion unequaled since the Warring States, of mass movement of populations, of the rise and fall of many more than six dynasties and, withal, of cultural intermingling, absorption, and synthesis. Climate and topography have always divided China into north and south. The breakdown of Han rule and the "barbarian" invasions of the Six Dynasties period split it along these lines politically and culturally as well, bringing hordes of Central Asian invaders to settle among and rule over the Chinese of the north, and impelling vast numbers of Chinese refugees southward to impose their rule on and mingle their culture with the indigenous populations. In general south China was not noted for its cave sites; an already traditional art of painting flourished more

continuously and more fully there, as did animal sculpture and tomb sculpture of traditional Chinese type. In the north, where foreign influence was greater, we find more Buddhist material, great cave sites, and probably greater artistic ferment and complexity.

Let us first consider the Archaic style and its representative sculptures. The colossal Buddha at Yungang gives some idea of the general nature of the first phase of the style (*fig. 175*). The tradition of carving into the living rock was probably imported from India. Little if anything like this had been known before in China. The colossal figure, with the drapery derived from the Bamiyan string pattern and the face showing traces of Gandhara style, gives the impression of a hybrid and stiff conformation. This style is repeated in the great profusion of polychromed sculptures in the interiors. The porch to one of the caves shows a typical Central Asian proliferation of images by simple addition, without much symmetry; above we see a carefully worked out order, in the lower frieze an asymmetrically balanced mixture (*fig. 176*). The images seem to have been added one after the other, with no preexisting plan, as donor after donor ordered and dedicated a

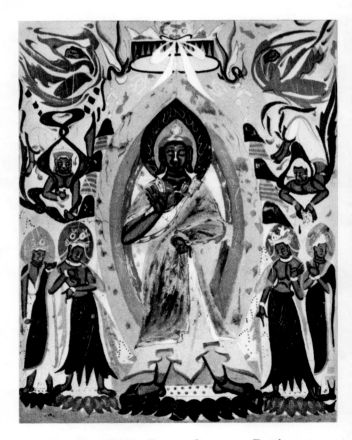

177. *Preaching Buddha.* Fresco. Cave 249, Dunhuang, Gansu, China. Northern Wei dynasty

142

carving. One might also note a trace of vulgarity in the coloring. Although much of the existing coloring is modern (at the bottom, for example), the original coloring, where it exists, is of similar quality. Bright blues, reds, greens, and whites were flatly applied, denying the sculptural form. The artists, largely of Central Asian origin or tutelage, were attempting to reproduce the paintings and stuccoes of Central Asia in sculptured stone. Above are representations of bodhisattvas under trees in a vaguely Indian manner, whereas the central image of the cross-legged Buddha below is taken from Iranian iconography. On the other hand, particularly in the flying figures of the ceiling, the flowing movements from one form into the other seem to be derived from native Chinese style, like that in late Zhou and Han dynasty painting, inlaid bronzes, and lacquer. The term "archaic" seems appropriate for this style: In addition to being the earliest of Chinese Buddhist styles, its figures reveal the smiling countenance characteristic of Archaic Greek art, which has so beguiled art historians that it has been christened "the archaic smile."

The influence of Central Asia is found as well in Buddhist painting of the fifth century, as can be seen in the earliest of the wall paintings at Dunhuang (*fig. 177*). These seem even more archaic than the sculptures, even to the point of caricature. The artist invests these figures with an almost frantic energy in his attempts to deal with such problems as the concept of modeling by light and shade. His eagerness reduces the more subtle Indian and Central Asian shading to a broad streak outlining the edges of the figures and the shapes within them. The result is more linear and energetic than any of the prototypes and may well testify to the first shock of the meeting of Chinese painting style with the new Buddhist imagery and foreign techniques of representation, perhaps as early as A.D. 420. Comparing these truly primitive forms with the contemporary and highly accomplished linear style of such native painters at the southern courts as Gu Kaizhi gives some hint of the discrepancy between the old tradition and the new stimulus—a large gap which was closed with startling ease and rapidity.

The second style, which we have called Elongated, can best be seen at the type-site, Longmen, where carving only began after the Northern Wei rulers had moved their capital to nearby Luoyang in A.D. 494. Here were no Central Asian craftsmen working for Chinese or Tartar patrons. We find at Longmen a thorough assimilation by the Chinese artist of the first elements of Buddhist iconography and of Central Asian style. There is a much greater use of linear movement than in the Archaic style; the sculpture appears flatter and the movements on the surface of

the sculpture, of the drapery, even of the halos and *mandorlas* behind the figure, are executed in very low relief, giving the effect of a flickering, sinuous, and rhythmical dance (*figs. 178, 179, 181*). The careful and continuous repetition of forms causes the rhythmical effect. The figures have become much more slender and elegant. The necks are longer; the faces are no longer of a Central Asian or Gandharan type. The poses are not static; they move. The guardian figures, instead of being stiffly alert, bend and grimace. Angels are not flat silhouettes against a ceiling but move within their outlines as well as in their silhouettes. A notable element of this style is the emphasis on the drapery. This assumes characteristic and repeated forms, especially a cascade or waterfall effect on seated figures. The artist obviously delights in the drapery falling over the knees and hanging down in carefully pleated folds below the legs. Such figures are repeated again and again, not only at Longmen but in other caves of lesser renown.

Perhaps we can see the style even more clearly in another form. Sculpture in stone was to be found

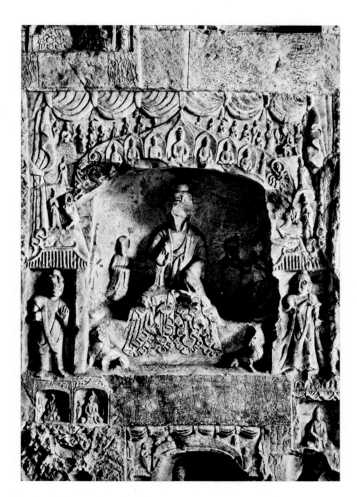

178. *Sculptured wall niche, cave 13.* Longmen, Henan, China. Dedicated A.D. 527

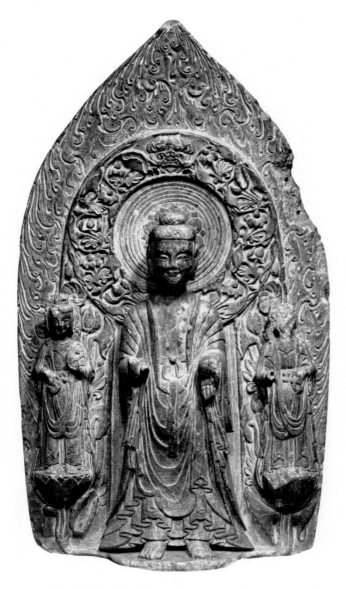

179. *Sakyamuni trinity*. Stela; limestone, height 30 1/2″. China. Eastern Wei dynasty, A.D. 537. Cleveland Museum of Art

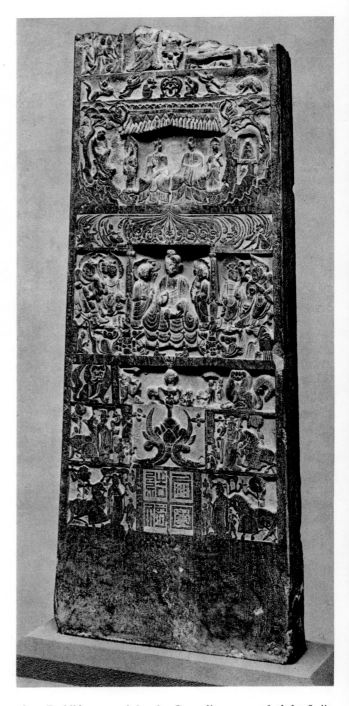

180. *Buddhist memorial stela*. Gray limestone, height 84″. Shanxi, China. A.D. 554. Museum of Fine Arts, Boston

the Buddha we can easily discern a demon mask. This mask dominates the lotus scroll derived from Buddhist iconography. In many other stelae artists introduce the traditional Chinese dragon or winged lion. These are evidences of the growing dominance of a Chinese idiom over the imported styles and iconographies.

not only in the caves but in the temple stelae. These were of two main types: one coming to a flame-shaped point and with high-relief images, the other a vertical tablet with figures carved in low relief or cut into niches. The pointed stela of the Eastern Wei Elongated style, dating from A.D. 537, is very much like the sculpture at Longmen (*fig. 179*). The archaic smile that we remember from Yungang is to be seen, greatly refined, more gracious and immediate. The eyes have a characteristic Chinese linearity. The long necks and waterfall drapery are emphasized wherever possible in an entirely new and easy way. They are carved in extremely low relief, so low that they almost appear to be painted. A Chinese note is introduced into the primarily Indian iconography of a Buddha flanked by bodhisattvas, for directly above

The tablet-shaped stela takes its form from the Chinese commemorative tablet, but in this example and in Six Dynasties sculpture generally it is adapted to the requirements of Buddhism, with many residual Chinese elements in iconography and style (*fig. 180*). The date of this stela is A.D. 554; thus it is a late example of the Elongated style. One element of that style, the waterfall drapery, is here somewhat decadently executed. But the figures of the angels, demons, and lions are carved in a fully Chinese rhythmical style. The seal, the inscription, and the long dedicatory inscription are carryovers from the Chinese commemorative tablet. The lower registers display Chinese motifs: a donor, horses, and chimeras or lions. Particular attention should be paid to a motif to be examined later in connection with the development of Chinese painting: the presence of landscape elements in stone relief. Here they consist of representations of trees flanking a scene in a pagoda, providing a landscape setting and an example of pictorial influence on stone sculpture. The tablet is simply divided into registers, and these in turn are divided into niches for figures. The arrangement is by no means always symmetrical. In effect, the ingredients of a cave-temple are here placed on a Chinese inscribed tablet, but figures of acrobats and monkeys are depicted with quite un-Indian angularity, their long, slender figures moving in seemingly frenetic activity.

The essential qualities of the Elongated style are perhaps most clearly seen in the gilt bronze ex-votos, or altarpieces, remaining from the sixth century. The illustration represents the meeting of the two Buddhas, Sakyamuni, the historic Buddha, and Prabhutaratna (*fig. 181*). The full and complicated story of this scene and of the Diamond Sutra associated with it is translated by H. Kern in the twenty-first volume of *The Sacred Books of the East*. Sakyamuni was seated on the Vulture Peak expounding the Lotus Law when a stupa appeared in the sky. He arose, "stood in the sky," and opened the stupa, where sat a Buddha of the past, Prabhutaratna, who had come to hear the Law. Sakyamuni sat beside him and continued his discourse. In the bronze in the Musée Guimet, in Paris, the two Buddhas are seen side by side, *mandorlas* with incised head-halos behind them, seated on a throne supported by lions flanking a caryatid. A design of a kneeling priest holding a censer is incised on the bronze base. In this altarpiece we find the elongated proportions, sharp noses, almond eyes, bewitching smile, waterfall drapery, and sawtooth drapery edges—another copybook motif—that occur again and again from about A.D. 510 to 550. Such gilt bronzes were made in some quantity as portable altars for family use or as offerings to temples; and very often they are inscribed and dated, this one to the year A.D. 518. The borders of the *mandorlas* are treated with a flame pattern recalling the late Zhou hook-and-volute motifs, almost as if these latter had persisted and been adapted as a flame motif.

The third of the pre-Tang styles is called here Columnar and evolves either through a specific kind of patronage or through a new wave of influence from India, probably from the Gupta period. The markedly linear character of the earlier sculpture in the round or in high relief is largely abandoned; instead we find rich, full-bodied monumental sculptures on which the jeweled ornament is applied to the smooth surface of columnar forms. The effect is highly architectonic, and quietly, reservedly imposing. The illustration is strikingly characteristic—a bodhisattva from the cave-temple complex at Xiangtangshan (*fig. 182*). The few details of ornament accent the smooth surfaces on the column-like figure. The facial type is developed largely from

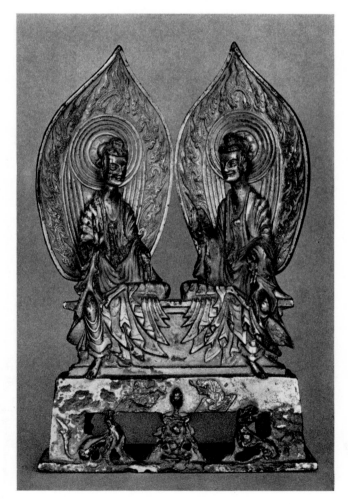

181. *Sakyamuni and Prabhutaratna*. Gilt bronze, height 10 1/4". China. A.D. 518. Musée Guimet, Paris

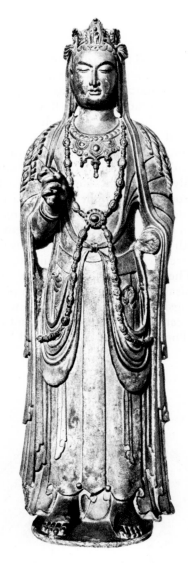

the Elongated style; it is the torso that shows the radical change in form. The monsters, whether attendants or caryatids, at Xiangtangshan are among the most imaginative and sculpturally convincing products of the period (*fig. 334*). Like other members of the same family in gilt bronze (*fig. 183*), they are bizarre arrangements of volumes and voids as well as being representational grotesques. They take their proper place in the long history of Chinese secular sculpture, though here they supplement a foreign imagery and faith.

Various sculptures in stone and metal epitomize the unification of style that took place during the Sui dynasty (A.D. 581–618), but none does this better than the famous bronze altarpiece in the Museum of Fine Arts, Boston, dated to A.D. 593 (*fig. 184*). It

182. *Bodhisattva*. Stone, height approx. 72″. Xiangtangshan, Hebei-Henan, China. Northern Qi dynasty. University Museum, Philadelphia

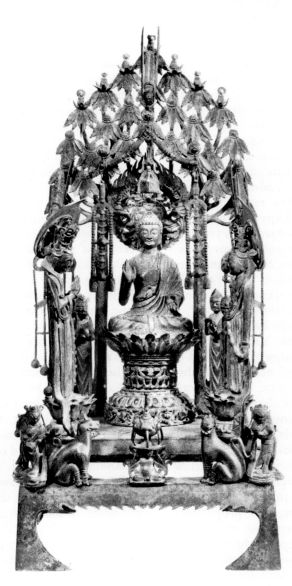

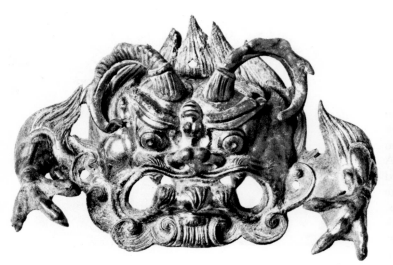

183. *Monster mask (pu shou)*. Holder for door ring; gilt bronze, height 5 1/4″. Northern Qi dynasty. Cleveland Museum of Art

184. *Amitabha altar*. Bronze, height 30 1/8″. Sui dynasty, A.D. 593. Museum of Fine Arts, Boston

represents the Buddha of the West, Amitabha (Chinese: Amitofo), seated beneath the jeweled trees of the Western Paradise and attended by two acolytes, two disciples, and two bodhisattvas, with a pair of lions and a pair of guardians flanking an incense burner directly in front of the Buddha, these last set into holes in the bronze altar base. The Amitabha altarpiece is, first of all, a carefully balanced composition with the axis at the center. There are minor variations in the poses of individual figures, such as the inward bend of the head of the bodhisattva on the right, but careful symmetry is the rule. The style is one of simplicity and restraint, with a harmony between major and minor figures not found in earlier compositions. There is no longer a discrepancy between the iconography and style of the major Buddha images and the qualities of the attendant figures. It is a mode based on the Columnar style of the Northern Qi dynasty, and from it the great Tang style develops. But before we turn to the Tang International style, let us examine the extension of the Six Dynasties styles into Japan.

EARLY BUDDHIST ART IN JAPAN

Although many see in early Japanese Buddhist art a native quality distinct from that of China, none but the most nationalistic would deny—on objectively assessing the elements of Chinese style and those of Japanese origin present in this material—that the proportion would be almost entirely Chinese with half of the tiny remainder Korean. To all intents and purposes, the early Buddhist art of Japan—the art of the Asuka (A.D. 552–645) and Nara (A.D. 645–794) periods—is Chinese art, first of the Six Dynasties period and later of the Tang International type. It is indeed fortunate that this is so, for the continuous warfare in China, both internecine and foreign, succeeded in destroying many of the great monuments of Buddhist art. There is almost no early Buddhist architecture left in China. There are few, if any, remaining Six Dynasties images of wood, few large bronzes, and scarcely any images in precious metal or in other exotic materials. The list of images in clay is brief indeed. But quite the reverse is true of the material in Japan. There the combination of great good fortune and a marked reverence for the past, including the early monuments of Buddhism, has succeeded in preserving a considerable number of works in pure Six Dynasties and Tang style. From these we can gauge something of the richness and splendor of Chinese sculptures in these phases.

Buddhism was introduced to Japan by a mission from Korea, traditionally in A.D. 552. We cannot overestimate the importance of Korea in the trans-

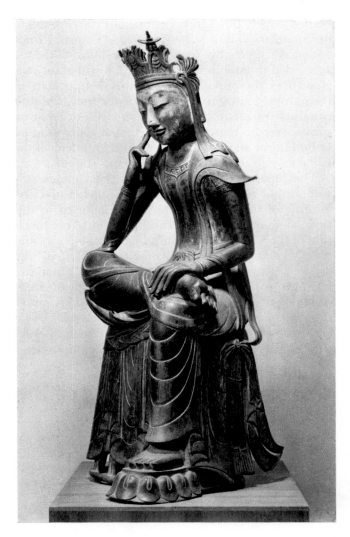

185. *Maitreya*. Gilt bronze, height 30″. Korea. Silla period, sixth–seventh century A.D. National Museum of Korea, Seoul

mittal to Japan of the style of the Six Dynasties period. We know that the first generation of image makers in Japan were from the mainland and nearly all second and third generation artists had some continental blood. Korean sculptors of the Silla period (57 B.C.–A.D. 935) were quick to master the imagery of Buddhism after the introduction there of that faith in the fifth century. Though few of their best images have survived, one gilt bronze masterpiece in Seoul shows how elegant and refined the Elongated style could be in a large metal image of nonprovincial type (*fig. 185*). Such linear refinement and accomplished stylization was probably common in the best Chinese and Korean work and provided an advanced starting point for the newly converted Japanese.

The introduction of Buddhism into Japan suc-

ceeded largely through the efforts of Prince Shotoku, or Shotoku Taishi (A.D. 572–622), Crown Prince "Sage Virtue." By means of his pure faith, he succeeded in establishing Buddhism as the state religion, over the opposition of powerful supporters of the native Shinto, in a relatively short time. Shinto's ritualism and its multiplication of deities or nature spirits were no match for the religious sophistication of Buddhism and the amplitude and grandeur of the Chinese culture attending it.

The Japanese ruling class embraced Chinese culture almost in toto and with unparalleled alacrity. Writing of Chinese characters was imported at this time, as were the customs and hierarchical organization of the Chinese court and the concept of city and temple planning along geometric lines. All the orderly, logical, and rational elements that we associate with China were brought in with Buddhism. Temples were built in great numbers; sculpture was produced in quantity; and the result was a flowering of figural art never surpassed in East Asia.

One must always be conscious of a time lag in assessing the relation between Chinese, Korean, and Japanese styles. The Asuka period lasted from A.D. 552 to 645, but the art of the period is the Chinese style common from about A.D. 500 to 550. The type-site for the Asuka style, Horyu-ji (the suffix -ji means "temple"), the cradle of Japanese art, probably was founded about A.D. 610 (fig. 186). There is great argument as to whether the existing structure is the original one; there are some who believe it was rebuilt in the early style at the end of the seventh century, after a disastrous fire. The golden hall (kondo), the pagoda, a part of the cloister, and the gate are in the original style but date from just after A.D. 670. Not only are these the oldest wooden buildings in the world, they also show the appearance of a Chinese temple complex of the Six Dynasties period. Early in 1949 a tragedy occurred. The golden hall, part of which had been removed for repair, was burned, and the great frescoes inside were greatly damaged. The Japanese have reconstructed the hall

186. *Horyu-ji.* Nara, Japan. General view. Asuka period, seventh century A.D.

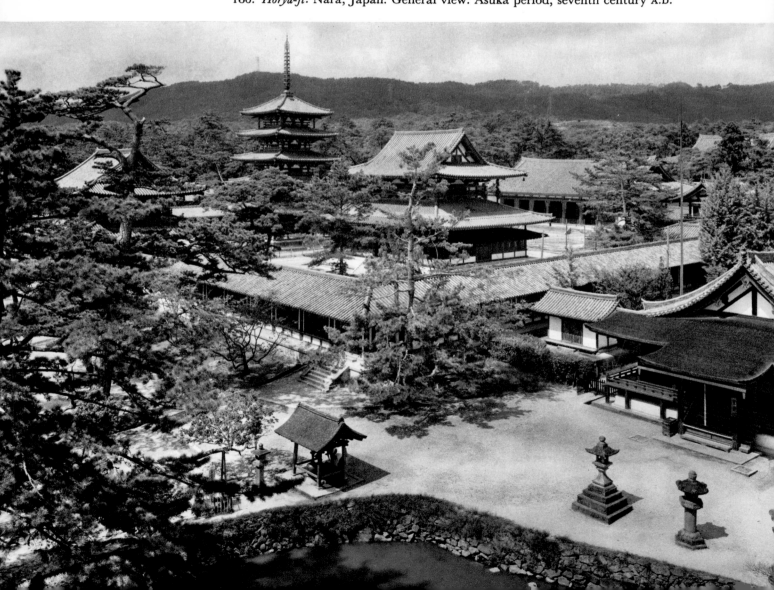

to its original appearance, using new materials to supplement the timbers that had been removed.

The beautiful and gently rolling hill country near Nara gives Horyu-ji an extraordinary setting, and the pine trees rising out of the sand of the courtyard add to the ancient, noble, and archaic air of the whole. The plan of the monastery is relatively asymmetrical, giving much prominence to the pagoda, a characteristic of a great deal of Six Dynasties architecture. The principal axis runs from the gate between the pagoda and the golden hall to a lost refectory behind. The east-west axis transects the golden hall and the pagoda. The pagoda and the golden hall are symmetrically placed on either side of the north-south axis, but the two buildings are not, of course, identical. Later, in the Tang dynasty, a more rigidly balanced plan became typical, with the golden hall on a central axis and two pagodas symmetrically placed in subordinate locations either inside or outside the cloister.

The individual buildings of Horyu-ji are typically Chinese, standing on raised stone bases and using the bay system, post-and-lintel construction, tile roofs, and elaborate bracketing designed to transmit the thrust and weight of the heavy tile roof down through the wooden members into the principal columns that support the structure (*fig. 187*). The gate has a more flying, winged character, typical of Six Dynasties architecture, than does the *kondo*. The latter had a covered porch added in the eighth century and, in the seventeenth, dragon-encircled corner posts. These tend to obscure the early form and make it appear more squat and cumbersome than was originally intended. A closer view of the *kondo* shows the bracketing system with its complicated use of jutting members, carved in a linear, cloudlike pattern (*fig. 188*). All this adds to the springing and light effect characteristic of Six Dynasties style, in contrast to the somber and rather dignified style that succeeded it. The golden hall is oriented to the four directions, with a stairway on each side leading to a double door. The interior is similarly oriented, with the three main images on a central dais and three carved and painted wooden canopies over them. On the four interior walls were painted frescoes in about A.D. 710, showing the four paradises of the four Buddhas of north, east, south, and west, with smaller wall panels of attendant bodhisattvas. These are the paintings largely destroyed in 1949, but fortunately they are thoroughly documented by photographs and color reproductions, though these are admittedly poor substitutes for the original.

Painting of the Asuka period is known to us principally through one monument in Horyu-ji known as the Tamamushi (Jade Beetle) Shrine, so called

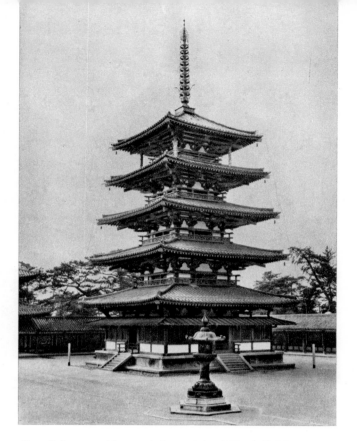

187. *Goju no to (five-storied pagoda) of Horyu-ji.* Nara, Japan. Asuka period, seventh century A.D.

because the pierced gilt bronze borders around the base and edges of the pedestal are laid over a covering of iridescent beetle wings (*fig. 189*). These shine against the gilt bronze and produce an extraordinary effect. The Tamamushi Shrine is a wood-constructed architectural model meant to enclose an image. Resting on a large, high pedestal placed on a four-legged base, the entire shrine is more than seven feet high and in almost perfect condition, with no restoration or addition. It is not only a beautiful form in itself, important for its paintings, but it is also of great value for the study of architecture of the Six Dynasties period. Naturally the Horyu-ji buildings themselves have been repaired, roofs have been changed, and oftentimes the lines of the structure are lost. But the Tamamushi Shrine is a small and perfect example of Six Dynasties architecture in excellent preservation. Indeed, modern Japanese architects were able to reconstruct the golden hall roof line more accurately by following this model. On the four sides of the pedestal are painted Buddhist scenes, one of them a jataka, or story of the Buddha in a previous incarnation. Here, in order to save a family of tiger cubs from starving to death, the Buddha-to-be offers himself as food for the mother, who could then feed her young (*fig. 190*). The story is told by the method of continuous narration in three episodes. Above, the Buddha-to-be carefully puts his clothes on a tree. He is then shown diving off the cliff toward a bamboo grove, the tiger's lair. At the bottom, partly veiled by bamboo

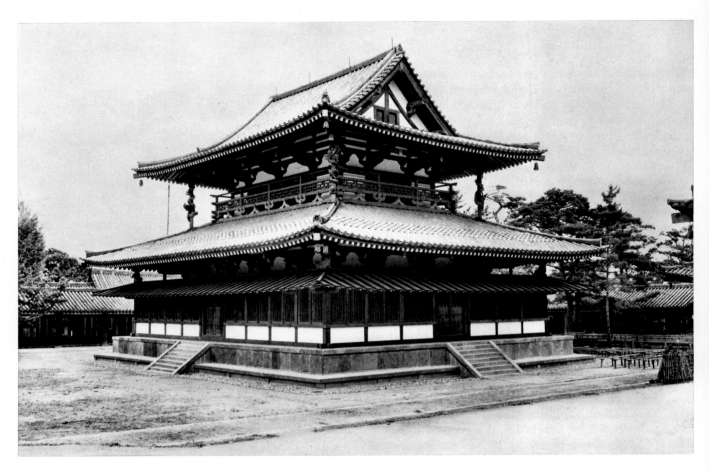

188. *Kondo (golden hall) of Horyu-ji*. Nara, Japan. Asuka period, seventh century A.D.

189. *Tamamushi Shrine*. Lacquer painting on wood, height 92″. Horyu-ji, Nara, Japan. Asuka period, seventh century A.D.

190. *The bodhisattva's sacrifice, from Tamamushi Shrine*. Detail of fig. 189

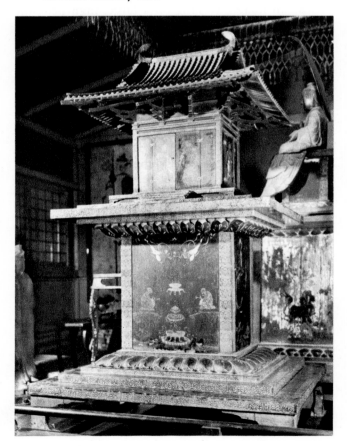

stems, is the gruesome conclusion: the tigress eating the willing sacrifice. The representation is of great interest as one of the earliest examples of the painting of bamboo, an East Asian specialty, and because its general style, particularly the way in which the curious rock formation is constructed with ribbons of yellow and red lacquer, recalls nothing so much as late Zhou inlaid bronzes. The whole construction of this cliff, with its linear accents and its hooks and bends, is in pure Chinese style. Note, too, that the human figure is long and slender, a perfect example of the Elongated style. There is great emphasis throughout on linear motifs, in the clouds, in the falling lotus petals, and in the drapery that trails behind the bodhisattva as he plummets to the bamboo grove below. The whole effect is replete with naiveté and charm and shows tremendous technical control.

The largest remaining Chinese bronze image of the Six Dynasties period is perhaps a foot and a half in height. At Horyu-ji there are several images, including the famous group illustrated here (*fig. 191*), almost six feet high. This Buddhist triad, by Tori, a sculptor of Chinese descent, was made in A.D. 623, and represents the Buddha Sakyamuni seated on a throne flanked by bodhisattvas, with a great *mandorla* behind. The image was made two years after the death of Shotoku Taishi and, as the inscription notes, was dedicated to the memory of the prince. It is in perfect condition, with considerable gilding remaining, and is a fine example of the Elongated style. If it were made of stone it might have come from Longmen: the waterfall drapery, the serrated edges of the side draperies on the bodhisattvas, the rather tall proportions, the type of the face, and the *mandorla* with its curling linear motifs are pure late Northern Wei. There is a slight tendency toward squatness in the proportion of the faces and in the relationship of the body to the feet, and this seems characteristic of some Japanese work of this period. Above the image is one of the three baldachins, or canopies, that were placed over the main images of the raised dais of this golden hall. It recalls the painted and carved canopies on the ceilings in such early Six Dynasties sites as Yungang and Longmen.

Perhaps the most beautiful of all the great images at Horyu-ji is the wooden Kannon housed in an octagonal hall of the eighth century, called the Hall of Dreams (Yumedono; *fig. 192*). Kannon is the Japanese name for the deity called Guanyin by the Chinese and Avalokitesvara by the Indians, the most popular of all bodhisattvas. The Yumedono Kannon has an extraordinary history. It was found by a group of scholars including the American, Ernest Fenollosa, who was then Curator of Oriental Art at the Museum of Fine Arts in Boston, carefully wrapped in cloth in

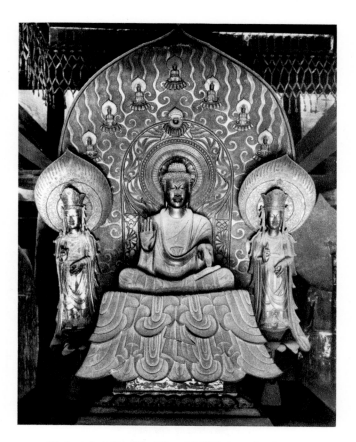

191. *Shaka triad*. By Tori Busshi (Master Craftsman Tori). Bronze, height 69 1/4". Horyu-ji, Nara, Japan. Asuka period, A.D. 623

its tabernacle, a secret image. Inside the wrappings lay the miraculously preserved image, some six to seven feet in height, with a halo that is one of the most beautiful examples in all the world of linear pattern carved in low relief. The figure had its original gilt bronze jeweled crown, with the jade fittings and gilding all preserved. Even such usually lost details as the painted moustache are clearly visible. The front view reveals the serrated drapery of the early Six Dynasties style and indications of the waterfall pattern and of the curling motifs of the hair at the side of the shoulders. The side view reveals the usual integrity of the Oriental artist in handling specific materials. We see an image that could not be anything but wood, despite the gilding. The serrated drapery derives its effect from its origin in a plank, first cut with a saw and then so finished that it retains, even in its finished condition, the character of sawn wood. Note, too, the flatness of the figure— how the hands are pulled together and compressed to the chest, maintaining a relief-like character, although the image is technically in the round. The Yumedono Kannon is, for this writer, perhaps the supreme example of the early Six Dynasties style in either China or Japan.

The second of the great wooden images at Horyu-ji is the so-called Kudara Kannon—the Korean

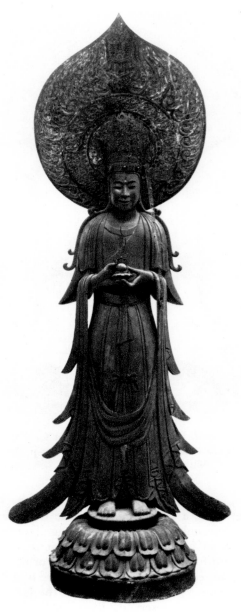

192. *Kannon*. Gilded wood, height 77 1/2″. Yumedono (Hall of Dreams) of Horyu-ji, Nara, Japan. Asuka period, early seventh century A.D.

later in style than the image in the Yumedono, embodying the Chinese style of A.D. 550 or 560 rather than 520. The support for the halo is wood carved to imitate bamboo.

In considering the sculpture of the Asuka period we cannot overlook an image quite different from the two that we have just studied, which seems particularly appropriate to its location, the little nunnery of Chugu-ji, an adjunct of Horyu-ji (*fig.*

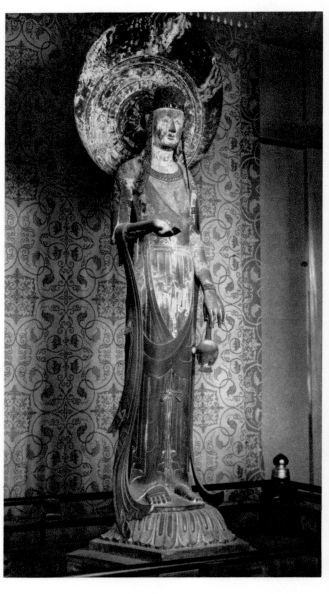

193. *Kudara Kannon*. Painted wood, height 82 1/4″. Horyu-ji, Nara, Japan. Asuka period, mid-seventh century A.D. Horyu-ji Museum, Nara

194. (opposite) *Miroku* (portion). Wood, height 62″. Chugu-ji of Horyu-ji, Nara, Japan. Asuka period, mid-seventh century A.D.

Kannon—since Kudara was the Japanese name for the kingdom of Paekche in Korea in the seventh century, and tradition assumes a Korean origin at least for the style if not for the image itself (*fig. 193*). In this image, while we have the same planklike character in the side draperies, we find a more columnar, trunklike quality in the torso, again most appropriate for wood. The Kudara Kannon is not in quite perfect condition; a great deal of the polychromy has been lost, and the rather spotty effect on the halo and on the body is due to this loss. But the tremendous elegance implicit in the elongation of the figure, and its individuality—greater than that of the Yumedono Kannon—make it unique. It is a little

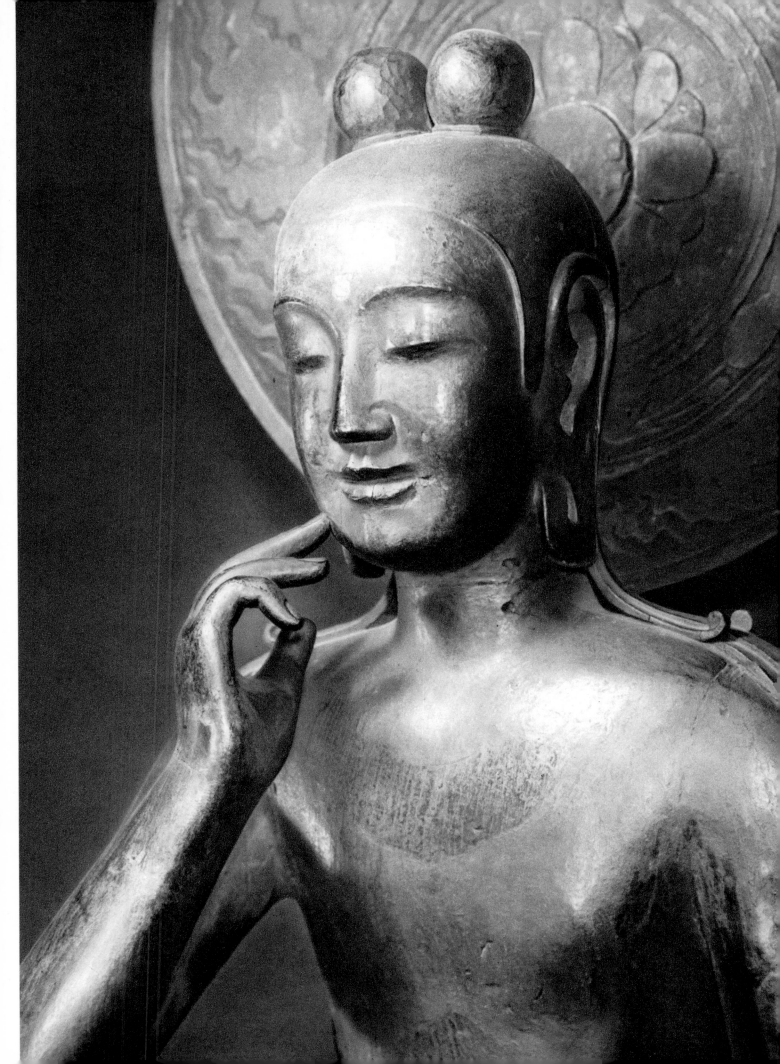

195. *Angel musician.* Polychromed wood, height
19 1/2″. Canopy of the *kondo* (golden hall) of
Horyu-ji, Nara, Japan. Hakuho period, c. A.D.
700

194). The figure is properly referred to as the Chugu-ji Miroku (Sanskrit: Maitreya), the Buddha of the future. The Chugu-ji image has the elements of Six Dynasties style seen in the other sculptures—the waterfall drapery, the simulated bamboo pole holding the halo, the beautiful linear, flamelike pattern on the edges of the halo, the archaic smile, the serrated and curling edges of the hair as it falls over the shoulders. But it has quite a different flavor—one of infinite sweetness and softness, in short, a very feminine quality. The gesture of the hand of the Miroku, as he places his finger close to his chin in a posture implying meditation, is a thing of infinite grace. Still, such images as Maitreya and Guanyin must be considered masculine, not feminine. Even Guanyin does not begin to acquire a female aspect until the eleventh or twelfth century.

The carved wooden canopies over the main altar of the golden hall of Horyu-ji were decorated with a sequence of fabulous birds and music-playing angels. Some of these were lost in the thirteenth century and replaced by contemporary copies, others were removed in the nineteenth century and sold to fortunate Japanese collectors. The original sculptures in place, such as this angel, with its pierced halo, its linear and rhythmical development of repeated lines and gently swaying profiles, are characteristic of Chinese art in general and a demonstration of the

truism that the Chinese are pictorial-minded (*fig. 195*). Their greatest sculpture looks more pictorial than sculptural; the Indians, on the contrary, are more sculptural-minded, and in the classic phase of their painting at Bagh and Ajanta they are concerned with the painted representation of sculptural forms in space. In its charm and delightful elegance this figure is related more to the Chugu-ji Miroku than to the earlier Yumedono or Kudara Kannon. There is good reason to believe that the angels do not date from A.D. 610, that is, from the earliest Horyu-ji construction, but from the end of the seventh century, when the canopies were probably put in place.

THE TANG INTERNATIONAL STYLE

Buddhist art of the Tang dynasty (A.D. 618–907) is rightly described as an international style, to which that of the Six Dynasties is but a somewhat heterogeneous preliminary. During the earlier period China was divided politically, in turmoil, and in the process of combining diverse racial, social, and religious components. But with the Tang dynasty we find a great world empire extending from the Caspian Sea to the Pacific, from Manchuria and Korea in the north into Vietnam in the south. At no other period before or since did China reach such powerful estate or exert such great influence. The capital, Changan, was one of the greatest cities the world had yet seen. Travel between East and West increased enormously under the protection of a unified and centralized empire. The empire developed integrated and sophisticated forms in its art, as in its literature and social organization. It was not an age of dawning faith, of pilgrims' fervor, but one of confident cosmopolitanism, born of mastery of the known world and society. Many foreign faiths were tolerated in Tang China—Buddhism, Nestorian Christianity, Hebraism, Muhammadanism, Zoroastrianism among them.

The derivations of the Tang Buddhist style were threefold: first, the India of the Gupta period; second, its own background of the Six Dynasties and the Sui period; and third, Central Asia and the Near East. Never before or since have so many Near Eastern motifs appeared in Chinese art nor, on the other hand, were so many Chinese motifs imported into the Near East. We will look only briefly at Tang material in China proper, because it is, like that of the Six Dynasties, more easily studied in Japan.

The type-site for Tang stone sculpture is Tianlong Shan (Heavenly Dragon Mountain) in Shanxi. In particular, cave 19 shows at its very finest the style achieved by the Tang sculptor (*fig. 196*). Its elements are clear. Where before we were conscious of

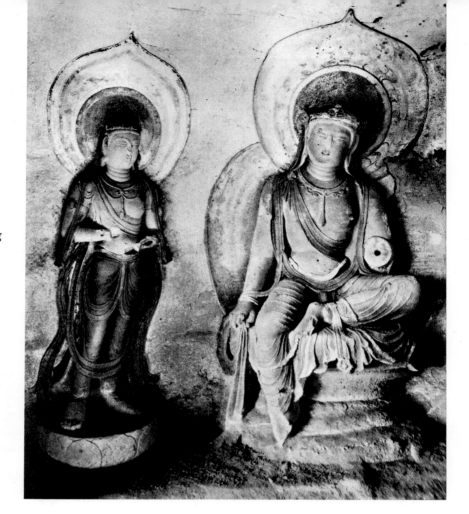

196. *Bodhisattvas.* Stone. Tianlong Shan, Shanxi, China. Tang dynasty, c. A.D. 700

religious fervor, of a more abstract and mystical handling of the figure, of linear pattern, and of elongation, here we are more aware of a unified and worldly approach. All the parts seem fused into a seamless whole. The modeling of the figures is fleshly and voluptuous, perhaps in part under the influence of the Gupta style of India. The forms flow one into the other; the curve, the sphere, and the tapering cylinder are the basic elements. The drapery is no longer, as it was in the Northern Qi and even in the Sui dynasty, applied on the surface of a volume beneath, but is integrated with the structure of the figure in a seemingly naturalistic way. This combination of a sinuous and sophisticated voluptuousness, together with direct, even realistic, observation of nature, is what makes the Tang style.

Few sculptures remain to exemplify the accomplished style that fully realizes the most sophisticated intentions of the Tang image maker. One of these, carved in a fine-grained sandstone, is an Eleven-headed Guanyin, probably from Shenxi Province, the home of the Tang capital, Changan (*fig. 198*). This bodhisattva, one of the most popular and holy saviors of Mahayana Buddhism, is revealed as a benign but worldly being. The rounded face is a foil to the graceful linear geometry of its features and a contrast to the vigorous realism of the "angry" heads above. No trace of the struggle for stylistic

assimilation remains; instead, the easy grace is matched by the technical ease of presentation. It seems a fitting visual and tactile summation of the Tang ethos, a fully realized language derived from a foreign art vocabulary. No one would mistake this Guanyin for a Gupta Avalokitesvara, though the same terms might be used to describe either—sensuous, worldly, yet removed from stress and struggle.

Much of this restraint derives from the veneration accorded the subject matter. The realistic and vigorous accomplishments of the Tang sculptor may be realized from such monuments as the small pagoda base now in Kansas City, on which the presence of guardians and dragons allowed the artist to indulge in the imaginative Chinese tradition of pre-Buddhist times (*fig. 197*). Such variety and technical ease were eminently suited to the worldly temper of Tang China and of the comparable Nara period in Japan.

We can see the development of the Tang temple plan in Japan at Todai-ji (*fig. 199*). The scale becomes huge—some five to six times the size of such small temples as Horyu-ji. The original main hall of Todai-ji was of such a size as to house a bronze Buddha image some sixty feet in height. The temple enclosure expanded to such a degree that almost twenty acres were enclosed by the ambulatory. The pair of pagodas, now destroyed, were originally

197. *Pagoda base.* Stone, height 27 1/4". China. Tang dynasty, early eighth century A.D. Nelson Gallery–Atkins Museum, Kansas City. Nelson Fund

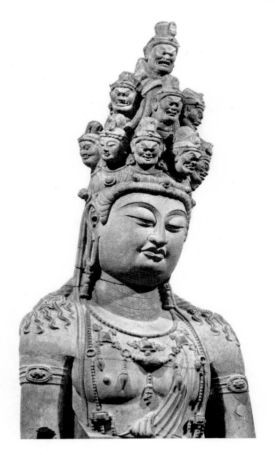

198. *Eleven-headed Guanyin* (fragment). Sandstone, height 51". China. Tang dynasty, c. eighth century A.D. Cleveland Museum of Art

flanking the entrance but outside the enclosure, thus enlarging the plan still further. Tang and Nara were centralized and growing societies in their architectural planning as well as in politics.

The buildings show the same tendency to expansion. Observe the golden hall of Toshodai-ji (*fig. 200*) in contrast to the same building at Horyu-ji. The latter's tightly organized and rather small dimensions, its vertical development, and its feeling of springiness are dwarfed by the scale and mass of the later building. The Horyu-ji *kondo* is completely enclosed; at Toshodai-ji there is an expansion into space in the form of a porch. This was dictated by the interaction of religious and social requirements: The sacred images were not for the eyes of seculars anywhere, but at Toshodai-ji (in contrast to Horyu-ji) the noble or wealthy layman was considered entitled to shelter while he listened to the ritual within. Not only is the building immeasurably bigger than that of the preceding period, but the interior shows a more focused and unified handling of space (*fig. 201*). At Horyu-ji, the altar was meant to be walked around in the traditional Indian rite of circumambulation; at Toshodai-ji, the altar proper is backed by a screen, so that although one can still make the circumambulation, one's attention is focused on a framed, frontal view of the images

and the altar. Again, this is a more unified and visually logical concept than the previous one. The various architectural members, columns, and bracketing are elaborate and massive. The color scheme in both temples remains the same: white-dressed clay on the walls, the large members treated with red oxide, window lattices painted a rich green, the roof tiles gray.

An interior view of one of these Nara period temples will demonstrate the arrangement of an altar and its focused quality. The interior of one of the subsidiary halls at Todai-ji, Sangatsu-do (Third Month Hall), possesses a very complete altar arrangement with original sculptures of the Nara period (*fig. 202*). This is the way a Tang temple looked: a raised dais, a wall screen behind the altar focusing attention on the frontal view, and finally an altar crammed with large-scale, imposing figures of guardian kings, bodhisattvas, and principal images, executed in a variety of materials—dry lacquer, clay, and wood—rich with polychrome and full of realistic movement. The whole effect is a balanced combination of realism and religious feeling.

Here, and only here in all the world, one can see a group of Tang sculptures arrayed on the altar of a moderately small temple. This is not, however, the original disposition. The complex represents an accu-

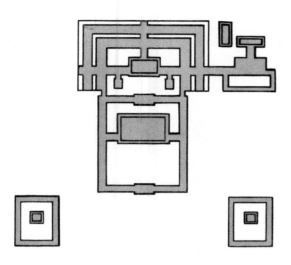

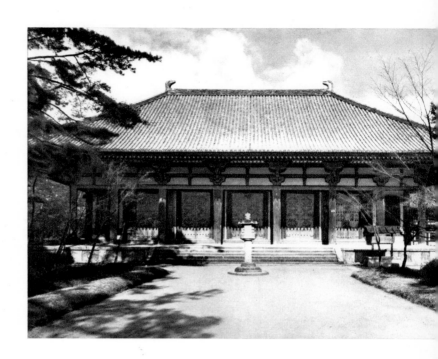

199. (above) *Old plan of Todai-ji*. Nara, Japan. A.D. 745–52

200. (right) *Kondo (golden hall) of Toshodai-ji*. Nara, Japan. C. A.D. 759

201. *Interior of kondo (golden hall) of Toshodai-ji*. Nara, Japan. C. A.D. 759

202. *Interior of Sangatsu-do of Todai-ji*. Nara, Japan. C. A.D. 730

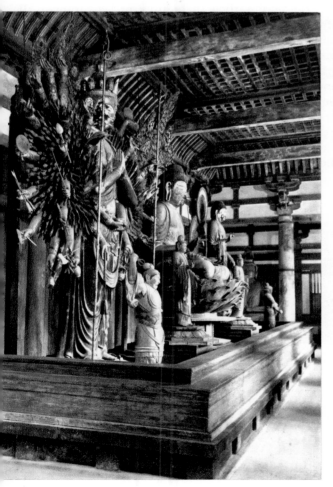

203. *Amida triad, from Tachibana Shrine.* Bronze, height of central figure 13 1/8″. Horyu-ji, Nara, Japan. Nara period, early eighth century A.D.

mulation of sculptures: Four of them, for example, were brought over in the tenth or eleventh century from another building of Toshodai-ji, destroyed by fire, and so it is not altogether sure that this is precisely the way they would have been placed in the eighth century at the time of their making. But the ensemble has integrity. The combination of clay, dry lacquer, and wood is normal; the relative scales are quite right; and the setting is appropriate: an eighth century building with an eighth century altar group on an eighth century altar.

We have seen an altar group; now let us look at some important individual sculptures. Certainly the most remarkable example of the early Tang style is the bronze trinity within the Tachibana Shrine, which is named for the lady of wealth and aristocratic birth who gave the shrine to Horyu-ji (*fig. 203*). It dates from the very end of the seventh century or the beginning of the eighth, about A.D. 700. This is some eighty years after the beginning of the Tang dynasty in China; but Japanese art in Chinese style is always subject to time lag, and thus the trinity represents early seventh century Tang style. It is made of gilded bronze and is housed in a wooden tabernacle of the same time. Three major units make the composition: a flat base, a background screen in the form of a triptych, and the three main images, which sit or stand on lotuses rising from the bronze base. The total ensemble is two to two-and-a-half feet high and remarkable for being a complete group of fairly large size, with its original base and background. Isolated figures of comparable quality might be found in Japan or, more rarely, in China, but to find such a complete ensemble intact is extraordinary. In the center is Amida Buddha (Sanskrit: Amitabha) sitting on a lotus, flanked by two bodhisattvas standing on lotuses. The Buddha makes the lotus-holding gesture, and the bodhisattvas the gesture of reassurance. All of this is still slightly stiff, but in the early Tang style, immediately following the transition from the late Six Dynasties and Sui styles. Although gestures are gracious and there is an easy naturalism in the faces and in parts of the drapery, the figures are still frontal and a certain rigidity is evident in the drapery, in the poses of the bodies and, particularly, in the mouth of the central image. The triptych screen behind the main images is executed in the most beautiful low relief, ranging from surfaces

204. *Screen, from Tachibana Shrine.* Detail of fig. 203

205. *Base of Tachibana Shrine.* Detail of fig. 203

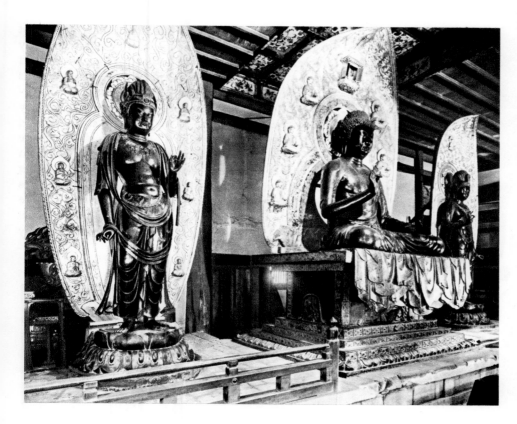

206. *Yakushi trinity*. Bronze, height of Yakushi figure 8'4". Yakushi-ji, Nara, Japan. A.D. 726

almost flush with the metal ground to a relief that projects, except in the small images of the Buddhas above, hardly more than a sixteenth of an inch or so from the surface (*fig. 204*). And yet within that very limited relief a tremendous amount is achieved. The representation is pictorial in its general effect; everything flows with much more ease, much greater rhythm and suppleness than in the three principal sculptures, as if it were a translation of painting into metal. The base, carved in low relief like the screen, represents a pond, thematically connected to the screen by octopi whose tentacles, reaching up around the lotuses, support little angels. The composition is formally and symmetrically balanced. The typical Japanese asymmetry is a later development; this composition is still purely Chinese. The Amida figure has a fiery halo, indicated by flames at the top, with the border of the larger disk treated in a fanciful cloud-and-hook pattern that, like so much late Six Dynasties material, recalls the hooks and spirals of late Zhou inlaid bronzes. The central part of the halo is in the form of a lotus; the equation of lotus with sun is primary in Far Eastern iconography. The subject of the base is equally elegant, with little waves interspersed with lotus leaves rippling in low relief over the surface and large twisting lotus stems rising to support the three principal images (*fig. 205*). The ensemble, despite the three dimensions of the main images, tends to be pictorial, showing

in this the influence of China, where sculpture often tends to develop pictorial effects.

A prime example of the middle, or classic, Tang style in Japan is a bronze trinity kept at Yakushi-ji (*fig. 206*). Yakushi is the name of the Healing Buddha, sometimes one of the Buddhas of the four directions, and his attribute is a medicine jar, which he usually holds in the palm of one hand. The main image of the principal hall at Yakushi-ji is a seated Yakushi, flanked by a pair of bodhisattvas often referred to as the Moon and Sun Bodhisattvas. These show the developed Tang style at its highest level in Japan, that is, in bronze. They are very large figures, approximately ten feet in height, a scale no longer extant in China. The halo is quite modern; the lumpy cloud pattern, so characteristic of late work, is offensive and contrasts crudely with the elegance and style of the figures. The bronze has turned green black with time and shines as if rubbed with oil. The bodhisattvas are not stiffly frontal but in a hip-shot pose, with a gentle sway of the body, one leg slightly bent and the other thrust forward. The draperies tend to flow more easily than those of the earlier period; the treatment of the hands is rounder and fuller, and the body too is fleshy. The linear notes in the drapery and face have been maintained, but the lips are now fuller and rounder, not abstract and sharp. The face too has become slightly corpulent, in contrast to the long,

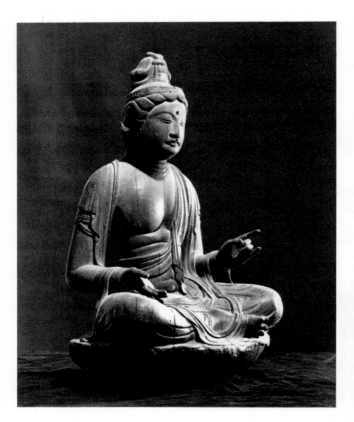

207. *Nikko (Sun Bodhisattva)*. Wood, height 18 3/8″. Japan. Early Heian period, c. A.D. 800. Cleveland Museum of Art

linen. When the approximate shape has been built up in laminated cloth and lacquer, a coating of dry lacquer—a moldable paste of lacquer, sawdust, and starch—is applied, and in this the precise shape is modeled. When dry, it can be completed by coloring or gilding. Sometimes, unfortunately, the dry lacquer was replaced by a kind of stucco paste, which deteriorates rapidly. The combination of these two procedures—the laborious building up of form by layers of cloth and lacquer, with the final touches executed in a temporarily plastic material—produces fluid details on an intractable foundation, a tense combination characteristic of work in dry lacquer. Obviously the technique imposes predominantly

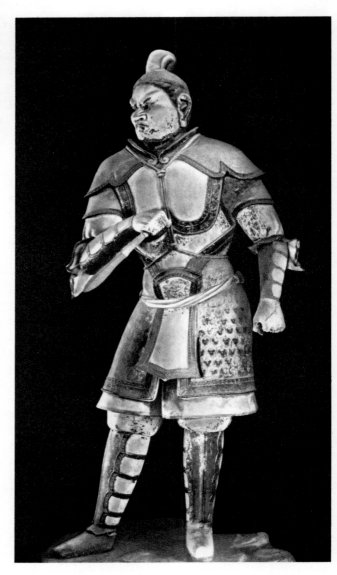

208. *Guardian King*. Dry lacquer, height 10′. Sangatsu-do of Todai-ji, Nara, Japan. Nara period, early eighth century A.D.

thin faces of the early Six Dynasties and the moderate fullness of Sui and early Tang. The whole effect is both sensuous and materialistic.

The transition from late Nara to the succeeding Heian period style (c. A.D. 800) can be seen in a tranquil Nikko Bosatsu (Sun Bodhisattva), carved from a single block of Japanese yew (*fig. 207*). Although some of the full Nara monumentality has diminished, the fluid and undulating rhythms of drapery combine with the subtle modeling of the body to produce a near perfect image of beatitude and compassion.

An an example of work in dry lacquer, no better image can be chosen than one of the four large Guardian Kings from the Sangatsu-do (Hokke-do) in Todai-ji (*fig. 208*). The dry lacquer technique is peculiar. Sometimes the image is formed over a clay base that is then dug out, but more usually a wooden armature is used. To this base or armature are applied layers of cloth soaked or brushed with lacquer, each layer being allowed to harden before the next is applied. The inner layers are usually hemp and the outer ones fine silk or, rarely, fine

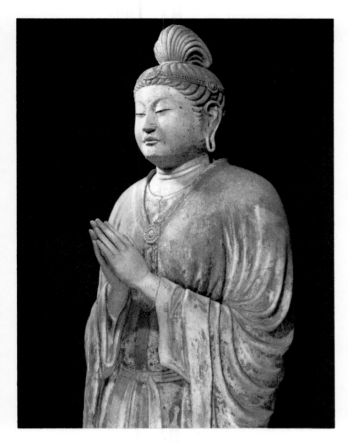

209. *Bonten (Brahma)*. Clay, height 81 1/4". Sangatsu-do of Todai-ji, Nara, Japan. Nara period, early eighth century A.D.

210. *Priest Ganjin*. Dry lacquer, height 31 3/4". Kaizando (founder's hall) of Toshodai-ji, Nara, Japan. Nara period, mid-eighth century A.D.

tubular shapes, and so the extremities—appropriately enough in this case, since the figure is armored—appear to be cylinders and increase in the whole a certain stiffness already inherent in the medium. On the other hand, such details as the modeling of the veins in the hands, the wrinkling of the nostril, or the bulge of the eyebrow, are accomplished in a plastic medium with a fluidity that belies the underlying geometric form. One may well ask why such a time-consuming technique was used. The most generally accepted reasons are that images of this type were light, easy to handle and move, and not susceptible to attack by termites and wood ants. Certainly it is a laborious method of making sculpture, and in China but few examples remain. We must look to Japan for great dry lacquer sculptures.

The technique of clay modeling was also much used in the Tang dynasty, and for the finest expression of this technique we must again travel to Japan and to the high altar of the Sangatsu-do (Hokke-do) where, on either side of the principal image of the Fukukensaku Kannon, are two images representing Bonten (Sanskrit: Brahma) and Taishakuten (Sanskrit:

Indra). They are life-size, and extraordinarily heavy because they are solid clay. In these figures (*fig. 209*) the fluidity of treatment of the face, drapery, and the bow hanging from the waistline reflect the plasticity of the soft clay in which they were modeled, a quality unattainable in wood or bronze. The pose of the figures, with folded hands and downcast eyes, has made them of special interest to photographers, and they have become two of the most famous sculptures from the Hokke-do. From China we have only the fired clay tomb figures and the sometimes provincial images from Dunhuang, and so these two must stand for the sophisticated art of Buddhist clay sculpture in both China and Japan.

Another Nara image epitomizes that combination of secular feeling—in this case, ferocity—with religious awe that seems so typical of the Tang dynasty and of its style (*colorplate 11, p. 123*). The twist of the body, the bend of the hip, the flow of the draperies around the figure, the openings in these draperies, and the straining muscles of the neck are combined in a way that summarizes the dynamic interests of the Tang sculptor. This life-size image behind the

screen of the Hokke-do portrays Shukongojin (Sanskrit: Vajrapani, the *vajra*, or thunderbolt, bearer). The conception is somewhat comparable to that of the avenging archangel Michael in Christian iconography; the deity frightens evildoers and demons and thus protects the faith. The image is a secret one, kept in a closed tabernacle that is opened only on rare occasions. But its magic power, even inside the tabernacle, continues to emanate in all directions.

The last illustration of sculpture in the Tang International Buddhist style introduces a new category: the portrait, executed in dry lacquer and polychromed (*fig. 210*). Priest Ganjin was the blind Chinese founder of the great temple Toshodai-ji. During this period the individual merit of a monk was recognized, and the representation of this merit in an image was considered an aid to worship and to right living. The skin of the figure has a slight yellowish tinge. The eyebrows are painted in, as are moustache hairs and the stubble of the beard, but without that particularity which is so characteristic of later types of Japanese realism. The figure is both an individual and a generalized type, and that is the way most Tang portraits strike us. The portrait of Priest Ganjin had much influence on Japanese art from the time it was made, and the school of portrait sculpture of the Kamakura period was to some degree inspired by it.

Buddhist painting in the Tang dynasty, both in China and in the comparable period in Japan, encompassed two major formats: the wall painting and the portable painting in hanging scroll and handscroll form. The wall paintings decorated either temples or the interiors of caves and were painted both by anonymous artisans and by painters of renowned excellence. One of the greatest names in all Chinese painting is that of the legendary Wu Daozi, creator of Buddhist wall paintings and reputed the greatest of Chinese figure painters. As none of his works is extant, we must look for Tang painting style in the works of anonymous artisans. The most sophisticated and beautiful of Tang style wall decoration is in Japan, but there are in China literally thousands of murals in some of the outlying provincial sites. Most important of these is the great pilgrimage center and entrepôt, Dunhuang, which we have mentioned before. The representation of the Western Paradise, with the Buddha Amitabha flanked by two principal bodhisattvas, many minor bodhisattvas, and other deities of Paradise, is from that site (*fig. 211*). Most of the deities are seated on a high dais, protected with canopies, flanked by pavilions, and fronted by a lotus pond with platforms on which a celestial dance is in progress. On either side are raised platforms holding other deities of the Western Paradise. The whole is a transcription in paint of passages from the *Sukhavati Vyuha* and *Amitayus Dhyana Sutra*, Buddhist texts that describe the Western Paradise and the pleasures of being there with the Amitabha Buddha.

When you have seen the seated figure your mental vision will become clear, and you will be able to see clearly and distinctly the adornment of that Buddha country, the jeweled ground, etc. In seeing these things, let them be clear and fixed just as you see the palms of your hands. When you have passed through this experience, you should further form [a perception of] another great lotus flower which is on the left side of Buddha, and is exactly equal in every way to the above-mentioned lotus flower of Buddha. Perceive that an image of Bodhisattva Avalokiteshvara is sitting on the left-hand flowery throne, shooting forth golden rays exactly like those of Buddha. Still further, you should form [a perception of] another lotus flower which is on the right side of Buddha. Perceive then that an image of Bodhisattva Mahasthama is sitting on the right-hand flowery throne.

When these perceptions are gained the images of Buddha and the Bodhisattvas will all send forth brilliant rays, clearly lighting up all the jewel trees with golden color. Under every tree there are also three lotus flowers. On every lotus flower there is an image, either of Buddha or of a Bodhisattva; thus [the images of the Bodhisattvas and of Buddha] are found everywhere in that country. When this perception has been gained, the devotee should hear the excellent Law preached by means of a stream of water, a brilliant ray of light, several jewel trees, ducks, geese, and swans. Whether he be wrapped in meditation or whether he has ceased from it, he should ever hear the excellent Law. . . .

He who has practiced this meditation is freed from the sins [which otherwise involve him in] births and deaths for innumerable millions of *kalpas,* and during this present life he obtains the *Samadhi* due to the remembrance of Buddha.

And again, O Ananda, the beings, who have been and will be born in that world *Sukhavati,* will be endowed with such color, strength, vigor, height and breadth, dominion, accumulation of virtue; with such enjoyment of dress, ornaments, gardens, palaces, and pavilions; and such enjoyments of touch, taste, smell, and sound; in fact with all enjoyments and pleasures, exactly like the *Paranirmitavasavartin* gods.

And again, O Ananda, in that world *Sukhavati,* when the time of forenoon has come, the winds are greatly agitated and blowing everywhere in the four quarters. And they shake and drive many

211. *Western Paradise*. Fresco. Dunhuang, Gansu, China. Tang dynasty, second half of eighth century A.D.

beautiful, graceful, and many-colored stalks of the gem trees, which are perfumed with sweet heavenly scents, so that many hundred beautiful flowers of delightful scent fall down on the great earth, which is all full of jewels. And with these flowers that Buddha country is adorned on every side seven fathoms deep.[3]

The Pure Land school of Mahayana Buddhism, with its Amitabha Buddha and his Paradise, appealed to the great mass of Tang people, and its iconography is most typical of the religious faith of the time. It pointed a relatively easy way to salvation: To be reborn into the Western Paradise one must simply worship the Amitabha Buddha with faith. The mural, while it represents the Western Paradise of Amitabha, simultaneously expresses the Chinese concept of hierarchical order and also something of the sensuous and worldly ethos of the Tang dynasty itself. The composition is perfectly balanced, centrally oriented, the principal figures slightly higher than the secondary ones. At the same time it emphasizes the pleasure-loving or sensuous aspects of this Pure Land and illustrates these with scenes that might have taken place in the court of a Chinese emperor. The foreground, for example, represents court musicians and between them a court dancer of Indian extraction performing on a court stage. The architecture is derived from the palace style of the Tang dynasty. Bordering the picture are continuous narrative representations of stories from the Lotus Sutra or from the life of the Sakyamuni Buddha. A photograph distorts the values of the colors, because the figures that appear black were actually in paler pigments; the colors have, however, indeed darkened with age.

An example of the larger portable paintings of the Tang dynasty is the famous painting on hemp in the Boston Museum of Fine Arts. Called the *Hokke Mandala* (lotus diagram, or lotus picture), it represents Sakyamuni Buddha flanked by two bodhisattvas in a landscape setting (*colorplate 12, p. 124*). The setting of typical Western Paradise figures in the midst of a lush landscape is unusual, even though landscape developed rapidly during the Tang dynasty, and has led to much argument whether this picture is Chinese or Japanese. It has been considered to be Chinese with Japanese additions and restorations. The latest opinion, however, based upon careful infrared analysis of the picture which reveals most of the original state without repaint, gives some support to the argument that the picture is Japanese; if so, it must be an eighth or early ninth century example of the Tang style in Japan. The composition is fairly symmetrical, with a central figure balanced on each side by similar groups. Within these groups we find variations and this, together with the landscape setting,

212. *Amida triad.* Fresco, height 10'. Kondo (golden hall) of Horyu-ji, Nara, Japan. Late Hakuho or early Nara period, c. A.D. 710. Horyu-ji Museum, Nara

provides a less rigid conformation than the Paradise pictures of Dunhuang or similar paintings.

But the classic examples—the greatest examples—of Tang style painting are the now damaged murals from Horyu-ji (*fig. 212*). You will remember that the golden hall had on its interior walls representations of the Paradises of the Four Directions (*see page 149*). These were oriented to the four directions, with a variation required by the fenestration of the *kondo*, which necessitated rearrangement of the main iconic panels and those representing bodhisattvas. The murals were painted on clay walls supported by bamboo mesh hung between the columns of the building. They were painted with considerable color, much of which had vanished even before they were damaged, and with an additional emphasis on linear development. We see in the illustration the Paradise of the West as it was before the fire. The murals still exist, but the color was burned off most of them so that in a few one can see a ghostly black-and-white image that seems to hover on the surface of the clay. They most likely date from about A.D. 710, and so they represent fairly early Tang style. The balanced composition uses a jeweled canopy with a gentle indication of hills behind, but not the

great, complicated palace structures of the type we saw at Dunhuang. It is as if we had taken a detail of one of those and enlarged it, concentrating upon the three main figures. The linear development is of the highest importance. In the bodhisattva on the right—the one most often reproduced, in large part because of its splendid preservation—we find linear technique at its height. The line is relatively even in thickness, without that variation in width so characteristic of much of later Chinese calligraphy and Chinese linear drawing. It is rather a thin, even, wirelike line, applied with the greatest care and in a pattern that can only be called geometric. The parabola that makes the elbow, the reverse curve of the forearm, the arcs of the neck and the face, or the absolutely straight line of the bridge of the nose seem to indicate that the painters had a geometric conception of boundaries and used an even pressure on the brush (*fig. 213*). At the same time, this line is so subtly made that it serves to indicate depth or volume by means of the line itself, or by the turn of a line into another line. This is an extremely sophisticated device, but also somewhat conventional. The general characteristics of the shapes of the figures are comparable to those we have noted in Tang sculpture. The forms are rounded and fleshy; there is a gentle sway to the body; the face is slightly rotund; the whole effect is of that combination of worldliness and spirituality which pleases both the iconoclast and the believer.

The other form of painting was the portable handscroll, probably the principal means of spreading Tang style and Buddhist iconography to the far reaches of China and Japan. The handscroll presented both writing and pictures to priest and layman alike. The scrolls, some as long as thirty or forty feet, could be rolled up and carried easily in robe or luggage. When unrolled a foot or two at a time and read, with text below and illustration above, they provided an illuminated "bible" for both initiate and uninitiate. The best-preserved and most famous of Buddhist handscrolls in early style is the Sutra of Cause and Effect (*Kakogenzai ingakyo*), existing in some rolls and fragments in Japan (*colorplate 13, p. 205*). The text is written in regular columns, in a fine, conservative, and legible style. The illustrations above display a slightly provincial air; they are not as supple as the Horyu-ji murals or some fragments of Buddhist painting from Dunhuang, but their color—bright oranges and malachite greens, yellows and azurite blues—conveys the sensuous worldliness so characteristic of Tang style, and contributes to their great charm. Note, too, the plump faces and the costumes derived from Chinese and Central Asian types.

Despite the provincial style and the slight naiveté

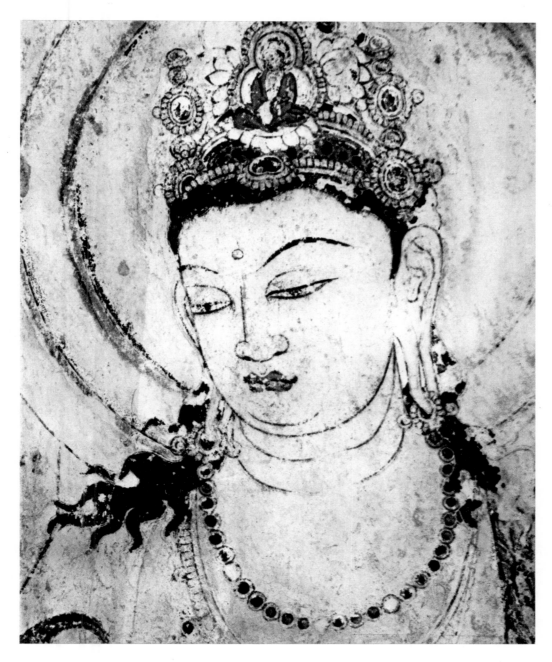

213. *Head of bodhisattva, from Amida triad.* Detail of fig. 212

of the conception, there is a general air of liveliness and of interest in the world—not just in religious narrative, but in landscape and in everyday happenings. It is the foreground conventions that betray provinciality. The artist simply made a few strokes over a blot of green to indicate a grass-covered area; this convention derives from the Chinese style, where it was more carefully worked into overlapping patterns indicating recession in depth. Here it is used simply as a kind of decorative note scattered over the surface of the ground. The trees

too show a conventional treatment rather than one based on observation of nature. Figure painting at this time in China and Japan was still ahead of landscape. The derivation of the painting style in this handscroll of the Sutra of Cause and Effect is quite clear: It comes from the curiously naive, cartoon-like style found also in subsidiary passages in the Dunhuang wall paintings and in the fragments that have been found in the library there (*fig. 214*). These are the two farthest reaches of the International Buddhist style of the Tang dynasty—

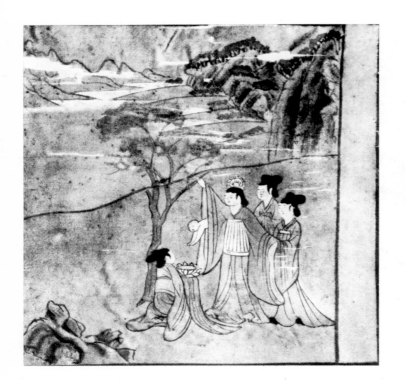

214. *Birth of the Buddha, from Scenes from the life of the Buddha.* Fragment of border of large mandala; ink and color on cloth, width 6 3/8". Dunhuang, Gansu, China. Tang dynasty. National Museum, New Delhi

Dunhuang in northwest China, and Japan, far to the east. The Dunhuang figures are almost exactly the same in style as those in the Sutra of Cause and Effect, especially the little nude figure of the Buddha and the trees. Notice that in China, even in a provincial area like Dunhuang, the landscape, with its receding hills and mountains and great distant peaks, is more sophisticated than that achieved by the relatively unsophisticated Japanese artist in his little handscroll. What the great Buddhist scroll creations from the urban centers looked like we can only imagine from these charming provincial remnants or from Chinese examples of slightly later date painted by traditional masters in the manner of late Tang (*fig. 215*).

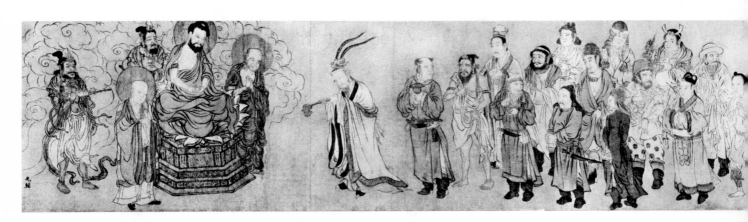

215. *Barbarian Royalty Worshiping Buddha.* Tradition of Zhao Guangfu. Handscroll, ink and color on silk; height 11 1/4", length 40 3/4". China. Northern Song dynasty. Cleveland Museum of Art

PART THREE

THE RISE OF NATIONAL INDIAN

AND INDONESIAN STYLES

8

Early Hindu Art in India

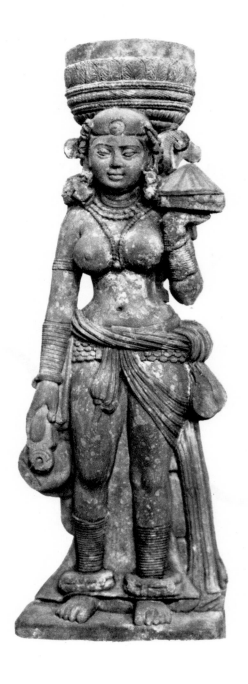

216. *Stone bowl supported by female figure.* Sandstone, height 38 5/8". Fyzabad, India. Kushan period, second century A.D. Bharat Kala Bhavan, Hindu University, Varanasi

THE HINDU COSMOLOGY

We have been following for some time the development of international Buddhist art and its iconography, and the spread of a largely Chinese style in East Asia. Now we must examine the development of an image style native to India and almost entirely associated with the Hindu faith. It was a style that did not survive export to Southeast Asia and Indonesia; there, especially in Cambodia and Java, distinctive regional styles developed.

Hinduism is vastly complex. A proper foundation in Hindu cosmogony or iconography would require mastery of an immense literature in translation and many volumes of philosophic or iconographic exegesis. Still, the art cannot be understood without knowing something of the faith; in the following brief picture of Hinduism we have of necessity oversimplified but not, it is hoped, falsified.

Developed Hindu thought may be said to have two distinct antecedents: Some elements derive from pre-Aryan elements of the population and are called Dravidian; others, called Aryan or Vedic elements, are associated with the invaders who probably destroyed the Indus Valley civilization. In general, the Dravidian elements can be described as sensual and

include qualities associated with the early fertility cults whose deities were found in Indus Valley sites of about 2000 B.C. They were frankly virile cults, involving a personal devotion (*bhakti*) to and worship of male and female deities associated with procreation, whose powers were called on to induce fertility in all things, to stimulate the very pulse of life itself. Beginning with simple representations in pinched clay of fertility deities, the images of these cults were later included in the service of Buddhism. The typical Indian ideal woman was the yakshi, like the one from Fyzabad, a fertility deity associated with the waters, who holds in her hand a flask containing the water of life (*fig. 216*). On her head she bears a lotus capital; behind her grow vines and water weeds. Female characteristics—breasts, hips, and pubic region—are emphasized forthrightly and with that slight exaggeration which allows the image to give full expression to the function of the deity. Emblems of fertility were oftentimes represented alone and

very literally, and served as symbols—the phallus of the great god Siva, the *yoni* of the great goddess Devi. Symbols such as these are Dravidian, and can be traced back to the very beginning of Indian civilization. The phallus symbol is found quite often at Mohenjo-daro and Harappa.

In contrast to these down-to-earth and intuitive elements are those derived from the Aryan tradition, which can be described as formal or intellectual. Among these are the concepts of hierarchy and caste, of levels of society, as, for example, in the representation of heaven and hell at Angkor Vat in Cambodia, in the late twelfth century A.D., where below we see the road to hell with its tortures and above the road to heaven with its rhythmical and ecstatic procession of the saved (*fig. 217*). Such concepts of hierarchy and caste, of the saved and the damned, are in keeping with the Aryan element of Hinduism, which emphasized religious rites conducted by the Brahmin, or priestly, caste in contrast to the personal

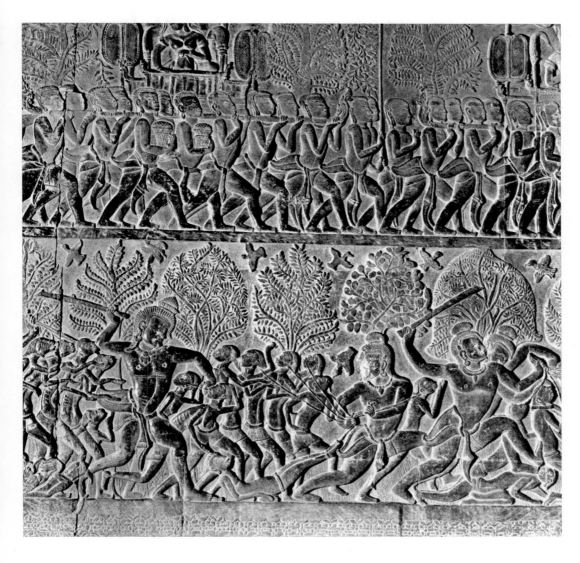

217. *Bas-relief of heaven and hell*. Sandstone. South wing, Gallery of Bas-reliefs, Angkor Vat, Cambodia. Second Angkor period, late twelfth century A.D.

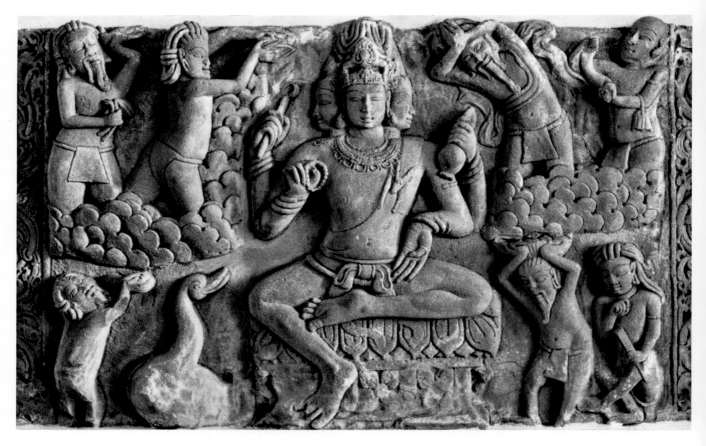

218. *Brahma*. Relief; stone, length approx. 96". Haccappyagudi Temple, Aihole, India. C. A.D. 500. Prince of Wales Museum, Bombay

devotion of the Dravidians. Connected with this formal, conceptual quality is the mathematics of theology, the endless proliferation of "significant" numbers, and the use of accretion as a means of assimilation and explanation. Thus we have the sixteen avatars of Vishnu, the many aspects of Siva, the three aspects of Being, the eight women in love (*nayikas*), and many others. This Aryan element of Hindu thought influenced later Mahayana Buddhism, with its emphasis upon hierarchy, caste, and number and its attempts to find the Buddha everywhere, at all times, throughout eternity. Abstractions and the concept of zero, elements associated with metaphysics and, to a lesser degree, with mathematics, were also primarily Aryan contributions. The Aryan pantheon that we know by name from the Vedas includes Agni, god of fire, especially the sacred flames of the altar; Surya, the sun god, whom we saw at Bhaja riding over clouds and dispelling the darkness of the old faith; and Indra, god of sky and storms, riding on an elephant over and above the tree-worshiping fertility cultists of the pre-Vedic tradition. The Vedic gods continue as lesser figures in the vast Hindu pantheon. Indeed, the roles and characters of some of them become absorbed by the slowly emerging Hindu deities who, growing by accretion, are a synthesis of popular and

philosophical concepts, their various aspects and activities accumulated from myth and epic and the later Puranic collections of cosmic myths and ancient semihistorical lore. So Rudra, god of storms and the destructive forces of nature, was absorbed into the figure of Siva; Varuna, lord of the waters, into that of Vishnu. If the combinations of gods or the various aspects of one god seem to reach the height of confusion at times, it must be remembered that to the initiated this multiplicity betokens one divine being whose energy is manifested in many forms, and that each of these forms has serene or divine (*sattvic*), active (*ragasic*), and fierce and destructive (*tamasic*) aspects. The various combinations of deities are instances of complexity. In one trinity representing the three great gods of Hinduism, Brahma is the creator, Vishnu the preserver, Siva the destroyer. In another, Siva alone plays these roles. In one image Siva is both male and female, in another Siva and Vishnu are combined.

Originally and in theory, Brahma, the creator, four-headed (as on a temple at Aihole), facing the four directions, and all-seeing, was one of the most important deities (*fig. 218*). But in the days of developed Hinduism his position as a primary deity was not strong, and certainly he is artistically far from important. In an important Vaishnavite sculpture of

the seventh century A.D. at Mahamallapuram his birth is shown: Vishnu lies on the waters on the coils of the serpent Ananta, and Brahma issues from his navel to activate the world (*fig. 219*). Of the members of the great Hindu trinity, Vishnu and Siva are predominant. Vishnu had many avatars, incarnations into various forms, including boar, lion, and fish, to save the world from one disaster or another. But one of his most important avatars is that of Krishna, the cowherd of Brindaban, a lyrical personification of universal love, whose exploits as the lover of village maids and conqueror of demons are celebrated in literature and in later art, especially in Rajput paintings of north India. The Krishna of the *Bhagavad Gita*, a work of the first century B.C., who as charioteer of the hero Arjuna revealed himself as the One God, was a more remote and abstract conception.

The third member of the trinity, Siva, is to his worshipers the supreme deity, encompassing all things. The most famous representation of Siva, to Western eyes, is his manifestation as Nataraja, the lord of the dance. Figure 220 shows Siva Nataraja dancing the cosmic dance, in which the universe

becomes a manifestation of the light reflected from his limbs as he moves within the orb of the sun. A fine description of the meaning of this image is to be found in the first section of Coomaraswamy's *Dance of Shiva*, a lyrical presentation as well as a reasonably complete one from an iconographic point of view. When Siva is represented as Mahesa, the supreme deity, he assumes all the functions of the three great gods; and thus we find him in the great sculpture at Elephanta, a large carving in the living rock, some eleven feet high (*fig. 256*). On the left his head is wrathful as a destroyer, in the center benign as a preserver, while on the right is his female aspect as creator and giver of fertility—the Beautiful One.

To the figures of the great gods must be added that of the goddess Devi, known under many names, whose worship as a supreme deity is as old as the Indus Valley culture. As Uma she is *sattvic*, the Great Mother; as Parvati she is the energy and consort of Siva; as Durga she is active or *ragasic;* as Kali, goddess of death, she is *tamasic*. As Durga, for example, Devi is shown accompanied by her retinue of dwarf soldiers, riding on her vehicle, the lion, slaying the wicked bull-demon Mahisha (*fig.*

219. *Vishnu Anantasayana*. Relief; granite. Mahamallapuram, India. Pallava period, seventh century A.D.

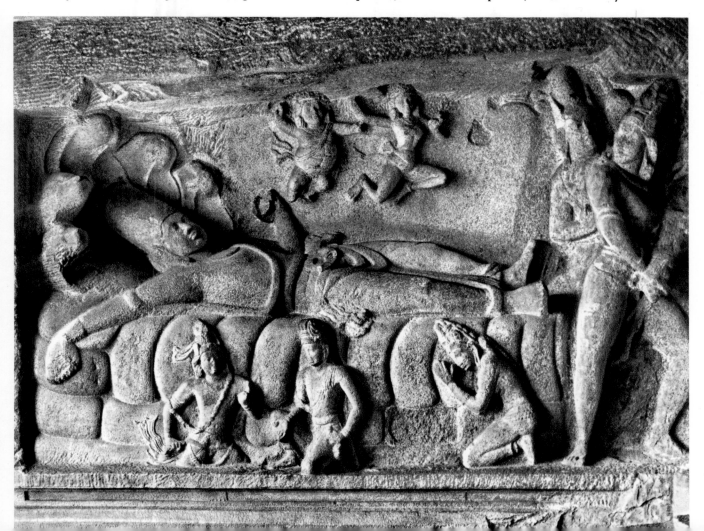

221). There are many lesser divinities, including Ganesha, the elephant-headed god of good fortune, and Kartikkeya, god of war.

Certain basic concepts are essential to any real understanding of Hindu art, and certain misconceptions must be avoided. The concept of image and worship has been clearly presented by Coomaraswamy. In theory, and to the most initiated and adept of the Hindu faith, the image is not a magical fetish, worshiped in itself, but stands for something higher—a manifestation of the supreme Being. The Hindu use of images was first of all an aid to contemplative discipline, a way of achieving identification with deity. Early and impermanent images of paste and clay were replaced with those of more permanent materials, describing the deity and his powers as accurately as possible. These representations were much influenced by devotional descriptions in poetry and scripture. If several heads or numerous arms were required to hold the symbols and attributes of the deity and his powers, then they were supplied. The end was realization of the deity's being, not the representation of a merely sympathetic human being. The distinction between image and idol was essential, but we must also understand that it was not clear to everyone, that to the average person the distinction was very hazy indeed. One can be sure that when a peasant went to Sanchi to

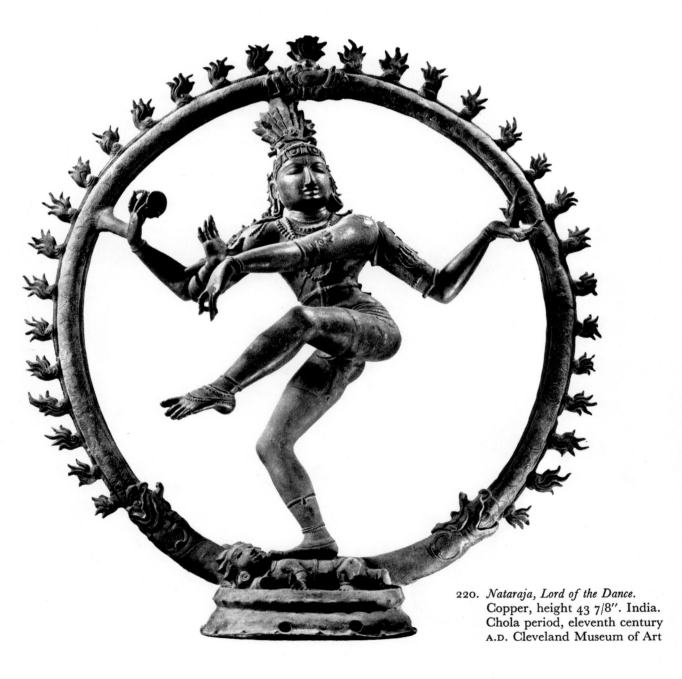

220. *Nataraja, Lord of the Dance.*
Copper, height 43 7/8″. India.
Chola period, eleventh century
A.D. Cleveland Museum of Art

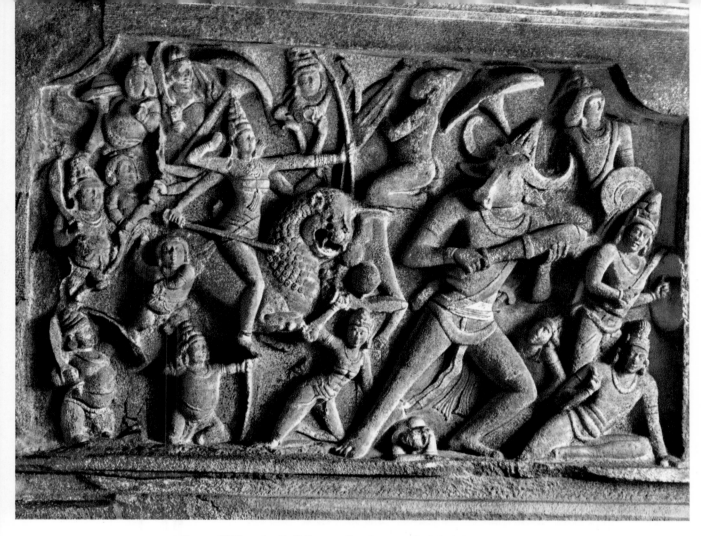

221. *Durga Killing the Bull-Demon.* Rock-cut relief, height approx. 108".
Mahamallapuram, India. Pallava period, seventh century A.D.

worship the Buddha, the fertility deities at the gateway were his principal concern; that when an ordinary devotee prostrated himself before the image of Kali, the goddess of death and destruction, or before Siva in his procreative aspect, he was indeed confusing the image with the god—in short, he was touched by idolatry. Still, the distinction exists in theory and high practice.

A further and significant characteristic of Hinduism is the concept of macrocosm and microcosm, the desire to see represented on a small scale the huge scale of the universe. For example, the Kailasanatha Temple at Ellora is not simply a massive stone cutting, but an attempt on the part of architect and sculptor to visualize the universe in a monument ninety-six feet high, and to orient and build that monument in such a way that it becomes a magical structure, one which contains the world within its compass. Thus the orientation of the plan is to the four directions, and in the cell of the temple—the unit for individual worship in the Hindu faith— there was buried a copper box containing "wealth of the earth, stones, gems, herbs, metals, roots,

and soils." At this time the Earth Goddess was invoked: "O thou who maintainest all the beings, O beloved, decked with hills for breasts, O ocean girt, O Goddess, O Earth, shelter this Germ."[4] This, in the words of some Hindu texts, inseminates the temple and gives it life.

BEGINNINGS OF HINDU ART: THE GUPTA PERIOD

The development of Medieval Hindu art was relatively rapid. Its foundations go back to Mohenjo-daro and the fertility cults of Indus Valley civilization of the second millennium B.C., and to such great remnants of early sculptural style as the Parkham yaksha, and the Besnagar yakshi (*figs. 93, 94*). These were previously discussed as examples of forest deities placed at the disposal of the new Buddhist faith. We mentioned briefly the place of the then emerging Hindu deities as servants of Buddhism, and particularly the possibility that their symbols were present on the lion capital at Sarnath

in the form of animals representing the vehicles of Surya, Siva, Indra, and another deity. On the walls of a Buddhist monk's cell at Bhaja were Indra and Surya, Hindu deities. But our study of Hindu art as a form in itself begins with the Kushan period and with the famous *lingam* image of Siva from Gudimallam, mentioned briefly in the earlier consideration of the Kushan period (*fig. 118*).

In the Gupta period, beginning in the fourth century A.D., we find an increasing number of Hindu sculptures in stone and earthenware, and of buildings dedicated to the purposes of Hinduism, indicating that religion's growing strength. Buddhism was at its zenith from about the second century B.C. through the fifth century A.D.; then it gradually declined, to be found later only in limited areas, notably in northeast India and in Nepal and Tibet. Hinduism offered a practical and worldly rather than an ascetic way of life and, with its old roots

and vigorous image cult, appealed to the mass of the people.

The first great Hindu monument of the Gupta period is a relief of the boar avatar of Vishnu at Udayagiri in central India, not far from Sanchi (*fig. 222*). There is no stylistic distinction in this period between Hindu and Buddhist subjects. Both are handled in the relatively quiet style of the Gupta artist. The colossal relief carved in the living rock at Udayagiri is conceived in a form that recalls the Sasanian Persian reliefs of Shapur and Valerian, carved in the living rock at Naksh-i-Rustam. The Udayagiri relief represents Vishnu as a towering boar-headed human, supporting on his shoulder the Goddess of the Earth, whom he has rescued from the Serpent-King of the Sea at the lower right. The scene is witnessed by a variety of small deities and angels carved in relief on the back and sides of the shallow cave. The composition is relatively static

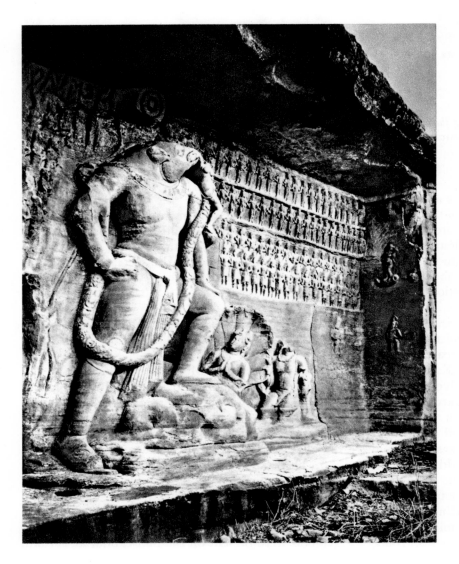

222. *Boar avatar of Vishnu.* Stone, height 12′ 8″. Udayagiri, India. Gupta period, c. A.D. 400

and organized in a single plane along the wall. The pose of the main figure fits into this plane, while the rigid rows of small deities forming a geometric pattern reinforce this static effect.

Such a form was admirably suited to Buddhist art, and to the expression of the serene and contemplative Buddhist ideal; although this was one of the ideals of Hinduism, other of its ideals required sculpture of tremendous dynamism, capable of portraying movement and the narration of great epics. Such a style did not evolve until the end of the Gupta period, then was further developed in the early Medieval period, and continued until the eleventh or twelfth century A.D., after which time, except in bronze or wood, it declined.

The first monument showing the transition from Gupta to Medieval style is the Parel Stela, a colossal marble image found by accident near Bombay some thirty or forty years ago (*fig. 223*). After excavation it was put into *puja*, or worship, at a nearby Hindu temple and is therefore removed from the eyes of Western man. But it has been thoroughly photographed, and so we are able to evaluate it as one of the greatest and most significant of Indian sculptures. The upper part of the stela probably represents the three aspects of Siva and their emanations. The main image wears the male and female earrings characteristic of all-embracing Siva. Below are dwarfs, the usual attendants of Siva. But even more interesting than its iconography is its style, because here we see for the first time that quality of movement and expansion whereby the sculptor denies the nature of the stone and makes the images appear to grow out of the material and dynamically project beyond its edges. This effect is achieved in part by representing the figures in markedly erect pose, with chin thrust out and with indrawn breath increasing their chest size, all helping the psychological creation of what H. Zimmer calls "expanding form." By the arrangement of numerous figures in a pattern suggesting movement and expansion, the main figures seem to grow as one watches them. Notice how the central figures rise almost to the top of the stela, and that the figures at the sides project to its edges. The repetition of the figures and of their parts, such as the knees or the patterns of hand and arms, creates an effect of rhythmic movement essential for Hindu art. The concept of such a dynamic deity as Siva, or of such an active one as Vishnu, or of such a sometimes terrible and awe-inspiring deity as the great mother-goddess Devi requires forms capable of more than contemplative beatitude. Such forms of expression, developing out of the Gupta mode, are called Medieval, a term chosen only because in point of time and social organization they parallel the period we call medieval in the

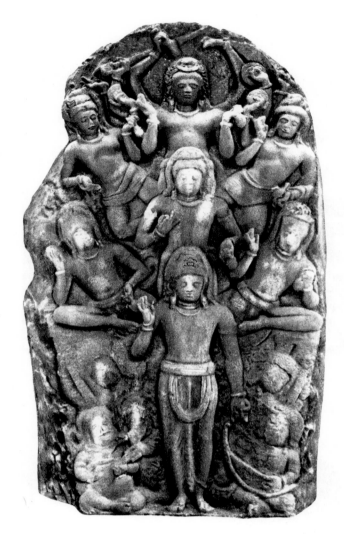

223. *Siva trinity and host, called the Parel Stela.* Stone, height 11′5″. Parel, near Bombay, India. Gupta period, c. A.D. 600

West. It is certainly an unsatisfactory, even arbitrary, term, but one now in general use.

During this period from A.D. 600 there were numerous contending states in India, but no great continental empire as in the Maurya and the Gupta periods. Hindu sculptures have been found at Sarnath, carved in the cream sandstone associated with the Buddhist sculptures from that region, and there are Hindu sculptures of Gupta date from central India. But *the* significant example, for our purposes, is the great stela from Parel.

MEDIEVAL HINDU ARCHITECTURE AND SCULPTURE: CENTRAL INDIA

Two sites in central India are of importance for the development of Hindu architecture and sculpture in the late Gupta and early Medieval periods: Badami and Aihole, in the Deccan. Here the early Chalukyan kings of Badami had temples carved and

175

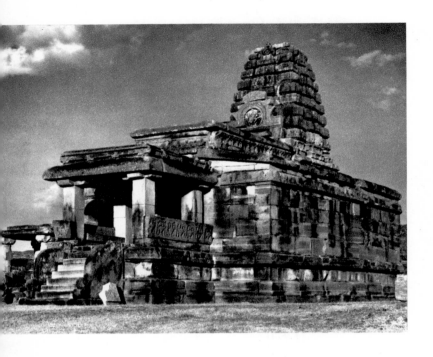

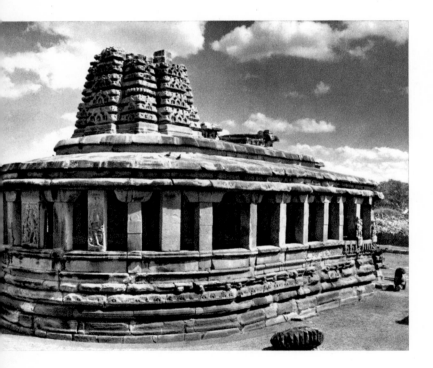

224. (left) *Hacchimalagudi Temple*. Aihole, India. Chalukyan period, seventh century A.D.

225. (below left) *Durga Temple*. Aihole, India. Chalukyan period, seventh century A.D.

lier periods. The new style in architecture, whether carved from the living rock or constructed, is increasingly sculptural in character. Two temples at Aihole, dating from as late as the seventh century, still preserve earlier elements. The plan of the Hacchimalagudi Temple (*fig. 224*) is a simple cell with a double ambulatory around it, and a porch. The temple is constructed on a post-and-lintel system derived from wooden architecture. The probable origins of such a style can be easily imagined: the combination of a stone or log base, wood post-and-lintel system, and thatched roof. The plan of this temple is the end of a tradition, not its beginning. The ambulatory was abandoned and thus also the concept of any kind of public access to the main area of the shrine.

The Durga Temple, built about the same time, can be paired with the Buddhist cell-temple at Sanchi (*fig. 129*) to demonstrate the derivation of the Hindu temple and to show significant changes of importance for the future (*fig. 225*). Whereas the Hacchimalagudi Temple stands for the end of a tradition, the Durga Temple represents a beginning. It has a stone megalithic roof, that is, a single stone covering the main area, deriving from archaic architectural construction in stone. Its ambulatory has become a porch; that is, the porch is extended to surround the building, so that one can walk outside the shrine rather than in the building proper. The base has been elevated considerably, and this is of particular significance because it tends to remove the building from the realm of architecture to that of sculpture. And as we shall see, Hindu architecture must be considered primarily as sculpture. The towers will develop until they dominate the temple; the base will develop until it seems to dominate the lower part of the structure. The apse end of the Durga Temple shows the influence of the Buddhist *chaitya* hall, but with an outer ambulatory. The rudimentary tower is carved in great detail, with numerous representations including figures and miniature *chaitya* arches. We have seen such decorations on the Buddhist *chaitya* facades and in the caves; they will develop into fantastic ribbon-like ornaments in the later Hindu Medieval style.

The sculpture at Aihole is more developed than comparable sculpture from the Bombay region, such as the Parel Stela, although it is of the same date or slightly later. An image of Vishnu, seated upon the

constructed in which appeared for the first time elements that were to become fundamental in the architectural vocabulary of the south. Although some of these were built before 600, the earliest dated structure is the Meguti at Aihole, of A.D. 634–35.

The architecture at these sites shows development beyond the single cell or the *chaitya* types previously seen in Buddhist architecture of the Gupta and ear-

Serpent Couch, is carved on the ceiling of the Vishnu Temple at Aihole (*fig. 226*). And here we can see a variation of the expansive quality in early Hindu sculpture. Where the Parel Stela seems to convey expansion by disposing a certain physical type in an unusual fashion over its surface, the Aihole sculptor, under the influence of clay technique, produces a more organic and fluid figure than any from the middle Gupta period. The joints of the knees and elbows have lost any suggestion of bony structure and have become pliable, as if they were worked in clay or some other soft, plastic material, although the relief is in fact carved in sandstone. To look upon this sculpture like those purists of the modern school who demand above all integrity of material and ask of painting that it "look like paint" is to rule it out as sculpture—along with the late Greek and Roman figures that convey skin textures superbly in marble, or the works of Bernini, which simulate flesh or bark or whatever the sculptor wished. Hindu sculpture—and especially this Medieval material—must be looked at as an art that denies or, better, transcends, the material it is made of. Figures may seem to float off or on the surface of the stone; others seem to emerge from the stone. The tendencies to be observed in the relatively balanced composition at Aihole enlarged and expanded as the Medieval style developed. In contrast to the fluid handling of individual figures, the Aihole compositions are relatively static compared with the Parel Stela, for the Aihole Vishnu is balanced by four other figures in a rigid arrangement.

226. *Vishnu*. Stone ceiling slab. Vishnu Temple, Aihole, India. Chalukyan period, seventh century A.D.

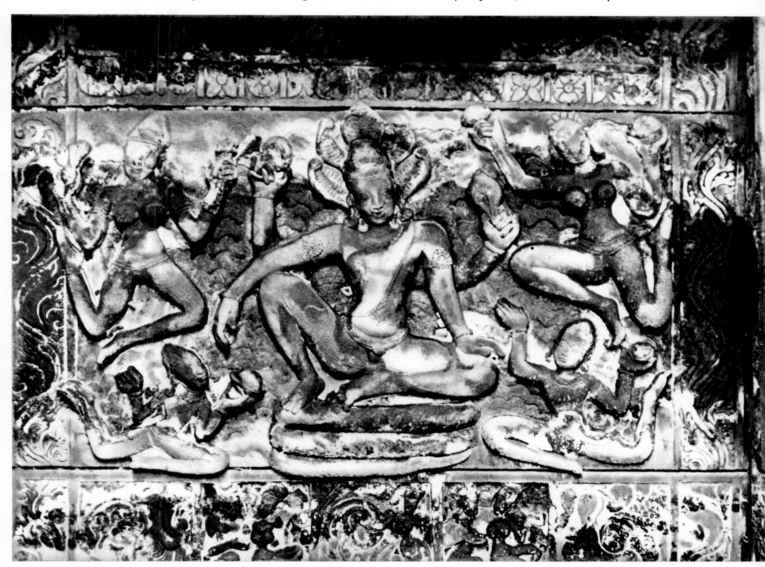

9

Early Medieval Hindu Art: The Southern Styles

PALLAVA ART AND ITS INFLUENCE

We are not far wrong if we think of Gupta sculptural styles as a primitive stage in Hindu art,—primitive in the sense that it is archaic, early, and formative— while for Buddhism it was a classic style expressing most completely Buddhist ideals and iconography. With this in mind, we can turn to the development of Medieval Hindu sculpture proper. We shall consider first the sculpture of the south of India, the region below the Kistna River, of which Madras is now the main city. From about A.D. 500 to about 750 this region was largely controlled by the Pallava kingdom, whose capital was Kanchi, the modern Kanchipuram, about fifteen miles west of Madras. Stylistic influences, which at first flowed from the Deccan to the south, so that Pallava architecture emulated that of Aihole, later reversed direction; the southern style in architecture and sculpture came to exert enormous influence on the Medieval art of central and even northern India. The origin of Pallava sculptural style we have already seen in the Buddhist sculptures of Amaravati and the neighboring Jaggayyapeta. Its character is organic: the figures more fluid and fleshy than structural and bony, depicted in vigorous movement, with often varied and sometimes extremely exaggerated poses. At the time of the Buddhist stupas this style was still kept within bounds by the use of architectural frames enclosing closely packed compositions, devices persisting almost until the end of the Amaravati school.

Not until then do we find large figures with some space around them within which they can expand and move.

The Pallava style, derived from Amaravati and further developed, is the dominant style of early Medieval art in south India and of great international importance. It was the Pallava kingdom that had contact by sea with Cambodia and with Java, and it was through this commercial and religious contact, carried on by trade and by pilgrimage, that the influence of Pallava art was carried to Indonesia. Pallava sculpture and architecture are also important for their influence on the style of central India, an influence resulting in part from the warlike activities of Pallava rulers, but also from a hearty respect and imitation of a successful architecture that was even thought to be magical. A considerable number of constructed monuments dating back at least to mid-Pallava times are still extant. But more than that, we have at Mahamallapuram large stone models of even earlier types. Mahamallapuram is a spit of land on the Indian Ocean about sixty miles south of Madras, close to a white sand beach and the blue sea, with richly colored trees not far inland and salt-water inlets dividing it from the mainland. Mahamallapuram was a great pilgrimage site, and at the time of its flourishing from the sixth through the eighth century there were numerous inns for pilgrims. The area was once populated by a considerable priest class, like any of the great present-day pilgrimage sites in south

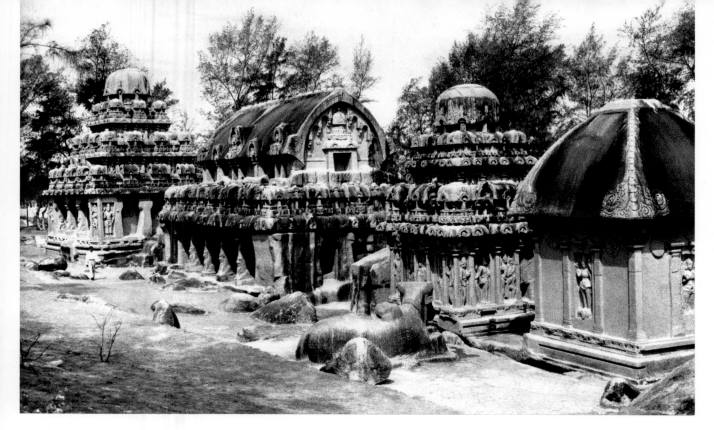

227. *The Pandava (Five) Raths.* Mahamallapuram, India. Eastern view. Pallava period, early seventh century A.D.

India, but it is now largely deserted except for a cabin belonging to the Archaeological Survey of India and frequent visitors.

Mahamallapuram

What distinguishes Mahamallapuram from other sites along the coast is the presence of great granite outcroppings in the form of thrusting masses of rock rising from the ground. Here was a material challenging to the sculptor and easily put to use, and the sculptors at Mahamallapuram carved a fantastic number of monuments in this living rock. One group, called the Five Raths, is an architectural museum, as if the designer had intended to produce five model shrines, each of a different type, showing the development of southern architecture from its origins to his own day (*fig. 227*). Such an intention was probably lacking, but fortunately the site provides just that. The Five Raths show the Dravidian, or south Indian, style in its early form. From right to left, we see the development of this south Indian style, beginning with a simple shrine dedicated to Durga, having a pilaster at each corner and a thatched roof imitated in stone. From the other side one sees a simple entrance to the shrine, all in a small structure not more than twelve feet in height, with the simplest proportions and the fewest elements, representing stage one in the development of the Hindu temple (*fig. 228*). Although these elements are embellished with carved designs of tendrils and

with images projecting from niches, they do not conceal the basic structure of a forest shrine—the simple cell.

The second building, the Arjuna Rath, shows an elaborated development of the cell type (*fig. 229*). It is still a square structure of post-and-lintel construction, but now we find a multiplication of sculpture around the sides of the building and an elaborately developed tower of a very specific type. The principal distinction between the northern and southern architectural styles lies in the towers. The southern tower resembles a simple forest shrine sitting on a base simulating a typical city wall with thatched lookout posts applied to its surface. It emphasizes a horizontal conformation and has a primarily architectural and horizontal rhythm, in contrast to the northern style, which emphasizes verticality and appears much more organic in character. The tremendous capstone is also characteristic of the south. This stone, though cut in a large mushroom shape, maintains an architectural character; the cap on the northern style is more like an actual organic growth on the top of the tower. The full development of the southern tower is seen in the Dharmaraja Rath (*fig. 230*). The vestigial wall has three levels, all with clearly visible buildings and lookout posts; there is a marked emphasis on the horizontal. The Bhima Rath, a communal hall modeled on the *chaitya* hall, with imitation thatched roof derived from parabolic wood-vaulted construction, is atypical for south India.

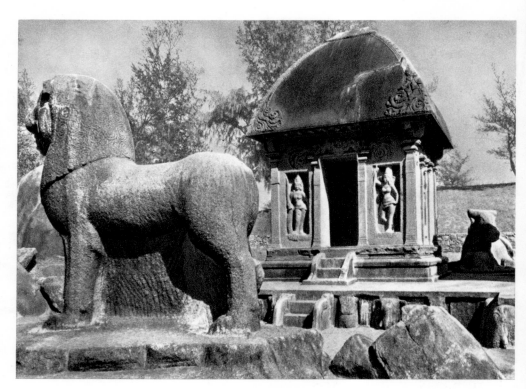

228. (right) *Durga cell of the Pandava Raths*

229. (below) *Arjuna Rath of the Pandava Raths*

230. (opposite) *Dharmaraja Rath of the Pandava Raths*

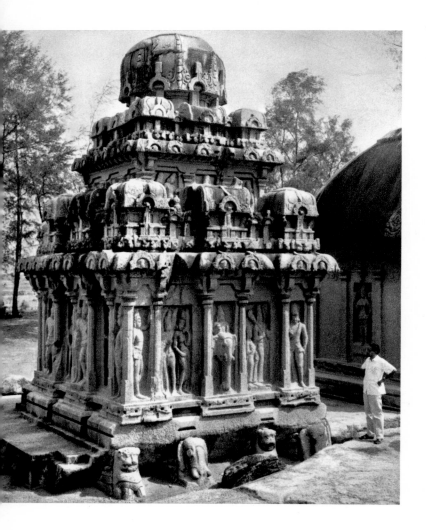

The term "stepped pyramid" may be used to describe the tower of the south Indian style, and we will call the railing around the tower, derived from the enclosing wall of a compound, "vestigial model shrines." These two elements, the vestigial model shrines and the stepped pyramid *sikhara,* or tower, are the basic elements of the southern, or Dravidian, style of architecture. There is one other architectural form found extensively in south India, a form corresponding to the Buddhist *vihara,* the cell cut into a great boulder or hill to house priests or, more rarely, as a place of worship. The type-site for early Pallava sculpture is the small *vihara* at Trichinopoly, dating from A.D. 600 to 625.

The great sculpture at Mahamallapuram and the one that concerns us most is the carving on two enormous granite boulders, often called the *Descent of the Ganges,* dating from the middle Pallava period, A.D. 625–74 (*fig. 231*). It is one of the most famous and most often published monuments of all Indian sculpture. One stands before a huge granite outcropping, some twenty feet high, with a natural cleft dammed so that the spring rains are collected in the pond formed at the top. At the height of the rainy season water pours over the dam and runs down the rock into the low enclosed pool in front of it, causing the calcium and iron discolorations at the central cleft. These hydraulics are essential to the sculpture, for here we have something comparable to a fountain by Bernini. The water moving across the face of the sculpture at the crucial point of the

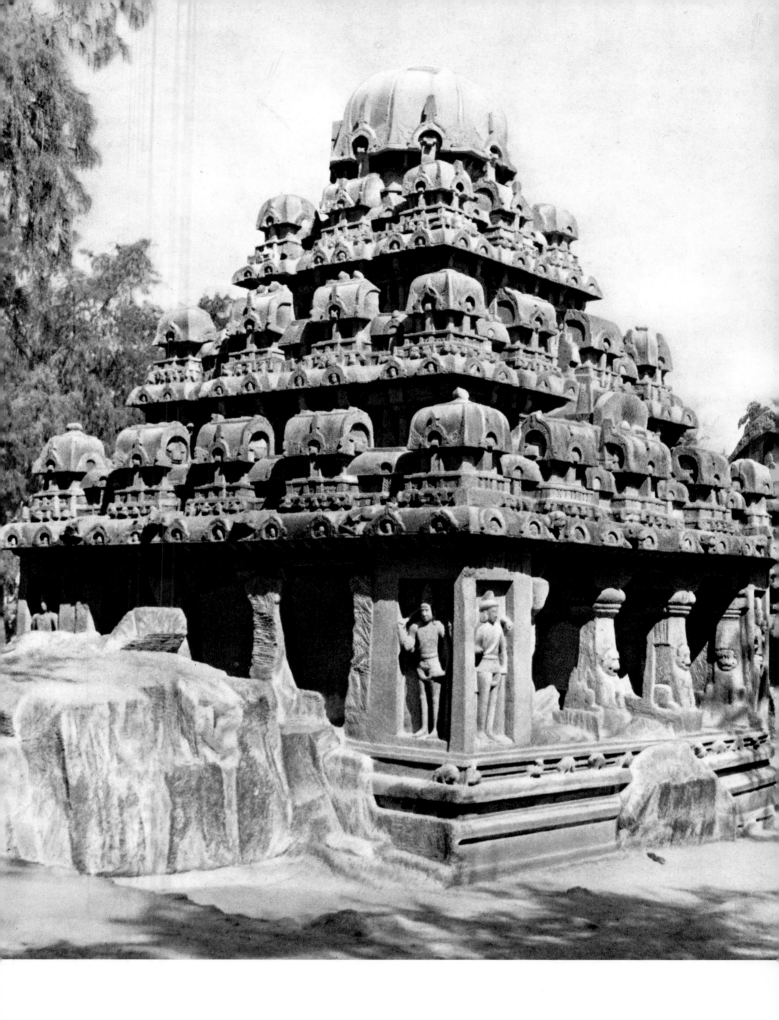

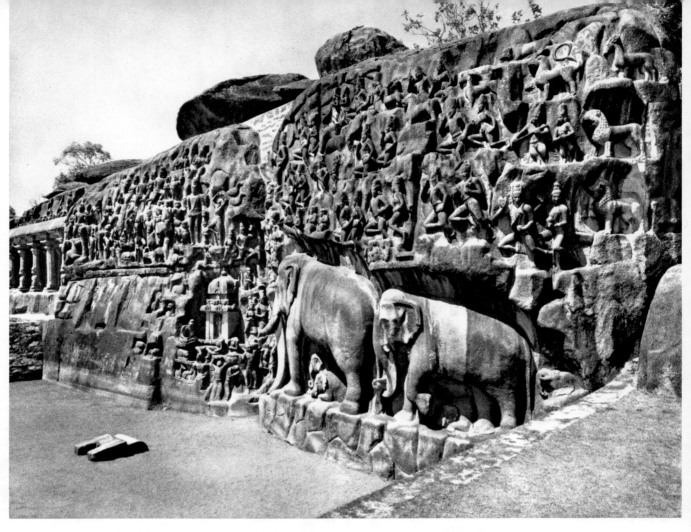

231. *Descent of the Ganges*. Mahamallapuram, India. Pallava period, seventh century A.D.

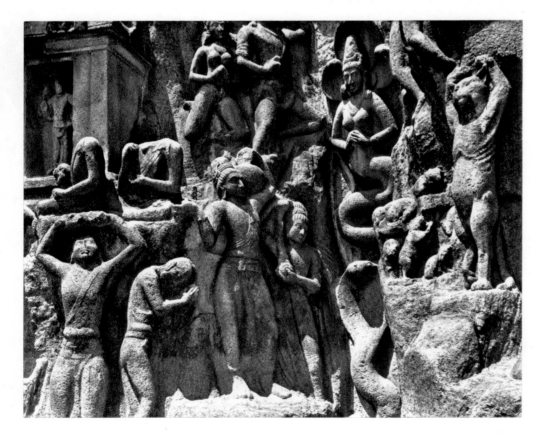

232. *Ascetics and nagas, from the Descent of the Ganges*

composition gives movement to the surface of the stone and reinforces the suggested movement in the stone itself. Nothing is more indicative of the aims of the Hindu Medieval sculptor than this combination of elements at Mahamallapuram. The iconography of this sculpture is much debated, but current opinion inclines to its identification as the Penance of Arjuna.

A petitioner, by austerity, receives a favor from Siva. The petitioner is shown twice—once standing in an ascetic pose with one foot elevated and arms raised overhead, looking up at the sun; and once seated in contemplation before a shrine. Siva is shown as the granter of the boon, namely, the water of the Ganges River. Seldom in the history of art has so complete a sculptural composition in stone been achieved. It is a vertitable microcosm: Deities of the river, elephants, bears, lions, gods, angels, men—all the living beings of the world congregate on the surface of this great carving. They move from left and right toward the cleft, which is obviously the focus of the action, bordered by representations of the activities of ascetics at the shrine and of ascetics with Siva on the banks of the river (*fig. 232*). The river itself is populated with *naga* kings and queens swimming upstream with their hands clasped in adoration of the god Siva.

Partly because of the nature of the material this is one of the most extraordinary achievements of the Hindu sculptor. The granite is very hard; the carving in some places is slightly unfinished. But everywhere the forms are more simplified than usual and

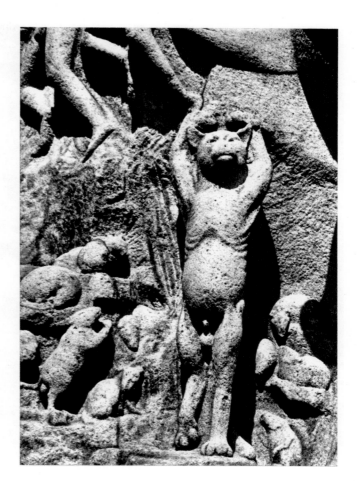

234. *The "Ascetic Cat," from the Descent of the Ganges*

the effect is of a slightly stronger, stonier style than is usually found in the softer sandstones of the north and central areas. If we look at a detail, we may be able to see more clearly the elements of representation and of style. Notice, for example, the figures that have come to the river bank to draw water—the chest of the dominant man, or the *naga* queen as she moves up the river. They all have that expansive quality which the Hindus call *prana*, or "inbreath." Notice too the representation of the animal world, for at Mahamallapuram we find a quality characteristic of Indian art in general: a sympathy for and understanding of the representation of animal forms, comparable in its way to Chinese painting of fur and feathers. The elephants, ranging from the massive bull and the female to the small baby elephants below, are a most successful representation of, let us say, the nature of elephants—of their mass, their bulk, their deliberate movement, and also of that expression which implies a degree of wisdom beyond their animal nature (*fig. 233*). At the foot of the bull elephant stands a cat with upraised arms, its ribs showing through the skin (*fig. 234*), and near the cat are rats in worshiping

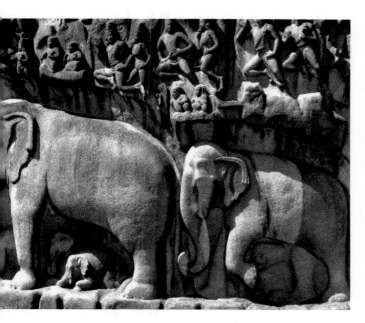

233. *Elephants, from the Descent of the Ganges*

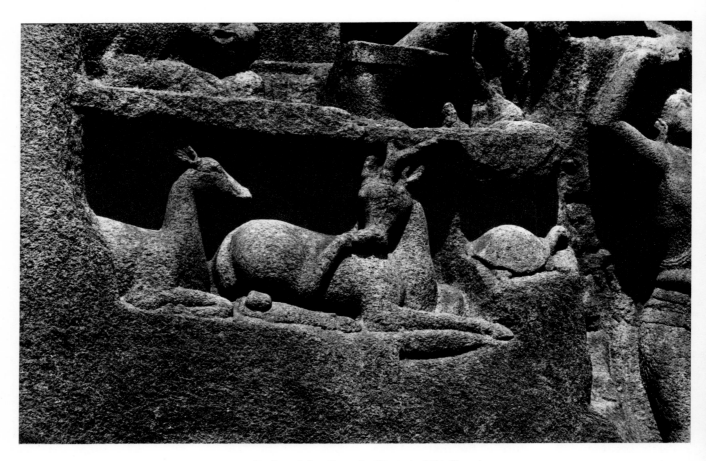

235. *Buck and doe, from the Descent of the Ganges*

positions. This is a key to the identity of the water coming down the cleft; the stream represents the River Ganges, one of the three great sacred rivers of India. The identification was made by Coomaraswamy and is based on an old folktale: A cat, pretending to be an ascetic, stood by the Ganges with upraised paws, gazing at the sun for hours. This convinced the rats and mice that he was holy and worthy of worship and so enabled him to procure food for more than the soul.

Some of the human figures derive from Amaravati; one sees behind them, so to speak, the flying angels of that earlier site. But the figures here seem much more natural and organic, with that quality of ease and amplitude so characteristic of developed Pallava style. The organization of the area beyond the central focus is relatively rudimentary and does not much surpass the arrangement of rows of figures in the boar relief at Udayagiri; but still it is not as rigid. There is more variation and flexibility in these ranks of celestial beings than in the earlier compositions. A detail at the lower left, of a buck and a doe by a river bank, displays a particularly interesting instance of that Indian sympathy for

animal forms which reached its height at Mahamallapuram (*fig. 235*). They are informed with that tremendous simplicity, even stylization, which recalls the works of some modern sculptors.

The granite cave-*mandapas* (pillared halls) at Mahamallapuram are filled with famous representations in relief of scenes from the legends of Vishnu and of Devi, the Great Goddess. Comparing the relief of Vishnu in the boar avatar from the Varaha Mandapa (*fig. 236*) with the same subject carved some two hundred years earlier at Udayagiri (*fig. 222*) reveals the difference between Gupta and early Medieval style. The monumentality and massiveness of the Gupta representation has been exchanged for a more human size. The figure of the Earth Goddess more closely approximates life size and is more in scale with the other figures. The attendant deities have been reduced to two or three in number, and they too are comparable in scale to the rest of the figures. The relief in these *mandapas* at Mahamallapuram is relatively high but is kept very much to one plane, so that the figures in general are related to the surface of the stone beneath. There are, however, some very curious and often striking excep-

tions. For example, considerable technical virtuosity is displayed in representing figures in a three-quarter view from behind, so that they are forcibly integrated with the rear plane of the stone. But in general we are conscious of a very simple and relatively balanced form of composition, with figures on a human scale and in a relatively quiet style quite different from that evolving in the north. Just as the architecture fo the southern style appears solid, more architectural, with less movement and appearance of organic growth, so Pallava sculpture seems when compared with the art of central and north India.

This by no means exhausts all the sculptures at Mahamallapuram. There is another representation, large-scale but unfinished, of the so-called *Descent of the Ganges*. It was left unfinished because the cleft in the rock evidently did not function properly as a source for the water, and so the sculptors moved to the second and final site. The quantity of work produced in this hard stone in a relatively short time is extraordinary. Also at Mahamallapuram, close by the shore, is a structure called the Shore Temple, which illustrates further development of the southern architectural style (*fig. 237*). It is not carved from the living rock but is constructed of granite blocks. The temple is probably to be dated from the middle of the eighth century. Horizontality is still manifest, but there has been considerable vertical development in the tower. The building was surrounded by numerous sculptures: representations of Nandi, the bull of Siva, in rows on top of the wall; and some remarkable representations of archers carved in low relief on the flanks of lions in the full round (*fig. 238*). One detail here is of great im-

236. *Boar avatar of Vishnu*. Height approx. 108″. Varaha Mandapa, Mahamallapuram, India. Pallava period, early seventh century A.D.

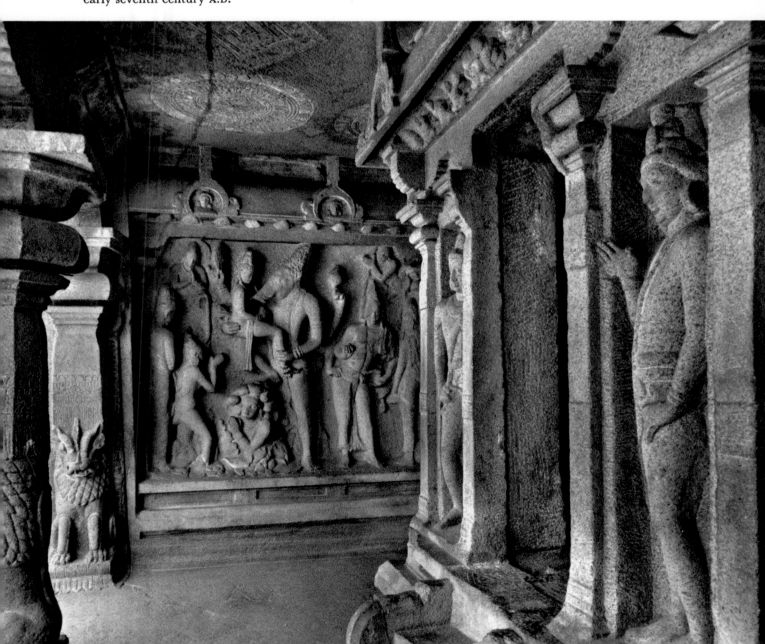

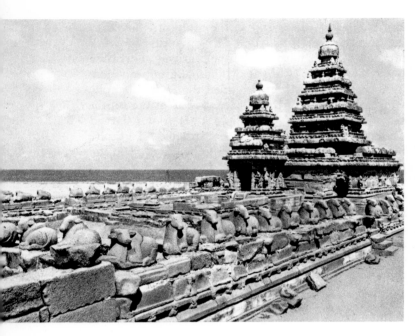

237. *Shore Temple*. Mahamallapuram, India. Pallava period, eighth century A.D.

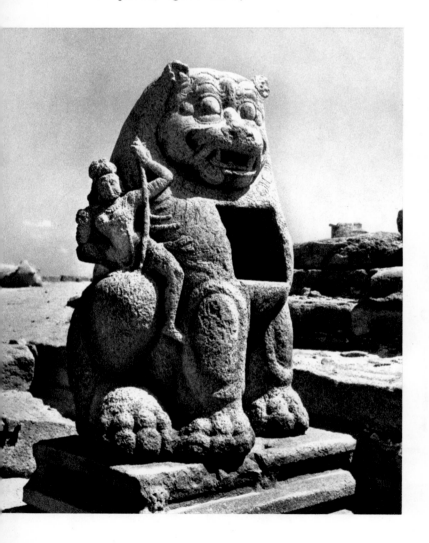

portance in the development of later Pallava and Chola architecture and is in keeping with the general tendency of Indian architecture toward a less architectonic treatment. This is the development of supporting animal figures into large sculptures whose dynamic pose seems to deny their supporting role. In the Shore Temple lions are used as architectural members, and they become almost a hallmark of later Pallava style at Mahamallapuram and especially at Kanchi, where there are many eighth and ninth century temples.

Kanchi and Pattadakal

A second great Pallava monument, perhaps not as fine as Mahamallapuram but of much greater importance for its later influence elsewhere, is the principal temple at Kanchi, the Kailasanatha, built just before A.D. 700 (*fig. 239*). It is one of many Kailasanathas, Temples of the Holy Mountain dedicated to Siva. Mt. Kailasa was the legendary birthplace and abode of Siva high in the Himalayas. The Kailasanatha at Kanchi is the first of a series of three we will illustrate, one of the most remarkable sequences in all Indian architecture and sculpture. This sequence begins with the Kailasanatha at Kanchi, moves north to a second at Pattadakal, and ends with the greatest of all, carved in the living rock at Ellora in the north Deccan. The Kailasanatha at Kanchi uses architectural elements that are to be repeated at Pattadakal and Ellora: a front screen with a main entrance gate, originally balanced on both sides by wall niches with images; a *chaitya* type structure placed athwart the gate as a tower; a porch behind the enclosing wall, attached to the main shrine; and a stepped pyramid tower of typical south Indian style. These elements of the Kanchi Kailasanatha are multiplied and elaborated at Pattadakal and Ellora: more mushroom shapes used on the surrounding walls; a greater and more realistic development of the horizontal vestigial enclosures on the tower; and a more elaborate development of the "brimming vase" (*purna-kalasa* or *purna-kumbha*) used as a decorative motif on the roof. But the plan of an enclosure with a main gate and a *chaitya* type tower over the gate, with the main temple inside, crowned by a stepped pyramid *sikhara*, is first established in these proportions and with this distribution at Kanchi.

The plan and elevation are copied almost literally at Pattadakal. The temple at Pattadakal is more often called Virupaksa, but it is also known as a

238. *Lion base, from the Shore Temple*. Detail of fig. 237

239. *Kailasanatha Temple.* Kanchi, India. Pallava period, eighth century A.D.

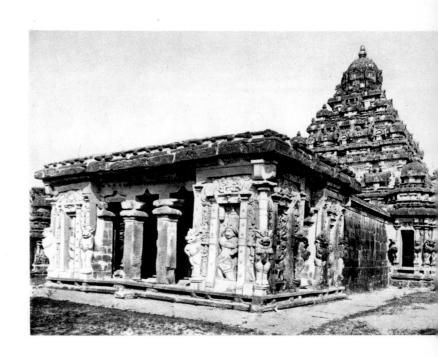

Kailasanatha (*fig. 240*). It was copied by a minor monarch from the one at Kanchi, employing architects and workmen removed bodily from Kanchi to Pattadakal during warfare. The illustration shows us a second important element of the plan, also present at Kanchi. Imagine that you are standing inside the enclosing wall: Directly ahead is the main shrine with its *sikhara* and to your right, between the entrance gate and the porch, is a separate shrine for the bull Nandi, the vehicle of Siva. Nandi is as usual a stone image placed in the Nandi Shrine, facing the image of Siva in the inner shrine of the nave of the main temple. The porch itself has the simulated thatched roof characteristic of south Indian style. The construction is southern but was adopted

240. *Virupaksa Temple.* Pattadakal, India. C. A.D. 740

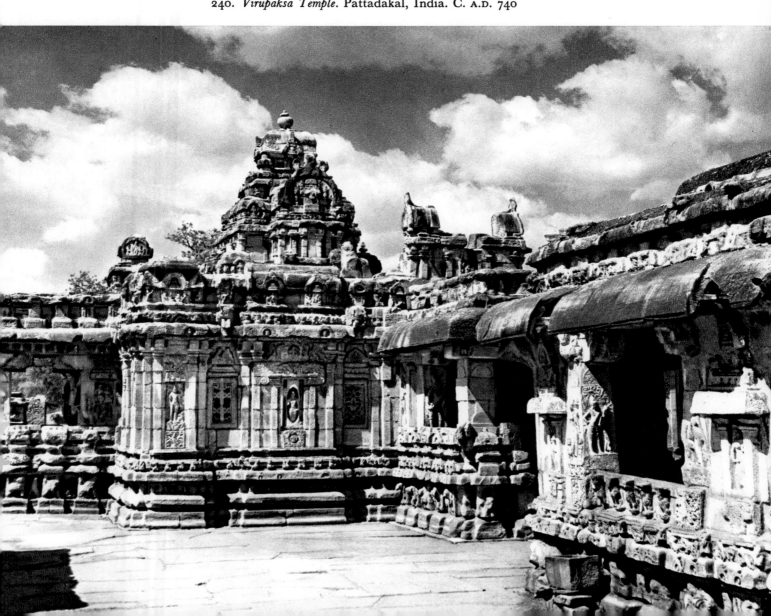

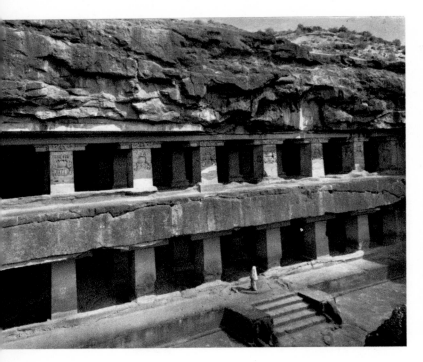

many miles north, at Pattadakal; and we will see it once again even farther north at Ellora. Note that the base, which is considerably increased and enlarged at Ellora, is at Pattadakal still relatively small in proportion to the rest of the building, as are the supporting animal forms. One further point: Note the repetition of images in niches, both on the main walls and on the corners of open buildings such as the Nandi Shrine. One must imagine them as representations of what is worshiped within, emanating from the interior of the building out to the presence of spectator or pilgrim. We can recognize, even at this distance, one or two representations of aspects of Siva, for all three temples—at Kanchi, Pattadakal, and Ellora—are dedicated to him. The first two of these, Kanchi and Pattadakal, are constructed temples made of blocks of stone and, though large, are not as large as the last and greatest of them all.

241. *Ravana Ka Kai* (cave 14). Ellora, India. C. A.D. 700–c. 750

242. *Dancing Siva*. Height approx. 96″. Ramesvara (cave 21), Ellora, India. C. A.D. 640–75

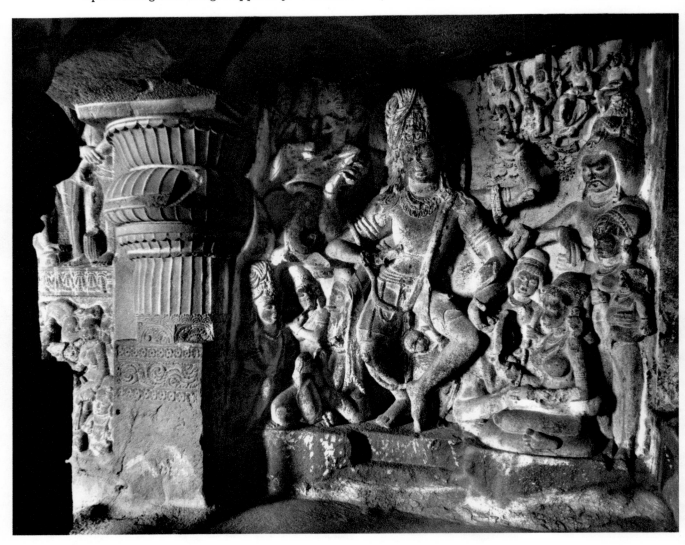

INFLUENCE OF CHALUKYAN ART

Before we turn to the Kailasanatha of Ellora, the culmination of much of what we are studying in the southern style, we must look briefly at developments in central India before its construction. This is particularly necessary in sculpture, because a sculptural style was developing in the west central area of the Deccan under the Chalukya kings which, when it was transferred to the north central area, was to influence the sculptural style imported from the south. While the architectural style of the south is preponderant in the region of the Deccan, the accompanying southern sculpture is changed, more often than not, by the native style developed under the Chalukyas. The Chalukyan dynasty, founded in A.D. 550, was largely destroyed in A.D. 753 by the Rashtrakutan rulers who built the Kailasanatha at Ellora. Let us consider some of the earlier caves at Ellora, constructed under the Chalukyas in the seventh and eighth centuries A.D.

Ellora: The Early Caves

Ellora is an escarpment, a projection of volcanic stone like the stone found at Ajanta, jutting up out of the plain. It is situated not far from Aurangabad, one of the two great cities of the former Hyderabad, on that central plateau called the Deccan. Ellora is the great site for the Hindu art of central India, and one of the greatest monuments in the world. There are some thirty-three caves at Ellora: Twelve are of Buddhist type, dating from just before the seventh century to the eighth; four are Jain caves; the remaining majority are Hindu. Some are two-storied *viharas,* and it is one of these, cave 14, Ravana Ka Kai, that we illustrate (*fig. 241*). The light filters in from the front to the back where the main shrine is located. In each niche around the square assembly area, which is supported by columns, we find representations of aspects of Siva carved from the living rock. The whole complex must be imagined as a sculpture—or rather as architecture in reverse, with the forms created by removing stone to "release" them.

Cave 21, Ramesvara, contains one of the earliest (c. A.D. 640–c. 675) representations of Dancing Siva in any medium (*fig. 242*). The image is also of interest because it is derived from Gupta style and so is characteristic of the early Chalukyan period, before the arrival of southern influence from the Pallavas. This early Dancing Siva is only mildly animated; nevertheless he moves, particularly through the arms, to a degree unknown in classic sculpture. But in contrast to later Dancing Sivas, the foot is hardly raised from the earth and the moving leg is not

thrown high and across the body. The movement of the figure, though sinuous from the front, is strictly aligned to the plane of the wall facing the spectator. Note the use of figures framing the main image like a halo. The whole effect, although possessing energy and vitality, only begins to be free from the rock, and achieves none of the frenzy to be realized a century later. Like the Dancing Siva, the representation of Siva and Parvati seated on Mt. Kailasa above the demon Ravana (in cave 29, Dhumar Lena), albeit more energetic than Gupta work, is relatively restrained, and the figures preserve almost unfailing frontality (*fig. 243*).

The most significant transitional cave at Ellora, which contains sculptures showing the "energizing" of the Gupta style, is Das Avatara, containing a representation of Vishnu as Narasimha, his avatar as a lion (*fig. 244*). This composition, one of the most interesting in all of India, was produced by early Medieval sculptors. We can sense the derivation of the eye and other parts of the face from Gupta sculpture. The manner in which the drapery clings to the surface of the rock recalls a little the late Gupta or early Medieval sculpture of the *naga* king and queen at Ajanta. But with the Narasimha we are aware of an expansive force already seen in the Parel Stela. The figures fill the frame; the Narasimha's headdress reaches to the top, and the figure

243. *Siva and Parvati on Kailasa.* Height approx. 96″. Dhumar Lena (cave 29), Ellora, India. C. A.D. 580–c. 642

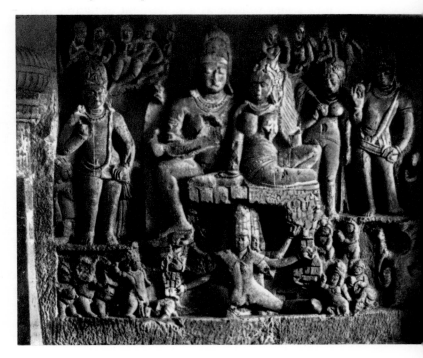

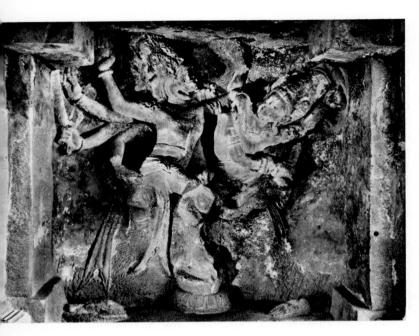

244. *Lion avatar of Vishnu.* Height approx. 96″.
Das Avatara (cave 15), Ellora, India.
C. A.D. 700–750

of a king fills the space to the right. The whole composition begins to burst its boundaries. And the figures are not so tightly related to the rear plane of the rock. The king's body is turned, with head thrust out and arms stretched back. The figure of Vishnu is turned sideways, with the shoulders toward the onlooker, but the hips are seen from the side as the leg thrusts forward. The whole sculpture now seems to exist as a movement of figures in the rather deep, atmospheric space of the niche. They seem strangely trancelike when we know the story, one of the favorite subjects of the Hindu dancer: Vishnu turns into a lion to destroy a wicked king who had used his name in vain. In later Indian art it is gruesomely shown, with the king stretched on the knees of Narasimha as the god tears out his entrails with his claws. The representation is quite different in early Indian art, as here, for though the subject can be frightening, it is treated lyrically and dramatically. The lion rushes toward the king, but his hand is lightly placed on the king's shoulder, delicately, almost as if in a dance. Observe the king, the expression of his face, the movement of his body, not retreating, but swaying toward the figure of Vishnu in the measured, rhythmical movement of the dance. Someday someone will make a thorough study of the relationship of Indian sculpture to the dance, because it is quite certain that many of the major elements of representation in Indian sculpture, especially of the Medieval period, are derived from

dance and dance-drama. The iconography is dictated by the faith, but the style is produced by the sculptor from observation of the dance.

Ellora: The Kailasanatha

The culmination of the early Medieval style of the north central Deccan is found in the Kailasanatha of Ellora, begun by A.D. 760 under the successors of the Chalukyas, the Rashtrakutans, and completed by the greatest early king of that dynasty, Krishna II, who reigned from A.D. 757 to 783 (*fig. 245*). The Kailasanatha is at the northernmost point of penetration of southern architectural style, and indeed its architecture is almost purely southern, or Dravidian. The sculpture, although influenced by Pallava style, is basically a continuation of the Chalukyan style found in Das Avatara, but carried to a higher pitch and in some carvings almost reaching a frenzy. No words express better the feeling one has on looking at this great monument than the words of Krishna II himself: "How is it possible that I built this other than by magic?"[5] It is literally a "magic mountain" in living rock, an achievement of sculpture rather than of architecture. Its chronology is much discussed since an article appeared in *Artibus Asiae,* in which Goetz attempts to apportion the construction of the temple over a considerably longer period of time than had previously been allowed. His argument is interesting but not widely accepted, and in general we must believe that the major part of the work at the Kailasanatha of Ellora was accomplished under Krishna II, even if some of it was finished by his successor.

It is a magic mountain with a court 276 feet long and 154 feet wide and a central tower reaching a height of 96 feet. The sheer physical problem of carving this tremendous temple from the living rock awes one. The beginning of the cutting is higher still, the drop directly down to the court behind the temple being 120 feet. The model used was that transmitted through Pattadakal from Kanchi; but this is on a larger scale, with more elaborately developed sculpture and architectural decoration. We see the same front screen and Nandi Shrine, but here the Nandi Shrine has been raised on a high base to a second story level and is connected by a bridge to the raised porch of the main temple. There is a tower over the main shrine, a subsidiary *chaitya* tower over the front porch, and the two side porches

245. (opposite) *Kailasanatha Temple.* Height 96′.
Ellora, India. Early Medieval period, Rashtrakuta dynasty, c. A.D. 760–800 with later additions

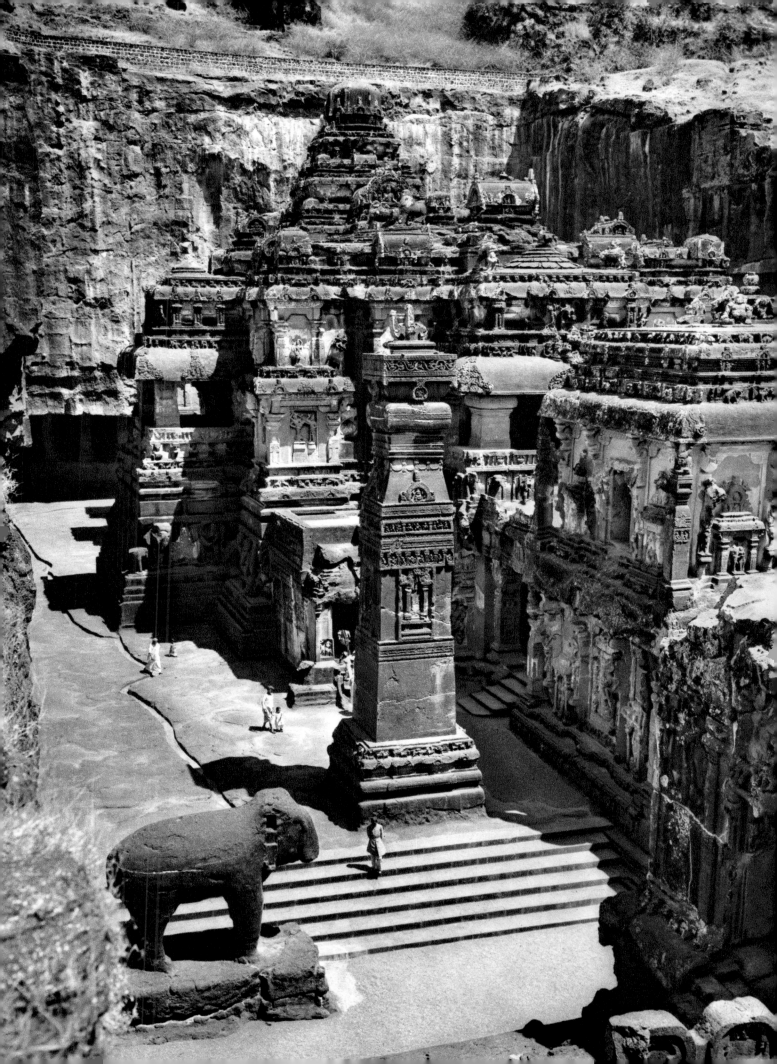

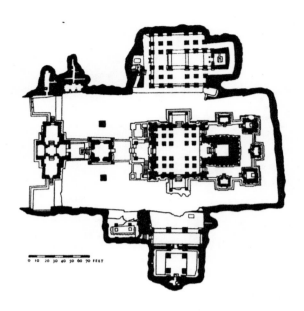

246. *Plan of the Kailasanatha Temple*. Ellora,
India

of the main building that are characteristic of this imported model. But in addition two tremendous stone columns, some sixty feet high, flank the entrance, with representations of jewels and other riches of this world. The plan (*fig. 246*) reveals the layout more clearly than any view, with the screen, the Nandi Shrine, the two towers, the porches, three in all, the gathering place with its columned hall, the shrine proper, and the five subsidiary shrines on a second story terrace outside the main shrine, dedicated to various deities associated with Siva. As if this were not enough, around the sides of this tremendous sculpture are carved subsidiary shrines in the vertical sides of the pit: the Shrine of Ablutions, or Shrine of the Three Rivers, with representations of the three great rivers; a long series of sculptures at the rear; a second story temple carved in the rock, with a set of reliefs relating to Siva; a series of reliefs of the avatars of Vishnu and

247. *Ramayana friezes and Nandi Shrine, from the Kailasanatha Temple*. Ellora, India. Second half of eighth and early ninth century A.D.

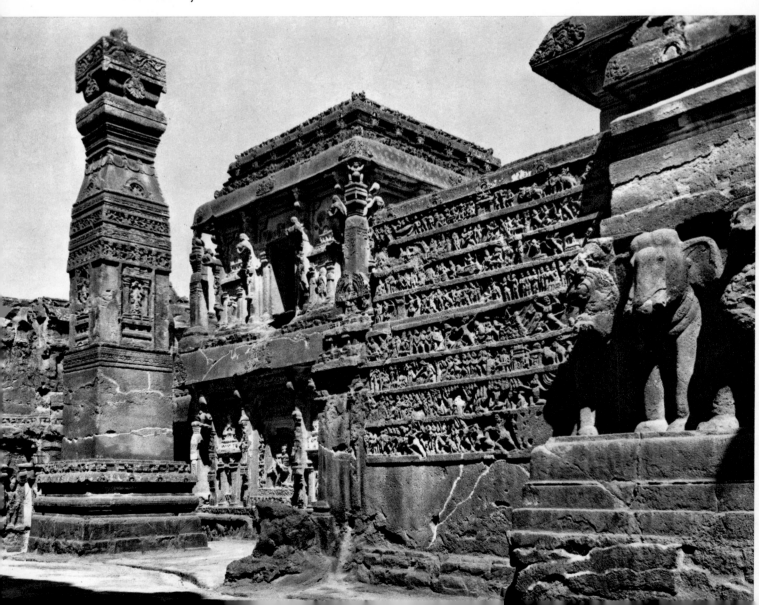

248. *Base of fighting animals, from the Kailasanatha Temple.* Ellora, India. C. second half of eighth century A.D.

aspects of Siva on the ground floor, surrounding the sides and completely enclosing the back end; and a two story complex on the right, once connected by a bridge to the porch, with representations of the Great Goddess (Devi) and the Seven Mothers. Numerous smaller shrines complete the ensemble. Although one can understand why Goetz believes that it was not all built in a short time, it does represent the achievement of a single architectural conception.

The Kailasanatha is a massive work of sculpture, not architecture. On entering, after passing through the main gateway, one is struck by the contrast of the brilliant sunlight of the Deccan Plateau, streaming into parts of the court, and the deep blue shadows cast by the high surrounding mountainside. The wildly moving sculptural representations, the angels flying on the walls of the temple, the representations of Siva, produce so overwhelming an effect that one feels feverish, as if overcome by wildly exalted feelings. It is one of the most extraordinary sensations to be experienced in looking at Oriental works of art.

The temple has never been fully published. There

are adequate illustrations of some of it, but no publication that reveals its tremendous wealth of material. Figure 247 demonstrates the relationship of the Nandi Shrine to the temple proper. The Nandi porch and shrine are on the second level, running across to the front porch of the main temple. Eight registers of friezes illustrating scenes from the *Ramayana* connect the flat-roofed Nandi Shrine in the center to the main shrine at the extreme right in figure 247. There are several points to be made with regard to this illustration. Note the enlargement of the base, which is now developed so that it is a full story in height. Indeed, if one removed the lower base, one would have the earlier Pattadakal forms preserved intact. The base has become gigantic, and the elephants and lions of the base have become life size or larger (*fig. 248*). Standard photographs of the base of the Kailasanatha usually show the elephants standing rigidly stiff, acting as a support for the great mass of the structure above; but this is the most atypical part of the whole base. The typical part is seen in the shadows where the figures of life-size elephants and larger-than-life lions are moving and rearing and tearing at each other. The very base

249. *Flying Devata*. Kailasanatha Temple, Ellora, India. Second half of eighth century A.D.

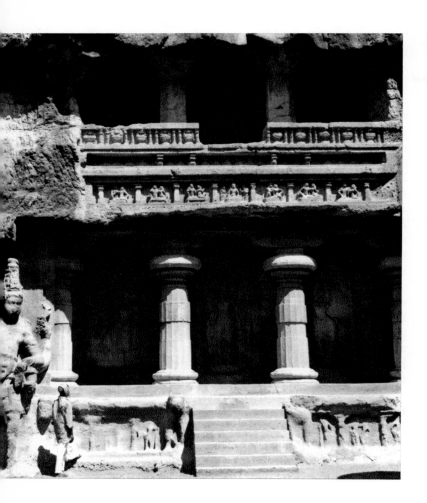

seems to move and tremble, and the whole structure appears ready to collapse in a cataclysmic fall. The standard representation of the base is of course the best-preserved one: It is neat and tidy and fits more stolid requirements. But it gives one no idea of the character of the rest of the base, with its violent shifting movement, as though an earthquake were in progress.

Perhaps somewhat later in date, in accordance with Goetz's suggestion, are the narrative reliefs of the *Ramayana* on the side wall below the porch of the main shrine. These are in almost a scroll-painting form, with the narrative running horizontally in registers. But the individual scenes do not have the character, movement, and life of the sculptures on the main structure. We can see the ultimate development of sculptural movement in the flying angels on the walls of the temple (*fig. 249*). These seem to soar off the walls and are completely non-architectural in character, almost denying the nature of the material, the substance and passivity of the architecture.

The original appearance of the building is difficult to determine. It may have been painted, over a covering layer of stucco. We know that it was painted when the Muslims conquered the Deccan at the beginning of the sixteenth century, because they called it Rang Mahal, the Painted Palace. There are remnants of a white gesso used to cover the volcanic rock; and on some of the angels, if one looks carefully with binoculars, one can see several older layers of gesso, which suggests that the figures may have been not only carved but modeled. The finishing touches in eyes, nose, mouth, and other details were achieved in gesso and by means of the fingers or other pushing instruments that modeled the soft material before it hardened. This fits the hypothesis that plastic materials influenced all Indian sculpture, but especially Medieval sculpture. Plastic techniques also influenced Pallava sculptures, particularly those on constructed temples. For example, the Kailasanatha of Kanchi has remnants of what appears to be an old gesso covering, polychromed.

The shrine at the left on the plan, the Shrine of Ablutions, has three niches with sculptures of the three goddesses Ganges, Jumna, and Sarasvati—the three great sacred rivers (*fig. 250*). In my own hierarchy of Indian sculpture, one of the river goddesses, Jumna, stands close to the top, particularly

250. *Shrine of the Three Rivers*, also called *Shrine of Ablutions*. Kailasanatha Temple, Ellora, India. Second half of eighth century A.D.

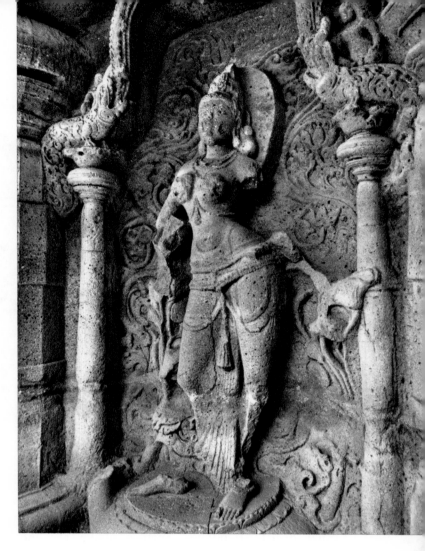

251. *Jumna, from the Shrine of the Three Rivers (Shrine of Ablutions).* Height approx. 72". Kailasanatha Temple, Ellora, India. Second half of eighth century A.D.

as representation of the female form. The three niches are similar, with a typical south Indian lion mask at the top of each niche. The background of each of the niches is rather deeply carved with a relief of lotuses, water flowers, vines, and tendrils. The background seems to be moving, almost as if water were running down its surface, and this background undulation makes a texture from which the goddess emanates. The figure is cut so deeply in the round, even completely undercut, that it seems to project far out beyond the skillfully achieved light and shade behind (*fig. 251*). This clever use of light and shade in sculpture is characteristic of the best work at Ellora and again serves to equate it somewhat with the work of the great Baroque sculptors of Europe, who also played with material and seemed to deny it. The representation of the goddess herself, with her small head, narrow shoulders and waist, large hips, and long thighs in the pose of the dance, accords with the

Indian ideal. The slight sway and curve of the body and the extraordinary use of the plant pattern as a foil for the torso produce one of the loveliest female figures in all of Indian sculpture.

But the most famous of the sculptures at Ellora is the representation of Siva and Parvati on Mt. Kailasa, with Ravana below shaking the foundations of the sacred mountain (*fig. 252*). The legend must be retold briefly to clarify the action. It is said that Ravana, a giant demon king, wished to destroy the power of Siva but was imprisoned in the foundations of the mountain. Grasping it with his numerous arms, he began to shake it, so that all the gods felt certain the world would be destroyed. But Siva, simply with the pressure of his toe on the mountain, crushed Ravana and thus saved the world. The subject is a demonstration of the power of Siva, and one with great representational possibilities. In contrast to the relatively static composition of the Dhumar Lena, the representation at the Kailasanatha is one of the most remarkable compositions in stone in the whole history of art. We are shown Ravana, a powerful, massive figure, with numerous heads treated as a massive block on top of great square shoulders and numerous arms placed in so deep a

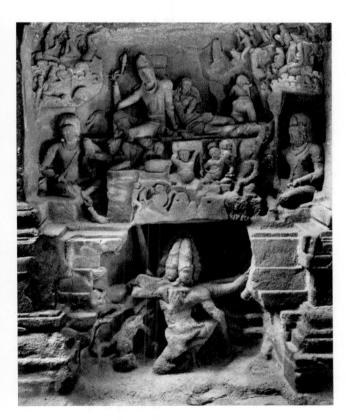

252. *Siva and Parvati on Kailasa.* Height approx. 144". Kailasanatha Temple, Ellora, India. Second half of eighth century A.D.

195

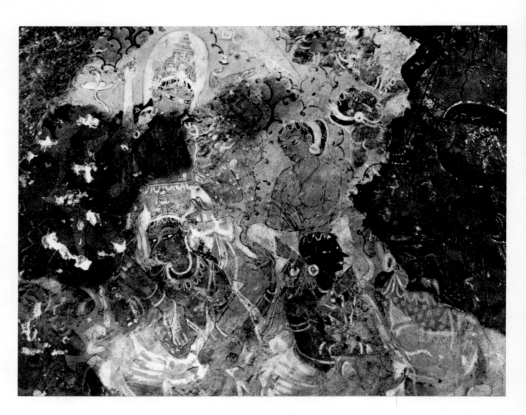

253. *Painting on porch, from the Kailasanatha Temple.* Ellora, India. Late eighth or early ninth century A.D.

recess that the figure seems actually to move and tremble. The arms seem to move in the play of light and shadow behind. Above, in a more evenly lit area, is the representation of the god Siva, with his consort Parvati, accompanied on either side by his usual dwarf attendants. Farther above are the inhabitants of heaven, the gods and spirits who have come to witness this great event. In addition to the pictorial handling of light and shade there are other pictorial devices used, more characteristic of painting than of sculpture: for example, the representation of rocks, mountains, and clouds by means of a linear pattern cut into the stone. The whole composition, partly as a heritage of the Gupta style and partly because it is a sculpture carved in a niche, is organized as an almost geometric grid or checkerboard, balancing a projecting mass against a receding void in a positive-negative pattern. Other shapes tie the whole action together and allow the frenzied movement to occur without completely destroying the enclosure. The niche is some eight or nine feet deep.

The composition is treated in depth not only in its use of light and shade, but also sculpturally and representationally. See, for example, the frightened maiden, alarmed by the shaking of the mountain, who runs off toward the back of the cave and seems to be dissolving into it. Notice, too, the pose of Parvati, whose knees are at the front of the composition, but who reclines back behind the god, clinging to him in fear. The figures of the two guardians at the sides show some trace of Pallava influence, as does the main figure of Siva himself. But the whole representation is a perfect blending of sculptural and pictorial quality in a unity that is not only aesthetic but psychological, expressed by the involvement of all the figures in an almost human way with the great activity that is taking place below. The result is a massive, large-scale composition, unique in Indian art and worthy of any great tradition at its peak.

We have mentioned that the Kailasanatha was called the Painted Palace. One illustration will show a bit of the remaining evidence. The underside of the roof of the porch still has remnants of mural painting (*fig. 253*). There are three layers of painting, of three different ages, the earliest apparently being slightly obscure figures in reddish brown, perhaps executed soon after the temple was built, late in the eighth century. Over this were placed figures of animals and cloud forms, and over those were placed other figures in a later, almost folk-art, manner.

The last related monument we shall consider is the cave-*mandapa* of Elephanta, on the island of that name in the harbor outside Bombay. It may originally have been called Puri and was an ancient capital, conquered by the Chalukyas and Rashtrakutans in turn. The date of the sculptures at Elephanta is a much argued question: Sastri says seventh century, Coomaraswamy says eighth century. It seems likely that Elephanta represents an isolated phenomenon, the survival of a somewhat earlier style at a late date. It is an excavated shrine, similar to some we have seen at Ellora; and aside from having two main axes instead of the usual one, it is not exceptional architecturally. The general view of the entrance and of part of the sculpture gives

some idea of its present condition (*fig. 254*). When the Portuguese occupied this area, it seems that the commander of the military garrison stationed on the island amused himself by having artillery practice down the aisles of the *mandapa;* and thus nearly all of the sculptures are thoroughly smashed from the waist down. The figures are of colossal size, between eight and ten feet in height, and are of the greatest interest. They represent one of the most notable expressions of early northern Medieval style, despite the fact that they may be somewhat late. Because Elephanta was politically a provincial site, it preserves some Chalukyan style elements without the influences of southern style seen at Ellora.

The shrine is dedicated to Siva and contains representations of his principal aspects. The sculptures at Elephanta are characteristically niche sculptures, predominantly square-framed, and reveal rather elaborate figural compositions. These usually involve a large-scale image of Siva, sometimes supplemented with a fairly large-scale image of his consort, with numerous smaller representations of other deities. The result is a complex focus often lacking in other Medieval sculptures. These huge and dominating figures, coupled with the complex representational elements behind, produce a rich and yet compact effect. And this is visually heightened by the fact

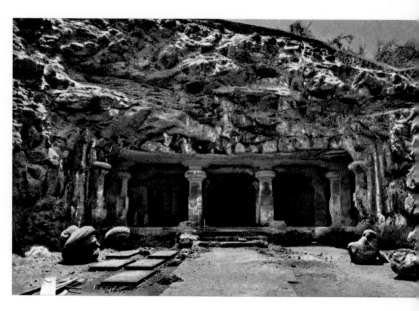

254. *Cave-temple at Elephanta, India.* General view. Seventh century A.D.

that the stone at Elephanta is not coarse volcanic stuff, nor a fine-grained cream sandstone which seems somehow rather light and delicate, but a rich, chocolate-brown, fine-grained sandstone. This material can be cut with great precision and detail, but when viewed as a whole it has the same rich but compact effect that the sculptures themselves display

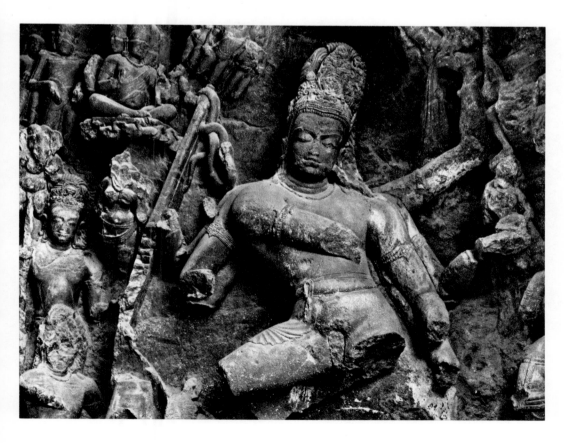

255. *Siva Nataraja, Lord of the Dance.* Height approx. 120″. Elephanta, India. Seventh century A.D.

in their organization. One supplements the other, and the whole produces an extraordinary unity. Compared with the same subject at Ramesvara (*fig. 242*), the Siva Nataraja at Elephanta shows more movement and more distortion of figure (*fig. 255*). The gentle S-sway of Ramesvara is changed here to a very definite and supple turn of the body in a full S; and, were the legs complete, we would undoubtedly find that one leg was raised quite high and that the dance was far more vigorous. The facial types at Elephanta, in contrast to those at Ellora and elsewhere, have a certain early, almost Gupta, quality about them. Their eyes are usually downcast and the mouths full, and they seem much more serene than the more frenzied and dynamic examples from central India. The modeling is soft and supple; and the rhythmical treatment is comparable to that seen before in Indian sculpture.

The most famous—and justly so—of the sculptures of Elephanta is considered to be the principal image at the site, even though it occupies, in relation to the usual central axis, a secondary position (*fig. 256*). It is marked quite clearly as the main image of the cave by being much larger in scale and cut in much deeper relief than any of the other representations.

It is the same height as the others, but shows only the shoulders and heads of Siva rather than the whole figure, and as a result dominates the interior. The niche is the only one, other than the *lingam* shrine or cell, that is flanked on either side by very large figures of guardians. The image represents Siva in his threefold aspect as Mahesa. On the left is Aghora, the Wrathful One, with moustaches and bulging, frowning brows, holding a cobra in his hand. In the center he is Tatpurusha, beneficent and serene in aspect. At the right is Uma Devi, the Blissful One, with the face of Uma, here Siva's consort, with feminine earrings and the full "bee-stung" lower lip of poetic description. The large lower lip and sharp, thin nose represent the very height of elegance and femininity. The combination of these three different aspects into one unified form is accomplished, in part, by the massive base of the shoulders, by the pattern of the jewelry in the headdress, and, above all, by a psychological unity which allows the wrathful to be not too wrathful, and unites it with the more serene and contemplative ideal expressed in the other heads. This is in keeping with the controlled character of the sculpture at Elephanta.

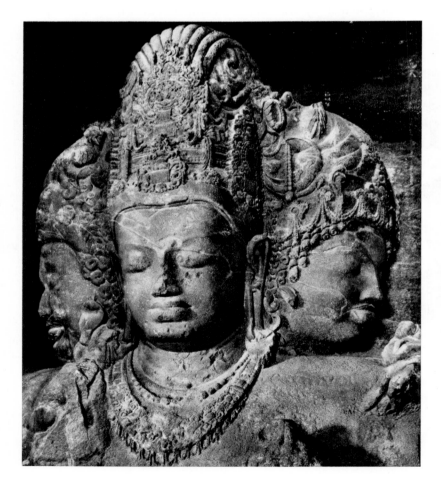

256. *Siva Mahesvara.* Height 10' 10". Elephanta, India. Seventh century A.D.

Later Medieval Hindu Art

The northern Medieval style of architecture, called Nagara by the Indians, as distinguished from the Dravida style of the south, is found at its most characteristic in that region of India ranging from Bengal and Orissa in the northeast through north central India, past the region of Delhi and on into the northwest area, including the Gujarat Peninsula. Various stones are found in these areas. There is the chlorite of Orissa, a brown purple stone, pockmarked when exposed to the weather but, when kept in an interior location, retaining a very highly polished, smooth surface. There is the cream-to-tan sandstone of the north central provinces, particularly the region of Bundelkhand, slightly north and west of Delhi and perhaps the greatest center of the northern style. This sandstone is very similar to that of the Gupta images at Sarnath. And then there is the white marble-like stone of the Gujarat area. These stones of the north contrast rather sharply with the material available in the central and southern areas, especially the granite of Mahamallapuram in the south and the volcanic rock of Ellora in the Deccan. We must bear in mind the influence of materials on styles of art, particularly in relation to sculpture. It is manifestly difficult to carve detail in a stone full of holes. It is equally difficult to achieve broad pictorial effects in stone, which fact seems to invite the carver to dwell on detail and smooth finish when working with sandstone, for example. So perhaps some of the characteristics noted in the sculpture of Ellora and Mahamallapuram, and those which we will see in the sculpture of the northern regions, can be traced to the reaction of the artist to the material in which he works. These northern materials, which

seem more refined than those of the south and the central areas, produced sculpture rich in detail; at the same time the temple structures retain the characteristics of sculpture rather than of architecture.

CHARACTERISTICS OF THE NORTHERN STYLE

Let us first look at one of the Hindu temples at Khajuraho in north central India, for an introduction to the form of the northern temple (*fig. 257*). It is made of the warm cream sandstone of the region and dates from about A.D. 950 to 1050. There are no distinctive sectarian styles at Khajuraho; that is, we cannot differentiate a Jain style from a Hindu one. The northern style appears more organic than that of the south. The emphasis is primarily on verticality; horizontality is suppressed. And, further, the architectural character resulting from the vestigial wall and enclosure used as a decoration for the towers of the southern style is absent; instead there is a series of small towers, repeated one against the other, building a form that ultimately becomes the large tower. There are quarter-towers, half-towers, and then, finally, the full tower, each part leading to the other as if an organic vegetable growth rose from the earth. The crown on each of these little towers and on the large, bulbous, mushroom-like tower is more organic than the capstone used in the southern style. The extremely high base again emphasizes the verticality of the whole; and the *mandapa* (pillared porch and congregation area), which in the south-

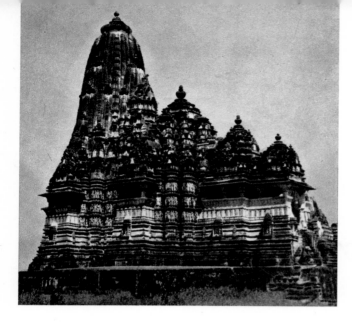

257. *Kandarya Mahadeva Temple.*
Khajuraho, Bundelkhand, India. C. A.D. 1000

258. *Bhubaneswar, Orissa, India.* General view.
Eighth–thirteenth century A.D.

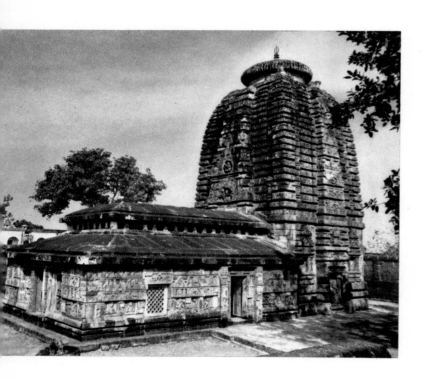

ern style was clearly separated from the tower over
the shrine, is integrated with the tower and appears
to lead up into its heights. The style of northern
structures, *mandapa* and tower, is more unified and
organic than that of southern ones. If it is true that
Hindu architecture is primarily not architecture at
all, but sculpture, then its most perfect expression
is the northern style.

Bhubaneswar

There are two main type-sites for the northern
style, Khajuraho and Bhubaneswar. We will con-
sider the latter first, since it has temples of somewhat
earlier date than those of Khajuraho. Bhubaneswar
is located in Orissa, the state immediately south of
Bengal in northeast India. A general view of the site
shows the great tank, or pool, with trees surrounding
it and the numerous towers of temples and shrines
in the area (*fig. 258*). These are but a small part of
the number of temples visible from vantage points
near Bhubaneswar. The effect at a distance is sur-
prising, resembling mushroom-like growths sprout-
ing over the countryside. The earliest of the complete
temples at Bhubaneswar is Parasuramesvar, of about
A.D. 750 (*fig. 259*). It shows a primitive stage in the
northern Medieval style, for here the separation of
the porch, or *mandapa*, from the tower is clearly
marked; the former is a horizontal slab structure,
whereas the tower is a primarily vertical structure
over the shrine. There is no transition from the
mandapa to the *sikhara* (tower). The *sikhara* on this
early temple at Bhubaneswar still has traces of
strongly horizontal units, and an angular four-sided
character like that of a primitive cell-shrine. But the
incrustation of the surfaces with numerous small
carvings tends to break down its architectural char-
acter and to produce a work of sculpture.

These tendencies, seen here in embryo, are carried
further in the later temples of Bhubaneswar. One of
the most fascinating of these is the Muktesvara
Temple, built about A.D. 950; it is the jewel of all
temples of the northern style (*fig. 260*). The Muktes-
vara is very small—the tower is certainly no more
than thirty to thirty-five feet in height—but it is
complete with its own tank, entrance gate, and low
railing around the whole enclosure. But what dis-
tinguishes the Muktesvara from all other temples of
this group is the rich sculptural adornment, ap-
proaching a form of incrustation, as if stone jewelry
had been hung on the surface of the tower. A
type of ornament based on the old *chaitya* arch motif

259. *Parasuramesvara Temple.* Bhubaneswar, India.
C. A.D. 750

appears with the Muktesvara Temple (*fig. 261*). The parabolic ceiling or roof line of a *chaitya* hall is playfully repeated, with numerous variations in the direction and thickness of the lines outlining the miniature arches. This ribbon-like ornament, which certainly begins to appear by the ninth century and becomes characteristic for the Nagara style, looks almost as if it had been squeezed out of a tube. Here we see one of its richest manifestations. On the Muktesvara the ornamental figure sculpture is somehow architectural in character. This is particularly true of the caryatids—potbellied dwarfs in square frames who support the weight above them. The projections made by their elbows, knees, stomachs, and heads form an abstract pattern of bulbous protrusions against the shadow of the undercut background. Another characteristic ornament of the northern style is the "mask of glory" (*kirttimukha*), a mask of a devouring leonine monster, often used as a main motif on each side of the tower as well as over the false doors from which images of the gods seem to emanate from the shrine within. The horizontality of the layers composing the tower, characteristic of the Parasuramesvara Temple, is broken here by the verticality of these ribbons that cut across the layers. Since the emphasis is definitely on verticality, the characteristic expression of the Nagara style is seen to be fully developed by the time of this little temple. The temples at Bhubaneswar are made of chlorite, which deteriorates somewhat under the influence of weather. But it is capable of being worked in great detail, as can be seen on the well-preserved side of the building. Chlorite is extremely rich in color, ranging from orange through red to purple; and in the brilliant sunlight of northern India it produces an extremely rich, even funguslike effect.

The largest temple at Bhubaneswar is the Lingaraja, dedicated to Siva and probably built about A.D. 1000 (*fig. 262*). It reveals the style at its height, or perhaps just past the peak. All the verticality of the little towers at the sides and of the small shrines surrounding the temple culminates in the main tower. The crowning stone, a giant mushroom-like shape, is of tremendous size and seems almost to overweigh the tower. The sculpture is less dominant on the Lingaraja, so that the towers seem slightly impoverished in their decoration, although the lower part of the *mandapa* and parts of the tower have much sculptural decoration. The side view of the Lingaraja is a classic picture of the developed northern style of Orissa.

The sculpture associated with these later temples at Bhubaneswar is overwhelming in quantity and often of very high quality. The detail shows the sculpture on the so-called Raja Rani, also built

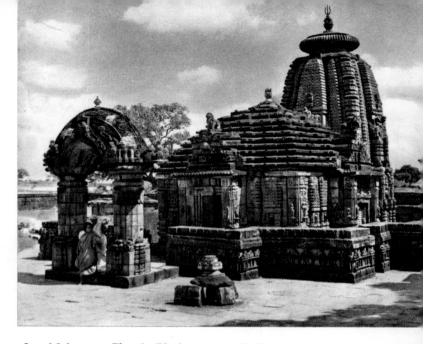

260. *Muktesvara Temple*. Bhubaneswar, India.
C. A.D. 950

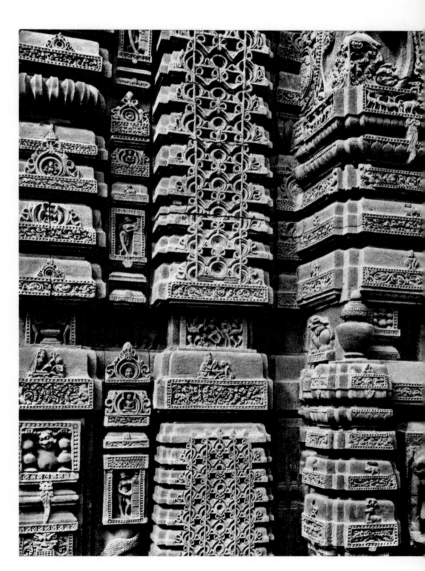

261. *Chaitya arch ornament, from the Muktesvara Temple.*
Detail of fig. 260

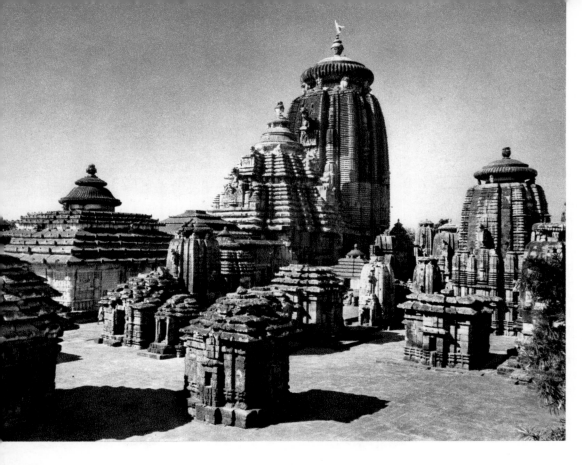

262. *Lingaraja Temple.* Bhubaneswar, India. C. A.D. 1000

about A.D. 1000, and situated on the outskirts of Bhubaneswar. In addition to the decorative carvings of vine-scrolls and lotus-scrolls, the lion monsters and masks of glory, the Raja Rani Temple provides one of the best Medieval expressions of the traditional motif of the female fertility deity. The Raja Rani sculptures of the lady under the tree, a motif going back as far as Bharhut (*see p. 83*), are justly famous (*fig. 263*). There are many variations on this theme, both on a large scale and in the small secondary sculptures around the niches. The poses tend to continue the classic Gupta tradition, and there is throughout a certain restraint in the sculpture at Bhubaneswar. Despite an occasional pronounced twist of the hips and torso, the figures are well contained within the pillar boundaries. The forms are ample and round, again maintaining the tradition of Gupta sculpture. We do not find the long, sinuous shapes common in north central India.

Konarak

The most famous, or notorious, of the temples of Orissa, depending upon the frame of reference, is the so-called Black Pagoda of Konarak, a temple past the prime of the northern style and dating from about A.D. 1240 (*fig. 264*). It was called the Black Pagoda because from the sea it appeared as a dark mass and was a useful landmark for mariners coasting up the Indian Ocean to make a landfall near Calcutta. It is dedicated to Surya, the sun god, and is properly called the Surya Deul. What is left is a magnificent

263. *Lady under a tree.* Height approx. 60″. Raja Rani, Bhubaneswar, India. C. A.D. 1000

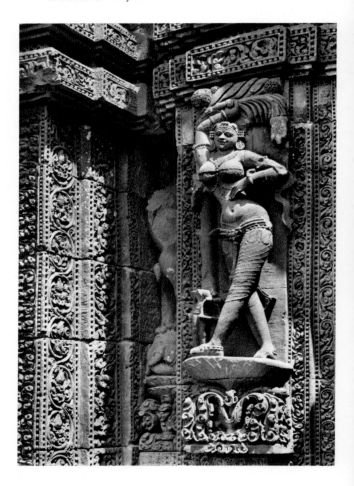

ruin. One sees only the *mandapa*, for the tower collapsed and is now no more than piles of fragmented sculpture and rock. The *mandapa* indicates that the temple was originally the largest of its type built in the north. The Black Pagoda is a particular temple type because, as it is dedicated to Surya, the temple—and especially the *mandapa*—was conceived of as a chariot whose wheels are carved in the stone at the base of the temple. Stone musicians play on the roof while colossal stone horses, still extant, draw the heavenly chariot. The temple was constructed of chlorite, and the salt air and sea wind have badly eroded it on the two sides exposed to the sea, so that much of the sculpture is gone.

The Surya Deul is "notorious" because it is adorned with perhaps the most explicit erotic sculptures that have ever been made of male and female figures. Certain writers try one's credulity by saying that such sculptures indicate solely the union of the soul with God. Let us hope that the sculptural adornment of this temple is dedicated to concepts of both physical and mystical union. One of the great wheels supporting the *mandapa* reveals the same style of vine-and-tendril carving seen in the Muktesvara, and so characteristic of ornament in Orissa (*fig. 265*). The wheel is adorned with figures in cartouches on the spokes and rim—single figures of celestial deities, motifs of the woman under a tree, and embracing couples. The large sculptures are like those on the Raja Rani, voluptuous and full-bodied, not linear in their emphasis and not exaggerated in movement. The sculpture still retains a certain Gupta restraint, perhaps due to the influence of Buddhist art of the Pala and Sena dynasties in Bengal, where the Gupta style was preserved well into the eleventh and twelfth centuries. Another detail on the main *mandapa* at Konarak shows a late decorative note developed to an extremely high degree (*fig. 266*). This is a pattern of perforations used to create texture behind the images and floral ornament. It suggests so intense a desire to negate any architectural character and to create an embroidered or encrusted effect that hardly a square inch of surface is left uncarved. The tendencies under strict control at the Muktesvara have here run riot.

Khajuraho

The second type-site for the northern style is Khajuraho. The side view of the Kandarya Mahadeva Temple (*fig. 257*) shows the elaboration and development of this regional version of Nagara style. There are three porches, each one increasing slightly in height and leading up to the great tower; the base is extremely high; and the miniature towers building up to the central tower are particularly numerous.

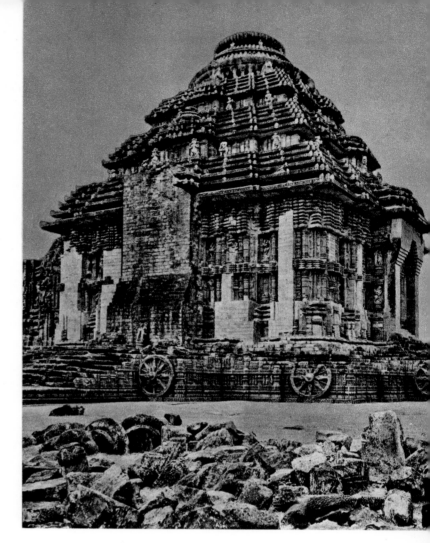

264. *Surya Deul (the Black Pagoda)*. Konarak, India. C. A.D. 1240

265. *Great Wheel, from the Surya Deul*. Diameter approx. 144". Detail of fig. 264

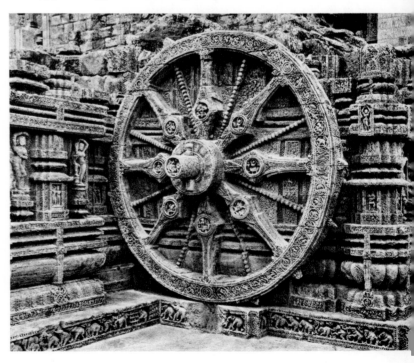

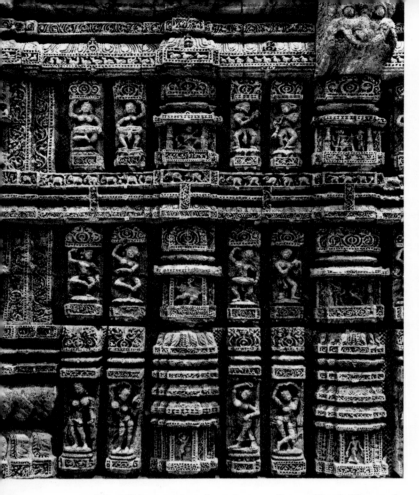

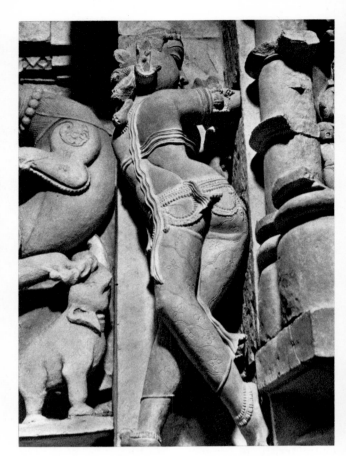

266. *Mithuna and perforated screen*. Surya Deul, Konarak, India. C. A.D. 1240

267. *Celestial deities*. Stone. Kandarya Mahadeva Temple, Khajuraho, India. C. A.D. 1000

268. *Celestial beauty*. Stone, height approx. 48″. Parsvanatha Temple, Khajuraho, India. C. A.D. 1000

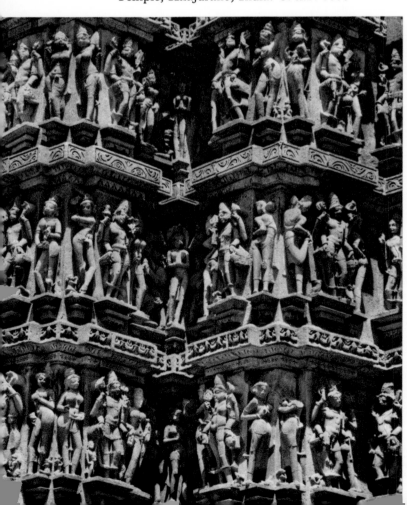

The temple sculptures at Khajuraho are quite different in style and character from those of Orissa, although the motifs are often the same. They seem more varied, and the general impression is of a richer sculptural style. The detail gives some idea of the variety: single figures of celestial beauties (*sarasundari*), lions, *mithuna* couples, and single images of deities (*fig. 267*). There is a marked development of the ribbon ornament we saw in Orissa. The Khajuraho variation is particularly arresting in its pictorial, or light and shadow, style. The flat surface of the sandstone is cut sharply and deeply in the form of tendril scrolls or arabesques, and the raking light makes a sharp contrast of light and dark, without variation or gradation or modeling around a shape. The result is like a drawing in black on white. This type of ornament is used to great effect throughout the structure and helps to maintain, on some areas, a flat architectural surface contrasting with the extreme development of the sculptured human forms on the rest of the building.

At Khajuraho the sculptured figures are tall and slim, and some have much elongated legs. The effects are linear, the poses exaggerated. A culmination of this tendency is to be found in one exquisite figure, perhaps the most interesting architectural sculpture at Khajuraho (*fig. 268*). It is a celestial beauty,

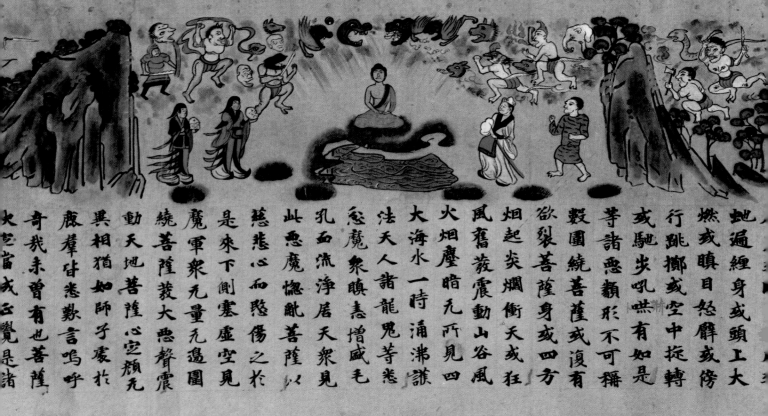

火彷我未曾有也菩薩　奇　火彷我未曾有也菩薩
麤葦甘悲歎言嗚呼　異相猶如師子壴扵
動天地菩薩心定顏无　繞菩薩發大惡聲震
魔軍眾无量无邊圍　是來下側鋻虛空見
慈悲心而愍傷之扵　此惡魔憋齓菩薩以
孔而流净居天眾見　愁魔眾瞋恚增盛毛
法天人諸龍鬼等慈　大海水一時涌沸坱
火燗塵暗无所見四　風奮姦震動山谷風
烟起炎燗衝天或狂　欲裂身菩薩身或四方
毂圍繞菩薩或復有　等諸惡顙形不可稱
或馳步吼然有如是　行跳擲或空中掟轉
燃或瞋目怒辟或傍　蚯遍經身或頭上大

Colorplate 13. *Kakogenzai Ingakyo*. Sutra scroll, ink and color on paper; height 11″.
Hoon-in of Daigo-ji, Kyoto, Japan. Nara period, mid-eighth century A.D.

205

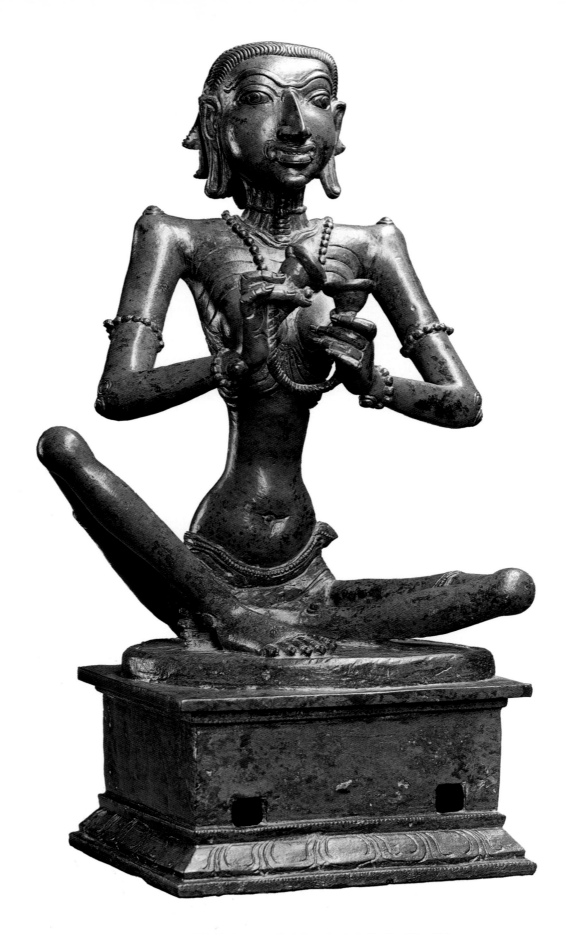

Colorplate 14. *Devotee of Kali.* Copper, height 16 1/4″. India. Twelfth century A.D.
Nelson Gallery–Atkins Museum, Kansas City. Nelson Fund

Colorplate 15. (opposite) *Allegorical representation of the emperor Jahangir seated on an hourglass throne.* By Bichitr.
Color and gold on paper, height 10 7/8″. India. Mughal, school of Jahangir, early seventeenth century A.D.
Freer Gallery of Art, Smithsonian Institution, Washington, D.C.

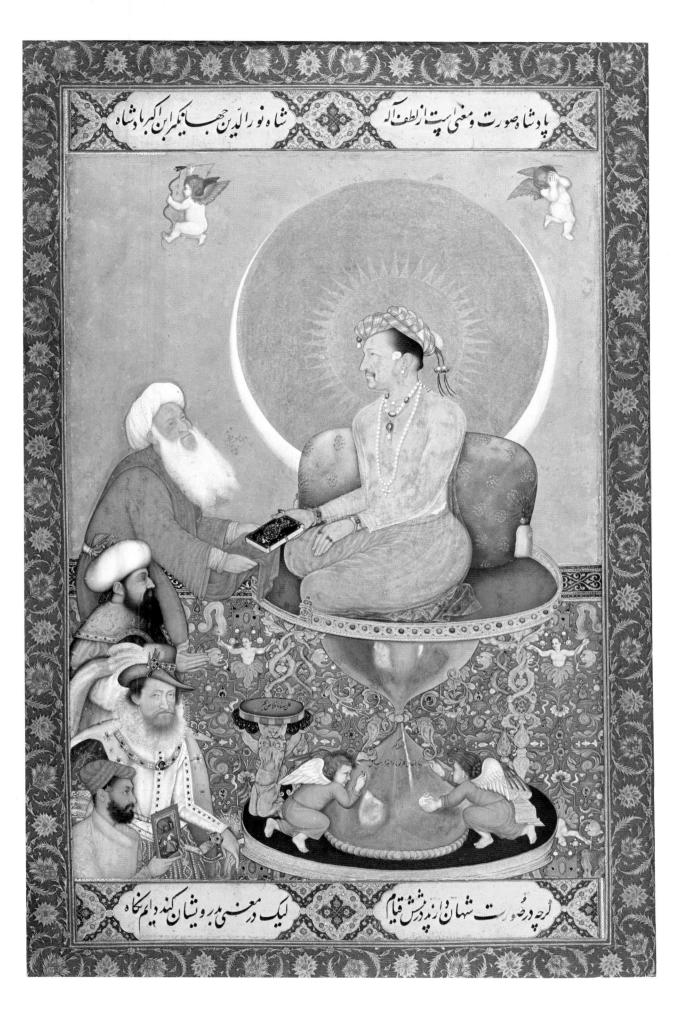

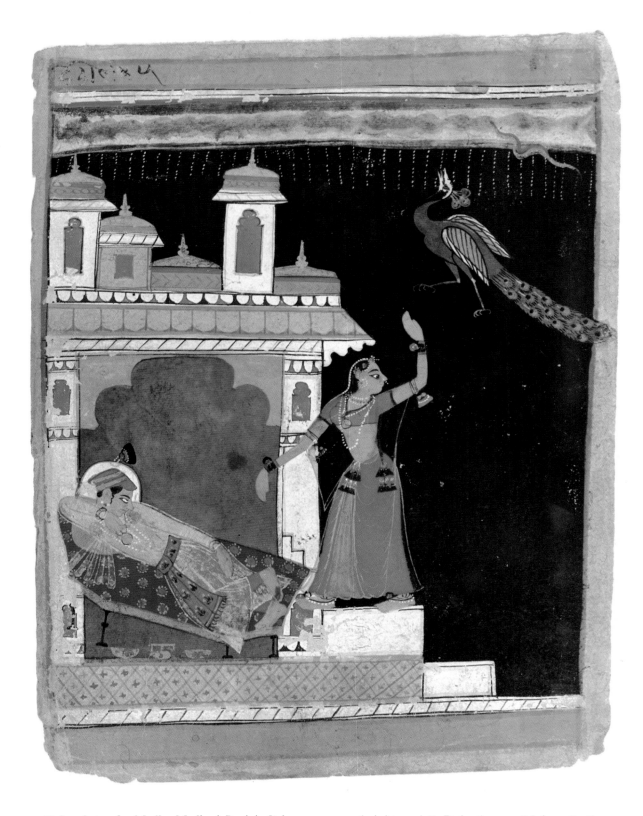

Colorplate 16. *Madhu Madhavi Ragini*. Color on paper, height 7 1/2″. Rajasthan or Malwa, India. Mid-seventeenth century A.D. Cleveland Museum of Art

Colorplate 17. *King Parikshit and the Rishis (?)*, from the opening of the tenth book of the *Bhagavata Purana*. Color on paper, width 8 1/2″. Southern Rajasthan or possibly central India. C. A.D. 1575. Cleveland Museum of Art

Colorplate 18. *Alam Shah Closing the Dam at Shishan Pass, from the Dastan-i-Amir-Hamza.*
Color and gold on muslin; height 32 1/8″, width 25 1/2″. India. Mughal, Akbar school, A.D. 1562–77.
Cleveland Museum of Art. Gift of George P. Bickford

Colorplate 19. *Gajahamurti (After the death of the elephant-demon)*. Color on paper, height 9 1/8″. Basohli, Punjab hills, India. C. A.D. 1690. Cleveland Museum of Art

Colorplate 20. *The Ramayana: The Visit of Ravana to Sita in the Asoka Forest in Lanka.*
Color on paper, width 33 1/4″. Guler, Punjab hills, India. C. A.D. 1720.
Cleveland Museum of Art. Gift of George P. Bickford

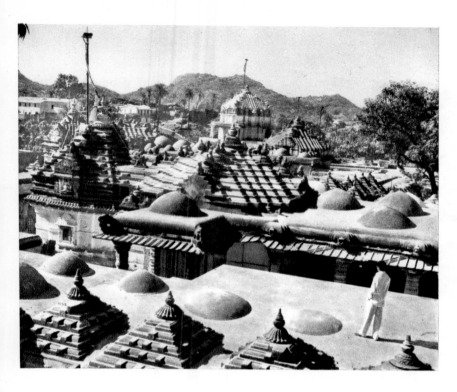

269. *Temples*. Mount Abu, India. General view. Late Medieval period

occupying a corner position transitional from one main wall face to another. She inhabits a space that could have been very simply filled. The classic Gupta solution would have been a figure standing there and looking out, but this was too easy for the complex and extraordinarily inventive minds working on this temple. They placed the figure in the space with one foot flat against one plane, the other foot on a different plane, the buttocks parallel to the spectator, the waist turned, and the shoulders on a plane perpendicular to the plane of the second foot; finally, the head is turned to the back of the niche, with the arm making a connection from the body to the niche. The figure is spirally twisted so that it relates to all the real and implied faces of the space. The posture seems easy and natural, for the artist was master of linear effects. The emphasis is on the long, easily flowing line that repeats, with variations, the swelling curve of the hip. The scarf and breastband seem to ripple lightly over the torso. The drapery clings to the body, and only the borders of the sari are used as proper subjects for the sculptor. Such consistent and subtle linearity is the most characteristic feature of the sculptures at Khajuraho.

A third variant of the northern Medieval style in this region is found at Mount Abu in the Gujarat area of northwest India, where there is a group of marble temples dedicated to the Jain faith (*fig. 269*). Because they are Jain temples, and separated geographically from the great region of northern Medieval sculpture, they show a curious mixture of two styles: one, the northern Medieval style, confined to the secondary images of celestial dancers and musicians and so on, and seen to better advantage at

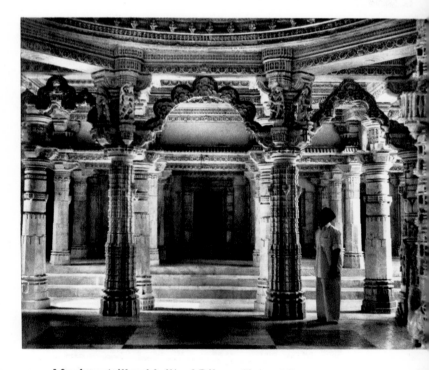

270. *Mandapa (pillared hall) of Dilvara Shrine*. Mount Abu, India. Thirteenth century A.D.

Khajuraho; and an ascetic and antisensuous style that can be attributed to the iconographic expression of Jain religious ideals and can be seen most clearly in the main images, though it carries over somewhat into the secondary images. If we examine a main image of a Tirthankara, or Finder of the

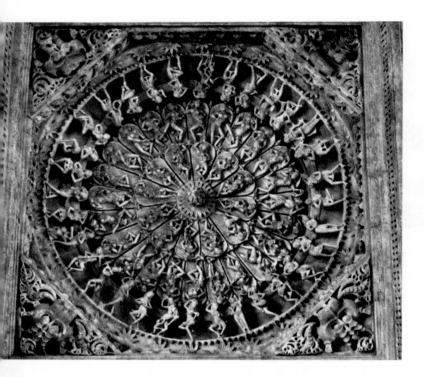

271. *Ceiling frieze of dancers, from Tejahpala's temple to Neminatha.* White marble. Mount Abu, India. A.D. 1232

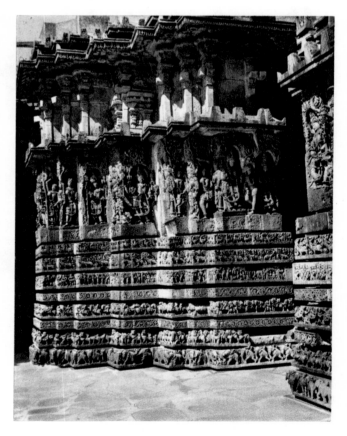

272. *Animal base and figures.* Hoysalesvara Temple, Mysore, India. Thirteenth century A.D.

Ford, we notice a smooth and geometric, almost tubular, treatment. In many images the style can be disturbingly geometrical and antihuman. The faith, more extremely passive in its pietistic attitude than Buddhism, has a rigid code; and these extremes are carried into the main images.

But in the secondary images—of the dancers, for example—some of the Medieval style remains. The paramount impression made by this latter variant of northern Medieval style is one of overelaboration of an embroidery-like ornament (*fig. 270*). In one of the great ceilings over the porches, or *mandapas*, the repetition of the dancing celestial beauties has become mechanical, despite minor variations (*fig. 271*). The whole effect is now merely one of intricacy, with an accompanying loss of spirit and movement, and a tendency toward the coarseness commonly found in the sculpture of north India after the fifteenth century. The only vitality then left is to be found in folk sculptures, not in the works of the professional artisan.

There are other variants of the Medieval style: the wood architecture of Kashmir, and the oddly similar wood architecture of the Malabar coast in the south. There is a peculiar style called Vasara to be found in the region of Mysore, where there are low, flat temples built on a star-shaped plan (*fig. 273*). Their squat, truncated appearance is modified on closer examination by profuse sculptural decoration. The high bases seem encrusted with varied friezes of animals in apparently endless procession (*fig. 272*). Even the images of deities in their niches are thoroughly covered with a heavy and ornate decoration, largely representing festoons of jewelry. What could have been excessive profusion is redeemed by the sensitive and precise cutting of detail as well as by the ever-present living breath of the Medieval style in stone.

SOUTHERN STYLE IN THE LATER MEDIEVAL PERIOD

We turn now to the south, and principally the region of the former Pallava kingdom. Here, because of geographic position and the political strength of the later south Indian kingdoms, the native tradition was largely able to resist the influence of Muhammadan arts of the foreign conquerors in north India. Here, too, in later Medieval times were preserved many Hindu crafts, especially textiles and jewelry, and the arts of the dance. During the Chola period, from the mid-ninth century to about A.D. 1310, one extraordinary monument, the Brihadesvara, or Great Temple, at Tanjore, was erected in about the year 1000. It was a combined fort and temple, with

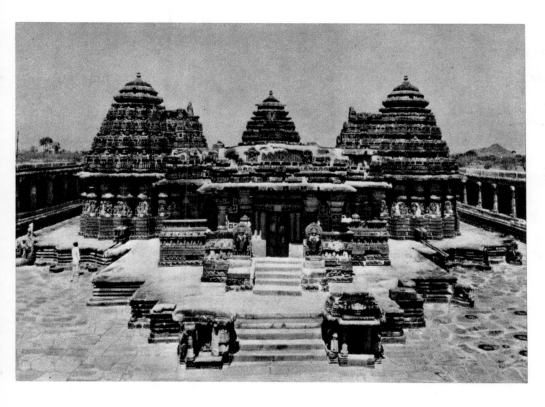

273. *Star Temple.*
Mysore, India.
General view.
A.D. 1268

elaborate battlements and a surrounding moat, which conveys some idea of the political state of the south. Tanjore represents the final development of the earlier southern style, before the decadence of later times. A general view of the Brihadesvara, with the separate Nandi porch in the foreground, reveals that although the tower has developed into a very high structure, its general effect is still angular (*fig. 274*). A closer view would reveal the horizontal stages of the stepped tower characteristic of the southern style. The temple is ninety-six feet high; the capstone is over twenty feet in diameter and weighs

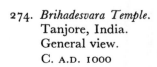

274. *Brihadesvara Temple.*
Tanjore, India.
General view.
C. A.D. 1000

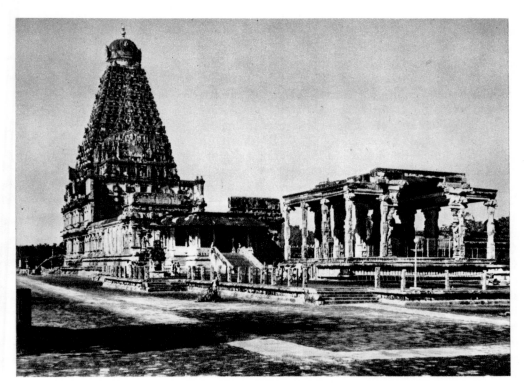

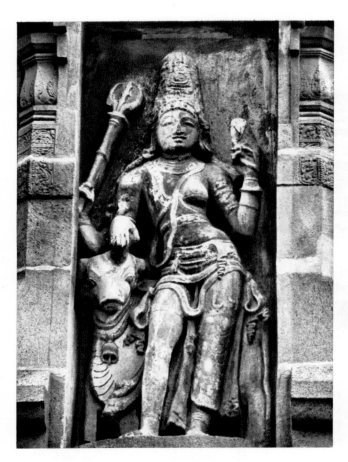

275. *Niche sculpture*. Stone, height approx. 84".
Brihadesvara Temple, Tanjore, India.
C. A.D. 1000

The post-Chola development of south Indian architecture can be briefly summarized by two illustrations. One demonstrates the almost perverse development of the tower, not as the main tower of the shrine, but as towers over the various entrance gates (*fig. 277*). The principal tendency here was toward increasing height, the outer-gate towers being the highest. In later southern architecture the outer buildings of the enclosure and the enclosing walls are overdeveloped at the expense of the temple proper. A typical example of the fourteenth or fifteenth century provides an exciting panorama of great towers rising up out of the hot and steaming plain—impressive until one realizes that the towers are simply gate-towers and that the temple proper, somewhere in the interior, is the architecturally insignificant center of a series of concentric walls whose towers become smaller as the walls approach the temple. Most of the activity of the town is contained in shops and bazaars within the various temple walls. Along with this tendency toward giant-

276. *Dancing apsaras*. Fresco. Chamber 7 of inner ambulatory of sanctuary, Brihadesvara Temple, Tanjore, India. C. A.D. 1000

approximately twenty tons. It was raised to position by means of a ramp two miles long, and is one of the most extraordinary and, in its implications, frightening feats of engineering in India. The sculptures on the temples of Tanjore, and in south India generally, do not have the exuberance exhibited by those of the north. They are usually single figures in niches, and for a very good reason (*fig. 275*). By the tenth century technical dominance in the field of sculpture had passed from stone workers to workers in metal, and the single figure comes into its own, taking on the character of sculpture in metal. The forms in the illustration imitate copper images.

It was not known until a few years ago that the Great Temple at Tanjore also contained important Chola paintings. There is a narrow and rough corridor inside the walls of the tower around the shrine, and on its walls are frescoes, illustrated here in a detail. Though the paintings can be seen only by Hindus, since the temple is still in worship, photographs show that the art of painting was in a high state in the Chola period and that motifs of the dance were dominant (*fig. 276*).

ism in the towers, one finds a proliferation of sculpture over all their surfaces, sculpture of such extremely poor quality that we need not examine it. The only sculptural achievement of any interest is the development of large columns or piers comprising rearing animals—horses, lions, or elephants—their forefeet usually supported by smaller animals or attendants (*fig. 278*). A whole facade of such columns produces an uneasy but impressive effect, until one examines the sculpture in detail. Then one sees the beginnings of a rather crude naturalism, of a petrified anatomical interest, of a frozen, hard, and gross expression in the faces, and of a marked impoverishment in the representation of ornament and movement. They are more like theatrical settings than great works of sculpture. Sometimes, in the subsidiary reliefs around the bases, or in narrative friezes of the *Ramayana* or other epics, there is still some descriptive or narrative power. But in general stone sculpture in the south after the Chola period is aesthetically unrewarding.

Southern Metalwork

Of interest from this time forward are the images in copper and bronze, particularly in copper, among which are some of the greatest metal sculptures in the world. They were meant to be used as aids to worship and range in size from almost life-sized images kept in *puja* (worship) in temples, and consequently often well preserved, to tiny images meant to be carried on one's person or worshiped in personal shrines. Most were cast by the lost-wax process by hereditary guilds of craftsmen. Some of the images were taken from their niches or places of worship in the temples and carried in processions. On these occasions they were dressed in rich silks and cloths which hid the sculpture except for the face. Sculpturally these bronzes, as we shall call them, are the most significant objects of later south Indian art. If early stone work in the Pallava period influenced metal, it is certainly true that, from the Chola period on, metal influences stone. There is a variety of subject matter, but the motif is usually a single figure.

In nearly all of the well-known image types the handling of the material, especially in the taut profiles and complicated turns of the limbs, seems particularly dictated by the requirements of metal. This lithe image of Siva, though relaxed in pose, has something of the spring and tension of metal in contrast to the more static character of stone (*fig. 279*). Its proportions are derived from Pallava sculpture, but its implied movement and conscious grace are contributions of the early Chola period.

Many of the images are badly worn at the face,

277. *Arunacalesvara Temple.* Tiruvannamalai, Madras, India. C. twelfth century A.D.

278. *Horse columns.* Height approx. 144″. Temple of Vishnu, Srirangam, India. Vijayanagar period, sixteenth century A.D.

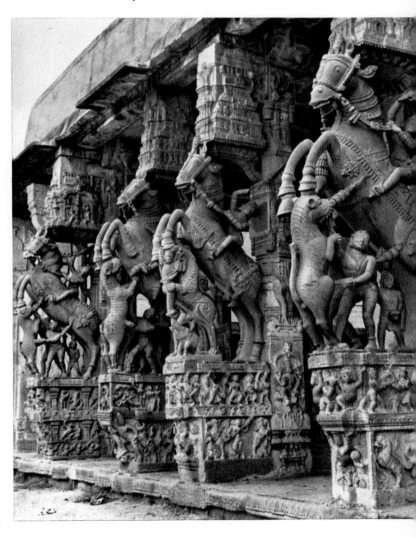

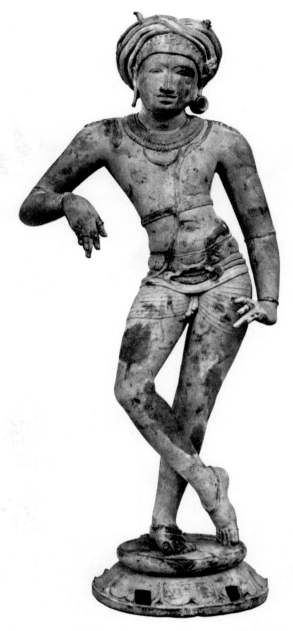

remember the Indian dancer Shankar will realize how much the bronze caster's art owes to the art of the dance.

Rarely do we find complex groups of figures, though occasionally two or three compose a single image, as in the excellent small trident of Siva, bearing a representation of Siva Ardhanarisvara (*fig. 280*). In this work a wonderful metamorphosis between male and female expresses a peculiarly Indian version of the hermaphrodite. The litheness of the pose, the gentle bend and reverse bends of the body, all show the Chola tradition of bronze casting at its best. The images were not always beautiful or handsome; some represent ascetic devotees of Kali, the goddess of death and destruction (*colorplate 14, p. 206*). These are shown as emaciated hags, with pendulous breasts, ribs starting out of the body, and awesomely hideous faces with fangs. But in this image, from the Nelson Gallery–Atkins Museum in Kansas City, we cannot but be impressed with the sculptural quality of the whole. The alertness of the carriage, the still wonderful quality of expansion, the physical well-being, despite the emaciated condition of the figure, seem to shine forth as from all great Indian sculptures.

One of the most entrancing of these conceptions, a subject particularly appealing to Westerners, is

279. *Siva* (from double image with Uma). Copper, height 41″. Excavated at Tiruvenkadu, Tanjore, India. Chola period, reign of Rajaraja I (A.D. 985–1016). Tanjore Museum

because the rite of *puja,* or worship, involves not only prostrating oneself before the image but also the ritual touching of it. Through the holes in the bases passed a rod that was fastened to the wooden base upon which the image was placed when in worship.

We have mentioned the influence of the dance before; here it is dominant. The poses of these figures, their attitudes and gestures, are all derived from the art of the dance. Something of the quality of movement, of rhythm, and of the physical expansiveness of these images is to be found in the great dancers and dancing traditions of south India. Those who

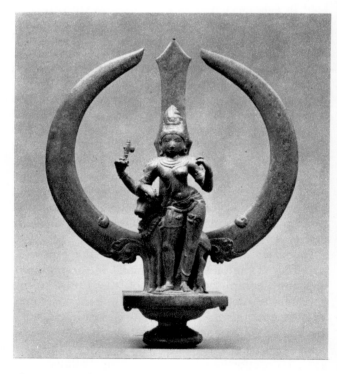

280. *Ardhanarisvara trident.* Bronze, height 15″. South India. Chola period, eleventh–twelfth century A.D. Cleveland Museum of Art

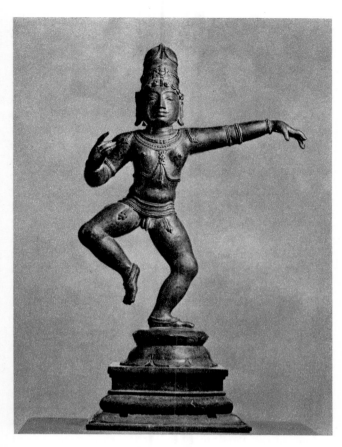

281. *Krishna as the butter thief*. Copper, height 19″.
South India. Fourteenth century A.D. Nelson
Gallery–Atkins Museum, Kansas City. Nelson
Fund

that of the Dancing Krishna—Krishna as the butter thief (*fig. 281*). It is one of the incidents in the Krishna legend, about a childhood prank undoubtedly common in Indian family life and therefore all the more endearing. Krishna is shown as a young, rather fat child, with one leg raised high, arms thrust out as counterbalances, dancing as he runs away with the butter. No subject shows more clearly the importance of the dance for these representational concepts, and none seems so singularly appropriate to the medium of bronze. The weight resting completely upon one leg, the thrust of the hip and of the left arm, all combine to make a metal image worthy of comparison with the great bronzes of the Italian Renaissance.

MUGHAL PAINTING

India's Mughal school of painting owed its existence to the munificent patronage of three outstanding emperors who were devoted to art. The development

of the school, the direction it followed, the subjects it undertook, and the character it achieved were directly influenced by the personalities of these remarkable men: Akbar, his son Jahangir, and Jahangir's son Shah Jahan.

The Mughals came from Ferghana and were descendants of Tamerlane and of Genghis Khan. The founder of the dynasty, Babur, who sought new lands to settle in and so moved to the conquest of India, was familiar with the refinements of Persian art; later, his son Humayun, driven from India by a minor aspirant to the throne, sought refuge in the Persian court of Shah Tahmasp, where miniature painting flourished. Wanting court painters of his own, he brought two Persian artists, Abd al-Samad and Mir Sayyid Ali, to his subsequent refuge in Kabul, where his young son Akbar studied drawing and painting with them. When Humayun returned in triumph to Delhi, the two Persians came with him. After his father's death Akbar increased the number of court painters; the majority of them, however, were not Persians, but Hindus. Akbar preferred their talents; his biographer reports his remark that "the Hindus did not paint their subjects on the page of the imagination"[6], that is, their paintings were close to nature. This judgment is confirmed by Taranatha, the Tibetan historian who wrote in 1608 that Indian painters showed close adherence to natural appearances.

The *Hamza Nama,* tales of the marvelous exploits of the emir Hamza, was the major manuscript produced early in the reign of Akbar. Executed on fine linen on a scale significantly larger than that of any other extant manuscript, the "miniatures" of the *Hamza Nama* (*colorplate 18; p. 210*) are documents of the amalgamation of Persian and Indian idioms into a unified Mughal style and are also works of art of the most bold and energetic character. The hot colors, strident juxtapositions of colors and shapes, and absorption in relatively realistic narrative detail make these pages the fount of later Mughal painting. Akbar's direct participation in the orientation of the work is documented by his contemporary scribe, Abu Fazl. A manuscript of the *Tuti Nama* [Tales of a parrot], more recently discovered and much smaller, must have been begun slightly earlier than the *Hamza Nama,* about A.D. 1560. Their numerous miniatures reveal the participation of various native Indian workshops and the emergence of certain individual masters who later achieved considerable fame—Basawan (*fig. 286*), Dasawanth, Lal, and others. The *Tuti Nama* shares with the *Hamza Nama* both the advantages and the disadvantages of a new school building on the various manners available to the supreme ruler of a strong new dynasty.

Artists of the Mughal school had not only the

earliest inspiration and the actual presence of Persian artists, they had access also to the imperial library with its numerous albums full of Persian drawings and paintings. We can see minor Persian influences in the painting of a ceremonial gathering to witness the meeting of Jahangir and Prince Parviz (*fig. 282*). The Persian manner tended to flatness, a fondness for surface pattern, extreme elegance in line and decorative detail, and some freedom from symmetry in composition. Our illustration shows this Persian influence in the border of the painting with its Persian script, in the dominant Persian arabesque that runs straight down the composition at the right of the scene, in the flat design of the textile in which the emperor is dressed, in the carpet, and in the Persian formula of the cypress and the flowering trees beyond the wall. Distinctly not Persian is the formal balance of the picture, the absence of elegance in the figures standing in stolid array, the very realistic portraiture. The Indian feeling is also revealed in the

mountain cluster at the top and in the flowers in the foreground, transforming them from flat patterns to warm and visually realistic areas.

Akbar was one of the world's great rulers and of a rare and remarkable character. Brought up a Muslim, in his role as emperor of India, which he took with profound seriousness, he sought to bring his Hindu and Muslim subjects together. To this end, he married a Hindu princess. His dream was the creation of a philosophy that would reconcile Muslim, Hindu, and Christian thought. But "divine worship in monarchs," he said, "consists in their justice and good administration."[7] He welcomed Jesuit priests, and on his walls and in his library were European paintings: Christian subjects, Dutch landscapes, and Flemish work. Mughal artists were quick to seize on the new aspects of these foreign pictures and to introduce landscape vistas, European perspective, and atmospheric effects—mist, twilight, or night light—into their pictures.

His artists were called upon to record history and legend in pictures full of action and figures. *Akbar Viewing a Wild Elephant Captured near Malwa*, from the *Akbar Nama*, a history of the emperor, is an admirable example of the work of his school (*fig. 283*). In the elegant horse with its intricately patterned saddle cloth and the curious rocks and shrubs are many echoes of the Persian style, but the elephants are not decorative—their form and action are masterfully depicted. Careful modeling brings out their massive bodies, and their expressions show close observation of individual creatures. These qualities are not Persian but Indian. The picture was painted by two artists, Lal and Sanwlah. Such collaboration was not unusual with Mughal artists, each man taking the subject best suited to his talents. Jahangir later boasted that he could recognize the brush of each of his artists, however small his part of the whole work.

The emperor was extremely interested in the work of his artists and provided the best possible materials. Fine papers were imported or made, delicate brushes and expensive pigments were sought—lampblack, ground lapis lazuli, gold leaf, and powdered gold among them. The resulting excellence of craftsmanship and delicate perfection of textures and atmospheric effects were admired by the Rajput princes often present in the palace. It became the fashion among them, as it was the custom of the Mughals,

282. *The Emperor Jahangir Receiving Prince Parviz in Audience, from the Minto Album.* Attrib. Manohar. Miniature, color on paper; height 15″. Mughal, Jahangir period, A.D. 1610–14. Victoria and Albert Museum, London

283. (opposite) *Akbar Viewing a Wild Elephant Captured near Malwa in 1564, from the Akbar Nama.* By Lal and Sanwlah. Miniature, ink and color on paper; height 15″. India. Mughal, Akbar period, c. A.D. 1600. Victoria and Albert Museum, London

284. *Zebra, from the Minto Album*. By Mansur. Miniature, ink and color on paper; height 7 1/4". India. Mughal, sixteenth year of reign of Jahangir, A.D. 1621. Victoria and Albert Museum, London

285. *Death of Inayat Khan*. Drawing, ink on vellum; width 5 1/4". Mughal, school of Jahangir, early seventeenth century A.D. Museum of Fine Arts, Boston

especially in Jahangir's reign, to bring a train of painters along on their travels.

Akbar's attitude toward painting, frowned on by orthodox Muslims, throws light on the devoted absorption of the Mughal painter in the essentials of his subject. "It always seems to me," he said, "that a painter has very special means of recognizing

God, for when he draws a living thing, and contemplates the thing in detail, he is driven to thinking of God, Who creates the life which he cannot give *his* work, and learns to understand God better."[8]

The influence of this attitude, which induced the artist to render with utmost care and skill the outward appearance of the subject, is most clearly seen in the paintings executed during Jahangir's reign. He had a great reverence for his father, Akbar, and a passion for life; people, birds, animals, and flowers absorbed his attention. He demanded that his artists follow him everywhere to record the amazing wonders that met his eyes. No perfunctory stylized record satisfied him. As can be seen in our illustration of the zebra, the gentle eye, the position of the ears, the delicate hair of the mane and forelock, and the dark, soft muzzle are all carefully recorded (*fig. 284*). Jahangir was not his father's equal in wisdom, but he inherited his father's dream of bringing together the contributions of many lands, a dream somewhat naively illustrated in the marvelous painting that shows Jahangir seated on a jeweled hourglass throne surrounded by a magnificent halo of sun and moon and receiving under his imperial aegis a Muslim divine, a Muslim prince, a European delegate, and an artist (*colorplate 15, p. 207*). The hourglass throne sits on a Renaissance carpet, and scattered about the composition are the figures of small cherubs, copied from European paintings.

The art of portraiture was one of the great contributions of the Mughal school to Indian painting, and the revelation of character in individual faces can be seen in figure 282, Jahangir receiving Prince Parviz, surrounded by the members of his court. Each face has been thoughtfully studied and reveals the person, aged and wise or aged and sterile, youthful and worried or unaware, middle-aged and strong or merely stolid. One of the masterpieces of Jahangir's reign has a curious history and reveals much of the emperor's personality. It portrays the dying Inayat Khan (*fig. 285*). Jahangir describes the occasion of its making in his diary:

On this day news came of the death of Inayat K[han]. . . . He was one of my intimate attendants. As he was addicted to opium, and when he had the chance, to drinking as well, by degrees he became maddened with wine. . . . By my order Hakim Rukna applied remedies, but whatever methods were resorted to gave no profit. . . . At last he became dropsical, and exceedingly low and weak. Some days before this he had petitioned that he might go to Agra. I ordered him to come into my presence and obtain leave. They put him into a palanquin and brought him. He appeared so low and weak that I was astonished. "He was

skin drawn over bones.'' Or rather his bones, too, had dissolved. . . . As it was a very extraordinary case I directed the painters to take his portrait. Next day he travelled the road of non-existence.[9]

Jahangir's artist drew the dying man with an awesome compassion, directly and without flourish. His frail body propped against massive, rounded bolsters, Inayat Khan looks at death with quiet acceptance.

During the reign of Jahangir's son, Shah Jahan, the painting of the Mughal school grew in elegance of texture and color. Portraits, *durbars,* and other subjects were painted so delicately that a hazy bloom seems to lie over the surface of forms. Some aspects of European painting appealed to the Indian artist, and these became assimilated into a thoroughly integrated style. During the reign of Aurangzeb, the last powerful prince of the dynasty, painting languished, for this emperor was a fanatical Muslim who discouraged figural art. A few portraits and battle scenes remain as a record of his day. Artists from the imperial household sought patrons elsewhere.

RAJPUT PAINTING

The Mughal style was primarily realistic, and its natural outlet was portraiture and narrative. But there are details in some of the most famous of Mughal manuscripts on which Indian artists apparently worked where a blending of the two styles occurs and the conceptual, abstract approach of the Jain tradition was wedded to the Mughal observation of nature to produce a fused style, which we can call Rajput. This style lay at hand and ready for a sympathetic subject matter, which was found in the literature of the later revival of Hinduism in northern India.

Rajput painting is the last expression of the northern Medieval tradition. With this subject, the question of decadent or retarded art forms in India immediately arises, for Rajput painting is in some ways a folk art or at least a semi-folk art, and it may well be this quality which has made it less appreciated in the West than it deserves. But there are signs that this attitude is changing, and numerous books on Rajput painting have appeared in recent years. The Rajput style is found in miniature painting, with subject matter ranging from the abstract and intellectual to the extremely concrete and emotional. The size may be partially due to the influence of the miniatures produced by Persian artists or artists under Persian influence at the Delhi Sultanate and later at the Mughal court. Although the art of miniature painting had been practiced in

India before the coming of Islam, it is likely that Rajput painting owes at least its format to the influence of Persian and Mughal painting. To this influence also may be attributed the heightened color, so characteristic of Rajput painting, which in many cases outdoes that of the paintings from which it is derived. Color is one of the most creative aspects of the Rajput style, often used much more arbitrarily than in Mughal art, and in a manner quite akin to that of creative modern painting.

These small Rajput paintings, meant to be kept in albums and seen in sequence, are a product of a cultural atmosphere that included independent city-states; a regional point of view as opposed to the national or imperial one of the Mughal court; and the very important matter of patronage, for the miniature painter could not survive without the patronage of wealthy or royal personages. The importance of Mughal influence notwithstanding,

286. *Tuti Nama* [*Tales of a parrot*]. Tale 5f. 36 v. By Basawan. Miniature, color, ink, and gold on paper; height 7 7/8". India. Mughal, c. A.D. 1570. Cleveland Museum of Art

223

287. One leaf from a *Kalpa Sutra manuscript*. Length 10 1/4″. India. Western Indian school, sixteenth century A.D. Cleveland Museum of Art

there is a basic difference between Mughal and Rajput painting. The former, for all its detail and marvelously taut and powerful drawing, is still naturalistic in its approach. It tends to be realistic, desiring to conquer the appearances of nature, particularly in human and animal portraiture. On the other hand, most Rajput paintings are conceptual; the artist was mainly concerned with the idea, whether religious or poetical, behind the picture, and used color and shape to express the mood or atmosphere of the idea, its *rasa* or flavor.

The origins of the Rajput style are twofold. We have already mentioned the underlying influence of Indo-Persian painters, who in turn were greatly influenced by Persian miniaturists. The second influence is one out of Indian Medieval tradition, and from a very particular and specialized part of that tradition—the Jain and Hindu manuscripts made in the Gujarat regions of western India for wealthy monasteries and merchants of the region. These manuscripts are painted on paper, with the text dominating a small illustration on each page (*fig. 287*). They employ certain mannerisms characteristic of Medieval Hindu fresco paintings, such as can be seen in the surviving murals on the ceiling of the

288. *Poems of Spring, from the Vasanta Vilasa*. Color on roll of cotton cloth. Western India. Gujarati-Rajput, mid-sixteenth century A.D. Freer Gallery of Art, Smithsonian Institution, Washington, D.C.

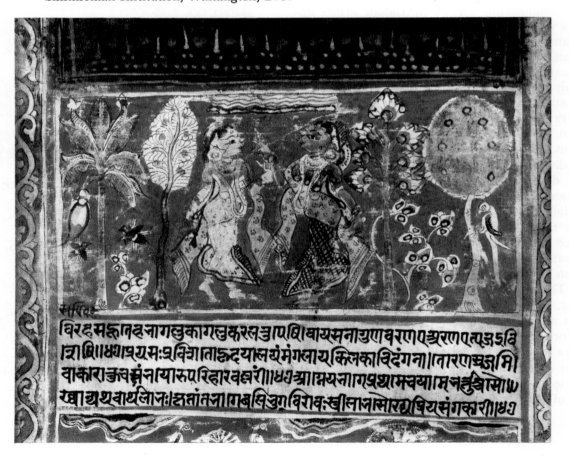

Kailasanatha at Ellora (*fig. 253*). Persian influences are found mainly in certain textile designs and sprays of flowers; but no Persian would ever have painted a miniature like figure 287, whose style partakes largely of the geometricizing, antihumanist approach seen in Jain sculpture in the Gujarat. Here is one of the most abstract, most conceptual forms of painting that the world has ever seen. Color is used in simple, flat areas. Figures are arbitrarily conventionalized; the eye, for example, in a three-quarter view of the face, projects conspicuously, as it does in the frescoes at Ellora. This approach is not confined to the handling of figures, for architectural details and interior furnishings, trees and sky, all have their lively, stylized formulae, so constantly repeated that they often become monotonous. The patterning of the textile designs and the use of gold are also part of a seemingly desperate effort by the painter to reduce the visible world to a small conceptual framework that can be comprehended as one comprehends the script next to the picture.

Though some see in Rajput painting only a decadent and degenerate form of Mughal painting, this little illuminated manuscript showing two dancers has enough of the elements of the Gujarati manuscript style—particularly the use of the projecting profile eye—to prove at least the partial development of Rajput painting out of that tradition (*fig. 288*). Color, however, is less abstract, more decorative, and we have the use, as W. G. Archer says, of passionate reds and verdant greens to produce a new style that is primarily lyrical rather than intellectual, one that appeals to the emotions rather than to the mind. The future of the Rajput style was not to be in the western region, but in north central India, at first in Rajputana, the same region that produced the Nagara style of Indian architecture and sculpture. Later the style would flower in the foothills of the Himalayas. The first phase of the Rajputana style was primitive, derived from the fusion of the Gujarat and Delhi elements, and found in a few rare manuscripts from the sixteenth and early seventeenth centuries. One manuscript in particular is of the highest importance. It is a painting representing the Month of Rains, with a cloudy sky and rain falling against a blue ground (*fig. 289*). There is an almost perfect fusion of the abstract patterning, the eye convention, and something of the color of the Gujarati manuscripts with a new, fresh complexity of composition, which becomes the Rajput style. Niches containing vases are still used as patterns; the figure is confined to profile or the full front view; but the new style is now capable of expressing an intensity of passion, particularly through color, that was most appropriate to that revival of personal devotion typical of the Krishna

cult in the later Medieval period. There are almost no traces of Mughal influence except in architectural motifs—and Mughal domestic architecture dominated north India. Representations of a cupola here, or of niches with pointed arches there, are derived from the familiar Mughal architecture rather than Mughal painting.

There are three major geographic areas and schools of Rajput painting. The first and earliest is that of Rajasthan and Malwa, active in the seventeenth and eighteenth centuries and occupying the area corresponding roughly to the region north and west of Delhi as far as the foothills. The second is the school of central India, the region of the Deccan Plateau. This school was active from the late six-

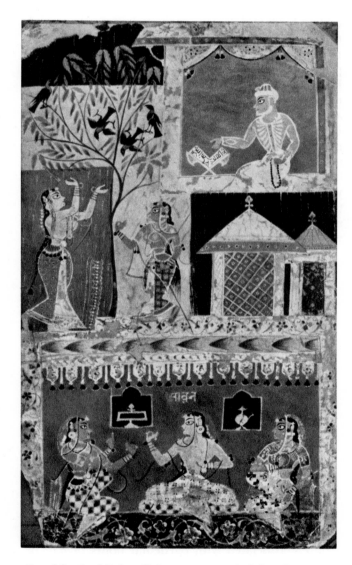

289. *Month of Rains.* Color on paper, height 9″.
Western India. Mid-sixteenth century A.D.
Central Museum, Lahore

teenth century on, heavily influenced by Mughal style. The third is the school of the Punjab hill states (Pahari), including such states as Basohli, Jammu, Guler, Garhwal, and Kangra, and particularly active in the eighteenth and early nineteenth centuries. It produced the most charming and lyrical of the Rajput paintings, as the Rajasthani school provided the most powerful and most daring.

The schools are unified to a certain extent by their subject matter and symbolism. Principal subjects illustrate seasonal songs called *ragas* (musical modes), epics, and literature concerned primarily with Krishna and, by the late seventeenth and the eighteenth century, with Siva. We find, particularly in the Rajasthani school, a union of music, literature, and pictorial art, through the musical mode. Such a unity could only occur where there was an accepted tradition of interpretation: where a given color, certain birds and flowers, suggested particular moods or situations; where a representation of the month of August brought to mind the musical phrase appropriate and traditional for that month. Within the Rajput tradition, there was a truly unique union of music, literature, and painting, even beyond that achieved by the Baroque painters under the motto *Ut Pictura Poesis*. A pictorial representation of a musical mode has many levels of reference all united in one vision: a specific musical theme, a particular hour of the day, day of the month, and month of the year, as well as a familiar romantic situation between the protagonists, usually Radha and Krishna. Coomaraswamy's description makes clear this interweaving of the *ragmala:*

A favorite theme of Rajasthani painters is a set of illustrations to a *Ragamala,* or "Garland of Ragas," poems describing the thirty-six musical modes. The *Raga* [male] or *Ragini* [female] consists of a selection of from five to seven notes or rather intervals, distributed over the scale from C to C, the entire gamut of twenty-two notes being never employed in a single composition. . . . The *Raga* or *Ragini* is further defined by characteristic progressions, and a leading note to which the song constantly returns, but on which it does not necessarily end. . . . What is most important to observe is that the mode is known as clearly by the mood it expresses and evokes as by the technical musical definition. . . . The moods expressed . . . are connected with phases of love as classified by Hindu rhetoricians, and are appropriate to particular seasons or elements . . . and all are definitely associated with particular hours of day or night, when alone they may be appropriately sung. . . . *Ragmala* paintings represent situations in human experience having the same emotional

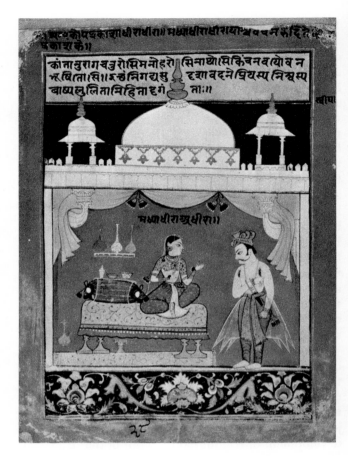

290. *Adhira Nayaka.* Color on paper, height 10″. Mewar (Udaipur), Rajasthan, India. Early seventeenth century A.D. Cleveland Museum of Art

content as that which forms the burden of the mode illustrated. In other words, the burden of the music, the flavor of the poem, and the theme of the picture are identical.[10]

The *nayaka,* a typology of women in love, generally eight of them, was also a favorite subject of the Rajasthani school (*fig. 290*). It treats of romantic love, that is, love at first sight, usually extramarital, and based upon a physical attraction that is not distinguished from a spiritual one. Such a concept of love seems characteristic of a well-guarded social order in which marriages are arranged. *Abhisarika Nayaka* is she who goes out to seek her beloved, and the appropriate poem tells us that

Serpents twine about her ankles, snakes are trampled under foot, divers ghosts she sees on every hand,
She takes no keep for pelting rain, nor hosts of locusts screaming midst the roaring of the storm,

She does not heed her jewels falling, nor her torn
dress, the thorns that pierce her breast delay
her not,—
The goblin-wives are asking her: "Whence have
you learnt this yoga? How marvellous this
trysting, O Abhisarika!"[11]

It is significant that in this early picture the rep-
resentation of this *nayika* is not literal but general
(*colorplate 16, p. 208*). In later depictions of this
heroine the representation becomes literal: We see
the serpents, the rain, and the jewels falling.

The *nayakas* and traditional religious subjects,
representations of Siva, of Durga, and of Vishnu, are
characteristic of Basohli, the earliest of the hill
schools; representations of the narrative stories of the
Krishna cult seem most characteristic of the later
hill schools. Portraits and court groups occur in all
schools, usually where Mughal influence is heaviest
and especially in the late eighteenth and the nine-
teenth century (*see fig. 296*).

Priority for the development of a recognizable
Rajput "primitive" style must be assigned to south-
ern Rajasthan and to Malwa, geographically a part
of central India but a close neighbor to Rajasthan.
Pages from a few series are known, all in a similar
style dated as early as 1540 by Gray and Archer, who
attribute them to Mandu (*colorplate 17, p. 209*).
Some Persian elements are discernible in the orna-
ment, but the colors and figural representations are
clearly derived from the west Indian manuscript
tradition and perhaps in part from an almost lost
mural tradition of the Medieval period.

This new manner appears to have spread to the
north, and by 1630 there is a broadly homogeneous
style ranging from Malwa to Mewar with, of course,
local variations and flavors. The famous Coomara-
swamy series, with its distinctive dark blue back-
grounds, is a particularly bold and daring rendering
of the Malwa style. *Abhisarika Nayaka* here is both a
musical mode (*Madhu Madhavi Ragini*) and a repre-
sentation of a heroine who goes in the night to meet
her lover (*see colorplate 16, p. 208*). She comes through
the black night with peacocks screaming about her,
as rain clouds form and lightning flashes, but the
representation is not frightening. The situation is
rendered "conventionally"; nevertheless, the use of
color, shapes, and patterns of shape and color is
hardly stereotyped. It is extremely daring and bold,
and recalls Egyptian painting as much as it seems to
anticipate some of the experiments of modern paint-
ing, particularly by artists such as Matisse. In this
manuscript of about 1630 we have an early and
classic statement of the Rajasthani style, after the
assimilation of the varied elements contributing to
it.

The development of Rajasthani painting in the
eighteenth century, under the influence of Mughal
painting, is toward greater finish and perfection of
detail, but it still maintains the brilliant and arbi-
trary use of color that is the hallmark of Rajasthan.
These qualities are clearly present in the Bikaner and
Jaipur pages. Bundi (*fig. 291*), and its derivative,
Kotah (*fig. 292*), continue the bolder traditions of
Rajasthan into the late eighteenth and early nine-
teenth centuries.

The third major school, that of the Punjab hills,
is in quantity of work probably the most important.
In many works it equals the Rajasthani school in
quality, but of quite a different kind. It emphasizes
linear drawing and, with the exception of the Basohli
school, a lyrical, gentle style. The Basohli is the
earliest school in the hills and makes the transition
from the Rajasthani style to the developed hill style.

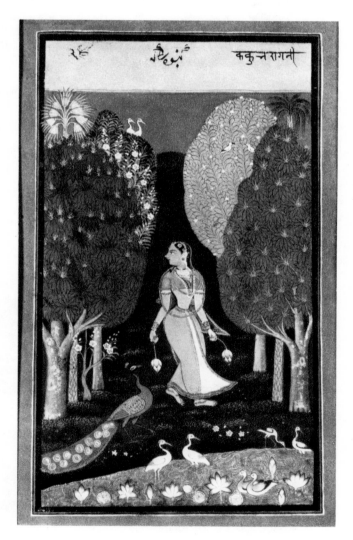

291. *Kakubha Ragini*. Color on paper, height 10 1/2".
Bundi, Rajasthan, India. C. A.D. 1680.
George P. Bickford Collection, Cleveland

292. *Tiger Hunt on a River Bend.* Color on paper, width 19 1/2". Kotah, Rajasthan, India. C. A.D. 1790. George P. Bickford Collection, Cleveland

Basohli miniatures have something of the rich color and daring juxtapositions found in Rajasthani painting, but with something that is peculiar to the early Basohli school and its derivatives, Kulu and Nurpur, and does not appear in other, later, paintings of the hill states (*fig. 293*). This unique quality is a use of extremely warm color, which makes them among

the "hottest" paintings ever created. These mustard yellows, burnt oranges, deep reds, and torrid greens are pulled together in a unity as hot as Indian curry. The rigidity of the poses of figures recalls Rajasthani miniatures.

A very fine Basohli page of about 1690 shows a category of subject matter in which the Basohli school

293. *Radha and Krishna.* Illustration of the *Rasamanjari* of Bhanu Datta. Color, gold, silver, and beetle wing on paper, height 9 1/8". Punjab hills, India. Basohli school, c. 1600–1670. Cleveland Museum of Art

excelled: the representation of deities in almost iconic form (*colorplate 19, p. 211*). The manner goes back to earlier traditions—that is, rigid figures in a balanced composition—and their representations of Siva, Vishnu, Brahma, and others. Here we have a representation of Siva and Parvati, emphasizing Siva as the slayer of the elephant-demon. They float in the sky on the elephant's hide, against stormy, curling clouds above a warm, if rather sparse, Basohli landscape.

But the characteristic work of the hill states is to be found in the paintings produced first in Guler and later, when the style expanded, in all the hill states (*figs. 294–96 and colorplates 20, 21*). It is a gracious and poetic style, somewhat under the influence of later Basohli painting but with heavy Mughal influences. Its technique is more complex and tighter than that of Basohli. The miniature technique of the Mughal school, with its use of polished white grounds, under-drawing, over-drawing, and then a rich, jewel-like application of color, was carried on by the hill painters; but at the same time some of the flat mural color of the Rajasthani school was also preserved. Subject matter tends to be involved with either the poetic revival of the Krishna cycle, with its pastoral symbolism and erotic overtones, or with the heroic epics of the past, the *Mahabharata* and the *Ramayana* (*colorplate 20, p. 212*). The musical modes almost disappear, though the heroines, the *nayikas,* continue, and also some of the traditional religious subjects. But in general the characteristic hill school subject matter is either from the *Krishna Lila* or from the two great Hindu epics.

An album page by the "Garhwal Master," as W. G. Archer calls him, presents the characteristic

294. *The Road to Krishna.* By the "Garhwal Master." Color on paper, height 8″. Guler, Punjab hills, India. C. A.D. 1785. Victoria and Albert Museum, London

elements of the developed later Punjab hill style (*fig. 294*). There is an emphasis on decorative pattern achieved by repetitions of line and shape. An attempt is made, perhaps under Western influence, at landscape vistas with architectural views and perspective in depth. A more realistic and observant delineation of the figure is achieved, in an attempt to characterize youth, old age, and social position. All this is combined with enough decorative character to distinguish the style very sharply from that of the

295. *Durga Slaying Mahisha.* Color on paper, width 10 3/4″. Kangra, Punjab hills, India. C. A.D. 1830. Cleveland Museum of Art

Mughal school. Guler produced works that combine the very best qualities of the Rajasthani and Mughal schools. Another page displays a rich use of color in the blue Krishna against pearly white accompanied by pale mustard yellow, a fascinating combination, while the pure linear drawing of the figure, profile, and drapery is a hallmark of the later hill schools (*colorplate 21, p. 277*). The introduction of perspective in the little porch leading off the main room is unobtrusive and actually serves as a point of focus, heightening the interest in the main figure of Krishna gazing into the distance and yearning for his beloved Radha. The knowing glances of the attendant girls are subtly depicted, and the whole picture shows the hand of one of the great masters of the school.

The later schools of the Punjab hills, particularly in rather large pages, are preoccupied with the Hindu epics. Here realism is combined with something of a fairy-tale quality in works of the greatest interest. Another Guler page is one of the master-pieces of the hill states and a rare representation of a traditional subject. It is the same subject seen in pages of Bundi and Kulu origin: Durga slaying the bull-demon Mahisha (*fig. 295*). The demon is a realistic bull, not a man issuing from a bull as in the earlier pages. Durga, on her chariot drawn by two tigers, attended by her child-warriors, is drawn in a beautiful fine-line style. The landscape, used to reinforce the meaning of the composition, is divided into two parts: Over the evil bull is a rather barren and distant expanse with a storm; over the forces of good, a lush view with a clear blue sky. At the same time the fairy-tale, never-never-land atmosphere of later Rajput painting permeates the picture. The imminent death of the bull seems forgotten; the tigers are almost playful; and the goddess herself, even in this her most vengeful aspect, appears as a lyrically beautiful young woman.

Rajput painting deteriorated sadly by the middle of the nineteenth century, although some artists produced reasonably good pages up to 1900.

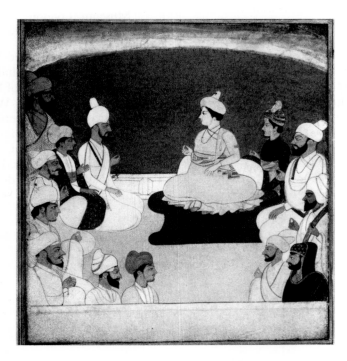

296. *Raja Sansar Chand of Kangra with His Courtiers.*
Color on paper, height 9 1/2". Punjab hills,
India. Jammu-Sikh school, c. A.D. 1780.
George P. Bickford Collection, Cleveland

11

The Medieval Art of Southeast Asia and Indonesia

CAMBODIAN ART

Popular interest in Cambodian art stems largely from a sentimental fondness for the "smile of Angkor." Nearly all tourists to Southeast Asia made a point of the pilgrimage to Angkor Vat, there to be properly impressed with the size of the vast stone structure in the midst of the jungle. But sentimental appreciation is a most limited approach to the unique Cambodian style. Whereas India produced great sculpture in an organic tradition, one emphasizing movement and sensuousness, Cambodian art moves us by a peculiar combination of sensuality allied to a strong architectonic character, almost as if the sensuous elements of Indian sculpture were merged with the formal characteristics of Egyptian sculpture into a single unity.

Cambodia comprises a relatively small area in Southeast Asia, where the earliest artistic manifestations were influenced from the north, whence came certain techniques from south China. A few intricately cast bronze drums and a few rudimentary animal sculptures in stone are among the artifacts left to us from this very early period. But sea contacts with India became important beginning about the third century A.D., and, as so often happens when a relatively low culture comes in contact with the high culture of a fully developed and expanding state such as India, the impact was sudden, dramatic, and overwhelming. Shortly after the fourth century A.D. manifestations of this Indian influence begin to appear in the regions of present-day Thailand and Cambodia. Indian influence affected not only

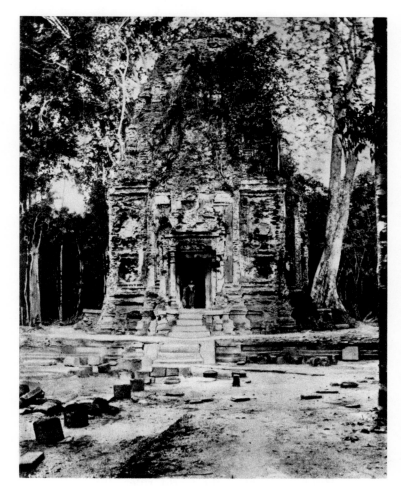

297. *Sambor Prei Kouk, Cambodia.* Early seventh century A.D.

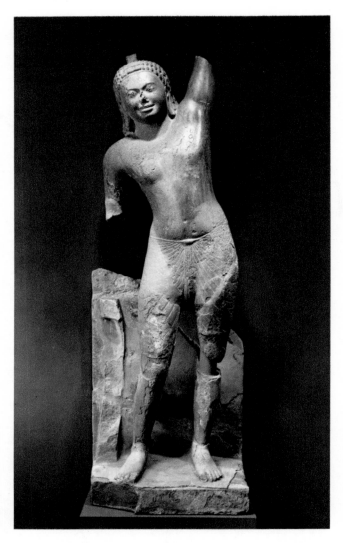

298. *Krishna Govardhana.* Gray limestone, height 96″.
Cambodia. Early Khmer, first half of sixth
century A.D. Cleveland Museum of Art

and all power, religious and secular, was centered in him. The monuments of Cambodian art, sculptural and architectural, can be considered the embodiments or continuations after death of the king and his world.

The common origin of the early styles in the region of Cambodia and Thailand is the Gupta style, that international style beginning in the third and fourth centuries A.D. in India and thence exported to Indonesia, Thailand, Burma, and Java. But although the point of origin was the same, stylistic development in these countries took different paths. Thai and Cambodian art, somewhat difficult to differentiate in their earliest manifestations, later become more and more divergent, more individual, and more easily distinguishable. Successive waves of Indian influence can be detected, some of them from

299. *Vishnu.* Gray sandstone, height 34 1/4″. Style of
Prasat Andet, Cambodia. Second half of seventh
century A.D. Cleveland Museum of Art

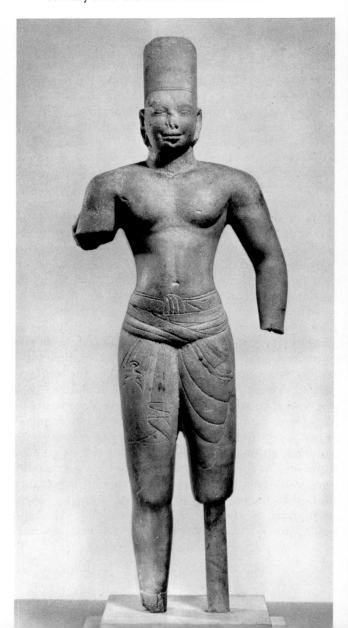

sculpture and architecture but involved the organization of the higher levels of society as well. The impact was relatively slight on the lower levels of society, where even today we can find traces of pre-Hindu culture. Buddhism and Hinduism were both imported into Cambodia at this time, with Hinduism by all odds the strongest and largely dominant influence, despite the evidence of numerous Buddhist monuments. The two were synthesized into a peculiarly Cambodian amalgam of state cult and religion—the cult of the *devaraja*, the god-king. This system, which may have originated in Java under the great Srivijaya empire at a time when it exercised some control over Cambodia and Thailand, became the characteristic expression of Cambodian society and of Cambodian art. The Javanese version, in turn, was probably derived from the Hindu concept of the world ruler, the *chakravartin*. But in Cambodia the cult of the *devaraja* took an extreme form; the king in effect became the god,

Bengal and some from the Pallava empire in south India. Cambodian art ended in the fifteenth century, when the Thai military power destroyed Angkor, after which the Cambodian style persisted only as a native folk art.

A monument antedating the cult of the *devaraja* is Prei Kouk of the sixth or seventh century A.D. (*fig. 297*). Its interest lies in its Indian origins and in its physical insignificance compared with the later, magnificent monuments of the cult of the *devaraja*. Prei Kouk is fundamentally a single cell, like the Durga Rath at Mahamallapuram, its entrance flanked by niches containing images of the deity worshiped inside. The basic structure, under the stone dressing, is brick; and this too marks it as primitive, for the later development and glory of Cambodian architecture is embodied in stone.

The sculpture of this early period, which we call early Khmer, from the sixth to the ninth century A.D., is of greater artistic interest than the architecture. Although the new sculptural style was derived from the Gupta manner of India, it seems to have acquired from the beginning a monumental and architectonic character radically different from its Gupta antecedents. The earliest sculptures are of one type, with the S-curve (*tribhanga*) of the body, magnificent squared shoulders, a large chest, and a delineation of the torso that is completely unknown in most Indian sculpture.

The Krishna Govardhana (*fig. 298*) is one of the most extraordinary of these productions, a work that ranks high in a world hierarchy of sculpture. The god is shown holding aloft the mountain as shelter for his devotees. The fusion of stress and superhuman ease is a complex problem not often assayed in early Cambodian art, and the solution here serves to raise the work above other, more iconic, sculptures found in the same area.

The earliest Khmer sculptures, properly enough, still retain a certain sensuousness derived from the Gupta style. The later sculptures of the seventh and eighth centuries A.D. have a far more powerful and architectonic character. Figures of this period, such as an image of Vishnu, still show something of the subtlety and soft modeling of the earliest Khmer pieces (*fig. 299*). But the Cleveland Vishnu is strongly cubic: The massive shoulders and neck, the almost geometric torso, the careful use of incising to indicate drapery without destroying the blocklike character of the whole—these are combined in a unified work of art easily distinguishable from any Indian prototype. These early Khmer sculptures, usually sculptures of Vishnu or of the deity known as Hari-Hara, a combination of Siva and Vishnu in one image, are the standard iconographical embodiments of early Khmer style: single figures

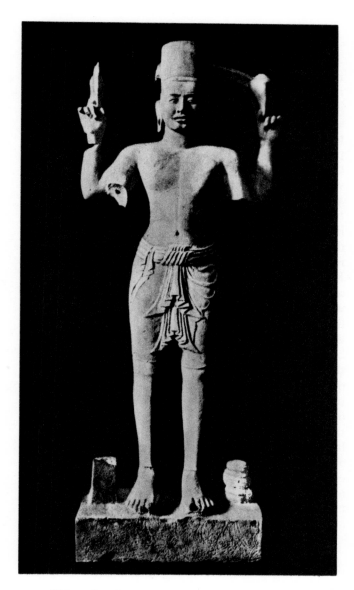

300. *Vishnu*. Sandstone, height approx. 60". Koulen, Cambodia. Koulen period, first half of ninth century A.D.

standing rather rigidly facing the spectator, oftentimes with a body halo in stone.

With the end of the eighth century and with the reign of the Javanese king Jayavarman II comes the introduction of the cult of the *devaraja*. The concept of the World Mountain in Cambodian architecture also dates from this time. The mountain becomes an integral part of the architectural organization, whether it is a natural mountain or, as in later Cambodian architecture, a constructed one. It is the axis of the universe and must be incorporated in the temple itself. The beginnings of this development consist in a simple cell-shrine, of the type of Sambor Prei Kouk, located on top of a natural holy eminence, as at the earliest site of the cult of the *devaraja* and at the first mountain-temple in Koulen. From this very simple beginning, a shrine on the natural mountain, the great complex stone architectural

monuments of Angkor Vat and the Bayon in the region of Angkor were to develop. The Koulen site is also important because it produced a sculptural style that marks the transition from the early Khmer to the developed Angkor styles. This relatively complete image of Vishnu from Koulen (part of the body halo is missing) shows the god holding the disk, or wheel—the *chakra*—as his principal attribute ·(*fig. 300*). Though it has still something of the architectural character of early Khmer sculptures, the lower limbs have begun to be modified. From the hips down, and particularly from the knees down, the modeling seems much less sensitive than on the early Khmer pieces. As in much of later Cambodian sculpture, the artist's sensitivity seems to end at the waistline; the legs become rigid and still, almost like tubes, while the upper part of the body retains the earlier sensitivity and finesse and the head begins to show, particularly in the modeling of the lips, something of that sensuous and romantic quality which has so endeared Cambodian sculpture to the modern world. The mysterious smile of Angkor is beginning to play about the corners of the mouth. The drapery, too, is developed into a larger and more important part of the composition, a decorative motif in its own right. The folds are emphasized in relatively high relief, not simply incised on the surface of the sculpture. This tendency toward a decorative handling of drapery and accessories is characteristic of later Cambodian sculpture.

Cambodian art is generally divided into three periods: early Khmer, from the sixth to the late ninth century A.D.; the First style of Angkor, from the late ninth to the beginning of the eleventh century; and the Second style of Angkor, from the beginning of the eleventh to the beginning of the thirteenth. The First style of Angkor introduces increasing architectural complexity. In the development that leads to Angkor Vat, two significant steps are represented by the temple complexes of Preah Ko, dated to A.D. 879 (*fig. 301*), and Ta Keo, dated to about A.D. 1000 (*fig. 302*). Preah Ko is of mixed construction, brick and stone, and is more complex and developed than Prei Kouk. Its six shrines, though single cells, are now grouped on a common pedestal. The architects have abandoned the concept of a shrine standing on a natural mountain and have begun building a microcosm that symbolizes the mountain. But the combination of the two is not yet organic. Ta Keo, on the other hand, offers a full statement of the essentials of the great Cambodian architectural style: a central shrine flanked by four subsidiary shrines, each shrine surmounted by a tower. All this is made of stone and placed on a stepped pyramid of stone, with the beginnings of galleries around the central structure, which represents the mountain. In the background near the palms, at the outer wall of the lowest level of the pyramid, there is a series of columns indicating a gallery around the whole structure. These essentials, towers of stone on a raised pyramid with surrounding galleries, are the basic elements of almost all later Cambodian architecture.

The development seen in architecture is paralleled in architectural ornament. We illustrate a sequence

301. *Preah Ko, Cambodia.* A.D. 879

302. *Ta Keo, Cambodia.* C. A.D. 1000

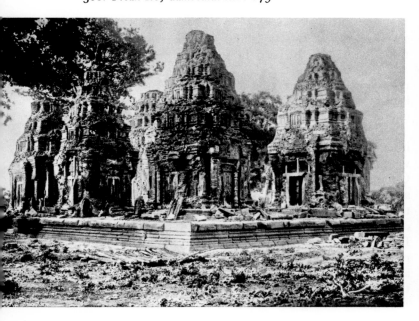

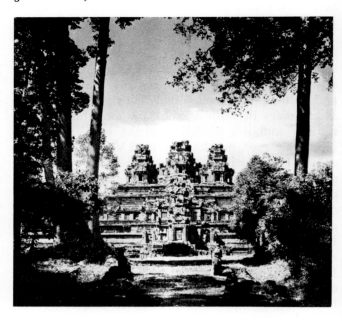

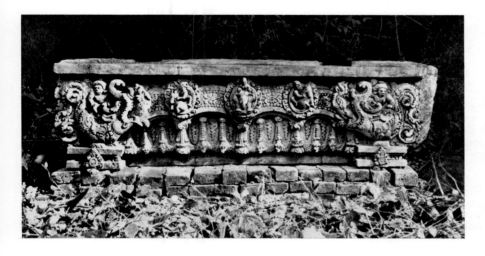

303. (left) *Lintel, from Sambor Prei Kouk*. Sandstone. Cambodia. Musée Guimet, Paris

304. (below) *Lintel*. Sandstone. Koulen, Cambodia. Musée Guimet, Paris

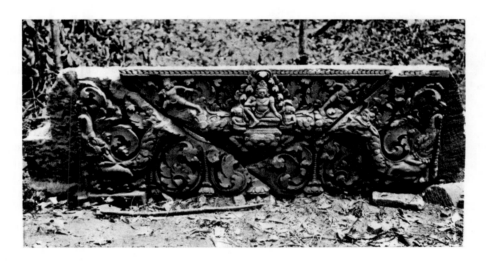

305. *Lintel*. Sandstone. Banteay Srei, Cambodia. Musée Guimet, Paris

of three lintels in stone that span the time traveled so far. Figure 303 is early Khmer, figure 304 is a transitional example, corresponding to the style of Koulen, and figure 305 is from Banteay Srei. Looking at the first, one can see that it is related in general format to the south Indian architectural style. The little roundels correspond to the windows at Mahamallapuram (*see figs. 229, 230*). There are *makaras* (dragon-fish), a typical south Indian and Sinhalese motif, and hanging jeweled garlands, found also in Sri Lanka and in some early monuments in south India. Note, too, how the whole design is held in bounds by a heavy border above and below, and that this border is repeated within the sculptural decoration, allowing the lintel to retain its architectural character. The carving is not insistent and does not yet dominate the shape of the lintel, when compared with what is to come. The second lintel (*fig. 304*) is sculpturally much more

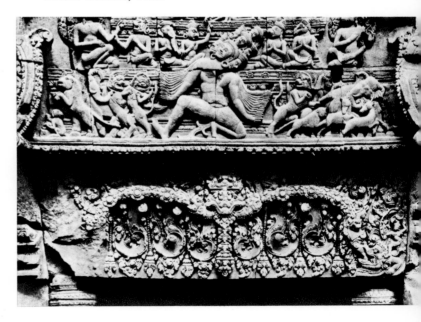

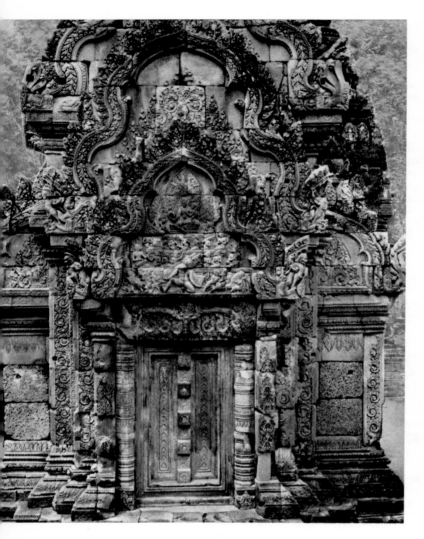

306. *Central chapels*. Banteay Srei, Cambodia. General view. Tenth century A.D.

elaborate. The architectural boundaries of the lintel are breached. The surface of the lintel is so broken up by the carving that the design tends to become an overall pattern. The third illustration (*fig. 305*) pictures a lintel of the First style of Angkor, and gives some idea of the beginnings of the last style in Cambodian architectural sculpture. Concern with architectural structure is now at a minimum; it is reduced to a small beaded border, and the form of the arch has become a hanging vine motif, incorporated into the sculptural foliage dominating the whole composition. Peering into this deeply cut vegetative ornament, one can make out *makaras*, lions, and small figures. But these figures are amalgamated with the foliage so that the whole effect becomes jungle-like. This type of architectural ornament—showing a profusion of vegetative motifs, an abhorrence of empty space, and a desire to cover every possible area with as much carving as pos-

sible—is characteristic of the developed Cambodian style.

One monument provides us with a classic example of relief sculpture in the early First style of Angkor. Banteay Srei is dated to the tenth century A.D., based on the incontrovertible evidence of inscriptions. The whole question of the dating of Cambodian sculpture and architecture is one of the most fascinating bypaths in art history. Before 1929 an apparently satisfactory system of dating had been proposed by French scholars. Then Philippe Stern published a small book called *Le Bayon d'Angkor et l'évolution de l'art Khmer*, completely reversing the accepted chronology and proving conclusively that monuments previously assigned to the thirteenth century were really of the ninth, and that monuments which had been considered ninth and tenth were of the thirteenth century. This was one of the most striking reversals in the dating of an important body of material ever published, as if European art historians had suddenly discovered that they had been transposing the dates of Romanesque Conques and Gothic Amiens.

Banteay Srei is the key monument in this sequence beginning with the tenth century (*fig. 306*). It is a jewel of a shrine, with important lintels showing scenes from the *Ramayana*. Note the character of the upper architectural ornament, a botanic maze surrounding the arch. The arch itself has taken on an undulating, almost snakelike, movement in keep-

307. *Relief*. Sandstone. Tympanum at Banteay Srei, Cambodia. Tenth century A.D.

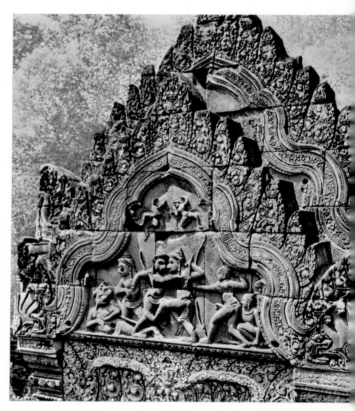

ing with the spirit of the carving. Inside the sinuously profiled arches the scenes are formally, almost symmetrically, arranged, with a central figure, flanking figures in reversed poses, and finally figures balancing the lower part of the composition on each side (*fig. 307*). This carefully balanced, rather static composition is characteristic of the single-scene reliefs of the First Angkor style. Above the central figures are two flying angels. Compared with the similarly placed flying angels on the walls of the Kailasanatha of Ellora, with their boundless energy and their striking effect of movement, these Cambodian angels are frozen to the wall; they do not move, much less fly. They are stone embodiments of the relatively static tendencies of Cambodian figure sculpture.

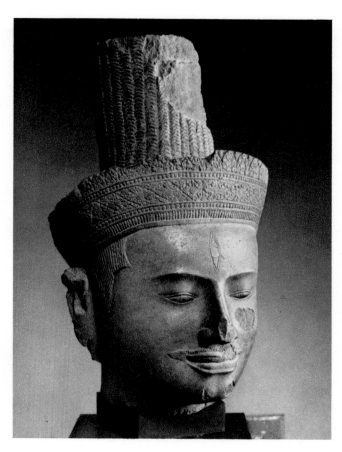

309. *Head of Siva*. Sandstone, height 16 1/2". Style of Koh Ker, Cambodia. Second quarter of tenth century A.D. Cleveland Museum of Art

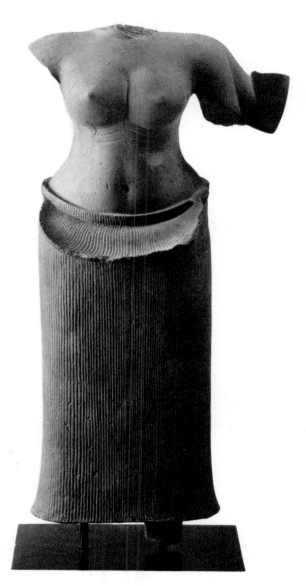

308. *Torso of female deity*. Stone, height 35". Cambodia. Tenth century A.D. Cleveland Museum of Art

The sculpture in the round is of even greater interest. Two basic manners are associated with the First style of Angkor, one with the monument at Koh Ker, and one with the temple complex at Angkor called the Baphuon. The Koh Ker style can be fairly seen in a relatively complete and characteristic female image (*fig. 308*). The drapery has increased in size and depth of modeling to become a strong architectural and decorative part of the composition of the figure. The female torso in figure 308 is a standard example of Koh Ker style, but the head of Siva in figure 309 is at the very summit of Cambodian sculpture and shows the style of Koh Ker at its most superb. The head is carved as an architectural unit; the skin of the stone is preserved, except for the high relief of nose and lips. Everything else is kept on the surface or breaks the surface as little as possible, so that when the piece is viewed in flat, frontal lighting almost all of the ornament and the cutting disappears. But in sharply raking light we can see a fine and subtle pattern, built not only in the ornament of the headdress but also in the treatment of the hair and moustache, the incising of

whole figure still retains a strong architectural character, strengthened here by the columnar appearance created by the ribbed, ankle-length skirt.

In addition to the stone images, numerous smaller images were made in bronze during the First and Second Angkor periods, usually ex-votos—small private altars or images—principally of Hindu subject matter and most often associated with Vishnu, though Buddhist images are often found (*fig. 311*).

The Second Angkor style, considered by many the classic Khmer style, is exemplified in the two most famous monuments of Cambodian art, Angkor Vat and the Bayon, the two great temple complexes respectively outside and inside the walls of the ancient capital at Angkor. It is possible to write the history of Cambodian art after the early Khmer period by reference to Angkor alone. It was the capital, where each god-king felt impelled to outdo his predecessor in the size and merit of his architectural and sculp-

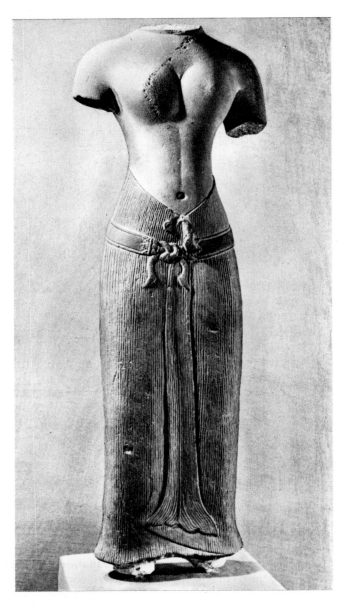

310. *Female torso.* Sandstone, height approx. 48″. Baphuon, Cambodia. Mid-eleventh century A.D. National Museum, Saigon

the lines for the eyes, and the double outlining of the mouth. All this is rendered with extreme delicacy, hardly breaking the skin of the stone, and producing an effect simultaneously architectonic and sensuous. This combination of two seemingly incompatible ideals makes Cambodian sculpture a unique expression, the best of it equal to the greatest sculpture in the world.

The later manner of the First Angkor style is that of the Baphuon, and we illustrate a typical female torso with a long skirt (*fig. 310*). The drapery now is not modeled in such high relief; the girdle is suppressed and tends to cling closer to the body. The

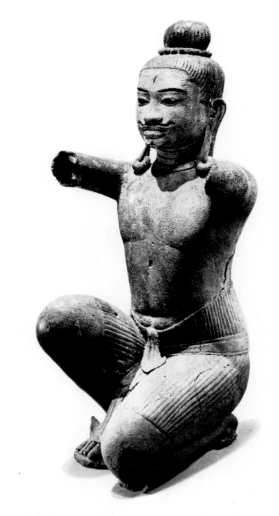

311. *Kneeling male figure.* Bronze, height 17″. Cambodia. C. A.D. 1010–80. Cleveland Museum of Art

tural accomplishments. Angkor Vat was built by Suryavarman II, who reigned from about A.D. 1112 to 1153. The aerial view of this great monument reveals that it is largely an elaboration and enlargement of the architectural model set by Ta Keo (*fig. 313*). There is the same central tower and towers at the four corners of the main pyramid, but the elaboration of the galleries is carried much further at Angkor Vat and the size of the ensemble is enormously increased. The aerial view shows the one moat still in existence, with two water tanks beyond it in the best south Indian tradition, but it gives no idea of the splendor or magnificence of the ensemble as it was in the twelfth century. For that we must examine a ground plan (*fig. 312*), which gives some idea of what the complete monument looked like, and of the tremendous size of the complex, with its great surrounding moat, the causeway over the moat leading to the exterior gallery wall, and the multiplication of these gallery walls, particularly in the main approach to the central shrine, all on a scale unknown before in Cambodia. The gallery roofs are

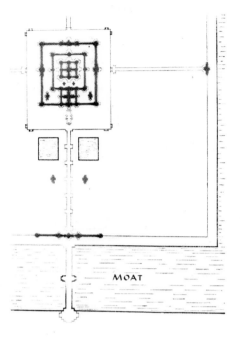

312. *Plan of Angkor Vat, Cambodia*

313. *Angkor Vat, Cambodia*. Aerial view. First half of twelfth century A.D.

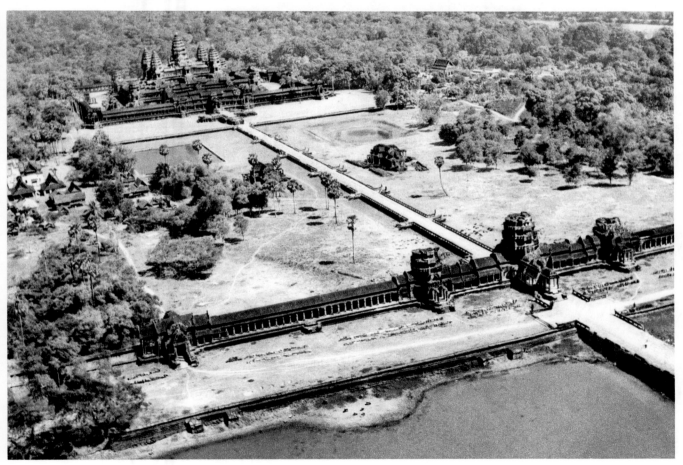

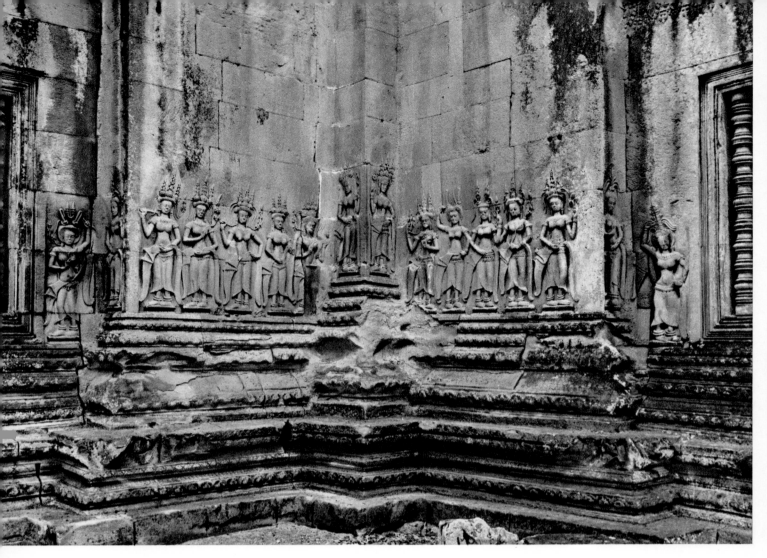

314. *Celestial dancers*. Sandstone. Angkor Vat, Cambodia. First half of twelfth century A.D.

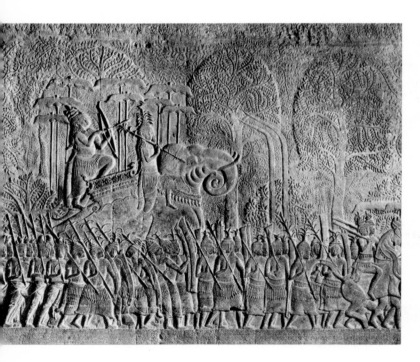

315. *Army on the March*. Sandstone. Angkor Vat, Cambodia. First half of twelfth century A.D.

corbeled; the arch was not used. Corbeling requires a high roof line, so there is a considerable expanse of roof and all of the side corridors and galleries are rather tall. A corbeled vault leads up to the main shrine, which is enclosed by a great tower.

Angkor Vat was dedicated to the god Vishnu, and most of the sculptures represent the various avatars of Vishnu. Before turning to the principal Vaishnavite relief, let us examine a characteristic grouping of architectural sculpture at Angkor Vat. The exterior walls of many of the galleries are decorated above the plinths with figures of dancing celestial beauties, the same motifs seen in India, but treated here in a peculiarly Cambodian way (*fig. 314*). After construction of the temple they were carved into the sandstone of a relatively plain wall, so that they appear more related to the architecture than do the high reliefs and undercut relief carvings of the later Indian Medieval school. The development of the drapery, the starched, band-shaped, heavy belts, and the complexity of the high head-dresses show a decorative emphasis quite different from that of India. The smile of Angkor is evident in each face, in some to the point of caricature.

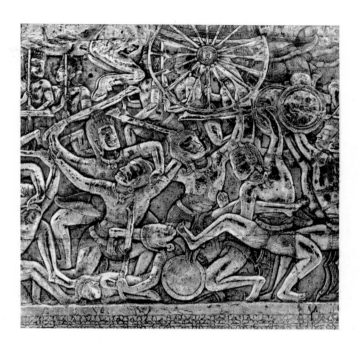

316. *Detail of a combat*. Angkor Vat, Cambodia. First half of twelfth century A.D.

The interiors of the galleries are carved in low relief, almost as if painted in stone, with various scenes illustrating incarnations of Vishnu. One reveals an army on the march, a scene from the *Ramayana*, in which the Cambodians have depicted their own soldiers as the forces ranged under Ravana and Rama (*fig. 315*). Note the abhorrence of the vacuum; every inch of the stone is carved with either jungle foliage or figures. Note, too, the rather awkward movement of the figures and their lack of narrative value. All the figures and their accoutrements are shown clearly and in detail, a great boon to the sociologist, anthropologist, and historian of costume, but they are static and decorative, a pattern rather than a depiction of movement. In a combat scene (*fig. 316*)

317. *The Churning of the Sea of Milk*. Angkor Vat, Cambodia. First half of twelfth century A.D.

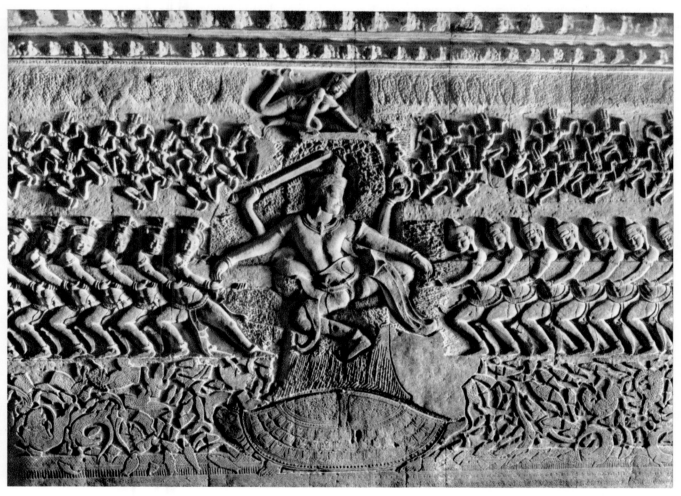

318. *The Bayon.* Angkor Thom, Cambodia. General view. Late twelfth–early thirteenth century A.D.

certain figures are livelier and their postures more active, but the emphasis is still upon drapery patterns and the repetitions of poses that we saw in figure 315. The warriors appear frozen in the postures of a ritual dance. There are no more complicated representations of numerous figures in all of Oriental art than in these relief sculptures at Angkor Vat. Compared with the great variety of the low reliefs at Angkor Vat, those simple little bands of figures in the reliefs of the *Ramayana* at Ellora seem the work of elementary and rather backward artists.

One of the most famous scenes at Angkor Vat

illustrates the story of the churning of the Sea of Milk, concerning the famous tortoise avatar of Vishnu (*fig. 317*). The gods and demons (*asuras*) made a truce so that they might churn the Sea of Milk, using the serpent Vasuki wound around the World Mountain, hoping to obtain the Dew of Immortality (*amrita*). As the Mountain began to sink in the Sea, Vishnu, assuming his avatar (a saving manifestation) of the tortoise, placed himself beneath it and supported it. The Sea gave forth various delights, ending with the Dew, which Vishnu then obtained for the gods alone by assuming the form of a desirable woman, Mohini, who seduced the *asuras* into abandoning the elixir. The gods then succeeded in defeating the demons, and thus Vishnu reconstituted the balance of good and evil.

In the relief Vishnu appears twice, once as deity guiding the operation, bearing his attributes of mace and discus, and once, below, in his tortoise avatar. The relief is so low that, like the *rilievo stiacciato* of Italian Renaissance sculpture, it is a painting in stone; unlike Italian relief, it is not flowing and naturalistic, but formal and hieratic, with an especially effective use of silhouetted forms against textured grounds. Because of their rhythmical repetition, these reliefs resemble an exotic, noble, and measured ritual dance, not unlike those till recently performed by the court dancers of Cambodia.

319. *Bridge showing the churning of the Sea of Milk.* The Bayon, Angkor Thom, Cambodia. Early thirteenth century A.D.

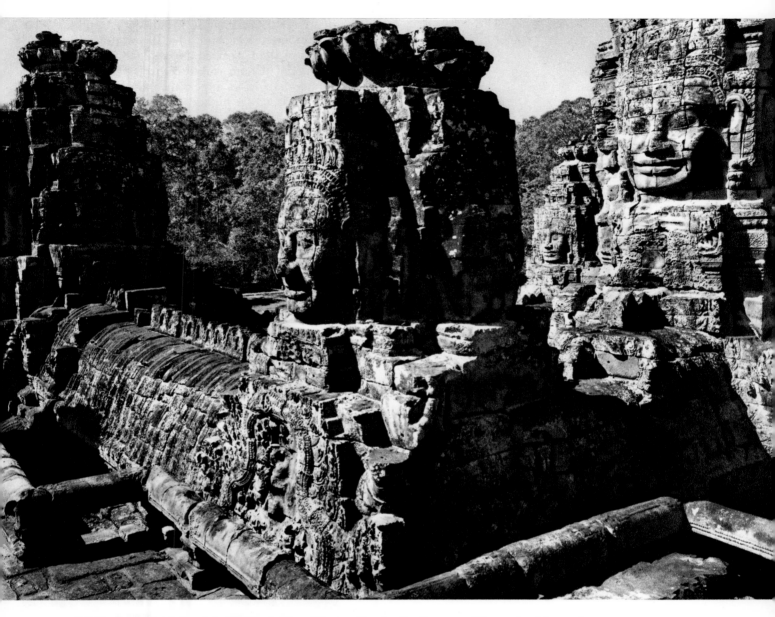

320. *Detail of central towers of the Bayon.* Angkor Thom, Cambodia. Late twelfth–early thirteenth century A.D.

The end of the Second Angkor style is to be found at Angkor Thom, in the great mass of the Bayon built at its center by Jayavarman VII, who reigned from about A.D. 1181 until some undetermined date early in the thirteenth century (*fig. 318*). The Bayon is a Buddhist monument, dedicated to the bodhisattva Lokesvara, a manifestation of the most popular of all Buddhist deities, the bodhisattva Avalokitesvara. Though nominally Buddhist, the Bayon is a syncretic construction that includes representations of Hindu gods. It appears neither Buddhist nor Hindu, but a Cambodian monument truly expressive of the character of Jayavarman VII, the god-king, the *devaraja*. One enters the Bayon over a bridge (now spanning only dry land) whose balustrade is a Hindu symbol: Giant figures of gods and demons are holding a long serpent, enacting the churning of the Sea of Milk (*fig. 319*). The Bayon itself is a forest of towers of the most curious appearance, because carved on the faces of all the towers are gigantic faces of the deity Lokesvara or, more probably, of Jayavarman himself (*fig. 320*). From Angkor, the symbolic center, he surveys the four directions, a multiplied image of the visage of the god-king looking out from the great central mass of towers over the kingdom of Cambodia. The architectural charac-

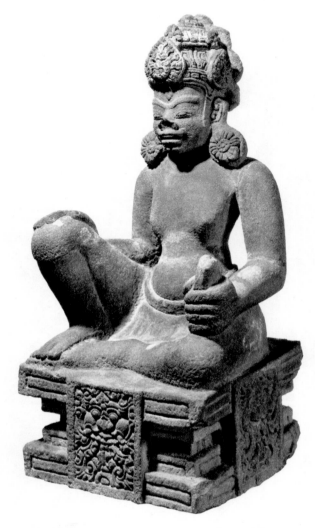

321. *Seated Siva*. Brown sandstone, height 34". Dong-duong, Vietnam (Champa). Ninth century A.D. Cleveland Museum of Art

in A.D. 1171 Champa captured Angkor and sacked it; Jayavarman VII built the Bayon to celebrate his defeat of the Chams and to replace shrines destroyed by them. Cham architecture generally parallels Cambodian in its appearance and stylistic evolution but tends to be higher, more massive, and simpler in plan. The principal difference is in material: The Cambodians (from about the ninth century) built in stone, the Chams in brick.

The evolution of Cham art can be traced best through its stone architectural decoration rather than through the monuments themselves, which changed relatively little in plan and conception. A chronological sequence of styles was established, as it was for Cambodia, by the French scholars of L'ecole française de l'Extrême Orient. Unfortunately, though we know which style followed which, we do not know the precise dates for each one. There are five in all: first, an early style; second, the style of Hoa Lai: third, and most important, the style of Dong-duong; fourth, Mi Son; and fifth, Binh Dinh, a style that corresponds typologically to the development of a folk style in Cambodia. In sculpture the most important style by all odds is that of Dong-duong. It is a mixed native Cham and Javanese

ter of the building has begun to be lost; instead we are confronted with something that is, at least in theory, more like Hindu architecture—a work of sculpture rather than of construction. A closer look at some of the towers shows how completely sculptural rather than architectural they are. The sculptural style has also changed; the smile of Angkor has broadened, the lips are thicker and the nose flatter. The modeling of the face, too, shows less emphasis upon linear incision and more on sensuous and rounded shapes. These are the most characteristic elements of the last style of Angkor.

THE ART OF CHAMPA

The kingdom of Champa, which lasted from about the third century A.D. to 1471, depended for a large part of its income on piracy and was one of Cambodia's principal rivals for military and political power. Its history was one of constant warfare, and

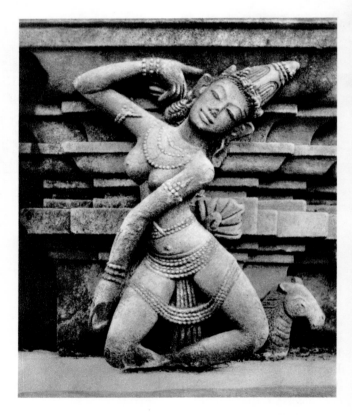

322. *Celestial dancer*. Sandstone, height approx. 36". Mi Son, Vietnam (Champa). Tenth century A.D. Museum at Da Nang, Vietnam

style, and its most characteristic products are images, not of Vishnu, but of the god Siva. The seated image of Siva in Cleveland is the only complete Cham image in the United States, and one of a very few outside of Champa proper (*fig. 321*). Dong-duong art, as revealed in this image, is highly individual and quite different from that of Champa's nearest neighbor, Cambodia. The blocklike character, based upon the original cube of stone, is paramount. Nearly all of the Dong-duong sculptures, whether standing or seated, are placed upon a heavy plinth that retains the original dimension of the stone block from which the sculpture is made and determines the positions of the arms and legs. Equally characteristic of Cham art and, again, very different from Cambodian is a certain broad, even coarse treatment of shapes, which produces an almost animal-like effect in the faces of the male figures. The combination is one of architectural strength with physical coarseness; and the result is a rare but powerful style, not as well known or represented by so many examples as is the art of Cambodia. The style of Mi Son is also of great interest, and it produced some extremely interesting figures of celestial dancers, derived from Gupta and Pallava sculpture (*fig. 322*). The Binh Dinh style is a final development along the lines of folk art, with a triumph of decorative detail in works that emphasize the grotesque character of dragons and other monsters. The type is familiar to us from the folk arts of Southeast Asia today.

JAVANESE ART

We have already considered perhaps the greatest monument of Javanese art, the Great Stupa of Borobudur. This Buddhist monument is so justly famous that it dominates the artistic map of Java. But we must remember that Javanese art began under Hindu influence, and despite the domination of Buddhism in the eighth and the first half of the ninth century the final triumph before the coming of the Muslims in the fourteenth century belonged to Hinduism. From A.D. 750 to 850 was the period of Srivijaya rule, with the capital on Sumatra. Though Buddhism was dominant, numerous Hindu shrines, based upon single-celled south Indian prototypes, were built in the early eighth century on the Dieng Plateau of central Java. They are relatively well preserved, as a result of splendid repairs accomplished under the Dutch services of archaeology, and two sites are of particular importance. One of them is Chandi (temple or shrine) Puntadeva (*fig. 323*). The Sailendras used the high base of the Pallava style (seen, for example, at Kanchi, and much elaborated at Ellora), with projections containing

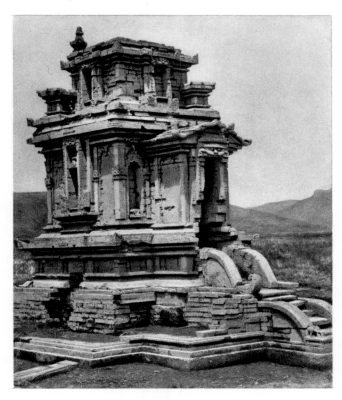

323. *Chandi Puntadeva.* Dieng Plateau, Java. C. A.D. 700

324. *Chandi Bima.* Dieng Plateau, Java. C. A.D. 700

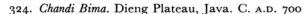

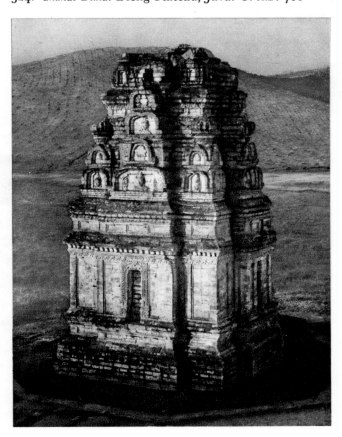

245

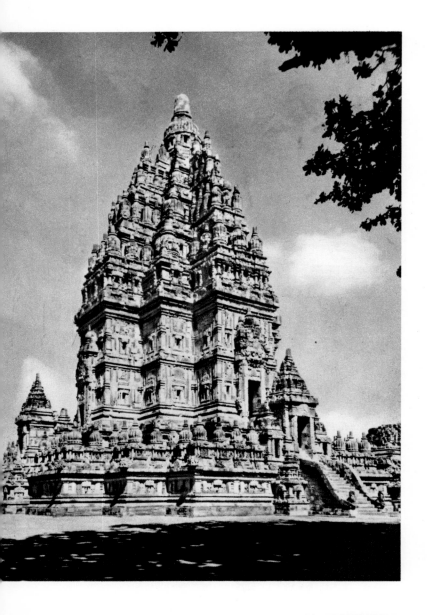

niches added all over the face of the building, even more than in the usual south Indian style. There is also a playful use of curves over the main door and on the balustrades up the steps to the main shrine, and a further playfulness in the handling of detail, elements we will find recurring in Javanese architecture.

The second shrine, Chandi Bima, is unexceptional except for its tower (*fig. 324*), which is carved with large *chaitya* hall openings enclosing relief heads derived from motifs found at Mahamallapuram and elsewhere in south India. These heads are almost comparable in size to the great faces that project from the Bayon, some three centuries later. But fundamentally Chandi Bima is still a simple cell, with one entrance from the front through a small porch to the shrine proper. Most of these shrines are dedicated to Vishnu or Siva—more often the latter.

After the period of Buddhist dominance that produced the great monument of Borobudur, there followed a distinct Hindu revival under the Javanese rulers of A.D. 850 to 930. This Hindu revival produced the principal monument of Hindu art on Java, the great temple complex called Prambanam, which, like the monuments of Cambodia, is a shrine on a man-built mountain (*fig. 325*). The principal temple is dedicated to Siva and has subsidiary dedications to Brahma and Vishnu. The appearance of the upper structure, thanks to restoration, is no longer problematical; one can see that it is a shrine placed upon a high-terraced pedestal. A distinctive feature is to be found in the reliefs circling the terraces, reliefs

326. *Scene from the Ramayana.* Relief; lava stone, height approx. 24″. Chandi Loro Jonggrang, Prambanam, Java. Ninth century A.D.

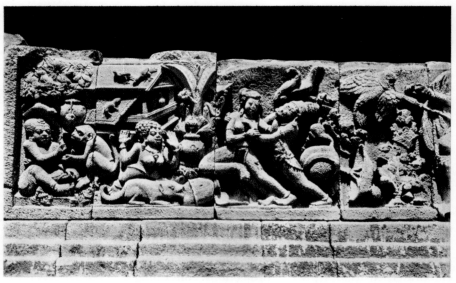

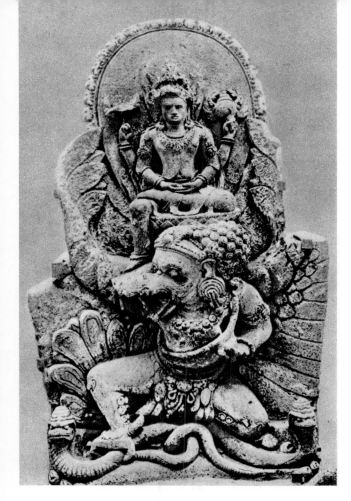

327. *Erlanga as Vishnu.* Reddish tufa, height 75″.
Belahan, Java. C. A.D. 1042. Museum at
Madjakerta, Java

usually composed of groups of three figures set in niches. The sculptures on the Prambanam deal not only with Siva but also with such Vaishnavite epics as the *Ramayana*. They show a continuation of the Srivijaya style of Borobudur, but with certain new elements indicating the future direction of Javanese sculpture. The principal figure of Sita as she is being carried off by Ravana, for example, is represented in the classic Srivijaya style, in turn derived from the Indian Gupta style (*fig. 326*). The attendant servant girl, on the other hand, is represented quite differently. Here we see an exaggeration of hairdress, of ears, of protruding eyes, of sharp and rather prominent teeth, along with an odd physique that includes a square and angular shoulder line, large, pendulous breasts, and peculiarly large extremities. This tendency to caricature becomes the principal characteristic of the later Javanese style known so well to the West through the Javanese shadow puppets. The rest of the sculptural relief from Prambanam shows the elaboration of this most interesting and rich narrative style, involving the representation in stone of architecture and plants against the relatively plain landscape background developed earlier at Borobudur.

The period of Hindu revival is followed by one described by Dutch scholars as the "intermediate period," when the capital was in east Java, not on

328. *Goa Gadjah
(Elephant's Cave).*
Bedulu, Bali.
Eleventh century
A.D. (?)

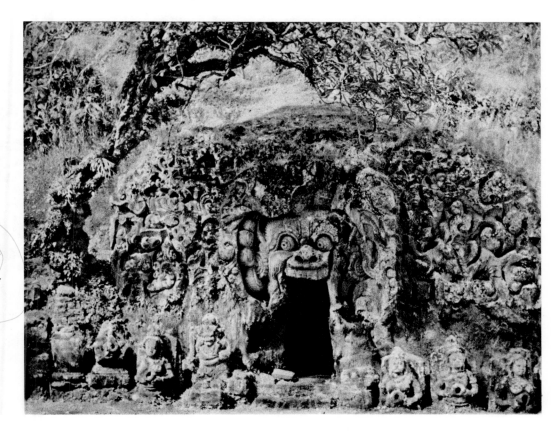

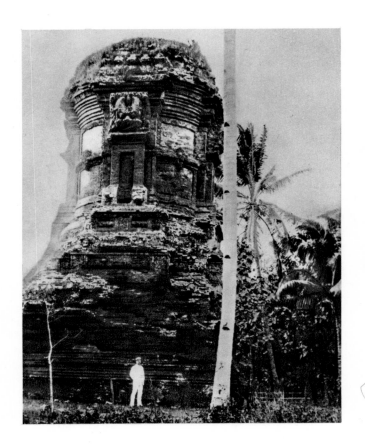

the plateau. The reign of Erlanga (A.D. 1010–42) is especially important, marked by the rise of a national literary language called *kawi*, and of the theater and shadow plays, among other arts. One of the most interesting productions of the whole reign is an image of Vishnu, carved about 1042 in the characteristic volcanic stone of the island (fig. 327). The individualized, rather pinched head, possibly a portrait of the god-king Erlanga, is curiously combined with the classic Gupta type of the body of Vishnu. Below, a huge Garuda, vehicle of Vishnu, tramples upon a snake. Embodied in Garuda and dominating the sculpture are elements that the Javanese particularly liked—exaggerated movements and grotesque animal and human forms. One of the most striking examples of this "grotesquerie" is the eleventh(?) century Goa Gadjah—Elephant's Cave—at Bedulu on Bali, where the colossal mask of a witch seems to emerge from a

329. (left) *Chandi Djabung, Java.* Mid-fourteenth century A.D.

330. (below left) *Kala head.* Lava stone, height 45″. Chandi Djago, Java. Early fourteenth century A.D.

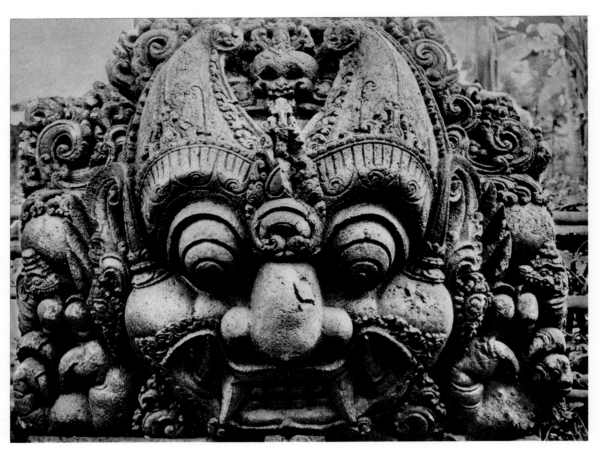

331. (below left) *Ramayana
scene, from Chandi
Panataran*. Stone relief,
height 27 1/2". Java.
Early fourteenth
century A.D.

332. (left) *Head of a figurine*.
Earthenware, height
3 1/4". Trawulan,
Java. Fifteenth century
A.D. Trawulan Museum

partly natural and partly carved mountain (*fig. 328*).

The final phase of Javanese art, before the coming of the Muhammadans and their triumph in A.D. 1478, is called the East Javanese period, encompassing the full development of the native, or *wayang*, style, the well-known style of the shadow theater. A typical monument of the late period is Chandi Djabung, a circular brick temple built before 1359. Here we see the most characteristic element of the later architectural style: the great masks over the entrances (*fig. 329*). These masks of glory, which on Hindu temples in India and even on earlier Javanese temples are subordinated to the architecture, increase in size until they seem almost to threaten and subdue the rest of the structure. The single mask from Chandi Djago probably dates from the fourteenth century (*fig. 330*). Brick was also used in smaller, clustered shrines, as at Panataran, an informally planned temple dedicated to Siva and built in the fourteenth and fifteenth centuries. The sculptures of the main temple are of particular interest because they are the first full statement of the *wayang* style, which was to last until modern times (*fig. 331*). The *wayang* mode involved a loss of the plasticity and roundness inherited from the Pallava and Gupta styles. Instead, the relief was flattened by deep but unmodulated cutting, which produced an effect of silhouette

against a dark background. The result, with these grotesque profiles and physical conformations, was a flat sculpture resembling a shadow puppet. But some earthenware fragments of figurines from the Majapahit capital, Trawulan, display a subtle and gracious handling of such attractive subjects as princesses or celestial beauties that rivals the finest achievements of the Gupta sculptors of India (*fig. 332*). The *wayang* style continued in outlying areas beyond the reach of the Muslim rulers, particularly in Bali. Even some of the old mosques, including one dated to A.D. 1559, were decorated with nonfigural reliefs in a rich *wayang* manner, emphasizing a pictorial treatment of the lush tropical landscape (*fig. 333*).

333. *Relief landscape.* Stone, height 19 5/8". Old Mosque, Mantjingan, Java. A.D. 1559

PART FOUR

CHINESE AND JAPANESE NATIONAL

STYLES AND THE INTERPLAY OF CHINESE

AND JAPANESE ART

12

The Rise of the Arts of Painting and Ceramics in China

THE SIX DYNASTIES

We must recapitulate certain elements of Chinese art in order to reestablish our position in time and space. Even during the Buddhist ascendancy—in the period of the great cave sculptures and religious paintings—native Chinese forms and styles continued. In the collapse of the Han dynasty the educated governing class fled south in great numbers, there to establish itself in many of the states afterward called the Six Dynasties. Here, in contrast to the foreign-ruled and predominantly Buddhist north, Confucianism persisted, albeit in a decline related to the political fragmentation and weakness of the Six Dynasties. Daoism too, though much diminished after the end of Han, continued to imitate and compete with Buddhism. The high Daoist tradition, represented by the philosophy and metaphysics of the *Dao de jing*, continued to influence painting; the lesser, popular, Daoist tradition of magic and alchemy was expressed in the iconography of certain pottery figures as well as in the literature of the time. It is not surprising that the first great advances in the scholarly arts—calligraphy and non-Buddhist painting—took place in the south, where the Confucian tradition endured most strongly.

334. *Squatting caryatid monster.* Stone, height 29 1/2".
Xiangtang Shan, Hebei-Henan, China. Six Dynasties period, late sixth century A.D. Cleveland Museum of Art

Sculpture

The continuity of native traditions is notable in the subsidiary sculpted figures of Buddhist stelae and in cave temples. Here the Zhou and Han spirit persists in the conformation and vigorous linear han-

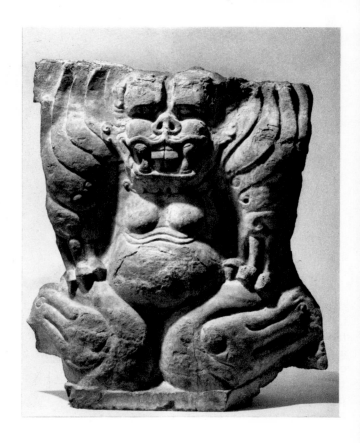

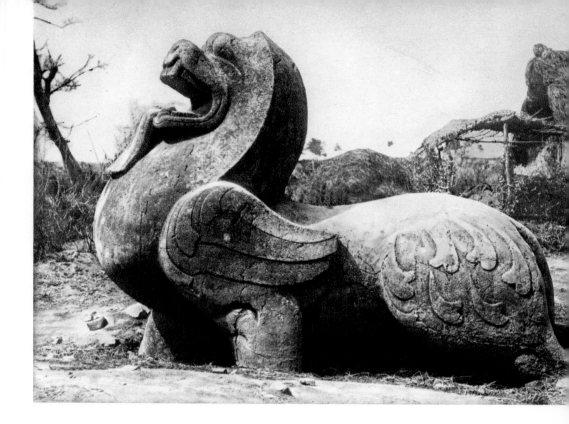

335. *Chimera*. Stone. Tomb of Xiao Xiu, Nanjing, Jiangsu, China. Six Dynasties period, A.D. 518

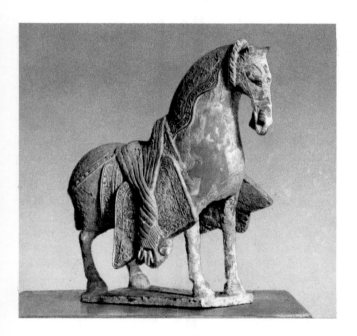

336. *Tomb figurine: horse.* Earthenware, length 8 3/4". China. Northern Wei dynasty. Cleveland Museum of Art

dling of the various dragons, lions, chimeras, and fabulous birds. In the Buddhist cave site of Xiangtang Shan was found a grinning chimera, originally a caryatid beneath a pillar to one side of a niche containing a Buddhist image (*fig. 334*). The squatting figure with square mouth, buck teeth, and great potbelly, its forepaws planted on its haunches, shows a degree of vigor and humor characteristic of the great Chinese animal sculpture of much earlier times. But there are monuments unrelated to Buddhism that show these qualities in an even more pure and undiluted form. A whole series of great chimeras of the third and fourth centuries (early Six Dynasties period) exists, many from the Liang dynasty tombs near Nanjing, showing the vigorous, almost magical, qualities of Chinese animal sculpture (*fig. 335*).

We find the same preservation of Han tradition in the numerous tomb figurines of the period. These are mostly of gray earthenware, unpainted or painted with slip colors, usually red, green, or yellow. They include chimeras like the stone figure from Xiangtang Shan, dogs, lions, camels, and, above all, horses; and these horse figurines of the Six Dynasties period are among the most admirable Chinese animal sculptures (*fig. 336*). Many of the saddle skirts bear elaborate molded designs, linear and completely Chinese.

Painting

But the most important medium for the development of native style was painting, and from the Six Dynasties period come the earliest known great Chinese masters and also the first treatises on painting and calligraphy. Xie He's *Six Canons of Painting* is the earliest of these, a work of fundamental importance in any study of the theory of Chinese painting. The six canons have been translated many times, but their interpretation has been open to some doubt until recently, when William Acker in *Some T'ang and Pre-T'ang Texts in the Study of Chinese Painting* and

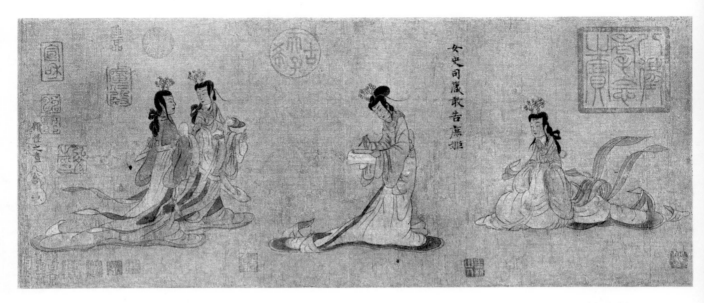

337. *Instructress Writing Down Her Admonitions for the Benefit of Two Young Ladies, last scene from Admonitions of the Instructress to the Ladies of the Palace.* Attrib. Gu Kaizhi (c. A.D. 344– c. 406). Handscroll, ink and color on silk; height 9 3/4″, length 11′ 6″. China. Six Dynasties period. British Museum, London

Alexander C. Soper in "The First Two Laws of Hsieh Ho" (*Far Eastern Quarterly* 8) threw real light on their meaning.

The six canons are: first and most important, *animation through spirit consonance,* qualified in Soper's translation by the phrase *sympathetic responsiveness of the vital spirit;* second, *structural method in the use of the brush;* third, *fidelity to the object in portraying forms;* fourth, *conformity to kind in applying colors;* fifth, *proper planning in the placing of elements;* sixth, *transmission of experience of the past in making copies.*

It can be seen that these canons represent general principles. Various interpretations are possible, and the first canon in particular allows great subjective latitude. Animation through spirit consonance is interpreted as a kind of resonance or rhythm in the painting, an expression of the heavenly inspiration of the artist himself. The painting must have what the Chinese call *qi yun,* the spirit or breath of life. This criterion is thoroughly meaningful, because aesthetic quality is in the last analysis a matter of this intangible spirit or breath which the great work of art displays and which the great artist can impart. In technique and composition, for example, the works of Gerard Dou resemble Rembrandt's, but few would hold that Dou was as great a painter as Rembrandt. *Qi yun,* the life spirit, is the quality that differentiates genius from competence. Acker relates the meaning of this canon to a complex of Confucian and Daoist ideas: the concept of cosmic rhythm in the *Dao de jing,* and the Confucian *li,* the inherent structure or principle of things.

The second canon, structural method in the use of the brush, is almost equal in importance to the first, because Chinese paintings are produced with the brush—the instrument used for writing. Because the written word is not only a vehicle of culture but itself a prized element of culture, and because Chinese characters are almost wholly abstract, calligraphy was considered a more creative art even than painting. Consequently paintings were judged on the character of individual brushstrokes, on the strength or weakness of a given line, or on the handling of a particular brush motif or technique. Embodied in this canon we have perhaps the most trying and difficult concept, the one that produces the greatest gulf between East and West in the judgment of Chinese painting. The Chinese judge a painting—its quality and authenticity—solely by the character of its brushwork, whereas the Westerner begins with composition, color, and texture, all qualities relatively unimportant to the Chinese. If we think of structural method in the use of the brush as being rather like the European concept of touch— of the difference between the "brush writing" of Rembrandt and Fabritius, of Seurat and Signac— then we may perhaps be able to comprehend something of the qualities that the Chinese are looking for in brushwork.

The third canon, fidelity to the object in portraying forms, implies a certain degree of naturalism; when portraying a horse one is governed by the conformation of a horse. The fourth canon, conformity to kind in applying colors, applies most particularly to the use of colors in the decorative sense. It does not, according to Acker, imply that brown horses

must be brown, but allows a certain leeway within a degree of naturalism. The fourth canon seems, therefore, related to the third. The fifth canon, proper planning in the placing of elements, involves the Western concept of composition but also, to a certain extent, qualities inherent in the first canon: that the composition, the placing of elements in the picture, should correspond to principle and thus, in some degree, to natural law.

The importance of the sixth canon, transmission of past experience, lies in its expression of the consistent Chinese persuasion that what has gone before is more important than what is to come. Copying was the discipline by which the painter, through studying the brush of his predecessors, learned to control his own. Such copying was not done to deceive, but as a way of study, of allowing one's brush to retrace the inspired hand and arm movements of great masters.

In contrast to the generalized and theoretical prescriptions of the *Six Canons of Painting* is the practical and specific approach of an earlier Six Dynasties text, Gu Kaizhi's *How To Paint Cloud Terrace Mountain* (translated by Sakanishi Shio in a little volume called *The Spirit of the Brush*). How does Gu Kaizhi say he paints? How does one paint Cloud Terrace Mountain? He says that he would place a figure at such-and-such a point, that he would paint this rock large and that one small, that he would use green here and blue there; in short, he tells you literally how he would paint Cloud Terrace Mountain. In Xie He we hear the critic speaking; in Gu Kaizhi, the artist. With only the six canons of Xie He, we might well hesitate to judge Chinese paintings. But Gu Kaizhi is describing directly and literally what he wishes to do. He is writing a painter's recipe, and his text allows us, with some modification of approach and a certain amount of training, to look at a Chinese painting and see almost as much, if somewhat differently, as does the understanding Chinese.

Much of the small remains of painting from the Six Dynasties period consists either of tomb murals by provincial artisan-painters or of copies of paintings, incised on stone or other hard materials. With regard to paintings of the first rank in their original formats, we are in a very unfortunate position. The ravages of war in the Six Dynasties period made contemporary Chinese paintings rare even for collectors of the succeeding Tang dynasty. And by the Song dynasty even the collection of that most ardent and puissant connoisseur, the emperor Hui Zong, formed in the late eleventh and early twelfth centuries, was amazingly weak in works of the early Chinese painters. Consequently we are skeptical of any painting purporting to be an original work by one of the great early masters. We have, however, a few exceedingly good copies in the style of these early masters, and one painting that seems to breathe the very spirit and style of Gu Kaizhi, to whom it is attributed. Master Gu lived in the second half of the fourth century and was attached to the Eastern Jin court at Nanjing in southern China, where traditional Chinese styles and the Confucian theory of art were maintained during a period of dominant Buddhist influence. Gu Kaizhi's subject is the *Admonitions of the Instructress to the Ladies of the Palace,* and its format is a handscroll painted on silk with ink and some color, mostly red with a little blue. Iconographically the picture is thoroughly Confucian. As the title suggests, it is a series of illustrations accompanied by text, incorporating rules of moral behavior proper to court ladies of the early Six Dynasties period. The very word "admonitions" implies Confucian rectitude. At the end of the scroll (which, incidentally, is thoroughly and insensitively plastered with seals of the eighteenth century Qian Long emperor), the moral tone is confirmed by the figure of the Instructress, holding a scroll of paper on which she writes, while the court ladies, who are presumably to follow her precepts, stand or kneel respectfully before her (*fig. 337*).

The painting shows impressive linear mastery, particularly in the handling of the drapery, where the effect is one of swirling and fluttering movement. The representational aspect of the picture is extremely archaic. These people look like the early tomb figurines of the Six Dynasties period. Their headgear is appropriate to the fourth century, and their voluminous garments, their rather square skulls, slightly pointed chins and noses, and sloping shoulders are completely of the period. All this can be copied, but if this scroll is a copy, it is indeed an extraordinary one. Close examination of the scroll reveals a technique quite unlike the method a copyist would employ. A free preliminary drawing in pale red establishes the positions of the figures, general location of the draperies, and details of character in the faces. These indications in red are then painted over, again freely, with a black ink that dominates the red line and produces the final impression. Such a technique is a very early one. We find it, for example, on Han or early Six Dynasties tomb tiles and in the earliest Buddhist paintings of the Tang dynasty, and would presumably find it in the portable Buddhist paintings of the Six Dynasties period, if any had survived. The device implies that the artist was somewhat uncertain about the location of the various figures and therefore did a preliminary drawing in red to establish the general layout and composition; once this satisfied him, it became the basis of the final picture. A copyist, having the figures already disposed on the original painting,

338. *Bed scene, fifth scene from Admonitions of the Instructress to the Ladies of the Palace*

would need no preliminary drawing. We may very well have here an original masterpiece of the period and a fine touchstone for the purportedly early works that follow. None of them approaches the *Admonitions* in style or spirit; until the middle or even the end of the Tang dynasty only a series of mediocre copies survives. The lacquer paintings on wooden panels of Paragons of Filial Piety, discovered in 1965 at Datong, Shanxi in the tomb of Sima Jinlong, which is dated to A.D. 484, provide stylistic confirmation of an early date for the *Admonitions* scroll.

The quality of an original can be seen in other details of the scroll. The famous scene in which the emperor talks with one of the ladies of the court has a marvelous archaic quality in its general disposition (*fig. 338*). We see a curious inverted perspective consistently followed in the upper part of the scene; the throne or dais on which the bed is placed is archaic in form, with toothlike projections on the base in the style of Six Dynasties gilt bronzes. The shading of the draperies suspended from the canopy over the bed is schematic and arbitrary and quite unlike conventions of the Tang dynasty or later. The disposition of the figures is fairly sophisticated and the relation of the figures to their immediate surrounding is sure and convincing. The setting itself is placed in abstract space, with no indication of a room or of other furnishings around the dais. Merely the essentials for the story are stated and this, though an advance over the kind of stage we have seen in certain Han dynasty compositions, is still a long way from the developed environment for figures in Tang paintings.

The *Admonitions* scroll is extraordinary also in having one of the earliest representations of landscape in Chinese painting. Perhaps one of the reasons why critics are so suspicious, or rather unkind, is that the scroll offers so much. It is not just a figure painting but a complete and remarkably developed world of its own: didactically, in its moral exposition; representationally, in depicting figures in motion and from various angles; aesthetically, in its organization of line and color. To have, in addition, a landscape is almost too much. The landscape is present, however, for moral and didactic purposes. The legend preceding it reads, "He who aims too high shall be brought low," and as illustration an archer takes aim at one of the *feng-huang* or pheasants aspiring to the top of the peak (*fig. 339*). Like the "stage properties" in the other scenes (for example, the bed in scene five), the mountain is shown in isolation. It does not rise from a plain, nor is it part of a range of hills, since these are not necessary to the narrative. It is also worthy of note that it is not only an accessory landscape, but a symbolic one as well, for carefully balanced on either side of the mountain are a sun and moon, borne aloft on little cloud motifs that recall those of late Zhou and Han inlaid bronzes. These carefully balanced celestial symbols on either side of the central mountain peak are unsophisticated in comparison with the naturalistic details of the mountain proper. Within the actual outline of the mountain is a highly developed landscape, with indications of space on plateau-like ledges, of different types of trees, of rock inclines along the slope, and at the lower left a plateau with a plain above leading to a forest just over the brow. One critic finds in this animated passage proof of a later date, but the amazing development of landscape in the Han pottery vases and hill censers makes it not at all impossible to believe that an accomplished southern master of the fourth century could achieve what we see in this scroll.

The brush line used throughout the scroll is not calligraphic. It is more like a pen line of consistent thickness—even wirelike—acting as a defining boundary around figure, drapery, or object. The brushwork of the text preceding each scene on the scroll is, however, more flexible than that used in defining figures or landscape. Though there is a relationship between calligraphy and painting, it has been overestimated, especially by Chinese scholars. The line used in the representation of early landscapes and figures is closer in many ways to that used, for example, in *quattrocento* drawing than to the flexible use of the brush in Song and later Chinese painting. It is not always essential to be a master of Chinese calligraphy to judge the quality of the brushwork in these early pictures.

339. *Landscape with hunter, third scene from Admonitions of the Instructress to the Ladies of the Palace*

A second handscroll associated with the name of Gu Kaizhi, now in the Freer Gallery in Washington, is *The Lo River Nymph*, painted on silk with ink and slight color and generally accepted as a copy of the late Tang or early Song dynasty (*fig. 340*). There are also other versions in the former palace collections in Taibei and Beijing. The Freer scroll is certainly based on an original by Gu Kaizhi, as literary records confirm that he painted a scroll of this title, and elements of the figure style, notably the draperies of the nymph floating above the stream, remind us of the *Admonitions of the Instructress*. But the drawing of the nymph's face is precisely what we would find in paintings of the early Song dynasty. The original must have been an apt illustration of the poem.

"I have heard of the Nymph of the River Lo, whose name is Mi-fei.

Perhaps that is whom Your Honour sees.
But what of her form? For I truly wish to know."
I replied: "She moves with the lightness of wild geese in flight;
With the sinuous grace of soaring dragons at play.
Her radiance outshines the autumn chrysanthemums;
Her luxuriance is richer than the spring pines.
She floats as do wafting clouds to conceal the moon;
She flutters as do gusting winds to eddy snow.
From afar she gleams like the sun rising from dawn mists;
At closer range she is luminous like lotus rising from clear waves.
Her height and girth fit exactly in proportion;
Her shoulders are sculptured forms, and her waist pliant as a bundle of silk.

340. *The Lo River Nymph*. Late Tang or early Song copy after Gu Kaizhi (c. A.D. 344– c. 406). Section of the handscroll, ink and color on silk; height 9 1/2", length 10' 2 1/8". China. Freer Gallery of Art, Washington, D.C.

Her slender neck and tapered nape reveal a glow-
ing surface,
Without application of scent or fragrant powders;
Her hair coils in cumulus clouds and her brows
curve in silken threads;
Her cinnebar [sic] lips gleam without, with snowy
teeth pure within;
Her bright eyes glance charmingly, and dimples
decorate her cheeks.
Her deportment is superb and her attitude tran-
quil;
Her manner is gentle and elegant, and her speech
bewitching;
Her unusual dress is that of another world and her
form worthy of depiction.
Wrapped in brilliant gauzes, she is adorned with
earrings of rich jade,
And hair ornaments of gold and feathers; her body
glistens with strings of pearls.
She treads upon "far-roaming" patterned slippers,
trailing a skirt of misty silk;
She skims among fragrant growths of delicate
orchids and wafts by the mountain slopes."[12]

The scroll reveals an elaborate fairyland landscape
in miniature, with curious shifts in scale, but of a
type, particularly in the overlapping mountain
ranges of the background, probably not realized in
Gu Kaizhi's day. Furthermore, the history of the
painting cannot be traced much before the twelfth
century, and this combination of factors would con-

firm it as a Song copy of a much earlier painting.
But it is as interesting for its general composition
and landscape as for its legendary subject, indicating
that to the artist the picture was the important thing,
be the subject Daoist, Confucian, or Buddhist.

There are many other names from the Six Dynas-
ties period; but this is not a list of the names of Chi-
nese artists, and we must confine ourselves to those
masters whose originals or reasonably good copies
therefrom are extant. And so we are forced to jump
some two or three centuries from Gu Kaizhi to a
great artist of the later Six Dynasties period, Zhang
Sengyou, active under the Liang dynasty (A.D. 502–
57), whose capital was also at Nanjing. The hand-
scroll of *The Five Planets and Twenty-eight Celestial
Constellations*, now in the Abe Collection in the Osaka
Municipal Museum, illustrates the style of this mas-
ter (*fig. 341*). It is not, however, an original but a
copy, probably of the Song dynasty. The detail il-
lustrated shows, especially in the drawing of the
hands, a line which, however excellent it is as a
boundary, lacks the life, or *qi yun*, to be found in the
Admonitions of the Instructress by Gu Kaizhi. Never-
theless, it is so far superior to other copies of similar
early paintings that it deserves our attention. Its
subject is astronomical-astrological, showing dif-
ferent figures and animals that symbolize in Chinese
lore the five planets and the twenty-eight celestial
mansions of star forms. Each animal or figure is
represented singly against a plain background of
silk, with an attribute shown where necessary to iden-

341. *Zhen Xing (Saturn), from
The Five Planets and
Twenty-eight Celestial
Constellations.* Song dynasty
copy after Zhang Sengyou
(act. A.D. 500–550). First
section of the handscroll,
color on silk; height
11 1/4", length 13' 6".
China. Osaka Municipal
Museum

342. *Sarcophagus engraved with stories of filial piety*. Stone, length 88″. China. Six Dynasties period, c. sixth century A.D. Nelson Gallery–Atkins Museum, Kansas City. Nelson Fund

tify the subject. If the figure must stand on a mountaintop, this is indicated as an adjunct to the figure, not as a true landscape setting. In contrast to the earlier style of Gu Kaizhi, with its flutter of draperies and movement of figures, it is more statically and more monumentally conceived, an approach characteristic of late Six Dynasties paintings. The change in effect is comparable to that change noted between the lively Northern Wei sculptures and the later, more massive ones of the Northern Qi and Sui dynasties, and reflects a change in intention from the desire for linear movement to one for more plastic, static forms. The use of color in *The Five Planets* is in sharp contrast to the simple, almost monochrome palette used in the *Admonitions*. Here are rainbow hues; the line tends to disappear among the varied colors and only comes to the fore on the whites, or in the hands or faces of figures. The inscriptions are interesting and much more formal than those found on the *Admonitions* scroll. They are written deliberately in pre-Han script, a type of archaism characteristic of the growing sophistication of China at this time.

One of the most important evidences for the development of setting in Chinese painting in this period is found on a stone sarcophagus in the Nelson Gallery–Atkins Museum in Kansas City, whose designs, lightly incised into dark gray stone, represent Confucian examples of filial piety (*fig. 342*). The monument is at once a sort of museum of archaisms, an adventuresome precursor of the future, and an enthusiastic fulfillment of the project at hand. Artisans who executed tomb sculpture picked their motifs from many sources. The cloud patterns here, used also by Gu Kaizhi, date from the late Zhou period; angular, prismatic rocks, the little knolls in the foreground, and even trees are elaborated treatments of forms seen in Han compositions. Some figures, like the one on the right with flying draperies, recall the lithe creatures in Gu Kaizhi's painting and in early

Buddhist frescoes; others are stocky peasants like certain tomb figurines of the late Six Dynasties period. But in the handling of space the craftsman followed now lost contemporary paintings, and records for us experiments definitely in advance of the picturesquely rendered earlier forms. In contrast to Gu Kaizhi's primitive background details or the plastic monumentality of Zhang Sengyou's celestial subject matter, the Kansas City sarcophagus shows real ingenuity in the treatment of space, limited to be sure, but still a convincing background for numerous groups of figures related to one another in action and motivation. The settings are a series of shallow cells enclosed by planes of rocks. In the foreground a kind of *repoussoir* keeps the spectator a certain distance from the scenes beyond—like the window ledge of fifteenth century Venetian portraits. The relations between near and fairly near are established, but there is no indication of deep space. Here, then, is one step forward in the achievement of subtlety and complexity in the representation of pictorial space.

Compared with Gu Kaizhi's work, the Kansas City relief is much more competent; in comparison with landscapes of the early Song it is hopelessly naive. Painters of the Tang dynasty who worked to create truly spatial scenes filled with life and atmosphere were hard indeed on the efforts of their predecessors. Critics said the mountains in Six Dynasties pictures were nothing more than the teeth of a lady's comb. Each generation thinks it has achieved a sense of reality in painting, and each succeeding generation finds its accomplishments amusing and inadequate.

Ceramics

The ceramic arts flourished in the late Six Dynasties period. Burial pottery continued in use, usually of

343. *Tomb figurine: woman.* Painted earthenware, height 10 1/4". China. Six Dynasties period. Royal Ontario Museum, Toronto

344. *Tomb figurine: western Asian warrior.* Gray earthenware with polychrome pigment, height 12 1/4". China. Northern Wei dynasty, first quarter of sixth century. Nelson Gallery–Atkins Museum, Kansas City. Anonymous gift

gray clay, sometimes painted with slip but rarely, if ever, glazed. Tomb figurines are of two basic types: one, the highly sophisticated and elegant figures of native warriors, court ladies, and others, reflects the art of men like Gu Kaizhi (*fig. 343*); the second, principally guardian figures based on Buddhist iconography and derived from the Central Asian and Gandharan tradition, is infused with a fierce grotesqueness characteristic of the Chinese conception of these quasi-military figures as well as of demons and mythical animals (*fig. 344*).

Ceramics for daily use experienced a remarkable development. The southern green-glazed stonewares, produced since the late Zhou period, underwent further improvement in the province of Zhejiang, just south of modern Shanghai. The principal kilns of the area all produced a pale gray-bodied porcelain with glazes ranging from gray green to olive green, called Yue ware. These wares are certainly descended from Han glazed stonewares and are furthermore direct ancestors of the celadon tradition of the Song dynas-

ty. They were made in a great variety of shapes: pots, bowls, vases, dishes, and cups. Figure 345 is a simple little pot, modeled to indicate the head and legs of a frog, and intended to hold water for a writer's brush. On many pieces a technically advanced treatment of the gray green glaze produces brown spots on the surface at regular intervals, called the buckwheat pattern by the Chinese. It is very much sought after both in China and Japan, and is the ancestor of the spotted celadon produced in the Yuan dynasty. The export of Yue ware marked the beginning of a long ceramic relationship between the Near East and East Asia. Yue vessels have been found as far away as Fostat in Egypt, Samarra in Iraq, Brahmanabad in India, and Nara in Japan. They must have seemed ultimately refined and luxurious compared with the crude earthenwares then produced in the Near East or with the even cruder material then made in Europe.

In the north, rather late in the Six Dynasties period, a white stoneware was produced that was the

precursor of the white porcelain of Tang and Song, especially the famous Ding ware (*fig. 346*). This new development apparently resulted from the discovery of suitable white porcelain clays in the north, principally in the region of Zhili. These white stonewares, such as the magnificent vase in the Nelson Gallery–Atkins Museum, are distinguished by robust and simple shapes, a creamy white glaze, and an almost white body. The shapes are extremely sculptural, with clear articulations between neck, lip, and body, as is also true of the southern Yue wares of the same period. As we begin to know more about Chinese ceramics—and this means adding to a still rather insubstantial foundation—developments in the Six Dynasties period become more and more important. Western appreciation of Chinese ceramics began at the end of the nineteenth century, with the porcelains of the Qing dynasty. In the 1920s we discovered classic Song wares, and in the 1930s we collected early Ming porcelains and began to appreciate Tang stonewares. Now we have discovered that many pieces thought to be Tang are really of the Six Dynasties period. As more excavations produce more material the picture may change again.

TANG

In considering the development of Tang painting, sculpture, and decorative arts, we must recall what was said of the Tang dynasty (A.D. 618–907) in our survey of Buddhist art of that period. Tang China was for most of its 289 years the best-governed polity in the world, the largest in extent and population, the strongest, and certainly the richest. Its

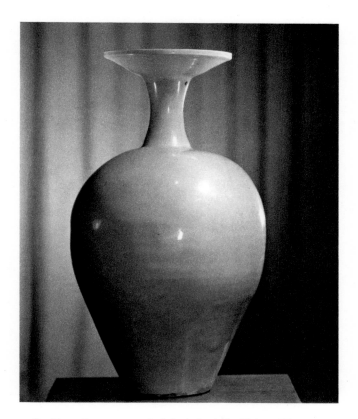

346. *Vase.* Stoneware, height 16 1/4". China. Tang dynasty. Nelson Gallery–Atkins Museum, Kansas City. Nelson Fund

brilliant high culture was the envy and model of all its neighbors. The empire ultimately reached its greatest extent, stretching from the Caspian Sea to the China Sea and from Korea to Annam, and trade flourished, especially with the Near East. Those catalysts of the social organism—printing, literacy, and the civil service examination system—progressed greatly toward that complex and central position they later occupied in Chinese civilization. The first task of the new dynasty was to reduce the dispersal of powers characteristic of the Six Dynasties period to order under centralized control, and this was accomplished within the first years of the regime. The combination of these conditions produced an especially rich environment for the rapid development of literature and the arts. Tang China was cosmopolitan and tolerant, open to new ideas and eager for contacts with the outside world. It welcomed the seven religions of the then known world: Buddhists, Hindus, Muhammadans, Christians, Zoroastrians, Manichaeans, and Jews were free to observe their rites, even to establish communities in the capital, Changan. Tang civilization was an extraordinary achievement, even if it lasted only through the first century and a half of the dynasty.

345. *Water pot in shape of frog.* Yue ware, length approx. 4". China. Six Dynasties period. Museum of Eastern Art, Oxford

Painting

In the arts the Tang style as seen in Buddhist sculpture mirrored the power and vigor of the empire. Sculpture was amply proportioned and fully three-dimensional. The same confident amplitude is found in painting, already discernible in the monumental tendencies of Zhang Sengyou. More than this, the self-confident and receptive spirit of this time permitted the artist to observe the world around him with fewer strictures of custom and tradition. The resulting realism in painting and sculpture is marked, and the artist commanded the technical means to record his observations in sketches to be translated into either schematic or idealized forms. Much attention must have been given to the problems of painting, since the considerable literature on the subject uses specific terms and accurately analyzes Chinese style as well as exotic ones, particularly the Indian shading techniques transmitted through Central Asia.

It is possible that highly calligraphic painting styles, including the extreme forms of "flung ink," began at this time, but probably not under Chan Buddhist influence, which figured in the religious life of the dynasty.

Tang affords us original paintings, or almost contemporary copies of them, in greater numbers than before. Recent discoveries include wall paintings from early Tang princely tombs, including hunting scenes in elementary landscape settings not unlike those in Buddhist works (*fig. 214; colorplate 13, p.*

205), elaborate formal architectural settings, and sophisticated figural compositions of court ladies and attendants (*fig. 348*). The accomplished placement of these figures, and their delineation by the subtle use of firm and even lines, confirm the meager evidence of portable works on silk and paper that Tang figure painting was highly developed at an early stage. All these works, however, reveal a noticeable lack of interest in placement of the figures in an environment beyond the shallow space they occupy.

One of the greatest masterpieces of all Chinese figure painting is the *Scroll of the Emperors*, almost certainly painted by Yan Liben (d. A.D. 673) in the early decades of the Tang dynasty (*fig. 347*). Yan was an official and administrator of the highest rank as well as an extremely important court artist, providing designs for architecture, sculpture, and wall paintings—in short, fulfilling all the Chinese requirements of an artist-hero. The *Scroll of the Emperors* is the one remaining work that can in any way be considered to be his own. It represents thirteen emperors with their attendants. The first part of the scroll, the part that would necessarily have been rather badly damaged by frequent unrolling, is a copy substituted for the original first six groups, but the latter part of the scroll contains seven groups of the highest excellence. In their brushwork, particularly line, their composition, and the poise of their figures is a quality worthy of a great master. Format, compositional methods, colors, and the history of the scroll, which from the evidence of collectors' seals goes back at least to the twelfth century, all combine to confirm the authenticity of the work. The work displays a relationship to what has gone before, particularly to Gu Kaizhi and Zhang Sengyou, at the same time that it evinces a completely new spirit in painting. The figures are larger, ample and serene, and though the delineation of the faces still relies principally on line, it creates a suggestion of mass and volume quite different from the more linear style of the Six Dynasties period. The modeling of the draperies, quixotic and decorative in the *Admonitions of the Instructress*, is here done more systematically, using shaded red, which undoubtedly reveals the influence of Central Asian and even Indian painting. The setting is still abstract. The figures are shown in relationship only to their immediate environment, the dais on which the emperor sits. The expanding perspective of the dais is precisely the opposite of

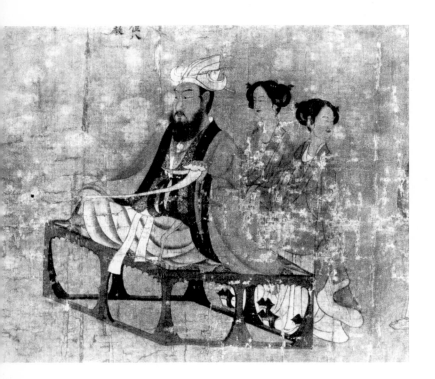

347. *Emperor Wen Di of the Chen dynasty, from Scroll of the Emperors.* Attrib. Yan Liben (d. A.D. 673). Section of the handscroll, ink and color on silk; height 20 1/8", length approx. 18'. China. Tang dynasty. Museum of Fine Arts, Boston

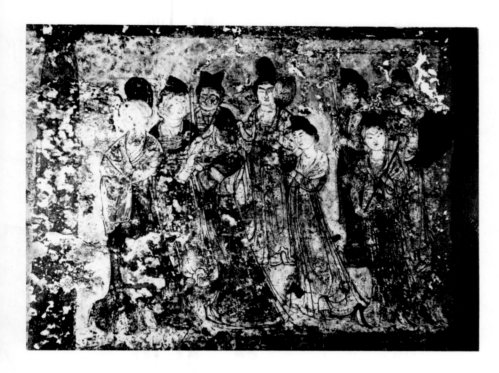

348. *Female attendants.* Wall painting from tomb of Princess Yongtai, length 14′ 5″. Qian Xian, Shenxi, China. Tang dynasty, A.D. 706

that used in most Western painting, but this expansion is handled much more convincingly than in the painting by Gu Kaizhi. The emperor of figure 347 is Wen Di; he is shown at ease, quietly sitting instead of standing in a dominating pose. His summer garments of soft materials contribute to the image of an effete rather than a dynamic person. This characterization is part of the trend toward individual realistic portraiture in the Tang dynasty. The convention of drawing an ear or a mouth—and it is a convention—is based on actual appearance to a much greater degree than in paintings of earlier periods.

The *Scroll of the Emperors* follows the same simple color scheme used by Gu Kaizhi, which seems especially appropriate to its exalted and didactic subject matter: the characters of emperors of the past providing moral lessons for the present. The simple sobriety of the colors, predominantly red, creamy white, and black, with occasional traces of blue or pale green, produces an effect of great austerity. The figures of the "strong" emperors stretch from the bottom to the very top of the silk. The large scale, sober color, and powerful but simple linear drawing combine to create a coherent, harmonious, and monumental effect, making this scroll one of the greatest

and most important of extant Chinese paintings. Yan was also commissioned to design sculpture, and his remarkable combination of realism and monumentality is to be seen in the four life-sized stone reliefs of the horses of the Tang emperor Tai Zong, two of which are now at the University Museum in Philadelphia (*fig. 349*).

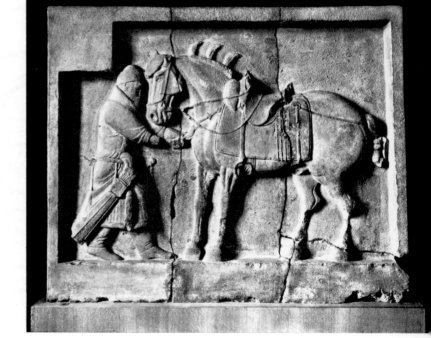

349. *Tang Tai Zong's horse with groom.* Designed by Yan Liben (d. A.D. 673). Stone, height 68″. Liquan Xian, Shenxi, China. Tang dynasty. University Museum, Philadelphia

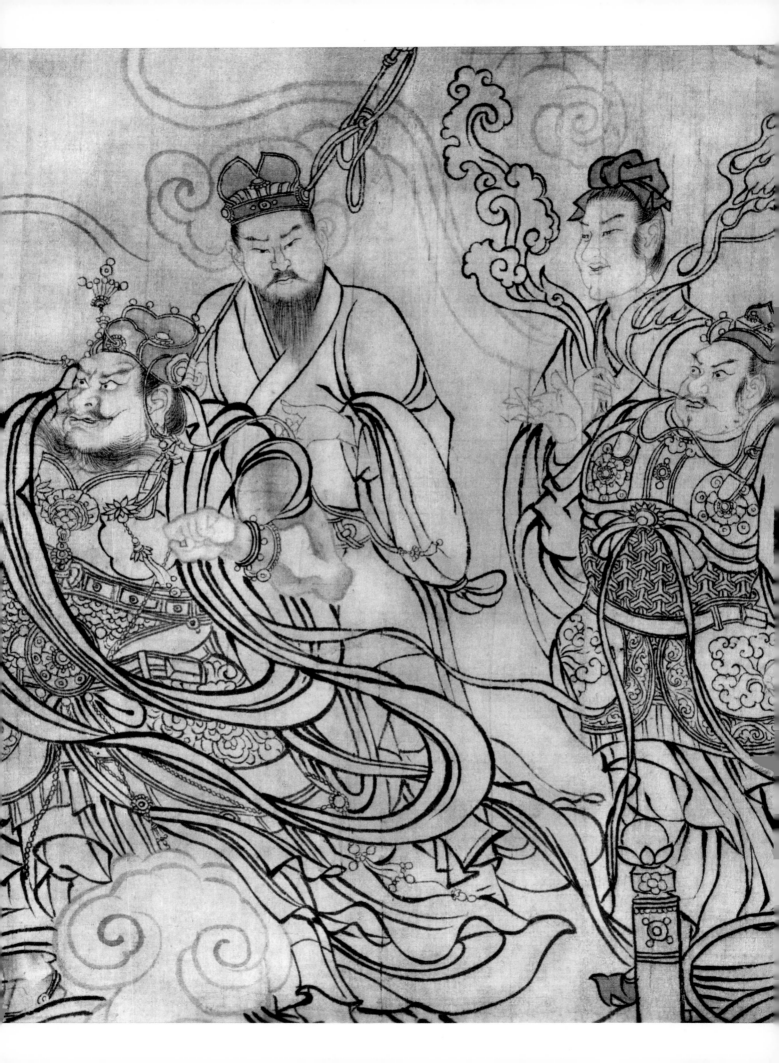

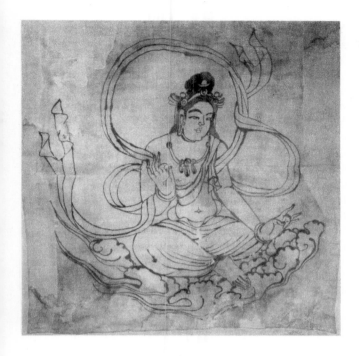

351. *Bodhisattva*, from a painted banner. Ink on hemp cloth, height 52 3/8". Japan. Nara period, mid-eighth century A.D. Shoso-in, Nara, Japan

probably gives a fair indication of his style (*fig. 350*). There is, however, in the Shoso-in at Nara, a contemporary painted banner representing a bodhisattva, the work of some fairly accomplished but unimportant painter, possibly an artisan employed by the emperor Shomu or the Todai-ji (*fig. 351*). It is painted with a brush on hemp, with considerable vigor, using a thick and thin line for depicting swirling drapery. It is our most spontaneous example of what may have been the art of Wu Daozi.

One of the few documented originals by a known artist of the Tang dynasty is by the hand of the minor master Li Zhen (*fig. 352*). A restored set of the *Seven Patriarchs of the Shingon Sect of Buddhism* is kept at To-ji, outside Kyoto. Five of the seven are Chinese orig-

Yan Liben dominates Chinese art of the seventh century, but the greatest name of the Tang dynasty, if not the greatest name in Chinese painting, is that of the eighth century master Wu Daozi (act. A.D. 720–760). Wu Daozi was extolled even in his day, praised as the greatest of all figure painters and the epitome of the divine artist—and yet we have nothing by or even remotely close to his hand. We know that he was primarily a figure painter, that Daoist and Buddhist subjects were his specialty, and that he was able to create a look of unusual power and movement, stress and strain, in figures and compositions. Of Wu Daozi it is told that when he finished his last wall painting, he opened the door to one of the painted grottoes, walked in, and disappeared. Such myths about great Chinese painters have become clichés, but this one actually suggests something of the magical impact of Wu's paintings. He is said to have introduced one of the most unrealistic elements of Chinese painting, although one of its greatest glories —developed calligraphic brushwork. To him is ascribed the honor of creating the thick and thin line to express the movement and power of the brush as well as to model drapery. The copy (fourteenth century [?]) after one of his followers, Wu Zongyuan,

352. *The Patriarch Amoghavajra*. By Li Zhen (act. c. A.D. 780–804). Hanging scroll, ink and color on silk; height 83". China. Tang dynasty. To-ji, Kyoto

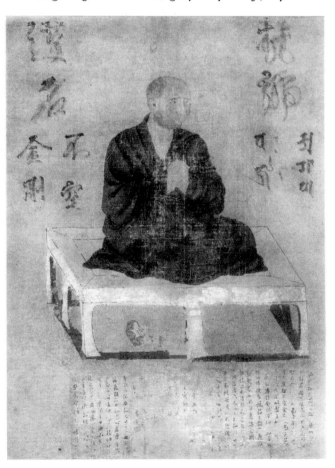

350. (opposite) *Eighty-seven Immortals*. Fourteenth century (?) copy after Wu Zongyuan (d. A.D. 1050). Detail of the handscroll, ink and color on silk; height approx. 16", length approx. 20'. China. Song dynasty. C. C. Wang Collection, New York

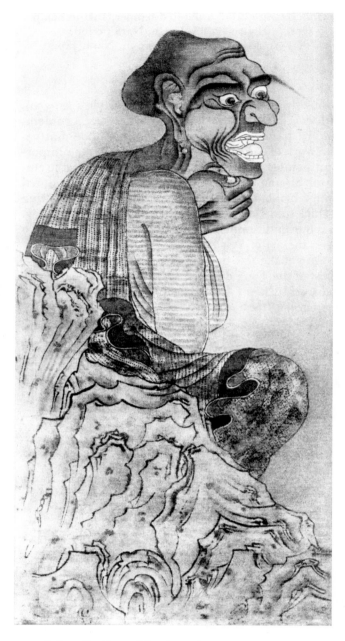

353. *Lohan.* By Guan-Xiu (A.D. 832–912). Hanging scroll, ink and color on silk; height 50". China. Five Dynasties period. Tokyo National Museum

Yan Liben. His slippers are under the dais, and he sits with his drapery falling about him, his hands in a ritual pose of adoration characteristic of the Shingon sect. Despite damage to the silk, details indicate a strangely powerful realism. If this is the work of a minor master, then what must the great paintings by Wu Daozi have been? The head, the ear, and the contour of the skull, which in later Chinese painting is represented as a very smooth arch, all have a sharply individual character, as do the eye, eyebrow, eye socket, and the unusually shaped nose. Such a search for individual traits was prompted by the artist's need to present Amoghavajra as he really looked, or at least was imagined to look, in the hope that these depicted traits, real or imagined, might reveal the nature of a truly holy man. Li Zhen's portraits are on silk in hanging scroll format of considerable size. Note the use of characters, Chinese and Sanskrit, around the figure in a formal pattern. This transforms the portrait into something of a magical mandala, a diagram of the type particularly associated with Esoteric Buddhism.

From this purposeful realism to the grotesque and to caricature is but a step. Indeed, in both Oriental and Western art there is a close connection between a concentration on individual character and a corresponding interest in caricature and satire. In the later Tang dynasty representations of the Eighteen Lohan (in Sanskrit, arhats, or enlightened beings) became the vehicles for extreme exercises in realism and the grotesque. Guan-Xiu, who lived from A.D. 832 to 912, through the very end of the Tang dynasty and into the period of interdynastic strife called the Five Dynasties, painted famous representations of such grotesque lohan (*fig. 353*). Unfortunately it is arguable whether the paintings attributed to him are original. The best examples are certainly those kept in the Imperial Collection in Tokyo. Guan's aim was to emphasize the holiness by means of the grotesque exteriors. There is no easy path to Enlightenment. The Way, which is torturous, terrifying, and exhausting, needs must leave its marks on those who have followed it to its end. The old gnarled tree is somehow a more rewarding object of contemplation than the young sapling. And so the more gnarled and grotesque the figure, the more eccentric the glance, the more hairy the beard, and the more horny the feet, the more noble is the character. It is not ugliness that we are being shown, but the outward aspect of supreme spiritual effort. The works of Guan-Xiu, as we know them from the paintings in the Imperial Collection, show a traditional thin, wirelike line used, like Li Zhen's, in the service of his version of realism. Evidently the use of the calligraphic line, in the tradition of Wu Daozi, represents a separate strain, one persisting in later Chinese

inals; two are Japanese additions to the set. The *Patriarchs* of To-ji, one in decent condition, are, by temple records, the evidence of the inscriptions, and the quality of the painting itself, originals painted by Li Zhen and exported to Japan in the ninth century. Li Zhen was active about A.D. 800, and these pictures are recorded in Japan from that time. The portrait of the patriarch Amoghavajra shows him seated on a dais, like some of the emperors in the painting by

painting as well as in the frescoes of the late Tang and the Song dynasties.

In contrast to these powerful painters of primarily masculine figures is the artist Zhou Fang, who lived past the end of the Tang dynasty and who was most famous for his depictions of women. The picture that perhaps best expresses his style is one of court ladies listening to the *qin,* a zither-like instrument, played by a lady seated on a rock *(colorplate 26, p. 283).* It is a short handscroll on silk, with the remains of quite brilliant color, ranging from yellow, red, and orange to lapis blue, malachite green, and the usual black ink. In the representations of court ladies and children the copious use of color was very much the mode. The two slender standing figures are servant girls. The three court ladies, ideal beauties of the middle and late Tang, are not the "morsels of jade" or "swaying willows" with "petal faces" and "waists like bundles of silk" that Gu Kaizhi loved to paint, but well filled out, with moon faces and bodies like plump pears. They express perhaps the pride and pleasure men took in ease and luxurious abundance in the waning years of the Tang dynasty. Tomb figurines of ladies of the late Tang period have the same proportions.

In most of the works we have seen so far, setting is minimal. Even the elaborately detailed *mise-en-scène* of the Nelson Gallery sarcophagus does not approach the environment Zhou Fang provides for his palace ladies. We look into a garden; two trees, one in the foreground, the other a little to the left and behind a broad rock, establish an adequate, if limited, measure of space for the figures to inhabit. Beyond this, however, is the abstract background characteristic of Chinese painting up to this time. Very rarely until the Song dynasty does one see in figure painting a setting that explains the relation of every part of the composition either to an interior room or to infinite space. This problem seems to have been left to the landscape painter for solution. It was enough for the figure painter to concentrate on figures and the delineation of a relatively shallow stage for them to function in.

There is also in this picture a subtle relationship between the figures and the surface spaces that contributes an almost musical quality to the composition. The wedge-shaped gaps between the figures are most sensitively and exactingly varied in size and shape. Note especially the studied and careful manipulation of the figures in relation to the picture plane and to each other, beginning with a two-thirds view from behind, a three-quarters view from the front, then an almost full back view, then a head-on view, and finally a three-quarters view from the front. The spectator observes from a respectful distance; he is not asked to participate. The strangely quiet effect adds to the musical mood and is achieved primarily by turning the very important foreground figure so that she looks away from the spectator.

Zhou Fang established the formula for the representation of noble Chinese femininity, and his works were copied and used as models by all the great painters of women in the Song, Yuan, and Ming dynasties. Later artists sometimes changed the physi-

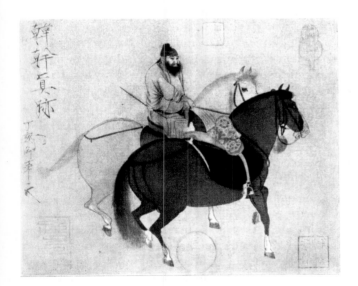

354. *Two Horses and Groom.* Attrib. Han Gan (act. A.D. 742–756). Album leaf, slight color and ink on silk; height 10 7/8″. China. Tang dynasty. National Palace Museum, Taibei

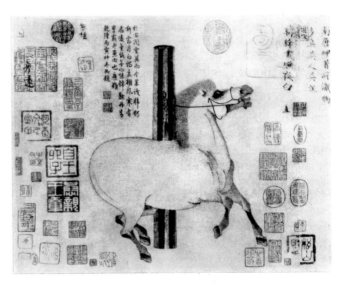

355. *Night-shining White Steed.* Attrib. Han Gan (act. A.D. 742–756). Album leaf, ink on paper; height 11 3/4″. China. Tang dynasty. Metropolitan Museum of Art, New York

356. *Wang Chuan Villa*. Fifteenth or sixteenth century (?) copy after Wang Wei (A.D. 699–759). Section of the handscroll, ink and color on silk; height 11 3/4", length approx. 9'. China. Ming dynasty. Seattle Art Museum

cal proportions in accordance with the taste of the time, but the general type of composition, subject matter, palette, drawing, and relationship between figures were largely established by Zhou Fang.

In addition to artists who confined themselves to figure painting, there were specialists in even more restricted fields. Thus for the first time we encounter painters whose primary subject was horses, or still lifes. Horses were as popular in art as in life, being equally necessary to Tang military strength and to the aristocratic recreations of polo and hunting. The greatest painter of horses, never surpassed in Chinese esteem, was Han Gan. Perhaps the finest painting attributed to him is one in the National Palace Museum in Taibei (*fig. 354*). It shows two horses, one ridden by a Central Asian groom, a combination often repeated in later painting. The realism of detail is notable, as is the now customary abstract setting. Another painting, long in the Chinese Imperial Collection, represents a tethered horse, and even though somewhat restored certainly shows the Tang style of horse painting (*fig. 355*). The head is modeled in very simple planes, the big forms blocked out as if hewn from jade. Modeling is accomplished by shading in the simple Indian or Central Asian style and is used to indicate the overlapping planes of the chest muscles. The stylized realism and the interest in the movement and characteristic pose of the horse, with one foreleg raised off the ground and the head thrown back, are in keeping with the aims of the period and produce a work which in its general outlines and composition is of impressive quality.

This small album leaf is a glaring example of the tasteless use of collectors' seals, which can be and often are used circumspectly and inoffensively.

One of China's most significant contributions to

the art of the world is landscape painting, which developed rapidly in the Tang dynasty and reached fruition by the early Song dynasty. Few can deny the unique character of Chinese landscape painting. Though the first heights of this great tradition were not attained until the tenth century, certainly the preparation was made during the Tang dynasty. We have already seen tentative approaches to landscape in tomb tiles and inlaid bronzes; summary landscape adorns Buddhist painting as a setting for the dogma of the faith; it occurs as an accessory to narrative in Gu Kaizhi's *Lo River Nymph*. But the beginnings of landscape for its own sake are to be found in paintings recording great historic events. They go back at least to the seventh century in the work of Li Sixun (A.D. 651–716), the greatest master of the "blue-and-green" narrative style, who was particularly famous for his use of color and gold to outline rocks, architecture, and decorative elements. His son and artistic successor was Li Zhaodao (act. c. A.D. 670–730). Both are known to us today only through copies and literary references. Their style was primarily decorative, their subjects great historical events or happenings at court. In the National Palace Museum in Taibei is one early copy on silk of a painting by Li Zhaodao, executed in brilliant color, which depicts a Tang emperor and his entourage traveling through a landscape (*colorplate 22, p. 278*). The title of the picture suggests that the narrative was most important, but the landscape has become the real subject of the picture. The figures, small in scale, are unimportant; even in the foreground they are lost among the rocks, trees, and bushes, with the mountain landscape dominating the scene. Though the unreal and decorative tall peaks derive from the "lady's comb-teeth" mountains of the Six Dynasties period, there

is a substantial development of space and setting, with realism in the mountain outlines, character in the rocks, overlaps and planes in the mountain structure, and interest in space beyond the mountains. The artist paints distant trees and rivers, a great river landscape stretching back into infinity, clouds behind the mountains, and mountains receding, layer on layer, into the distance. Compared with great tenth century landscapes, this is still a relatively archaic and simple composition despite an apparent complexity largely achieved by adding as much detail and high color to the picture as possible. There is, for example, a definite lack of correlation between the view on the right and the view through the little gorge on the left. The trees in the foreground are not in proportion with the dwarfed figures of the travelers below. The whole problem of the precise location of elements in space and the unification of that space by means of atmosphere and logical relationships in scale is yet unsolved and even poorly understood. Still, in the works of Li Sixun and his followers a style that we can call courtly offers the beginnings of a landscape art, albeit as an adjunct of narrative.

The master most closely associated with the beginnings of pure landscape painting is the artist-scholar Wang Wei (A.D. 699–759); he was reputed not only one of the greatest of landscape painters, but the pioneer of monochrome landscape painting. That any one artist alone originated the ink landscape we can well doubt; it was, however, in his time that some kind of landscape rendered predominantly in ink developed. In many of the great paintings of the tenth century faint washes or even some bright and opaque color was used. But it was certainly Wang, judging from the evidence of

remaining stone engravings, who "invented" landscape per se, and that further inventions are attributed to him is understandable. The scroll-painting of his country estate, called Wang Chuan Villa, is the first true Chinese landscape (*fig. 356*). The few figures are incidental; the landscape itself is the subject of the picture. *Wang Chuan Villa* is known to us in a variety of copies, all remote from the original but some less so than others. An engraving of it in stone was also made, which is some help in judging the quality and faithfulness of the painted copies. If the stone engraving (at Lantian, Shenxi) is a fairly accurate version of the *Wang Chuan Villa* scroll, there is a late copy, perhaps of the fifteenth or sixteenth century, sufficiently close to indicate something of the contribution of Wang Wei. This handscroll is painted on silk and, appropriately for its time, in color. Here is true landscape: a scene on an estate, a group of buildings, a few peasants working, a fishing boat on a stream. There is no narrative; instead we have a topographical treatment of nature. Each section is named for the part of the estate it represents, almost as if a surveyor making the rounds of the estate had produced a pictorial map for both identification and delectation.

Interestingly, this painting, which after all is based upon an eighth century "invention," still betrays uncertainty in the development of locations in the landscape. One space cell, almost as simple and limited as those in the Nelson Gallery–Atkins Museum sarcophagus, is rimmed by mountains with curiously balanced and uniform waterfalls popping from their lower reaches. There is little indication of anything beyond these mountains, almost as if the landscape were tilted toward the spectator, who is presented with a segment instead of the whole.

Then there is the great problem of the middle ground. In the foreground scenes the artist has evaded the most difficult problem of all landscape painting—creation of a convincing space between foreground and distance—by putting water there, a well-known escape device for all primitive painters, indicating a still archaic state of development. The rest of the scroll is much in the same vein, each section tilted as if it were a map and made into a space cell by the simple device of encircling mountains or rocks.

No monochrome landscapes of Tang date, or even copies of such, are now known, though there was undoubtedly some monochrome figure painting. But a small group of paintings, all monochrome and one of them excavated from a tomb of the early tenth century, indicates that the attribution of monochrome landscape to Wang Wei and to the eighth century may not be wrong. The best of these is a small album leaf on silk (*fig. 357*), formerly in the Manchu Household Collection, attributed to Wang Wei in an early twelfth century inscription written by the emperor Hui Zong. The subject is a winter landscape, a theme it shares with some others in this

358. *Kichijoten.* Color on hemp, height 20 7/8". Japan. Nara period, eighth century A.D. Yakushi-ji, Nara

357. *Snow Landscape.* By Wang Wei (A.D. 699–759). Album leaf, ink and white on silk; height approx. 18". China. Tang dynasty. Formerly Manchu Household Collection

group. The artist used opaque white pigments on the silk, producing a reverse monochrome painting; the toned silk provides the darks and the white opaque paint builds the highlights. The simple and archaic modeling of rock forms is beautiful and unusual, as is the "primitive" architecture. The intimate quality of this album leaf is reminiscent of the *Wang Chuan Villa* scroll, as is the solution of the middle ground problem by means of an expanse of water.

A few secular paintings of importance, preserved in Japan, shed additional light on some of the Chinese paintings we have just seen. Although the subject of the small painting kept at Yakushi-ji, a depiction of the female deity of abundance, Kichijoten, derived from the Indian Lakshmi, is nominally Buddhist, the manner of representation and the style are purely Tang, derived from such courtly representations of beauties as those by Zhou Fang (*fig. 358*). Indeed, so well documented and preserved is

the Kichijoten that she may well serve as a standard by which to judge the various Chinese paintings that claim her age and style. The plump physical proportions we have seen before, but the lovely linear rhythm of the windblown draperies, the delicate and variegated color in the textile patterns, and the conscious grace of the hands seem far superior to almost all of the pretenders to her place, though a handscroll from the Chinese Imperial Collection, now preserved at the Liaoning Provincial Museum in Shenyang, must be reckoned with as a Chinese original of the period. The graceful geometry of the facial features, notably the eyebrows and the small cupid's-bow mouth, are closely related to the high style of Tang art in the eighth century, whether in paintings, sculptures, or the more lowly grave figurines.

The set of screen panels kept in the Shoso-in, rep-

359. *Lady Under a Tree*. Detail of screen panel, ink and color on paper; height 49 1/2''. Japan. Nara period, first quarter of eighth century A.D. Shoso-in, Nara

360. *Plectrum guard on five-stringed biwa, with landscape design*. Painted leather, height 20 3/8''. Nara period, eighth century A.D. Shoso-in, Nara

resenting court ladies beneath flowering trees, is purely decorative and secular in nature (*fig. 359*). Time and wear now reveal the painting without its original sumptuous over-decoration of applied feathers in iridescent hues. The painted figure is in the style of Tang painting we associate with Zhou Fang. Probably such talented and famous artists worked on decorative panels of this sort in addition to the more usual formats of handscroll or hanging scroll. The linear basis of this figure style is evident, for the loss of decorative color does little to diminish the sophisticated effect of the whole. The line varies with the subject matter: rock and tree are drawn with a varying, almost calligraphic line, the figure with a more measured, wirelike line.

Even landscape painting is to be found on some of the useful objects preserved in Japan. The plectrum guard on one of the *biwa* (lutes) in the Shoso-in displays a fanciful landscape with musicians riding an elephant in the foreground (*fig. 360*). The fairy-tale appearance of these mountains, with their repetitive,

271

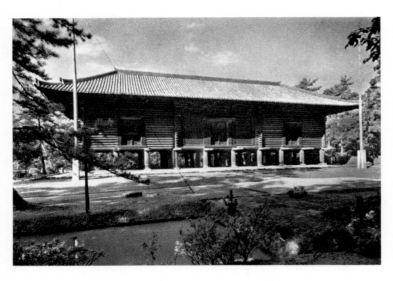

361. *Shoso-in, Nara, Japan*. Front view. A.D. 756

undulating outlines of receding ridges, recalls the courtly style of Li Sixun. The vertical format is one of the few remaining evidences for the landscape hanging scrolls of the Tang period, and the division of the space between near mountains on the left and a distant vista on the right is a rather advanced compositional device. Despite the charming miniature style, however, the actual definition of space and of the objects within that space is still highly schematic and little advanced beyond such late Six Dynasties works as the Nelson Gallery–Atkins Museum sarcophagus. It is noteworthy that the musicians are Central Asian types, for nearly all of the arts of the Tang and Nara periods, especially the utilitarian arts, show much influence from Central Asia and even Sasanian Persia and Mesopotamia.

Decorative Arts

The worldly magnificence of Tang civilization naturally called into being large-scale manufacture of luxurious decorative arts, more varied and opulent than any since the late Zhou period. On the mainland, unfortunately, only those objects that could survive burial and were buried (as tomb furnishings or for safekeeping) are left, notably numerous splendid ceramics in both earthenware and stoneware. Fortunately there is another source for our knowledge of Tang decorative art—Japan, which we have seen to be still a cultural and religious satellite of China during the Nara period. Almost miraculous circumstances contributed to the preservation, in the region of Nara, of decorative arts as well as of Buddhist sculpture and painting. Horyu-ji and To-dai-ji, the homes of so much of the best sculpture in

Tang style, also preserved some examples of the useful and secular arts. But the greatest repository of all is surely the Shoso-in in the precincts of Todai-ji, a warehouse of court furnishings and accoutrements donated by the empress Komyo in memory and for the salvation of her husband, the emperor Shomu, in A.D. 756. This treasure is almost completely preserved to the present day in its original cypress log storage building (*fig. 361*).

The more than six thousand objects in this remarkable assemblage, ranging from herbs and weapons to carpets, games, and musical instruments, do not all date from the empress's original donation, but almost all of them entered the Shoso-in during the eighth century A.D. Many are as if made yesterday, for the log construction breathes with the seasonal changes in humidity, keeping out the damp and allowing the dry air of late summer and fall to circulate freely, airing the three interior storerooms. Here, ranged row on row in chests and cases, are the imperial accoutrements of the Nara court, and these must have been but a fraction of what the Chinese emperor could command at Changan. Some of the objects in the Shoso-in are undoubtedly of non-Japanese origin, being gifts from abroad or the usual imperial accumulation of rare and exotic luxury items.

The textiles are particularly varied and numerous, and this is to be expected, for the East Asian silk industries were renowned. Indeed, the trade routes to the West were called the silk roads. Many of the silks are printed, some by stencil-dyeing, the more abstract patterns by tie-dyeing. The most sumptuous of the dyed fabrics were made by the Southeast Asian technique of batik, or wax-resist dyeing. The designs on all the fabrics use typical international Tang motifs—the hunt in a landscape with the horses and animals at the Scythian flying gallop (*fig. 362*), or plump court ladies playing musical instruments beneath large-leafed trees.

The silks with woven patterns comprise gauzes with varied and fine abstract patterns, rich brocades with figural designs placed in repeated roundels enclosed in vine arabesques linked by semiabstract floral units, and twills of the same designs but usually with a more thoroughly Near Eastern flavor closely related to, even copied from, Sasanian twills with their pearl-bordered roundels enclosing heraldic figure groups. Some of the textiles are fragments; others are incorporated in objects such as pillows, arm rests (*fig. 363*), shoes, mirror-box linings, costumes, folding screens, and banners. Carpets are plentiful in the Shoso-in, made by the Central Asian technique of pressed hair with inlaid designs of large floral units.

The many metal objects too reveal the interna-

tional civilization of the time. Vessels in bronze or gilt bronze may be purely Chinese in shape and decoration or they may be direct copies of Sasanian silver and gold objects like the many found in south Russia and now in the Hermitage in Leningrad. There are numerous unusually large mirrors whose backs are of plain specular bronze, or silver- or gold-covered bronze, or of lacquer inlaid with precious metal, gemstones, and mother-of-pearl (*fig. 364*). All are decorated with Chinese or Near Eastern designs of the same type as those on the textiles. Repoussé dishes and flasks are also to be found.

The most extraordinary of the metal objects are the large silver bowls in Buddhist alms bowl shape with engraved designs of hunting scenes. Smaller ones are known from excavations in China, but the

362. (above) *Hunt in landscape*. Detail of screen panel, batik-dyed silk; height 64 1/4". Nara period, eighth century A.D. Shoso-in, Nara

363. (right) *Arm rest*. Wood covered with brocade; design: *feng-huang* in floral roundels; height 7 7/8". Nara period, eighth century A.D. Shoso-in, Nara

364. (below) *Eight-lobed mirror with design of flowers and birds*. Specular bronze coated with lacquer inlaid with gold and silver (*heidatsu*); diameter 11 1/4". Nara period, eighth century A.D. Shoso-in, Nara

365. *Jar engraved with hunting scene.* Silver, height 19 5/8″. Nara period, eighth century A.D. Shoso-in, Nara

366. *Hunter and boar.* Detail of fig. 365

367. (above right) *Foot rule with design of animals, birds, and flowers* (left, reverse; right, obverse). Carved and stained ivory, length 11 5/8″ Nara period. Shoso-in, Nara

368. (right) *Go gaming table.* Shitan wood, with marquetry, ivory, and deer-horn inlays; length 19 1/4″. Nara period. Shoso-in, Nara

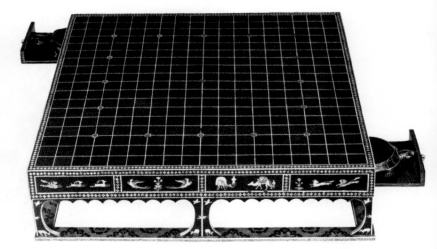

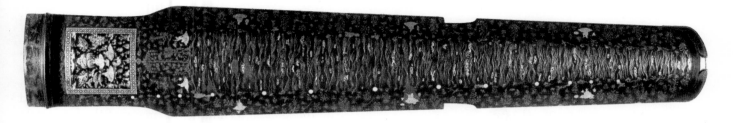

369. *Decorated kin.* Lacquered wood inlaid with gold and silver (*heidatsu*); length 45″. Nara period. Shoso-in, Nara

great size and accomplished technique of the Shoso-in bowls place them at the head of their class (*fig. 365*). The landscape setting with its miniature mountains, scattered floral-and-foliage ground, and specialized decorative character provides a tapestry-like background for spirited vignettes of hunters and prey at the flying gallop. One detail might almost be a literal copy of the Sasanian royal hunt motif as found on the incised or relief-molded Persian dishes (*fig. 366*). The rider has passed the prey and turns in the saddle to shoot his arrow back over the hindquarters of his galloping horse at the charging, bristling boar. The motif is surely Sasanian, but the apparent speed of the moving figures is achieved by imposing the linear devices peculiar to Chinese painting upon the derived silhouettes.

Ivory, too, is a favorite material, almost completely destroyed on the mainland but preserved in the Nara treasure hoard. There are plain peces of it, along with measuring rules decorated with carved and color-stained designs marking the units of measure (*fig. 367*). In these patterns, smaller and more formal than those on metalwork, birds, animals, and flowers or floral medallions alternate. All belong to the same international decorative vocabulary already noted in textiles and metalwork. Ivory was also used along with precious colored woods for marquetry work, particularly in the gaming boards and tables of the court. One *go* table in almost unbelievably splendid condition has side panels amounting to framed pictures, with genre scenes of foreshortened camels and attendants as well as the more usual galloping creatures (*fig. 368*). If these lively scenes are the work of skilled artisans, what must the greatest paintings of the Tang court have been?

Lacquer and lacquered wood were an East Asian medium since the late Zhou period, and it is not surprising that they comprise some of the most beautiful objects in the Shoso-in. Vessels, mirrors, and other objects were decorated with designs painted, incised, or inlaid in lacquer, but the most conspicuous and complex example of lacquer work is the musical instrument called the *kin*, decorated in the *heidatsu* technique (*figs. 369, 370*). Delicately

cut sheets of silver and gold in floral and figural designs were imbedded in a carefully lacquered wood ground and then covered with additional coats of lacquer. The whole was then polished down until the precious metals could be seen clearly. The result is one of the most refined and beautiful utilitarian objects in all the world. The flower, wave, and cloud patterns compose the overall background for the figures of musicians placed at regular, widely spaced intervals over the surface of the instrument. A square at the head is treated as a framed picture, with a carefully balanced composition of three musicians

370. *Decorated kin.* Detail of fig. 369

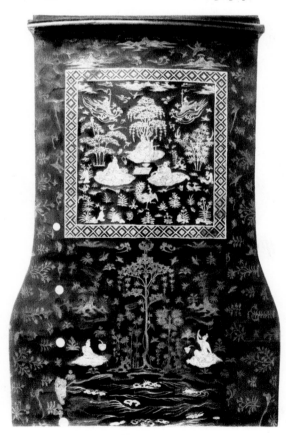

371. *Biwa plectrum guard*. Tortoiseshell inlaid with mother-of-pearl, height 12". Nara period. Shoso-in, Nara

372. *Gigaku mask*. Lacquered wood, height approx. 11 3/4". Nara period. Shoso-in, Nara

playing and drinking on a flower-and-bird-carpeted ground beneath a flowering tree flanked by bamboo. Above, in the rhythmically cloud-decked sky, balanced groups of fairies riding *feng-huang* on waves of clouds complete the subtly symmetrical arrangement. Enormous technical virtuosity was required by the *heidatsu* technique, for many of the intricately detailed trees are cut from single sheets of gold and silver. The delicate rhythms of the designs, combined with the soft show of silver and gold, make a visual counterpart to the limpid and gentle sounds produced by the *kin*.

Experimentation with exotic materials was the order of the day. One *biwa*, again from among the marvelous group of musical instruments, will serve to demonstrate this facet of Tang genius (*fig. 371*). It combines sandalwood, tortoiseshell, and mother-of-pearl in a plectrum guard design representing a musician playing a *biwa* while riding a camel in a spare landscape indicated only by a centered plantain tree and few rocks and flowers. The mother-of-pearl silhouettes are incised on their interiors to give greater realism and movement to the scene. In China we know of such *tours de force* only through representations in painting or from a few battered and eroded mother-of-pearl fragments.

Realism, exoticism, and, by extension, caricature were characteristic interests of the artists of the Tang dynasty and the related Nara period in Japan. Various details and secondary images in the Buddhist sculpture of the period evidence this. But the most direct and specialized expression of this interest is found in quantities of wooden and lacquer dance masks preserved at Horyu-ji, Todai-ji, and the Shoso-in (*fig. 372*). These *gigaku* masks were used for dance interludes in Buddhist festivals, but their intent and derivation were more profane than holy. Unlike the small and subtle *no* masks of later times, whose message was for the few, the *gigaku* masks had to make their message carry over considerable distance to large numbers; hence their larger-than-life size and their often very exaggerated conformation. Most writers agree that the masks as well as the dances for which they were designed have a Central Asian origin. But this tradition may refer largely to the racial types, represented with characteristic Tang curiosity and exaggeration. The realistic effect of these heads was much enhanced by the use of actual hair on the skulls and for moustaches, and sometimes in the ears or nostrils. All were painted in the desired flesh tone, and where hair was not used, a painted subterfuge was substituted. The facial expressions run from rage to hilarious laughter, from low cunning to benign wisdom.

Two important Tang materials, ceramics and jade, are little or poorly represented in the Shoso-in, and

Colorplate 21. *Krishna Awaiting Radha*. Color on paper, height 7 1/4".
Guler, Punjab hills, India. C. A.D. 1740. Cleveland Museum of Art

青錄開山迴
嶺嗚道路長
宅人多結秦行
李自周祥絲
為名和利那
費勞興忙年
陳失姓氏北宗
近乎唐
甲午新秋
尚題

Colorplate 22. *The Emperor Ming Huang's Journey to Shu.* After Li Zhaodao (c. A.D. 670–730). Ink and color on silk, height 21 3/4″. China. Tang dynasty. National Palace Museum, Taibei

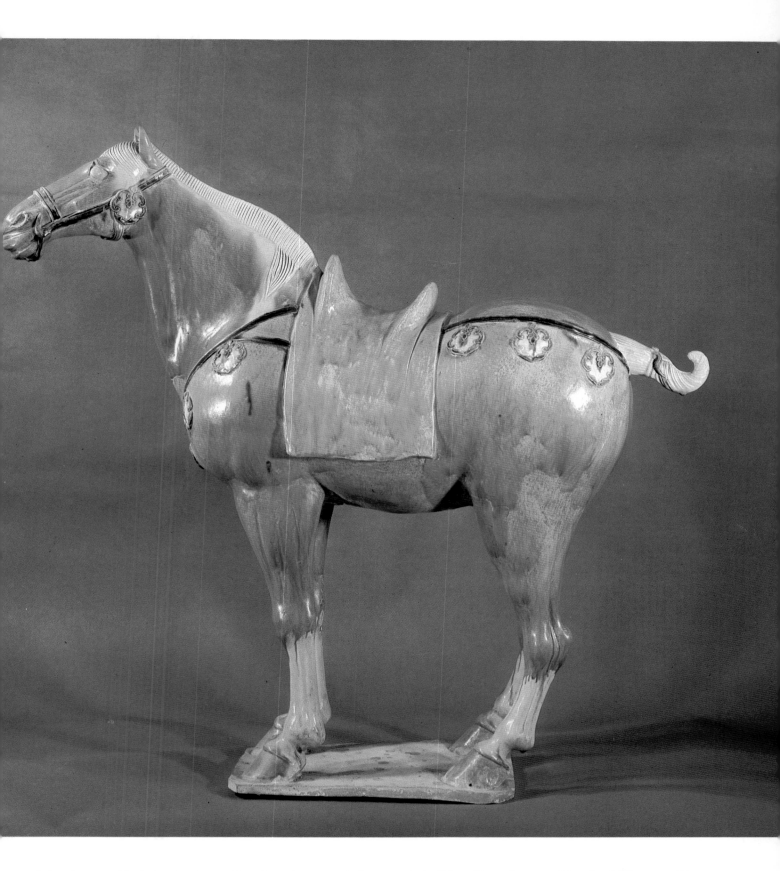

Colorplate 23. *Tomb figurine: horse*. Glazed earthenware, height 30 1/4″. China. Tang dynasty. Cleveland Museum of Art

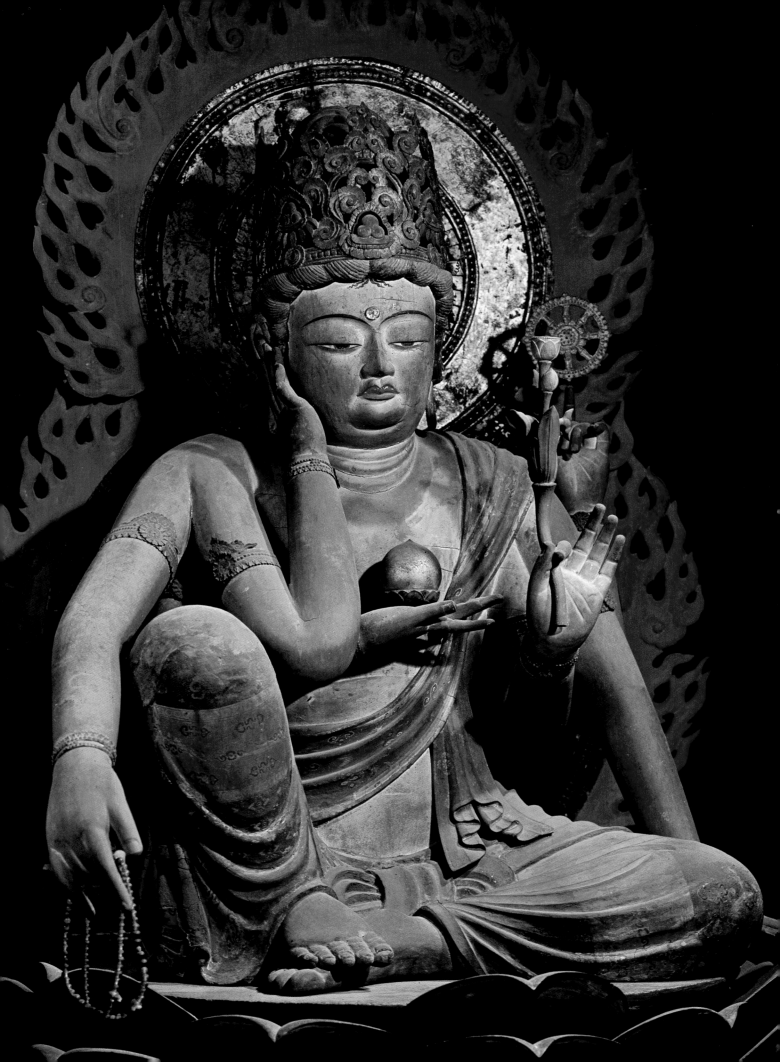

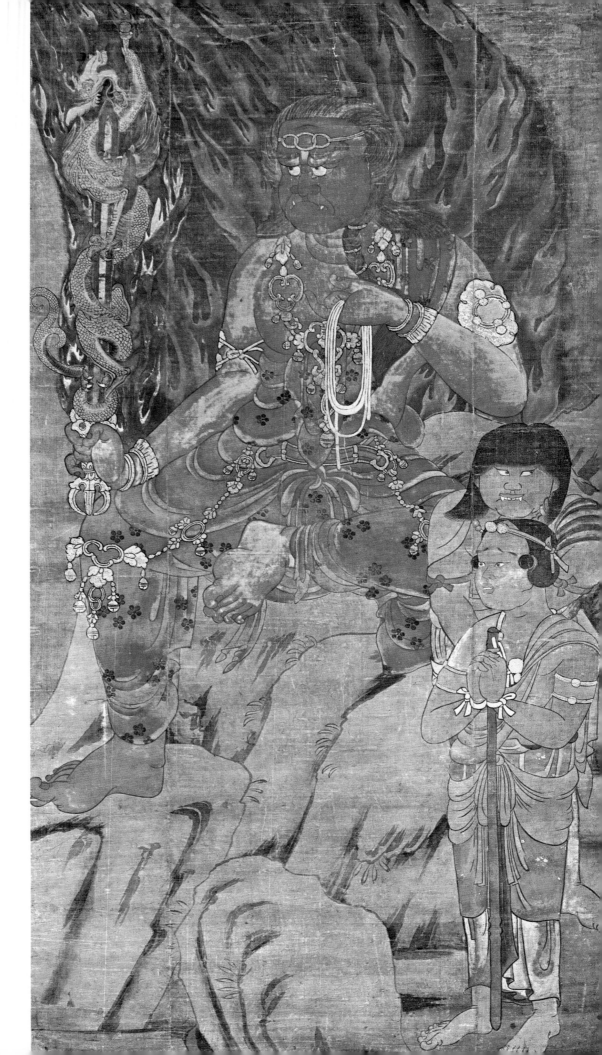

Colorplate 24. (opposite) *Nyoirin Kannon.* Colored wood, height 43″. Kanshin-ji, Osaka, Japan. Early Heian period, early ninth century A.D.

Colorplate 25. *Red Fudo.* Color on silk, height 61 1/2″. Myo-o-in, Koyasan, Wakayama, Japan. Early Heian period

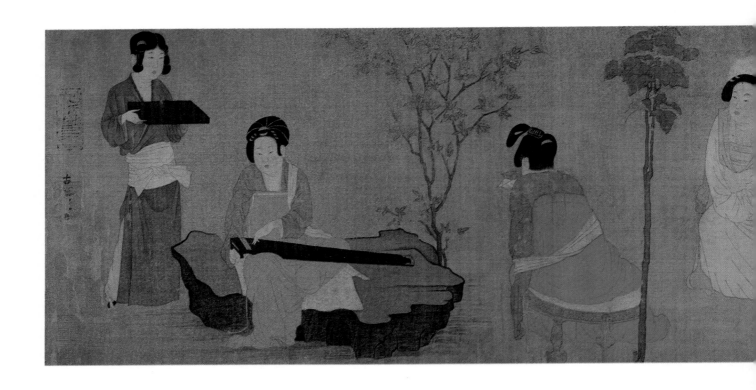

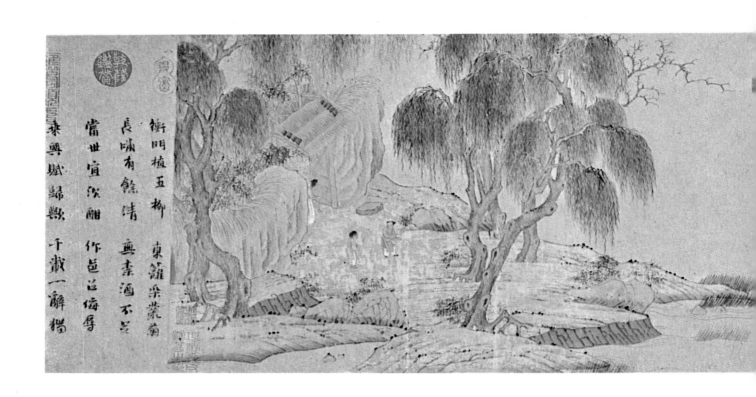

衡明植五柳
東籬采業菊
長嘯有餘清
無素酒不共
當世宜沈酣
作邑近偽辱
乘興賦歸欤
千載一辭獨

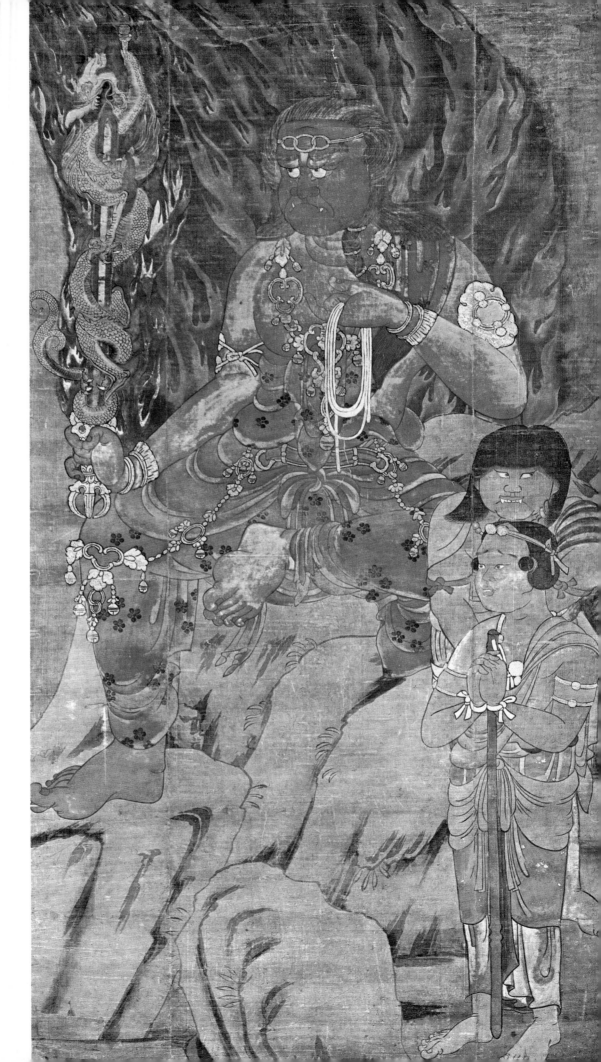

Colorplate 24. (opposite) *Nyoirin Kannon*. Colored wood, height 43″. Kanshin-ji, Osaka, Japan. Early Heian period, early ninth century A.D.

Colorplate 25. *Red Fudo*. Color on silk, height 61 1/2″. Myo-o-in, Koyasan, Wakayama, Japan. Early Heian period

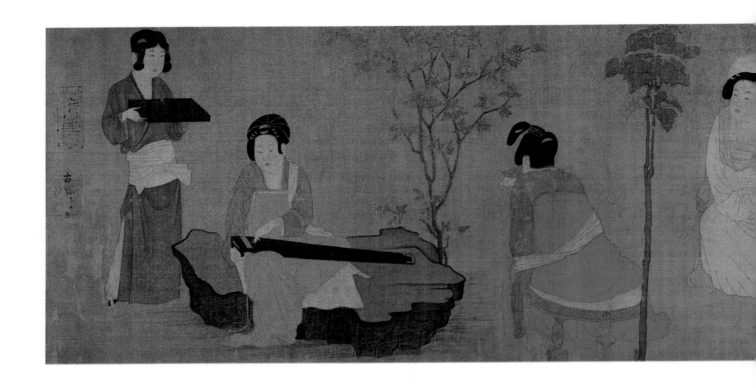

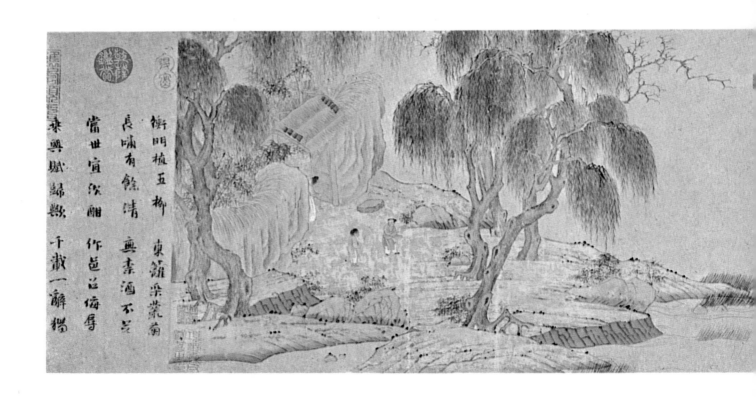

衡明楯五柳　東籬采藜菊

長哺有餘清　畫素酒不吳

當世寅次醐　作邑呂侮辱

乘興賦歸歟　千載一醉楷

Colorplate 26. *Palace Ladies Tuning the Lute*. Attrib. Zhou Fang (act. c. A.D. 780–810). Handscroll, ink and color on silk; height 11″, length 29 1/2″. China. Tang dynasty. Nelson Gallery–Atkins Museum, Kansas City. Nelson Fund

Colorplate 27. *Home Again.* By Qian Xuan (A.D. 1235–1290). Handscroll, ink and color on paper; length 42″. China. Yuan dynasty. Metropolitan Museum of Art, New York

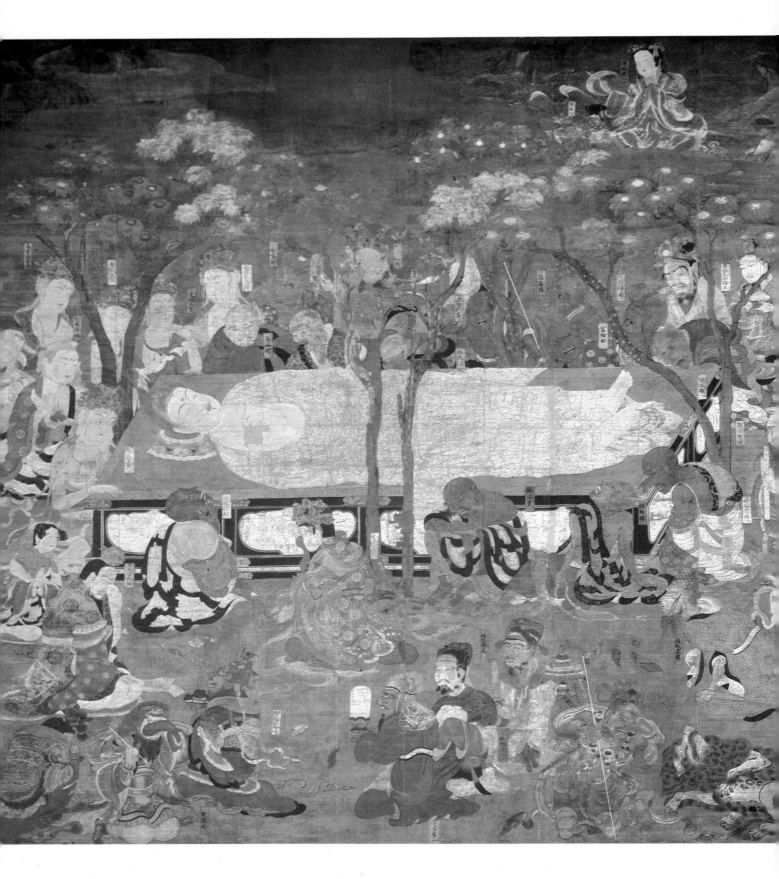

Colorplate 28. *The Parinirvana of the Buddha*. Color on silk, height 106″. Kongobu-ji, Koyasan, Wakayama, Japan. Late Heian period, A.D. 1086

for these we must study the fortunately numerous materials from Chinese excavations and collections. The few ceramics in the Shoso-in are of a glazed earthenware comparable to more highly refined and dexterous Chinese varieties. Such lead-glazed earthenwares, in the form of animal and human figurines or of useful vessels such as ewers, jars, plates, and cups, were predominantly used as burial furniture (*fig. 373*). Their bold, splashed coloration of brown, green, yellow, or, more rarely, blue is quite unlike the subtle monochromes of the succeeding Song dynasty, and many would see in this a reflection of western Asian tastes. Still, such colors correspond well with the rich coloration of Tang figure painting and polychromed sculpture. Like all other aspects of Tang civilization, taste was robust and vigorous and expressed by bold use of color in the arts.

Tang burial figurines have become especially well known in the West. These amazingly realistic and animated figures, intended to be seen only at funerals and then buried—forever, it was hoped—provide a kaleidoscope of the Tang world. All levels of society are represented, as are many of the beasts known to the artist of the time. The Han tradition of architectural models, however, had largely died out, perhaps because their static shapes held little interest for the dynamic vision of the Tang sculptor. The figurines of horses and camels, some almost three feet high, are perhaps the most interesting of all (*colorplate 23, p. 279*). Seldom has the horse been so expressively represented as in this period of such great painters of horses as Han Gan. The successful firing of such large ceramic objects was in itself a tremendous accomplishment; yet so skilled were the artisans that literally hundreds of thousands of the figurines were made in varying quality for the different levels of society. The rarest of these ceramic sculptures, and often the finest, are not glazed but painted with colored pigments over colored slips covering the clay, which ranges in hue from white through buff to terra-cotta red.

Few Buddhist subjects save for guardian kings— and these might be Daoist or Confucian as well—are to be found among the tomb figurines. The greater number are of secular subjects—music-playing ladies, exotic court dancers, humorous foreign types, hunters, and many other categories are known in countless examples, some of them apparently made from the same or similar molds and differing only in hand-finished details (*fig. 374*). The overall appearance of a complete set of tomb furnishings can be gauged from well-preserved excavated groups now in the Royal Ontario Museum (*fig. 375*). Whole cavalcades of horses and camels with Central Asian grooms, whole troupes of dancers and musicians,

373. *Shallow dish.* Polychrome-glazed earthenware. China. Tang dynasty. Private collection, Tokyo

374. *Harpist.* Earthenware, height 12 5/8″. China. Tang dynasty. Cleveland Museum of Art

375. *Tomb figurines.* Glazed earthenware. China. Tang dynasty. Royal Ontario Museum, Toronto

battalions of cavalry or infantry were the usual accoutrements of the tomb of a wealthy official. Their magical purpose was still to accompany the deceased, and perhaps their extreme sophistication and realism made them seem even more suitable to this purpose than the earlier, more stylized figurines.

Such lead-glazed earthenwares do not represent, however, the most advanced sector of the Tang ceramic industry. Stoneware continued to develop, and true porcelains, in the modern Western definition, were created at this time. The Chinese term porcelain all ceramics whose glaze has been inseparably bonded to the body by high-temperature firing. Western connoisseurs require that the body fabric be white and translucent as well. Song celadons, for example, are porcelain to the Chinese, but rank only as porcelaneous stoneware in the Western hierarchy—in ascending order of firing temperature—of earthenware, stoneware, porcelaneous stoneware, and porcelain.

The Yue celadon wares of the south flourished and were exported far and wide. Their decorative freedom, greater than in earlier ceramics, reflects the cosmopolitanism and wide-ranging interests of Tang society. Molded, incised, and gilded designs of flowers and figures were the order of the day, but few complete examples have survived, though the skillful designs are well known from shards found at the kiln sites in northern Zhejiang.

By the end of the dynasty the north was producing a pure white porcelain known as Xing ware, usually in simply shaped bowls and dishes. More elaborate Xing vases are extremely rare, the most extraordinary being the well-known vase formerly in the Eumorfopoulos Collection and now in the British Museum (*fig. 376*). This robust vase with its bird's-head lip and floral arabesques on the body seems an epitome of the vigorous, worldly, and technically gifted Tang tradition. These celadons and white porcelains were to be the foundations of the numerous and more subtle porcelain traditions of the following period.

We are only now beginning to recognize some Tang examples among the thousands of jades preserved today. Enough has been found and reasonably well established to be of the period to make clear that here, too, the artists tried to find ways to work the material in the forms of their accepted vision. This most precious and equally intractable material was, however, the least amenable to Tang ideals of realism and movement. Consequently, however lovely they may be as things in themselves, the few remaining jades seem the least Tang-like of the decorative arts.

376. *Ewer*. Xing ware, height 15 3/8". China. Tang dynasty. British Museum, London

13

The Beginnings of Developed Japanese Art Styles

Japanese art of the Tempyo period truly mirrored the great Chinese imperial style of the Tang dynasty. But changing conditions and mood were both signified and advanced by the removal of the court to Heian-kyo (modern Kyoto), and in this increasingly transforming environment styles in art began likewise to change. In the Heian period (A.D. 794–1185) a native Japanese spirit emerges, one in many respects quite different from the Chinese style from which it was ultimately derived—the first original contribution of the Japanese to the art of the post–Bronze Age of East Asia. This did not, of course, happen overnight; the Early Heian, or Jogan, period (A.D. 794–897) was the time of transition. Early Heian emperors still ruled, though progressively less effectively, and the style of the Early Heian period displays qualities of power and strength. But as real power slipped into the grasping hands of the Fujiwara clan, leaving reigning but impotent emperors surrounded by a largely ceremonial court, style in the Late Heian, or Fujiwara, period (A.D. 897–1185) became primarily delicate, fine, decorative, and highly aesthetic.

A singularly new kind of Buddhism took powerful hold in Japan during the Jogan period, having swept out of northern India, Nepal, and Tibet and established itself in China. This was Esoteric Buddhism, called *Mikkyo* in Japan, and principally embodied in the Shingon and Tendai sects, both brought to Japan in the first decade of the ninth century by Japanese monks of extraordinary charismatic force who had studied in China. Esoteric Buddhism emphasizes secrecy and mystery. Secret images were kept from the eyes of the laity in special tabernacles, to be revealed rarely or not at all. It includes an enormous and complex pantheon of deities and their multiple manifestations, whose interrelationships are precisely detailed in schematic diagrams called mandalas. And it stresses religious exaltation and magical numbers, incantations, gestures, and equipment. The iconography of Esoteric Buddhism is forbiddingly complicated, but fortunately some of the flavor of Esoteric faith is found in the style of buildings, images, and paintings produced under its influence.

EARLY HEIAN ARCHITECTURE

The temple complex of Muro-ji, outstanding for its sculpture, its painting, and especially its architecture, can be described as the type-site for the Jogan period (*fig. 377*). Here stand the only two remaining structures of the Jogan period. Muro-ji, a late Nara temple converted to Shingon use, is in a relatively remote area, some forty miles from Nara and twenty to thirty miles from Ise, among high, heavily forested mountains principally covered with cryptomeria, great cedar-like trees reaching heights of over a hundred feet. That other Jogan architectural monuments had similar settings we know from literary sources and archaeological remains. In the Asuka and Nara periods temples had been located on open plains, accessible to clergy and laymen alike, but the new sects wanted sites far from worldly distractions and corruptions, and Jogan

377. *Muro-ji*. Nara Prefecture, Japan. General view.

temples were secluded in the mountains, among some of the most magnificent scenery in the world. The setting of Muro-ji, with a forested mountain behind it and a small village resting at its foot, is unforgettable.

A second characteristic of the Jogan temple complex, again in contrast to the Nara temples, is its deliberately asymmetrical plan, forced upon the architect by the lay of the land. This irregular ground plan manifests tendencies that develop into the strongest characteristics of Japanese architecture in native style: asymmetry, irregular ground plan, and a close relationship to the natural site. This relationship, first seen in pre-Buddhist Shinto shrines such as Ise and Izumo, recurs in the architecture of the Jogan period. Other evidence for the development of a native style in architecture can be seen in the shingle roof of the *kondo* of Muro-ji (*fig. 378*) and in the thatch roof of another partially restored structure. Tile roofs and stone platforms were predominant in periods when Chinese influence prevailed. At Muro-ji are shingle or thatch roofs and wood supports. Japanese shingles are made of very thin sheets of cryptomeria bark, thickly layered to produce a carpet of wood.

Buildings in the Jogan period, as exemplified at Muro-ji, are smaller and more intimate than before. The *kondo* nestles in the trees on a small, grassy platform and seems a part of the forest. The small, shingle-roofed, five-storied pagoda, or *gojunoto*, seems almost a toy compared with the great pagodas of earlier periods (*fig. 379*); yet the proportions of this lovely structure, with the gentle decrease in the size

of the roofs and the small base on the stone platform, create an intimacy and refinement quite different from the massive scale and impressive style of the buildings of the Nara period.

At the Nara temple of Toshodai-ji a porch was added to the *kondo*, so that for the first time laymen might be separated from the clergy in the worship

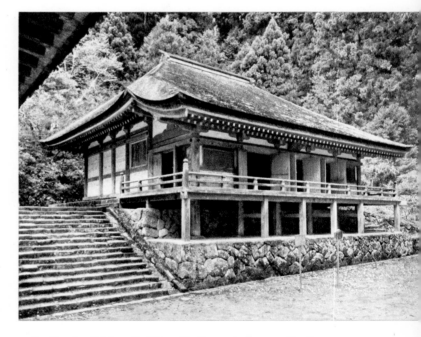

378. *Kondo of Muro-ji*. Nara Prefecture, Japan. Early Heian period, early ninth century A.D.

289

tion of one room from another to preserve secrecy in these esoteric rituals.

EARLY HEIAN SCULPTURE

Jogan sculptures have survived in greater number than Jogan buildings—some fifty or sixty, which is few enough, but still more than two. Indeed, works of sculpture are the most numerous monuments of the period. Jogan sculpture presents one of the truly remarkable sculptural styles in the world, and also one of the most difficult, confronting the modern art historian with the familiar problem of unintelligibility in relation to art. Art that is difficult tends to be either ignored or disliked; but the twentieth century has rediscovered various styles—European, African, and Pre-Columbian—that were once considered forbidding or even ugly but are now looked upon as aesthetically interesting, indeed, aesthetically great. To enjoy sculpture of the Jogan period, we must bear in mind that it is a hieratic art, produced in the service of a faith and strictly regulated by that faith. It is physically forbidding, and its image types do not accord with present-day ideals of beauty. At the same time they are awesome, perhaps the most awesome images created in East Asia, just as the Byzantine images may well be the most awesome created in medieval Europe. Although Jogan sculpture is representational and primarily concerned with rendering an image, the style in which these austere types are presented to us is almost geometrical.

Let us look at an extreme example of Jogan style. The small seated image of a Buddha, Sakyamuni or Miroku, perhaps sixteen inches high, is carved from a solid block of cryptomeria wood (*fig. 380*). The deity is presented as extremely corpulent, with a heavy body, almost flabby chest, large round face, wide lips and nose, and very wide eyes; the whole effect is massive or, in critical eyes, merely fat. But if we can suspend for the moment our dislike of fat, we begin to notice that the figure's very simple contours convey a massive quality that belies its small size. We note also that the rhythmical repetition of the drapery ridges adds to the solemn deliberation of the image. The hands are exaggeratedly large, as befits a figure of monumental and forbidding aspect. From the side, where its grossness is less evident, the figure is immediately more attractive, and this in itself is a degree of proof that current notions of physical beauty oftentimes condition our aesthetic reaction. From the side, the fatness is seen only in the double chin, and we can concentrate more upon the deep but not undercut modeling, which seems to indicate the simple, measured rhythm and flow of the drapery without destroying the character of the block of

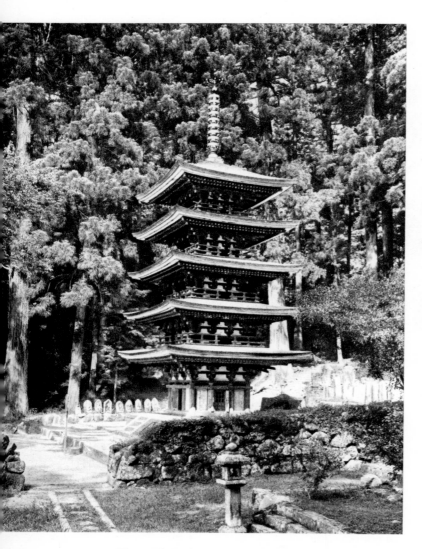

379. *Five-storied pagoda of Muro-ji*. Wood, plaster, bronze, and cedar shingle; height 53'. Nara Prefecture, Japan. Early Heian period, early ninth century A.D.

area, yet protected from the weather. This division becomes standard in the Jogan period: The icon hall (*kondo*) continues to be used by the clergy, and the *raido*, a separate covered hall for the laity, appears. The first version of the *raido*, which we know only from literary sources, is at once interesting and rather naive. It took the form of a slightly smaller building in front of the icon hall, where laymen could hear the ritual proceedings in the hall. Then a covered passage was added to connect the *raido* and the icon hall. The next logical development was to place *kondo* and *raido* side by side under a double gable. From this to numerous variations, such as the gabled roof with a closed porch, making the *raido* an integral part of the icon hall, was but a step, but such variations never got beyond the simple separa-

wood. We are also aware of certain forms, such as the ear, which have been simplified to an almost geometric formula of great abstract beauty.

We have begun with perhaps the most difficult of all Jogan images, simply to indicate the problems involved. Now let us look at some of the more famous images, which show the style at its fullest and even most ingratiating. The classic Jogan image of the healing Buddha, Yakushi, is kept at Jingo-ji in the mountains west of Kyoto (*fig. 381*). Both hands and forearms are modern restorations, and these disturbingly puffy and formless attachments make one realize that the Jogan style consists not in mere fatness or size, but in what is achieved within those conventions assumed by the sculptor.

The image, like most Jogan sculpture, is carved from a single block of wood, answering to the desire for a columnar and massive icon. From the Fujiwara period various inlays and laminations of wood (*yosegi* technique) were used to allow greater un-

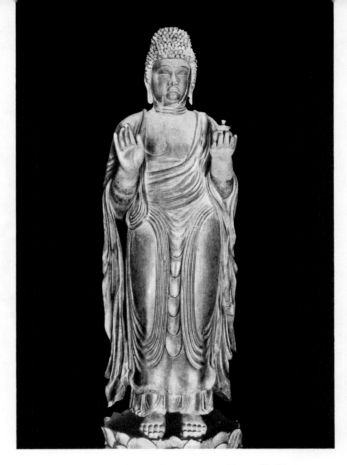

381. *Yakushi.* Wood, height 42 1/4". Jingo-ji, Kyoto, Japan. Early Heian period, early ninth century A.D.

380. *Shaka (Sakyamuni) or Miroku (Maitreya) Buddha.* Wood, height 15 3/8". Todai-ji, Nara, Japan. Early Heian period

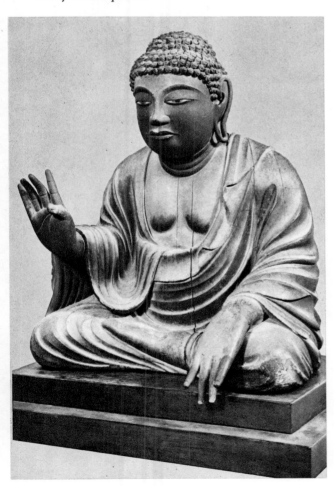

dercutting and ease of pose and to prevent warping and checking. One can almost guarantee that any genuine Jogan sculpture has a large split caused by the contraction of the heartwood. The Yakushi of Jingo-ji shows the Jogan style at its most hieratic and formal. The Buddha stands erect, evenly balanced on both feet in a perfectly symmetrical pose, facing the worshiper with no sway, no bending of the head, in a pose as rigid and formal as that of the most formal Byzantine icon. The expression of the face is forbidding; one rarely sees smiling Jogan figures. They were born without a sense of humor but are not less beautiful for that. The breast of the image is indicated by an almost purely geometric arch, and the disposition of the folds of drapery, with a large area on the thigh left plain, emphasizes the columnar character of the wood. The drapery is in a sense forced to the edges of the pillar-like legs, producing a pattern that again is symmetrical, balanced, and formal.

The head of the Yakushi reveals certain other features characteristic of Jogan sculpture (*fig. 382*). The most important of these is a keen sense, not only of the material, but of the tool used to work it. There was no attempt, as there was in much work of the earlier periods and again in later sculpture, to smooth over the cuts of the knife. This does not mean that

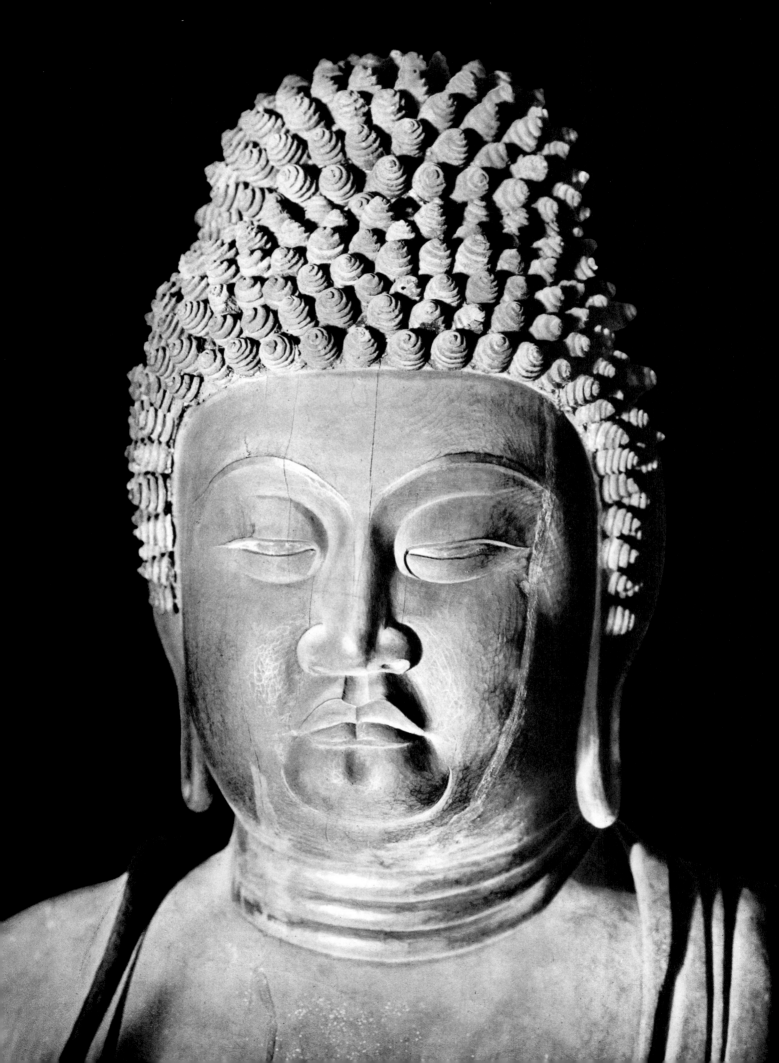

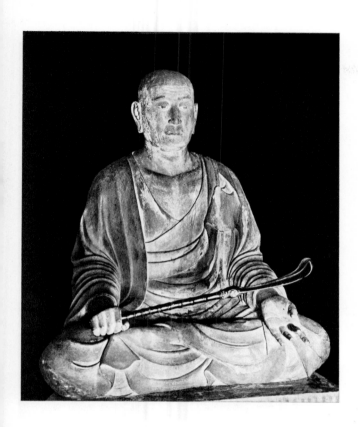

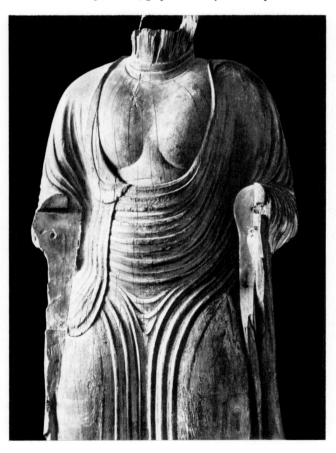

383. *Priest Roben* (act. c. A.D. 773). Colored wood, height 36". Kaisan-do (founder's hall) of Todai-ji, Nara, Japan. Dated to A.D. 1019

The derivation of the characteristic drapery of the Jogan period is reasonably clear. The motif is called *hompa* (wave) by the Japanese, and comes from the sculptural style previously seen in the colossal image of the Buddha at Bamiyan in Afghanistan. This towering image (*see fig. 168*) was a focus of attention for all pilgrims traveling the Central Asian pilgrimage routes to Bamiyan and thence to India. A number of works in this style were carried back by pilgrims to China and Japan and so became prototypes for particular sacred or holy images. The peculiar "string-drapery" pattern of the Bamiyan Buddha, in turn derived from the Kushan art of India, was the dominant stylistic motif in these "souvenirs." This motif was then modified in various sculptures of bronze and wood to produce a style first perfected, in the transitional period from Nara to Jogan, in a series of sculptures kept at Toshodai-ji in Nara. Of these the torso, figure 384, is per-

384. *Torso of a Buddha*. Wood, height 69 1/4". Toshodai-ji, Nara, Japan. Early Heian period

the work was crude, though some provincial Jogan pieces were. It does mean that the knife was used extremely skillfully to produce very small but discernible finishing cuts, which show on the now darkly polished wood like the facets of a cut diamond. Observe the treatment of the Mongoloid fold of the eye; notice the similar delicacy in the treatment of the nostrils and mouth. The edges are sharp, and again the knife was the final finishing tool. Few sculptural styles display such a proper and convincing union of technique, tool, and material as that of the Jogan period. The detail of the head shows particularly well the stern, almost scowling, expression characteristic of these Jogan images.

Even portrait sculpture, rare in the Jogan period, has a massiveness and purposely somber facial expression characteristic of the style and contrasting with the more sympathetic portrait sculptures of the Nara period. The portrait of the priest Roben at Todai-ji, Nara, dated to A.D. 1019 but preserving many elements of Jogan style, is unusual in being extensively polychromed over gesso (*fig. 383*). In most Jogan sculpture the wood forms the principal surface. Color is most sparingly used, and applied directly to the wood.

382. (opposite) *Head of Yakushi*. Detail of fig. 381

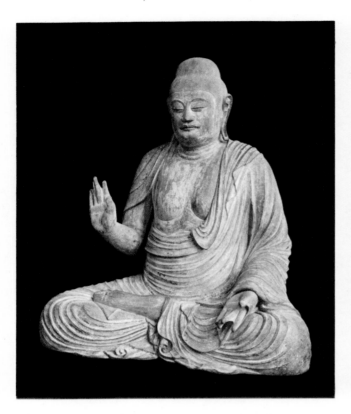

385. *Seated Shaka*. Wood, height 41″. Muro-ji,
Nara Prefecture, Japan. Early Heian period

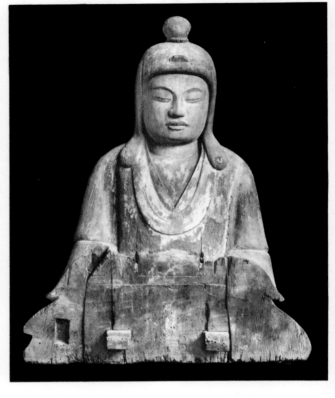

386. *Female Shinto image*. Wood, height approx. 39 1/4″.
Koryu-ji, Kyoto, Japan. Early Heian period

haps the most beautiful and famous example, much
admired by Japanese and foreigners alike for its
purity of form. It shows an intermediate stage in the
development of the *hompa* drapery motif from the
Bamiyan image: The drapery folds at the elbow are
not stringlike but triangular or wavelike. A classic
example of *hompa* drapery is to be found on the
Shaka at Muro-ji, a figure which originally had some
color applied on a white gesso ground and is
otherwise in almost perfect condition (*fig. 385*). The
folds of the draperies are everywhere composed of
large, rounded waves alternating with shallower
waves with pointed profile. This rolling rhythm of
alternate small and large ridges is subtly varied in
places and is produced wholly with the knife.

There are also some Shinto sculptures of the Jogan
period, images dedicated to typically animistic
deities associated with the forests, fields, and water-
falls and used at shrines or at temples. A female image
from Koryu-ji in Kyoto shows a simple variation
of the *hompa* pattern on the drapery folds and is
related to the seated Buddha images by her blocklike
massiveness and by her somewhat severe, or at least
noncommittal, expression (*fig. 386*). The headdress
is aesthetically interesting and also exemplifies the
standard upper-class female headdress of the period.

It is certainly no coincidence that massive headdresses
and heavy draperies are characteristic costumes of a
period that produced sculptures with similar qualities,
and it would be an interesting exercise to correlate
sculptural styles with contemporary dress.

For contrast to this somewhat provincial Shinto
goddess, let us look at one of the more suave and
aristocratic productions of the Jogan period (*color-
plate 24, p. 280*). Its quality and fine state of pres-
ervation make it one of the two or three most
important Jogan sculptures. The base, the figure, and
the body halo (*mandorla*) are all original and of the
period, as is the polychromy. The figure of the six-
armed Nyoirin Kannon holding his attributes is
shown in the usual pose, seated, with one leg up and
hand against cheek in a thoughtful gesture. Though
the sculptor intended the image to be attractive, the
mouth does not smile and the narrowed eyes, with
their long, flat upper lids, are at best neutral or
guarded in expression. The face is the roundest of
any of the Jogan figures we have seen. But compared
with the Shinto figure, the difference between an
urban, aristocratic work and a provincial one is
clear.

All these figures have been in wood, the natu-
ral Japanese sculpture medium. Yet, significantly

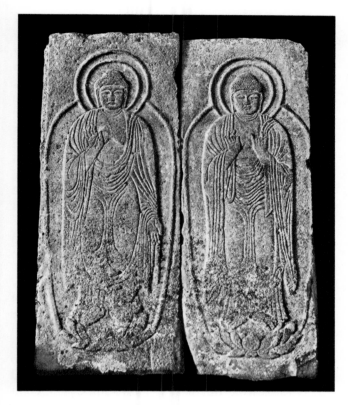

387. *Shaka and Miroku.* Stone relief, height 9'6".
Kanaya Miroku-dani, Nara, Japan. Early Heian
period

enough, the one period from which some important
figures in stone exist is the Jogan, when Japanese
sculptural style achieved its most compact and mas-
sive qualities and when the carving was largely
limited to the surfaces of the material. Two reliefs of
Buddhas, a Shaka and a Miroku, translate the
characteristic *hompa* drapery style into low relief of a
somewhat provincial rendering when compared with
the great works in wood (*fig. 387*).

EARLY HEIAN PAINTING

Paintings of the Jogan period are extremely rare,
but those few we have are of great interest. One
type, the mandala, derived by the Esoteric sects
from China, came into being at this time and con-
tinued to be made almost to modern times. Now, the
mandala is simply a diagram designed to make clear
the relationships between various deities or to out-
line a cosmogony in visual form. Two mandalas are
particularly important for the Esoteric Buddhist
sects of the period. The Garbha-dhatu (in Japanese,
Taizo-kai) is the "womb circle," containing some
407 deities in twelve sections, explaining principles
and causes. The Vajra-dhatu (in Japanese, Kongo-

kai; *fig. 388*) is the "diamond circle" with some 1,314
deities in nine sections, expounding reason and
effect. Naturally the supreme Buddha Mahavairo-
cana (in Japanese, Dainichi Nyorai) is at the core of
each mandala, or diagram explaining the complex
Shingon hierarchy. Each of the myriad deities is an
emanation from, and acting for, Dainichi Nyorai.
The mandalas are combinations of representation
with extreme symbolism, the images being arranged
according to a rational and cosmologically significant
scheme of interrelationships. Thus the mandalas are
nearly always laid out geometrically, on a grid pat-
tern or in a circle, or combining square and circle.
Borobudur, the great monument in Java, is a
mandala in stone (*see fig. 160*); the Kongo-kai is a
painted one. In figure 388 the central square con-
tains the five most important deities, with Dainichi
in the center. The Buddhas of the Four Directions are
the central figures in each of the four large circles,
and the deities of the Four Elements occupy the
four smaller circles. The geometric and primarily
intellectual placement is not aesthetically enchant-
ing, either in its subtly abstract arrangement or in
its gold and dark blue coloring. Indeed, the Kojima-

388. *Kongo-kai mandala* (detail of central section called
the Joshin-kai). Gold on purple silk, height of
whole 156". Kojima-dera, Kyoto, Japan. Early
Heian period

dera mandalas are eleventh century versions, with variations, of a much earlier and finer, if sadly damaged, pair preserved at Jingo-ji in Kyoto. If one looks at details of these earlier paintings, one sees some remnants of the earlier style of the Nara period, a certain grace in rendering figures recalling the frescoes of Horyu-ji or the painted banner in the Shoso-in. The small details of the mandala show that the style is really a continuation of the linear style of the Tang dynasty (*fig. 389*). Here a bodhisattva attended by two angel musicians is doing a dance like those seen in the foregrounds of representations of the Western Paradise at Dunhuang in northwest China (*see fig. 211*).

The great contributions of the Jogan period in painting are not to be found, however, in the restricted art of mandalas but in the representational pictures that correspond to the sculptures, particularly in those icons representing the terrible aspects of deities. These manifestations are epitomized by the famous *Red Fudo* of Koyasan, a representation of an Esoteric deity, dubbed the Immovable, a terror to evildoers (*colorplate 25, p. 281*). Adamant upon his rock, Fudo sits attended by his usual two youthful acolytes, glaring out past the worshiper. The composition, filling the frame from the very bottom at

389. *Taizo-kai mandala* (detail). Gold on purple silk, height of whole approx. 156″. Jingo-ji, Kyoto, Japan. Early Heian period

390. *Attendants of Fudo.* Detail of colorplate 25

391. *Sui-ten.* Color on silk, height 63″. Saidai-ji, Nara, Japan. Early Heian period

the attendants' feet to the top, where the red flames reach even beyond the edge, produces a massive effect controlled by the figures, especially Fudo, whose red color dominates the whole conception. The expression of the deity, with one fang up and the other down and rolling, glaring eyes, combines with the *vajra* sword, a thunderbolt with a dragon coiled about its sharpened blade, to produce a convincing pictorial realization of the awesome and the terrible. Fudo's two boy attendants, one with fangs, glaring eyes, and thick lips, conform to the Jogan physical type (*fig. 390*). The style of the representation—the drapery with its reversed shading of the *hompa* folds, the heavy line creating simple, geometric forms, not graceful and elegant as in the Nara period, but massive and almost deliberately simple and rude—invests this image, overall, with tremendous awesomeness.

One of the most arresting examples of Jogan pictorial style, despite its bad condition, is a depiction of a lesser deity of Esoteric Buddhism, Sui-ten (*fig. 391*). These squared, thrown-back shoulders and the massive chest proclaim strength. Unlike the bird or animal vehicles of earlier and later periods, which may be rather small, even playful, Sui-ten's large tortoise vehicle has a dragon-like head as awe-inspiring and massively convincing as the image it bears. The big, sweeping curves of the tortoise's neck, the dragon crown, the halo, and the roll of the drapery over the shoulders recall the stately rhythms of a *hompa* drapery pattern. These repetitions are part of the means used by the artist to achieve monumentality.

EARLY HEIAN METALWORK

In metalwork, numerous ritual tools of Esoteric Buddhism—bells, *vajra* (thunderbolts) ritual daggers, and other implements—were used in connection with the intricate hand motions, rhythms, and sequences that were part of worship (*fig. 392*). These too are part of the Jogan ethos and are continued in the later periods.

We know secular art only from literary sources. These indicate the beginnings of a decorative style of great importance for the later development of Japanese art, a development whose first flowering followed the now lost objects of the Jogan period.

THE LATE HEIAN PERIOD

In the Late Heian period art becomes more refined, decorative, and aristocratic. It is all too easy, but not necessarily correct, to assume the influence on Fujiwara art of political events and changing social

392. *Bell with vajra*. Gilt bronze, height 6 1/4″. Japan. Early Heian period. Y. Yasuda Collection, Japan

structure. But social and artistic similarities do not necessarily guarantee causal relationship or even chronological sequence. All we can say is that in the ethos of the Fujiwara period there seems to be a definite correlation between the type of society then developing and the new tendencies of Japanese art. The power of the emperor was usurped by the aristocratic Fujiwara clan at Kyoto, but this did not lead, as it might have in Europe or even in China, to the founding of a new dynasty. The emperor and the emperor's lineage were maintained with full honors and, in theory, full power. In practice power was wielded—i.e., Japan was governed—by the dominant clan, at first the Fujiwara; and this was the beginning of a system of government that continued in Japan without much change or interruption to the present day. Once real power no longer inhered in imperial lineage but was available to whatever clan could grasp and hold it, the stage was set for palace struggles and intrigue and internecine war on a grand scale, this in contrast to the relative tranquillity and centralized power of the preceding periods. There were now in effect two courts at Kyoto, and the imperial one, shorn of political power and ad-

ministrative responsibility, was left with considerable leisure for the appreciation and practice of the arts.

This is the period when exquisite refinements of court life were developed; it is the period of the great poets, and of the earliest Japanese novel, *The Tale of Genji*, by Lady Murasaki. This new ethos, highly aesthetic, self-conscious, almost overly subtle, is reflected in the painting and sculpture of the period, particularly in that associated with the court, for in the religious centers, despite new influences, the Early Heian tradition was still strongly maintained. We will first consider traditional religious art and its gradual changes, finding in those changes some hint of aesthetic attitudes that were to reach their clearest and most unalloyed expression in the secular art associated with the court. The conservatism of a period is almost as historically instructive as its innovation. We can tell a great deal about any period by asking what kind of art continued from the previous period and what kinds of modifications were introduced.

LATE HEIAN RELIGIOUS ART

In the Fujiwara period the painting of Buddhist icons, as one might expect, continued in the earlier style, particularly in representations of the terrible aspects of deity, such as Daitoku Myo-o (*fig. 393*). Daitoku Myo-o was one of those fearsome deities imported to Japan with the rise of the Shingon and Tendai sects, and his image is handled by the early Fujiwara artist much as it was before: a large-scale figure filling the entire silk to the edges of the frame; ample extremities; large planar structures boldly and vigorously patterned. Only in certain minor details, notably in the more elegant geometry of the knees, legs, and body structure, is there any sign that this icon was painted over a century after the Jogan period.

Iconic art is traditionally conservative, because the magic that (in the minds of most believers) resides in the image may not work if the image is not accurate (i.e., like earlier, proven images). Something like the same belief attaches to representations of founders of the various Buddhist sects. The simple monumental style, based upon Tang Chinese painting and continued in the one or two remaining fragments of the Jogan period, is maintained in the Late Heian period. The *Portrait of Jion Daishi* carries on the Tang figure painting tradition in its fine, even, linear drawing and in its nearly empty background, the only indication of actual setting being the dais, a water vessel to the left, and a little table holding scrolls and brushes to the right (*fig. 394*). But in the original color, especially the varicolored,

gay bands under the calligraphy, one senses the difference between the austerity of a Jogan portrait and the relaxation of that austerity in this portrait of the Fujiwara period.

If the icons and single figures tend to be conservative, certain other paintings associated with Buddhism show significant modification. One of the most important Buddhist paintings in Japan or, indeed, in East Asia is the great representation of the *Parinirvana of the Buddha*, a very large hanging scroll at Koyasan (*colorplate 28, p. 284*). The painting is beautifully preserved and presents a veritable kaleidoscope of soft greenish yellows, pale oranges, greens, blues, mild reds, the usual malachite green, and numerous touches of gold. The effect is not unlike that of a complex Italian altarpiece of the fourteenth century. The *Parinirvana* is dated to A.D.

393. *Daitoku Myo-o.* Color on silk, height 76″. Japan. Middle Heian period. Museum of Fine Arts, Boston

394. *Portrait of Jion Daishi.* Color on silk, height 63".
Yakushi-ji, Nara, Japan. Late Heian period,
eleventh century A.D.

ciples and, of course, the animals, are shown in color only. The psychological states correspond to this order. The Buddha and the bodhisattvas are impassive, their eyes closed or almost closed, wearing the traditional masklike, slightly smiling countenance of beatific deity. The disciples, on the other hand, mourn, pray, cry, or even shout, looking to the sky, their faces distorted in agony (*fig. 395*), resembling grotesque Tang representations of founders or patriarchs. Even the figures of the Guardian Kings of the Four Directions at the lower left show realistically observed emotion. One of them shields his eyes with a hand covered by his sleeve, a usually fierce and overpowering figure here reduced to sadness and tears. The guardian on the right is in the same state, his teeth bared in a mask of sorrow. The animals, the lowest of the hierarchies presented, are even more violently affected. At the lower right a lion, presumably the vehicle of the bodhisattva Manjusri, rolls on his back with his legs in the air in paroxysms of grief. The combination of space, color, and pattern with a unified psychological progression from sublime calm to extreme emotionalism produces a masterpiece of Buddhist painting.

395. *Mourners, from the Parinirvana.* Detail of colorplate 28

1086 and incorporates both Jogan survivals and important changes of the Fujiwara period. The Buddha, represented completely in gold, lies on a dais, with his head resting on a lotus pillow. About the dais are the many bodhisattvas, disciples, and followers of the Buddha who have come to mourn the great event, even including some grieving animals at the edges of the composition. The setting is a placid landscape of a decorative Tang dynasty type, with flowering trees reaching to the sky where the Buddha's mother, Queen Maya, appears to witness the "final extinction" of her son, the fulfilled Buddha. The composition also follows Tang style by occupying a completely defined, stagelike space. The foreground area leads up to the dais, which is slightly tilted toward the viewer in a space further marked by the careful placement of four trees slightly off center at each of the axes of the dais. Foliage and clouds finish the picture surface and also create a convincing spatial setting, modified and made more flat and decorative by the way in which the color is applied.

The representation of the figures is extraordinary, particularly in its hierarchical revelation of psychological states. As a mark of reverence the Buddha is shown in gold, as are the bodhisattvas, while the lesser members of the Buddhist hierarchy, the dis-

There is one other work comparable to the *Parinirvana*, not only in subject matter but in quality—a most unusual representation of the resurrected Buddha preaching to his mother, Queen Maya, who is just to the left of the dais (*fig. 396*). This hanging scroll might almost be by an artist trained in the studio that produced the *Parinirvana*. Here the Buddha's aureole, or halo, is dotted with representations of other Buddhas. The landscape setting with its Tang type trees recalls the slightly earlier work, as does the differentiation of types, from the Buddha and bodhisattvas to disciples and commoners who have fallen to their knees in adoration of the event. It is important to recognize that both of these paintings are not only icons, but also decorative and rich color orchestrations. This in itself is a distinct change from the art of painting of the Jogan period, which tended to simpler color arrangements. Common to the two Fujiwara paintings, then, are the tradi-

396. (above) *Shaka Emerging from the Golden Coffin*. Hanging scroll, color on silk; height 63″. Choho-ji, Kyoto, Japan. Late Heian period, late eleventh century A.D.

397. (right) *Ichiji Kinrin*. Painted wood, height 29 1/8″. Chuson-ji, Hiraizumi, Japan. Late Heian period

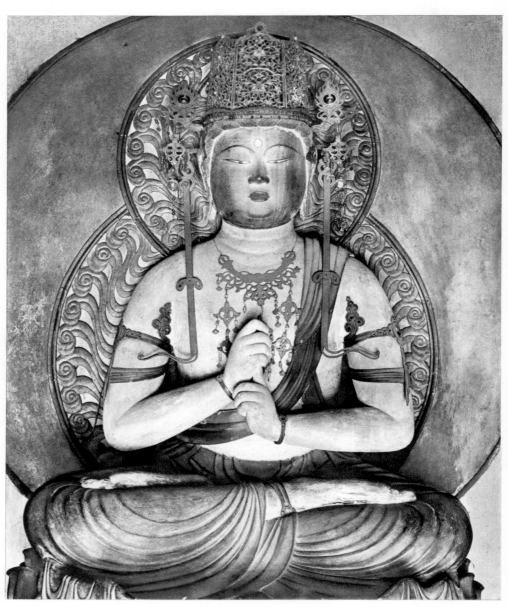

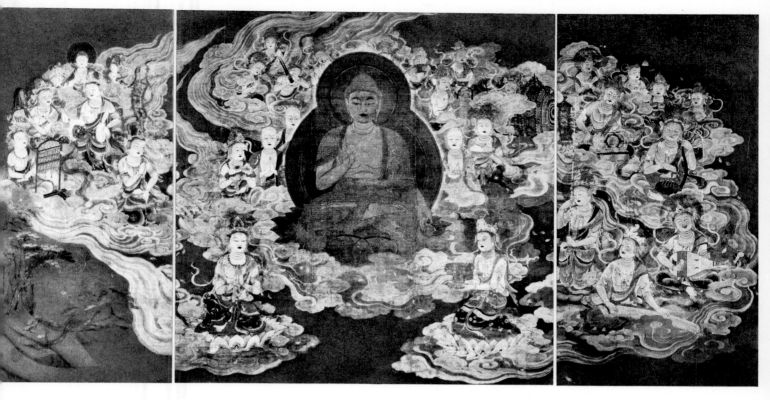

398. *Amida raigo triptych*. Color on silk, height 83″. Japan. Late Heian period, late eleventh century A.D. Koyasan Museum, Wakayama

tional Tang style settings and a new interest in psychological characterization and in the decorative use of color. These two modes, the decorative and the realistic, emerging clearly and in native form, constitute a dualism that remains one of the outstanding characteristics of Japanese art.

In sculpture, too, similar changes are evident. Many sculptures of the earlier part of the Fujiwara period are, in essence, continuations of Jogan style; but by the middle of the period, and certainly at the end, the sculptural style for even the principal—hence most conservative—icons changed radically. The image of the supreme Buddha, Dainichi Nyorai, or Ichiji Kinrin, kept in a secret tabernacle at Chuson-ji, a temple in northern Japan near Sendai, is a telling example of this change in sculpture (*fig. 397*). The wood is completely covered by polychromy, with elaborate cut-gold (*kirikane*) patterns on the draperies. It is modeled not in the round but in half-round, with a softness quite unlike the powerful forms of earlier periods. The face is no longer stern and austere but aristocratic, almost effeminate, with small, rosebud mouth, high-arching brows, and very narrow, short, sharp nose, not unlike that to be seen shortly in the *Genji* scrolls.

But the work that summarizes fully developed Fujiwara tendencies in sculpture is a famous representation of the goddess Kichijoten (*colorplate 29, p. 333*). The figure, from Joruri-ji, is one of the most beautifully preserved sculptures of the period. It is executed in richly polychromed wood and makes a gay, almost gaudy, first impression. In contrast with the relatively simple female forms of the Nara and Early Heian periods, the Kichijoten of Joruri-ji has the same kind of feminine elegance to be seen in the Dainichi Nyorai; but here it seems somehow more appropriate and more related to the structure beneath, producing a unified and coherent work of art. One can see remnants of older traditions in the underlying structure of the figure, notably the wide, falling sleeves with the hollow recesses, simply carved so as to preserve the essentially trunklike character of the body. All the complicated drapery and the jewelry hanging from the neck and waist and ornamenting the hair is executed in carved and painted wood. Thus a simple basic structure is overlaid by elegant and aristocratic detail expressive of the new Fujiwara interest in decorative style. In the Nara period such detail would have been simply painted on; by Fujiwara times it has acquired complex sculptural form.

A new subject appears in Late Heian religious art, associated with the new sect of Jodo (Pure Land) Buddhism. This sect is primarily devoted to the worship of the Buddha of the West, Amida (in Sanskrit, Amitabha), whom we have seen rep-

301

resented in Tang art in a formal, Chinese style Paradise. The Jodo sect took great hold in China in the seventh century A.D. and then in Japan. In contrast to the secret, awesome, and complicated practices of Shingon, Jodo was simple and comforting. One needed only to adore Amida to be saved. The Western Paradise was painted as a bounteous land of celestial sights and sounds, where jewels and flowers bloomed on every tree. The cult appealed tremendously to both aristocracy and commoners—to the aristocracy, because its approach to faith was relatively worldly and sensuous and its Western Paradise resembled a particularly refined Heian court; to the common people because salvation by faith is an accessible and consoling doctrine, certainly in comparison with that of the Esoteric sects.

A favorite theme of the new sect was the *raigo*, or descent of Amida Buddha. It is a subject that first appeared in Japanese art perhaps about A.D. 1053 on the doors of the Phoenix Hall. It is very likely that the *raigo*, which represents one of the most lyrical visions of deity achieved by any faith, is a Japanese invention. The essence of the *raigo*, in sharp contrast to the secret and forbidding nature of the Esoteric icon, is that it shows the Buddha coming to the believer. Amida is not merely approachable; he approaches to receive and welcome the soul of the dying believer into his Western Paradise. Now, this is psychologically an extraordinary change and is accompanied by a very interesting pictorial development from an iconic representation of the coming of the Buddha to an asymmetrical composition, realistic in detail—a gracious and personal depiction of his descent.

399. *Amida Kosho-ho*. Drawing, ink on paper. Japan. Heian period, dated to A.D. 1146. Kuroda Collection, Kyushu

The orientation of the earlier *raigo* is toward the spectator, as if he were the dying person, as in the great *raigo* triptych at Koyasan (*fig. 398*). Here the large figure of Amida accompanied by twenty-five bodhisattvas floating on clouds faces the spectator and moves toward him, a movement indicated by the perspective of the clouds as they rise and recede to the left and top of the central panel. The vision hovers above a landscape clear at the lower left but barely visible at the right. But the landscape is a small and unobtrusive part of the picture, so that the whole effect is a rather more iconic than realistic presentation of an imagined scene. Details of the figures reveal, just as in the *Parinirvana* at Koyasan, a marked development of decorative detail, color, and realism. The angel musicians are particularly interesting. They are shown in poses observed from nature, dancing or playing their instruments, and puffing out their cheeks as they blow into the more difficult wind instruments.

Usually one can find the more advanced pictorial tendencies at a given time in secondary parts of pictures. In Italian painting, for example, new developments appear first on the predella panels or in secondary figures. In these the artist seems to feel freer to invent and improvise, whereas the central figures must remain true to their iconic types. So it is here. The observation of nature and the development of new decorative patterns and color chords are recorded in the angel musicians surrounding the Buddha rather than in the Buddha himself.

The development of realism in the *raigo* is perhaps best seen in a small and wickedly humorous sketch, but recently discovered and now in a private collection (*fig. 399*). It is a monochrome satirical representation of an Amida Buddha pulling an unwilling soul toward him by a string around the neck. The sketch is dated to A.D. 1146, close to the end of the Fujiwara period, but is executed in conservative style using a thin, wirelike line. Apparently realism and even satire were sometimes allowed in the sacred precincts of the icon.

The *raigo* is also represented in sculpture, and for this we turn to the Phoenix Hall, a remarkable intermingling of the secular, aristocratic, and religious arts of the Fujiwara period (*fig. 400*). Because its plan and appearance suggest a great bird in flight, it is called the Ho-o-do (Phoenix Hall; *fig. 401*). The Ho-o-do stands beside the Uji River, entirely surrounded by a pond, and its lovely reflection in the water is unforgettable. It is part of the temple complex of the Byodo-in, originally a country villa of the Fujiwara family, and many elements of its design derive from secular palace pavilions. There is a central hall with three large doors, a covered porch, and a covered runway leading out

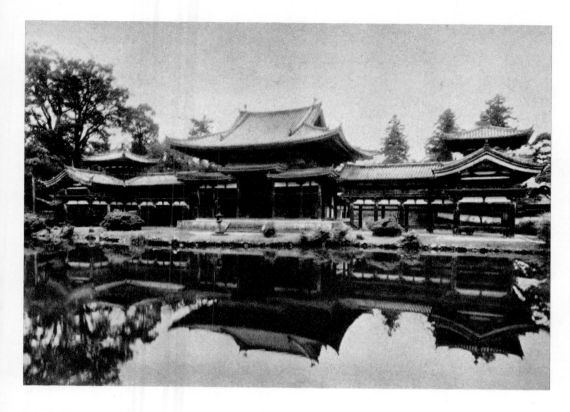

400. (left) *Ho-o-do (Phoenix Hall) of Byodo-in.* Uji, Japan. General view. Late Heian period, eleventh century A.D.

401. (below) *Plan of Phoenix Hall of Byodo-in.* Uji, Japan. Late Heian period, eleventh century A.D.

from each side to covered tower pavilions. All of this is raised rather high above the ground on posts, except for the central hall, which is placed on a stone platform. Certain Chinese elements—the tile roofs and the stone platform—have reasserted themselves here. Indeed, the whole arrangement recalls very much the kind of Chinese architecture portrayed in representations of the Western Paradise at Dunhuang. The Ho-o-do may thus be a conscious imitation of a building type associated with the Western Paradise and hence may exemplify the importance attached to magical structures. Despite Chinese influence, and in contrast to the severe strength of Jogan architecture, this Fujiwara building is decorative, light, and aristocratic in appearance, a mirror of the essential stylistic qualities found in the painting and sculpture of the period.

The interior of the hall was originally richly polychromed, and much of that polychromy still remains (*fig. 402*). The architectural form of the temple interior is transformed and to a certain extent negated by the rich decorative quality of the ornament. Not only are parts of the interior painted with representations of lotus, falling lotus petals, and other flowers, but there are mother-of-pearl inlays on the central dais and in some of the columns. All of this combines to produce the same kind of complex, encrusted effect that we saw in the sculpture of Kichijoten at Joruri-ji.

The interior of the main hall is used to house a

sculptured *raigo*. The image of the Buddha of the West, Amida, is seated on a richly carved lotus throne, backed by a halo carved of wood and gilded, on which are many angel musicians in high relief (*fig. 403*). The ensemble is the most famous work of Jocho, the leading sculptor of his day, and was dedicated in A.D. 1053. The Buddha is more elegant than earlier seated figures, appearing lighter in weight, with a distinctly aristocratic turn of lip and eyebrow. Around the dais, fastened by hooks to the upper walls, are sculptured representations of bodhisattvas and angel musicians accompanying

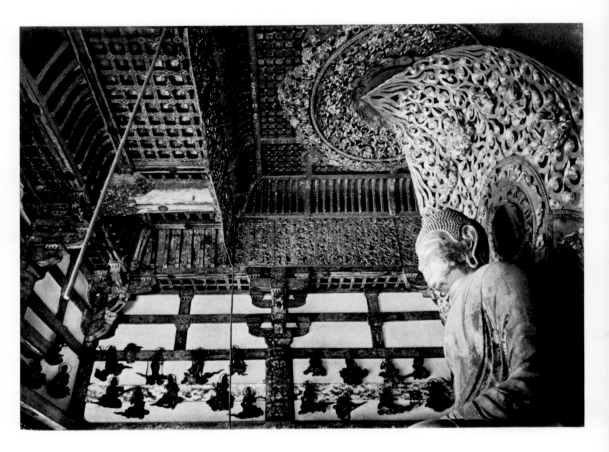

402. *Interior of Ho-o-do (Phoenix Hall) of Byodo-in.* Uji, Japan. Late Heian period, eleventh century A.D.

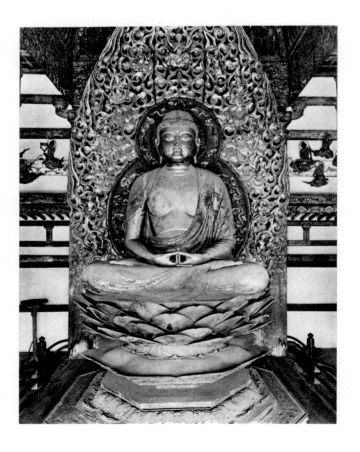

the Buddha as he descends from the Western Paradise. Standing just inside the icon hall and looking directly to the altar, one sees in sculpture the same stylistic traits found in the painted triptych of Koyasan. The little music-playing angels, seen close up, show that same observation of natural movement displayed in the Koyasan picture, as well as a playfulness, an elegance, and a charm that are extremely courtly (*fig. 404*). With its original color and inlays and the complete ensemble of figures, this image hall must have been one of the most lyrical sculptural expressions of religious art ever seen in East Asia.

Phoenix Hall is a rather large building. The same aristocratic elegance was attempted on a smaller scale in the far northeast corner of Honshu, at Hiraizumi, near Sendai, where a powerful northern branch of the Fujiwara clan undertook to create a smaller version of Kyoto. The Amida hall of Chuson-ji, called Konjiki-do, is the only surviving structure

403. *Amida.* By Jocho (d. A.D. 1057). Gilded wood, height 112″. Ho-o-do (Phoenix Hall) of Byodo-in, Uji, Japan. Late Heian period, A.D. 1053

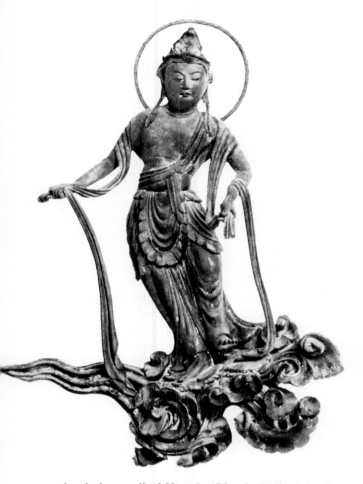

404. *Angel, from wall of Ho-o-do (Phoenix Hall).* Wood, originally gilded; height approx. 28 3/8″. Byodo-in, Uji, Japan. Late Heian period, eleventh century A.D.

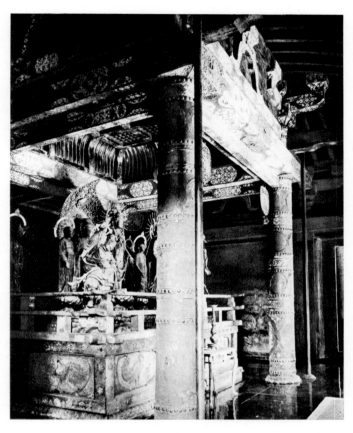

405. *Interior of Konjiki-do of Chuson-ji.* Hiraizumi, Iwate, Japan. Late Heian period, twelfth century A.D.

of this enterprise. Inside it resembles fine cabinetry more than it does architecture, being lavish with gilded metal and mother-of-pearl inlay on lacquered wood (*fig. 405*). Even the exterior retains traces of gold leaf on lacquer decoration.

LATE HEIAN SECULAR ART

We must begin the study of secular art of the Fujiwara period with a work that is nominally religious but also the earliest remaining example of the style of secular and aristocratic court painting in the period. Scrolls of the Lotus Law, the *Hokke Sutra,* were offered by the Taira family in the twelfth century to the Shinto shrine at Itsukushima, south of Osaka, as an act of piety and devotion. There they are kept in a box adorned on the outside with traditional Nara style dragons in gilt bronze on a ground of dark brown lacquer (*fig. 406*). This conservative housing would not lead one to expect anything so radically new as the twenty-nine scrolls

inside. The text sections are simply written, in columns of gold and silver characters, as one would expect; but the endpapers—the first eight or ten inches of each scroll—are decorated with scenes of ostensibly religious subject matter (*fig. 407*). An aerial view of a house with the roof removed (a pictorial convention allowing the viewer to look inside) shows a monk sitting next to a woman, with a court noble behind them at his writing desk holding a scroll; golden rays come from the left, the direction of the Western Paradise of Amida Buddha. The priest in the middle ground, hidden in part behind the rolling hill, is praying, with his head turned toward the rays. The rays and the written characters, some Japanese and others Sanskrit, incorporated into the rock structure of the garden outside the house tell the Buddhist initiate that this is a religious scene. But what is shown and the style in which it is shown make this picture one of the first examples of a characteristically Japanese secular style that reached its greatest heights in the *Genji* scrolls to be considered shortly. In color these sutra endpapers are brilliant, with purples, reds,

oranges, deep blues, yellows, and ink, and with a copious use of sprinkled gold as well. In the left foreground, for example, in the pond outside the garden, large squares of cut gold are apparently floating in the water, and little strawlike sticks of cut gold are clustered on the surface of the water. All are part of the decorative cut-gold patterning that we have seen to be characteristic of religious paintings also. Reality is painstakingly observed here: the bundled-stick hedge in the middle ground; the long bamboo runner with the water coming out and pouring into the pond; and the house itself. The representation of all these details shows a peculiarly Japanese quality, particularly the aerial view of the house with the roof removed. This representational device, so arbitrary and extreme as to be untypical of China, was used by the Japanese with great abandon.

The landscapes in the Itsukushima sutras are derived from Tang type landscapes but have become distinctively Japanese (*fig. 408*). The term that the Japanese use again and again to describe the landscape of Japan seems most appropriate to the style representing it here: lovely. Hills and rocks have a gentle, rolling rhythm; trees branch gracefully. All elements of the picture are treated in subtly decorative fashion. This lyrical style, called *yamato-e*, meaning Japanese picture, is particularly important in the twelfth and the very beginning of the thirteenth century. It is a late Fujiwara style, secular and decorative; the realistic or even satirical *yamato-e* style that is more characteristic of the thirteenth century will be considered when we come to the Kamakura period.

The greatest monument of *yamato-e* is the group of illustrations of *The Tale of Genji*, usually attributed to the painter Takayoshi and now distributed between the Tokugawa Art Museum at Nagoya and the Tokyo National Museum (*fig. 409*). They were originally part of a series of handscrolls, of which only remnants remain. The pictures have been cut into small panels, and are now kept flat to avoid the constant rolling and unrolling necessary to view scrolls. Their narrative scheme of organization was fairly primitive: Each picture follows the block of text it illustrates in strict alternation. In marked contrast with later, more complexly organized narrative scrolls, these are individual, separate pictures, enclosed as if framed between blocks of text. The text pages are almost as decorative as the illustrations, being unevenly and asymmetrically sprinkled with cut gold in a way that seems typically Japanese.

But the pictures especially command our attention and repay study. They illustrate *The Tale of Genji (Genji monogatari)*, a novel by Lady Murasaki, justifiably famous in English-speaking lands through translations by Arthur Waley and Edward Seidensticker. Its story is simple in outline and complicated in detail and is principally concerned with the doings and intrigues and amorous affairs of the high aristocracy at Kyoto, especially the aristocracy of the emperor's court. The narrative proceeds in leisurely fashion, creating characters of great psychological complexity and an atmosphere redolent of the peculiarly exquisite sensibility and hyperaestheticism of the Heian court. One passage may give some idea of the flavor and style of the literary work that Takayoshi illustrated:

On a morning of heavy mists, insistently roused by the lady, who was determined that he be on his way, Genji emerged yawning and sighing and looking very sleepy. Chujo, one of her women, raised a shutter and pulled a curtain aside as if urging her lady to come forward and see him off. The lady lifted her head from her pillow. He was an incomparably handsome figure as he paused to admire the profusion of flowers below the veranda. Chujo followed him down a gallery. In an aster robe that matched the season pleasantly and a gossamer train worn with clean elegance, she was a pretty, graceful woman. Glancing back, he asked her to sit with him for a time at the corner railing. The ceremonious precision of the seated figure and the hair flowing over her robes were very fine.

He took her hand.

406. *Box for sutra offered by the Taira family*. Dark brown lacquer with gilt bronze fittings, length 13 3/8". Itsukushima Shrine, Hiroshima, Japan. Late Heian period, twelfth century A.D.

407. *Prayer offering, from sutra offered by the Taira family.*
Scroll, ink and color on paper; height 10 1/2".
Itsukushima Shrine, Hiroshima, Japan. Late
Heian period, c. A.D. 1164

> "*Though loath to be taxed with seeking fresher blooms,*
> *I feel impelled to pluck this morning glory.*

Why should it be?"
She answered with practiced alacrity, making it seem that she was speaking not for herself but for her lady:

> "*In haste to plunge into the morning mists,*
> *You seem to have no heart for the blossoms here.*"

A pretty little page boy, especially decked out for the occasion, it would seem, walked out among the flowers. His trousers wet with dew, he broke off a morning glory for Genji. He made a picture that called out to be painted.[13]

Now, we can see from this that a great deal is going on, but veiled in images of color, of costume, of rooms and screens, of hurrying figures, of draperies fluttering—in short, in all of the things so represented in the scroll by the artist Takayoshi that the pictures become a delight for the eye at the same time that the narrative content is kept to a minimum (*colorplate 30, p. 334*). The colors of the scroll are applied rather thickly over a preparatory ink drawing on the paper and range from pale mauve to deep browns, purples, oranges, and greens, the whole effect being distinctly aristocratic and decorative. The artist uses the screens, walls, and sliding panels of the Japanese aristocratic house of the Fujiwara period as a means of breaking up the composition and of indicating the mood of the composition. Soper sees a correlation between the mood represented in each scene and the angle of the principal lines of the composition: The higher the degree of the angle, the more agitated is the scene represented. Such an interpretation may well be true, since the *yamato-e* is a calculatedly decorative style, an art of careful placement and juxtapositions of color and texture. Placement in particular is almost everything, along with the interrelationships of elaborate patterns of angle and line, of triangle and square, and of the large overall patterns on the costumes (*fig. 409*).

In the paintings the figures are shown only as heads and hands emerging from great masses of enveloping drapery. The women especially, with their fashionably high, arched eyebrows painted on white-powdered faces and their rivers of loose jet-black hair, seem to be little heads set on top of voluminous

408. *Landscape scene, from sutra offered by the Taira family.*
Scroll, ink and color on paper; height 10 1/2".
Itsukushima Shrine, Hiroshima, Japan. Late
Heian period, c. A.D. 1164

elaborately pleated and starched costumes. With care one can follow the narrative content, but this is subtly restrained—cloaked or hidden by the overall decorative emphasis on color and arrangement. Colorplate 30 shows a group of ladies and their maids. Naka no Kimi is having her hair combed after washing. Her half-sister, Ukifune, facing her, looks at picture-scrolls while a maid reads from the

409. *First and second illustrations to the "Suzumushi" chapter of The Tale of Genji.* Handscroll, ink and color on paper; height 8 1/2". Japan. Late Heian period, twelfth century A.D. Tokyo National Museum

accompanying text. The picture contains no suggestion of Ukifune's tension and dismay over her attempted seduction only a few hours before.

In several scenes clouds arbitrarily cut off the top of the composition, a device used by the Japanese scroll painter and screen painter in all subsequent periods to enhance the aesthetic development of his composition. Certainly, if one is to pick any one example of painting as the beginning of what we call here the Japanese decorative style, then the *Genji* scrolls are that beginning. There are related works in other collections, but the *Genji* scrolls are by all odds the most precious of all.

The refinements of court life included and the rise of *yamato-e* reflected a growing interest in landscape, as seen in two panels of a famous six-fold screen at To-ji, in Kyoto, reproduced in figure 410. Here a highly colored and decorative style of landscape painting is used on an object whose purpose is primarily decorative—a folding screen. The figures are in Tang rather than *yamato-e* style, and certain realistic tendencies relate them to developments in the narrative scrolls of the succeeding Kamakura period.

But here one's attention is drawn particularly to the landscape, the gently rolling hills, the flowering trees with the rhythmical profile of their trunks, and the use of the fence to add an architectural organization comparable to that found in the *Genji* scrolls.

The useful arts, too, show the same development from a religious art with decorative overtones to an almost purely secular one in a decorative style. The subject matter of the early Fujiwara sutra box (*fig. 411*) is Buddhist—the sword of Fudo, the Immovable, on a rock in the sea, flanked by the two youthful acolytes previously noted in the *Red Fudo* of Koyasan (*see colorplate 25, p. 281*). The representation is in gold and silver on a brown lacquer ground, with falling lotus petals as a decorative accent in the background on either side of the flaming sword with its dragon. Here is a primarily religious subject with decorative overtones. But on later Fujiwara boxes the decoration has become largely secular with strong literary overtones, as on the clothes box in figure 412 with its design of irises by a stream with plover flying overhead. The plover are made of mother-of-pearl, the iris and the stream banks are gold and silver,

411. *Box for Buddhist sutra.* Lacquered wood, length
12 1/4". Taima-dera, Nara, Japan. Mid-Heian
period

410. *Landscape screen.* Two panels from a six-fold screen,
color on silk; height 57 3/4". To-ji, Kyoto, Japan.
Late Heian period

against a dark, brown black lacquer ground. The
whole effect is decorative in the best sense of the
word. Much of such subject matter was derived from
poetry of the early Fujiwara period, in which place,
episode, and feeling (usually of love or longing) are
mutual resonances of a single theme. The subject of
figure 412 comes from Ariwara no Narihara's *Ise mo-
nogatari*, and was used again in the *Iris* screens by
Korin and Shiko some six centuries later. A lacquer
toilet box has a pattern of cart wheels half sub-
merged in water, also derived from the poetry of
the period and here interpreted as a bold, asymmetri-
cal decorative design: The wheels, most carefully
grouped and angled to create variations on a theme,
are united by the wave pattern of the water (*fig.
413*). The wheels are in mother-of-pearl and gold on

412. *Garment box with plover and iris design.* Lacquered
wood, height 11 5/8". Kongobu-ji, Koyasan,
Wakayama, Japan. Late Heian period

309

the dark ground, and the silver handles of the box repeat the wheel pattern. For the first time in the Japanese utilitarian arts we have an original style, purely decorative in intention and secular in subject matter. The decorative style is the most important artistic contribution of the Fujiwara period, and one that was to have great influence on later Japanese art.

At the same time that the decorative style was flourishing, we note the germination of a narrative style, which can be called *e-maki* style. The Japanese are inclined to use the term *yamato-e* for all these pictures, whether of the decorative Genji type or the more realistic narrative type. The resulting confusion can be mitigated by arbitrarily calling the *Genji* style *yamato-e* and the narrative, realistic style *e-maki*. *E-maki* also began in religious art. You will remember that in the subsidiary areas of religious icons we found an interest in realism, in the way people act and move, the way people look when they are frightened or trying to be fierce, and this interest burgeons at the end of the Fujiwara period. Full fruition comes only in the Kamakura period, but we must mention at this point one or two forward-looking examples of *e-maki* style.

One is a work of satire, the famous scroll, or rather scrolls, at Kozan-ji, associated with the name Toba Sojo and dated by most Japanese scholars at the end of the twelfth century (*fig. 414*). There may be good reason to date them slightly later, perhaps in the thirteenth century, but they have been long associated with the late Fujiwara period, and in certain details, such as the treatment of the flowers and reeds in the lower left or the rhythmically drawn tree trunks, we find elements related to the *yamato-e* style. But the satiric depictions of deities as frogs, priests as monkeys, and nobles as rabbits, all behaving more or less discreditably, are certainly based upon wry observation in the service of an astringent judgment. These elements—pragmatic observation followed by the distortion of form in order to comment upon what is observed—are basic in the narrative, or *e-maki*, style. The scenes range from amusing to sacrilegious, from rabbits diving into the water holding their noses to a large frog sitting as a Buddha against a banana leaf halo, receiving the adoration of monkey priests (*fig. 415*). Other scrolls illustrate absurd wrestling matches and contests between corpulent and emaciated yokels, and one scroll is devoted to vigorous line representations of domesticated animals, notably of two bulls battling head on. Though all four scrolls are in a style associated with the name Toba Sojo, they are certainly not all by the same hand or of the same date.

A second genre of religious painting containing the seeds of the *e-maki* style comprises representations

413. *Toilet box with design of cart wheels in water.* Mother-of-pearl and gold on lacquered wood, length 12 1/8". Horyu-ji, Nara, Japan. Late Heian period. Tokyo National Museum

414. *Rabbit diving.* Attrib. Toba Sojo (A.D. 1053–1140). Section of the handscroll *Choju Giga,* ink on paper; height 12 1/2″, length 37′. Kozan-ji, Kyoto, Japan. Late twelfth century A.D.

415. *Monkeys worshiping a frog.* Attrib. Toba Sojo (A.D. 1053–1140). Section of the handscroll *Choju Giga,* ink on paper; height 12 1/2″, length 37′. Kozan-ji, Kyoto, Japan. Late twelfth century A.D.

of the Buddhist hells. The most famous of these, dating from the late twelfth century and in some respects the most archaic of all the Buddhist hell scrolls, is the *Gaki Zoshi,* the Scroll of Hungry Ghosts (*fig. 416*). The Buddhist sutras describing the ghosts say that these are the souls of men and women condemned to hell but sent back to earth in shapes invisible to the living but visible to themselves. These horrible and monstrous specters are condemned to a life of eternal thirst and hunger, so they seek their food in graveyards and their water at holy wells from which they cannot drink. The subject matter is nearly always gruesome, a cautionary reminder of the penalties for a misspent life. The style of the paintings is of the greatest interest, because in dealing with this abhorrent subject matter the artist was

416. *Hungry ghosts*. Section of the handscroll *Gaki Zoshi,* ink and color on paper; height 10 3/4″, length 17′ 8″. Japan. Late Heian period, late twelfth century A.D. Tokyo National Museum

forced to observe and to translate his observations into painting. The ghosts were based upon observation of poor, unfortunate wretches, and their "food" required the artist to look at bones or corpses. Everyday scenes of a sometimes repellent nature were natural vehicles for Buddhist comments on the "dusty world." Though observation of the poses and movements of individual figures is close and keen, as in the reaching gesture of the ghost at the upper left,

the landscape setting is relatively archaic. The little hummocks with their small trees are really not much advanced beyond the type of landscape setting seen in the Sutra of Cause and Effect of the Tempyo period (*see colorplate 13, p. 205*). The convincing rendering of nature as a setting providing a space for figures to move about in will occupy the handscroll painters of the Kamakura period.

14

Japanese Art of the Kamakura Period

Aside from very general notice, the foundation periods of the Japanese art tradition, Heian (A.D. 794–1185) and Kamakura (A.D. 1185–1333), are scantily published by Western scholars, and so the student of art often receives an inadequate impression of the original nature and significant achievements of Japanese art. The purpose here is to present a critical synthesis of the products of the Kamakura period as documents of that culture and in many cases as original contributions to the history of art. Although the decorative arts of Tempyo are most beautiful, they are still derivative from Tang China. But the portrait sculptures, narrative scrolls, and landscapes of Kamakura are original statements. We shall consider the arts of Kamakura as manifestations of the Contemplative Life, the Active Life, and the Aesthetic Life, with the understanding that for this period the first represents a fundamentally conservative or regressive style, the second a style most expressive of the period, and the third anticipates the developments of the succeeding Ashikaga period.

THE CONTEMPLATIVE LIFE

The highest aims of traditional society in the Orient have been contemplative, and the mature Heian Buddhism of the Tendai and Shingon sects was no exception. Its intellectual strength produced an austere, complicated iconography, well seen in sculpture, which was displaced in Late Heian by a gentler complexity more suitable to the medium of painting. The greatness of Late Heian, or Fujiwara,

is to be found in its pictures and decorative arts rather than in sculpture. The early Kamakura period, inheritor of this unchanged Buddhist tradition, maintained it briefly before its inevitable decline (*colorplate 31, p. 335*). The pictorial representations of the principal Esoteric subjects and scenes continue in the Heian style, with perhaps a sweeter air.

The most striking example of the continuing Heian tradition is the *raigo* (*fig. 417; see also fig. 398 and p. 301*). This vision of Amida Buddha and his attendants come to welcome the departing soul is one of the great achievements of Buddhist painting. The concept is peculiarly real and immediate, a touching vision of heavenly joy made manifest in paint, and as such particularly suited to the spiritual temper and artistic interests of the Kamakura period. It may be said to have achieved its highest expression in the Late Heian and early Kamakura periods. The classic Heian example at Koyasan (*see fig. 398*) concentrates on the concept, portraying the figures themselves with little attention to the setting; but with the growing interest in the tangible world during Kamakura an attempt is made to present the vision not only as it appears to the dying one, but also from a spectator's view—to show not only Amida descending but the world into which he comes. This is a less strictly religious approach, perhaps, but in keeping with the spirit of the age.

In decorative materials, such as lacquer work with mother-of-pearl or metal inlay, the Late Heian style continued, but in sculpture it had declined past continuance.

clan and de facto dictator of Japan, to provide the funds and energies needed for rebuilding Todai-ji. A group of sculptors was at hand and new sculptures—as well as restoration of old—were in prospect. With their eyes on the relics of Nara, they bypassed the intervening periods; the stimulus they received was of the sort that the thirteenth century sculptors of Pisa received from the relics of classical antiquity. This influence is clearly apparent in the two sections of the Sangatsu-do, one Nara, the other Kamakura; in a Kamakura gilt bronze image of the

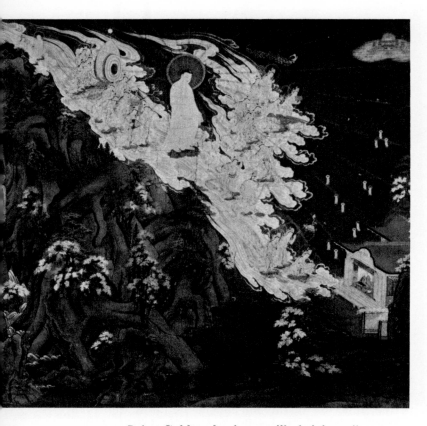

417. *Raigo*. Gold and color on silk, height 57". Chion-in, Kyoto, Japan. Kamakura period, early thirteenth century A.D.

Between A.D. 1156 and 1185 Japan was convulsed with strife, ranging from minor skirmishes and private murders to bloody pitched battles, as the chief among the warrior clans, Taira and Minamoto, struggled for supremacy. A short-lived Taira victory in A.D. 1160 brought only two decades of relative quiet. The court aristocracy, including the once all-powerful Fujiwara clan, were helpless and apprehensive onlookers at this contest, retaining of their former power only a social ascendancy acknowledged even by the warriors. Even monastic communities became embroiled in the general disorders, sending frightening, if ill-trained, mobs of monks with fire and sword against each other or the court. A spirit of apocalypse was abroad, not surprisingly, since famines, plagues, and great fires accompanied war through the capital and the Home Provinces. Peace returned only with the total defeat of all enemies of Minamoto no Yoritomo.

The Taira clan, in one of its last campaigns to retain power, had burned Todai-ji, and the rest of Nara, especially Kofuku-ji, suffered as well. The old capital had fallen into neglect and would have been doomed to worse, had it not been for the decision of Yoritomo, head of the newly victorious Minamoto

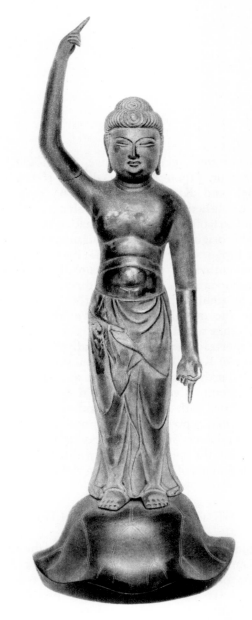

418. *Youthful Shaka (Sakyamuni)*. Gilt bronze, height approx. 12". Kofuku-ji, Nara, Japan. Kamakura period, thirteenth century A.D.

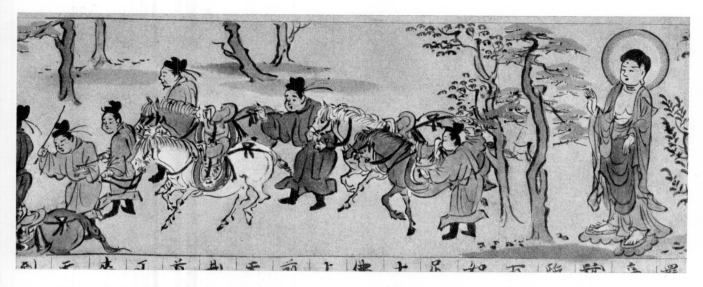

419. *Kakogenzai Ingakyo*. By Keinin. Dated to A.D. 1254. Section of the handscroll, ink on paper; height 11″, length 37 1/4″. Japan. Kamakura period. Nezu Institute of Fine Arts, Tokyo

Youthful Shaka, a type popular in Nara but almost unknown in Heian (*fig. 418*); in the Kamakura rebuilding of Saidai-ji, by Eison, on the plan of Shitenno-ji, a temple of the Nara period; in the Nara period *azekura* (tightly fitted log construction) technique used in the Kamakura period storehouses of To-ji and Toshodai-ji. In painting there are two Kamakura versions of the Tempyo scroll *Kakogenzai Ingakyo*, one close to Nara style, the other in a free Kamakura version dating from A.D. 1254 (*fig. 419*).

The sculptors' main accomplishments we will see presently, but now we can observe that, if only for a brief time, images such as those of Dainichi Nyorai, Amida, and Miroku were imbued with a new and vigorous spirit within the traditional Fujiwara shapes (*fig. 420*). The sculptor Unkei leads the revival, and other names—Kaikei, Jokei—are associated with these images, all products of the earlier quarter of the period. The later decline of this brief Nara revival appears in the Amida of Horyu-ji, a Kamakura (A.D. 1232) version of an Asuka bronze, as well as in the famous Great Buddha of Kamakura city (*fig. 421*), a paler recollection of its Nara predecessor.

While the principal images and icons witness to the revival and decline of earlier tradition, a totally different picture emerges with regard to the secondary images. Just as in early Renaissance Italy, where the most startling innovations seemed to be found in minor sections of the large altarpieces, so the guardians, attendants, and grotesques of Japanese Buddhism attracted the most creative instincts of the artists. The two figures of the priests Seshin and Muchaku, attributed to Unkei and dating from

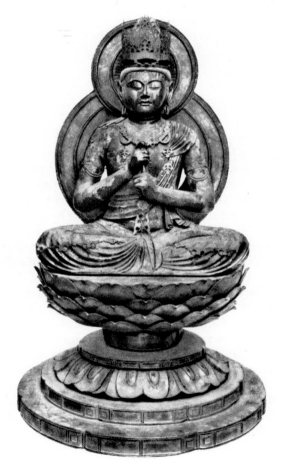

420. *Dainichi Nyorai*. By Unkei (act. A.D. 1163–1223). Dated to A.D. 1175. Lacquered wood, height 39 1/4″. Onjo-ji, Nara, Japan. Late Fujiwara period

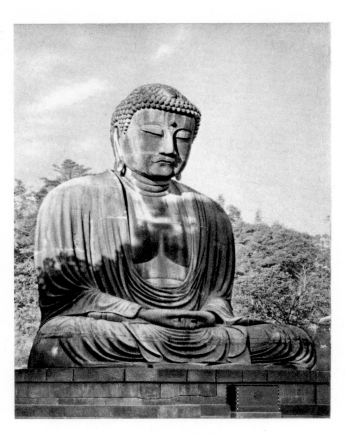

421. *Great Amida Buddha*. Bronze, height 37′ 4″.
Kotoku-in, Kamakura, Japan. Kamakura period,
A.D. 1253

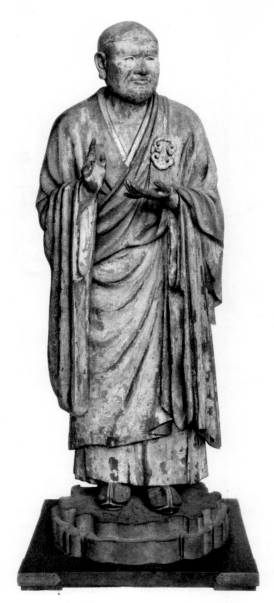

422. *Priest Seshin*. By Unkei (act. A.D. 1163–1223).
Painted wood, height approx. 74″. Hokuen-do of
Kofuku-ji, Nara, Japan. Kamakura period, c.
A.D. 1208

the earliest part of the Kamakura period, are unique sculptures (*figs. 422, 423*). Larger than life and with a powerful realism hitherto unknown, they command instant respect. These figures are carved in several pieces from separate blocks of wood (*yosegi* technique), a construction that became common in the Fujiwara period and was intricately developed in the Kamakura period. Large statues made in wood by this technique would not split or check. The polychrome-painted figures of Seshin and Muchaku convey intense realism in the character of the drapery and especially in the treatment of the head. Note the use of crystal inlay for the eyes, a characteristic technique of the Kamakura period and an index to the growing interest in realism. They may seem at first unprecedented, but the dry lacquer figures of the Ten Disciples, made in the Nara period for the same temple, Kofuku-ji, were their prototypes. Whereas the Nara dry lacquer figures of the Ten Disciples are uncertain in their bodily forms, however intense in expression, Unkei's masterpieces have a massive monumentality that emanates from the firm handling of the drapery as well as from the broad characterization of the face. Although maintaining the structural character of a tree trunk, these Kamakura figures possess an ease of pose suggested

by daring and deep cutting of the mantle folds.

The intense realism of the early Kamakura works can also be found in the wooden guardians, the *Kongorikishi*, of the same temple, where the volatile nature of the subject allows greater freedom of motion and an opportunity for characterization bordering on the grotesque (*fig. 424*). We should note that these figures partake of the renaissance of Nara period style in that they are still not greatly twisted or undercut. Broad, contained surfaces, however intense, are still very much in evidence (*fig. 425*). The figures have a beautifully preserved layer of polychromy: The flesh is a cream color, the drapery is heavily painted with decorative textile patterns, and the eyes have the typical Kamakura crystal inlay. The second guardian figure maintains an

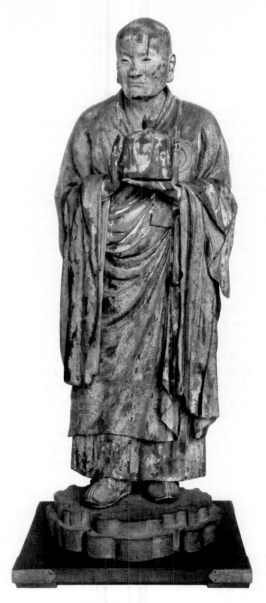

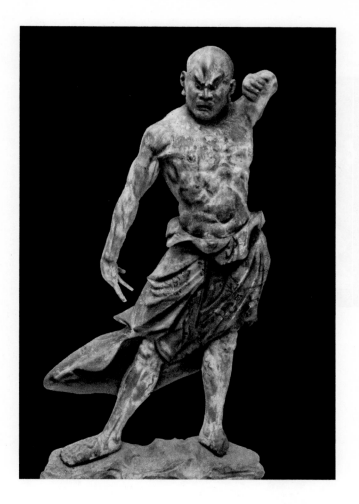

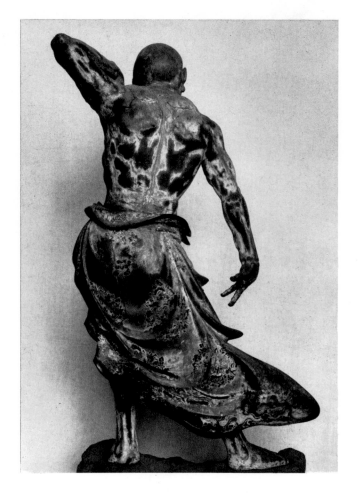

423. *Priest Muchaku*. By Unkei (act. A.D. 1163–1223).
Painted wood, height approx. 74″. Hokuen-do
of Kofuku-ji, Nara, Japan. Kamakura period, c.
A.D. 1208

even more vigorous pose and threatening expression.
In Western terms the exaggeration of muscular
structure, of tendons and veins, is not particularly
realistic. Though the figure is plausible, its anatomy
is inaccurate, with an element of exaggeration or
caricature characteristic of Japanese art in this period.

The *Twelve Generals of Yakushi* at Muro-ji, the great
Jogan site, epitomize the next developments at
their highest expression (*fig. 426*). Though small,

424. (above right) *Kongorikishi*. By Jokei. Painted
wood, height 64″. Kofuku-ji, Nara, Japan.
Kamakura period, c. A.D. 1288

425. (right) *Kongorikishi*. Back view of fig. 424

426. *Five of the Twelve Generals of Yakushi*. Wood, height approx. 48″. Muro-ji, Nara Prefecture, Japan. Kamakura period, thirteenth century A.D.

their effect as an ensemble and individually is completely new and without close precedent. In the sculpture of Nara and Heian, the breakup of planes, volumes, and movements is on the surface of the figure. In the developed Kamakura style, whether in a violently agitated guardian or a silent, contemplative priest, the volume is penetrated by space. The trunk of the tree is no longer a sacrosanct unit. The sculpture is built up of many joined blocks, allowing the sculptor greater freedom as well as protecting the wood from checking. The wood can therefore be pierced and twisted; it can express vividly the violent emotions and tendencies of a short-lived, perfervid, and unreserved society. These relatively realistic sculptures are truly dramatic. The juxtaposition of the Kamakura figures against the background figures of the Jogan period in figure 426 is particularly revealing. The stolid, massive quality of these earlier figures is dimly seen in the background, while the photographer's light picks out the volatile swirl of drapery and exaggerated facial expression in the figures of the generals.

The most extraordinary examples of undercutting and of the dramatic style of sculpture in the Kamakura period are the two large guardian figures by Unkei, housed in opposite sides of the Great South Gate (Nandai Mon) outside the great temple of Todai-ji in Nara (*fig. 427*). The wooden figures are almost thirty feet high and made in many sections, undercut, and strikingly emphasizing that exaggeration of muscle and tendon by which the Kamakura sculptor expressed a great vigor and strength. The temple of Kofuku shows us another outstanding example of this sculptural style in a type peculiarly sympathetic to the artists of the period, the grotesque (*fig. 428*). Dated to A.D. 1215, these weird lamp bearers support their burdens with a vehemence that borders on the comic.

The grotesque is to be found in painting as well, both in subject and in treatment. The Six Worlds are a traditional Buddhist concept, but not until the end of Heian and the beginning of Kamakura did they become subjects for representation. The *Jigoku Zoshi* scroll representing the world of hell combines the grotesque with an observant and illustrative style that we shall see again (*fig. 429*). No better description of the artist's narrative achievement can be given than that in the inscription on the scroll preceding the scene illustrated:

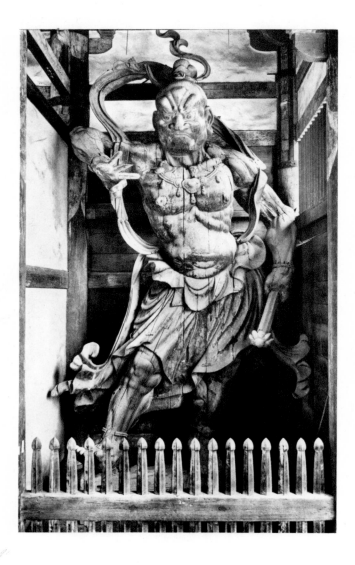

427. *Kongorikishi*. By Unkei (act. A.D. 1163–1223). Wood, height 26′ 6″. South gate of Todai-ji, Nara, Japan. Kamakura period, A.D. 1203

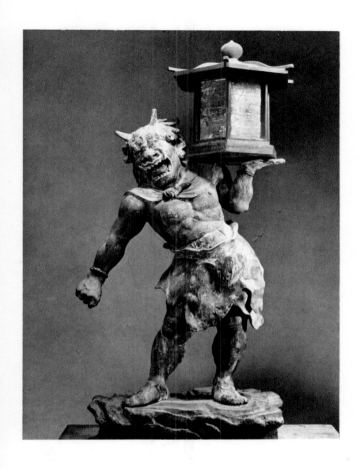

428. *Lamp bearer* (one of two). By Koben. Painted wood, height 30 5/8″. Kofuku-ji, Nara, Japan. Kamakura period, A.D. 1215

demons are rich, full, and "round nail-headed" types, producing powerful figures, almost like star batters on a demonic baseball team, wielding iron rods with obvious pleasure and vigor. The rendering of fire is perhaps as effective as any painted representation in East Asian or any other art. The sense of impermanence and the revulsion against those who "[fail] to conduct themselves properly and [have] no kindness in their hearts," both impeccable Buddhist sentiments, must have been given a gloomy emphasis by the forty-odd years of violent chaos that was just beginning to subside.

The representations of principal deities in their terrible aspects are allied to the grotesque. Many of the beatific representations have only a watered-down sweetness with little of the gently lyric qualities of earlier periods, but the terrible deities convey such real and palpable and overwhelming wrath as to make their Heian counterparts seem remote and abstract by comparison. The *Bato Kannon* (Horse-

Within the Tetsueisen there is a place called the Shrieking Sound Hell. The inmates of this place are those who in the past accepted Buddhism and became monks. But failing to conduct themselves properly and having no kindness in their hearts, they beat and tortured beasts. Many monks for such cause arrive at the Western Gate of Hell where the horse-headed demons with iron rods in their hands bash the heads of the monks, whereupon the monks flee shrieking through the gate into Hell. There inside is a great fire raging fiercely, creating smoke and flames, and thus the bodies of the sinners become raw from burns and their agony is unbearable.

In drawing the figures of these monks, the artist has deliberately used a series of rather short strokes, producing figures that are pathetic in their naked plight. The strokes used to show the horse-headed

429. *Hell scene*. Section from the handscroll *Jigoku Zoshi*, ink and color on paper; height 10 3/4″. Japan. Kamakura period, c. A.D. 1200. Seattle Art Museum

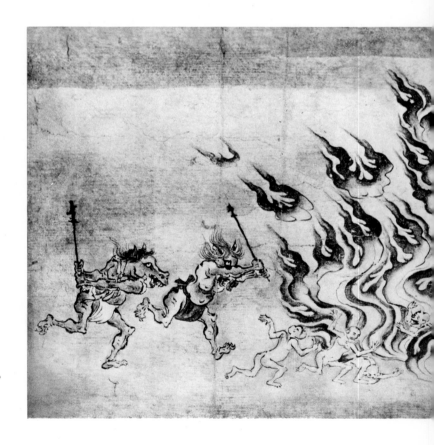

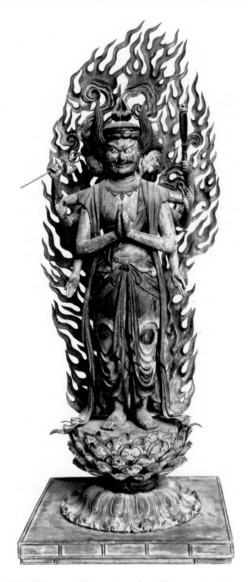

430. *Bato Kannon* (Horse-headed Kannon). Dated to
A.D. 1241. Wood, height 41 3/4″. Joruri-ji, Nara,
Japan. Kamakura period

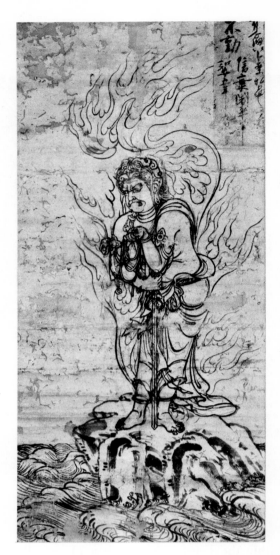

431. *Fudo*. By Shinkai. Hanging scroll, ink on paper;
height 46″. Daigo-ji, Kyoto, Japan. Kamakura
period, A.D. 1282

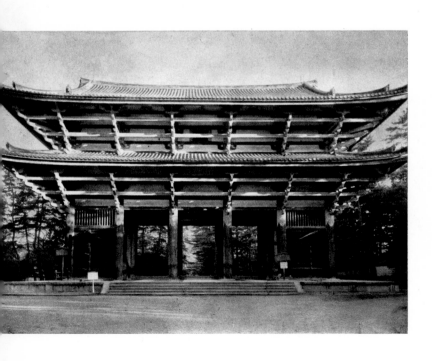

headed Kannon), dated to A.D. 1241, reveals the
extraordinary power of the new sculptural style
(*fig. 430*). But this new-found power is not to be
attributed to the sculptural medium alone; it can be
seen in the *Fudo* attributed to Shinkai and painted
in A.D. 1282 (*fig. 431*). The extent to which this
latter figure has become real can be gauged by the
head, where reality borders on the merely humanly
terrible rather than the true *terribilità* of the *Horse-
headed Kannon* of A.D. 1241. Note, too, that the im-
movable rock on which Fudo stands is rather more
realistically represented than in earlier periods, as
are the waves beating on the rock. Shinkai's *Fudo*
is only an ink sketch on white paper, and was un-
doubtedly either a preliminary study for a painting

432. *Great South Gate of Todai-ji*. Nara, Japan. Dated
to A.D. 1199

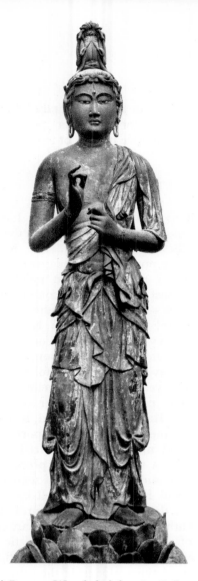

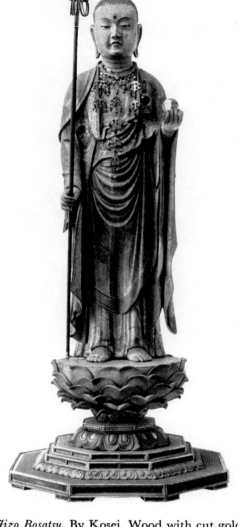

433. *Seishi Bosatsu*. Wood, height 5′10″. Japan. Kamakura period. Tokyo National Museum

434. *Jizo Bosatsu*. By Kosei. Wood with cut gold and color, height approx. 40″. Japan. Late Kamakura period. Hara Collection

to be done in color or a copybook model executed for members of the workshop.

Architecture, constrained by structural and practical requirements, expresses less clearly the stylistic predispositions of the period. But perhaps the vigorous and grotesque can be equated with the *tenjiku-yo* (Indian) style of architecture best seen in the Great South Gate of Todai-ji, built in A.D. 1199 (*fig. 432*). Although called Indian, its origins are to be found, as Soper shows, in the provincial style of Fujian Province, on China's southeast coast. The gate structure is logical but simple, almost heavy rather than lucid, with a brute strength that overpowers memories of the refined Heian architectural style and that finds no later repetition. The life of *tenjiku-yo*, like that of the great period of Kamakura sculpture, is as short as its energies are long.

The decline of the Hojo Regency after the Mongol defeat of 1281 ended in a culture that stressed near-perfection on a small and derivative scale but never achieved the powerful victories of the earlier men: the sculptured demons, the painted grotesques, and the defeat of Kubilai Khan. The decline in religious art begins quickly after A.D. 1250 and continues steadily. Human realism, dramatic style, and a false echo of Late Heian sweetness combine to produce a series of images that range from the lovely, such as the bodhisattva Seishi with its almost feminine quality of elegance (*fig. 433*), to the vulgarly sentimental, such as the Jizo figure in the Hara Collection, which seems about to walk off the pedestal and become merely human (*fig. 434*). Even the terrible fails. The *Fudo* of Todai-ji, while made technically and aesthetically interesting by the sculptor's dexterity, has none of the fierce reality or vigorous dramatic qualities of its predecessors (*fig. 435*). The forms are puffy, the facial furrows are part of a stylized grimace. The driving energy of the *Horse-headed Kannon* here is spent.

In painting, stylization rules. In the *Kasuga*

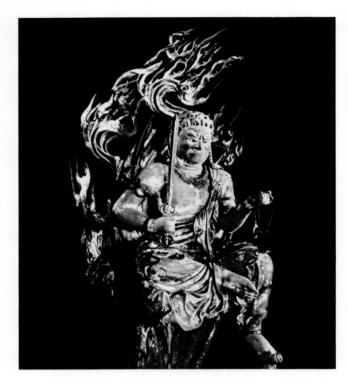

435. *Fudo Myo-o*. Wood, height 34″. Todai-ji, Nara, Japan. Late Kamakura period

Gongen scroll, dated to A.D. 1309, the flames of hell are patterned but do not burn, and the demons are shells of calligraphic but often meaningless lines and shapes (*fig. 436*). Soon even interest in the subject of the Six Worlds recedes. It appears safe to say that the great Japanese tradition of Buddhist art, founded

in Early Heian, is dead by the end of Kamakura in A.D. 1333, except for the later products of Zen Buddhism, which were really not iconic in character.

THE ACTIVE LIFE

The guardians and the *Bato Kannon* have already introduced us to one facet of the active life as it influenced the world of icons. The ideal of the outlanders, who now wielded the power of the state, was the military man, the more active the better. Reaction against the elegant contemplatives—let us say aesthetes—of Kyoto led to the removal of the de facto capital from Kyoto to Kamakura. The Kyoto aristocracy might term the new period crass, vulgar, and brutal, but its vigor and determination produced a convincing and forceful self-portrait in the short fifty years before it declined into sentimentality. The parallel in temper with the early Renaissance in Italy, though limited, is striking; and as in Italy a fine development of portraiture, narrative art, and military art occurred. In a sense portraiture was a revival of Nara precedents. Some extant lacquer and clay figures of seated priests at Toshodai-ji and Horyu-ji may well have served as prototypes for the Kamakura sculptures. The eighth and thirteenth century portraits share a general frontality of pose and a characteristic dramatic treatment of the drapery. But the Nara figures seem like generalized types alongside the vibrant realiza-

436. *Hell scene*. By Takashina Takakane. Dated to A.D. 1309. Section of the handscroll *Kasuga Gongen*, color on silk; height 16″. Japan. Late Kamakura period. Imperial Household Collection, Tokyo

437. *Priest Jugen*. Wood, height 32 1/4". Shunjo-do of Todai-ji, Nara, Japan. Kamakura period

tion of individual character to be found in Kamakura. The head of Muchaku (*see pp. 315–16, fig. 423*) provides a starting point for a series of priest and warrior portraits, beginning with the truly remarkable portrait of Priest Jugen at Todai-ji, an old man holding his prayer beads with an intense concentration of effort visible in every line of the frail body (*fig. 437*). This is no mere surface likeness achieved by skillful technique, but a searching gaze through the physical structure to the character within. In the later portrait of the nobleman Uesugi Shigefusa, kept in a Kamakura temple, a sculptural development can be seen from the taut and incisive forms of the earlier *Priest Jugen* to softer and more self-conscious surfaces (*fig. 438*). Perhaps this latter character can be attributed partly to the influence of Zen Buddhism, to be discussed shortly.

Although there were relatively few Heian precedents for real portraiture in sculpture, in painting the ideal portraits of the seven patriarchs of the Shingon sect, as well as representations of Shotoku Taishi, the historic founder of Buddhism in Japan, and others, provide a starting point for the surging interest of Kamakura painters in individual characterization. The famous portrait of Yoritomo, the "Great Barbarian-Subduing General" who established the capital at Kamakura, contains much of

438. *Uesugi Shigefusa*. Wood, height 26 3/4". Meigetsu-in, Kamakura, Japan. Kamakura period

439. *Minamoto no Yoritomo*. Attrib. Fujiwara Takanobu (A.D. 1142–1205). Hanging scroll, ink and color on silk; height 54 3/4″. Jingo-ji, Kyoto, Japan. Kamakura period

440. *Retired Emperor Go-Shirakawa*. Hanging scroll, ink and color on silk; height 52″. Myoho-in, Kyoto, Japan. Kamakura period, c. A.D. 1200

Late Heian stylization in the draperies (*fig. 439*). The stiffness and flat planes are characteristic of actual formal costume of the day, but the daring outline is striking testimony to a new boldness in design. The head, defined by a wirelike line of infinite strength, expresses attributes most serviceable to the new Kamakura rulers and the temper of the times: serious and direct, practical in attitude, ruthless in application. An even more expressive and complete example of painted portraiture is the hanging scroll of the retired emperor Go-Shirakawa, at the Myoho-in, Kyoto (*fig. 440*). The body seems three-dimensional and fills the field of view, even expanding beyond its boundaries. The setting is also more complete. Delicate paintings of birds and flowers on the screens behind serve to magnify the dominance of the powerful figure.

The second expression of the Active Life is to be found in narrative art with a corollary interest in everyday life. The Tempyo period is documented by the utilitarian and decorative objects preserved in the Shoso-in from A.D. 756 onward; the appearance and culture of the Kamakura period have been vividly and unforgettably preserved in pictorial form. The

makimono, or handscroll, originated not in Japan but in China. The earliest known narrative scroll of Japanese origin, the *Kakogenzai Ingakyo*, illustrating the life of the Buddha, was painted in the Tempyo period of overwhelming Chinese influence. But whereas the Chinese used the handscroll to depict landscape, the Japanese largely ignored landscape and developed the narrative-figural handscroll to a level hardly reached by surviving Chinese examples. The technique should be obvious to people reared on comic strips, but only the Japanese have realized the enormous possibilities of the method.

Imagine a scroll more than forty feet long, unrolling from right to left and filled with hundreds of men, women, and children, animals, demons, storms, quiet landscapes, great fires—all the elements of divine and human drama. The story unfolds in space and time. The characters enter on stage from the left and pursue their quiet or turbulent ways. Rest spaces are provided by tranquil landscapes or blank spaces, while stiffening and setting for the story are provided by architecture depicted in conceptual fashion, rising sharply across the paper, limiting and defining the stage on which the characters move. The

very method is exciting, but never before or since the Kamakura period has the method been imbued with such enormous vigor and technical dexterity. Whereas the Fujiwara scrolls in the aesthetic court style are underpainted and carefully but stiffly spaced, the scrolls from the beginning of Kamakura are executed with robust haste. The brush is used directly, without underpainting, and the line is marvelously varied, bending to the grace of reeds or knotting to the bulging muscles of a demon. Line, and shape defined by line, convey the essentials. The color, largely incidental, is washed on surely but freely.

Narrative material was available in abundance. Each temple or shrine had its legend, which now could be put in vivid and readily understandable form. The miraculous episodes depicted in the *Shigisan Engi E-maki* (*Narrative Scroll of the Origins of Mt. Shigi Temple*), seen here in a detail from the first scroll, tell the story of a priest with a miraculous golden bowl (*fig. 441*). In this scene the bowl, having been refused alms at a rich but proud and greedy household, lifts into the air an entire storehouse full of rice, and flies with it over hills and valleys to the solitary residence of the priest in the mountains of Wakayama. Fat ladies, well-fed members of the rich man's household, dash out through the gateway as they see their sustenance disappearing through the air. In the center the owner, or rather the former owner, of the warehouse hastily

mounts his horse to make pursuit, while at the left household hangers-on gesticulate and grimace wildly with surprise, and a priest, another member of the rich household, tries by rubbing his prayer beads to bring the warehouse back to its owner. But the miraculous virtues of the golden bowl triumph: The warehouse flies on to the priest's house and ultimately is used as a means of bargaining with the rich man.

The historical feuds of the noble families were freely used as subject matter, and these produced one of the greatest of the narrative scroll-paintings, *Ban Dainagon E-kotoba*, the story of how a children's quarrel revealed a conspiracy to discredit a rival clan by burning a palace gate and accusing them of arson. The scene chosen from the second scroll shows two children engaged in a typical village quarrel (*fig. 442*). At the upper left an overly protective father runs out to separate the two boys, while at the lower left the father, holding on to the miserable but triumphant urchin that is his son, gives the other boy a kick that sends him flying. At the right spectators cynically observe the disturbance. The story goes on to tell how, as a result of this quarrel, arson was brought to the attention of court authorities and the guilty party banished. One should note especially in this detail the drawing of the figures in a realistic style based upon observation. The movements of the father as he comes running out of the house and of the boy sent flying, or the

441. *The Flying Storehouse*. Section of the handscroll *Shigisan Engi E-maki*, slight color and ink on paper; height 12 1/2″, length 116′ 8″. Chogosonshi-ji, Nara, Japan. Late twelfth century A.D.

442. *Ban Dainagon E-kotoba*. Section of the handscroll, ink and color on paper; height 12 1/4", total length (of three scrolls) 85 1/4". Japan. Late twelfth century A.D. Tokyo National Museum

expressions on the faces of the bystanders, all show a close and detached observation of nature. The artist looks upon these doings coolly, even satirically. There is little sympathy to be seen in Kamakura realism in particular or in Japanese art in general.

The *Ban Dainagon* and the *Heiji Monogatari* (*colorplate 32, p. 336*) scrolls contain two of the world's great depictions of fire and in their enormous crowd compositions show a mastery of grouping and disposition worthy of the term genius. The complex spacing in figure 443 from the *Ban Dainagon* scroll is achieved by turning people in various poses, arranging some in a semicircle and others in thrusting diagonals. This mastery of fire and

crowds is a good indication of the principal origins of this style in observation of everyday life. No one who has seen a large-scale fire in Japan can doubt the accuracy of the artist's comment. The earlier contemplative discipline involved in drawing the fire halos of Fudo and other Esoteric Buddhist figures contributed to the painters' technique.

Everything is grist for the scroll painters' mill: Servants bantering, wild and domestic animals, storms at sea, human birth, growth, disease, and death—all these and more are in the scrolls. Thus in the *Yamai no Zoshi* scroll (*Scroll of Diseases*) an obese woman attended by two other females is laughed at by village loafers (*fig. 444*). Again, one

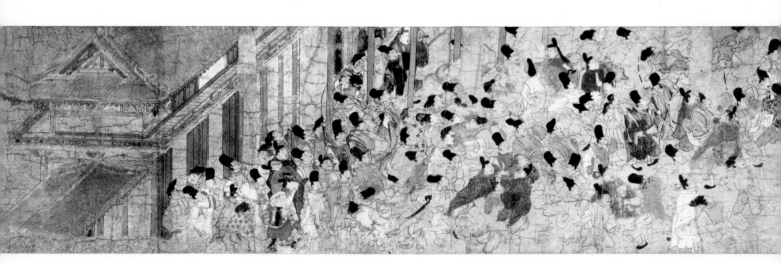

443. *Figures.* Section of the handscroll *Ban Dainagon E-kotoba*, ink and color on paper; height 12 1/4", total length (of three scrolls) 85'4". Japan. Late twelfth century A.D. Tokyo National Museum

444. *Yamai no Zoshi scroll.*
Section of the handscroll,
ink and color on paper;
height 10″, length approx.
18″. Japan. Late twelfth
century A.D. Matsunaga
Kinenkan Museum, Tokyo

is aware of a lack of sympathy in the representation. Patrons commissioned scrolls with appropriately lofty subject matter, but the age was not content with only the pious life of a great saint or the story of a great battle. To the august subject the spice of human life was added, presenting a complete picture of the high and low in Kamakura culture. A corollary of this narrative concern is the interest in what amounts to caricature—faces distorted through emotion, pain, or disease are humorously or cruelly handled, as in the *Scroll of Diseases*. These are the observations of a more pragmatic and cruder mind than that of the preceding age. Still, a low tradition can be traced here and there in earlier times, in the scribblings or sketches found on statue bases and more recently in the remarkable caricatures and obscenities discovered on the ceiling boards of Horyu-ji near Nara and probably dating from the early eighth century (*fig. 445*). These were probably doodles by artists who painted the representations of Buddhist deities on the walls of the *kondo*, especially the famous and much admired representation of the Western Paradise (*see fig. 212*). This interest in facial types, caricature, and narration had always existed covertly. It remained for artists of the Kamakura era to express it fully and freely in such accepted art forms as the narrative scroll. Such observation of everyday life extended to landscape and the native scene, which we shall discuss presently.

The last expression of the Active Life was in arms and armor. We can only allude to their importance and their nature. The foundation of the social order in the Kamakura period was military strength. Minamoto no Yoritomo conquered the Taira by

war, and the feudal outlanders who were the sinews of the new supreme general were primarily military men, in contrast to the courtiers of Kyoto. The brutality of the period was frank and unabashed. The aesthetic life expressed in the tea ceremony and its allied cults, which would afford warriors an acceptable peaceful discipline and temporary refuge from their own violence, had not yet been developed. The great advances in armor and sword making are those of the twelfth and early thirteenth century, and it is claimed that no sword of any age or country excels the Japanese sword of Kamakura (*fig. 446*). Keen of edge, strong in substance, severely and terribly beautiful in form, it was the

445. *Caricatures.* Ceiling of Horyu-ji, Nara, Japan. Tempyo period, eighth century A.D.

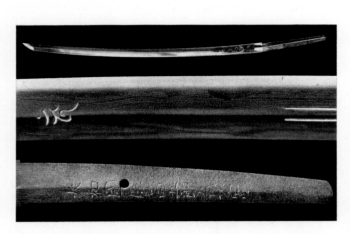

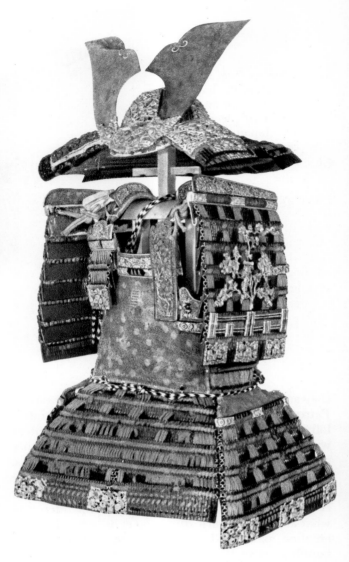

446. (above) *Sword Blade*. Signed: Yamato no Kuni Hosho Goro Sadamune (act. A.D. 1318–1335). Japan. Kamakura period. Metropolitan Museum of Art, New York

447. (right) *Grand Armor*. Japan. Kamakura period. Tokyo National Museum

448. (below) *Mongol Invasion*. Section of the handscroll, ink and color on paper; height 15 1/2″, length approx. 78′. Japan. Kamakura period, late thirteenth century A.D. Imperial Household Collection, Tokyo

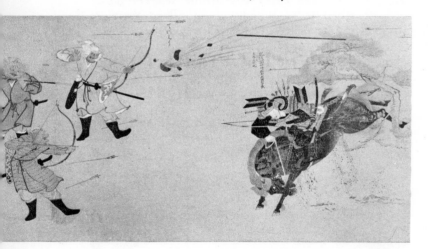

image of deity to those who wielded it. Its sacredness was no mere fancy, for the sword maker, like a priest, performed rites of purification and consecration for the making of a blade. Extant Heian blades are few, but Kamakura swords exist in considerable number. Their variations alone are evidence of the rise of feudalism and of provincial pride, for Homma identifies sixteen provincial types and subdivides the local styles of Kyoto, Bizen, and Yamashiro still further into schools. Armor too was prized, as in late Gothic Europe. At first the style of the Late Heian period continued, on a heavier and grander scale. The antlers or horns increased in size and dominated the headdress (*fig. 447*). Kamakura grand armor is especially rich in its decoration of gilt bronze, patterned leather, and figured textile. With the enlargement of the art of war, especially under the continued Mongol threat which, despite two defeats, did not abate till about A.D. 1300, the foot soldier became tactically more important and the cavalryman less, and as a consequence ordinary armor grew lighter. The direct influence of the lightly armored Mongol soldier may be assumed. In Europe, similarly, heavily armored horsemen were superseded by lightly armored men-at-arms.

The influence of the military on other arts was enormous. Tales of war and battles make up a large part of scroll painting, the *Heiji Monogatari* being the most often reproduced. The most interesting, not aesthetically but for military history, is the scroll of the Mongol invasion in the Imperial Household Collection (*fig. 448*). While supporting one officer's claims for reward, it records in some detail the deeds of the defending army and graphically illustrates the disposition and appearance of both Japanese and Mongol troops. One scene in particular, of

449. *Running Fudo.* Hanging scroll, color on silk; height 50″. Japan. Kamakura period, c. A.D. 1280. Formerly Inoue Collection, Odawara

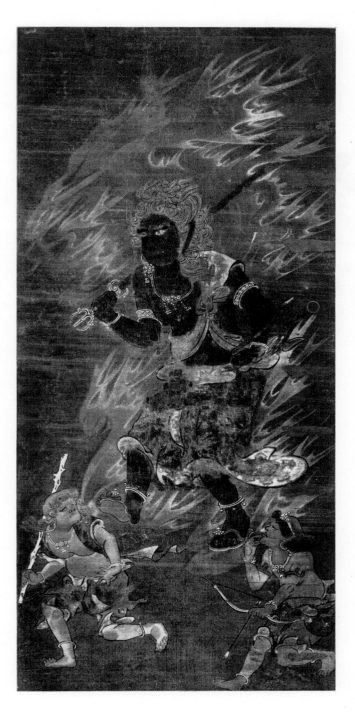

Mongol foot bowmen attacking a Japanese warrior, illustrates the military lesson that led to lighter armor. Military and athletic tastes extended to an interest in the strength and movement of horses, so well and cursively set down as to defy the competition of earlier or later Japanese artists. The military and court hierarchy also employed the painter for recording, in semidiagrammatic fashion, the order of seating on the occasion of state ceremonies.

But a unique and most significant example of the far-reaching influence of the military aspect of the Active Life is to be found in the well-known *Running Fudo,* formerly in the Inoue Collection (*fig. 449*). Now, Fudo has from his earliest representations been recorded as the Immovable, a terrible manifestation of Mahavairocana in Esoteric Buddhism, a scourge of the sinful. His energy is prodigious, but being eternal and immovable, he is usually depicted seated or standing still. In this picture, however, attributed to the time of the Mongol invasion, he is shown running, his sword held behind and high, a veritable epitome of attack. This pose is entirely congruent with the tradition that the image was used by Emperor Kameyama in prayer for deliverance from the Mongol armies. No more striking example of the joint operation of the contemplative and active principles can be presented, and their union in this picture occurred in Kamakura's greatest hour.

THE AESTHETIC LIFE

The cost—in military expenditures and decreased agricultural production—of repelling two Mongol invasions and maintaining a state of defensive readiness for two generations afterward impoverished Japan and fatally weakened the Kamakura government. Kamakura culture, whose brief strength was expressed in powerful, realistic, kinetic art, failed to recover, and its subsequent history is one of progressive decay in religious art, of decline in narrative effectiveness, and of an increasing tide of aestheticism, which in effect rushed into the growing vacuum left by the decline of religious and narrative art. The aesthetic mode most common in the late Kamakura period took the form of a restatement of the court style of the Fujiwara period, a style which, though moribund, had never died in Kyoto. The themes of this restated style were mostly literary, and the patterns it created were mostly bold and striking, even

in so delicate a medium as inlaid lacquer. The aestheticism of the Fujiwara court, best exemplified in delicate calligraphy and poetry, was viewed with growing interest from the mid-Kamakura period on.

The initial expression of the Aesthetic Life in late Kamakura painting was decorative. The Thirty-six Poets were a favorite topic for pictorial art and were treated in a relatively traditional manner, with great attention to the fascinating angular pattern of draperies (*fig. 450*). But the most significant examples of the revived decorative tendencies are to be found in the narrative scrolls, where patterns of shape, space, and color rule the paper and figures are

450. *Portrait of the poetess Saigu Nyogo Yoshiko,* from a set of *Thirty-six Famous Poets.* Attrib. Fujiwara Nobuzane (A.D. 1176–1268). Originally a section of a handscroll, ink and color on paper; height 14 1/8″. Japan. Kamakura period. Freer Gallery of Art, Smithsonian Institution, Washington, D.C.

451. *Hondo of Kanshin-ji.* Osaka, Japan. Kamakura period, fourteenth century A.D.

frozen into immobility. Faces revert to stereotype; colors become emphatically bright. The foundations of the decorative style of screen painting, culminating in the works of the Momoyama and early Edo periods, were laid in the declining years of Kamakura. Even where color is not used, pattern dominates. Modern abstractionists are not far removed from this world of almost pure form. Even in architecture pattern is triumphant. The main hall (*hondo*) of Kanshin-ji, dating to A.D. 1334–35, at the

end of Kamakura, best exemplifies that multiplication of interpillar bracketing which in later periods often made a functional jungle of the simple and monumental temple architecture of Japan (*fig. 451*).

This formalization extended into other fields, with varied effects. Drama and the masks used for its various forms were strongly influenced by the new interests. At the end of Heian, *bugaku,* a form of musical dance-drama derived from Tang China and associated with Buddhist ritual, was the standard form (*fig. 452*). Gradually *bugaku* itself began to split. The ritualistic form became especially associated with the Kyoto aristocracy, and during the Kamakura period, like religious art in general, it declined. *Gigaku* and *bungaku,* popular performances, developed in the folk tradition from the *bugaku.* For the aristocracy *bugaku* was replaced by a stylized and formalized dance-drama that became *no.* The difference between the magical masks of early Kamakura *bugaku* and the subtle, aesthetic masks of the later *no* drama is apparent (*colorplate 33, p. 337*). In domestic architecture the Fujiwara style, with some Song Chinese modifications, was accepted. The forms of brackets and pillars were simplified and lightened, creating an effect of delicacy and refinement.

But in addition to the revival of decorative Fujiwara court style, the fourteenth century also witnessed the stirring of a second, austere, and more significant aesthetic mode. This was rooted in the ever present Japanese love for the spontaneous and irregular in nature, and in the philosophic tradition of Zen Buddhism, which demanded intuitional (as opposed to intellectual) understanding, prized extreme simplicity, and stimulated direct and highly personal visions of the real world and most particularly of nature.

It would require a separate text to discuss the critical influence of Song dynasty China and Chan, or Zen, Buddhism upon late Kamakura Japan. Zen reached Japan in the last decade of the twelfth century. Its stress on intuitive understanding, self-discipline, and simplicity, and its avoidance of ritual and scholasticism, had powerful appeal for the warrior class, and it quickly expanded to become virtually their official religion. The refinement of *no* drama and of Kamakura architecture, and the tea ceremony, reflect strong Zen influence. After the Kamakura period Zen was modified in spirit, the intuition elaborated into extremely sophisticated and subtle forms, and the simplicity formalized and "aestheticized" into an often superb ritual. Still later, the complicated means to achieve simplicity often attained greater importance than simplicity itself; thus the *no* drama and thus also the tea ceremony (which developed out of drinking tea

as an aid to contemplation and an act of brotherhood) became abstract, aesthetic art forms of great complexity. The humble qualities of everyday teabowls of Chinese Jian ware and Japanese Seto ware were exalted, and the early tea masters commissioned bowls that honored and often attained or surpassed this rustic simplicity.

The end of the Kamakura period witnessed the split of tradition into a high aristocratic art of great aestheticism which masked the virile qualities of earlier Kamakura, and a low, humble, but traditional folk art of great frankness. Folk art is an excellent index to the aesthetic stage of a culture. A folk art distinct from so-called fine art can only exist when that fine art has been removed from a common tradition to a more sophisticated plane. In every case it will be found that folk art is a submerged continuation of powerful early tradition, primarily religious in nature, while the contemporary sophisticated art of the higher social levels will be found to be more advanced, secular, aesthetic, and refined. Thus the most interesting religious images of post-Kamakura times are not the synthetic sentimentalisms of professional sculptors, but the coarse, common, and crude products of the pious village

453. *Courtesan. Otsu-e,* hanging scroll, ink on paper; height approx. 30". Japan. Eighteenth century A.D. Folk Art Museum, Tokyo

craftsmen. The true preservers of the narrative scroll style are the provincial artists of Ashikaga and, later, the plebeian *ukiyo-e* painters and printmakers of Tokyo and the folk painters of Otsu (*fig. 453*). But these manifestations are outside the later recognized artistic traditions. The future development of the purely Japanese style was channeled into the decorative mode, and it is this style, devoid of the daring of Sotatsu or the control of Korin, that confined the Japanese academy of the early twentieth century.

In the century between the costly rout of the Mongols and the beginning of Ashikaga hegemony in 1392, both the reality and the appearance of authority in Japan were inordinately fragmented. The Minamoto succession had failed not long after Yoritomo's death, and puppet shoguns at Kamakura were of even less consequence than the reigning emperors in Kyoto. The abdicated, or

452. *Bugaku mask.* Painted wood, height approx. 12". Kasuga Jinja, Nara, Japan. Kamakura period

454. *Kumano Mandala.*
Hanging scroll,
color on silk;
height 52 3/4".
Japan. Kamakura
period, C. A.D. 1300.
Cleveland Museum
of Art

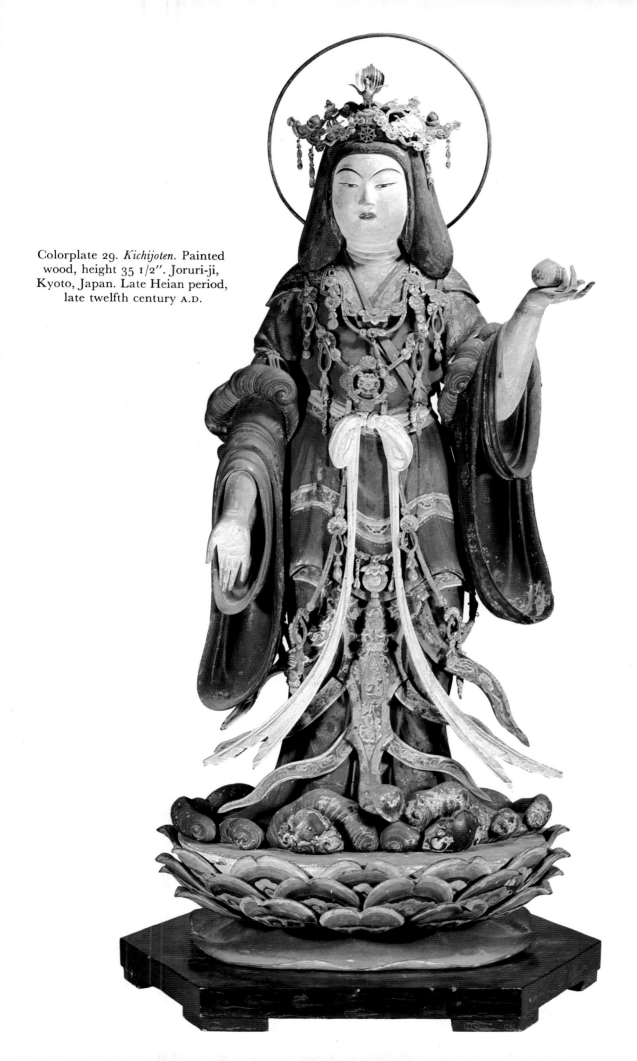

Colorplate 29. *Kichijoten*. Painted
wood, height 35 1/2″. Joruri-ji,
Kyoto, Japan. Late Heian period,
late twelfth century A.D.

333

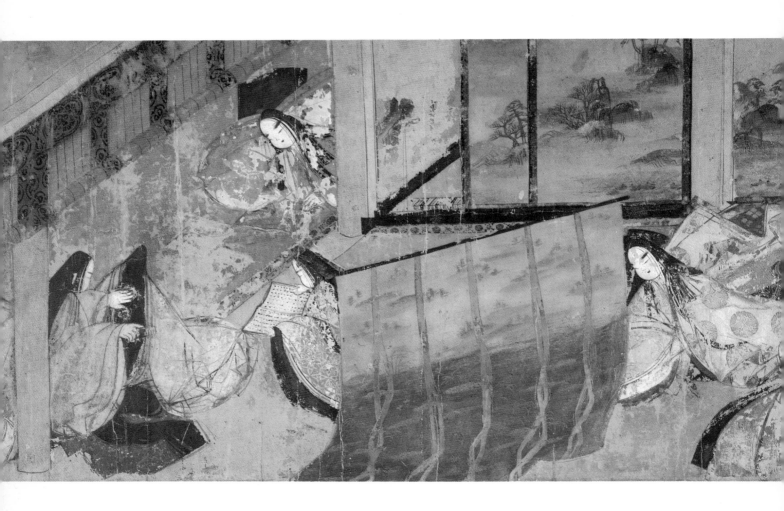

Colorplate 30. *First illustration to the "Azumaya" chapter of The Tale of Genji.*
Handscroll, ink and color on paper; height 8 1/2". Japan. Late Heian period, twelfth century A.D.
Tokugawa Art Museum, Nagoya

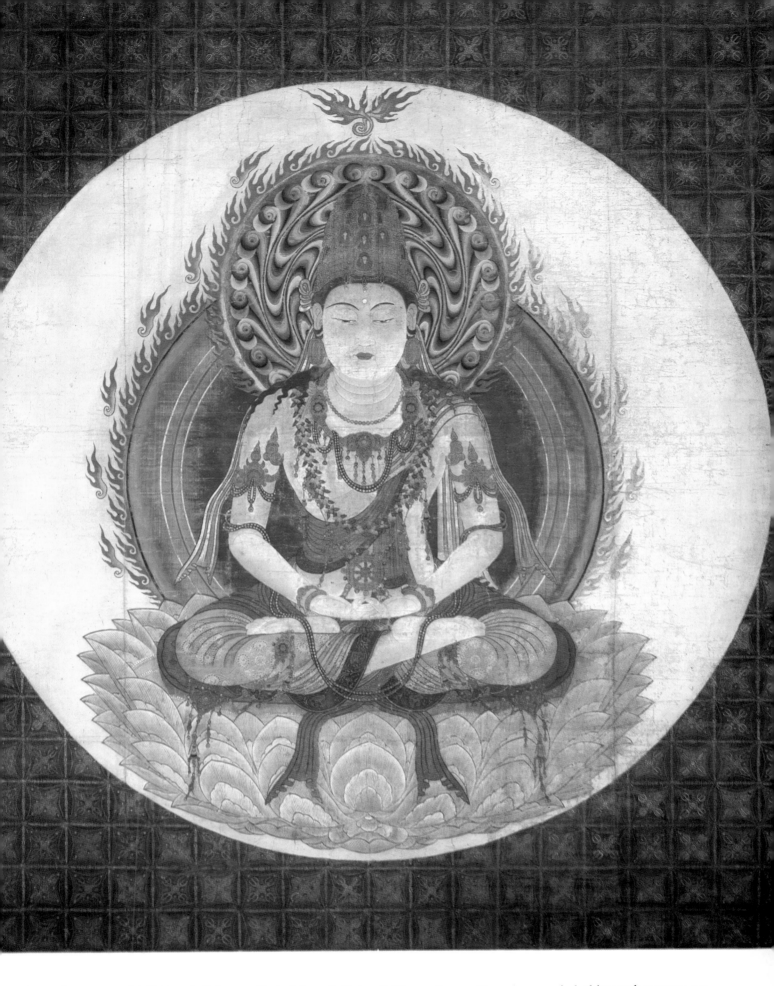

Colorplate 31. *Dainichi Nyorai*. Color on silk, height 37″. Daigo-ji, Kyoto, Japan. Kamakura period, thirteenth century A.D.

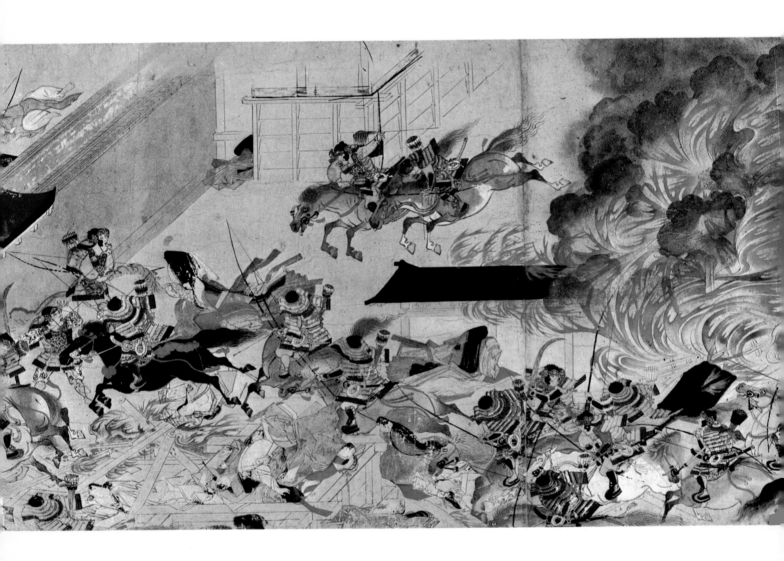

Colorplate 32. *Burning of the Sanjo Palace*. Section of the *Heiji Monogatari* handscroll, ink and color on paper; height 16 3/4″, length 22′9″. Japan. Kamakura period. Museum of Fine Arts, Boston

Colorplate 33. *No mask: Ko-omote*. Painted wood, height about 10″. Japan. Ashikaga period, fifteenth century A.D. Kongo Family Collection, Tokyo

Colorplate 34. (opposite) *River and Mountains in Autumn Color*. By Zhao Boju (A.D. 1120–1182). Section of the handscroll, ink and color on silk; height 22 1/2″, length 10′ 6″. China. Southern Song dynasty. Palace Museum, Beijing

Colorplate 35. *Ladies Preparing Newly Woven Silk*. Attrib. Song emperor Hui Zong (reigned A.D. 1101–26), but probably by court academician, after lost painting by Zhang Xuan (act. A.D. 713–741). Section of the handscroll, color on silk; height 14 1/2″, length 57 1/4″. China. Northern Song dynasty. Museum of Fine Arts, Boston

Colorplate 36. (above right) *Covered vase*. Jun porcelaneous stoneware, height 3 3/4″.
(above left) *Flowerpot stand*. Jun porcelaneous stoneware, diameter 9 1/4″.
(right) *Dish*. Ru porcelaneous stoneware, diameter 5″. All: China. Northern Song dynasty. Cleveland Museum of Art

"retired," emperors, of whom there were usually two or more at once, divided lucrative estates and the weight of imperial prestige, which could be used to considerable political effect. The governing power rested first with the Hojo regents, who had stepped into the power vacuum created by Yoritomo's death, then became increasingly dispersed and vitiated as the Hojo family lost control and rival warlords and imperial lines jockeyed for supremacy. Society as a whole had been divided for a century before, ever since Yoritomo in 1185 moved the military and governing center to Kamakura, leaving the civilian and artistic center in Kyoto. The split in the Kamakura period between the Active and the Aesthetic Life, like the split in the Japanese personality between warrior-administrator and aesthete, may be attributed to the division of leadership between Kamakura and Kyoto. Certainly fusion between aesthetic and practical leadership, between the Active, Contemplative, and Aesthetic Life, began to occur only after the return of the center of government to Kyoto in 1333.

The contributions of the Kamakura period can be summarized by an examination of landscape painting. Throughout most of the twelfth century, landscape was an adjunct to the representation of deity or aristocratic narrative. With the thirteenth century, interest in portraiture and character was not confined to the individual, but extended to the topography of shrine or temple areas. Thus the mandalas, or diagrams, of Shinto and Buddhist enclosures began to show more of the landscape, more directly observed and faithfully rendered. The *Kumano Mandala* is a representation of three Shinto shrines in the mountains south of Nara, separated by a good many miles but drawn together in the painting for iconic purposes, allowing believers to travel easily, if only visually, to these great pilgrimage shrines (*fig. 454*). The Buddhist deities inside circular *mandorlas* hovering over the Shinto shrines exemplify the Buddhist-dominated religious syncretism developed in late Fujiwara and Kamakura times. But the portraiture of the Japanese landscape—gently rolling hills, flowering trees, all the "loveliness" of nature—is especially developed in the late twelfth and thirteenth centuries. The hills and valleys of Nara, or the waterfall of Nachi, were portrayed in a style rich in color and vigorous in detail. Above all it was specifically Japanese landscape, a loving rendering of the local scene,

455. *Nachi Waterfall.* Hanging scroll, ink and color on silk; height 63″. Japan. Late Kamakura period. Nezu Institute of Fine Arts, Tokyo

456. (left) *Saigyo Monogatari*.
Section of the handscroll,
ink on paper; height
12 1/4", length approx. 38'.
Japan. Kamakura period.
Tokugawa Art Museum,
Nagoya

457. (below) *Ippen Shonin Gyojo
Eden*. By Priest En-i. Dated
by inscription to A.D. 1299.
Section of the handscroll,
ink and color on silk;
height 15", length approx.
30'-38'. Kankiko-ji, Kyoto,
Japan. Kamakura period

despite the fact that these mandalas, this *Nachi Waterfall* (*fig. 455*), were primarily religious pictures, sacred diagrams of a holy place and symbols of the deity residing there. The narrative scrolls include scenes of pure landscape, the hills of Shigisan, the forests of Mie, or the coastal beaches of Sumiyoshi (*fig. 456*). But, again, these are scenes that adorn the narrative in the best and truest sense of the word. In the year 1299 we can sense a new spirit in the *Ippen Shonin Gyojo Eden*, a narrative scroll in the best Kamakura tradition, with scenes of local Japan, including Enoshima and Fujiyama, but also with landscapes of a careful and subtle spaciousness that strongly suggest the painting of Song China (*fig. 457*). This influence grows quickly with the influx of Chan priests and paintings, and soon after the Kamakura period we find monochrome landscape in the Chinese style. From this to the many Japanese monochrome landscapes, Chinese-inspired in style and subject, associated with the tea ceremony but unrelated to the landscape of Japan, is but a natural step. The surviving school of local landscape, in narrative scrolls or on panels, falls into the decorative mode.

Landscape painting has thus split in these two directions—native and Chinese-inspired—the Kamakura shrine and temple mandalas being the first great school of Japanese landscape painting. These landscapes, the sculptures of secondary deities, the portraits, the military arts, and the narrative scrolls are the distinctive and significant contributions of the Kamakura period to Japanese and world art.

Chinese Painting and Ceramics of the Song Dynasty

PAINTING

Strangely enough, conditions of political and military decline and contraction during the Song dynasty in China proved particularly appropriate for the development of painting. A uniquely deliberate and consistent civilian and pacifist emphasis in government, combined with perennial "barbarian" pressures along the steppe frontier, eventually brought about the contraction of the dynasty into south China before the onslaught of the Jin Tartars in A.D. 1127, and its final demise at the hands of the Mongols in A.D. 1279. For parallels, one can think of Florence in the *quattrocento,* already declining from its great period of commercial enterprise in the fourteenth century; one can think of Holland in its golden age of art in the early seventeenth century, its economic ascendancy already beginning to wane with the waxing of English sea power; the glories of eighteenth century Venice were products of a refined but decaying social order; conditions in France during the Impressionist and Post-Impressionist periods come to mind as well. Two things are certain: that one of the reasons for a great artistic development is patronage, which implies leisure, and that in the Song dynasty there was abundant patronage and abundant leisure. The result was a unique intellectual and artistic flowering: a period of philosophic reformulation and synthesis embodied in Neo-Confucianism and a period of artistic glory in which painting and ceramics reached perhaps unequaled heights. The Song dynasty produced the first really important academy of painting in East Asia. Other academies were to follow, but the one formed by the painter-emperor Hui Zong was the prototype and perhaps the only aesthetically effective academy in East Asia.

Problems of Painting Scholarship

Problems in the study of Song painting are many. We now have a great many paintings claimed to be of the Song period, and undoubtedly many, though fewer, paintings that actually are of the Song period. But our scholarship has made slow progress, hampered by misconceptions, false starts, and unscientific attitudes. Compared with the number of surviving Ming and Qing paintings, Song paintings are few. Surviving Song literature on painting affords us many names of paintings no longer extant. At the same time the correlation of literary sources with rational judgment, a scientific attitude to the examination of the paintings, and a stylistic analysis of their aesthetic form can bring some order to this chaotic field and allow a reasonable determination of what probably is Song and what probably is not.

We must distinguish first between contemporary and later source material. Song dynasty sources—lists of paintings and descriptions of styles—are most useful. But the later the sources of information, the less reliable they usually are. Nothing more quixotic can be imagined than the usual opinion of a seventeenth or eighteenth century Chinese scholar-critic examining a purportedly early painting.

The kernel of the problem is the question of authenticity. It is misleading to discuss the stylistic

qualities of painting in the thirteenth century while looking at a seventeenth century copy of a fifteenth century copy of a thirteenth century painting; and this is all too often done. The problem is complicated further by the emphasis, in Xie He's sixth canon, on copying the paintings of the past as a means of brush discipline and of acquiring skill in composition. This tradition of copying produced a great many competent paintings of good quality that are copies of now lost earlier paintings. Still, a judicious use of literary sources, scientific analysis of pigment, silk, and seals, and a careful study of the style of Song painting can help us to identify originals. What are the pictorial assumptions of the Song painter? What does he see, in common with others of his time, that a painter of the sixteenth century does not see? Comparison of unimpeachable Song originals with their copies is most useful in answering these questions, and even partial answers can help separate sheep from goats and identify probable Song originals.

Painting Formats

The major formats of Chinese painting were by this time firmly established. Painting of large mural decorations continued, and the three portable formats—the hanging scroll, handscroll, and single sheet—were in full use. These latter three are of primary importance for both the professional and literary painting traditions. The hanging scroll is a painting surface of paper or silk, mounted with paper backing and cloth facing, stored in rolled-up form, and exhibited unrolled and suspended from a peg or portable stick some seven to nine feet above the ground. The hanging scroll is therefore usually vertical in format, although some approach the square and rare ones have a horizontal arrangement.

Handscrolls are also rolled up for storage but, unlike hanging scrolls, are horizontal in shape. The painting surface is likewise paper or silk, and the exterior binding is usually a rich brocade. The scroll is unrolled from right to left, revealing first a brocade border, then the painting, usually preceded by its title, and finally a number of *di ba*, which we would call colophons. These are written either by an owner of the painting or by a person invited to comment on the painting or improvise on its theme or mood at some auspicious time. Some sets of colophons number over thirty, often on a painting a foot or two in length. Handscrolls, however, may be many feet long, occasionally as much as forty feet.

The single sheet format, also on paper or silk and always small, has two subtypes: the square or round album leaf and the oblate circular fan shape.

The hanging scroll and the single sheet are framed in a border (sometimes in multiple borders) of silk. They correspond in general format to Western painting. The handscroll is not used in the West. In addition to these the traditional types of religious wall painting on wood, plaster, or other permanent material continue and ultimately decline.

Painting Theory

Certainly the most rapid development of painting in the Song dynasty occurred early—that is, at the end of the Five Dynasties period and the beginning of Song, when a consummate school of landscape painting arose. Beginning in the tenth century, when landscape (despite a beginning under the Romans) was virtually unknown in the West, the Chinese produced a school of landscape painting of the utmost complexity and subtlety, both in its representation of natural forms and in its organization of these forms in suggested space. This came relatively late in Chinese painting; figure painting developed more rapidly and reached a higher point earlier. Certainly Chinese thought in earlier times was more concerned with human beings than with landscape, and this preference received additional impetus from the importation of figure style from India through Central Asia. But as we have seen, by the end of the Tang dynasty landscape has become a subject in its own right, and under the influence of such men as Wang Wei the first full attempts at landscape art occur, exemplified by the lost Wang Chuan scroll (*fig. 356*). After that, in the tenth and eleventh centuries, development is rapid.

To the Chinese, landscape was not merely a pretty picture or a recorded scene; it held major philosophical implications. The developing Neo-Confucianism of the Song dynasty, a selectively syncretic reformulation of earlier Confucianism, Daoism, and Buddhism, contained an all-embracing philosophy of nature amenable to a school of landscape painting. Confucius in his *Analects* regards nature with a somewhat human bias: "Wise men find pleasure in water, the virtuous find pleasure in mountains"—with the emphasis on the wise and the virtuous men rather than on water and mountains. But the later (probably Han) *Zhong yong* [The conduct of life] states a position greatly to our purpose: "Nature is vast and deep, high, intelligent, infinite, and eternal." This attributes to nature an order or principle (*li*), which is the inherent congruence of each natural thing with what Neo-Confucianism calls the Supreme Ultimate and Daoism calls the Way. The changing, variegated, visible landscape has become a map of the one, unchangeable moral and metaphysical heart of things, and therefore a fit subject for understanding. Painting a landscape, as well as observing one either

real or painted, has become an act of spiritual knowing and regeneration. The great early tenth century landscape painter Jing Hao writes about the appearance of trees with reference to *li* and morality: "Every tree grows according to its natural disposition. Pine trees may grow bent and crooked, but by nature they are never too crooked; they are upright from the beginning. Even as saplings, their soul is not lowly but their form is noble and solitary; indeed, the pine trees of the forest are like the moral character of virtuous men, which is like the breeze." Certainly Song artists were interested in the appearance of nature. For this we have both literary evidence—descriptions of Chinese artists sketching from nature—and the evidence of the paintings themselves, where we find the most beautiful representations of and conventions for natural forms. Additionally, they were interested in the rational and ethical correspondences of nature. Rationality, the manifestation of *li*, is of utmost importance in Northern Song (A.D. 960–1127) painting; with few exceptions, its absence strongly suggests a painting of later date. Next in importance is faithfulness to nature, achieved through brush conventions, and by the early Song dynasty such conventions, satisfactory both as calligraphy and as symbols for natural form, were being developed for the representation of rocks, foliage, bark, water, and so on. The *cun*, or contour strokes by which rocks and mountains were defined, developed during this early period, as well as many other conventions that later became standard.

Song Landscape Styles

Before we study the landscapes, let us briefly outline a framework that has been found useful for the study of Song painting. It is only a convention, but only by such a convention are we able to impose some order on a chaotic mass of material. This schema has real relation to the actual development of the painting of the period, insofar as we are able to determine it. It divides Song painting into five major categories, to be considered in part as progressive. The first is the earliest, and despite its persistence represents an archaic manner; the last is the final development of the Southern Song period (A.D. 1127–1279), although it may have had a few precursors. A painter may work in one, two, or even three styles; but in general he works in two styles that are adjacent in point of development. The names for the styles are descriptive only in a general sense, indicating the flavor of the painting rather than offering a scientific description of its style.

The first, or courtly, style, usually in color, is the continuation of the Tang tradition of narrative and courtly art. The second is the monumental style, primarily of the Northern Song period, and comprising the great early school of landscape painting. The word "monumental" is especially descriptive of these paintings. The third, or literal, style, particularly associated with the Northern Song Academy of the emperor Hui Zong (reigned A.D. 1101–26), is transitional between the courtly and monumental styles and the later styles of the Southern Song period. The fourth, or lyric, style, which is classic for the Southern Song period, abstracts and develops certain elements of the monumental and literal styles to create landscapes that appear romantic, though not in the European sense. The fifth and last is the spontaneous style, which develops logically out of the lyric style but is an extreme and radical expression of certain brushwork tendencies within that style.

The Courtly Style

The first, or courtly, style is seen perhaps at its most characteristic in the handscroll by Zhao Boju, the most famous practitioner of this Tang-influenced style (*colorplate 34, p. 338*). The picture in the National Palace Museum is painted in rather bright malachite green and azurite blue. The composition is crowded and full, with sustained attention to detail. One of the commonest clichés of Western writers on Chinese painting, and one harder to kill than any other, is the characterization of Chinese painting as a great expanse of empty silk or paper with just a few brushstrokes in the corner. Rhapsodies on the contrast of nothingness with something, and myriad other philosophical inferences, follow in the turbulent wake of this misapprehension. Nothing could be less descriptive of the majority of fine Chinese paintings of all periods. Complexity is at least as important as the convention just described. The use of large blank spaces is characteristic of one period, Southern Song; it certainly does not represent Chinese painting as a whole. A composition such as this in the courtly style—complex, rich, varied, and detailed—is much more typically Chinese. Other conservative and traditional painters, too numerous to name, worked in the courtly style. Zhao Boju is, let us say, the type-artist for courtly paintings in this dynasty.

The Monumental Style

The second category, and perhaps the most important, is the monumental style. It certainly begins in the Five Dynasties period, between the fall of Tang and the founding of Song in A.D. 960. The first and, to us, legendary painter in the monumental style is Jing Hao, whose remarks on the nature of trees were

quoted above (*see p. 345*). Unfortunately we have no works that can be considered his. There is, however, an impressive hanging scroll by Wei Xian in the Palace Museum in Beijing, whose tall, stiffly contoured, vertical mountains remotely recall the comblike mountains of Tang and earlier painters (*fig. 458*). What it shows is radically different from the decorated and incidental landscapes of the Tang dynasty: landscape as the subject of the picture. The title, *A Noble Scholar,* may imply human activity, but the subject of the picture is the landscape, and the landscape dominates the whole composition. In general, the monumental style seems best accomplished in the hanging scroll. The verticality allows the development of height particularly appropriate to the rational and monumental aims of the painters who produced some of the greatest masterpieces of Chinese painting.

The second master, Dong Yuan, is perhaps identified by Westerners with an early and beautiful painting in Boston, a handscroll on paper called *A Clear Day in the Valley.* Actually, this painting is probably a product of a Jin dynasty painter of the late twelfth century A.D. There are, however, several paintings that may well be early and close to his manner. One of them is a large scroll in the National Palace Museum, one of the few hanging scrolls with more horizontal development than vertical (*fig. 459*). Ostensibly it represents a festival scene, but the human activities are completely dominated by the landscape. In contrast with the verticality of figure 458 and most other hanging scrolls, Dong Yuan's work was most famous for its development of far space and rolling, resonant mountain shapes. He paints the geography of southern China more often than the dry and barren landscape of the north. In figure 459 the considerable use of color, principally green and blue, recalls to some extent the Tang courtly style. But the deep space, the long vista with the water zigzagging back into the distance between overlapping projecting peninsulas, is quite in the new monumental style. There are still some difficulties with space organization. The planes of the different water areas are not consistent: Foreground, middle ground, and background seem to follow three different plans. This division of the space and the surface organization into self-contained and separate parts is rather characteristic of the monumental style. There is also great rhythmical repetition in the points

458. *A Noble Scholar.* Attrib. Wei Xian (act. A.D. 937–975). Hanging scroll mounted as a handscroll, ink and slight color on silk; height 53″, width 20 3/4″. China. Five Dynasties period. Palace Museum, Beijing

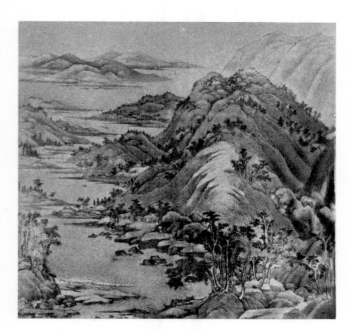

459. *River Festivities of Dwellers in the Capital.* By Dong Yuan (act. late tenth century A.D.). Hanging scroll, ink and color on silk; height 61 1/2". China. Five Dynasties period. National Palace Museum, Taibei

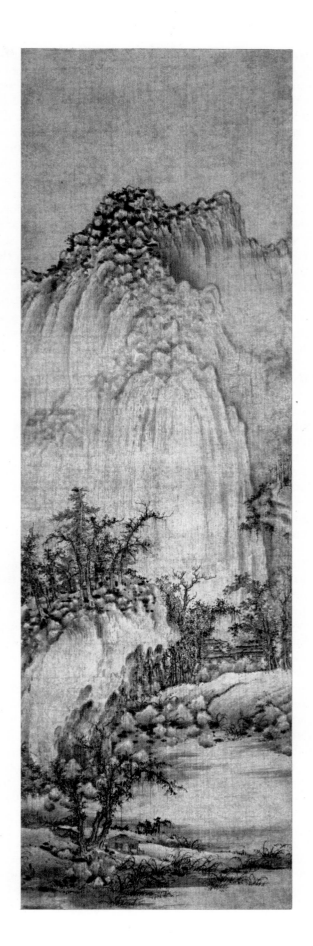

of land, in the forms of trees, and particularly in the folds of mountains; all of these are cunningly rendered to produce an inner rhythm that dominates the whole composition.

In this painting we can also see an increase of realism in landscape. The viewpoint is that of a spectator seated high on a mountain looking out over the mountains in the painting. Added to this realism in the general appearance of things is a growing realism in the handling of details—the differentiation of greater numbers and varieties of trees, and the representation of different types of marsh grasses and other foliage. There is also greater differentiation in the conventional *cun,* those brushstrokes that form the different kinds of wrinkles and so describe types of rock and mountain: soft, hard, crystalline, and others.

Ju-Ran, another great tenth century master, was famous for towering mountain compositions. In the Cleveland Museum of Art is a hanging scroll by him showing a landscape with high mountains (*fig. 460*). In this picture there occurs one device that is used

460. *Buddhist Monastery in Stream and Mountain Landscape.* By Ju-Ran (act. c. A.D. 960–980). Hanging scroll, ink on silk; height 73". China. Northern Song dynasty. Cleveland Museum of Art

again and again in the early vertical formats, that is, the division of the picture into two fundamental units: a foreground unit, which includes everything usually considered foreground and near middle ground; and a background unit, separated from the foreground by a gap where the far middle ground would have been, had it been represented. The foreground is conceived as nearby, and the eye of the spectator travels over the near detail, taking in the sure brushwork in the foliage and the architecture. But then comes a subtle break between the foreground and the area behind, which is treated as if it were a backdrop suspended and fitted into a slot behind the foreground. This device adds to the towering quality of the mountains, as they rise precipitously behind the foreground unit. The large, wet brush spots provide almost musical accents and may well be the first appearance of this technique, so important in the unique style of Mi Fei, an artist of the late eleventh century A.D.

We must never forget, despite these aesthetic devices, despite some conventions in the representation of space, such as the tilting of the foreground and the flattening of the background, that one of the things uppermost in the Chinese landscape painter's mind at this time was the question of representation and especially of achieving a believable path through the painting. The Chinese write constantly about landscape painting that it shows country good to walk in; we read in the colophons that one travels through the painting, that here we see so and so, and there is such and such, over there a wine shop, and that we cross a ford and reach a certain place. We must remember that the hanging scroll, though rather like a framed picture, does have a path that one follows through space and time. This path for the viewer becomes notably important in the handscroll. One of the tests of authenticity for a Song painting is the believability of the landscape as a place to walk in. One must not suddenly climb a rock and find nothing behind it; one does not arrive at a wine shop and find the wall falling over. The Song painter is intensely interested in logical detail. Each part is a separate part, but each part fits into the whole and the whole is the sum of the parts with nothing left over.

Perhaps the greatest single example of the monumental style is the hanging scroll on silk in the National Palace Museum, attributed to the tenth century master Fan Kuan (act. c. A.D. 990–1030; *fig. 461*). All that has been said about figure 460 certainly applies to this painting. Here rocks in the foreground create a visual barrier so that the spectator's eye is not suddenly pulled into the landscape. There is tremendous complexity in the forest on the cliff, with its small temples nestled among the trees.

Sharp brushwork clearly differentiates all the various deciduous and coniferous tree forms. The rocks are typical Fan Kuan rocks, slightly more crystalline than, for example, the smooth-flowing rocks of Dong Yuan or the peculiar tabletop rocks characteristic of Ju-Ran. The backdrop is a magnificent towering peak topped with patches of low bush. A single cascade of water falls at the right of the picture, balanced by the cleft in the small mountain at the left. It is one of the simplest compositions of Chinese

461. *Travelers amid Mountains and Streams.* By Fan Kuan (act. c. A.D. 990–1030). Hanging scroll, ink on silk; height 81 1/4". China. Northern Song dynasty. National Palace Museum, Taibei

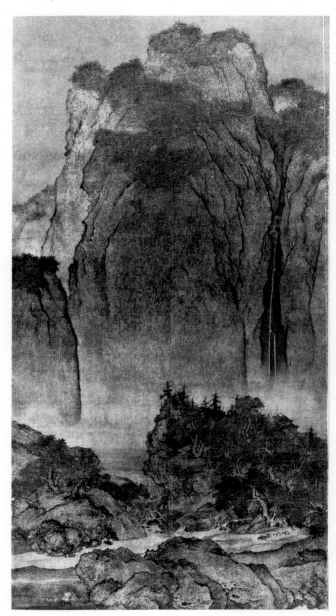

landscape painting, and it is overpowering. The immensity and the manifest greatness of nature are rationally expressed here, without resort to clichés of empty space. The vastness of nature is observed and realized in complex detail and careful organization. In this respect it bears comparison with any of the great complex landscapes of Western art.

We are fortunate in having available for comparison both a copy and the presumed original of this painting. Remember several things about the Fan

462. *Travelers amid Mountains and Streams*. Copy of Fan Kuan scroll from an album attributed to Wang Hui (A.D. 1632–1717). Hanging scroll, ink on silk; height approx. 24″. China. Ming dynasty. National Palace Museum, Taibei

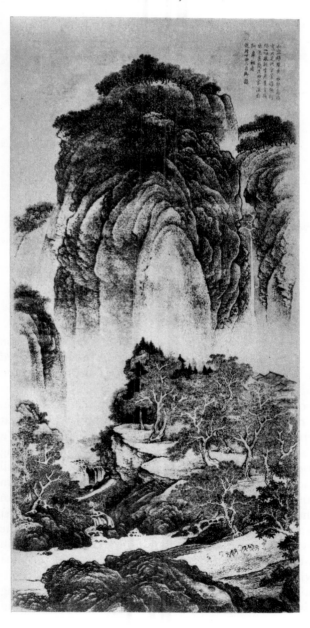

Kuan: the natural appearance of the slope; the sharp differentiation of little things, such as the clear silhouette against a light background of the mule team and caravan going down to the ford; the sharp definition of the waterfall against the background by light and dark pattern; and the separation of the background massif from the foreground forest and ford. With these in mind, let us turn to a copy probably made in the seventeenth century, a copy that the Qian Long emperor and his curators accepted as the original Fan Kuan, at the same time that they owned the other painting, which they evidently did not consider to be authentic (*fig. 462*). There is great satisfaction in this, for it tends to confirm that the usual Chinese critic of the seventeenth or eighteenth century, being unscientific and subjective, could not help preferring the work closer to his own way of thinking over that of the Northern Song painter. Notice how much nearer everything seems; the spectator is physically and psychologically more involved in this landscape than in the other, which appears to be more remote. Note how the waterfall has lost contrast and become hardly noticeable. Note how the lines of the mountain bases are pulled down and become involved with the foreground. Visually, the copy is more textured, more unified, and less realistic than the work of the Northern Song period. It can be shown to be seventeenth century by comparison with dated seventeenth century pictures, which used the same textural and visual devices. The authentic work, on the other hand, emphasizes rationality, separation of parts, and realism. Comparisons like this improve our ability to distinguish original from copy.

Another great figure in the development of the monumental landscape style was Li Cheng, the master of Guo Xi. He was most famous for his representations of gnarled, twisted trees and of distant vistas of the barren north. A hanging scroll in the Nelson Gallery–Atkins Museum depicts his style and is the most aesthetically rewarding picture to which his name is attached (*fig. 463*). The treatment of the mountains and trees is complex, but each individual tree and bush partakes of that twisted and gnarled character traditionally associated with the artist. The architecture is rational and clear and demonstrates the logic we should expect from an early Song landscapist. It is interesting that this painting and figure 460, attributed to Ju-Ran—one northern, the other southern—were both in the Northern Song Imperial Bureau Collection.

Li Cheng's unmistakable style was carried on by his most famous pupil, Guo Xi, one of the greatest of all Northern Song landscape painters (c. A.D. 1020–c. 1090). In *Early Spring*, the most important picture attributed to Guo, one can see the derivation

of some elements of the style from a painter such as Li Cheng: the gnarled trees, the topography of the dry and barren northern country (*fig. 464*). But Guo Xi informed his work with a distinctive rhythmical quality and complexity that was the envy of his contemporaries. He was acclaimed the very greatest artist of his day and a rival of the giants of the past, and this for a Chinese is the highest possible praise.

464. *Early Spring.* By Guo Xi (c. A.D. 1020–c. 1090). Dated to A.D. 1072. Hanging scroll, ink and slight color on silk; height 62 1/4″. China. Northern Song dynasty. National Palace Museum, Taibei

463. *A Solitary Temple amid Clearing Peaks.* Attrib. Li Cheng (d. A.D. 967). Hanging scroll, ink and slight color on silk; height 3′ 8″. China. Five Dynasties period–Northern Song dynasty. Nelson Gallery–Atkins Museum, Kansas City. Nelson Fund

One is conscious of a strongly rational construction in *Early Spring* despite the baroque impression created by the abnormalities of tree formations and twisted rocks. The picture is organized on a grid, with forms growing out from either side of a vertical midline in a regular and rhythmical order. Again we see that separation of near and far which appears almost a mannerism in these early paintings. The dividing line runs from the valley up and around the near hill and then on through and past the distant mountain range on the far right. The separation leaves an unexplained area between the end of the nearest peak and the lowest point of the beginning of the highest peak. The explanation can be found in nature: The Chinese painter had looked at the mist swirling about the mountains and used it in his painting. In the monumental style of Northern Song mist became a device to solve the problem of relating

near, middle, and far ground. The full solution, without the aid of mist, was found probably in the fourteenth century and from that time was handled with great skill by the Chinese painter. So from the standpoint of the conquest of visual space, the monumental style is, in a sense, archaic. It is of interest that the paintings we consider to be of the Northern Song period usually allow the silk to represent mist, in contrast with later paintings, in which there is a tendency to make the mist appear palpable. The treatment of mist by the Northern Song painter is far more abstract. On the other hand, there is much of convincing reality in the Guo Xi, notably in the vista up the valley to the left, depicting the almost tundra-like country of north China, reaching past dry washes of loess soil to the distant mountain ranges. No representational elements have been lost; the differentiation of pine and of gnarled and twisted deciduous trees is clear; the architecture is believable and strongly drawn. Another of the hallmarks of Northern Song landscape painting is its rational handling of architecture, from the standpoint both of construction and of placement in space. This is a radically different picture from the relatively simple composition of Fan Kuan, but both are encompassed within the monumental style.

With the end of the eleventh and the beginning of the twelfth century a new intimacy enters the painters' approach to nature. We find this particularly in the work associated with one artist, Zhao Lingran, where near views and views of relatively low and nearby horizons replace the monumental format (*fig. 465*). These small, charming, and intimate views of idyllic, nearby, and understandable nature seem a part of the new atmosphere of the Academy of the emperor Hui Zong and of the accompanying literal style. In a sense, this innovation of Zhao Lingran, the low horizon and the near view, can be described as part of that style, since it tends to be a more visually realistic depiction of nature than the great, noble, and remote compositions of the preceding two centuries. Figure 465 is one of two or three leaves probably by or close to Zhao Lingran. He was a much admired master, much copied in later days.

At this point it seems appropriate to show the handscroll *Streams and Mountains Without End,* because it is a somewhat eclectic picture, painted about A.D. 1100, and recapitulates much of the previous development (*fig. 466*). It begins with a small, low, intimate landscape in the then up-to-date and fashionable style of Zhao Lingran, goes on to a

465. *River Landscape in Mist with Geese and Flocking Crows.* By Zhao Lingran (act. c. A.D. 1070–1100). Album leaf, ink on silk; height 9 1/2". China. Northern Song dynasty. Yamato Bunka-kan, Nara

466. *Streams and Mountains Without End.* Handscroll, ink and slight color on silk; height 13 3/4″, length 83 7/8″. China. Northern Song dynasty. Cleveland Museum of Art

mountain-encircled space recalling *Wang Chuan Villa,* then proceeds to a style of painting rather like Dong Yuan's, rolling and resonant in its form, followed by a crystalline style based upon another Northern Song master, Yan Wengui, then moves to a climactic mountain unit painted very much in the towering style of Fan Kuan, and finally ends with a forest and distant mountain area, perhaps close in style to Guo Xi.

The painting is also of great interest because of its format and its organization within that format. The handscroll, being unrolled from right to left, not only allows development of pictorial structure within a frame formed by the beginning and end of the painting but also demands organization in time and space. In a way it is the ancestor of the motion picture; one can vary the frame by rolling either end, or both, thus creating innumerable small pictures at will. At the same time, in moving along the composition from right to left, viewing a few feet at a time, one passes in time through a landscape, something not possible in the hanging scroll or album painting. In some paintings this passage through time and space can be quite long, though in *Streams and Mountains Without End* one traverses a distance of only seven feet.

This temporal character permits an almost musical quality to the aesthetic and representational organization of the painting. Sequence and spacing can be used to create "movements," as in music. *Streams and Mountains Without End,* for example, begins with a gentle, quiet theme, then gradually shifts to a first climactic theme of mountain peaks and village. This

alters to a strong and rolling but quieter passage, ending in a second climactic variation of the mountain theme, which recalls the recent past and hints at things to come. Here a new, staccato motif begins, of vertical mountains with an almost crystalline structure. This ends, and a rocky variation prepares us for the final great climactic mountain theme. This is the largest unit in the picture, and the emphatic ink tones produced by the overlapping planes of the craggy style accent it further. Finally, the scroll ends with a variation on the quiet opening passage, incorporating mountain elements that have occurred throughout most of the picture. This coda, though not dramatically as powerful as some earlier passages, summarizes the whole.

The representational organization is fully as important as the aesthetic one; from the Chinese point of view, of prime importance. Thus one begins on a path and moves through the village, down and across a ford, up and past a wine shop, then over a bridge to another road that leads past a mountain temple to another ford, back up into the mountains, and then around and down past the foot of the great craggy peak to another ford, where a ferryman waits to escort the traveler across the stretch of marsh and water into the distant reaches at the end of the scroll. Faint, pale washes of green or of red in certain areas lend coolness or warmth to the rich, cool black ink.

Except in the one climactic mountain, *Streams and Mountains Without End* lacks the monumentality of the great hanging scrolls and even of other extant handscroll fragments. The Northern Song format par

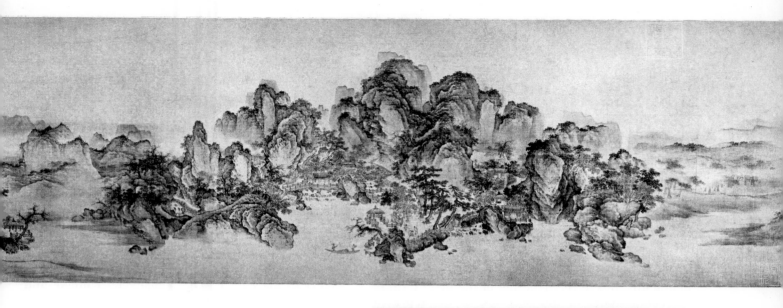

excellence for expressing monumentality was the hanging scroll; the horizontality and extension of the handscroll represented a new challenge, which in pictures of the eleventh and early twelfth centuries, such as *Streams and Mountains Without End,* is only beginning to be met.

There is a maverick aspect of middle Song painting that involves a technique of brushwork probably derived from Ju-Ran. This is the Mi style, named after the great painter-critic Mi Fei (A.D. 1051–1107) and his son Mi Youren (A.D. 1072–1151). Some art historians deny that Mi Fei was a painter at all and call him simply a collector and critic. But a certain style of brushwork, in which forms are built up out of massed horizontal dots or dashes of ink, has always been associated with the name of Mi Fei. Used in the vertical hanging scroll format, the style could be very imposing, as in figure 467, probably a slightly later version of a painting in the style of Mi Fei. There is also a short handscroll by the son, dated to A.D. 1130 (*fig. 468*) and painted perhaps a generation after *Streams and Mountains Without End.* In this work we find the Mi style with traces of opaque color, almost an archaistic revival of Tang coloring. The Mi Fei style was particularly appropriate for represent-

467. *Grassy Hills and Leafy Trees in Mist.* Style of Mi Fei (A.D. 1051–1107). Hanging scroll, ink on silk; height 60″. China. Late Song or Yuan dynasty. Freer Gallery of Art, Smithsonian Institution, Washington, D.C.

468. *Cloudy Mountains*. Mi Youren (A.D. 1072–1151). Dated to A.D. 1130. Handscroll, ink and slight color on silk; height 17 1/8″, length 76″. China. Southern Song dynasty. Cleveland Museum of Art

ing the topography of south China, such as the low, wet hills of Fujian Province. The picture has suffered a great deal; there is some repaint in parts of the mountains. But in the handling of the main form of the composition, of the overlaps, of the repeated rolling rhythms of these low-lying hills, and of the twisting mist with its archaic, trefoil plumes in Tang style, we have a successful portrait of the southern coastal region of China.

The Mi style, which became a favorite of amateur scholar-painters, was abundantly used. There is no easier method by which to obtain a semblance of a landscape; there is no more difficult method by which to achieve a great painting. A few painters of the fourteenth century were masters of the style, as were a few individualists in the seventeenth

century. This relationship between the Mi style and the "literary painting" (*wen ren hua*) invented in the Yuan dynasty was dear to the hearts of later writers, and a strong case has been made by Chinese and Westerners alike that certain Song masters were spiritual and aesthetic ancestors of the "gentleman-scholars" (*wen ren*). In this view artists who were basically nonprofessional—Mi Fei, Mi Youren, Zhao Lingran, the bamboo specialist Wen Tong, even Li Longmian—qualify as scholar-amateurs, artists more similar in intention to the later *wen ren* painters than to their Song contemporaries. To judge by the visual evidence, this may be so only to an extremely limited degree. One needs only to compare figures 465, 468, 469, and 478 with figures 548, 550, 554, and 556 to sense the similarities and the greater differences.

The Literal Style

The literal style is associated particularly with the Academy of the emperor Hui Zong, but Li Longmian, who lived from A.D. 1049 to 1106, painted in what can well be described as a literal mode, at the same time that most of his pictures seem to be derived from Tang narrative or figure composition. The picture that, more than any other, shows Li Longmian's realistic linear style is a scroll reported destroyed during World War II. It is reproduced from a prewar photograph in figure 469. The handscroll depicts five horses with their five grooms, rendered mostly in ink line with some modeling and an occasional touch of color. It follows the tradition of Tang horse painting, such as that of Han Gan, but shows greater analysis of equine anatomy and a knack of catching the individuality and racial character of the grooms. Other works attributed to Li Longmian reveal similar close observation of nature and of everyday life.

The greatest exponent of the literal mode and founder of the Academy that practiced it was Hui Zong, last emperor but one of Northern Song, who

469. *Five Tribute Horses*. Attrib. Li Gonglin (Longmian; c. A.D. 1049–1106). Section of a handscroll, ink on silk; height 11″. China. Northern Song dynasty. Formerly Kikuchi Collection, Tokyo

was carted off to fatal captivity by the invading Jin Tartars in A.D. 1127. He was a painter of some skill, but far more important for his patronage of the Academy and his taste in collecting. Simply as a technical performance, the brightly colored copy of a famous Tang painting of court ladies preparing silk, by Zhang Xuan, shows the great knowledge of the ancient style and the skill in copying required of Song court artists (*colorplate 35, p. 339*). But the emperor's primary interest was in the academicians' representation of what the Chinese call "fur and feathers," the literal depiction of animals or birds, often in conjunction with flowering tree branches, which is the hallmark of the literal style (*fig. 470*). The desire for realism is such that the birds' eyes are sometimes indicated with lacquer in slight relief, creating an appropriately bright and beady look. Shapes, colors, and textures, and their translation into brushwork, are carefully examined and analyzed. The feathery texture of the parakeet in figure 470 is wonderfully contrasted with the satiny texture of the apricot blossoms and the rough texture of the bark. The emperor's calligraphic style is distinctive; his encomium on the right, partly visible, is written in his long, spidery hand, much copied but very difficult to imitate. The style that he encouraged may well derive from details found in Tang paintings of the courtly style. Such details, enlarged to almost larger-than-life size and set against the abstract ground of the silk in order to concentrate the

spectator's eye on the object in all its complexity and reality, are essential characteristics of the literal style.

The literary background of the style is to be found in the subjects set for Academy painting competitions. Judging from the examples described, the painter who offered the most literal interpretations usually took the palm. The most famous and often quoted contest subject was a poem whose title translates, "The Hunters Return from the Flower Fields." The winning picture showed horses going through a field with butterflies fluttering about their heels. This naive, literal attitude is typical of the Academy. The attention of the artist was directed very specifically at the object being painted, and many marvelous small-scale paintings—usually album leaves of birds, animals, fruit, and flowers—are products of this Northern Song Academy.

The Lyric Style

With the fall of Kaifeng and the triumph of the Tartars in A.D. 1127, the court fled south, taking with them what they could of the great imperial collections. For the next century and a half of their existence at the southern capital of Hangzhou, leisure and the life of the senses were more important than the political and military well-being of what was left of the empire. It was in the south that the lyric style evolved, and a very important figure in this transi-

470. *Five-colored Parakeet on the Branch of a Blossoming Apricot Tree.* Bearing the signature of Hui Zong, emperor of the Northern Song dynasty, and a poem in his hand, but probably by a court academician. Handscroll, color on silk; height 20 7/8", length 48 1/4". Museum of Fine Arts, Boston

355

471. *Mountain Landscape with a Winding Stream and Knotty Old Trees.* By Li Tang (c. A.D. 1050–c. 1130). One of a pair of hanging scrolls, ink on silk; height 38 1/2". China. Song dynasty. Koto-in of Daitoku-ji, Kyoto

472. *Mountain Landscape with Two Men Looking at a Steep Waterfall.* By Li Tang (c. A.D. 1050–c. 1130). One of a pair of hanging scrolls, ink on silk; height 38 1/2". China. Song dynasty. Koto-in of Daitoku-ji, Kyoto

tion between Northern and Southern Song style was the painter Li Tang. For the rediscovery of Li Tang's work and of his importance we are in part indebted to that most mundane of all things, Western science. Very few of Li Tang's works were known until shortly after World War II, when the Japanese examined by infrared photography two paintings, kept in a Zen monastery in Kyoto, that had always passed under a traditional and obviously false attribution to the great Wu Daozi (*figs. 471, 472*). The signature of Li Tang was found hidden in the trees in the center of one of the two pictures, after having escaped notice for some seven hundred years.

It seems only logical to suppose that these are authentic works by Li Tang; and these, with a very few paintings in the National Palace Museum in Taibei, make many things fall into place without the help of seals or literary sources. These pictures retain strong traces of the monumental style in their vertical format with soaring cliffs and peaks. But there has been a very significant change. The compositions seem cut off at the top, which could have occurred if these paintings are in fact fragments of original screen paintings now converted to hanging scrolls. But in addition the disposition of the elements is not rational or self-contained. There are traces, particu-

larly in the general type of the composition, in the convolutions of the trees, and in the simplified treatment of the rocks, of a more direct and intuitive attitude than hitherto. The most significant change is the cropping of the view so that it becomes, in a sense, a detail of one of the older monumental compositions. This fragmentation of nature is to reach its zenith after the development of the lyric style, in the Chan masterpieces of the spontaneous style. Li Tang was a master painter, and the strength of his brushwork, particularly in the great "ax-cut" rocks of the lower left foregrounds, holds its own with that of any of the great names of the past.

The transition was made by artists like Li Tang, who served both Northern and Southern courts.

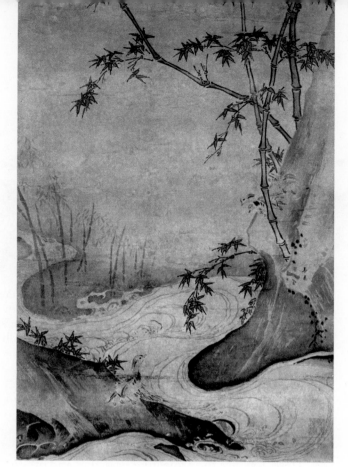

474. *Bamboo and Ducks by a Rushing Stream.* By Ma Yuan (act. c. A.D. 1190–c. 1225). Hanging scroll, ink and slight color on silk; height 24″, width 14 1/2″. China. Southern Song dynasty. Cleveland Museum of Art

473. *Landscape in Rain.* By Ma Yuan (act. c. A.D. 1190– c. 1225). Hanging scroll, ink on silk; height 43 3/4″. China. Southern Song dynasty. Seikado Foundation, Tokyo

The development and the culmination of the lyric style were accomplished by two artists whose names are perhaps the best known to Westerners with any acquaintance with Chinese painting: Ma Yuan and Xia Gui. In Chinese opinion, where aesthetics and morality tend to be closely commingled, they are ranked less high than in the West, particularly during the sixteenth to eighteenth centuries. In part this is because they were important painters at a time when the dynasty was politically and morally weak. A sixteenth century critic, in speaking of Ma Yuan and Xia Gui, said: "What have I to do with the tail ends of mountains and truncated streams, the products of ignoble refugees?" (translated by A. Waley). This was hardly an objective aesthetic judgment. Furthermore, to the later Chinese painting tradition, the lyric style was unorthodox.

A vertical composition in traditional hanging scroll format recalls something of the monumental style and of Li Tang, but with a telling difference (*fig. 473*). Two fragile pine trees with fantastically elongated and twisted branches, which would in the earlier style have been a detail of the composition, here project dramatically into space, their prominence exemplifying the painter's new approach. More

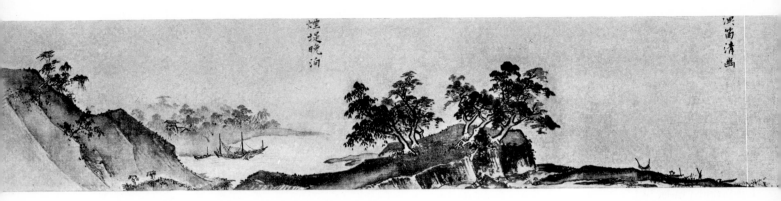

475. *Flying Geese over Distant Mountains, Returning to the Village in Mist from the Ferry, The Clear and Sonorous Air of the Fisherman's Flute,* and *Boats Moored at Night in a Misty Bay;* from *Twelve Views from a Thatched Hut.* By Xia Gui (c. A.D. 1180–1230). Section of a handscroll, ink on silk; height 11", length 91 1/4". China. Southern Song dynasty. Nelson Gallery–Atkins Museum, Kansas City. Nelson Fund

characteristic of Ma's developed style is the picture of ducks and bamboo beside a stream (*fig. 474*). The Chinese writers called him "one-corner Ma," and with reason. Here is a painting where one can speak of the asymmetric balance, or rather tensions, of space against form, mystery against sharp explicitness. Here, too, are the projecting branches and other elements so important in the Zhe school of the early Ming dynasty, and to the Japanese painters of the fifteenth century.

There has been, for various reasons, an unjustified disparagement of the lyric style in favor of the *wen ren* styles of late Ming and Qing. First, its enormous popularity in Japan gave rise to so many Japanese copies and even forgeries that the great majority of paintings in the lyric mode are not Song at all, if indeed they are Chinese. Second, the style is much appreciated in Japan, making it incumbent upon the Chinese to dislike it. Third, it was much appreciated many years ago, therefore modern critics must not like it. Nevertheless, lyric paintings of Song China deserve admiration and repay study. Ma Yuan is the most romantic and exaggerated practitioner of the asymmetrical composition that is the hallmark of the school; and he, his father, his son, and his nephew, forming the Ma school, all painted very much in the same style and with the same results, creating a great collective contribution that ranks with the

476. *The Clear and Sonorous Air of the Fisherman's Flute.* Detail of fig. 475

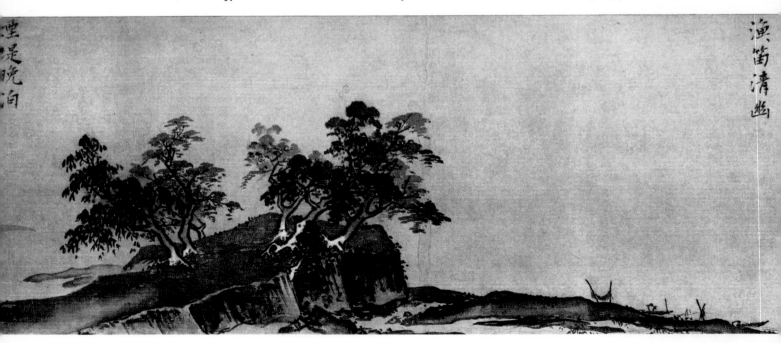

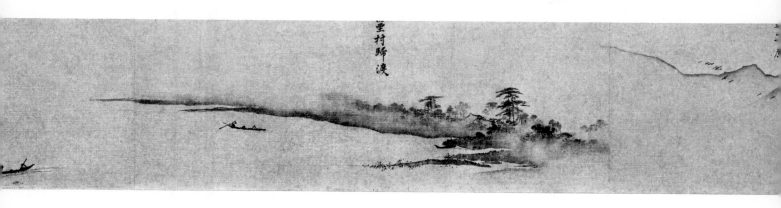

重村歸渡

477. *Clear and Distant Views of Streams and Hills.* By Xia Gui (c. A.D. 1180–1230). Handscroll, ink on silk; height 18 1/4", length 34'. China. Southern Song dynasty. National Palace Museum, Taibei

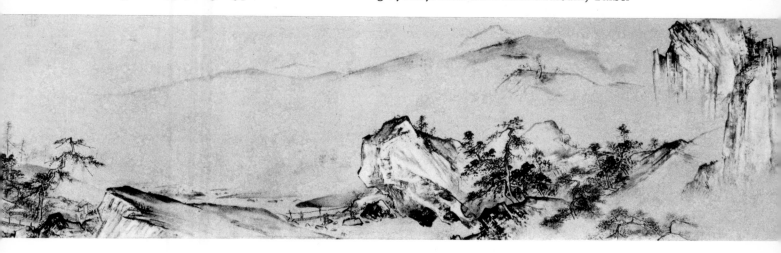

earlier monumental and later spontaneous styles.

The second great master of the lyric style is Xia Gui, active in the first quarter of the thirteenth century, with two distinct styles associated with his name. One of these appears in a fragment of a longer scroll, *Twelve Views from a Thatched Hut,* of which only four views now remain (*fig. 475*). This handscroll is in a way much more sophisticated than any handscroll of the Northern Song period. At the same time it is simpler, with much less control and complexity in organization. The brushwork is completely in ink; there is no color. The forms are much simplified: Tree trunks are indicated by heavy, thick lines that outline them and at the same time seem to model them in the round; rocks and mountainsides are treated as planes indicated by washes, with no great use of *cun.* Types of foliage and textures of tree bark are relatively undifferentiated, the emphasis being upon silhouette and the projection of shapes into areas of blank silk. Distant objects are misty and simplified to an almost abstract, hazy ink pattern, a technique

of some significance in the later development of the spontaneous style. One view from the *Twelve Views from a Thatched Hut* reveals why the "one-corner" epithet was given to the Ma school (*fig. 476*). It also demonstrates that in the hands of a master the convention produces as aesthetically satisfying a result as any of the more complex and rational products of the Northern Song period. Figure 476, with its brusque and rapid representations of forms against water only vaguely indicated with a few ripples, displays the suggestive and asymmetric style of the lyric mode at its most developed and sophisticated best. Xia Gui is also famous for another manner more directly based on Northern Song style and very much respected and admired in China. This is best seen in a long handscroll, *Clear and Distant Views of Streams and Hills,* kept in the National Palace Museum (*fig. 477*). It should not be confused with another and more turbulent scroll of the Yangzi River, also in the National Palace Museum, with greater emphasis upon water,

359

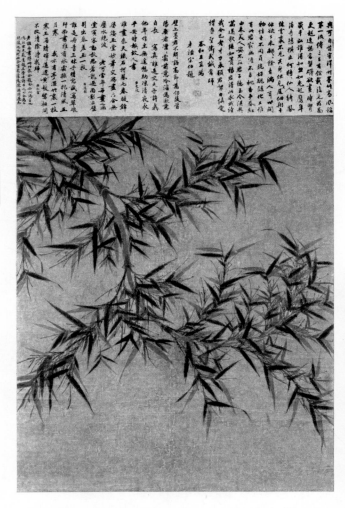

tenth century, had been a preoccupation of the scholar-painter and calligrapher wishing to transfuse the discipline of writing into pictorial form. The second influence was that of the lyric style, particularly in its gradual dissolution of pictorial form and its emphasis upon rapid, calligraphic brushwork, pure monochrome ink, and the importance of the enlarged detail. In figure 478, attributed to the first great master of bamboo painting in Chinese history, Wen Tong (A.D. 1019–1079), brush discipline is evident in the control of each leaf stroke, and compositional mastery in the great S-curve of the main stalk and

478. *Bamboo.* By Wen Tong (A.D. 1019–1079). Hanging scroll, ink on silk; height 52″. China. Northern Song dynasty. National Palace Museum, Taibei

fishing boats, and ferries, which was sent to the London exhibition of 1935. The latter is certainly a Ming copy, if indeed it is a copy of Xia Gui at all. The former painting combines sharp and crystalline brushwork in its representations of mountains and rocks with the same silhouette treatment of tree foliage to be seen in the *Twelve Views from a Thatched Hut.* The *Clear and Distant Views* scroll, some thirty-four feet in length, shows an amazingly complex development through time in the finest handscroll tradition. This picture and others like it were of great importance in the development of early Ming painting and also influenced such Japanese painters as Sesshu, in his long scroll in the Mori Collection.

The Spontaneous Style

The last of the five categories of Song painting, the spontaneous style, is twofold in origin. Its abbreviated techniques were derived from ink painting of bamboo and kindred subjects, which, as early as the

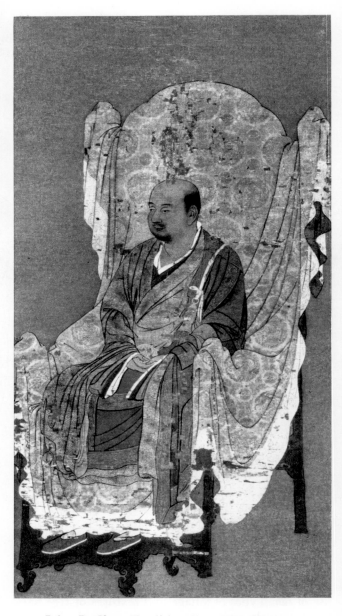

479. *Priest Bu-Kong.* Traditionally attrib. Zhang Sigong. Hanging scroll, ink and color on silk; height 45″. China. Southern Song dynasty. Kozan-ji, Kyoto

the disposition of the almost moving sprays and stems that branch from it.

To the influence of calligraphic discipline and of the lyric style was added the emphasis of Daoism and Chan (Zen) Buddhism on intuitive response to nature. Together these produced the spontaneous style at the end of the Song dynasty, particularly in the monasteries of south China. Chan provided much of the subject matter, just as its monasteries provided many of the retreats for these painters. The prime factor, however, was the gradual shift of the lyric mode toward highly specialized, intuitive, and personal expression. One cannot discount the influence of an early and still little understood attitude of scholar-amateurs to ink painting.

Chan was also interested in individual character. Figure 479 shows the careful, detailed style, derived from Tang portraiture and decorative painting, used by a Southern Song painter to reveal the saintly individuality of Priest Bu-Kong. After all, the original Chinese Chan patriarchs lived in the Tang dynasty, the greatest period of figure painting, and

that conservative style seemed appropriate for the portrait. Such portraits were also a part of other traditions—Daoist sages, powerful rulers, noble officials were depicted in similar styles but with different iconographies. The wildly different spontaneous style was used for metaphoric subjects—landscape, still life, visual *koans;* and it was used by Daoist, Confucian, and Chan artists alike. The larger number of extant Chan portraits is undoubtedly due to the Chan teachers' custom of providing pupils with a "souvenir portrait" at the time of their parting.

The monk Mu-Qi, better known in China as Fa-Chang, was one of the two greatest exponents of the spontaneous style. His triptych in the Zen monastery of Daitoku-ji in Kyoto, painted in ink and very slight color on silk, shows the lyric mode executed with such rapidity and abbreviation of brushwork and such boldness of composition that the result is, in effect, a new style (*fig. 480*). The pine branches and monkeys, as well as the bamboo grove behind the crane, reveal an extreme spontaneity in brush

480. *Triptych:* (left) *Crane in a Bamboo Grove;* (center) *White-robed Guanyin;* (right) *Monkey with Her Baby on a Pine Branch.* By Mu-Qi (Fa-Chang; c. early thirteenth century A.D.–after 1279). Hanging scrolls, ink and slight color on silk; height 70″. China. Southern Song dynasty. Daitoku-ji, Kyoto

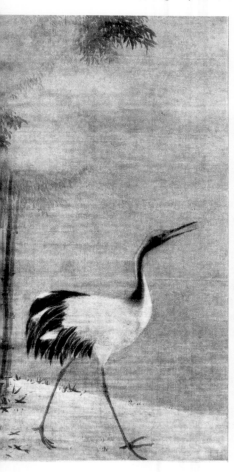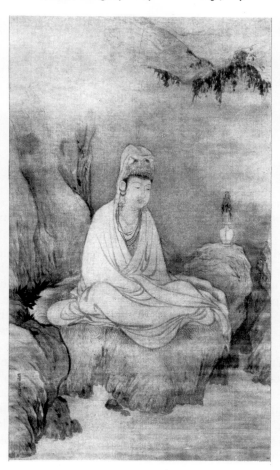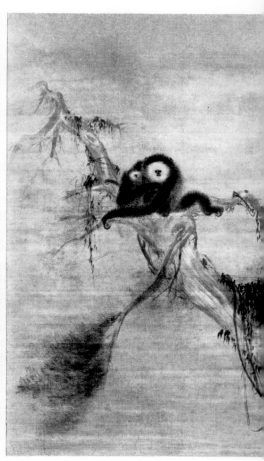

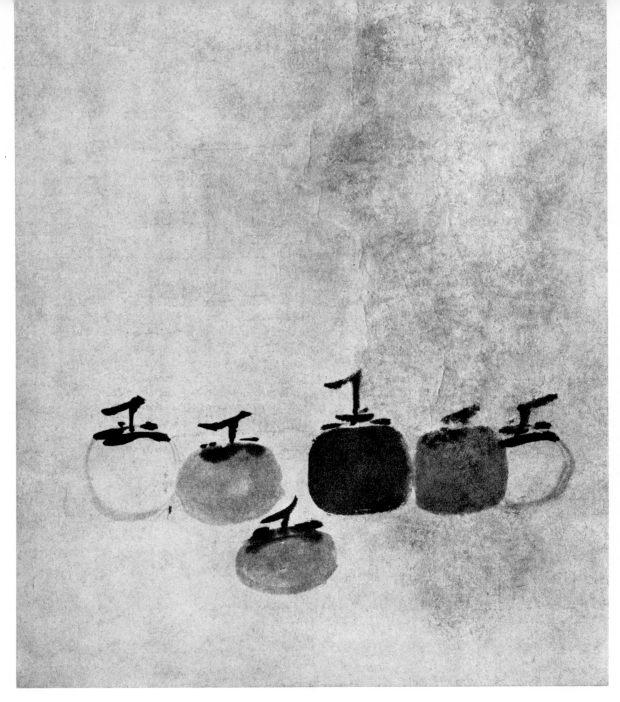

481. *Six Persimmons.* By Mu-Qi (Fa-Chang; c. early thirteenth century A.D.–after 1279).
Ink on paper, width 14 1/4". China. Southern Song dynasty. Daitoku-ji, Kyoto

handling; the crane and white-robed Guanyin are more carefully painted. The overall misty tone is still related to the works of the Ma-Xia school.

Mu-Qi's consummate expression of the spontaneous style is the famous *Six Persimmons,* kept at the same monastery in Kyoto (*fig. 481*). Painted in cool, blue black ink on paper, the *Six Persimmons* has been described by Arthur Waley as "passion . . . congealed into a stupendous calm."[14]

The painting communicates many of the qualities that we associate with Chan Buddhism: It is intuitive, brusque, enigmatic. But one cannot help noting as well the tremendous skill of hand and brush that painted these persimmons. Their subtlety of

modeling is remarkable. The darkest one, painted as an oblate circle, seems the heaviest as well. The long, flowing, thick-and-thin brushstroke that models the lightest of the persimmons makes it seem to float in contrast with the heavy, dark one. Note the subtle placement of these "inanimate" objects: The two at the left overlap slightly, the heavy one in the center has a wide and a narrow margin, the two at the right overlap greatly, the single fruit below the others stands separate from all of them. All of these subtleties and refinements, including the treatment of the stems and leaves as if they were Chinese characters, reveal brush control at its very highest level. The combination of sharpness and vagueness, of great

darkness with extreme lightness, contains extremes unknown even to the lyric mode. They recall the short tests or problems, the *gong-an* (in Japanese, *koan*) of Chan Buddhism:

"Who is he who has no companion among the ten thousand things of the world?" "When you swallow up in one draught all the water in the [Xi River], I will tell you." Another is: "Who is the Buddha?" and the answer, "Three *jin* of flax." Still another example: "What is the meaning of the First Patriarch's visit to China?" with the answer, "The cypress tree in the front courtyard."[15]

The second great master of the spontaneous style was Liang Kai, who, although not a monk, is famous for Buddhist subjects. His extant works show considerable stylistic range. The famous *Sakyamuni Leaving His Mountain Retreat* combines elements of Tang Central Asian figure style with the lyric landscape mode and shows Liang as a disciplined and original painter, but still within the Academy tradition in which he began (*fig. 482*). One of the great expressions of the spontaneous style is his *Hui Neng, the Sixth Chan Patriarch, Chopping Bamboo at the Moment of Enlightenment,* which unites Shakespeare's conviction that much can be learned from a seeming fool with the Chan esteem for roughness and spontaneity and meaningful illogicality (*fig. 483*). The technique is matched to each part of the subject and ranges

482. *Sakyamuni Leaving His Mountain Retreat.* By Liang Kai (b. third quarter of twelfth century A.D., d. probably after 1246). Hanging scroll, ink and slight color on silk; height 46 1/2". China. Southern Song dynasty. Tokyo National Museum

483. *Hui Neng, the Sixth Chan Patriarch, Chopping Bamboo at the Moment of Enlightenment.* By Liang Kai (b. third quarter of twelfth century A.D., d. probably after 1246). Hanging scroll, ink on paper; height 29 1/4". China. Southern Song dynasty. Tokyo National Museum

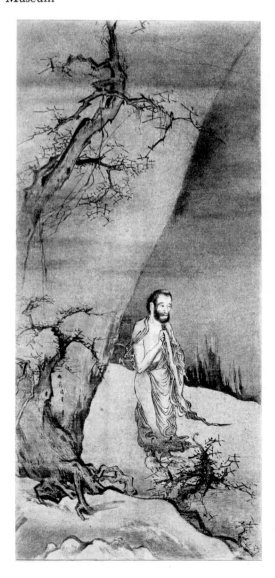

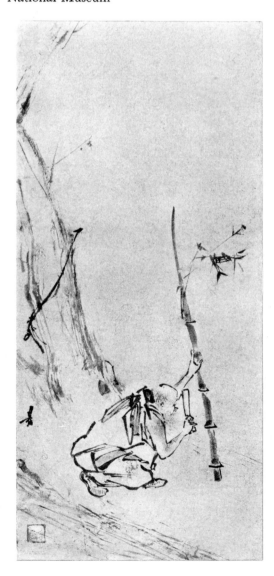

from the most precise use of calligraphic brushwork to indicate the joints and movement of fingers, through long curves indicating the roundness of the arms, to the almost scrubby use of a tremendous ropelike brush for the texture of the tree bark. At the left is the artist's signature, not the neat, carefully written signature of a Li Tang or a Li Anzhong, but a bold, almost illegible, powerfully conceived insignia. Liang Kai and Mu-Qi are the greatest masters of the spontaneous school. Their few extant paintings survive for the most part in Japan; very few Song works in this style remain in China. For the logical development of the spontaneous style in China, we must wait for the works of the seventeenth century individualists.

CERAMICS

Chinese ceramics of the Song dynasty are probably the classic expression of ceramic art not only in China but in all the world. By classic we mean that Song ceramics achieved an unsurpassed integration of shape, glaze, and decoration, and Song potters acquired a superlative command of potting and firing techniques and glaze making. The result was a flawless series of wares that remain the admiration as well as the despair of the modern potter. The shapes of Song dynasty wares are mostly extremely simple. They tend to be subtle and suavely flowing, in contrast to the robustly swelling, sharply demarcated ceramics of the Tang dynasty and earlier. In a Tang vessel, neck, body, and foot are clearly differentiated, but in many Song wares the parts are so smoothly and fluently connected that it is hard to know where the neck commences, the body leaves off, or the foot begins. The glazes of Song ceramics are mostly monochromatic, with rather soft, mat surfaces that appear an integral part of the ceramic form, and with a depth and texture wondrously inviting to the touch. They were created, not by scientific experimentation in the modern sense, but by a skillful and knowledgeable trial-and-error pragmatism. The fortunate inconsistencies and imperfections of technique served to obviate the hard, bright uniformity so characteristic of later Chinese glazes. Shape is the dominant aesthetic element of Song vessels. Except on one type of ware, ornament, where used at all, is spare, chaste, and subdued. The glaze, applied over the carved or incised or molded decoration, serves to mask and subdue it even further. Usually this minimal ornamentation is floral, though figures are known, and always it is arranged to enhance the form of the pot.

There are important general distinctions between northern and southern wares, though recent and con-

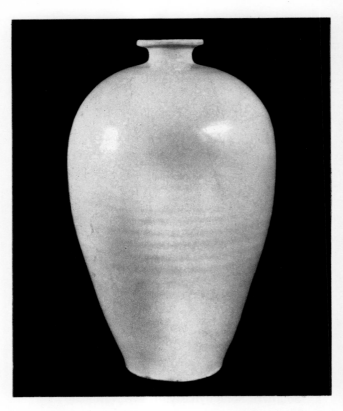

484. *Mei-ping vase*. Ci Zhou stoneware, height approx. 18″. China. Song dynasty. Formerly C. T. Loo Collection, New York

tinuing excavations on the mainland have indicated that these are not absolute or ironclad. Nevertheless, wares from the north generally tend to be white or creamy white both in body and in glaze. White stoneware was pervasive in the north, used by peasant and rich man alike, with certain special wares made for a limited aristocratic consumption. In the south the ubiquitous ware was gray-bodied and glazed either pale blue white or, more often, green, ranging from olive to blue green. The pervasive northern white wares, except for some Ding types, were not fired at a high enough temperature to qualify as porcelain, but most of the celadons, the predominant ware of the south, are porcelain in the Chinese sense. Some of these geographically based distinctions may be attributable to topography and natural resources. Even by Song times the mostly flat north was mostly deforested, and local coal was fast becoming the major fuel. The south, by contrast, is hilly or mountainous, and even today is partly forested. The beehive kiln required by the flat terrain of the north could not often, in its Song stage, reach temperatures high enough to create porcelain. Moreover, coal burns at a lower temperature than wood. But the southern hills lent themselves to dragon kilns, which stretched up the hillsides with their vents at the highest point; in these, the natural draft together with wood as fuel created temperatures high enough to make porcelain production simple—often, indeed,

inevitable. These geographical distinctions do not apply to Imperial wares. The court, whether at Kaifeng in the north or at Hangzhou in the south, commanded sufficient wealth and sufficiently advanced techniques to obtain whatever wares it wished. Thus one can find green wares and black wares in the north, and as many white wares were produced in the south, especially in the Southern Song dynasty. But in general, the distinctions between northern and southern ceramics are valid and help to simplify a complicated picture.

We will consider first the classic northern wares, then those of the south. Both northern and southern wares were made at the same time, but the most refined and aristocratic wares, being made for court use, were produced in the north at the end of the Northern Song dynasty and in the south during the Southern Song dynasty.

Ci Zhou Ware

The everyday, common ware of the north is a slip-decorated stoneware called Ci Zhou, after one of the principal kiln-site towns. A better name would be Ci Zhou type or, more accurate still, northern slip-decorated stoneware, for the varieties of this ware are extremely numerous, and the quality runs from rough and crude to highly refined. The essential elements of the Ci Zhou type are a stoneware body, usually creamy in color, covered with a white slip that was sometimes left plain and sometimes used as the ground for further colored or carved and colored decoration. Figure 484 shows a vase intended to hold plum blossoms (*mei-ping*, plum vase). Its rich, slightly creamy white color is produced by the slip

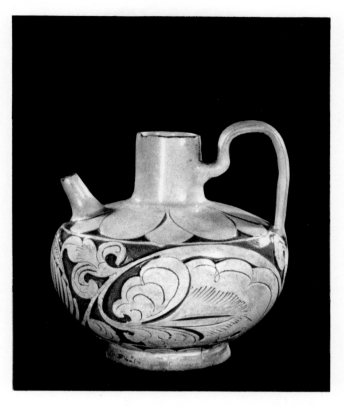

486. *Winepot or teapot.* Ci Zhou stoneware with carved decoration, height 6 7/8″. China. Song dynasty. Cleveland Museum of Art

over the buff body, which is just visible at the base of the pot. A variation of this undecorated monochrome ware is not white but black or brown—the color created by a thick glaze applied directly to the buff body without the use of slip. This type is also found throughout north China and is sometimes called Henan ware.

The simplest type of decoration on the white ground is painted. Such decoration was executed in dark brown or black slip, the blacker the color, the more desirable to Chinese taste. Ci Zhou being a utility ware, shape and decoration often tended to be rough and robust. Judged by the imperial standards of the Song and later dynasties, it was not part of the classic tradition. Ci Zhou pillows were made in great abundance, many decorated with naturalistic and freely painted designs (*fig. 485*). The bird on a branch looking at an insect gives us a very good idea of the freedom with which the artist used his brush and of the influence that must have filtered down to him from contemporary painters. At the same time, the vigorous, rather offhand brushwork and composition are characteristic of folk art.

Another type of Ci Zhou decoration is achieved by incising or carving or a combination of these. Figure 486 shows a Ci Zhou teapot or winepot with a floral design created by carving away the thick white slip down to the buff body in the background areas. The whole is then covered with a transparent glaze. The

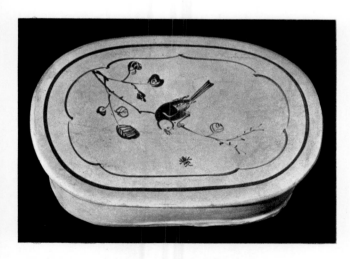

485. *Pillow.* Ci Zhou stoneware, length approx. 12″. China. Song dynasty. St. Louis Art Museum

487. *Mei-ping vase.* Ci Zhou stoneware with carved decoration, height 12 3/4". China. Song dynasty. Inoue Collection, Tokyo

488. (above) *Vase.* Ci Zhou stoneware with incised decoration, height 16 1/4". China. Song dynasty. Cleveland Museum of Art

489. (right) *Bowl with bird and floral patterns.* Ci Zhou stoneware, diameter 6 3/8". China. C. A.D. 1300. Cleveland Museum of Art

result is a two-color design with a powerful sculptural quality somewhat related to designs on Tang and early Song silver work. Much of the best Ci Zhou ware appears at the beginning of the Song dynasty and shows the influence of Tang metalwork and of Tang shapes. This pot, with its sharp differentiation of neck, body, and high foot, has inherited its general form from Tang. A variation on the carving method in figure 486 is to be found in a *mei-ping* where the decoration is created by carving the background away from a brown slip and filling in the cut-away areas with a white slip (*fig. 487*). Here the design is the standard peony motif used so often on the best Ci Zhou wares, displaying that rich combination of blackish brown and creamy white which is one of the most characteristic and decorative effects of the ware.

An even more complex feat of incising and inlaying creates the design on a large vase considered by many to be one of the two or three greatest Ci Zhou vases in the world (*fig. 488*). Its shape continues the style of the Tang dynasty, with sharply differentiated spreading lip, long neck, prominent shoulders, and sharply cut high foot. Its combination of incising and inlaying is among the rarest of the techniques found in Ci Zhou ware, and one that seems characteristic of a site in Henan Province called by various names, but perhaps most commonly Jiaozuo. Here a combination of brown slips and needle-point incision inlaid with white slip produces a type of decoration clearly under the influence of metalwork, particularly of incised silver. The bold strength of Ci Zhou shape and decoration is especially marked in this piece.

At the end of the Song Ci Zhou tradition colored enamels—yellow, red, and green on top of the standard white Ci Zhou slip—come into use, replacing plain black or blackish brown slip in a series of wares, some dated, ranging from A.D. 1204 until

490. *Bowl.* Ding porcelain with incised design of ducks swimming amid waves and water reeds, diameter 7 7/8″. China. Song dynasty. Museum of Fine Arts, Boston

491. *Bowl.* Ding porcelain with molded design of scrolling peonies, diameter 10 1/8″. China. Song dynasty. Cleveland Museum of Art

well into the Yuan dynasty (*fig. 489*). These appear to have been made under Mongol or Tartar influence and, though they form but a small part of Song dynasty Ci Zhou ware, are of great importance as the origin of the enamel-decorated porcelains that took pride of place in the Ming and Qing periods. The enamel decoration represents a Chinese allowance for what might be considered barbarian taste: rich color and a rather gay and full effect quite unlike that desired by the Song court. It should be said in conclusion that Ci Zhou ware has been made from early Song times until the present day, and many of the pieces that were formerly considered to be of Song or Yuan date are now known as Ming or even Qing.

Ding Ware

Of the porcelains made in the north the most important was the ware called Ding, after the type-site at Ding Zhou in Hebei Province in north China. Shards of the ware have been found in various parts of north China, and though production appears to have centered around Ding Zhou, the ware may have been made at various distances from that site. In contrast to Ci Zhou ware it is, by Chinese definition, porcelain: a ware in which glaze coalesces with the body, and which, when struck with a hard instrument, produces a clear, resonant tone. (It does not fulfill the traditional Western definition of porcelain, which requires translucency.) But obviously almost anything can be made translucent if sliced thin enough; it is also possible to make a true industrial porcelain of the highest known vitreous substance, but too thick to be translucent. The Chinese test of

resonance for porcelain is inconclusive only in that certain low-fired earthenwares containing a high proportion of chalk can also be resonant. In general, resonance is as good an indication as any that a piece sufficiently high-fired to fuse glaze with body is indeed porcelain. Ding ware, then, is porcelain, with a creamy white body covered with a transparent, almost colorless glaze that occasionally accumulates in thick straw-colored drops called tearstains by Chinese connoisseurs (*fig. 490*). The standard shapes are bowls or dishes, though some vases are known. The bowl illustrated is the finest known example of the common Ding decorative motif of ducks swimming amid water reeds and waves. The design is incised in the white paste of the porcelain, the waves indicated by comb marks. Ding ware has delicacy and refinement combined with simplicity of shape, which makes it particularly attractive to the modern Western connoisseur. The ware is relatively thin and was usually fired on its raw rim, which was then bound with a narrow metal rim, usually of copper, rarely of silver, and even more rarely of gold. Designs were molded as well as incised (*fig. 491*). The peony, as on Ci Zhou ware, is a favorite decorative motif.

492. *Bowl.* Ding porcelain with gold and lacquer decor, diameter 6 7/8″. China. Song dynasty. Inoue Collection, Tokyo

In addition to the incised and molded white porcelains, Ding potters produced a rare brown- or black-glazed ware, called black or purple Ding by the Chinese (*fig. 492*). This was simply the usual white porcelain body covered with an iron-oxide glaze that ranged from cinnamon brown to a deep and lustrous black. These thin and resonant wares, very seldom decorated with painted or gold-stenciled designs applied with lacquer, are among the rarest of all Song ceramics. One other type of Ding ware, seen in a few vases and pillows, has a decoration in iron oxide under the transparent glaze, usually of peony scrolls clearly related to Ci Zhou decor. In figure 493 we see a truncated bottle-vase from the Iwasaki Collection, perhaps the most perfect and beautiful specimen of this technique known. It is differentiated from its Ci Zhou counterparts by its thinness, hardness, and resonance.

Northern Celadon

Ci Zhou and Ding wares form the largest proportion of northern ceramics, but there are also important colored wares. Northern Celadon is a gray-bodied porcelaneous stoneware, usually with a rather brilliant sea green or olive green glaze over bold designs that may be incised or carved or, more rarely, molded or applied. It appears to have been made in the north in an attempt to rival the southern Yue wares of the Tang and early Song dynasties, and to have used at first decorative motifs derived from contemporary Ci Zhou and Ding wares, especially the peony, or, as in figure 494, the water lily and lotus decoration most characteristic of Northern Celadon. Japanese attempts to identify it as Ru ware have proved abortive, and the best name for this ware, apparently not described in the ancient

493. (right) *Truncated bottle vase.* Ding porcelain with iron-oxide design, height 7 1/2″. China. Song dynasty. Iwasaki Collection, Tokyo

494. *Dish*. Northern Celadon porcelaneous stoneware with carved design of lotus and water lilies, diameter 7 1/4". China. Song dynasty. Cleveland Museum of Art

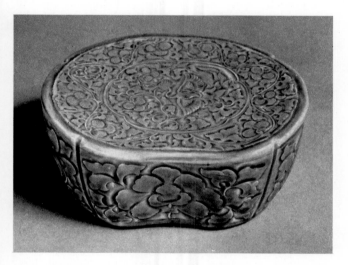

495. *Pillow*. Northern Celadon porcelaneous stoneware with molded design of *feng-huang*, peonies, and flower-scrolls; length 9 1/4". China. Song dynasty. Iwasaki Collection, Tokyo

Chinese texts, is still Northern Celadon. Perhaps the most extraordinary specimen is the porcelain pillow in the Iwasaki Collection, on which a decor of peonies on the sides and of peony scrolls surrounding a flying *feng-huang* on the top recalls the decoration on southern Yue wares (*fig. 495*).

Jun Ware

A second northern colored ware, related to Northern Celadon, is called Jun ware. It has the same gray to gray tan stoneware body as Northern Celadon, and

although its glazes, predominantly blues, purples, and mauves, seem radically different from Northern Celadon greens, chemical analysis reveals that they are very close indeed. The difference seems to have been produced by the use of certain ashes thrown into the kiln at the crucial moment to create the reducing atmosphere necessary for the opacity of color in the Jun glazes. Jun ware was extremely popular with Western collectors after the initial discovery of Song dynasty wares, from about 1910 to 1930, in part because its brilliant color made it easier to appreciate for lovers of Qing porcelains, especially the powder blues, "ox-bloods," and "peach-blooms." Jun experienced something of an eclipse in recent years, but the vessels in true ceramic shapes—those that do not imitate metal prototypes—are now returning to favor. The covered vase illustrated (*colorplate 36, p. 340, top*) is one of the rare vessels whose cover has been preserved. It illustrates the essentials of the Jun glaze: opacity, milky texture, and color ranging from soft powdery blue to deep purple, with occasional flushes or splashes of green or mauve. Another group of Jun vessels shows a brilliant, glassy glaze in brighter reds and purples as well as powdery blue, and many of their shapes reflect metal prototypes. Though Ming or even early Qing dates have been ascribed to certain of these, they may well be Song pieces. Many have a number from one to ten incised on the bottom; these were apparently used as flower containers (*colorplate 36, p. 340, center*). The illustration shows a flower container in a typical combination of liver red and blue. The foliate rim and three scroll legs recall silver shapes of the late Tang and early Song dynasties.

Northern Imperial Wares: Ru and Dong

By the end of the eleventh century the potters who made Jun and Northern Celadon had developed, in response to imperial request, a new ware called Ru, after the kiln-site of Ru Zhou in Henan Province. Since production ended with the destruction of Northern Song, Ru ware is the rarest of all Imperial wares made during the Song dynasty. Although undoubtedly some Ding and Jun wares were made for imperial use and hence could be called Official, or *guan*, the first eclectic ware—combining elements of Jun and Northern Celadon—made for imperial use was Ru ware. An incised testing disk now in the Percival David Foundation in London gives the date of A.D. 1107 for its first firing. One of the few known Ru pieces in the United States is in the Cleveland Museum of Art (*colorplate 36, p. 340, bottom*). It appears to be based upon the the Jun style. Its color is a unique and indefinable hue of soft, almost robin's-egg blue. The shapes

of the known Ru vessels are very simple but subtle, with certain reflections of Tang shape, particularly in the concave roll of the foot. But the most defining characteristic of Ru ware, because some Korean celadons do approach its color, is a special flaky crackle peculiar to all examples of the ware and resembling a very fine and regular pattern of glaze flakes laid over the surface of the body. The result is one of the most subtle wares ever produced under imperial patronage, and powerfully appealing to the senses of touch and sight. The one little black spot is identified in Chinese sources of the fourteenth century as one of the slight imperfections characteristic of genuine Ru ware, which even by the fifteenth century was being forged for the Chinese connoisseur. Even present-day auction prices pale beside the prices paid for Ru ware by Ming and Qing collectors; it was valued only somewhat less than fine jade.

Another Imperial ware, also made for a very short time, was called *dong*. It appears to have been derived from Northern Celadon, although its typical glaze color is a warm leaf green, quite different from the greens of Northern Celadon. Certain Northern Celadon decorative techniques were used, but usually with great refinement and precision, as in

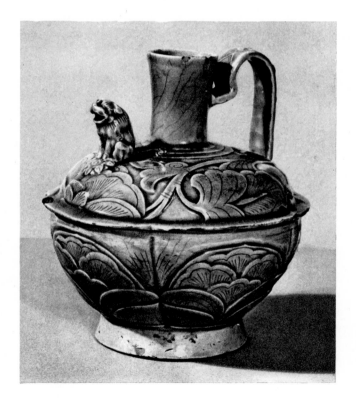

496. *Winepot.* Dong porcelaneous stoneware, height 7 3/8″. China. Northern Song dynasty. Cleveland Museum of Art

the winepot of figure 496. It was acquired as a particularly fine Northern Celadon ware, but is now almost certainly identifiable as one of the finest examples of *dong* ware. The little lion that forms its spout shows the influence of southern style, particularly of Yue ware, and the sharply carved design relates the ewer's overall appearance to metalwork.

Other Imperial (*guan*) wares, probably made at special kilns in the northern capital, are almost impossible to differentiate from Imperial wares produced in the south after the capital was moved. The pieces we have chosen to discuss here as examples of southern *guan* ware form a homogeneous group, although some of them may in fact have been made in the north before the fall of Northern Song. When the capital fell, the potters went with the fleeing court. We know, for example, that Ding potters reestablished themselves at Ji Zhou in Jiangxi Province, and there continued to produce wares almost indistinguishable from those they had made in the north. The court, however, was now located in the great center of green ware production, with the result that the greatest of the *guan* wares were produced by the Southern Celadon potters.

Longquan Celadon Ware

The pervasive ware of the south is Longquan Celadon, after the kiln-site Longquan in southern Zhejiang Province. Its ancestor was Yue ware, which had continued to be made, you will remember, in northern Zhejiang from the early Six Dynasties period. The finest of early Song Yue pieces is a bowl with carved dragon decoration in the Metropolitan Museum of Art (*fig. 497*). The gray green glaze is a little thin and watery, showing some of the imperfections in the body, and the decoration is somewhat overdone to compensate. Nevertheless, the piece is masculine and powerful, and Yue ware was considered the finest and rarest of ceramics in the Tang dynasty. By the tenth century, Yue ware was surrendering its primacy in the south to the products of the Longquan kilns, and with the arrival of the court at Hangzhou, and the changing taste of the Song dynasty, we witness the rapid development of Longquan and the waning of the Yue kilns.

Late Song Longquan Celadons and *guan* wares must be understood and appreciated as responding to the characteristic taste of the court and the scholar-gentry, for whom jade was the most precious of all materials. At the heart of the great development of ceramics in south China during the Song dynasty is the desire to produce a ware resembling jade. In producing wares that evoked the unctuous look and feel of jade and its wonderful depth and range

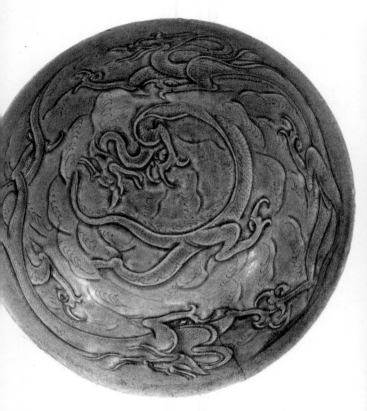

497. *Bowl.* Yue porcelaneous stoneware with carved dragon design, diameter 10 1/2″. China. Song dynasty. Metropolitan Museum of Art, New York

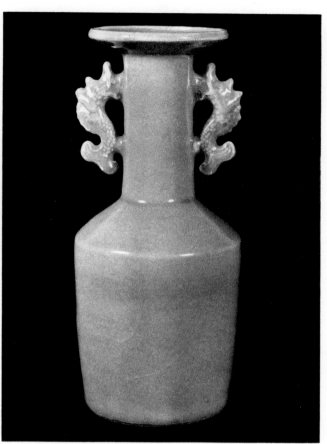

498. *Kinuta vase.* Longquan Celadon porcelaneous stoneware, height 10 1/8″. China. Song dynasty. Freer Gallery of Art, Smithsonian Institution, Washington, D.C.

499. *Vase in shape of zong.* Longquan Celadon porcelaneous stoneware, height 7 3/4″. China. Song dynasty. Tokyo National Museum

of colors, from rich greens through grays, browns, and brown greens, the Yue kilns failed, and the Longquan kilns succeeded.

The typical Longquan ware can be seen in the vase shown in colorplate 37 (*see p. 389*). It has a white to whitish gray porcelaneous stoneware body that burns to a sugary brown or even a reddish brown where exposed to the flame of the kiln. Its glaze color is a blue green of great depth, and the thickness of the glaze covers any imperfections in the body. Longquan glazes are characteristically viscous and thick, with many tiny bubbles beneath the surface, and range in color from this blue green to sea green, olive green, and a powder blue much like Jun blue. They produce a material that does indeed rival jade in appearance. It is from such Longquan wares that the great *guan* wares developed. The bowl (*colorplate 37, p. 389*) is a perfect example of the sea green color and also shows the extremely subtle carved decoration sometimes used in Longquan wares. The new decoration tends to adhere to the shape, to help form the body; here a simple carving of the exterior conveys a suggestion of althea petals. Reflections of light from its surface reveal undulations in the thick glaze. A variety of shapes was developed especially for the antiquarian taste of the court, including archaistic bronze shapes, but with color and luminosity to rival jade.

500. *Kundika (Buddhist holy-water ewer).* Stoneware with incised design of *feng-huang*. Korea. Koryo period. Cleveland Museum of Art

All of these pieces are devoid of crackle, as the perfect Longquan pot usually is. Certain celadons, however, show an apparently accidental crackle, and experiments of the Longquan potters in the use of crackle, at first accidental and then purposeful, were certainly the origin of the characteristic controlled crackle of *guan* wares. The Longquan crackle can be seen in a Freer Gallery vase (*fig. 498*), called *kinuta*, meaning club-shaped. The name, descriptive of shape, came to be applied to the blue green color seen here, and to the Japanese *kinuta* is the finest of all celadon colors. The fish handles are especially well modeled, and the proportion of their size to the neck and body of the vase is beautifully calculated. The square vase illustrated in figure 499, from the National Museum in Tokyo, shows an apparently purposeful crackle, yet the glaze and the body seem to be of typical Longquan manufacture. It is a moot question whether this is a crackled Longquan vase or one of the early crackled *guan* pieces derived from celadon. The shape again reveals the antiquarian interests of the court. It is a *zong*, the symbol of earth, often found in jades of the middle and late Zhou periods.

Korean Celadons

Related to the Chinese celadons are those made in Korea during the Koryo period (A.D. 918–1392; *fig. 500*). The shapes and decoration characteristic of Yue tradition were continued by the Koryo potters, but the watery Yue glaze was modified in color to a distinctive blue green. Korean potters also transferred the carved-and-inlaid decoration of Chinese slip-decorated stonewares to Korean celadons, doubtless finding the decorative variety and nonchalant technique of Ci Zhou ware sympathetic to their own inclinations. The difficult slip-inlay techniques of the Chinese ware were seized upon and elaborated, producing a rich style called *mishima* by the Japanese (*fig. 501*). Where the Chinese strove for and achieved subtle perfection, the Koreans'

501. *Mei-ping vase.* Korean celadon porcelaneous stoneware with inlaid design of birds and trees, height 13 1/2". Korea. Yi dynasty. G. M. Gompertz Collection, England

subtlety lay in their free use of pottery technique to achieve spontaneity.

There is no "perfect" Koryo celadon; each has a flaw, however minor, deriving from the potter's rapid execution and the circumstances of large-scale production. For the ceramic enthusiast the expected blemish enhances the relaxed beauty of Koryo wares. The best works rival the greatest of Song achievements; even the Chinese connoisseur acknowledged their merit (*figs. 501, 502*).

Guan Ware

The technical and aesthetic culmination of the Song celadon tradition is found in the *guan* wares made for the court. The tradition of a special Imperial ware goes back at least to the Ru ware produced for the northern capital in the early twelfth century. Imperial taste combined antiquarianism with subtle sensuality, and imperial resources made almost anything possible. *Guan* ware is an even more

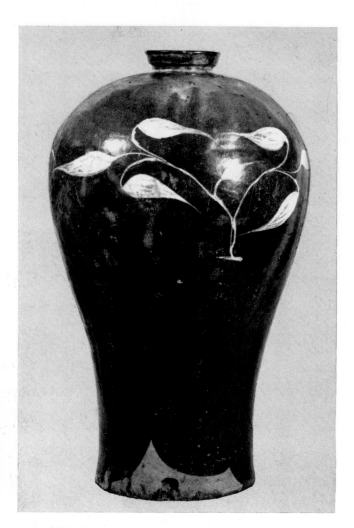

503. *Mei-ping vase.* Black stoneware with incised floral scroll, height 13 1/2". Korea. Koryo period. Freer Gallery of Art, Smithsonian Institution, Washington, D.C.

502. *Mei-ping vase.* Korean celadon porcelaneous stoneware with incised design of dragons amid clouds, height 13 7/8". Koryo period. Museum of Fine Arts, Boston

exquisite simulation of jade than Longquan ware. In the high-fired celadon glaze, off-white to gray to green to brown, like jade itself, the potter developed a purposeful stained crackle that may have simulated the fissures and earth stains of jade. The glaze was made thicker, and the body thinner and darker. This latter change was a true innovation of the highest importance, for the dark ground tempered the brilliance of the glaze, softening it, making it "lustrous as jade." Thinning the body and thickening the glaze heightened the new effect. *Guan* ware became a glaze suspended on the frail framework of the body.

Some idea of the rarity and desirability of such wares may be had from a tale told in later times:

Ts'ao Ch'iung of the Chia district of Hsiu, a man of substance and a connoisseur, got hold

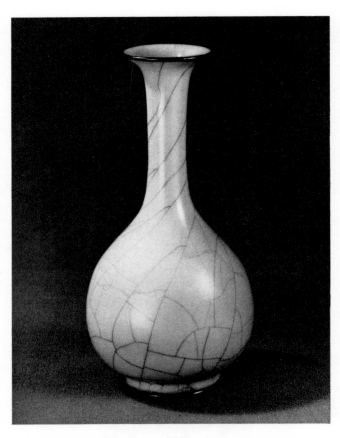

504. *Bottle vase. Guan* porcelaneous stoneware, height
6 5/8". China. Song dynasty. Percival David
Foundation of Chinese Art, London

of a censer two inches and more in height and
broad in proportion; the cover consisting of a
beautifully carved piece of jade representing a
vulture seizing a wild swan—a really lovely piece.

News of it trickled through to the ears of the
local Governor Mo, a eunuch, who jailed Ch'iung
and demanded it by way of ransom; and Ch'iung's
son had no option but to hand it over. Later a
certain powerful person in charge of the Board
of Rites seized it from Mo.

In the time of Cheng Te thieves stole it and
sold it in Wu-hsia where Chang Hsin-fu of Tien-
shan in Shanghai acquired it for two hundred
ounces of gold. Chang took it home and resold it
to an expert; and the palace never recovered it.
That was a genuine old Ko piece.[16]

Two types of *guan* ware are now clearly distinguish-
able. Type A is possibly northern but definitely
more opaque in glaze and wider in crackle than
type B (*fig. 504*). Most of the shapes in this A type
are simple and pure ceramic types, notably the
"althea-petal bowl" and the "gall-bladder vase"
(*colorplate 38, p. 390, left*). The B type, including

those wares ascribed to the Phoenix Hill kiln in
Hangzhou, is bluer in glaze color with a more grainy
body and often a smaller crackle pattern. It occurs
both in purely ceramic shapes and in archaistic
imitations of ancient bronzes, notably the *lu* incense
burner (*colorplate 38, p. 390, right*). Of a third *guan*
type, the "Suburban Altar" wares from Hangzhou,
part may have been for court use, but most were
probably made for general use or as souvenirs for
Altar pilgrims.

Readers may find occasional references to *ge*
(elder brother) ware. This seems to be a term of later
invention and not applicable to true Song Imperial
wares.

Temmoku Wares

A quite different ware of humble origin was equally
specialized and functionally successful. Jian ware,
named for the province of its manufacture, Fujian,
is a heavy, dark brown- and purple-bodied ceramic
with a thick iron-brown glaze. It was made only in
teabowls, but these achieved a functional truth
equaled only by modern insulation porcelains (*fig.
505*). The tea cult, sometimes associated with Chan
Buddhism in China, may well have been the spur to
the special development of Jian ware. Like the spon-
taneous ink-painting style associated with many
Chan monk-painters, Jian ware was seemingly rough
and direct, but with concealed subtleties. Tea should
be hot; the cupped hands holding the bowl should
be no more than pleasantly warm. Tea is green and

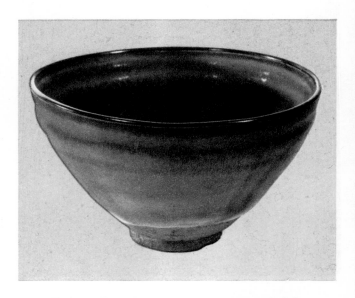

505. *Teabowl.* Jian porcelaneous stoneware, height
2 3/4". China. Song dynasty. Cleveland Museum
of Art

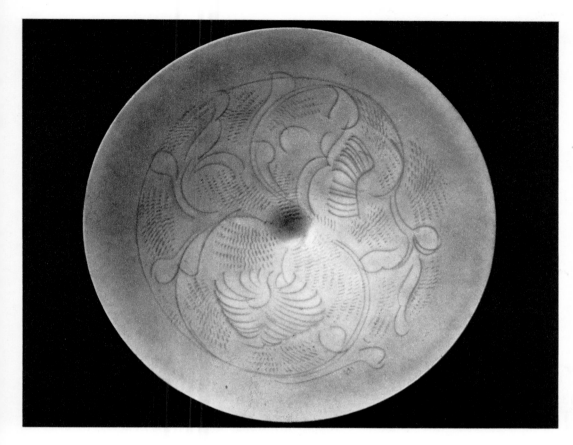

506. *Bowl. Qingbai* porcelaneous stoneware with incised floral scroll, diameter 5 3/4". China. Song dynasty. Victoria and Albert Museum, London

needs, especially for the residue, a dark brown background for full aesthetic appreciation. The base of the bowl should feel quietly rough to the palm of the hand; the lip of the bowl should tend to prevent unseemly dripping. All of these requirements were perfectly met by the Jian teabowl, and its success led to imitation both near at hand, in the Ji Zhou wares (sometimes called Kian wares, after Ji-an, the older name of the site) of Jiangxi with their "tortoiseshell" exteriors, and in Henan Province in the north, where the white body of the teabowl was camouflaged to counterfeit Jian by the application of a dark brown or purple slip over the foot where the dark glaze did not reach.

All these wares—Jian, Ji Zhou, and Henan—were termed *temmoku* by the Japanese and were much admired by Japanese tea masters of the Ashikaga and later periods. The Seto kilns near Nagoya made excellent imitations for the Ashikaga tea masters, the only major difference being in the characteristic gray body of the Japanese bowls.

Qingbai Ware

Unloved in its own day—we have no contemporary Chinese name for the ware—the pale blue white *qingbai* ware, made in Jiangxi Province near the sites of the later imperial kilns of Jingdezhen, was of the utmost importance for the future of Chinese porcelain. Although its extreme thinness and the frail, sugary texture of its cream white body would seem to disqualify it as a traveler, *qingbai* ware was a staple export. Shards and complete pieces were and are found in Korea, Japan, Southeast Asia, India, eastern Africa, and Egypt. The delicately incised floral and figural designs on *qingbai* made for Chinese use recall those of Ding ware, but the paper-thin walls of these household vessels lend added delicacy to *qingbai* decoration (*fig. 506*). *Qingbai* evolved into the Yuan dynasty Imperial ware called *shu fu*, with a whiter and heavier body, a thicker and more opaque pale blue green glaze, and molded designs on the inside. With a clearer glaze and decoration in underglaze cobalt blue, *qingbai* became the Imperial Blue-and-White of the Ming dynasty. All of its better-esteemed contemporaries—Ding, Ru, Jun, Longquan, *guan*—were continued and imitated in declining quality. The styles of the two poor relations, Ci Zhou and *qingbai*, the one with its rich painted and enameled decoration, the other with its pure, fragile whiteness, were later combined in the Imperial porcelains of the Ming and Qing dynasties.

16

Japanese Art of the Ashikaga Period

The Japanese period known as Muromachi or Ashikaga (A.D. 1392–1573)—Muromachi after the quarter in Kyoto housing the shogun's palace, Ashikaga after the family name of the ruling shoguns—is one of failure of central authority, disastrous political confusion, and continual fierce warfare among the feudal barons hungry for power and domains. The split between the court and the warriors, between the prestige of the emperor and the power of the shogun, was becoming thoroughly institutionalized, at the same time that the authority of both was being superseded by relationships of pure military vassalage. The Ashikaga family and their chief advisers exercised an uneasy, brief, and limited dominion that imposed relative peace for about three generations; thereafter for about a century and a half all supremacy failed, war convulsed the country, and the house laws of the feudatories were the only law in Japan.

By removing the shogunate from Kamakura to Kyoto, seat of the imperial court, the Ashikaga shoguns promoted, in this age of political fragmentation, a process of cultural synthesis between rude, provincial, military society and elegant, metropolitan, civilian society. In Kyoto the increasingly powerless shoguns could devote lives largely emptied of political responsibility to the cultivation of refinement and the arts, and upstart captains eager for social acceptability could seek lessons in taste and deportment from impoverished court nobles.

During this violent, bloody age, trade and the arts—as in China during the similarly anarchic Warring States period—flourished. The paradox is more seeming than real. Fighting was vicious, but farming, the chief wealth of the country, was not much disturbed. Warlords needed arms for their troops, furnishings for their households, luxuries to signify and celebrate their triumphs. The "sudden lords" (contemporary term for men of humble origin aggrandized by the fortunes of war) needed fine things to remove the stigma of boorishness. And the Buddhist sects continued rich and strong enough to serve as havens for apolitical artists and aesthetes. Finally, the very absence of central authority both permitted and demanded the emergence of a strong mercantile class to furnish the necessities of the military *arrivistes*.

Among the "new men" the old styles of *yamato-e* and *e-maki* fell into disfavor. After five hundred years of slight and rare contact, Japan turned its eyes again to China.

From China at the very end of the twelfth century had come Zen (in Chinese, Chan) Buddhism, and elicited from the Kamakura warriors a vigorously enthusiastic response. Zen doctrine was simply stated, brief, and direct; to pragmatic and doubtless laconic military men its appeal is obvious. Zen practice dispensed with image worship and ceremonial sutra reading in favor of meditation under the tutelage of an already enlightened master; to feudal warriors and their overlords the master-disciple relationship must have seemed natural and congenial. By the Ashikaga period Zen dominated intellectual as well as religious life. In its company came the art and literature of the Song renaissance and its continuation during the Yuan and early Ming

dynasties, and so overwhelming was the Japanese response to these that interest in native Japanese subject matter and style withered. Chinese models and Zen masters influenced virtually every aspect of life among the new rulers and high intellectuals. The ideal for the Japanese scholar of the Muromachi period was China: Chinese style painting and most particularly monochrome landscape, Chinese ceramics, Chinese poetry and philosophy. To say that Zen influenced all of these is not, of course, to imply exclusive Zen parentage. But Ashikaga art expresses the Zen apprehension of the spiritual identity of all created things and the Zen appreciation of direct, intuitive perception, and it shares the Zen aesthetic standards of subtlety, allusiveness, and restraint.

507. *Table Top.* Lacquered wood with design in gold and silver, length 23″. Japan. Ashikaga period. Cleveland Museum of Art

CONSERVATIVE STYLE

We have mentioned the importance of first looking at the traditional or conservative side of a period. In the applied arts and in some paintings the Fujiwara decorative style of *yamato-e* was continued, largely by artists of the Tosa school. Lacquer in particular was made for the court in Fujiwara style, and surviving pieces in this most fragile medium are of great value today. The top of a small lacquer table illustrates a style of decoration almost identical with that on twelfth century lacquer clothes boxes (*fig. 507*). Only in the summary application of the silver spit of land at the left directly over the gold grasses and tree trunks is there any indication of a slightly different attitude. This rather brusque and arbitrary

quality is found often in painting and especially in the tea ceremony works of this period.

Paintings of the Tosa school perpetuated the Fujiwara and Kamakura narrative handscrolls in various sizes and proportions and in a rather de-based style, but in the now revived form of the folding screen the Tosa painters produced some of the most important conservative works of the fifteenth and sixteenth centuries. A particularly attractive subject, known in several examples, shows warriors, gentlemen, and priests pursuing leisure occupations in front of a stable with horses so finely bred, so well groomed and cared for that they require halters around their bellies to prevent them from lying down (*fig. 508*). Individual elements of this style are derived from the *e-maki* style of the Kamakura

508. *Horses and Grooms.* One of a pair of six-fold screens, ink and color on paper; length 11′ 5 3/4″. Japan. Ashikaga period. Cleveland Museum of Art

509. *Portrait of Abbot Shoichi Kokushi.* By Mincho (Cho-Densu, A.D. 1352–1431). Hanging scroll, ink and color on silk; height 8′ 4 1/2″. Tofuku-ji, Kyoto, Japan. Ashikaga period

period. The simple, repetitive arrangement is intended decoratively, and these screens are precursors of the full-fledged decorative style of the Momoyama period.

Portraiture was also continued, particularly *chinzo*, remembrance portraits of Zen masters, which would be given as mementos to departing disciples (*fig. 509*). The portrait of Abbot Shoichi by the artist Mincho, also known as Cho-Densu (A.D. 1352–1431), perpetuates unaltered the portrait style of Southern Song and Kamakura (cf. *figs. 479, 440*). Though it adds nothing new to previous Chinese or Japanese painting, it is an excellent traditional portrait; the forthrightly rendered face allows, in the Zen phrase, "direct pointing to the heart of the man." Figure 509 also exemplifies the combination of Japanese decorative and realistic styles that emerged in the Kamakura period: The patterning of the abbot's throne is as marked as the character of his face.

One unusual aspect of the traditional art of the Ashikaga period is illustrated by a pair of six-fold screens called *Spring Landscape in Sunlight, Winter Landscape by Moonlight* (*fig. 510*). Their style is a wild, rough continuation, bordering on folk art, of the decorative *yamato-e* treatment of the rolling, gentle hills of Japan and of pine trees, water, rocks, and waves. The sprinkling of gold leaf in the upper left and of some silver in the area to the right of the

510. *Spring Landscape in Sunlight, Winter Landscape by Moonlight.* Pair of six-fold screens, ink, color, gold, silver, and gesso on paper; length 10′ 4 1/2″. Kongo-ji, Osaka, Japan. Ashikaga period

mountain and around the moon recalls the use of this technique in the *Genji* scrolls, but the total effect is not elegant or aristocratic in the Fujiwara manner. Other works of this rare type presumably were painted in some quantity at the end of the Ashikaga period and are of considerable importance for the development of a later decorative style.

THE CHINESE MONOCHROME STYLE

The mainstream of creative Japanese painting in the Ashikaga period comprises monochrome painting in Chinese style of Chinese subjects. It was almost a point of honor to ignore the Japanese landscape, though there were notable exceptions. Monochrome painting was associated with Zen, and many of the greatest practitioners of the Ashikaga monochrome style were painter-monks. The style first reached Japan in the Kamakura period, when certain sketches and a few finished paintings reveal the new mode imported from China. The *White-robed Kannon,* from Kozan-ji in Kyoto, is one of these: a Zen subject in the new Chinese monochrome technique (*fig. 511*). The subject, seated upon a rock amid the waters, now seems more female than male. The thick and thin brushstrokes forming the rock; the flowing, waterfall drapery; the Chinese style of the face, with straight nose, small eyes, and a withdrawn expression rather than the animation usually found in Japanese representations—all these derive from such Chinese works as those of Mu-Qi. Nevertheless, minor details of brushwork, notably the hints of "nail-head" brushstroke technique in the foreground

511. *White-robed Kannon.* Hanging scroll, ink on paper; height 36". Kozan-ji, Kyoto, Japan. Late Kamakura period. Cleveland Museum of Art

rock, indicate this to be a work by a Japanese painter, schooled in native style, making an early attempt at the new Chinese monochrome style. The Ashikaga monochrome school developed from such beginnings.

Mincho, in addition to portraits in traditional style, also painted landscapes in monochrome. Of his presumably numerous works, only one is left: a landscape in the Konchi-in in Kyoto depicting a thatch-roofed cottage in a grove of trees overhanging a stream; in the distance are "ax-cut" mountains, executed in broad strokes with the side of the brush (*fig. 512*). Knowing that this painting is Japanese, one can then "see" differences from Chinese style, but one's overwhelming spontaneous impression of the painting is completely and utterly Chinese. So

512. *Hermitage by the Mountain Brook.* Attrib. Mincho (Cho-Densu, A.D. 1352–1431). Hanging scroll, ink on paper; width 13 1/4". Konchi-in, Kyoto, Japan. Ashikaga period

513. *Catching a Catfish with a Gourd.* By Josetsu (act. c. A.D. 1400). Hanging scroll, ink and slight color on paper; height 32 3/4". Taizo-in of Myoshin-ji, Kyoto, Japan. Early Ashikaga period

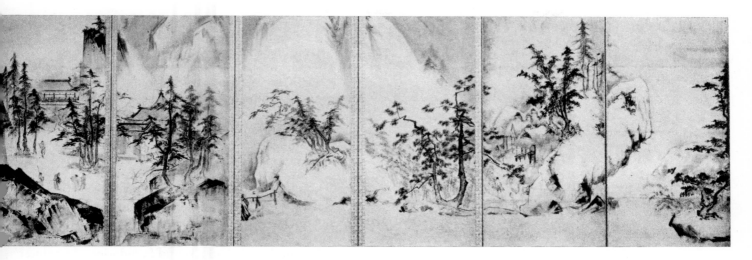

514. *Winter and Spring Landscape*. Attrib. Shubun (c. A.D. 1390–1464). Six-fold screen, ink and slight color on paper; length 144″. Kyoto, Japan. Ashikaga period. Cleveland Museum of Art

extensively and thoroughly did the Japanese priest-painter appropriate the Chinese Ma-Xia style of the Song and Yuan periods and use it to develop the Ashikaga monochrome school. These artists believed so completely and fervently in Song culture and style that their recreations of the lyric style of the Southern Song dynasty equal or surpass their Chinese prototypes. No Chinese critic or sinologue would ever allow such a statement to go unchallenged, but then—there are the paintings! The little painting by Mincho stands at the threshold of this fruitful development.

Another artist of great importance is Josetsu, active about A.D. 1400, of whose work we have left only one widely accepted painting, *Catching a Catfish with a Gourd* (*fig. 513*). The subject, a man trying to catch a catfish with a gourd, is typical of Zen: a preposterous notion, presented to shock the mind awake. Josetsu's man stands on the shore of a little stream opposite a grove of bamboo, holding his gourd, while in the stream a catfish looks up at the absurd combination. In the distance is the bare outline of a mountain, and at the top are thirty-one poems by Zen priests, one of which mentions that this picture was painted as a small screen for the third Ashikaga shogun, Yoshimitsu, some time before A.D. 1415. *Catching a Catfish* symbolizes the extent to which the Japanese absorbed and were absorbed by the new Zen ideal. Though it came from China, it became, literally and figuratively, their faith. An idea penetratingly understood and passionately adhered to is, in a sense, thereby recreated, and something of that reinvented quality is at the heart of the Ashikaga monochrome school and informs the whole ethos of the period.

Josetsu was, according to tradition—and there seems no reason to dispute it—the real founder of the Ashikaga monochrome school. His pupil was Shubun and Shubun's was Sesshu, and from this line came most of the later main developments. Shubun, active in the first half of the fifteenth century, is perhaps its greatest master, but he is for us a shadowy figure. We know that he was a priest, that he not only painted for the shogun but was a painter of sculpture as well, that he made a trip to Korea and presumably was familiar with the Ma-Xia style of Korean painting of the time. He was primarily a painter of screens and large scrolls, though a few small hanging scrolls are attributed to him. Skeptics tell us that not a single extant work may be surely attributed to Shubun. Still, a small but important group of screen paintings, some with the seal of Shubun, are traditionally ascribed to him. They are painted in a manner derived from the Ma-Xia style of the Southern Song dynasty and in power and richness seem, if anything, superior to earlier and later works. One of them is the screen *Winter and Spring Landscape*, illustrated in figure 514. The subject should be read from right to left, as if the screen were a handscroll. Winter with its soft snow and cold mist grips the landscape of the first four panels. The selfsame atmosphere is rendered by two famous haiku (poems of seventeen Japanese syllables) by Zen monks:

Under the winter moon,
The river wind
Sharpens the rocks. Chora: IV, 213

I walk over it alone,

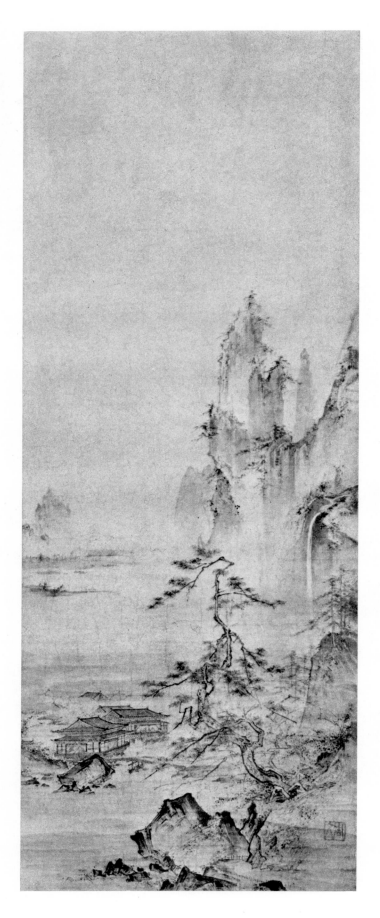

In the cold moonlight:
The sound of the bridge. Taigi: IV, 205

The last two panels convey a softer message; a slight warmth in the tones of the ink changes the chilly steam of winter to the soft breath of spring:

Peace and quiet:
Leaning on a stick,
Roaming round the garden. Shiki: II, 43

Suddenly thinking of it,
I went out and was sweeping the garden:
A spring evening. Tairo: II, 54[17]

Shubun's style had a sound foundation. As painter to the shogun he undoubtedly had access to Yoshimitsu's great collection of Chinese Southern Song paintings. The brush style of Ma Yuan is evident in the "ax-cut" strokes defining the rocks; Xia Gui's manner is to be seen in the trees; and the general disposition of the trees against the nearby towering, truncated mountains markedly resembles the two famous hanging scrolls by Li Tang, once in Yoshimitsu's collection and now kept at Daitoku-ji in Kyoto. But the artist has not merely borrowed; he absorbs the essence of the Chinese masters and makes their techniques and thoughts his own. It now appears certain that Shubun borrowed much from Korean monochrome paintings as well as Chinese. This included some knowledge of northern Chinese styles, transmitted through Korean artists such as Ri Shubun (not to be confused with Shubun), and of collections of Chinese works in the Korean capital, Kyongju. Shubun added a breadth of scale in part inherent in the large, decorative expanse of the folding screen. Though grouped hanging scrolls with landscape subject matter were used by the Northern Song masters, the folding screen in Chinese usage was never more than decorative. It remained for the Japanese genius to make decoration and profundity congruent. Shubun was able to do this by avoiding the extremes of stylized composition and brushwork to which so many later Japanese monochrome painters became addicted. His ink varies from the lightest tones to the darkest; his brush can be soft or harsh at will. Complexity lies side by side with simplicity, fused by an almost magical ability to convince without display. The *Winter and Spring Land-*

515. *Landscape.* Attrib. Shubun (c. A.D. 1390–1464).
Hanging scroll, ink and slight color on paper;
height 35″. Japan. Ashikaga period.
Seattle Art Museum

scape screen is a product of this mature style, an embodiment of intellect and emotion in perfect harmony.

It should not be thought that Shubun painted only large pictures, screens, or wall paintings, although his strong brushwork and ability to unify intricate compositions in a simple overall pattern were particularly suited to such forms. Of the hanging scrolls that bear hopeful attributions to Shubun, very few are generally accepted as his, but in our judgment a few are close to his style. One of them, *Landscape,* is illustrated in figure 515. Here, as in the screen paintings, is the satisfactory unity and complexity underlying simplicity. The painting owes a great deal to the Song artist Xia Gui, particularly in the reaching pine tree and the structure of the rocks in the foreground, and yet it exceeds any of the Southern Song masters in the extreme use of vertical composition. The elements of the landscape —waterfall, distant mountains, points of land, even the rocks and trees in the right foreground—seem more arbitrarily and decoratively disposed than such elements in the works of Southern Song painters. The brushwork is suave, and the "ax-cut" strokes used in the foreground rock are related to similar strokes in the screen paintings. The architecture is convincing, a characteristic of work attributed to Shubun. The position of the buildings on the land plane and the logical quality of their structure and perspective are realized to the fullest degree. The painter did not allow excessive emphasis on brushwork to render the architecture an unbelievable pattern of sticklike strokes. Shubun, the master of Sesshu and the first great artist of the Ashikaga period, was never surpassed.

The *Winter Landscape* by Sesshu in the Tokyo National Museum (*fig. 516*) is a fitting contrast to the hanging scroll by Shubun. The technique is the same, but the effect and the temperament it reveals are vastly different. In Sesshu there seems to be an impatience with suavity and detail, a desire to cut through to what he considered the heart of the matter, and in this he seems more a Zen painter than Shubun. The brushstrokes in the *Winter Landscape,* in the style called *shin,* are rapid, sharp, and angular, applied either very light or very dark, and unified by washes of ink that simulate the wetness and grayness of the snow in the half-light under the mountain cliff. The outlines of the distant mountains now dis-

play the agile but domineering brush. In Shubun's *Landscape,* the brush portrays the mountains; in Sesshu's, the mountains reveal the brush. The architecture, though still believable, has become more an exercise in vertical and angular strokes than Shubun's. Complexity has been deemphasized, and the result is a direct and extreme simplicity that has been well described as "crackling." Sesshu, like Shubun, was a Zen priest. He too rose high in the hierarchy and at the end of his life retired to the mountains, spending his declining years in Zen disciplines, painting pictures for a few close friends and associates.

His work can be divided roughly into two types, *shin* and *so: shin* defined by sharp, angular, and relatively complex brushwork; *so* a soft, wet, explosive, and ultrasimplified style, also called by the Japanese *haboku,* or "flung ink." Sesshu has customarily been ranked higher than Shubun, and the number of his known works, compared with the num-

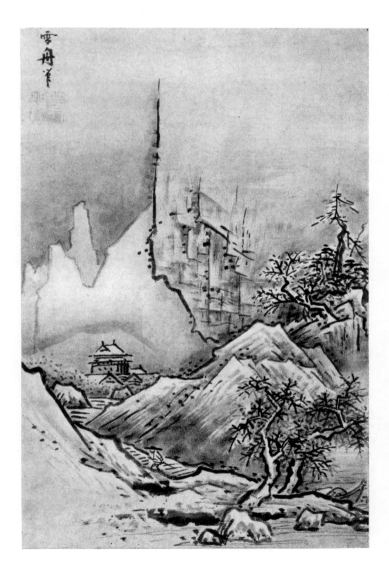

516. *Winter Landscape.* By Sesshu (A.D. 1420–1506). Hanging scroll, ink and slight color on paper; height 18 1/4". Japan. Ashikaga period. Tokyo National Museum

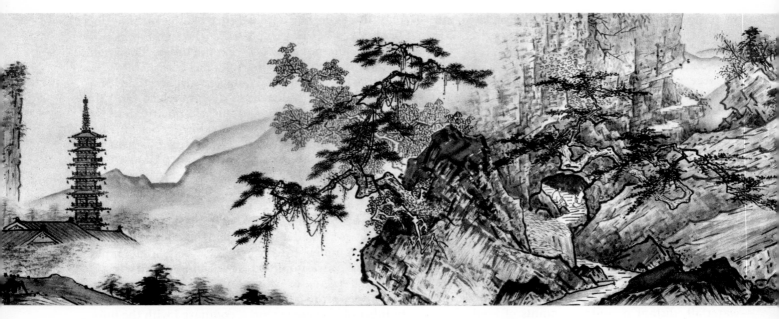

517. *Longer Landscape Scroll*. By Sesshu (A.D. 1420–1506). Section of the handscroll, ink and slight color on paper; height 15 3/4″, length 624″. Japan. Ashikaga period. Mori Collection, Yamaguchi

518. *Longer Landscape Scroll*. Detail of fig. 517

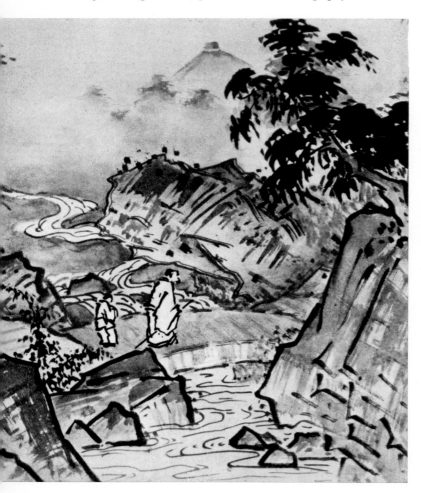

ber plausibly associated with his master, is considerable. Some thirty-five works can, with some degree of certainty, be attributed to Sesshu. Most famous of all is the so-called *Longer Landscape Scroll*, a handscroll of some fifty-two feet, belonging to the Mori family for many generations. It is the most developed of all his works and represents a series of "Chinese" scenes. The detail showing the pagoda tower, flanked on the right by pine trees reaching into space from a craggy mountaintop and on the left by a pine-forested plateau extending into the background, is a typical section of the scroll (*fig. 517*). The pine trees recall Shubun, though they are perhaps less soft and a little more mannered in their handling. Indeed, each detail of this scroll sounds overtones that recall other painters, both Chinese and Japanese, and in this sense it is an eclectic work. We know that Sesshu copied Southern Song masters—Xia Gui, Ma Yuan, Li Tang, and others. Small album leaves, signed by Sesshu with his notation that they are copies of these masters, still exist. He was also familiar with China itself. He traveled there in A.D. 1468 as part of an official mission that landed in Fujian Province and moved slowly north to Beijing. He mentions seeing the work of some of the important Ming painters of the fifteenth century academic school, among them Li Zai. He said that the Ming painters did not equal the finest of the Japanese masters, notably his own teacher, Shubun. Certainly the basic elements of the

early Ashikaga monochrome style are derived from Southern Song paintings rather than those of the Ming period. At the same time details in Sesshu's works remind us of certain Ming painters of the fifteenth century. In the *Longer Landscape Scroll* the general handling of the pine trees on the right and the rather exaggerated near-and-far treatment in the right corner recall the work of masters of the Zhe school such as Dai Jin, and the plateau on the left, reaching into the distance, is a favorite device of fifteenth century Chinese painters.

A close detail of one of the river and forest scenes with figures will best illustrate that quality which raises Sesshu to the pinnacle he occupies in Japanese art history: the strength of his brushwork, the brilliance of his handling of ink on paper (*fig. 518*). A passage such as the one in the center, with an old man followed by a boy attendant amid sharply projecting rocks and rippling water, is not as naturally rendered as in the work of Shubun. Still, it seems remarkably expressive of the Japanese feudal spirit and of those Zen Buddhist qualities that appealed to the martial spirit: Direct and intuitive understanding has been translated into pictorial style by direct and immediate brushwork. Certain decorative qualities are to be discerned here that are quite different from those of Chinese painting, whether Song, Yuan, or Ming. Forms are more arbitrarily placed; transitions from near to far are abrupt; the patterns of the wrinkles on the rocks, the patterns of foliage, and the movements of branches are more exaggerated. Such conscious emphasis is not Chinese and points the way to the growing decorative tendencies of the late fifteenth and the sixteenth century, ultimately to reach their fullest expression in the Japanese decorative style of the seventeenth and eighteenth centuries. One can readily see whence the Kano masters, those rather academic followers of the monochrome school, received the elements of their style and how in overemphasizing decorative qualities they underestimated the primacy of brushwork and the directness of Sesshu's style.

Sesshu painted, as did most of his colleagues, the Chinese landscape in the Chinese style. Nevertheless, there are certain rare works by Ashikaga masters in which monochrome ink is used to represent Japanese scenery. By far the most important of these is the painting *Ama no Hashidate* by Sesshu (*fig. 519*). Along the coast of the Japan Sea northwest of Kyoto a sandy spit of land reaches across the mouth of the bay. Ranks of pine trees march along the peninsula to the very end of the point. The scene is represented again and again in later Japanese art and is one of the great pilgrimage sites for travelers, Japanese or foreign. Sesshu represents it in the cold blue ink typical of his later work, with just a few touches of pale orange red giving some warmth to the mountains on the left and to the roofs of the village. The painter has somewhat modified his style. The hills are undulating, not as angular or steep as the imagined Chinese mountains. This intimate quality recalls the landscape of the Fujiwara and Kamakura periods. If the dominant elements of the style are Chinese, their modification produces one of the most interesting of Sesshu's landscapes in the *shin* style.

He also painted a few folding screens of the paired six-fold type. One of the finest, *Flowers and Cranes*, illustrates the decorative development of monochrome painting at this time (*fig. 520*). Slight touches of color—red and green—while decorative, also contribute a lifelike quality to the cranes and foliage. But certainly the placement of the elements

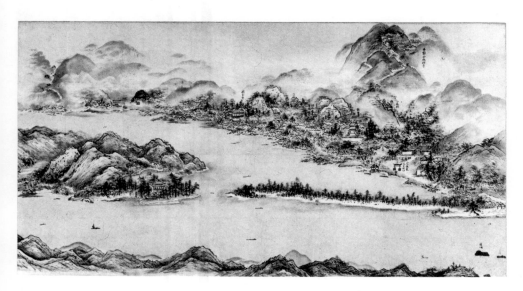

519. *Ama no Hashidate*. By Sesshu (A.D. 1420–1506). Hanging scroll, ink and slight color on paper; length 70″. Japan. Ashikaga period. National Commission for the Protection of Cultural Properties, Tokyo

of the composition—pine branch, pine trunk, reeds, rocks, flowers, and the cranes—is extremely arbitrary, almost as if the artist had selected these motifs and then disposed them on the surface of the screen for maximum decorative effect. It is not yet an extreme decorative style, but motifs derived from China are here adapted to a different and Japanese taste.

The *so,* or *haboku* (flung ink), style, also used by Sesshu, is rightly considered the most extreme form of Chinese monochrome painting, and is often asso-ciated with Chan Buddhism in China and Zen in Japan. *Haboku* was practiced in China, but not often and to no great acclaim. Most Chinese *haboku* paintings ended in Japan, brought by Zen monks returning from study in China. The famous imaginary portrait by Sesshu of the first Zen patriarch, Bodhidharma, known in Japan as Daruma, emphasizes fervent faith (*fig. 521*). It is told that once Bodhidharma, meditating on the Buddha, fell asleep; upon waking he punished himself for this

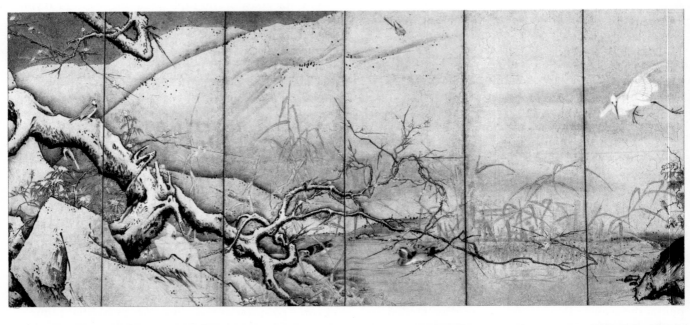

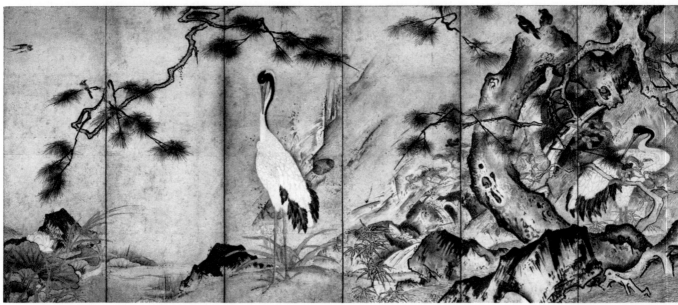

520. *Flowers and Cranes.* By Sesshu (A.D. 1420–1506). Pair of six-fold screens, ink and slight color on paper; length 12′ 4″. Japan. Ashikaga period. Kosaka Collection, Tokyo

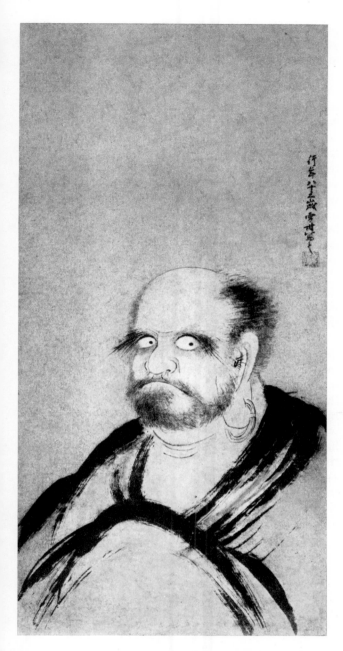

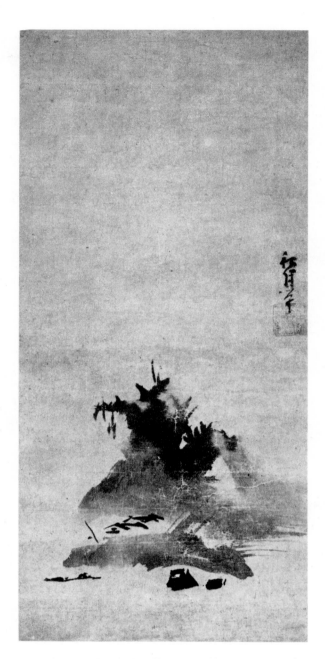

521. *Daruma*. By Sesshu (A.D. 1420–1506). Hanging scroll, ink on paper. Japan. Ashikaga period. Yoshinari Collection, Tokyo

522. *Haboku landscape*. By Shugetsu (d. c. A.D. 1510). Hanging scroll, ink on paper; height 23 1/4″. Japan. Ashikaga period. Cleveland Museum of Art

lapse by cutting off his eyelids to assure perpetual contemplation of the Buddha. Thus he is represented by Sesshu, with glaring eyes, pressed lips, and clenched teeth expressing the ardor of his devotion. In the flung ink style the brush is used rapidly but purposefully: Here the drapery is roughly indicated, with greater care devoted to the features. Sesshu's powerful brush seems as downright as a sword cut, as direct as the intuition Zen holds to be the heart of understanding, and owes much to such Chinese masters of the flung ink style as Liang Kai or Mu-Qi.

Haboku was also used in landscape painting, and in a few works painted at the end of his life, Sesshu made extreme use of this style. The most famous and often reproduced example is the one painted for Josui Soen, his disciple, now in the National Museum in Tokyo. Another hanging scroll, by Sesshu's pupil Shugetsu, is illustrated in figure 522. The style of both is of such simplicity and subtlety that although it is

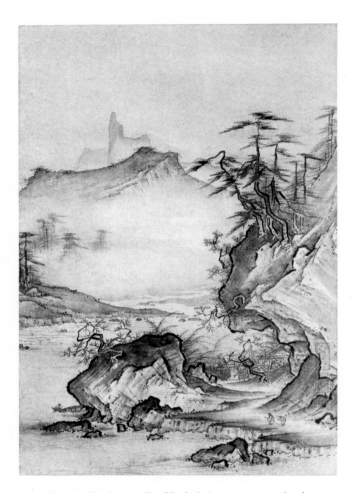

possible to analyze it, to demonstrate that the variation of wash is subtly controlled, that the tones are minutely calculated so that each wash occupies the imaginary space provided for it, that a foreground rock does come forward, that a distant building and its surrounding shrubbery recede, still, ultimate knowledge of the picture remains beyond our grasp. In contrast to much later works in the flung ink style, this has a wide range of tone. But the fundamental touchstone of this style is its immediate and convincing impact. If the painting is sensed in the Zen way, visually and intuitively, one is emptied and only calm remains. Such works are the silent dialogue between a great and aged artist and the materials—brush, ink, and paper—that he knew best and on their own terms.

Among the most important followers of Sesshu at the end of the fifteenth century, particularly in the *shin* style, was Shokei. One of his pictures, kept in the Nezu Institute of Fine Arts in Tokyo, represents a grotesque hollowed-out cliff with a small hut between its jaws, while beyond is a simplified view of mountain ranges and pines (*fig. 523*). Here is even more arbitrary brushwork and composition than that of Sesshu. The rhythms of the rocks, the twisting branches of the pine trees, and the gradations of the washes seem more calculated, even if brilliantly handled. Soami (of the family school of painters to the shogun, Noami, Geiami, and Soami, d. A.D. 1525) tended to work in a softer, rounded style, and the sliding-screen panels (*fusuma*) in the Daisen-in, Kyoto, constitute one of the great examples of this softer style of painting.

The ranking artist of the first half of the sixteenth

523. *Spring Landscape.* By Shokei (act. A.D. 1478; d. 1506). Hanging scroll, ink and slight color on paper; height 20 1/8". Japan. Ashikaga period. Nezu Institute of Fine Arts, Tokyo

524. *Wind and Waves.* By Sesson (b. A.D. 1504; act. till 1589). Hanging scroll, ink and slight color on paper; height 8 3/4". Japan. Ashikaga period. Nomura Collection, Kyoto

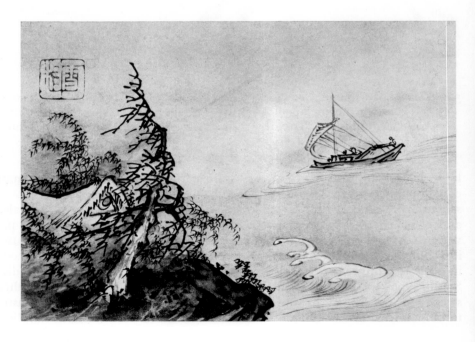

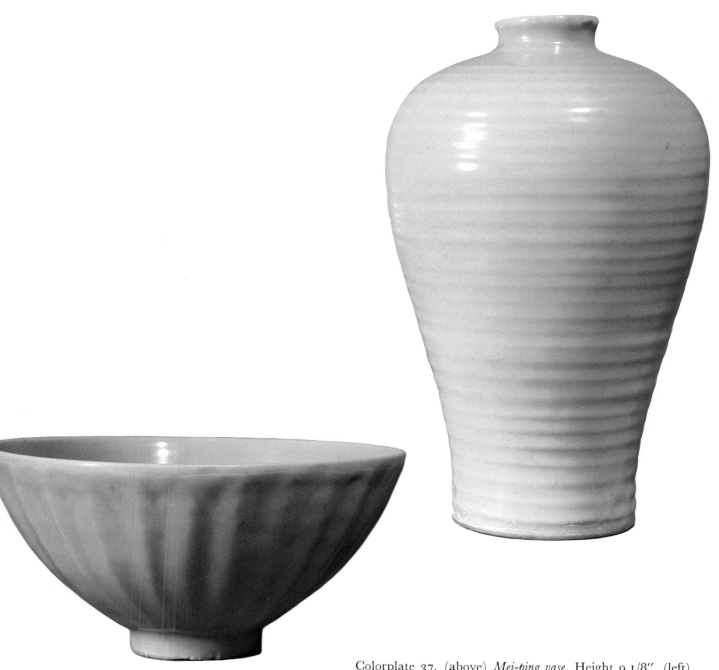

Colorplate 37. (above) *Mei-ping vase.* Height 9 1/8″. (left)
Althea bowl, diameter 8 1/2″. Both: Longquan
porcelaneous stoneware. China. Song dynasty. Cleveland
Museum of Art

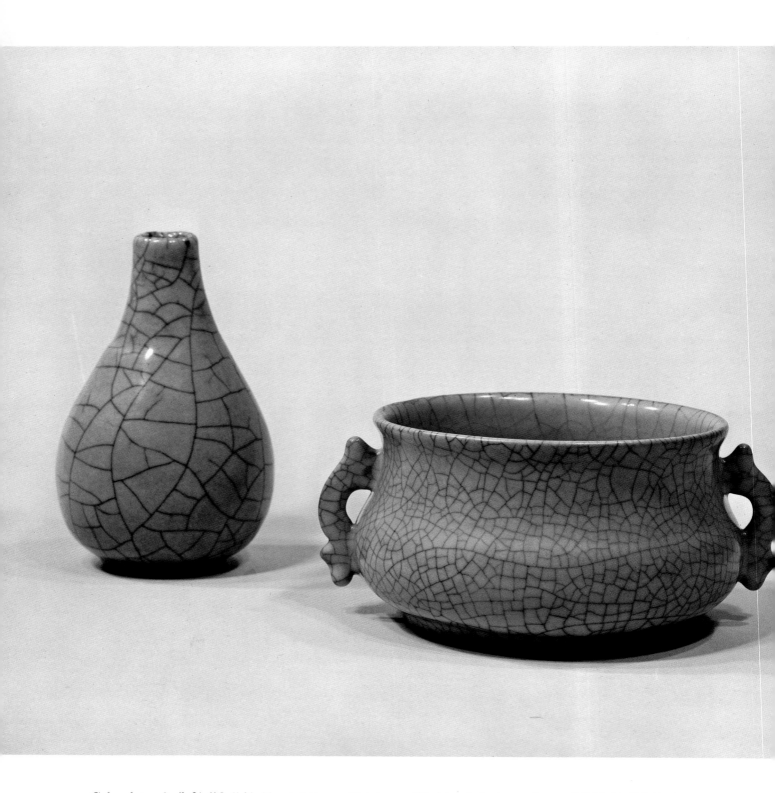

Colorplate 38. (left) *"Gall-bladder shape" vase*. Height 5 1/8″. (right) *Lu incense burner*. Width 6 1/8″. Both: *Guan* porcelaneous stoneware. China. Song dynasty. Cleveland Museum of Art

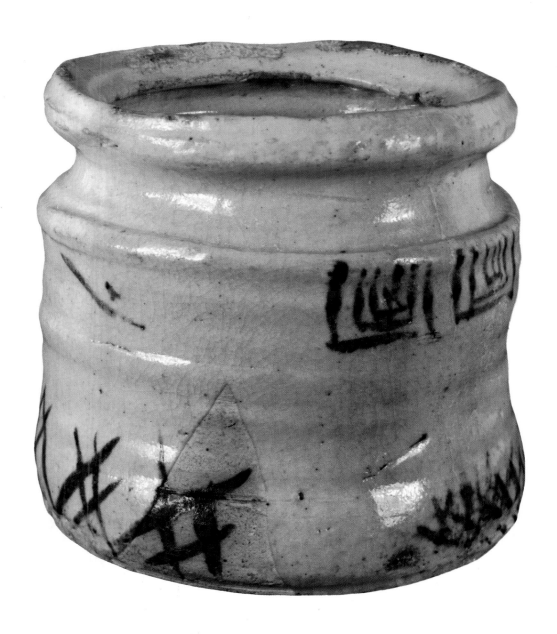

Colorplate 39. *Cold water jar*. Shino stoneware, height 7 1/4″. Japan. Momoyama period.
Cleveland Museum of Art

Colorplate 40. *Lion Grove Garden (Shizi Lin)*. Suzhou, Jiangsu, China. View west to Heart of the Lake
Pavilion. Yuan dynasty, A.D. 1342, with later additions

525 *Tiger and Dragon.* By Sesson (b. A.D. 1504; act. till 1589). Pair of six-fold screens, ink on paper; length of each 11' 1 1/2". Japan. Ashikaga period. Cleveland Museum of Art

century, almost equal in esteem to Shubun and Sesshu, is Sesson. He avoided the metropolitan and Zen centers of Kyoto and Kamakura, but the works of Sesshu and of Song and Yuan masters were available to him for study in northeastern Honshu. His considerable body of work shows a distinctive style that emphasizes the decorative possibilities of rhythmic and graceful brush movements rather than the placement of elements within the composition. Sesson's most famous picture is a tiny rectangle,

perhaps twelve inches long. One looks out past a point of land with a swaybacked hut and a windblown tree to a strong sea and a small boat running landward before the wind (*fig. 524*). In the waves in the right foreground, in the type of brushstroke used to represent the windblown tree or the curve and bend of the bamboo above the hut, one senses an elegant and refined decorative quality within a masterful *shin* style. The combination is so simple and arbitrary that, in order to sustain it, the brush-

526. *Zhou Maoshu Admiring the Lotus Flowers.* By Kano Masanobu (A.D. 1434–1530). Hanging scroll, ink and slight color on paper; height 36". Japan. Ashikaga period. Nakamura Collection, Tokyo

stroke must be flawless. Even in passages close to the *so* style, the same elegance and decorative quality inform each individual brushstroke. No one could mistake his work for Sesshu's. The effect is perhaps more calculated and less immediate, but it is certainly much more "stylish," with a light and witty quality quite lacking in the paintings of the fifteenth century. Shubun, Sesshu, Shokei, Soami, and Sesson are the titans of Japanese painting in the fifteenth and early sixteenth centuries.

THE KANO SCHOOL

The founding and early development of the Kano school are artistically interesting; its later manifestations seem more properly a matter of national historical interest. The school is traditionally derived from Kano Masanobu (A.D. 1434–1530), who is represented by one important masterpiece, the painting of the Chinese scholar Zhou Maoshu, seated in his boat under an overhanging willow tree, admiring lotuses (*fig. 526*). The general effect recalls the richness and breadth of Shubun, but it has some decorative qualities related more to Shokei or to Sesson. It is not a standardized or academic work, though the Kano school did ultimately standardize the monochrome style. The school became in a very real sense an academy, with a founder and an elaborate genealogy of acknowledged masters. The Kano masters devoted themselves also to art criticism and the authentication of paintings, both of the Kano school and of Chinese and Ashikaga monochrome types. The man responsible more than any other for the crystallization of a Kano style was the second of the line, Kano Motonobu (A.D. 1476–1559). Motonobu's most famous works are at the Reiun-in in Kyoto, in the form of quite large hanging scrolls originally intended as sliding screens, or *fusuma* (*fig. 527*). The crane and pine, motifs already seen in Sesshu, are treated in a way that can only be described as decorative. The arbitrary curves of the rather woolly pine tree and of the twisting branches, the particularly self-conscious placement of the individual elements—crane, tree, water, and dimly seen cliff, one behind the other like a series of stage scrims—show developed decorative tendencies that became standard for the Kano school.

ARCHITECTURE AND LANDSCAPE ARCHITECTURE

Architecture in the Ashikaga period shows the growing influence of certain Chinese temple styles rapidly transformed by the influence of earlier Japa-

nese traditions into a simple, light, and serene style. Its best qualities are associated with aristocratic pavilions and the teahouse. Temple buildings become overelaborate, particularly in their bracketing, and also develop a tendency toward minutely detailed surface embellishment approaching cabinetwork. The most famous temple structure in the *kara yo,* or Chinese style, is Engaku-ji in Kamakura (*fig. 528*). The heavily thatched double roof is a later addition;

the original roof was of tile and much lower in profile. The brackets under the eaves have increased in number and intricacy past the point of function. Window and door openings and latticework have become fine and delicate, quite different from the strong, architectural treatment, whether simple or complex, of earlier Japanese styles.

The most successful and interesting buildings of the Ashikaga period are those associated with leisure

527. *Cranes and Pines.* By Kano Motonobu (A.D. 1476–1559). Section of the sliding screen, ink and slight color on paper; height 70″. Reiun-in, Kyoto, Japan. Ashikaga period

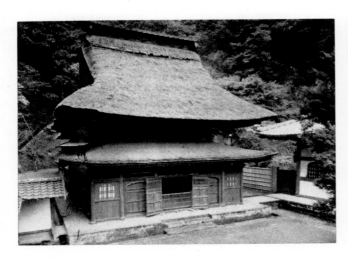

528. *Shari-den (relic hall) of Engaku-ji.* Kamakura, Japan. Late Kamakura period, A.D. 1293–98

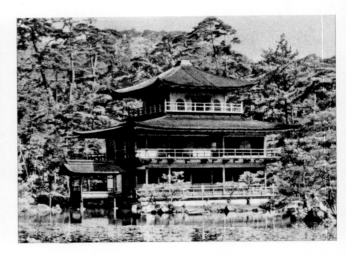

529. *Kinkaku (Golden Pavilion) of Rokuon-ji.* Kyoto, Japan. Ashikaga period, A.D. 1394–1427

and pleasure—with the contemplation of the moon, the landscape, or the garden, and with the tea ceremony. The most famous of these, tragically destroyed in 1950 by a crazed Japanese monk, was the Golden Pavilion in Kyoto, the Kinkaku (*fig. 529*). It has lately been rebuilt according to the original plan, but of course with new materials. The illustration shows the original structure, set on a manmade platform jutting out into a pond and surrounded by pines and deciduous trees carefully planted in "natural" profusion to show seasonal changes in foliage to best advantage. The pond has small rock islands, artificially placed but appearing spontaneous and natural. It could be a scene from a Southern Song painting. Elaborate bracketing is

not used in this "secular" style structure, intended for Zen recreations as well as private worship. Tile roof and round columns, typical of Chinese style, are avoided. The roof is of native shingle and the whole is constructed of squared timbers with plain surfaces of largely natural wood, though the roof line, most of the exterior, and parts of the interior were actually covered with gold leaf; hence the name Golden Pavilion. The posts along the exterior corridors of the simple three-story post-and-lintel structure are placed with deliberate asymmetry. The whole is carefully calculated to give an effect of extreme simplicity, of studied nonchalance, of spontaneity. In emulation of Kinkaku-ji, built by the third Ashikaga shogun, Yoshimitsu, a second structure, Ginkaku-ji, the Silver Pavilion, was built nearly a century later by the eighth shogun, Yoshimasa (*fig. 530*). It is no coincidence that these two rulers also formed fine collections of Chinese paintings. Ginkaku-ji is almost a small version of Kinkaku-ji, with two stories instead of three. Nearby on the same estate (Higashiyama Palace), in a garden designed by the painter Soami, is the Togudo, a small four-room building that served Yoshimasa as private chapel, study for copying the sutras, and teahouse. In the chapel a portrait sculpture of Yoshimasa has replaced the original sculpted Amida trinity. The essential elements of the teahouse, already present in the nature-viewing pavilions, have

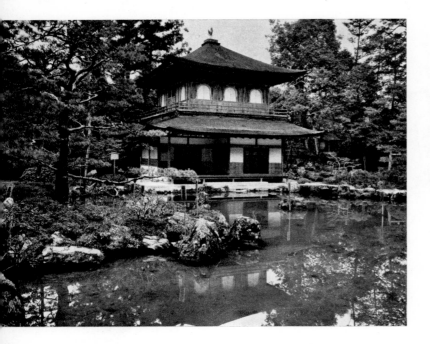

530. (left) *Ginkaku (Silver Pavilion) of Jisho-ji.* Kyoto, Japan. Ashikaga period, c. A.D. 1500

531. (opposite) *Garden of the Daisen-in of Daitoku-ji.* Attrib. Soami (d. A.D. 1525). Kyoto, Japan. Ashikaga period

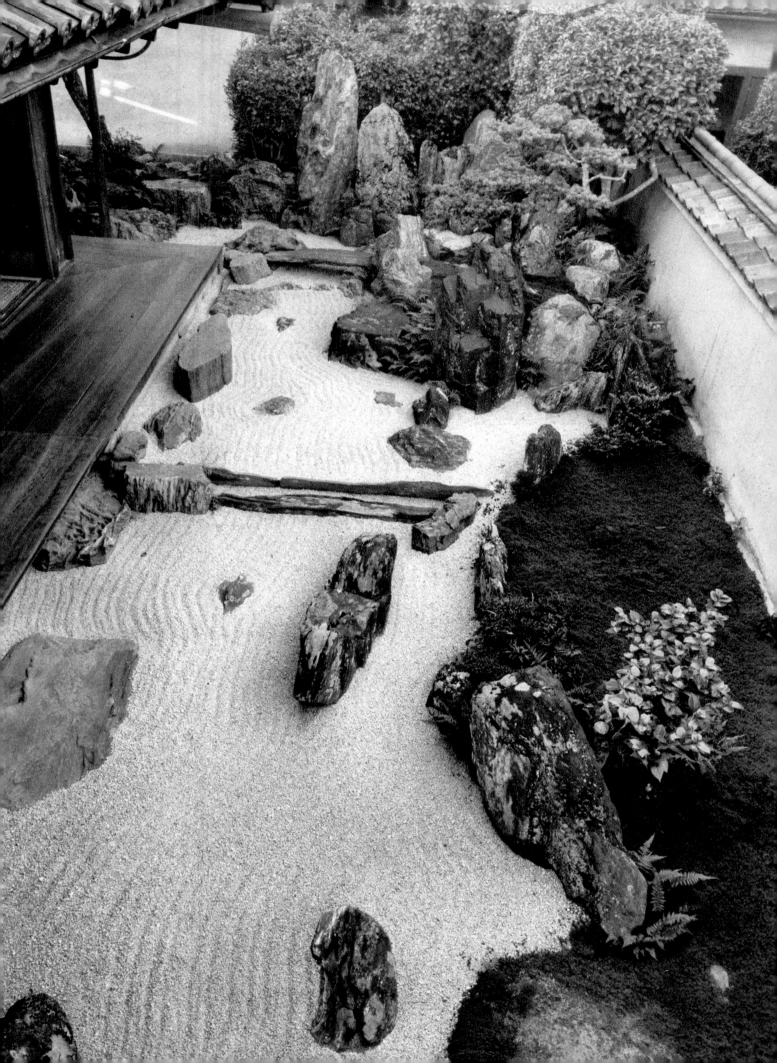

here become far smaller, humbler, and simpler.

The tea pavilion, based on a combination of Chinese pavilions seen in paintings and farmhouses actually seen in Japan, is an unpretentious structure whose subtlety and refined detail were calculated to appeal to the complex tastes and motivations of the cultured samurai. Stone platforms, characteristic of Chinese style, were replaced by pilings or wooden posts under the floor structure, almost as in Fujiwara secular architecture. This native Japanese style, modified by the simplicity of contemporary Chinese taste, was placed at the service of Zen and of its accompaniment, the tea ceremony.

An integral part of the teahouse was its surrounding garden, which could be of various types. A large garden, such as the one around the Golden Pavilion, was like a beautiful glen or clearing in the woods. Sand gardens were also used, some as large as the garden at Jisho-ji (the former Higashiyama Palace), where the dry sand was conceived as water and the larger trees and shrubs as distant mountain ranges or larger elements of a landscape in the midst of the water. Significantly, many of these gardens were designed by the most famous painters of their day, including Soami and Sesshu. In a curious inversion particularly characteristic of the subtlety and complexity of Japanese taste, the garden was conceived of very much as if it were a painting. Out of the raw material of nature, the landscape painter made gardens to look like paintings. No convolution could be more suited to the Japanese taste. The sand gardens are intended only for contemplation—landscape paintings in the round, so to speak, to be viewed from all sides but not entered. Strolling would destroy the fragile raked patterns. In contrast with these arrangements of sand and rock are the moss gardens, landscapes created not of white and black, as in ink painting, but of different greens. The effect is richer, more sensuous, perhaps related to the old native tradition of landscape painting and to the Japanese garden of the Fujiwara period.

Perhaps the most interesting of all is the tiny garden microcosm, representing the vastness of nature with nature's own materials. The most famous of these, and by all odds the most beautiful, is the Daisen-in garden in Kyoto, whose design is attributed to Soami (*fig. 531*). This small garden, constructed of rocks, sand, and shrubs—the sand intended as water, the rock slabs as a bridge from one spit of land to another, and the carefully selected rocks of the background serving as a mountain range—is, in an area of ninety-two square yards, one of the greatest of all the gardens in Japan. It is meant to be seen from the two adjacent porches of the abbot's house and from its approach, where it is possible to sit in the changing light of day or evening and contemplate a landscape as rich and complex as a painting by Shubun or Sesshu.

TEA CEREMONY

The tea ceremony (*cha no yu*) was a significant byproduct of the same Ashikaga culture that produced the related arts of monochrome landscape painting and garden design. But it is a debatable point whether the cult of tea is a proper subject for inclusion with the visual arts. Like the dance, the tea ceremony was a series of actions involving the use of works of art—gardens, teahouses, iron kettles, bowls, dishes, hanging scrolls, and others. Beginning as an informal and uncodified meeting of congenial spirits, it became a rigid cult of taste, as ritualistically and artificially dedicated to simplicity as a Byzantine coronation was dedicated to mystic splendor. The actual event in both cases was something less than met the eye.

Tea was first imported from China by the ninth century; its use in Japan for more than refreshment probably derives from the tea pastimes of the Tang and Song literati, in which the color and savor of the tea were artfully considered and judged along with the discussion or even creation of poems and works of art. Tea also came to be associated with Chan monasteries, perhaps because it is a stimulant and a pleasant relief from knotty discussion or deep meditation. We have seen that a kiln complex in Fujian Province specialized in producing Jian ware solely in the form of bowls especially designed for the drinking of tea. The combination of Zen tea and Temmoku teabowl was certainly established in Japan at the beginning of the Ashikaga period. It seems equally certain that the tight codification of the tea ceremony did not begin until the end of that period, at the same time that the art of monochrome painting began to suffer from the equally rigid formalism of the developed Kano school of painting.

The traditional founder of the ceremony was Murata Shuko (A.D. 1421–1501), who reputedly designed the first tea ceremony with the aid of the painter Noami, at the command of the shogun Yoshimasa, whom we have already noted as a great aesthete and collector. But the most famous and revered name in tea is Sen no Rikyu (A.D. 1521–1591), tea master to both Nobunaga and Hideyoshi, the two successive warlord-unifiers of Japan, who ended his life by suicide at Hideyoshi's order. From Rikyu comes the first codification and from his time the various hereditary lines of tea masters (*chajin*). His four requirements for the ceremony—harmony, respect, purity, and tranquillity—are understandable defenses for the conservative and cultivated few

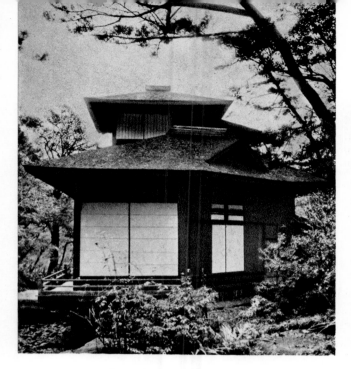

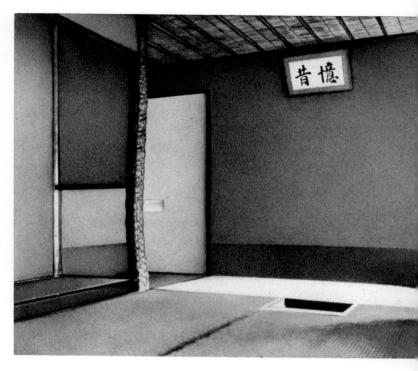

532. (above) *Teahouse named Taigra.* Japan. Momoyama period. Hara Collection, Yokohama

533. (right) *Interior of Taigra,* fig. 532

against the robust, gorgeous, and sometimes gaudy tendencies of the new dominant classes of the seventeenth century. Two all-important tea ceremony qualities, *sabi* ("reticent and lacking in the assertiveness of the new"—Sadler) and *wabi* (quiet simplicity), can also be best understood against such a historical background.

Reduced to essentials, the activities of the tea ceremony participants can be simply described. The guests, usually five in number, approach the teahouse through an informal garden, stopping en route by a stone water basin to perform what amounts to a ritual purification of hands and mouth in the old Shinto tradition. When they arrive at the house, a small and calculatedly rustic structure designed with only the interior in mind, they enter through an almost square entrance so small that they must bend low and literally crawl into the tea room, presumably shedding their status as they do so. In the soft light within they admire in turn the hanging scroll—either a painting or calligraphy—and the vase with a flower arrangement, artfully placed in the *tokonoma,* a niche specifically designed for their display. The guests then seat themselves on mats in a row, the place of honor—for rank has reappeared—being before the *tokonoma.* After they have disposed themselves, the host appears and wordlessly proceeds to serve powdered green tea to each guest in turn, preparing each bowl separately in a graceful, elaborate, and precise ritual involving an iron water kettle, bamboo water dipper, stoneware vessel for cold water, teabowls,

powdered green tea from a lacquer or ceramic caddy, bamboo scoop for the tea, bamboo whisk for mixing the tea and water, incense from a lacquer or ceramic box, and a tidily folded, unfolded, and refolded silk napkin. Today the ritual even prescribes the number of sips required to drink the tea (three and one half), the *chajin*'s manner of turning the bowl on presentation, and the recipient's manner of turning it before and after imbibing. After drinking, the utensils used are laid out for inspection and admiration. The guests depart as silently as they came, but not before noting carefully the small interior with its clean and asymmetrical arrangement of windows, posts, and mats, all made of the humblest materials with conscious rusticity combined with an almost Mondrian-like purity as the aesthetic end in view (*figs. 532, 533*). What had begun in the fifteenth century as an informal gathering has become an exercise in studied nonchalance with overtones of repression and symbolic poverty. One says "symbolic" because the prices of tea ceremony objects often reach fantastic heights, depending not so much on their intrinsic aesthetic worth as on their history and association with distinguished tea masters of the past. One small implement may sell for half a million dollars.

The recent fossilization of *cha no yu* is mirrored in the extreme self-consciousness of the nineteenth and twentieth century objects used in the ceremony. A teabowl made on the wheel may be purposely bashed into an asymmetry that was a natural result of mass

399

534. *Teabowl named Shibata*. Ido stoneware. Diameter 5 5/8″. Korea. Late sixteenth century A.D. Nezu Institute of Fine Arts, Tokyo

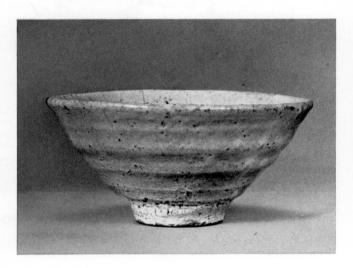

535. (above) *Jar*. Yellow-glazed Seto stoneware with *tomoe* design, height 8 5/8″. Japan. Late Kamakura period, fourteenth century A.D. Umezawa Collection, Tokyo

536. (below) *Bowl*. Seto stoneware with leaf design. Japan. Ashikaga period. Private collection, Japan

production in the beautiful Korean *Ido* bowls of the late sixteenth and the seventeenth century (*fig. 534*). The tea wares produced in Japan in the sixteenth and seventeenth centuries, largely in the neighborhood of Nagoya at the Seto kiln complexes, have abundant natural charm. Beginning with olive- or brown-glazed stonewares of the late Kamakura period, the Seto potters developed a varied repertory of wares for everyday as well as tea ceremony use (*fig. 535*). Bowls imitating Chinese Jian ware are the first evidence of a specialized tea production, and these rather simple wares are followed by more accomplished and artful ones. Yellow Seto, with its freely incised floral and vegetable designs heightened by splashes of soft green, is one of the rarest and most attractive of these later efforts (*fig. 536*). Another type, called Shino, uses an opaque, thick, and bubbly white glaze, transparent where it runs thin, enlivened by natural orange brown burns from the kiln fire and by hastily but delicately drawn black or dark brown floral or abstract designs, usually on teabowls or cold water vessels (*colorplate 39, p. 391*). Oribe ware is characterized by boldly asymmetric shapes in teapots, bowls, plates, and serving utensils. Its equally novel and asymmetric designs are executed in iron brown pigment or white slip, and the glazes are mostly pale buff or bright green and blue. Kilns in other regions, notably those that continued a medieval folk tradition, such as Bizen (Okayama Prefecture), Shigaraki (Shiga Prefecture) (*fig. 537*), Iga (Mie Prefecture), and Tamba (Hyogo

Prefecture), continued to produce their monochrome brown, olive, and unglazed biscuit wares, but in shapes appropriate to the tea ceremony.

The great artistic contribution of the early tea ceremony consists in these ceramics, so different in

TEA CEREMONY

do-way of
picked up by military
 sen no Rikyu - head tea master, high priority on rustic, unpretentious
 talk of non controversial topics

wabi - unpretentious, quiet simplicity
sabi - non ostentation behavior - resonance
Momegi - Jap Maple - brilliant red
 traditional founder shoku
 chajin - tea master
 hollow rock to wash up
carefully planned path fork in road with string to tell you where
to go.
 4½ straw mats standard size for tea platform
 usually a hanging scroll and vase w/ one flower asymmetric
tea caddy - holds tea woven fabric covering
bamboo ladle
 iron kettle, water jar, whisker, bowls, stonewear vessel for cold
 water tea bowl lacquer box holding incense, silk napkin.
box to hold all stuff
Kyoshi - outdoor tea ceremony
Shigaraki - ancient storage jars, grainy
Shino - opaque thick white bubbly glaze orange brown burns
oribe - boldly asymmetrical iron brown pigment, greenish
doodle deco.
Edo - deliberately warped & cracked
Karatsu - glazes cracked or crazed glazes run together underglaze
painting, footwear decorated
Seto - yellow

537. *Storage jar.* Shigaraki stoneware, height 16 1/2″. Japan. Ashikaga period, fourteenth–fifteenth century A.D. Cleveland Museum of Art

538. *Kettle.* Iron, height 7 1/8″. Japan. Ashikaga period. Cleveland Museum of Art

appearance from the subtle perfection of the Chinese wares. These Japanese stonewares are justly admired by contemporary Western potters for their rugged simplicity, their daring asymmetric shapes and designs paralleling the developments of seventeenth century decorative painting and expressing the qualities implied by the words *wabi* and *sabi*. The same may be said of the iron kettles made primarily at Ashiya in Hyogo Prefecture (*fig. 538*). Teahouse

architecture reflects on a small scale that peculiarly Japanese originality expressed more completely in religious and domestic architecture. Although the tea ceremony is of interest as an exercise in taste and a symbol of later Japanese aestheticism, it also seems an appropriate subject for cultural history and anthropology as well as for the history of art. The many other manifestations of art in the Ashikaga, Momoyama, and Tokugawa periods should place it in proper perspective as an expression of elite conservatism as well as an instrument for aesthetic education.

17

Later Chinese Art: The Yuan, Ming, and Qing Dynasties

THE YUAN DYNASTY

In their progress from nomad horde to Yuan dynasty (A.D. 1279–1368) the Mongols were materially aided by Chinese foreign policy. This policy of "using barbarians to fight barbarians" had in the early twelfth century rid the Chinese of their old enemies the Liao, but the price they paid to their erstwhile allies, the

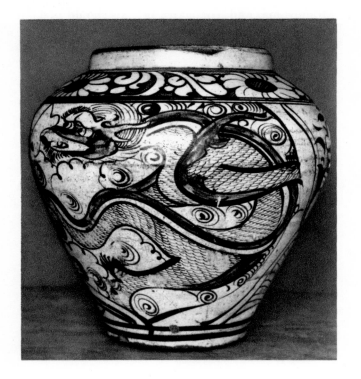

539. *Jar.* Ci Zhou stoneware, height 11". China. Yuan dynasty. Cleveland Museum of Art

Jin, was all of northern China. A short century later the Southern Song government embraced an identical opportunity with far worse results. The Mongols, with Song help, annihilated the Jin, laying north China waste in the process, and went on to the destruction of Southern Song as well, becoming the first "conquest dynasty" to master all of China.

Though Marco Polo, in the service of Kubilai Khan, was overwhelmed with admiration for Yuan China, to Chinese scholar-officials the *pax Mongolica* and its enhancement of trade, and the rude creative vigor of Mongol tastes, counted as less than nothing against the brutality of the conquest, the repugnant and unassimilable foreignness of Mongol culture, and the rapid descent into incompetence and corruption of an administration mostly foreign-staffed and ill adapted to Chinese governance. Considerations of personal and, even more, of family advancement dictated service to the new regime. Confucian precepts of political loyalty, reinforced by deep distaste for the Yuan, demanded retirement from the "dusty world" into private life and political noncooperation.

Ceramics

Developments in the ceramic tradition in the fourteenth century are of the utmost importance for the future development of porcelain. Traditional ceram-

ics, on the whole, declined in quality, due in part to a relative decrease in court patronage for fine wares. The Ci Zhou tradition of decorated slip ware, made for high and lower classes alike, continued in the Yuan dynasty, using the traditional techniques, perhaps with less refinement and with greater emphasis on painting than on the more complicated and expensive techniques of incising and inlaying. Painted jars are rather bolder in their decoration and tend toward a more pictorial treatment of the design. A frame is placed about the picture, as in the dragon side of the jar illustrated in figure 539. The borders, which in Song dynasty wares tended to be integrated into the main design, are in Yuan wares also framed, cut off like strips of continuous decoration to be applied where necessary. Nevertheless, the robustness of Yuan period draftsmanship, combined with the usually vigorous qualities of northern slip-decorated stoneware, continued the traditions of this ware.

The same was not altogether true of other classic wares of the Song dynasty. Jun ware tended to become somewhat simpler and cruder in its techniques and coloring. Ding ware declined in importance. Longquan and other celadons produced in the south continued rather high in quality, particularly in vessels displaying the new decorative technique of design in the biscuit (the fired but unglazed porcelain body): Certain areas of the vessel would be "reserved," or left unglazed, and these would fire to a terra-cotta color that contrasted handsomely with the celadon glaze, as in the dragon amid cloud-scrolls and border florets of figure 540. This is a move away from the monochrome glazes over slight relief patterns or none, characteristic of Southern Song wares, and toward the designs in highly contrasting colors characteristic of later Chinese porcelains.

Chinese porcelains from the Yuan dynasty until modern times have developed out of a combination of two ceramic traditions: *qingbai* ware, the pale blue or sky blue porcelaneous stoneware made principally in Jiangxi Province, and a robust form of decoration in underglaze blue. An obvious offshoot of *qingbai* wares is the Yuan court ware called by the euphonious name *shu fu* (*fig. 541*). Its body material resembles *qingbai*, but more refined and homogeneous, whiter, thicker, and stronger. The glaze is pale blue green, thicker and more opaque than *qingbai* glazes, and the bond between glaze and body is more cohesive. The result is a ware with a slightly thick, milky quality in the glaze and a pleasing heft when lifted. It combines the strength of the celadons with a color very close to that of *qingbai* wares. Now this *shu fu* ware had a relatively short production span, but decoration added to it in underglaze blue began the great Chinese tradi-

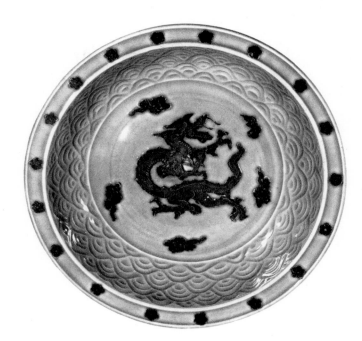

540. *Basin.* Longquan porcelaneous stoneware, diameter 17″. China. Yuan dynasty. Cleveland Museum of Art

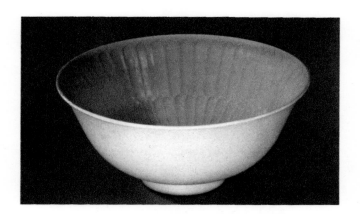

541. *Bowl. Shu fu* porcelain, height 3 1/2″. China. Yuan dynasty. Cleveland Museum of Art

tion of Blue-and-White. The earliest Blue-and-White dates from the fourteenth century and has been identified by John A. Pope as to type and date. The body is a fine white porcelain related to *shu fu*. The glaze is rather transparent, but slightly green and milky over the underglaze cobalt decoration on the white body. The forms are traditional ones, related to some of the Ci Zhou jars. They combine the strength to be found in folk wares with a rich decoration that would have been considered barbarous in the Southern Song period but evidently satisfied the new Mongol ruling class. The large jar from the Brooklyn Museum shows the elements of this four-

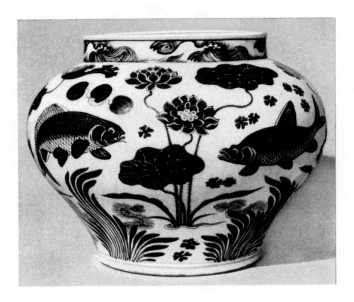

542. *Jar*. Porcelain with decoration in underglaze blue; height 12″. China. Fourteenth century A.D. Brooklyn Museum

teenth century Blue-and-White at their best (*fig. 542*). The decoration is pictorial. It might almost be a painting by one of the traditional Yuan dynasty painters of fish, such as Lai-An. The wave pattern on the neck is discontinuous from the main design on the body. The rich effect required great skill in draftsmanship and in the organization of the picture —for such it is—in relation to the shape of the vase. Blue-and-White represents a progressive tendency in the ceramics of the time, out of which developed the great Imperial porcelains of the Ming and Qing dynasties.

Sculpture

Sculpture continued under imperial patronage. Secular sculpture comprised mostly large-scale relief decorations for walls and gates, and Buddhist sculpture revived under the impetus of the new Tantric, or Esoteric, sects, whose complicated forms derived ultimately from Nepal (*fig. 543*) and Tibet. The Mongols and the Central Asians who flocked after them into China were strong adherents of these sects, and many sculptures of the time show Himalayan influence or handiwork. Still, nothing new of importance was said in the field of sculpture.

543. *Bodhisattva*. Dry lacquer, height 22 7/8″. China. Nepalese style. Yuan dynasty. Freer Gallery of Art, Smithsonian Institution, Washington, D.C.

Painting

Chinese creativity in the Yuan period flowed mostly into painting, and the innovations of this time dominated the work of all later artists. Those scholar-officials who withdrew from public life under the Mongols included many of the more creative painters; those who took service at court tended to be more academic and conservative. As we have said, it is usually rewarding to study first in the painting of any period its traditional or conservative aspects, which reveal by contrast what constitutes the originality of its progressive works. The tradition of the Song dynasty was by no means dead, and it was continued with some degree of quality and force by numerous painters of the day. The Southern Song tradition of Ma Yuan and Xia Gui, the tradition of "one-corner" or asymmetrical composition, was continued by masters such as Sun Junze, whose works are almost indistinguishable from those of his predecessors (*fig. 544*). His paintings, when first imported to Japan in the fourteenth century, were even more popular than those of Ma Yuan, until in the fifteenth century the Japanese discovered the great Southern Song masters themselves. Two types of Buddhist painting endured: brightly colored works in Tang and Song style that preserved, with some weakening of draftsmanship and composition, the ideas of the great

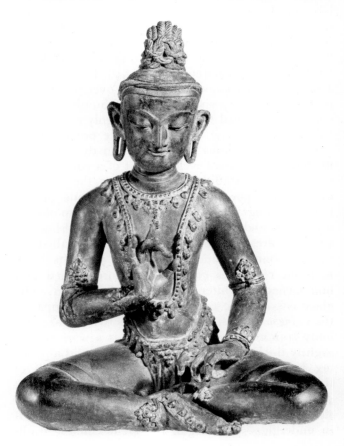

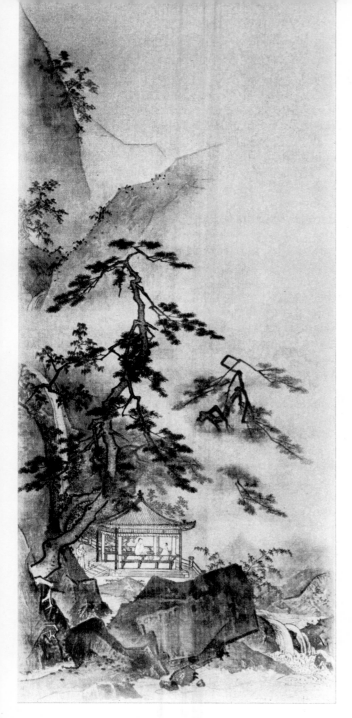

544. *Landscape*. By Sun Junze (act. beginning of fourteenth century A.D.). Hanging scroll, color on silk; height 56 1/8″. China. Yuan dynasty. Iwasaki Collection, Tokyo

massiveness of the figure recall the Tang tradition of Yan Liben, but that tradition is combined with something of the mysterious and romantic qualities of Southern Song, particularly in the distant rocks and water and in the rough and rapid treatment of the rock on which Li sits. Yan's own genius, particularly inclined to the grotesque, is to be found in the modeling of the figure itself, the sad eyes and projecting profile, the grotesquely twisted fingers and toes. There were also Buddhist paintings of the new Hima-

545. *Li Tieguai, Daoist Immortal*. By Yan Hui (c. fourteenth century A.D.). Hanging scroll, ink and color on silk; height 63 3/4″. China. Yuan dynasty. Chion-in, Kyoto

early Buddhist paintings, and another and more original form, though not part of the creative mainstream, best exemplified in the works attributed to the painter Yan Hui. Typically, they are found in Japan, where the Southern Song tradition has been prized, and are relatively rare in China, where it has been coolly regarded. Yan Hui painted Buddhist priests or disciples and Daoist sages, emphasizing their strange, gnarled, and rude aspects. *Li Tieguai, Daoist Immortal* gives some idea of Yan Hui's characteristic style (*fig. 545*). The large scale and

546. *Shi De* (one of two paintings of Han Shan and Shi De). By Yintuole (Indara; act. second half of thirteenth century A.D.). Hanging scroll, ink on paper; height approx. 36″. China. Yuan dynasty. Maeyama Collection, Tokyo

layan Lamaist iconography; some of these even show the stylistic influence of Nepalese painting.

A third type of Buddhist painting, representing a continuation of Song tradition, is found in the works of artists such as Indara, perhaps more properly known as Yintuole, whose art, unknown in China, is found only in Japan (*fig. 546*). Yintuole's work is derived from the Chan-inspired tradition of Mu-Qi and Liang Kai. The emphasis upon rapid and spontaneous use of ink, which reaches a culmination in Japan in the flung ink style, is evident in the picture of one of a pair of Buddhist sages, where the wet, dark washes of the edges of the garment are contrasted with the gray but sharply drawn strokes representing head and fingers, strongly recalling the style of Liang Kai. Numerous painters besides Yintuole worked in the Chan tradition. And since many Chan monks fled from the Mongols to Japan, it is only natural that their works should be found there in considerable quantity when even their names were lost to Chinese tradition.

Another aspect of traditionalism is found in paintings that cannot be classified as religious or official but are in a sense derived from other great Song traditions. Foremost among the artists in this vein, and oftentimes grouped with painters of the Song dynasty, was Qian Xuan, born in A.D. 1235, and particularly famous for bird and flower painting. Qian Xuan was a traditionalist in the Confucian sense. The subject matter of his figure paintings was derived from old Confucian stories, and his stylistic traditionalism consisted of a conscious archaism to be found in parts of the paintings attributed to him. Such a painting is *Home Again,* based on a prose-poem by the fifth century Tao Yuanming and embodying both traditional and new ideals (*colorplate 27, pp. 282–83*). The scholar-official returns from distasteful government employment to his rustic home in the country. The blue, green, and gold courtly style, common in Tang and early Song, is seen here in the touches of green, gold, and blue in the foreground rocks and especially in the far distant mountains to the right. The peculiar and exaggerated perspective of the old earthen wall at the far left makes it seem tilted, like the work of a Six Dynasties painter rather than a great master of the fourteenth century. The figures too, where they are not damaged or retouched, seem deliberately stiff and archaic. On the other hand, the fluent handling of the dead branches of the tree and the carefully realistic willow tree are very much up-to-date and in the accomplished still-life manner that was Qian Xuan's specialty. This picture is one of several short handscrolls that Qian based upon the life of the great Confucian poet and scholar Tao Yuanming, all of which share this combination of realism and archaism.

406

547. *Two Doves on a Branch of a Blooming Pear Tree*. By Qian Xuan (A.D. 1235–1290). Handscroll, ink and color on paper; height 12″, length 38 1/2″. China. Yuan dynasty. Cincinnati Art Museum

But Qian Xuan is most famous as a bird and landscape painter, and his paintings in this genre have something of the archaic manner seen in the handscrolls with landscape and figures. The pigeons on a pear-tree branch, illustrated in figure 547, are executed in this formal manner. The soft browns and the careful treatment of beak and eye recall the technique in the Northern Song academic painting of the *Parakeet* (*see fig. 470*). It is precisely the spirit one would expect from the traditionalist Qian Xuan, and the charm of these rather still silhouettes seems consistent with other paintings attributed to him. The bark of the pear branch is shaded at the outer edge, giving a semblance of volume, and painted with a blotting technique that uses a dry brush to absorb the ink and color on the branches, producing a crystalline pattern that simulates the texture of the rough bark in a mixed realistic and stylized way. The flowers and leaves, on the other hand, are painted with softness and delicate precision. These are almost surely characteristic works by Qian Xuan, judging from the remarkable recent chance excavation in an early Ming tomb of a monochrome handscroll depicting lotus, signed by the master. He is indeed an arch-disciple of the Song tradition rather than a forward-looking Yuan artist.

The second master often called a traditionalist is Zhao Mengfu (A.D. 1254–1322), so described because he abjured the protest of reclusion and rose high in the ranks of the Yuan government. Despite this collaboration with the barbarian, he was ranked by later Chinese scholars and critics as one of the greatest of painters and calligraphers—ample proof of his abilities. Unfortunately his name has become a byword for one subject: horses. Every Oriental horse painting from the year of Zhao's birth to the present day, with few exceptions, has been attributed to—indeed, inscribed by—this master. If, however, one studies the works reasonably attributed to Zhao Mengfu, a personality and a style emerge considerably at variance with the hackneyed view of Zhao Mengfu as a realistic horse painter. The Freer Gallery possesses a very short handscroll from the former Imperial Collection, the *Sheep and Goat*, with calligraphy by Zhao at the left in his characteristic rational yet pleasingly cursive style, which may well

548. *Sheep and Goat*. By Zhao Mengfu (A.D. 1254–1322). Handscroll, ink on paper; length 19″. China. Yuan dynasty. Freer Gallery of Art, Smithsonian Institution, Washington, D.C.

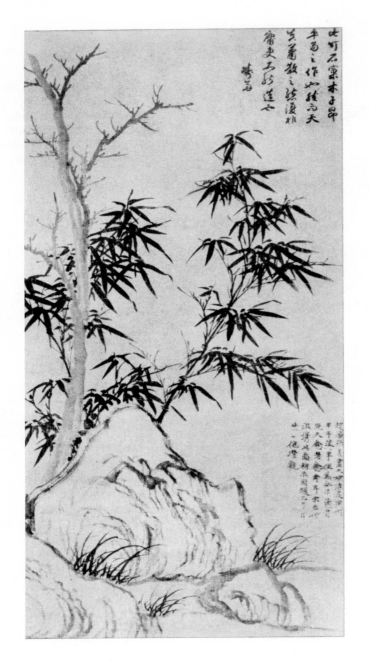

549. *Bamboo, Tree, and Rock.* By Zhao Mengfu (A.D. 1254–1322). Hanging scroll, ink on silk; height 39 1/8". China. Yuan dynasty. National Palace Museum, Taibei

provide us with a standard for judging other animal paintings attributed to him (*fig. 548*). The contrast between the sheep and the goat is made preternaturally sharp. The sheep is shapeless, pudgy, awkward, motionless, its dappled wool and stupid expression emphasized. But the goat is all grace and suggested movement, with emphasis on the delicate sharp hoofs, the firm spine, and the linear rhythm of the beautifully delineated long coat. The two are rendered with a minimum of line and effort, and the effect is convincing.

If this painting represents Zhao Mengfu's conservative style, there are other pictures, particularly those of bamboo and of landscape, that reveal a more original intent. The painting on silk of a dead tree with rock and bamboo at its base, in the National Palace Museum, is one of the finest examples of Zhao's originality (*fig. 549*). The rock is outlined with rapid strokes of the brush. The bamboo leaves are not painted in the careful traditional style, but rapidly, in an attempt to catch the warm, humid limpness of the plant. The tree is a tour de force, created with a large brush that outlined only in part the exterior edge of the trunk, leaving a rough texture of ink scraped over the silk to simulate bark and provide modeling in light and shade. This brushstroke, called "flying white" by the Chinese, is particularly associated with Zhao Mengfu. It requires extraordinary control of the brush and a sure sense of when to press and when to lift so as to produce the white areas in the center while the exterior edges of the brush produce the ink modeling. This brush discipline created bamboo-

550. *Autumn Colors on the Qiao and Hua Mountains.* Zhao Mengfu (A.D. 1254–1322). Dated to A.D. 1296. Handscroll, ink and color on paper; height 11 1/4", length 36 3/4". China. Yuan dynasty. National Palace Museum, Taibei

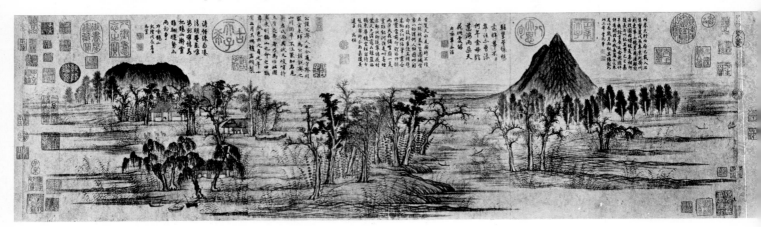

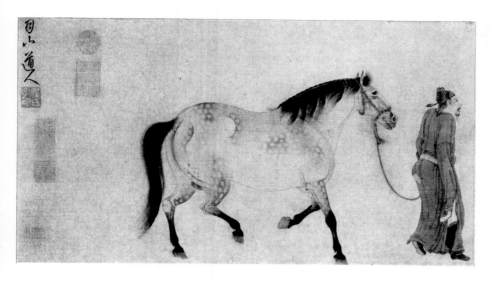

551. *Horses and Grooms*. By Ren Renfa (A.D. 1254–1327). Detail of the handscroll, ink and color on silk; height 11 3/8″, length 53 7/8″. China. Yuan dynasty. Cleveland Museum of Art

552. (below) *Old Trees*. By Cao Zhibo (A.D. 1272–1355). Dated to A.D. 1329. Hanging scroll, ink on silk; height 52″. China. Yuan dynasty. National Palace Museum, Taibei

and-rock pictures that influenced other painters of the fourteenth century and of the mid-Ming period as well.

But Zhao's historical importance rests on at least two handscrolls in which he invented the appearances of the *wen ren*, or scholarly, style: the *Autumn Colors on the Qiao and Hua Mountains* of A.D. 1296 (*fig. 550*), and *Water Village*, recently published from the Beijing Palace Museum and dated to A.D. 1302. These are the first of the seemingly artless works whose heavy reliance on open paper and superb brushwork are the invention of the Yuan artists and the hallmark of the *wen ren* style. Zhao's artlessness is obviously deliberate, as we can see by comparing *Autumn Colors* with the preceding two works. His aim seems to be to produce a work with only the barest pictorial existence, with the emphasis transferred to the writing of the brush. Obviously such a specialized manner appealed only to those "in" on the method—the *wen ren* themselves. Zhao's innovation was not to bear its full fruit until about A.D. 1350, in the work of the Four Great Masters.

Zhao Mengfu's son, Zhao Yong, is far more conservative than his father, less brilliant in brushwork but rather more solid in his approach to nature's shapes. Even more specialized than Qian Xuan or Zhao Mengfu is the archaistic painter Ren Renfa. His *Horses and Grooms* (*fig. 551*) harks back stylistically to the Tang horse painters, whose high quality of line and color it perpetuates most remarkably.

A group of important painters in the Yuan dynasty seems to have worked in both traditional and progressive styles, as Zhao Mengfu did. We will consider only two, the first being Cao Zhibo, who produced several pictures now in the National Palace Museum. One is *Old Trees*, dated to A.D. 1329, recalling the works of Li Cheng and Guo Xi, with its subject mat-

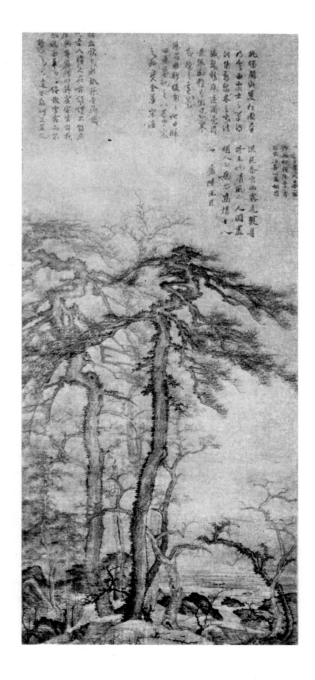

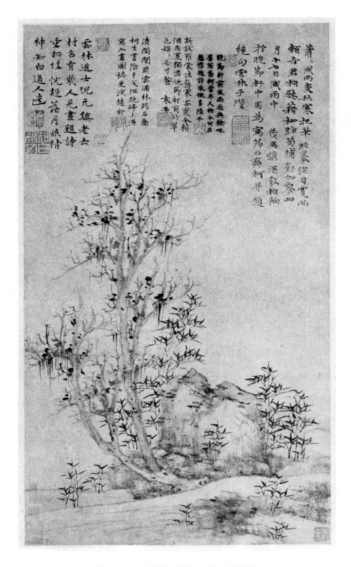

553. *Bamboo, Rock, and Tall Tree.* By Ni Zan (A.D. 1301–1374). Hanging scroll, ink on paper; height 26 1/2″. China. Yuan dynasty. Cleveland Museum of Art

ter of gnarled trees as symbols of Confucian morality and uprightness (*fig. 552*). But in the paintings attributed to the older masters forms are sharp and precise throughout. In *Old Trees,* by contrast, the foreground is sharp but the background fades out, an effect realized by a shift of light and shade that tends to make the painting visual and pictorial, something seen rather than something conceived solely in the mind and translated into brush terms. The shadowy pine in the middle ground behind the two sharply delineated foreground pines is a device developed in the Yuan dynasty and characteristic of many landscapes of that time. Still, such a picture, despite new tendencies, is fundamentally traditional. A characteristic *wen ren* rendering of a similar subject, painted some thirty years later by Ni Zan, shows how rapidly the *wen ren* style took hold and how consistent

a manner it was, considering the short time of its development (*fig. 553*). Cao seems far closer to the remote past of Northern Song than to the slightly younger artists of the near future.

The second painter who illustrates this combination of conservatism and progressivism is the painter Li Kan. Li Kan too paints old pine trees, in rather a stronger and more traditional style than that seen in the picture by Cao Zhibo. But in Li's painting of *Bamboo* a new style can be seen (*fig. 554*). The Chinese critic-scholar especially admires the strength of the brushwork and the accuracy of the brush in depicting bamboo leaves. No artist of the Song dynasty or earlier would have dared to emphasize so much the different tones of the leaves and to omit almost completely the actual stalk of the bamboo, an unusual effect which seems to have reached its height in this work.

In Li Kan's progressive pictures a great amount of white paper shows. This implied purity is most important and leads us to the Four Great Masters of the Yuan period, whose close connection with the traditionalists is demonstrated in one beautiful picture in the National Palace Museum in Taibei, a collaborative work of two men (*fig. 555*). The bamboo is painted by the great bamboo painter Gu An, the rock by one of the Four Great Masters, Ni Zan. In the delicate refinement of that rock with its barely sketched outline, in the emphasis upon a maximum of untouched paper and a minimum of ink, we have some of the qualities associated with Ni Zan and with at least two of the other three masters.

The Four Great Masters of the Yuan dynasty—Huang Gongwang, Wu Zhen, Ni Zan, and Wang Meng—are traditionally looked upon as founders of the new school of literary painting. Unlike Zhao Mengfu, they refused service under the new dynasty. They emphasized what might be described as an art-for-art's-sake attitude, a growing development and codification of calligraphic technique, and the importance of purity and cleanliness in mood. Works on silk by these men are almost unknown—an indication of the importance they attached to the calligraphic touch of the brush on paper and to the sharpness and precision with which the paper received the ink. Their subject is almost always landscape, that visible key to the invisible reality. They did not paint horses or still life or mundane things. It is also of some significance that they knew each other and restricted their acquaintanceship to like-minded *wen ren.*

Huang Gongwang (A.D 1269–1354), the oldest of the Four Great Masters, is known through very few works indeed. A long handscroll on paper, painted between A.D. 1347 and 1350 and representing the Fuchun Mountains, is the only work of major im-

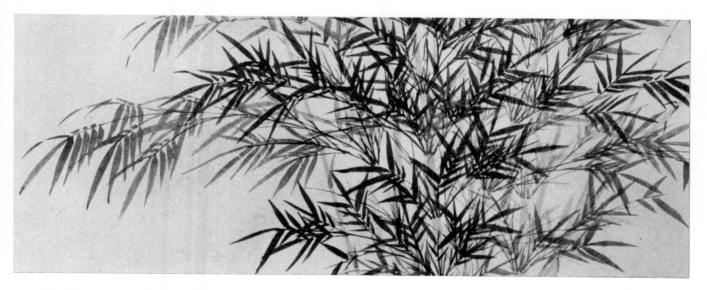

554. *Bamboo*. By Li Kan (A.D. 1245–1320). Dated to A.D. 1308. Section of the handscroll, ink on paper; height 14 7/8″, length 93 1/2″. China. Yuan dynasty. Nelson Gallery–Atkins Museum, Kansas City. Nelson Fund

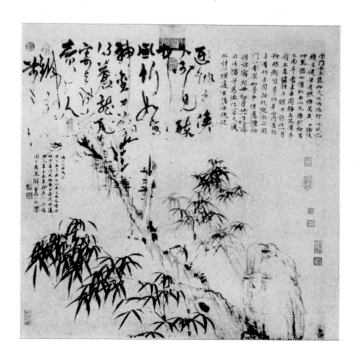

555. (right) *Bamboos, Rocks, and Old Tree*. By Gu An (act. c. A.D. 1333) and Ni Zan (A.D. 1301–1374). Hanging scroll, ink on paper; height 36 3/4″. China. Yuan dynasty. National Palace Museum, Taibei

556. (below) *Dwelling in the Fuchun Mountains*. By Huang Gongwang (A.D. 1269–1354). Dated to A.D. 1347–50. Section of the handscroll, ink on paper; height 12 7/8″, length 20′11″. China. Yuan dynasty. National Palace Museum, Taibei

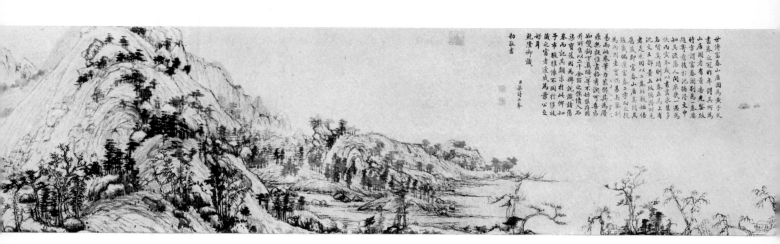

557. *Poetic Feeling in a Thatched Pavilion.* By Wu Zhen (A.D. 1280–1354). Dated to A.D. 1347. Handscroll, ink on paper; height 9 3/8", length 39 1/8". China. Yuan dynasty. Cleveland Museum of Art

portance possibly from his hand (*fig. 556*). He was influenced by the monumental style of Northern Song, but instead of the closed Northern Song composition in which mountains could be seen in their fullness and to their heights, the Yuan master arbitrarily used the mountains as a means of orchestrating the length of the handscroll, cutting off the tops at will, extending the *repoussoirs* and points of land beyond the lower limits of the handscroll. Note the use of the paper and ink, particularly the emphases created by closely grouped sharp strokes, which replaces the older practice of dispersing the ink throughout the surface of the paper. One can say of this, as of most late *wen ren* works, that it is written, not painted. The style can be complex, as in the heavy mountain scene illustrated, or simple, as in another section of the same scroll, where the dry, almost barren topography supports only a small clump of trees at the center, revealing the close connection between the art of Huang Gongwang and that of Ni Zan. Huang's works seem more complicated and cerebral than those of his two colleagues to be considered next.

In place of rationality and complexity Wu Zhen (A.D. 1280–1354) offers intuitional simplicity, conveyed in coldly brilliant ink. His brusque shorthand, epitomized by the Chinese as the "single-stroke" style, combines rapid certainty with calculated but bold compositions and deliberately rough representations. The handscroll *Poetic Feeling in a Thatched Pavilion,* dated to A.D. 1347, embodies these qualities in a nostalgic reverie of scholarly delights, which would have been hackneyed but for the artist-individualist's deliberate obliteration of sentimentality (*fig. 557*). Until one realizes that the content of the scroll is primarily bold brushwork, supported by a daring use of open paper and sharp tonal contrasts, *Poetic Feeling* is incomprehensible. Perhaps the qualities that distinguish Wu from the other three masters grew out of his love of painting bamboo, which requires ultimate discipline of brushwork and effective-

ness of each single stroke. But Wu's brushwork never degenerates into mere formula. The early Chinese scholar-painter might force man and man-made things into set forms, but never landscape, the prime subject of his art. This was inviolate until the sixteenth century innovator Dong Qichang succeeded in transforming landscape into pure painting.

The *Poetic Feeling* scroll is entirely given over to the original brusque, sharp, single-stroke style associated with Wu Zhen's name, but other pictures, particularly in the National Palace Museum—notably a hanging scroll with twin pine trees by a ferry crossing—indicate his sources for that style. Like so many of the creative Yuan masters, he looked back to the monumental landscape style of Northern Song and especially to the powerful brushwork of Ju-Ran (*fig. 558*). And it was brushwork that ultimately became Wu Zhen's main preoccupation, whereas the monumentality of the earlier master is reflected in but a few hanging scrolls. This one might almost be taken for a Ju-Ran, were it not that the tilted mountain creates a tension more characteristic of a later period than the tenth century. The sharp break between the foreground and the distant mountains on the far right, linked by that wide, bare expanse of water, is most typical of Yuan masters. In detail the brushwork is summary, sharp, and bold—an end in itself. Still, these essays by Wu Zhen in Northern Song style are so effective that some have been taken for Song originals, and certain paintings in the National Palace Museum, hopefully attributed to Ju-Ran or Dong Yuan, are probably by Wu Zhen. Wu Zhen's art is "rough," in the very best sense of that word. It is a sturdy, forthright style, not necessarily pleasing at first sight, largely dependent upon the strength and simplicity of its brushwork. Consequently, he is enormously admired by the Chinese and rather more difficult for the Western critic and connoisseur to approach.

The third of the Four Great Masters of the Yuan dynasty, Ni Zan (A.D. 1301–1374), is the most famous

away—the scholar-painter-amateur background, the eccentricity, the snobbism—Ni's paintings alone qualify him as one of the Four Great Masters of Yuan. In contrast with Wu Zhen and Huang Gongwang, Ni Zan's forte is neither strength of brushwork nor intellectual consistency; he is preeminently a poet in paint. His style is delicate, almost feminine in its effect. His brushstrokes are specialized: long, thin lines to define rocks or mountains, short, delicate dashes for bamboo or leaves or the shrubbery on distant mountains. His compositions are characteristically simple, usually a dominant rock, a few trees, a few sprigs of bamboo, sometimes a pavilion, often a distant mountain, never a human being. Their effect is greatly dependent upon sensitive placement and upon that tension, characteristic of the period, between foreground and background widely separated by water. The *Rongxi Studio,* its empty pavilion perhaps symbolizing the artist's disdain for humanity, is pure Ni Zan (*fig. 559*). As Chinese painting texts

559. *The Rongxi Studio.* By Ni Zan (A.D. 1301–1374). Dated to A.D. 1372. Hanging scroll, ink on paper; height 29 3/8″. China. Yuan dynasty. National Palace Museum, Taibei

558. *A Lone Fisherman on a River in Autumn (after Ju-Ran).* By Wu Zhen (A.D. 1280–1354). Hanging scroll, ink on paper; height 74 3/8″. China. Yuan dynasty. National Palace Museum, Taibei

of them all, not only for his painting, which certainly excites our admiration and interest, but also for his legendary character. To the Chinese he was the scholar-painter par excellence, and no praise was higher than to compare a painting to the work of Master Ni. Son of a wealthy family, he began painting relatively late and always described himself as an amateur. His inscriptions record a certain nonchalance, a certain contempt for the ordinary workaday world that greatly appealed to the later Chinese scholar-critic. With the biographical clichés stripped

repeat, great painters used their ink sparingly, as if it were gold, and Ni Zan is most sparing in his use of ink. In paintings such as this the blank paper dominates, with brushstrokes scattered on its surface like notes of quiet music. Ni Zan invented a characteristic brushstroke much imitated in later times—a crystalline stroke that begins fluently and then angles sharply. Such strokes are used repeatedly in the rocks and mountains, sometimes one on top of the other to produce *cun,* or wrinkles, and effects of light and shade. Ni Zan has been extravagantly admired and much imitated, making his works perhaps the most difficult to authenticate in all of Chinese painting.

Some three and one-half centuries later the great individualist painter Dao-Ji characterized Ni Zan's art: "The paintings by master Ni are like waves on the sandy beach, or streams between the stones which roll and flow and issue by their own force. Their air of supreme refinement and purity is so cold that it overawes men. Painters of later times have imitated only the dry and desolate or the thinnest parts, and consequently their copies have no far-reaching spirit."[18]

Although the tall, vertical landscape with the sharp separation of near and far is characteristic, there is another type of composition for which Ni is equally famous, from which the elements of landscape are largely omitted and only the bare essentials are left: a rock, a tree, and bamboo. There are several of these, including the one in Cleveland (*fig. 553*). Here the brushstrokes are crystalline and the dots are sparingly used. The same kind of dot indicates a lichen on a rock or a leaf on a tree. The bamboo is less readily recognizable than in versions by the great Song master Wen Tong, or by Li Kan or

Wu Zhen, nor does it have that systematic organization or strength of brushstroke supposedly essential in all bamboo painting. Ni Zan, speaking of one bamboo painting, explains what he sought: "[Chang] I-chung always likes my painted bamboo. I do bamboo merely to sketch the exceptional exhilaration in my breast, that's all. Then, how can I judge whether it is like something or not, whether its leaves are luxuriant or sparse, its branches slanting or straight? Often when I have daubed and smeared a while, others seeing this take it to be hemp or rushes. Since I also cannot bring myself to argue that it is bamboo, then what of the onlookers? I simply don't know what sort of thing I-chung is seeing."[19] And by that last sentence he means that he really doesn't care, an attitude shared by contemporary painters in the West. Ni Zan stands among the first conscious rebels against tradition.

The *Lion Grove in Suzhou* (*fig. 560*), painted toward the end of his life, reveals an unusual aspect of his art. This famous garden (*see colorplate 40, p. 392*) featured curious and fantastic rock formations suggesting lions' heads and bodies. Using his typical brushwork, the artist has created a composition with hardly a focal point or pattern; rather it is a collection of individual elements placed on the paper with relatively equal emphasis. Here his limitations in comparison with the other three of the Four Great Masters are revealed. Ni's compositions tend to be simple and stereotyped; everything depends on the mood and the sparse brushwork, in contrast with the boldness of Wu Zhen or the complexities of Huang Gongwang and Wang Meng. But however enjoyable the individual details of brushwork in the *Lion Grove,* one senses in its lack of focus a curious aloofness. At

560. *Lion Grove in Suzhou.* By Ni Zan (A.D. 1301–1374). Handscroll, ink on paper. China. Yuan dynasty. Whereabouts unknown

the left of the scroll are the famous rock formations behind a typical Ni Zan bamboo grove, more texture than bamboo. The architecture is summarily rendered and certainly repudiates the earlier pictorial ideal of a believable, habitable building. Instead it is part of the new individualist trend, an abstract pattern of brushstrokes intended to represent an aesthetic statement, not a gross material thing.

Its varied textures relate the *Lion Grove* scroll to the work of the last of the Four Great Masters, Wang Meng (A.D. 1308–1385). Wang was the youngest of the group and perhaps less famous in his time than Wu Zhen, Huang Gongwang, and Ni Zan. Nevertheless his style greatly influenced later Chinese painting, and in some ways he stands as the most original and creative artist of the four. Where Ni Zan was simple, noble, and elevated, Wang Meng is complex and almost coarse, with his hemplike, ropy brush-

561. *Scenic Dwelling at Juqu.* By Wang Meng (A.D. 1308–1385). Hanging scroll, ink and color on paper; height 27 1/4″. China. Yuan dynasty. National Palace Museum, Taibei

562. *The Dwelling in the Qingbian Mountains.* By Wang Meng (A.D. 1308–1385). Dated to A.D. 1366. Hanging scroll, ink on paper; height 55 1/2″. China. Yuan dynasty. Shanghai Museum

strokes piled one on the other to produce masses of texture combined in dense and extremely involved overall patterns. Wang reminds us of something that most Chinese landscape painting and theory largely ignore—that nature can be restricted and unkempt as well as vast and ordered. By Yuan dynasty standards, it is a viewpoint of extreme heterodoxy. *Scenic Dwelling at Juqu* is the most complex and congested of his works, perhaps the most extreme example of his horror of a vacuum (*fig. 561*). Nevertheless the closely woven brushstrokes are not merely a surface

563. *Leisure Enough to Spare*. By Yao Tingmei. Dated to A.D. 1360. Handscroll, ink on paper; height 9″, length 33″. China. Yuan dynasty. Cleveland Museum of Art

pattern but have substance and do imply movement in restricted space. Textural analysis and variations are the staples of his style, which was somewhat tidied up in the numerous works "after Wang Meng" by later *wen ren* painters. These dynamic compositions by Wang Meng retain elements of monumentality. Their very complexity recalls details of Northern Song masters. One masterpiece by Wang Meng, *The Dwelling in the Qingbian Mountains*, dated to A.D. 1366, may with reason be considered the most monumental of all Yuan landscapes (*fig. 562*). The combination of rich brushwork, undulating contours, grand scale, and size is unforgettable—and so it proved for later Chinese painters fortunate enough to see it, such as Dong Qichang, who painted the same subject almost three hundred years later (*fig. 598*). Wang Meng, then, is the last of the great fourteenth century masters and, appropriately enough, lived to act as a link between the artists of Yuan and those of the Ming dynasty.

A painting by a little-known master, Yao Tingmei, will serve to sum up the interests and contributions of the Yuan painters. It is a short handscroll formerly in the Imperial Collection, dated to A.D. 1360 and entitled *Leisure Enough to Spare* (*fig. 563*). *Leisure Enough to Spare* is on paper, the favorite ground of Yuan painters, and represents an oft-repeated subject: a hut, a scholar seated by a waterfall, an old gnarled pine tree, and distant mountains. There is nothing new in this, but the disposition of elements is important, and the brushwork more so. The twisted strokes in the rocks and trees, the crumbly textures of the rocks around the waterfall, the style of the architecture, the distant mountains, and the rhythmical swirling of the pine boughs as they reach out to repeat the rolling motif of the distant hills, all recall the style of Wang Meng. The painting is followed by colophons written by famous poets and calligraphers

of the Yuan and Ming dynasties, all extolling the virtues of leisure, and particularly of scholars' leisure. In this it is characteristic of the Yuan period, when the gentleman-scholars attained the preeminence they enjoyed till the mid-twentieth century. True painting was not a profession but a recreation of gentleman-scholars, intimately connected with poetry. Inscribed on almost all Yuan paintings, even hanging scrolls, are numerous poems, either encomiums of the painting or poetic analogues of the pictorial mood, but rarely the literal descriptions of the painting found on many works of the Song dynasty.

THE MING DYNASTY

Beginning in the 1340s a succession of natural disasters exacerbated Mongol incompetence and disunity and Chinese antipathy to "barbarian" rule, touching off a series of rebellions that culminated in the founding of the Ming dynasty by the peasant-born Chinese Hong Wu emperor. Accompanying this native resurgence was a wish to obliterate the Yuan experience from every department of life, including the arts and crafts, and to turn back for inspiration past the defeated Song to the potent Tang dynasty. The Hong Wu emperor proved a ferocious and paranoid antiintellectual, whose purges decimated the painters, scholars, and calligraphers tolerated under the supposedly tyrannical Mongol rule and whose persecutions depleted the scholar-gentry class. Nevertheless the arts flourished under the Ming dynasty, mainly by virtue of strong imperial political and economic support in all fields. Imperial patronage was revived in painting. A great imperial kiln complex was set up in Jiangxi Province at Jingdezhen, where all the great porcelains of the Ming and Qing periods were made.

Lacquer, textiles, and all those industries that require stable conditions and dependable patronage proliferated and prospered.

Now, however, a real gulf appeared between art and handicraft, a split that had germinated in the attitudes of the Song scholar-painters. The scholar-painter differentiated between the work of the artist, in our sense of the word, and that of the artisan; and in the term artisan he included painters who worked in the Ma-Xia style of the Southern Song dynasty, and painters of religious pictures, and all those who were not amateur scholar-gentlemen but professionals who made their living by their art. Of course the term also included all ceramic, lacquer, and textile workers.

Architecture and City Planning

Since the Ming dynasty was a period of strongly centralized administration and reasonable peace and prosperity, both reconstruction and new building were undertaken on a grand scale by the government. Much of present-day Beijing—the general layout of the city, the Temples of Heaven and Earth, and the palace—is Ming dynasty design, executed by the architects of the Yong Le emperor.

The Ming architects whose work dominates the present Beijing scene made no fundamental changes in architectural construction. Earlier techniques were merely elaborated. Post-and-lintel construction, bracketing, tile roofing, stone platforms, the modular system of bays—all were retained in the Ming period.

The plan and organization of cities and of palace areas is one of the most significant manifestations of the Chinese mentality. The orientation of a typical Chinese city or palace is based upon philosophical and cosmological concepts primarily rational in origin and geometrical in appearance. The aerial view of the Imperial City in Beijing shows logical order and symmetrical arrangement which, while characteristic of most great empires and pyramidal political structures, was developed with distinctive Chinese consistency and balance (*fig. 564*). The area is almost square, and its principal buildings and gates face south along the north-south axis. Other buildings and gates front on the main axis, and yet others are disposed in walled compounds along the same north-south axis. The thickly clustered buildings on the east within the Forbidden City housed offices and departments of the imperial government, and their number and structural elaboration suggest the intricacy of the political organization.

The whole is surrounded, of course, by a wall. The wall, so essential to a Chinese city, village, or town, temple, palace, or house, achieved not only protection but also privacy for the unit within, symbolizing

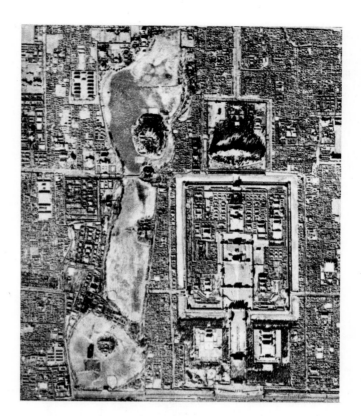

564. *Forbidden City.* Beijing, China. Aerial view

that containment and strong in-group feeling characteristic of the Chinese family and of Chinese society in general.

One approaches the walled Imperial City from the south. The Gate of Heavenly Peace (Tian-an Men) comprises five vaulted gateways topped by a pavilion with double eaves lines. This is the entrance to the Imperial City enclosed by the Inner City. A short distance beyond the Gate of Heavenly Peace is the similar Noon Gate (Duan Men), opening into a plain courtyard formerly flanked by the Altar of Agriculture and the Imperial Ancestral Temple. Proceeding north, one arrives at the Meridian Gate (Wu Men), which housed government offices and held flanking pavilions above its massive wall with jutting wings. The Meridian Gate is the entrance to the Imperial City and leads to a spacious courtyard crossed from east to west by a bow-shaped waterway spanned by five parallel arched marble bridges, symbolic of such auspicious fives as the five elements, the five virtues, and the five Confucian relationships. Beyond the bridges is the Gate of Supreme Harmony (Tai-he Men), set high on a marble platform and flanked by subordinate buildings. North of the Tai-he Men is an even larger courtyard, the precinct of the three primary ceremonial halls, whose impor-

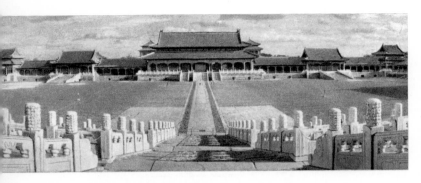

565. *Tai-he Men (Gate of Supreme Harmony)*. As seen from the platform of the Tai-he Dian (Hall of Supreme Harmony). Forbidden City, Beijing, China. Ming dynasty, A.D. 1627 and after

566. *Hall and Garden of the Summer Palace*. Beijing, China. Seventeenth–eighteenth century A.D. and after

tance is emphasized by the three-staged white marble terrace on which they stand. The largest is the Hall of Supreme Harmony (Tai-he Dian), where ceremonies for the new year, the winter solstice, and the emperor's birthday were held (*fig. 565*). Directly behind stands the small square Hall of Middle Harmony (Zhong-he Dian), and beyond is the Hall of Protecting Harmony (Bao-he Dian), where the emperor met the embassies of vassal states and scholars whose successful examinations made them eligible for office. On either side of the surrounding court, which was walled in with galleries, were large pavilions used for libraries, temples, the government printing office, and halls for Confucian lectures and for sacrifices to ancient sages.

Behind the Hall of Protecting Harmony the Qian Qing Men (Gate of Celestial Purity) leads to the inner court, where the buildings, which repeat on a smaller scale the plan and shape of the three ceremonial halls, were devoted to the emperor's personal life. In the Palace of Cloudless Heaven he held audiences; imperial seals were kept in the square pavilion behind it; and the farther Palace of Earthly Tranquillity was that of the empress. Beyond and surrounding this central core of palaces were walled-in compounds with gardens for royal residence, the emperor's ancestral hall, his library, offices, studies, theater, Daoist, Lamaist, and Buddhist temples, treasure rooms, and a park.

So, through symmetry and balance, masses of buildings—relatively uniform in structure, shape, and color—create a serene and magnificent pattern. Their ordering was related to their function, and the whole organization symbolized the underlying harmony of the universe which, in the age-old tradition, the emperor, Son of Heaven, maintained on earth.

Three basic building types, the hall (*dian*), the tower (*tai*), and the pavilion (*ting*), were unified by their common elements: tile roof, bracketing, stone platform, and modular bays constructed of wooden posts and lintels. The tile roofs of Ming buildings were highly decorative. Glazing techniques were advanced to permit mass production, and black-and-white photographs belie the colorful patchwork of city roofs—gray, blue, green, and, in Beijing, yellow for the imperial palaces. The effect is brilliant, not unlike the mosaic-covered domes of Persian mosques. Bracketing, too, was elaborate, with much polychrome painted decoration. In contrast to Japan, where monochromatic and subtle coloring was desired, the whole tendency of Chinese architecture was toward brilliance and vivid contrast.

In less official architecture, associated particularly with the residences of the aristocratic or well-to-do and even found in the Summer Palace outside Beijing, informality ruled, though the principles of balance and symmetry remained. Such buildings were less elaborate and their bracketing was simpler, tending to draw attention away from the building to its surroundings, as if the resident had consciously moved into a landscape to escape the "dusty world" of officialdom.

Lattice was developed in these less formal surroundings to an amazing degree of complexity and variation within the simple purpose of providing interesting grilled windows. But the environs of the Chinese palace or house are quite different from the restrained and natural-seeming gardens of Japan (*fig. 566*). The Chinese garden reflects the same interests and tastes as does painting—a fondness for old and interestingly shaped trees, sometimes of great size; flowers and living still lifes in beds or basins as if arranged from or for a painting; and above all

strange and fantastic rocks that suggest mountains or fabulous beasts, such as the Lion Rocks of the garden in Suzhou made doubly famous by Ni Zan. The Chinese garden is more formal and obviously composed than the Japanese with its emphasis on the appearance of spontaneity and on the careful suppression of any evidence of man's handiwork. The use of cut stone in pavements or railings or planted borders creates an effect reminiscent of European garden styles (*colorplate 40, p. 392*).

Ceramics

Centralization of power and money in the emperor and his court was a spur to the decorative arts. In old records the quantities of porcelains or lacquers ordered by the court for a given year are nothing short of astounding. Seventeen thousand first-class "round" pieces was a commonplace order for the Imperial kiln, and this for only one year. Such figures suggest the extent of subsequent destruction: The wonder is not that we have so many Chinese porcelains but that we have so few.

In the private kilns Song traditions were maintained. The distinctions between northern and southern wares continued. Ci Zhou ware—northern slip-decorated stoneware—was still produced in quantity at the great beehive kilns, though the quality began to decline. In the south, in Zhejiang Province, celadon wares were made for domestic use as well as for export in great quantities. These Ming celadons are found throughout Indonesia, Southeast Asia, India, and Japan, wherever the Chinese export trade flourished. But these are fundamentally regressive wares, less fine than in earlier times. The creative wares were the Imperial wares, made at Jingdezhen in Jiangxi Province.

We have seen that during the Yuan dynasty a new porcelain style evolved from the *qingbai* tradition of the Song dynasty, beginning with the *shu fu* ware made for the Yuan court. Decoration in underglaze blue began at this time, and the technique was available at the beginning of the Ming dynasty for further advances and refinements. We will consider this florescence in a chronological sequence of basic types, beginning with monochrome white porcelain and white porcelain with decoration painted in underglaze blue. The classic period for white porcelain was the Yong Le reign (A.D. 1403–24). Although Blue-and-White and monochrome colored wares were produced as well, it is usually accepted that the white porcelains of the reign are among the greatest ever made (*fig. 567*). The body of these white porcelains is almost pure white with a slight grayish tinge and has a tendency to burn slightly pink or yellow where the glaze stops. A transparent glaze enhances the

brilliant whiteness of the body, and many vessels were further enriched by incised or molded decoration under the glaze, so subtle and so skillfully executed that much of it qualifies as *an hua*—secret or hidden decoration. Since the shapes were often wheel-thrown, particularly the vases (some bowls being made by slip casting), the surfaces of the pieces are slightly irregular. The relatively thick transparent glaze fortified the irregularity, producing an undulating surface with a texture that the Chinese liken to various citrus skins. These variations, lovingly described and catalogued by the Chinese collector, are in sharp contrast with the more perfect, glossy-smooth glazes standard in the best porcelains of the Qing dynasty.

The next step in the development of porcelains was the addition of underglaze decoration, already begun in the Yuan dynasty. In the Ming dynasty such underglaze decoration in cobalt blue was applied in a variety of styles and with extraordinary color control. Although Blue-and-White porcelain was made during the Yong Le reign, the Xuan De reign (A.D. 1426–35) is considered by many to be its classic

567. *Vase*. Porcelain, height 12 5/8". China. Ming dynasty, reign of Yong Le (A.D. 1403–24). Mr. and Mrs. Severance A. Millikin Collection, Cleveland

period, in which decoration achieved a notable clarity of drawing and richness of color, as seen in such objects as the large plate with concentric designs of grapes, flowers, and waves (*fig. 568*). The variety of early Ming shapes is extraordinary, including dishes, vases, teabowls, wine cups, and utensils for Buddhist ceremonial offerings. The designs are typically in blue verging on blue black, with a pleasing unevenness of shade contrasting with the more perfect but colder blues of later times. Despite their rich decoration the Xuan De Blue-and-White porcelains convey an impression of austerity and simplicity.

Underglaze copper red is a far more difficult medium than cobalt blue, tending to turn faded brown or cold gray at the high kiln temperatures needed for porcelain. A few pieces of varying quality exist from the Xuan De period. The dragon bowl in the Percival David Foundation shows one of the rare successful marriages of underglaze blue and underglaze copper red (*fig. 569*).

Enamel color, later a most important decorative technique, was added to rare pieces of Xuan De Blue-and-White. A singular specimen bears the six-character imperial mark, as did most of the porcelains made at the factory, inside the bowl of a stem cup decorated with a wave pattern in underglaze cobalt blue (*colorplate 41, p. 425, top*). Sporting in the waves are mythical beasts rendered in overglaze red enamel. The addition of a second color enriches the effect. The transition from this relatively sparing use of enamels to the gay and brilliant five-color enamels of the later Ming dynasty probably occurred in the Cheng Hua reign (A.D. 1465–87). A unique Cheng Hua wine cup, once in the palace, was copied in the Zheng De period (A.D. 1506–21), suggesting that it was already a classic specimen. Cheng Hua enameled porcelains are usually of the so-called three-color type: underglaze cobalt blue with overglaze red and green enamels. The small wine cup, only some two inches high, combines freedom of drawing and pure, clear enamel color with a glaze that was perhaps one of the finest technical achievements of the Chinese potter (*colorplate 41, p. 425, center*). The slightly greenish tinge of the glaze and the slightly yellowish burn

568. *Plate.* Porcelain with grape decoration in underglaze blue; diameter 17″. China. Ming dynasty, reign of Xuan De (A.D. 1426–35). Cleveland Museum of Art

569. *Bowl.* Porcelain with decoration in underglaze blue and copper red; diameter 6 3/4″. China. Ming dynasty, mark and reign of Xuan De (A.D. 1426–35). Percival David Foundation of Chinese Art, London

570. *Dice bowl.* Porcelain in curdled underglaze blue; diameter 9 1/2″. China. Ming dynasty, mark and reign of Xuan De (A.D. 1426–35). Percival David Foundation of Chinese Art, London

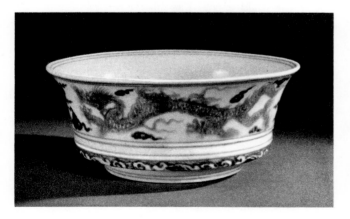

of the thin glaze and body at the foot are firm indications of authenticity. Such wares were much copied from the next reign to modern times and are the rarest of all the enameled porcelains of China. The five-color enamels, which became the standard decorated ware, may also have originated in the Cheng Hua period but reached their apogee in the Jia Jing (A.D. 1522–66) and Wan Li reigns (A.D. 1573–1620). To make the small but brilliantly colored Wan Li covered jar, parts of the decoration were painted in underglaze blue onto the white body and covered with transparent glaze. Over this fired glaze the decoration was completed in red, green, yellow, and brown enamels, and the whole refired (*colorplate 41, p. 425, bottom*). The complex process required several firings, but the final result was a richly colored ware, admirably effective in narrative scenes and freely painted floral designs, which became even more refined and complex in the Qing dynasty.

The Imperial kilns were set up for mass production or at least for the division of labor. One man made the pot; a second painted the decoration; a third glazed it; yet others applied the enamels. The painting of a pot can be a rapid and even mechanical business for a man who has done it his whole life long, as did his father and grandfather before him, and such hereditary specialization often obtained.

Simultaneous with the development of two-, three-, and five-color porcelains arose monochrome porcelains of more subtly brilliant aspect, using either colored glazes or colored overglaze enamels. In the Xuan De reign, monochrome vessels with a copper red glaze, the so-called sacrificial red, were made. They are extremely rare, and genuine examples are to be counted, even from the former Imperial Collection, on the fingers of two hands. The red is usually a little mottled and is sometimes described as "liver red." The feature that distinguishes this early Ming copper red glaze from the rather more common and more famous *lang*, or "ox-blood" red, of the late Ming and Qing dynasties is to be found where the red meets the white of the body at foot and lip. In the earlier "sacrificial red" vessels the transition is subtle and cloudy; in the later "ox-bloods" it is much sharper and clearer (*colorplate 42, p. 426, right*).

Predictably, monochrome blues were also made. Uniform cobalt blue glazes were relatively common in later reigns, but the "curdled" blue of the Xuan De reign is of great beauty and rarity (*fig. 570*). This curdled blue embodies the same taste for forms grotesque, ancient, and gnarled that led to the creation of Chinese rock gardens. Bowls of the same shape occur often in underglaze Blue-and-White and in plain white. This bowl has very thick walls and appears to have been used as a dice bowl for gaming.

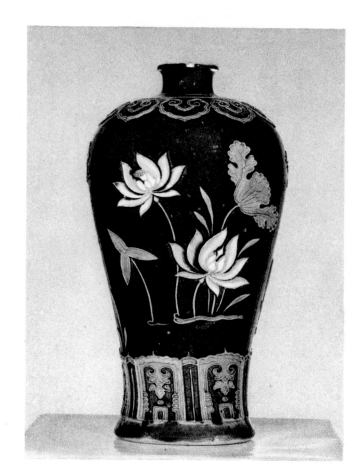

571. *Mei-ping vase. Fa hua porcelain, height 14 3/4".* China. Ming dynasty, late fifteenth century A.D. Cleveland Museum of Art

The most famous monochrome ware of the Ming dynasty is the overglaze yellow-enameled porcelain, most often found in bowls and plates (*colorplate 42, p. 426, left*). The classic period for resonant yellow is the reign that produced the great three-color porcelains, Cheng Hua, though the yellows of the following Hong Zhi (A.D. 1488–1505) and Jia Jing (A.D. 1522–66) reigns are also important.

Porcelains of great interest and importance were also made outside the Imperial kiln. *Fa hua* decorated ware is one of these, a process deliberately imitating cloisonné enamel (*fig. 571*). The white porcelain body was decorated with raised flowers or figures outlined in slip, and the areas inside the raised slip boundary were painted with various enamels. On this lotus-decorated *mei-ping* the lotus blossoms are reserved in white and covered with transparent enamel, and the balance of the design is pale yellow and pale blue enamel against a background of dark blue glaze. The result seems very much in keeping with the Blue-and-White tradition, and in this vase has a restraint not always found in the *fa hua*

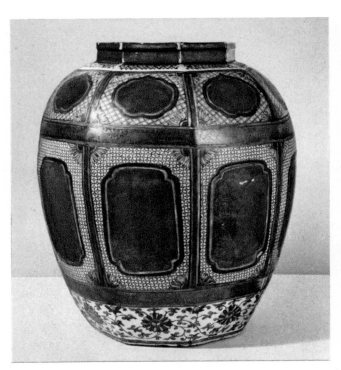

572. *Octagonal jar.* Porcelain with overglaze enamels; height 15". China. Ming dynasty, early sixteenth century A.D. Percival David Foundation of Chinese Art, London

573. *Guanyin. Dehua* porcelain (*blanc de Chine*), height 17 3/4". Fujian, China. Late Ming or early Qing dynasty, c. seventeenth century A.D. Cleveland Museum of Art

574. *Wine bottle. Punch'ong* stoneware, height 10 1/2". Korea. Yi dynasty, fifteenth–sixteenth century A.D. National Museum of Korea, Seoul

575. *Vase.* Porcelain with decoration in underglaze blue and copper red; height 17 1/4". Korea. Yi dynasty, A.D. 1599–1717. Private collection, Japan

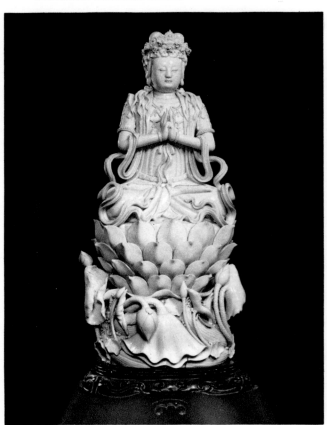

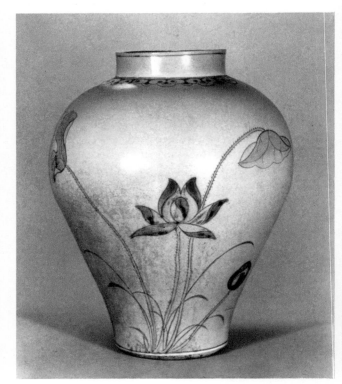

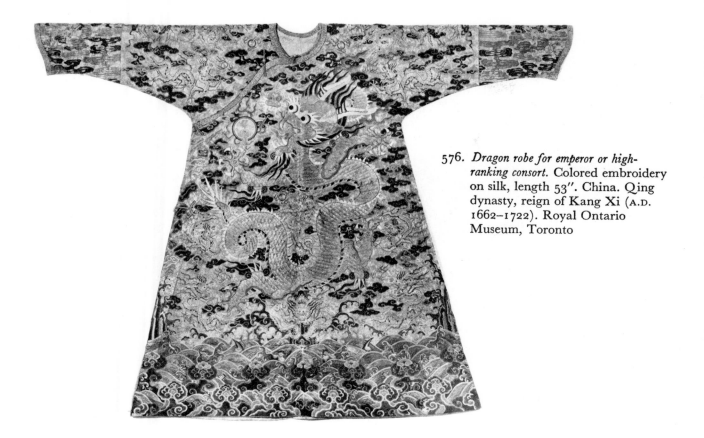

576. *Dragon robe for emperor or high-ranking consort.* Colored embroidery on silk, length 53". China. Qing dynasty, reign of Kang Xi (A.D. 1662–1722). Royal Ontario Museum, Toronto

technique. There were also three-color and five-color bowls and vases embellished with gilding in addition to the overglaze enamel decoration. These were made for use in China, but especially for export to Japan. The vase in the Percival David Foundation suggests their rich, almost brocaded effect (*fig. 572*). Indeed, in Japan they were called brocaded vessels and were very much sought after for use in the tea ceremony. Later Japanese imitations founded a new tradition of Japanese porcelain in the seventeenth and eighteenth centuries.

White porcelain, the so-called *blanc de Chine,* more properly called by its Chinese name, Dehua, probably inspired by the Imperial porcelains of the Yong Le period, was made in large quantities in Fujian Province, near the seacoast (*fig. 573*). It was sold in China and exported. The white porcelain of Fujian can often be distinguished from that of the imperial kiln by its creamier color and glassier surface.

Korean Ceramics

Related to these Ming porcelains as a country cousin to the urban sophisticate are the porcelains produced in the sixteenth and seventeenth centuries under the Yi dynasty in Korea. These somewhat rough but original variations on Koryo and Ming themes greatly influenced Japanese stoneware and porcelain of the seventeenth and eighteenth centuries. Precisely

those qualities of devil-may-care informality derived from hasty and unconstrained technique endeared the Yi ceramics to the Japanese tea-ceremony devotees.

Among the considerable variety of Korean ceramics two types are especially worthy of mention. One is derived from the decorated celadons of the Koryo period, with white or gray slip beneath the now grayer green celadon glaze (*fig. 574*). Sometimes this slip is merely wiped onto a smooth surface, and the marks of the cloth or brush form the sole decoration other than the glaze. In other vessels the slip is wiped over punched, incised, or carved abstract, floral, or fish designs before the piece is glazed. These stonewares are matched by heavy-bodied porcelains with decoration in underglaze blue or, more rarely, blue and copper red (*fig. 575*). The spare and hasty but sure drawing is notable. Such porcelains were little appreciated until the modern Japanese folk art (*mingei*) movement and allied Western aesthetic trends brought attention to them.

Textiles

The textile industry flourished in the Ming period. The *ke si* silk tapestry technique was continued and was often used to produce pictorial effects, even to copy famous paintings (*colorplate 43, p. 427*). The results are never direct imitations but art forms in

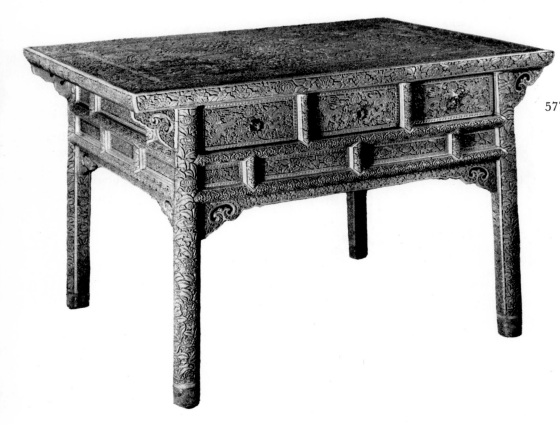

577. *Table*. Cinnabar lacquer with carved design, length 47″. China. Ming dynasty, mark and reign of Xuan De (A.D. 1426–35). Victoria and Albert Museum, London

their own right, with flat, soft color schemes that enhance the tapestry technique. Embroidery continued as an important textile industry, and the growing use of elaborate costumes whose decoration designated the wearer's social status or official rank furnished a continuing market (*fig. 576*). Few, if any, Ming robes have survived, but many early examples preserve their style.

Lacquer

As early as the late Zhou period lacquer had been used for painted designs of remarkable finesse and beauty. This art attained what was probably its second peak in the Ming dynasty. The same imperial patronage responsible for the great porcelains required carved cinnabar lacquer, painted lacquer, and incised or gilded lacquer of high aesthetic quality. The early reigns of the Ming period, such as Yong Le and Xuan De, are well known for their carved cinnabar lacquer. The table in the Victoria and Albert Museum dates probably from the Xuan De reign (*figs. 577, 578*). The dragon is of the type found on the underglaze Blue-and-White porcelains, but here the red color combined with richly sculptured low relief produces an effect quite different from the austerity of the Blue-and-Whites and rather closer to the aesthetic overtones of the *ke si* and embroidered textiles and polychrome enameled

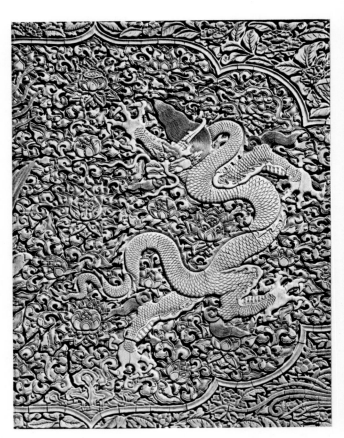

578. *Table*. Detail of fig. 577

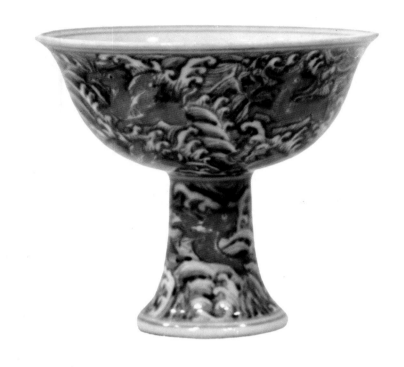

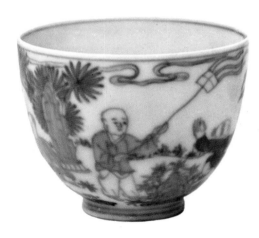

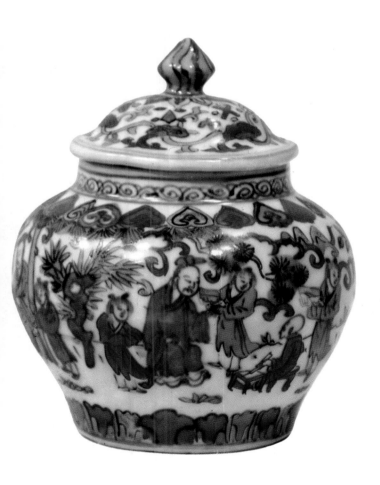

Colorplate 41. (above left) *Stem cup.* Porcelain with
decoration in underglaze cobalt blue and overglaze iron
red enamel; height 3 1/2″. China. Ming dynasty, mark and
reign of Xuan De (A.D. 1426–35). (above right) *Wine cup.*
Porcelain with three-color decoration in underglaze cobalt
blue and overglaze red and green enamels; height 1 7/8″.
China. Ming dynasty, mark and reign of Cheng Hua (A.D.
1465–87). (left) *Covered jar.* Porcelain with five-color
decoration of underglaze cobalt blue and overglaze red,
green, yellow, and brown enamels; height 4″. China.
Ming dynasty, mark and reign of Wan Li (A.D. 1573–1620).
All: Cleveland Museum of Art.

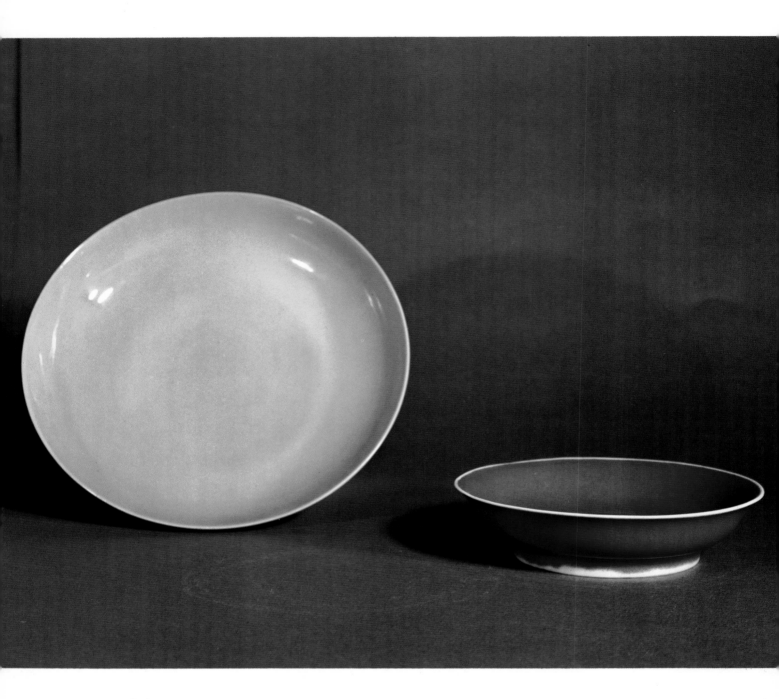

Colorplate 42. (left) *Plate*. Yellow-enameled porcelain, diameter 8 3/8″. China. Ming dynasty, mark and reign of Cheng Hua (A.D. 1465–87). (right) *Plate*. Porcelain with copper red glaze, diameter 5 1/4″. China. Ming dynasty, mark and reign of Xuan De (A.D. 1426–35). Both: Mr. and Mrs. Severance A. Millikin Collection, Cleveland

Colorplate 43. *Ke si*. Silk and gold tapestry, length 78″. China. Ming dynasty. Cleveland Museum of Art

Colorplate 44. *Emperor
Guang Wu of the Western Han
Dynasty Fording a River.* By
Qiu Ying (act. c. A.D. 1522–c.
1560). Hanging scroll, ink
and color on silk; height
67 1/4″. China. Ming
dynasty. National Gallery
of Canada, Ottawa

Colorplate 45. *Landscape*. By
Wen Boren (A.D. 1502–
1575). Hanging scroll, ink
and color on paper; height
70 1/2″. China. Ming
dynasty.
Cheng Te-kun Collection,
Hong Kong

Colorplate 46. *Lotus*. By Chen Shun (A.D. 1483–1544). Handscroll, ink and color on paper; height 12″, length 19′1″. China. Ming dynasty. Nelson Gallery–Atkins Museum, Kansas City. Nelson Fund

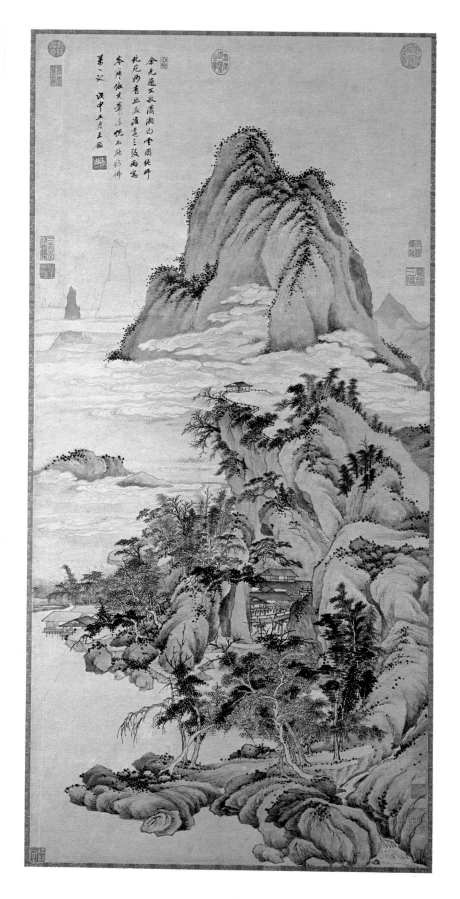

Colorplate 47. *White Clouds over Xiao and Xiang (after Zhao Mengfu)*. By Wang Jian (A.D. 1598–1677). Dated to A.D. 1668. Hanging scroll, ink and color on paper; height 53 1/4″. China. Qing dynasty. Freer Gallery of Art, Smithsonian Institution, Washington, D.C.

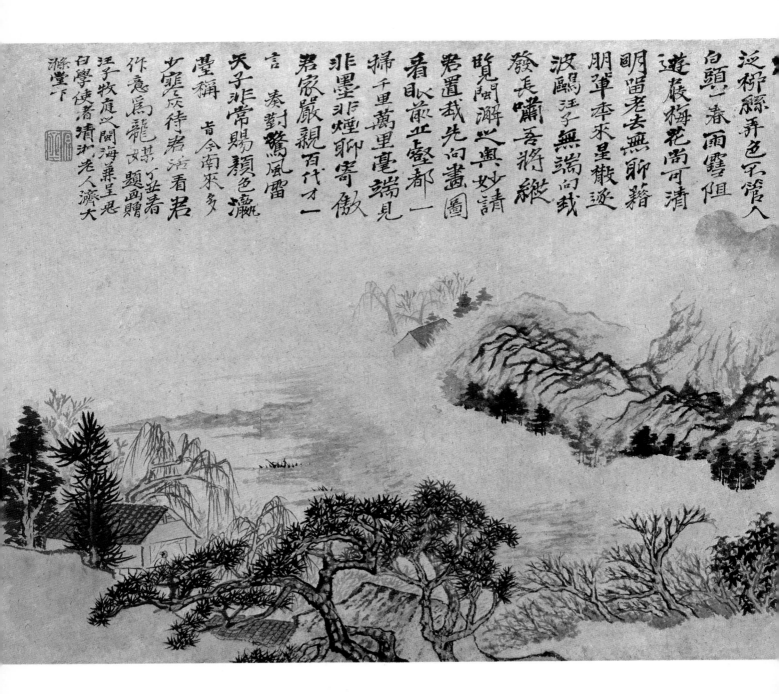

泛柳縣弄色不留人
白頭一春雨雪阻
遊蓬梅花尚可清
明晚老去無耶籍
朋翠牽來星幾逐
波酈汪子無端向我
發長嘯吾將縱
覽閒澥之奧妙請
君置裁先向畫圖
看眼嚴正壑都一
掃千里萬里毫端見
非墨非煙聊寄傲
君家嚴親百代才一
言 奏對驚風雷
天子非常賜顏色壞
壘稱 古今南來多
少婆娑待君泷看君
作意為龍媒改題畫贈
汪子牧庭以閒海菜生思
白學使者清汕老人濟大
滌堂下

Colorplate 48. *Spring on the Min River*. By Dao-Ji (Shi-Tao; A.D. 1641–1707). Dated to A.D. 1697. Hanging scroll, ink and color on paper; height 15 3/8″. China. Qing dynasty. Cleveland Museum of Art

579. *Plate.* Carved lacquer with design of garden and terrace scene; diameter 13 1/2″. China. Ming dynasty, reign of Yong Le (A.D. 1403–24). Mr. and Mrs. John D. Rockefeller, 3d Collection, Asia Society, New York

580. *Chest.* Lacquer with incised and gilded design; width 22 3/8″. China. Ming dynasty, reign of Xuan De (A.D. 1426–35). Victoria and Albert Museum, London

581. *Chest.* Detail of fig. 580

porcelains. The lacquer is built up layer on layer before being carved, a painstaking technique requiring superlative patience and near-magical skill. In the rare authentic examples from the early Ming period the carving has a vigorous and slightly rounded quality quite different from the later flat and decorative effects. In the early reigns the carved cinnabar technique was used principally for dragon and peony and lotus decoration; pictorial effects, rare at first, later became increasingly popular. The shape of the plate in figure 579 is derived from porcelain shapes; its decoration, showing a garden and terrace scene, is inspired by the work of academic court painters. Each pattern, whether of waves or clouds, is carved with refinement and delicacy and developed consistently, logically, and painstakingly, so that one texture complements another. In contrast with the monochrome cinnabar red of the early Ming carved lacquers, those of the Jia Jing and Wan Li periods combined cinnabar with black, dark brown, and occasionally yellow. Painted lacquer, often in the form of trays and dishes, was generally for ordinary use. But the most complicated technique used by the imperial lacquer craftsmen required the incising of the lacquered object with a design, often of dragons, flowers, or *feng-huang*, the simple coloring of the incised design with a few colored lacquers, and finally the gilding of details to bring out linear elements of the design. This technique is seen at its best in the chest with drawers dating from the Xuan De reign (*fig. 580*). A view of the whole chest reveals the richness of the design, which is related to the pictorial effects of later Ming porcelain and textiles. A detail (*fig. 581*) displays the meticulous refinement characteristic also of the carved lacquers of the middle Ming period.

Painting

If we consider the history of painting during the Ming dynasty solely as a chronological sequence, we do a stylistic injustice to the material. The very early years of the dynasty, from about A.D. 1368 to 1450, show a continuation of the styles already formulated by the conservative and the creative masters of the Yuan dynasty. The period from A.D. 1450 until the close of the dynasty in 1644 witnesses a steady stream of creative painting, almost all of it by members of

the scholarly class that we have seen emerging as the dominant school of Chinese painting. The body of critical writing on painting is enormously enlarged during these centuries, contributed to by nearly all the scholars, scholar-painters, and scholar-critics. A great body of work surrounds the figure of the painter-critic Dong Qichang (A.D. 1555–1636), who with his immediate associates was principally responsible for the classification of all painters into the "northern" or "southern" school. Although the terms are arbitrary and misleading, they are essential to any discussion of Chinese painting.

The distinction is neither geographic nor in any way associated with the Northern and Southern Song periods. It is a critical distinction, based on a tenuous analogy with the northern and southern schools of Chan Buddhism in the Tang dynasty. "Northern" implied, on the whole, reactionary and bad, "southern" implied progressive, good, and scholarly. The "northern" school was derogated by the literati as a professional artisan school, and to this limbo they relegated court painters, academicians, practitioners of all realistic, decorative, or romantic styles, including Ma Yuan and Xia Gui. The "southern" school they held to begin with Wang Wei of the Tang dynasty and to include subjective, expressive, calligraphic painting. The differentiation was beclouded, however, with moral considerations: Zhao Mengfu's art was impeccably "southern," but his allegiance to the Mongol government barred him from the "southern" category. Fundamentally the two categories reflect a qualitative and class distinction, and different critics have been known to assign the same painter to different schools. For us these distinctions are of secondary importance. The conservative Ming masters, whom we shall consider first, fell largely into the "northern" school, the more progressive *wen ren* painters into the "southern" school.

The early years of the Ming dynasty saw the continuation of numerous conservative tendencies already in evidence during the early Yuan period. For example, the "blue-and-green" Tang landscape style, exploited by Qian Xuan and Zhao Mengfu, was continued by some of the early Ming court painters. A second type of conservative painting of quality and interest is associated with the Zhe school, so called after Zhejiang Province where many of its practitioners lived. This school, banished by later Ming critics to the "northern" category, produced some of the most interesting paintings in the Ma-Xia

582. *The Poet Lin Pu Walking in the Moonlight.* By Du Jin (act. c. A.D. 1465–1487). Hanging scroll, ink and slight color on paper; height 61 5/8". China. Ming dynasty. Cleveland Museum of Art

583. *Peacocks.* By Lin Liang (active c. A.D. 1488–1505). Hanging scroll, ink on silk; height 63 1/2″. China. Ming dynasty. Mr. and Mrs. Severance A. Millikin Collection, Cleveland

tradition. Such masters as Dai Jin (A.D. 1388–1462), whose famous *Fishermen on the River* scroll is in the Freer Gallery in Washington, or Wu Wei (A.D. 1459–1508), with his rapidly brushed figures of sages and scholars, are typical Zhe school masters. A fine picture and a rare example of the work of Du Jin, a master of the Zhe school, is *The Poet Lin Pu Walking in the Moonlight* (*fig. 582*). It is a hanging scroll with slight color on paper and represents a famous poet of earlier times. He is walking between two rocks on a path by a stream; nearby is a twisted tree with one branch thrust beneath the water's surface—a typical motif of early Ming painters. The style, based on that of the Ma-Xia school, is even freer and seems halfway between the lyric and the spontaneous. The brushwork depicting the twigs and branches of the tree is of particular interest, as is the pictorial effect of the pale figure before the lightly washed rock, creating a visual impression of moonlight. Associated with these conservative painters is the great bird and bamboo artist Lin Liang, active until about A.D. 1505. One of his paintings represents two peacocks in a bamboo grove (*fig. 583*). In a picture of this type the Chinese approach the decorative style of the great Japanese painters of the Momoyama and Tokugawa periods. But what distinguishes this painting from Japanese decorative style is precisely that sober and rational control of composition we feel to be Chinese, and especially that emphasis upon the integrity of every brushstroke which is at the heart of all Chinese painting. The Chinese painter will never, as the Japanese painter occasionally may, sacrifice the ideal nature of the brushstroke to the decorative requirements of the painting by making a brushstroke that is primarily decorative in itself. Thus, if we examine the tail of the great cock, with the differentiation of tones in the eyes of the feathers, and the contrasts between the long, thin strokes of the tail feathers, the sharp, heavy strokes of the wing feathers, and the shorter, fuzzier strokes of the hackle feathers, we see that the brushwork has maintained its inflexible integrity at the same time that it differentiates natural textures in the most subtle way. The contrasts, for example, between the softness of the feathers, the firmness of the body underneath, and the spiny, stiff legs and talons of the bird are remarkably well achieved. The bamboo is a classic example of fifteenth century bamboo painting, and again, every stroke reveals the sharpness and sure

placement achieved by the great Yuan bamboo painters. Lin Liang's bamboo is rather delicate in the leaves but very firm in the construction of the main stalks of the plant. The rationality of the composition is evident, particularly in the use of thrusting diagonals and the balancing of the principal stalk of bamboo by the large area of rock at the lower right.

Yet another form of conservatism at the beginning of the Ming dynasty consisted of a continuation of the creative styles of the Four Great Yuan Masters, the scholar-painters Huang Gongwang, Wu Zhen, Ni Zan, and Wang Meng. Xu Ben, who worked in this vein, is a transitional figure. He began painting at the end of the Yuan dynasty and became an official at the Ming court, where he offended the ruthless Hong Wu emperor and so died in prison in A.D. 1403. Xu Ben arrived at a style of his own within Wang Meng's idiom. In the small *Streams and Mountains,* one of his few extant paintings, he, like Wang Meng, emphasized texture, covering the whole

surface of the picture, except for a very small area of sky, with brushstrokes that produce the foliage of trees and bushes and the wrinkles of mountains (*fig. 584*). The composition is extremely complex, taking its compositional devices from the Northern Song period rather than the forbidden masters of Southern Song, the Ma-Xia group, called "northern" school by the critics. Xu Ben, of course, was an accepted member of the "southern" school, a major figure in the tradition of the late Yuan period. A close view of *Streams and Mountains* discloses again that Chinese integrity of brushwork which we have already analyzed in the quite different work by Lin Liang.

584. *Streams and Mountains.* By Xu Ben (d. A.D. 1403). Hanging scroll, ink on paper; height 26 3/4". China. Ming dynasty. Mr. and Mrs. A. Dean Perry Collection, Cleveland

585. *Beggars and Street Characters.* By Zhou Chen (d. after A.D. 1534). Dated to A.D. 1516. Section of the handscroll, ink and light color on paper; height 12 1/2", length 96 1/4". China. Ming dynasty. Cleveland Museum of Art

In the clearly distinguished deciduous foliage conventions—triple-dotted foliage, straw stick foliage, and black dot foliage—each stroke, each dot, each movement of the brush that puts ink to paper can be looked at as an individual stroke and not found wanting. In this, perhaps, is one of the major distinctions not only between Chinese and Japanese painting but also between Chinese and Western handling of the brush. In the West the usual intention until recently has been to obliterate the brushstroke in order to achieve the effect of reality in nature. In the scholarly "southern" tradition, on the contrary, the artist insisted primarily upon precision and integrity of brushwork, even at the expense of verisimilitude to nature.

Three painters stand between the "northern" and "southern" schools of the early Ming period. They have been called both "northern" and "southern" but should be associated with the conservative group. The first of these is Zhou Chen (d. after A.D. 1534), probably the master of the other two painters of this triad, Tang Yin (A.D. 1470–1523), and Qiu Ying (act. c. A.D. 1522–c. 1560). Zhou's landscapes owe much to Li Tang of the middle Song period. His carefully controlled brushwork can be found in numerous handscrolls and hanging scrolls, on both silk and paper, well composed and full of rich detail. In this he was probably surpassed by his two major followers, but one of his surviving works displays a singular facet of his artistic character—his interest, unusual for its day, in low life and the grotesque. In general, the subject matter appropriate for the later Chinese painter, and especially for the scholar-

painter, was landscape. If he did paint figures, they would illustrate famous narrative histories of the past, scenes from famous poems, or members of his own class. He might occasionally turn out pseudo-poetic representations of woodcutters or peasants, idealized images of Confucian rusticity. But Zhou Chen seems to have an almost sociological interest in the lower classes. Whether it was sympathetic or critical the paintings do not divulge. A handscroll made up of leaves from an album and now divided between the Cleveland Museum and the Honolulu Academy is one of the most striking, touching, and powerful works by this very important artist (*fig. 585*). It is a representation of unfortunates, a series of single or paired figures executed in ink and color on paper: a gaunt and demented-looking woman with an infant at her shriveled breast; a poor beggar in tatters leading a dog. The other figures are crippled or diseased, and all are subjects unpleasant in themselves and outside the accepted range of subject matter. Another of his pictures, in the Princeton University Art Museum, represents a cockfight with a group of peasants watching. Zhou Chen applies the brush discipline learned from his master with a rapid and free technique to these unusual subjects. The one precedent for this subject matter is the demons and damned souls appearing in the subsidiary parts of Buddhist icons representing scenes in hell.

Tang Yin also reaches back beyond the Zhe school to the great Song master Li Tang, whose work is transitional between the early monumental style of the Northern Song dynasty and the lyrical style of the Ma-Xia school. Tang Yin occupied a somewhat similar position in the late fifteenth century. His brushwork is rather conservative—a means of representing nature with relative realism as well as an expressive end in itself—and his compositions are sober. He characteristically builds up his rocks from the center to the surface, like an oyster producing a pearl, creating a shell-like form with a series of strokes of increasing circumference. His mostly tall, vertical compositions are monumental in the earlier tradition, but with overtones of poetic unity implying a mood quite different from the generalized and cool aloofness of the Northern Song painter. In a hanging scroll in the National Palace Museum, a monumental landscape format presents a summery and luxuriant scene with a marked counterpoint between the rich and soft textures of the foliage and the more austere and angular faces of rocks and mountains (*fig. 586*). One is always conscious of a vigorous and robust talent behind his brushwork. Most of Tang Yin's paintings, like those of the Song masters, are on silk, the characteristic medium of the conservative "north-

586. *Murmuring Pines in a Mountain Path.* By Tang Yin (A.D. 1470–1523). Hanging scroll, ink and slight color on silk; height 77 1/2". China. Ming dynasty. National Palace Museum, Taibei

ern" painters; the scholarly painters of the "southern" school tended to work on paper.

Qiu Ying is one of the most admired and forged of Chinese painters. He worked in a variety of styles with a sheer technical skill that commanded the nuances of Tang, Song, or Yuan styles at will. He was famous for his copies of pictures, some of them painted for such great patrons as the noted sixteenth century collector Xiang Yuanbian. His technical brilliance in the execution of minuscule detail as well as his broad and abstract use of the brush earned the respect of

437

critics who would gladly have relegated his type and style to the "northern" school. In the West he is maligned with an endless series of album leaves and scrolls representing aristocratic ladies in bright colors playing in the park or puttering in houses—pretty, decorative paintings in the worst sense of the words. Needless to say, these are nearly all forgeries produced by the artisans of Hangzhou and Suzhou, who have manufactured Qiu Yings ever since the in-

587. (above) *A Harp Player in a Pavilion.* By Qiu Ying (act. c. A.D. 1522–c. 1560). Hanging scroll, ink and color on paper; height 35 1/8''. China. Ming dynasty. Museum of Fine Arts, Boston

588. (right) *Landscape in the Style of Ni Zan.* By Shen Zhou (A.D. 1427–1509). Dated to A.D. 1484. Hanging scroll, ink on paper; height 54''. China. Ming dynasty. Nelson Gallery–Atkins Museum, Kansas City. Nelson Fund

evitable demand began. From these poor counterfeits to Qiu Ying's finest works is a tremendous distance. A large landscape, *Emperor Guang Wu of the Western Han Dynasty Fording a River*, shows his conservative style at its very best (*colorplate 44, p. 428*). The figures illustrate a subject derived from Western Han history, but they are relatively unimportant in the overall composition. In general style the work shows the influence of Tang Yin and of the early Southern Song painters, notably Zhao Boju. But *Emperor Guang Wu* is visually unified in a way that the Song painters never attempted: foreground, middle ground, and background are continuously and plausibly related. The virtuoso handling of detail is carried to such a degree that even a magnifying glass reveals nothing cursory or imperfect. Opaque color of considerable brilliance produces a decorative effect that probably did not endear him to the scholar-critics of the succeeding century. Almost all the paintings of Qiu Ying, regardless of size, can be characterized as the works of a great miniaturist, in which the smallest brush, sensitively used, creates exquisitely refined detail. He also had strong antiquarian interests, and friends such as the collector Xiang Yuanbian enabled him to study Song ceramics and bronzes of the Shang and Zhou dynasties. His pictures are full of archaistic details that are archaeologically accurate and interesting, and this too distinguishes his work from the later artisans' copies. One of the finest and most unusual pictures by Qiu Ying in this country is a hanging scroll on paper in the Museum of Fine Arts in Boston, showing a lady in a summer pavilion set among a grove of trees beside a large lake or river (*fig. 587*). Here Qiu Ying rivals the scholar-painter at his best. In its pure, serene air and in the distant view of mountains and spits of land the style of Ni Zan is apparent, but in the exquisitely fine detail of the scholar's table and female attendants we see the delicate miniature quality that is most characteristic of the style of Qiu Ying. His architecture is accurate and believable, the implements on the table in the scholar's study are correct in drawing, and yet the painting of the trees and their foliage, despite its lapidary precision, shows a freedom and spontaneity of brushwork that make him one of the great painters of the Ming dynasty.

The "southern" style of the early Ming period is dominated by one great master and his immediate successor, Shen Zhou (A.D. 1427–1509) and Wen Zhengming (A.D. 1470–1559). Shen Zhou was the founder and leading spirit of the Wu school, named for the district around Suzhou where its members lived, and Wen Zhengming was his pupil. Between them, they set standards for scholarly painting that lasted until the end of the sixteenth century. Shen Zhou looked especially to the traditions of the Four

589. *Gardeners*. By Shen Zhou (A.D. 1427–1509). One of five album paintings mounted as a handscroll, ink and color on paper; height 15 3/4″. China. Ming dynasty. Nelson Gallery–Atkins Museum, Kansas City. Nelson Fund

Great Masters of the Yuan period. In works such as the hanging scroll dated to A.D. 1484 one cannot mistake the style of Ni Zan: the tall thin trees, the open spaces of paper, the dotted brushwork indicating lichens on the rocks, the open, spare style in the distant mountains (*fig. 588*). But in the hands of Shen Zhou, Ni's style becomes much stronger, bolder, and sturdier, revealing in this the predilection that led Shen especially to the works of Wu Zhen. Wu was famous for a powerful, economical style, representing figures with just four or five telling brushstrokes or a landscape with a few washed and a few sharp strokes. Shen Zhou's mastery of the style equaled Wu Zhen's, and to it he added in certain works a boldness of composition and touches of color that anticipate several of the seventeenth century individualists. His masterwork in this country is a series of album paintings, mounted as a handscroll (*fig. 589*). One of the album leaves shows idealized peasants working in the fields beyond a wooden fence. The leaves and trunks of the trees, and more especially the outlines of the peasants' bodies, show the powerful, emphatic brushstroke derived from Wu Zhen. But the complex composition, with its zigzagging fence and its trees that fade to nothingness as they approach the alley at the central axis, is characteristic of Shen Zhou's advanced interests. The finest of the leaves in this scroll depicts a poet on a bluff overlooking a chasm, in heavy and rich ink with slight color on paper (*fig. 590*). It is a monu-

590. *Poet on a Mountaintop*. By Shen Zhou (A.D. 1427–1509). One of five album paintings mounted as a handscroll, ink and color on paper; height 15 3/4″. China. Ming dynasty. Nelson Gallery–Atkins Museum, Kansas City. Nelson Fund

mental composition, with a great thrusting mountain topped by a steeply tilted plateau, and at the right a temple in a fold of hills. The artist's brush made rapid, thick strokes, the mountains being represented by simple, even-toned washes, rather abstract, even cold. The mood of the picture combines the coldness—in the best sense of the word—attributed to Ni Zan with the strength of Wu Zhen. Shen Zhou's paintings are not "attractive"; he does not make picturesque and charming compositions. He inherited the revolution instituted by the Four Great Masters of Yuan and consolidated it, producing an objective and complete rendition of its aims.

The last leaf of the scroll under discussion is by Shen's pupil, Wen Zhengming (*fig. 591*). Its inclusion in this scroll illuminates the difference in temperament and style between the two men. Wen's leaf, depicting a stormy seashore, with trees and a small boat being driven by the wind and rain, shows the same disciplined brush as the album pages by Shen Zhou: the same manner of outlining tree trunks, the same manner of forming foliage and

591. *Storm over the River*. By Wen Zhengming (A.D. 1470–1559). One of five album paintings mounted as a handscroll, ink and light color on paper; height 15 1/4″. China. Ming dynasty. Nelson Gallery–Atkins Museum, Kansas City. Nelson Fund

rocks. But his painting is much more elegant, without that brusque coldness found in Shen Zhou's work. The distant waves are broken and curled, painted in a delicate, detailed style almost like Qiu Ying's or the paintings of Southern Song. In the trees and foliage the strokes are not quite as wide, the dots not quite as fat as Shen Zhou's, while the number of dots in the rocks is reduced so that the elegant profile becomes more evident. The effect is of a refined, aristocratic, and elegant rendition of Shen Zhou's style: in short, what we would expect in Wen Zhengming's early work.

But Wen's fully developed style, complex and gnarled, is completely his own, though much imitated in later times. Its most characteristic exemplars are works like the hanging scroll of a high waterfall amid grotesque cypress and cedar trees, in the National Palace Museum (*fig. 592*). Executed in ink and color on paper, it has overtones of Qiu Ying's detailed rendition, but the tightly knit and convoluted composition conveys a slightly inverted, even repressed, quality that seems characteristic of Wen Zhengming. The grotesqueness of Wen's trees and rocks and his interest in tortured and intertwined forms also appear in a more fluid work, *Old Pine Tree* (*fig. 593*), and in the small *Old Cypress and Rock* (*fig. 594*). The former is daring in its composition, with the partially seen pine tree moving in and out of the handscroll format to produce an expanding, larger-than-life effect. The likeness of the tree to dragons is made explicit in the artist's own inscription on the painting and is part of the metamorphic character to be found in many of Wen's later works. *Old Cypress and Rock* is a perfect jewel and an epitome of Wen's brilliant brushwork and ability to convey the age and complexity of nature's elements. In this it embodies concepts analogous to those found in the Chinese garden (*see colorplate 40, p. 392*)—indeed, Wen Zhengming is reported to have contributed to the design of at least one of the famous Suzhou gardens, that of the "Impractical Official."

Wen Zhengming painted in many different styles, but this seems to be his most characteristic and most creative manner. The ability of the Chinese painter, especially of the Ming and Qing painter, to adopt different styles did not proceed from lack of integrity but is, rather, comparable to a musician's

592. *Old Trees by a Cold Waterfall.* By Wen Zhengming (A.D. 1470–1559). Dated to A.D. 1549. Hanging scroll, ink and color on paper; height 76 3/8". China. Ming dynasty. National Palace Museum, Taibei

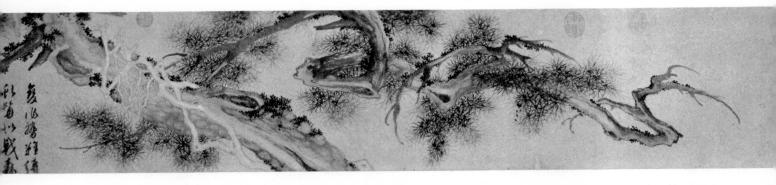

593. *Old Pine Tree.* By Wen Zhengming (A.D. 1470–1559). Handscroll, ink on paper; height 13 3/4″, length 54″. China. Ming dynasty. Cleveland Museum of Art

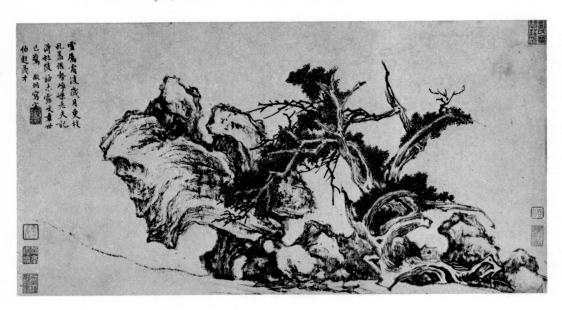

594. *Old Cypress and Rock.* By Wen Zhengming (A.D. 1470–1559). Dated to A.D. 1550. Handscroll, ink on paper; height 10 1/4″. China. Ming dynasty. Nelson Gallery–Atkins Museum, Kansas City. Nelson Fund

595. *Rocky Landscape.* By Lu Zhi (A.D. 1496–1576). Handscroll, ink and color on paper; length 44 3/4″. China. Ming dynasty. Nelson Gallery–Atkins Museum, Kansas City. Nelson Fund

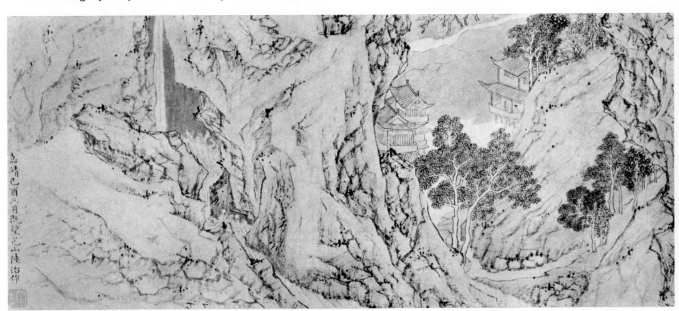

442

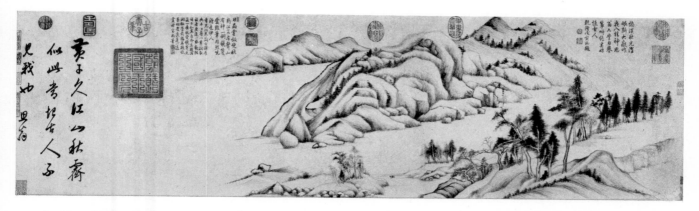

596. *Rivers and Mountains on a Clear Autumn Day.* By Dong Qichang (A.D. 1555–1636). Handscroll, ink on Korean paper; height 15 1/8″, length 53 5/8″. China. Ming dynasty. Cleveland Museum of Art

infusing someone else's composition with his own technique and interpretation to create an individual performance. At its most creative, in the hands of such an artist as Wen Zhengming, the process is comparable to one composer's writing variations on another's theme, producing thereby a new and seamless idiom.

Many of Wen Zhengming's relations worked in his style; at least four prominent painters could be cited. The most important of these, and the one who added the one last fillip to Wen Zhengming's style, was his nephew Wen Boren (A.D. 1502–1575), who painted the remarkable large *Landscape* in the Cheng Te-kun Collection (*colorplate 45, p. 429*). From his uncle Wen Boren adopted the tendency to detail but abandoned the twisting, grotesque, and ancient quality, producing complex texture studies that are most lyrical and elegant pictures. The whole *Landscape* composition is based on the Yuan master Wang Meng, but its aspect is so light and fluffy, so animated and gay, that it becomes a completely new creation. In the generations following Wen Zhengming other masters perpetuated and enlarged upon this allover patterning. Lu Zhi, in the handscroll *Rocky Landscape*, shows another variation of this manner (*fig. 595*). Rocks, trees, and landscape details fill the scroll from bottom to top and side to side; no horizon line, no sky mitigates the complexity of the composition. His brushwork is delicate and refined, but sharp and crystalline. To overall patterning and small scale Lu Zhi added a peculiar tartness of color, like lemon and lime, in contrast with the sweet and mellow palette of Wen Boren.

Shen Zhou painted a few flower and foliage pictures, to which his bold brushwork was most appropriate. But the most interesting flower paintings in this manner are by the slightly later artist Chen Shun (A.D. 1483–1544), whose handscroll of lotus (*colorplate 46, p. 430*) combines soft and decorative color with vigorous "boneless" brushwork—that is, areas of ink and color applied without outlines. Still, the dominant mode of the first half of the sixteenth century was that of Wen Zhengming—detailed, complex, and dignified.

By the end of the sixteenth century the creative momentum of the Wu school was beginning to subside. New impetus was forthcoming in the theories and paintings of Dong Qichang (A.D. 1555–1636), who dramatically changed the course of Chinese landscape painting. His importance and the extent of his influence is comparable to Caravaggio's in European painting. The two men, incidentally, were active at about the same time.

Dong Qichang is the watershed figure of later Chinese painting. His influence on literature, criticism, calligraphy, and painting is paramount. In his writing he asserts the supremacy of the Northern Song and Yuan masters, and in his paintings he attempts to recapture the monumental strength of the former and the controlled calligraphy of the latter. No one could describe the later productions of the Wu school as universal, monumental, or markedly rational, and in opposing the direction of this scholar-painters' school Dong Qichang was simultaneously a supreme reactionary and a supreme revolutionist. His painting theory brought about a loss of the outward reality of nature but a significant aesthetic gain consisting in a fiercely arbitrary reorganization of the elements of landscape painting into a monumental scheme (*fig. 596*). In his most typical pictures this aesthetic reformulation is manifested in striking distortions. Ground and water planes are slanted, raised, or lowered at will. Foliage areas are forced into unified planes regardless of depth, often with striking textural juxtapositions. No small details of form or texture are allowed to impede the artist's striving for a broad and universal expression of the traditional attitudes to nature

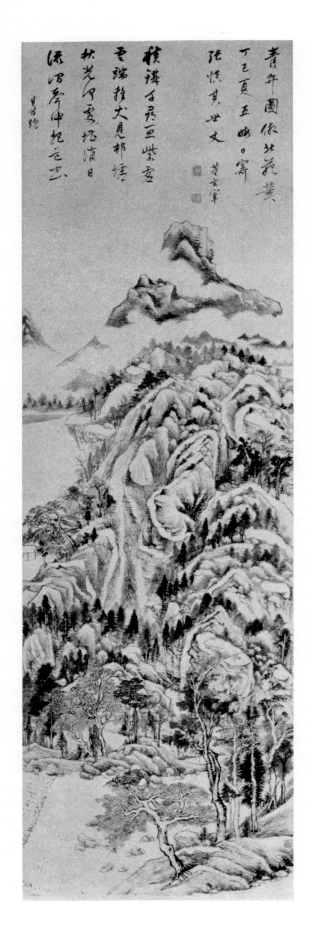

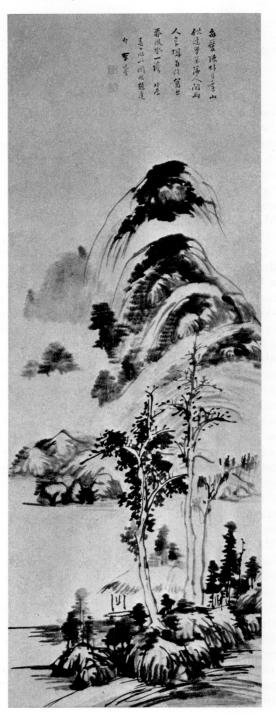

597. (left) *The Qingbian Mountains*. By Dong Qichang (A.D. 1555–1636). Dated to A.D. 1617. Hanging scroll, ink on paper; height 88 3/8″. China. Ming dynasty. Cleveland Museum of Art

598. (below) *Thin Forest and Distant Mountains*. By Li Liufang (A.D. 1575–1629). Dated to A.D. 1628. Hanging scroll, ink on paper; height 45″. China. Ming dynasty. Cleveland Museum of Art

(*fig. 597*). Malraux's subtle distinction between Chardin and Braque, "In Chardin the glow is on the peach; in Braque, the glow is on the picture," applies as well to the works of Dong. His pictures realize his theories incompletely and with difficulty by comparison with the works of such later giants as Zhu Da or even the more academic Wang Yuanqi, for theirs was a pictorial genius that accomplished what Dong Qichang proposed. Other later individualists, Gong Xian for example, pursued and enlarged upon specific elements in Dong's painting.

We must not assume, as the writer once did, that Dong Qichang's pictures look as they do because the theorist was an incompetent painter. Like the Post-Impressionists, the artist was desperately striving to reconstitute the powerful and virile forms rather than the surface likeness of the earlier painters. Dong Qichang had the last word: "Those who study the old masters and do not introduce some changes are as if closed in by a fence. If one imitates the models too closely one is often farther removed from them."[20]

Dong's high position in government and his influence as arbiter of taste and authenticity confirmed the lofty prestige of the scholar-painters' tradition identified by him and his colleagues with the "southern" school and the denigration of the "northern" tradition represented by the Zhe school. His own immediate following, including Chen Jiru and Mo Shilong, is usually described as the Songjiang school, after the town near Suzhou that was their center.

Dong influenced many other important painters who can only be described as seventeenth century individualists—a description that can be narrowed to these late Ming figures alone, or extended to all the distinctive personalities of the troubled later years of the century. But these later individualists, occupying the changed social and political matrix of the new and alien Qing dynasty (A.D. 1644–1912), will be considered subsequently, as a contrast with the almost neoclassic academicism that was the early Qing outgrowth of the Songjiang school. Their multiplicity and relatively recent discovery by Westerners preclude all but a summary presentation of the other Ming individualists. Although the poem on one of Li Liufang's boldest pictures mentions Ni Zan and the brushwork is influenced by the brusque style of Wu Zhen, the overall effect of the landscape would be unthinkable without the intervention of Dong Qichang (*fig. 598*). Its bottom-to-top visual and compositional unity is noteworthy, and characteristic of the post-Yuan "Ni type" of composition. The excellent preservation of the ink and the exceedingly simplified brushwork reveal the order of the successive strokes and washes with an almost kinetic force. Consider as well the fantastic

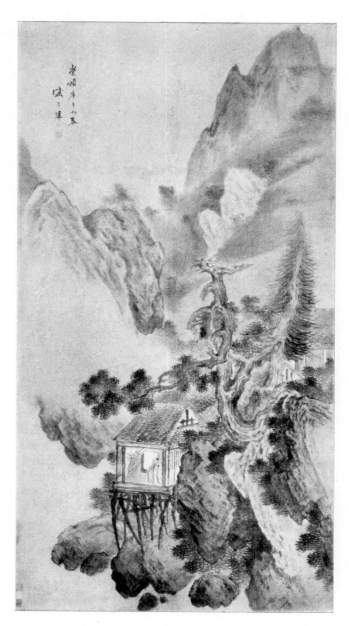

599. *Lonely Retreat Overlooking a Misty Valley*. By Sheng Maoye (act. c. A.D. 1607–1637). Dated to A.D. 1630. Hanging scroll, ink and slight color on silk; height 71". China. Ming dynasty. Cleveland Museum of Art

boldness of Sheng Maoye's *Lonely Retreat Overlooking a Misty Valley* dated to A.D. 1630 (*fig. 599*). Sheng has taken a small segment of a monumental landscape, a mountain notch, and magnified it, treated it with great bravura, producing a large-scale painting with an immediate rather than a cumulative effect. Nevertheless, the fading mists are handled with the suggestive subtlety found in many of the artist's smaller pictures, and the figure of the sage

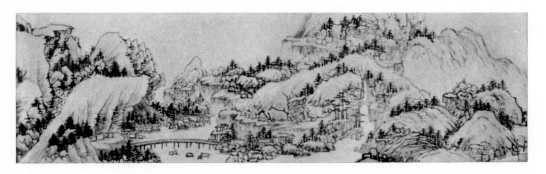

600. *Dream Journey Among Rivers and Mountains.* By Cheng Zhengkui (act. c. A.D. 1630–1674). Dated to A.D. 1658. Section of the handscroll, ink and light color on paper; height 10 1/4″, length 11′ 3 1/2″. China. Qing dynasty. Cleveland Museum of Art

and the grotesque trees reveal a sense of humor. The painting fascinates precisely because of its wild, offbeat quality.

Another of these individualists was a direct pupil of Dong Qichang. We can see the art of Cheng Zhengkui in a handscroll modeled stylistically after the Yuan master Huang Gongwang (*fig. 600*). The composition is in equal measure strange and willful, based on a jerky, erratic rhythm of near masses and sudden apertures into the far distance that is typical of the artist. In other scrolls he exploits this mode even further, but with an even wetter brush and rapid, unshaded handling, using slight color. His extreme specialization in subject matter is carried over into the titles and inscriptions on the pictures, for he uses the same title for nearly all his scrolls and even numbers them sequentially in each year.

Of course many in this period continued to practice a more conservative and detailed style, often combining it with the new directions indicated by Dong Qichang. Wu Bin (act. A.D. 1591–1626), who was also a master of fine-line (*bai miao*) figure painting (*fig. 601*), has left a number of finely executed colored landscapes whose dynamic convolutions amaze the eye and express the twisted and grotesque aspects of nature. *Greeting the Spring* nominally presents the annual equinoctial sacrifices with their accompanying festivals (*fig. 602*). Hundreds of figures throng the handscroll—scholars traveling the mountains or groups of festive townsmen. But the real subject of the picture is the landscape, ranging from calm waterways bordered by tranquil willows to high mountains darkly reaching beyond the upper edges of the scroll. The color is structured rather than decorative and serves to accent the openings and movements of the slate gray hills. The idiosyncratic use of color becomes one of the major contributions of the Qing individualists whom we shall soon consider.

THE QING DYNASTY

The second great alien dynasty to master all of China was the Qing (A.D. 1644–1912), and between its rule and the Mongols' the differences could hardly

601. *The Five Hundred Arhats.* By Wu Bin (act. A.D. 1591–1626). Section of the handscroll, ink and light color on paper; height 13 1/4″, length 76′ 11 1/4″. China. Ming dynasty. Cleveland Museum of Art

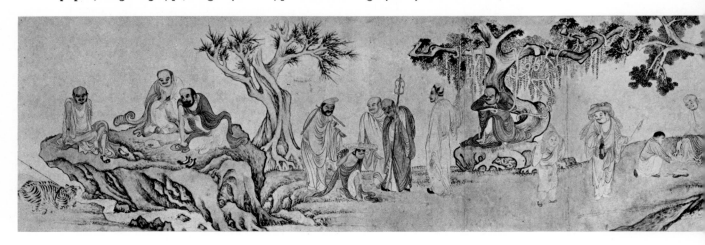

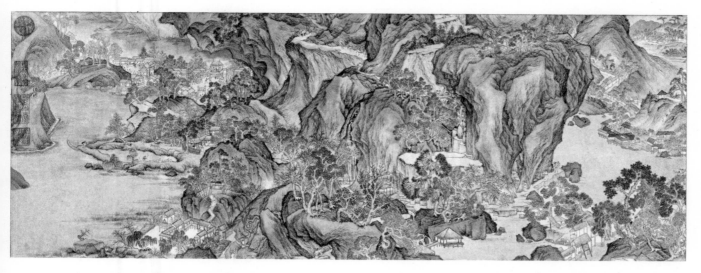

602. *Greeting the Spring*. By Wu Bin (act. A.D. 1591–1626). Dated to A.D. 1600. Section of the handscroll, ink and color on paper; height 13 3/4″, length 99 1/2″. China. Ming dynasty. Cleveland Museum of Art

have been greater. As their name implies, the Manchus came from Manchuria, sufficiently close to China to learn selectively from Chinese ideology and institutions, but sufficiently independent of Chinese control to become a formidable military rival. Imperial incompetence and corruption and economic depression had led to the rebellion that toppled the Ming dynasty, and the Manchus, presenting themselves less as conquerors than as liberators from chaos and oppression, won China with relatively small popular opposition. So successfully did their Qing dynasty woo the scholar-gentry that Confucian odium against collaborators with the new regime was soon dissipated. Because they esteemed and diligently acquired Chinese culture, adopted Chinese administrative techniques, and preserved the Chinese social structure (while imposing themselves at its apex), the Manchu conquest was the

least traumatic of Chinese dynastic transitions, and the first century and a half of Qing rule was the last golden age of imperial China.

The Manchu rulers themselves, particularly with regard to art, became more Chinese than the Chinese, concentrating in the imperial city of Beijing the great Palace Collection—today divided between the National Palace Museum in Taibei and various museums in Beijing.

Painting

The division of the history of Chinese art into dynastic periods is sometimes sound, but between the Ming and Qing dynasties the continuity in the arts is such that the first part of the Qing dynasty, particularly the seventeenth century, may be considered a continuation, in some ways a culmination, of ten-

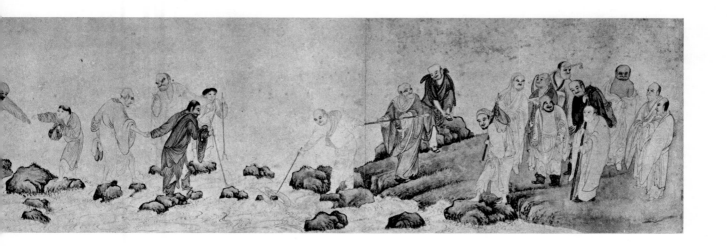

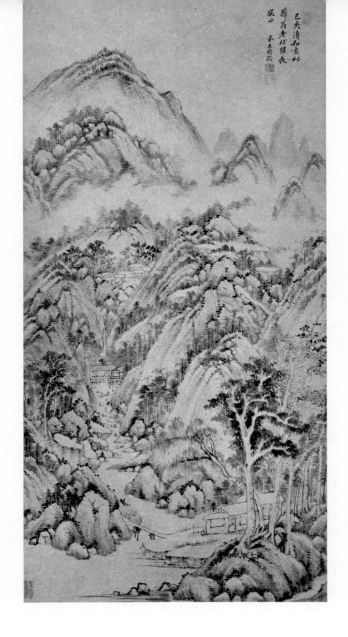

603. *Mountain Village Embraced by the Summer*. By Wang Shimin (A.D. 1592–1680). Dated to A.D. 1659. Hanging scroll, ink on paper; height 49 1/2″. China. Qing dynasty. Mr. and Mrs. A. Dean Perry Collection, Cleveland

dencies already present in the painting and decorative arts of the later Ming dynasty. It was by no means—as undue concentration on Chinese decorative and export porcelains might lead one to think —a period of decline in taste and standards.

The painting of the Qing dynasty comprises two basic styles: the conservative, based upon the late Ming scholars' painting stemming from the great innovator Dong Qichang; and an original movement more thoroughly individualistic than any previous school. Such a division into conservative and original forces deliberately overlooks other and stagnant pools of Chinese painting, which are truly declining phases of the earlier styles of the Song, Yuan, and early Ming periods. We will pass over these competent but usually uninspired painters, though in their own fashion they too made a contribution.

The conservative style of the Qing dynasty, based upon the scholar-painter tradition of Dong Qichang and his school, is epitomized in the works of the Four Wangs: Wang Shimin (A.D. 1592–1680); Wang Jian (A.D. 1598–1677); Wang Hui (A.D. 1632–1717); and Wang Yuanqi (A.D. 1642–1715). They are listed in order of birth date. Wang Shimin, the oldest, was also the most traditional (*fig. 603*).

604. *Ten Thousand Miles of the Yangzi*. By Wang Hui (A.D. 1632–1717). Section of the handscroll, ink and slight color on paper; length 53′. China. Qing dynasty. H. C. Weng Collection, New York

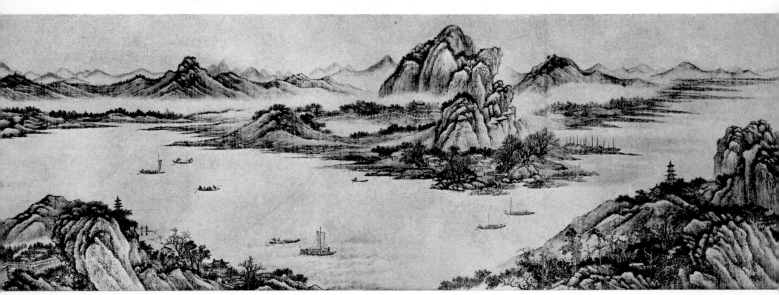

He based his style largely on a combination of Yuan versions of Northern Song painting with the more monumental character and arbitrary handling of space and brushwork that were the original contribution of Wang Shimin's teacher, Dong Qichang, fifty or sixty years earlier. His compositions tend to be traditional and rather uninspired. They are always solid, massively built up, and usually of great complexity, with repetition of trees, rocks, and mountains in a basically similar set of rhythms. Wang Shimin's use of brushwork, and his patterning of it over the whole surface of the picture, are correct and consistent, recalling perhaps that rational master of the Yuan dynasty, Huang Gongwang. Probably Wang Shimin is more important for his antecedents and successors than in himself, as the pupil of Dong Qichang and the practical and spiritual master of the three other Wangs.

At least in his compositions, Wang Jian is the more original and interesting painter. The rolling rhythms that dominate his landscapes even more than Wang Shimin's are highly repetitive and relatively complex but also pleasant and elegant. Compared with Wang Shimin's more imposing and forbidding works, Wang Jian's seem lyrical, with something of that loveliness characteristic of the rolling landscapes of the early Japanese schools. One seldom finds, in the work of this artist, a monumental composition of imposing scale or powerful brushwork, but rather a consistent and elegant use of the brush in compositions dominated by gentle rhythms and sometimes highly decorative color (*colorplate 47, p. 431*).

Wang Hui, who belongs to the following generation, is probably the best known of the group. He was perhaps the most famous painter of his day in China, a prolific master whose genuine works exist in considerable quantity. Wang Hui's style, based primarily on gifted brushwork, is much more varied than that of the two older Wangs. From the first, like such geniuses as Dürer and Leonardo, he seems to have been able to do whatever he willed with the brush. His long scrolls, some, like the one in the Weng Collection, over fifty feet in length, show the most remarkable consistency of brushwork at the service of the most complex temporal and spatial organization to be found in Chinese painting (*fig. 604*). No painter of the Song dynasty or later produced works of greater competence. If at times they seem a little dry and less inspired than earlier works, it is only because Dong Qichang's revolution had, over about a century, become Wang Hui's orthodoxy. The followers of the bold innovator were a bit academic. Albums, handscrolls, or hanging scrolls executed as variations on the themes of earlier men certainly dominate the pictorial production of the conservative artists. Perhaps the main reason for the Western neglect, until recently, of the orthodox painters of the Qing dynasty has been their relative lack of originality in composition. But in Chinese eyes composition is a secondary point.

The last and youngest of the Wangs, and certainly the most original, was Wang Yuanqi, who also stands closer than the others to the individualist painters. His pictures testify to his understanding that the

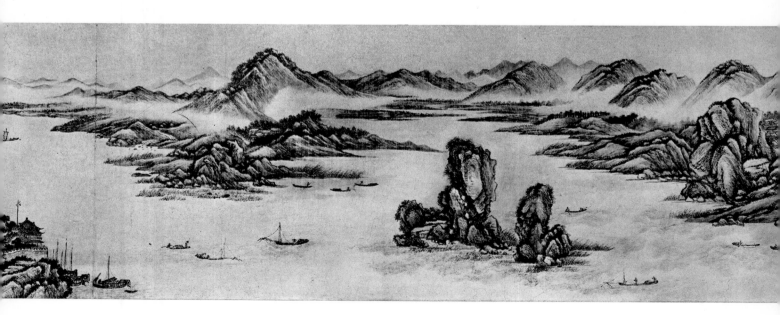

605. *Landscape in the Color Style of Ni Zan.* By Wang Yuanqi (A.D. 1642–1715). Dated to A.D. 1707. Hanging scroll, ink and color on paper; height 31 5/8″. China. Qing dynasty. Cleveland Museum of Art

revolutionary essence of Dong Qichang did not consist in the lovely pictorial effects often achieved by Wang Jian and Wang Hui but in the arbitrary reorganization of the elements of nature in terms of brushwork and of an almost abstract pictorial structure. Consequently, when Wang Yuanqi paints a picture in the style of Ni Zan (*fig. 605*), it is in homage to Ni Zan's spirit only, to the coldness and serenity of that Yuan master. The actual means by which this was achieved were much more under the creative influence of Dong Qichang. The enormous contrast in scale between the trees and the

house, the distortion of the tree trunks and the heaviness of their foliage as a balance to the compactly constructed distant mountain-island—these are combined to make a picture that, while recalling Ni Zan, bespeaks only Wang Yuanqi. In this sense he is an individualist: His work is recognizable as his and his alone. His brushwork is bold, and particularly in the distant landscape he is inclined to arbitrary tilts and shifts of terrain, startling if one looks at the picture from a purely representational point of view, but remarkably effective in creating dynamic intensity. For this reason, his paintings have been compared with Cézanne's watercolors, and the comparison is just and illuminating. Seeing them side by side, one can perceive the relationship between their aims, although Cézanne had richer coloristic means at his disposal than those simple color schemes of tart orange, green, and blue available to the Chinese master.

Outside the group of the Four Wangs, also known as the Loudong school, were some painters who fit into neither orthodox nor individualist categories. Of these, two are especially worthy of note. One was Wu Li, unique as the only prominent Chinese painter ever to become a Christian. He died a Christian priest, and consequently has been one of the few Chinese painters of the later orthodox school to be early and effectively studied and published in the West. Wu Li, like the four Wangs, uses the discoveries of Dong Qichang, particularly in the construction of his monumental backgrounds and in the distortions of the distant mountains and their tops, to create tense and sometimes contorted effects. Some of these forms seem metamorphic; like the rocks of Ni Zan's *Lion Grove*, they resemble animals or faces. In this painting, *Pine Wind from Myriad Valleys*, the topmost vertical peak looks rather like a squatting animal, with a tufted head, haunches a third of the way down, and a face hunched between the rocky shoulders (*fig. 606*). Such suggestions of zoomorphic forms in the midst of landscape occur frequently in the work of Wu Li and are not unknown in Western painting, notably in the modern Surrealist school. This composition also reveals Wu's ability to construct a monumental composition by continuous overlaps in the foreground leading up to the markedly vertical mountain in the background, recalling, at least in spirit, some of the compositions of the Northern Song period. In detail his brushwork is less elegant than but almost as precise as Wang Hui's, a little sharper and more angular, almost as if engraved with a burin.

The second of the painters who was neither orthodox nor individualist is Yun Shouping (A.D. 1633–1690). Yun has been unjustly typed as a flower painter, for some of his landscapes are among the most

beautiful, limpid, and delicate productions of later Chinese painting. But it is as flower painter that he is best known, and in the picture from the National Palace Museum we can see—even in a black-and-white reproduction—something of his distinctive wet style (*fig. 607*). The bamboo, even the tree trunk on the right, seem to be painted with a very wet brush that slithers over the surface of the paper, leaving not a blurred impression but a sharp one, in contrast with the medium-dry brushwork of Wu Li and Wang Hui. The effect of this wetness of the subtle tints can perhaps be described as rather French and decorative. Many small albums with mixed landscapes and flower subjects by Yun are known. His style, how-

ever, is similar to that of the four Wangs and Wu Li and is largely based on the late Ming painters; hence he is classified, not with the most original and creative of Qing painters, but with the more orthodox group.

The individualists are a different sort. Many were resentful of the new dynasty and felt that they, like the Yuan masters, should retire to the mountains or to Buddhist or Daoist retreats where they could practice their art and compose protests against the dynasty. One of them, Zhu Da, was of the Ming royal line, and hence had good reason to oppose the new dynasty. Others, like Kun-Can, were monks with a pronounced antipathy to the Chinese world of the seventeenth century. They are united by a revolu-

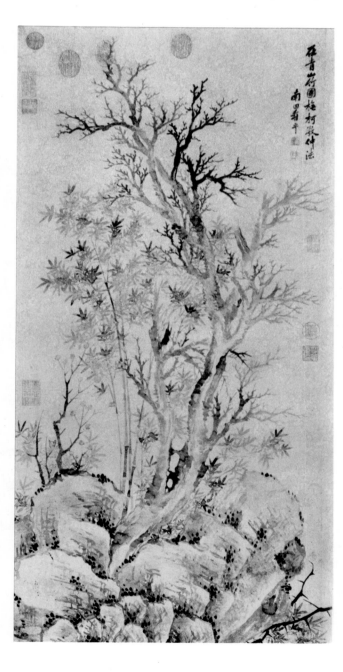

606. (far left) *Pine Wind from Myriad Valleys.* By Wu Li (A.D. 1632–1718). Hanging scroll, ink and light color on paper; height 43″. China. Qing dynasty. Cleveland Museum of Art

607. (left) *Bamboo and Old Tree.* By Yun Shouping (A.D. 1633–1690). Hanging scroll, ink on paper; height 40″. China. Qing dynasty. National Palace Museum, Taibei

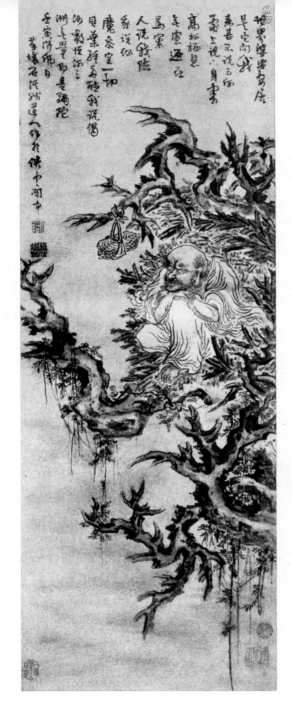

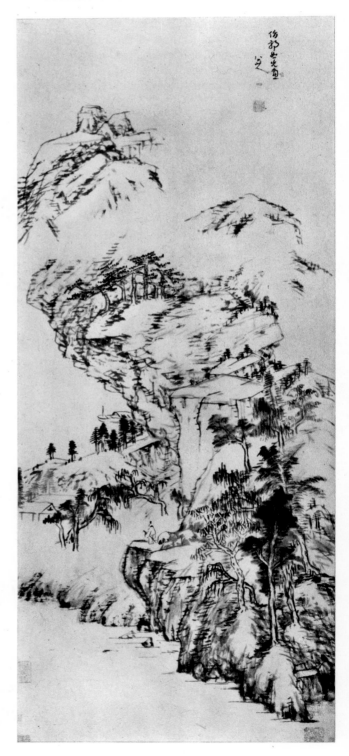

608. (left) *Monk Meditating in a Tree*. By Kun-Can (Shiqi; A.D. 1612–c. 1674). Hanging scroll, ink on paper. China. Qing dynasty.
Whereabouts unknown

609. (below) *Landscape After Guo Zhongshu*. By Zhu Da (A.D. 1624–1705). Hanging scroll, ink on paper; height 43 1/4". China. Qing dynasty. Cleveland Museum of Art

tionary position within the limits of Chinese society and by their common interest in painting. Kun-Can, for example, on a well-known painting representing a monk in a tree (*fig. 608*), a traditional subject with which the artist indentified himself, wrote the following inscription: "The question is how to find peace in a world of suffering. You ask why I came hither; I cannot tell the reason. I am living high up in a tree and looking down. Here I can rest free from all trouble like a bird in its nest. People call me a dangerous man, but I answer: 'You are like devils.' "[21]

Or that surprisingly vocal artist, Dao-Ji, writes: "I am what I am because I have an existence of my own. The beards and eyebrows of the ancients cannot grow on my face, nor can their lungs and bowels

be placed in my body. I vent my own lungs and bowels and display my own beard and eyebrows. Though on occasion my painting may happen to resemble that of so-and-so, it is he who resembles me, and not I who willfully imitate his style. It is naturally so! When indeed have I ever studied past masters and not transformed them!"[22]

Such sentiments have been heard before, notably from certain Ming painters complacent about their versions of earlier artists' works, but never so vehemently expressed. If the individualists had been all talk, then there would be nothing to write about. But their paintings justify their pride and their revolutionary position in art history. Although aesthetic and, to some extent, social revolutionaries, they were not as isolated as one might think. Wang Hui, for example, who painted for the emperor and was considered the leading master of the orthodox school, called Dao-Ji the finest painter south of the Yangzi. Their paintings were collected by many contemporary connoisseurs, and, unlike their early Ming counterparts, they died natural deaths. But it is also true—and our good fortune—that imperial and orthodox collectors ignored their works, which are therefore better seen in Western museums and private collections than in China or Taiwan.

Zhu Da (A.D. 1624–1705) is known also by the sobriquet Ba-da-shan-ren. His work comprises at least two main styles, the first heavily indebted to the principles of Dong Qichang. Whereas most other painters tended to adopt the more easily understandable aspects of Dong Qichang, Zhu Da derived his style out of the more radical of Dong's innovations. This style he tended to use most often in landscape, as in figure 609. According to Zhu Da's inscription the painting is based upon a composition of the Northern Song master Guo Zhongshu, but no one would ever mistake it for a Northern Song painting, nor would

one, without the inscription, realize the artist's reference, which probably applies to the twisting monumentality of the mountain. In boldness of brushwork and in his unique angling of the trees to support the almost jazzlike rhythm of the picture, Zhu Da surpasses even Dong Qichang. The construction of the picture by means of a series of tentative brushstrokes searching for final forms rather than crystal clear and fully realized, is wholly characteristic of this style of Zhu Da. In these landscapes one senses the form emerging beneath the brush; one imagines the painter producing the picture. This is a direct contradiction of the oft-repeated old saw that all Chinese paintings were first conceived and then put down complete, perfect, and without correction from the image in the mind. Some were so painted, but certainly not most. Indeed, one can study the works of almost any painter and see where the artist corrected, changed, added, or in some way showed a method of thinking and working comparable to the methods characteristic of Western artists.

Zhu Da's other style, the one most characteristic of his art and most appealing to Western critics, is an extremely abbreviated one, brilliantly thought out and then set down, seemingly, with great rapidity and ease. We see it exemplified in the short handscroll *Fish and Rocks* (*fig. 610*). It begins with the overhanging rock and chrysanthemums, executed with a fairly dry brush in big swinging strokes, accompanied by a poem that refers to the overhang, the color of the chrysanthemums, and the clouds in the sky. This is followed with a wetter section, not quite so sharply painted as the preceding one, representing a fantastic rock and two small fish identified as carp in the inscription, and shifting the onlooker's point of view from the world above to the world below, from sky to water. The fish in particular are characteristic of Zhu Da's work, with their almost whimsical vitality,

610. *Fish and Rocks.* By Zhu Da (A.D. 1624–1705). Section of the handscroll, ink on paper; height 11 1/2″, length 62″. China. Qing dynasty. Cleveland Museum of Art

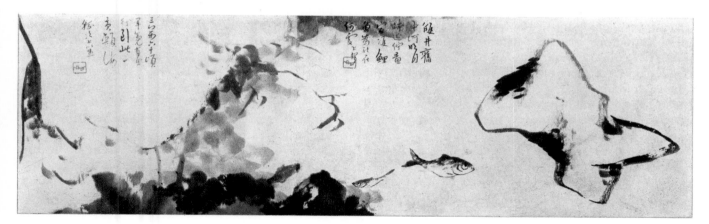

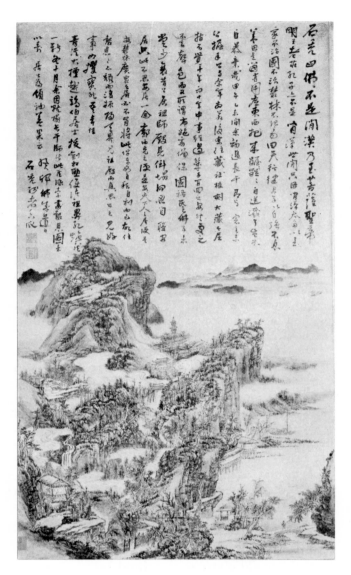

611. *The Bao Temple*. By Kun-Can (Shiqi; A.D. 1612–c. 1674). Dated to A.D. 1663. Hanging scroll, ink and color on paper; height 52 1/2″. China. Qing dynasty. Kanichi Sumitomo Collection, Oiso

their eyes looking up to the rock and the sky above. The humorous sympathy characteristic of most of Zhu Da's bird, animal, and fish paintings is the most easily imitated facet of his art and consequently the most often forged. The scroll ends with a completely wet passage. One has passed from dry brushwork to increasingly wet brushwork, from very sharp forms to very soft and ill-defined forms, like those of the lotus in the water, where the fish can escape from the world. The third poem alludes to the lotus as a Buddhist symbol and a haven. The poetry of Zhu Da is as sharp and laconic as his painting. Poetry, calligraphy, and painting are unified by succinctness of expression.

Another of the great individualists, the monk-painter Kun-Can (also called Shiqi), is a more complex painter than Zhu Da but more limited in his stylistic vocabulary. In interest and profundity he equals any other painter of his time. Figure 611, representing the Bao Temple, shows his style at its best. Next to Dao-Ji he is the most effective colorist among the four individualists, and warm orange hues enhance the ropelike, close-knit texture produced by the complex interweaving of his brushstrokes. His brushwork, brisk or rolling, creates a style more compact and graciously rhythmical than that of the Yuan painter Wang Meng. In contrast with Wang's direct and uncompromising brusqueness, Kun-Can displays a greater elegance, and something of this can be seen in the cloud forms, in the rocks and trees, and even in the convincing representation of thatch on the hut. Kun-Can's work is very much rarer than that of the other individualists, and the best of it is almost nonexistent in the West.

Dao-Ji (A.D. 1641–1707) is, by general consensus, the most protean of these four individualists. (He is also called Shi-tao, and he and Kun-Can, whose other name is Shiqi, are often referred to as "the two stones," since the character *shi* in both names means "stone.") His use of color is innovative—richer, deeper, more like the Western use of watercolor than any Chinese painter of his own time or earlier (*colorplate 48, p. 432*). He is addicted to an extremely bold use of the brush for washes laid one next to the other, sometimes creating a rounded and solid effect not unlike that achieved in Western watercolor technique. He is also capable of work of the utmost refinement and detail. In the realm of composition he is also an innovator, for he creates in each picture a new, unique, and often intimate world, reinventing, as he said, every composition in Chinese painting. The small album from the Sumitomo Collection gives some idea of his detailed style, of the refinement of his brushwork and, at the same time, of the complete originality and daring of his composition (*fig. 612*). Two figures—an old, bearded sage coming from the lower right, half of his body invisible in the mist, attended by a boy similarly half visible—stand under a grass-fringed overhang against a massive, bottomless cliff, with a waterfall like parallel ribbons running over the rocks. The effect is one of arbitrary yet consistent and successful placement in relation to the inscription incorporated into the page. The contrast between the delicate, precise little strokes of the leaves on the bushes at the left of the cliff and the long, writhing strokes that form the layered rock formations of the cliff, and the movement of the hanging vines and grasses which seem to parody the old man's beard and the boy's hair, all reveal a bold mind, oriented to visual perception. Like

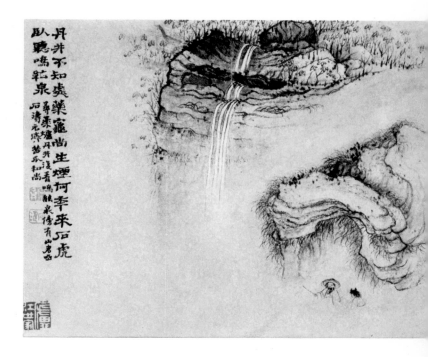

612. *One leaf from Eight Views of Huang Shan.* By Dao-Ji (Shi-tao; A.D. 1641–1707). Album leaf, ink and color on paper; width 10 5/8″. China. Qing dynasty. Kanichi Sumitomo Collection, Oiso

many of these painters, Dao-Ji traveled a great deal and particularly delighted in the scenery of certain places, notably Huang Shan in Anhui Province, the Taihang Shan range in Shanxi, and the region of the Xiao and Xiang rivers in Hunan. Paintings that were in a sense reminiscences of travel form a special subgroup of Chinese painting in general and of Qing painting in particular. Each picture by Dao-Ji, whether small album leaf or large hanging scroll, is a new adventure; in many ways he stands with Dong Qichang as the most individual and revolutionary figure of the sixteenth and seventeenth centuries.

The fourth of the great individualists is Gong Xian (c. A.D. 1619–1689), and although the most limited in style, he is clearly the most forceful and dramatic in impact. His work has been described variously as gloomy and full of foreboding, almost funereal, a world populated by ghosts and wraiths, or the expression of a monumental, dramatic genius of somber and passionate temperament. Certainly his paintings are dramatic and somber: His characteristic format is the hanging scroll, painted in perhaps the richest blacks ever achieved in Chinese painting, shading to melancholy grays and contrasting with the sunless whites of cloud and mist and

rock, and his landscapes, like those of Ni Zan, are unpeopled (*fig. 613*). Nature expresses all that he wishes to say; even the dwelling places and boats of men are presented in the thinnest and most abbreviated possible manner. He wrote a treatise on landscape painting, and in many of his paintings one clearly senses Western influences on the handling of light and shade. Gong Xian carried the exploration of the possibilities of light and shade as far as anyone in the history of Chinese painting.

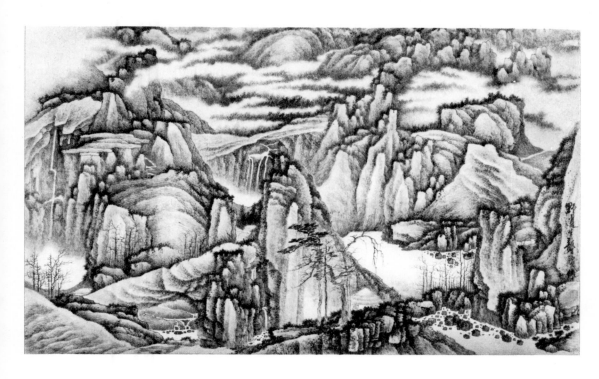

613. *A Thousand Peaks and Myriad Ravines.* By Gong Xian (c. A.D. 1619–1689). Hanging scroll, ink on paper; height 24 3/8″. China. Qing dynasty. Rietberg Museum, Zurich

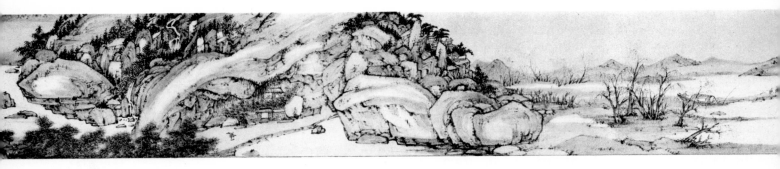

614. *Pure Tones Among Hills and Waters*. By Xiao Yuncong (A.D. 1596–1673). Dated to A.D. 1644. Section of the handscroll, ink and light color on paper; height 12 1/8″, length 25′ 7 3/4″. China. Qing dynasty. Cleveland Museum of Art

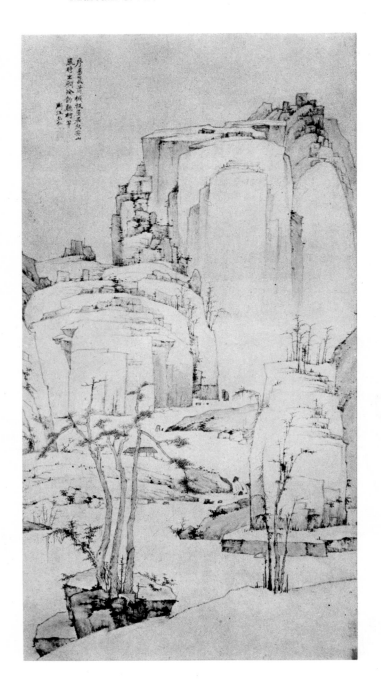

The individualists of the seventeenth century number enough to make a crowd. Typical is a group associated with the province of Anhui in south China, whose Yellow Mountains (Huang Shan, beloved of Dao-Ji) are a characteristic and famous geographic feature. Paintings of the Yellow Mountains are known from the Song dynasty on, and in these wild and fantastic ranges four early Qing painters found inspiration. Probably the senior member of this group was Xiao Yuncong (A.D. 1596–1673), important not only for his painting but for his book illustrations. Xiao designed many of the woodcuts illustrating one of the most popular seventeenth century treatises on the technique of Chinese painting. The woodcuts from this book were collected in Japan as well as China and influenced numerous scholar-painters of both countries. Xiao is also important for his influence on slightly younger contemporaries from Anhui Province. His style is represented in a work called *Pure Tones Among Hills and Waters*, dated to A.D. 1664, which shows his indebtedness to the great Yuan master Huang Gongwang (*fig. 614*). This long handscroll ends with a harbor amid clearing banks of mist, following a penultimate scene of a cave housing a lone monk and his attendant. A detail shows a typical unit of the composition, with numerous plateaus and a characteristic swinging rhythm based upon the careful juxtaposition of an arc and a countering angle. This slightly syncopated and oft-repeated rhythm constitutes Xiao's characteristic and individual flavor. His color scheme is also in part derived from Huang Gongwang. The use of slightly lavender blue and pink is similar to the palette reputedly used by Huang Gongwang, from whom we have only one work in color.

615. *The Coming of Autumn*. By Hong-Ren (A.D. 1610–1664). Hanging scroll, ink on paper; height 48″. China. Qing dynasty. Honolulu Academy of Arts

456

Xiao was slightly older than the second of the Anhui Masters, the monk-painter Hong-Ren (A.D. 1610–1664), who, judging from all the evidence, studied with him. Hong-Ren's style is utterly distinctive but just as clearly reveals its origin in the works of Ni Zan. Hong-Ren's style is even chillier and more abbreviated: spare, crystalline, wintry, and rendered especially fine by the extreme sensitivity of his brushwork. Judging from one or two pictures, he also learned much from Xiao Yuncong, as the rhythmical repetition in the big hanging scroll of figure 615 seems to suggest. Other paintings by Xiao, in turn, seem to show the influence of his pupil. Hong-Ren's style, limited and specialized as it is, shows how the style of one of the Four Great Masters of the Yuan period could still serve as original theme for a creative variation.

The third of the Anhui Masters, Cha Shibiao (A.D. 1615–1698), is a different personality. Cha seems more easygoing and extroverted, a painter with few problems or inhibitions who enjoys painting. His pictures look free and easy, as if they had been rapidly and joyously done, with no thought of profound philosophical implications. One of his album masterpieces, containing twelve scenes, most of them in color, presents a favorite Qing theme, variations on the styles of earlier masters, but so radically rephrased that they become fresh and creative

new works. One of these, most original in its coloring, is a representation of spring that owes nothing to the great masters of the past (*fig. 616*). The use of green and orange enclosed by black ink produces a glowing effect. This, combined with the gentle washes of blue in the grass and trees, gives a coloristic effect not unlike that of the great individualist Dao-Ji. The seventeenth century individualists, whether the four great masters or such secondary figures as the Anhui group, are particularly inventive in their use of color, and at this time color became a serious means of pictorial construction.

The last of the Anhui individualists, Mei Qing (A.D. 1623–1697), has perhaps the most individual style of the group and seems, like Cha Shibiao, to have been a rather blithe spirit. He goes to great lengths in distorting pictorial elements, whether they are mountains rendered in crumbly, scalloped strokes or trees and forests that look like enormously enlarged exotic and decorative flowers (*fig. 617*). Like Xiao Yuncong, Mei uses repetitive rhythms, but creates with them billowing, almost rococo effects.

The eighteenth century saw the continuation of the individualist tradition in the work of many painters. One of the most delightful of these is Hua Yan (A.D. 1682–1765), famous not only for his landscapes but for his paintings of animals and birds in a new,

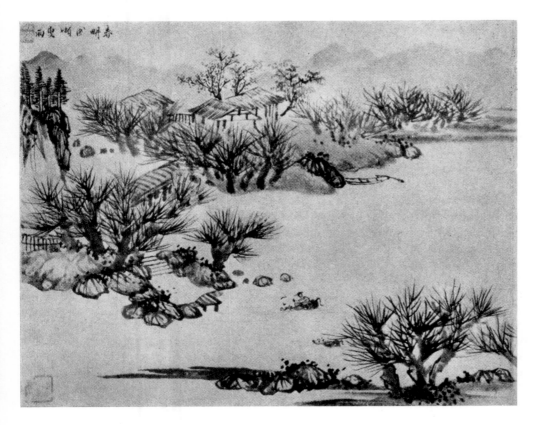

616. *Spring, from Landscape Album in Various Styles.* By Cha Shibiao (A.D. 1615–1698). Dated to A.D. 1684. Album leaves, ink or ink and light color on paper; height 11 3/4", width 15 1/2". China. Qing dynasty. Cleveland Museum of Art

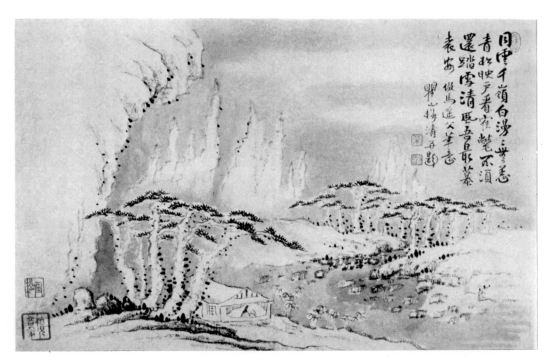

617. *One leaf from Landscapes After Various Styles of Old Masters.* By Mei Qing (A.D. 1623–1697). Dated to A.D. 1690. Album leaves, ink or ink and light color on paper; height 11 1/4″, width 17 3/8″. China. Qing dynasty. Cleveland Museum of Art

enlarged, and decorative style of his own, which secures him an honorable place in the history of bird and animal painting. One of his masterpieces is the landscape hanging scroll *Conversation in Autumn,* an illustration of a famous Song dynasty work of rhymed prose by Ouyang Xiu (A.D. 1007–1072; *fig. 618*). The author wrote of the curious softness of the rustle of leaves, the trickle of water, in autumn. Hua Yan seems to have caught these qualities, in a work famous in China from the time it was painted. The almost impossibly tall mountain—not unlike those found in the work of the Anhui painter Mei Qing—seemingly stretches up to the sky, as if it were a plastic substance rather than a thing of rock and earth. The lower part of the picture combines the twisting rocks supporting the scholar's hut with a delicate treatment of the foliage of trees and bamboo. The leaves, spare and drifting as one would expect in the autumn, have a delicate, almost musical quality, suggesting at the same time the rhythm of a lilting tune and the look of its notes on paper.

Others of the individualists were monks, in the great Chinese priest-painter tradition. Two of these are Jin Nong (A.D. 1687–1764) and Luo Ping (A.D. 1733–1799), whose relationship was that of teacher and pupil and whose styles were often identical. Chinese tradition has it that Jin Nong was not much of a painter and that many of the pictures signed in his characteristic rather square calligraphy were actually painted by Luo Ping. The curious style of these two masters harks back to the metamorphic tradi-

tion of landscape painting—the visual pun—already seen in Ni Zan's *Lion Grove.* The picture by Luo Ping shows us Zhong Kui, the famous demon-queller, drunk and supported by ghosts (*fig. 619*). The oddly gnarled and striated draperies recall the drawing of tree trunks, and the amalgamation of the four figures in one purposely convoluted mass adds to the effect of the simile. The lyrical hues of the flowering foliage are typical of the later individualists' experiments in color. Their compositions are oftentimes distorted; tall, narrow pictures and odd juxtapositions are common in their work. These two were perhaps the last significant individualists of the Qing dynasty. From about A.D. 1800 on, painting in China became repetitive, although interesting work surfaced from time to time. Modern efforts in the traditional "individualist" style are being increasingly and favorably studied. But efforts to inject "people's realism" into modern painting have only produced results comparable with the dreary efforts of Soviet and Nazi academicians.

Extremely competent and sometimes very gifted painters of flowers and birds, a genre much liked by the Qian Long emperor, are well represented in the National Palace Museum. Excellent landscapes in the orthodox tradition, deriving from the Four Wangs of the seventeenth century, were also being painted. But these add nothing to a general survey of the field. Still, one painter should be mentioned as a symbol of Western influence in eighteenth century China, the Jesuit priest-painter Giuseppe Casti-

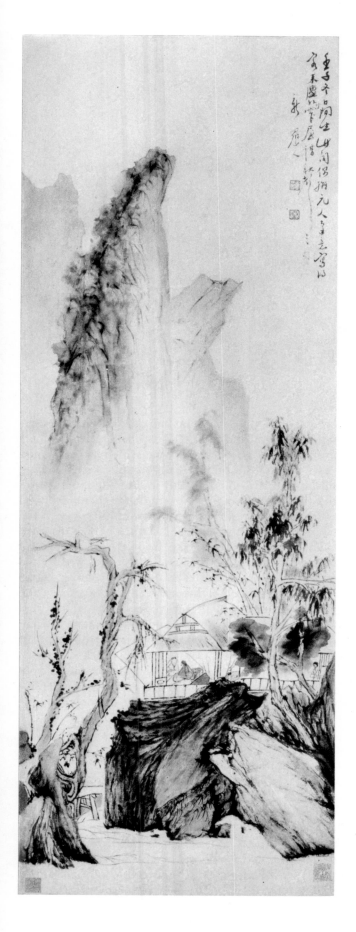

618. (left) *Conversation in Autum.* By Hua Yan (A.D. 1682–1765). Dated to A.D. 1732. Hanging scroll, ink and light color on paper; height 45 3/8″. China. Qing dynasty. Cleveland Museum of Art

619. (below) *Zhong Kui Supported by Ghosts.* By Luo Ping (A.D. 1733–1799). Hanging scroll, ink and light color on paper; height 38 1/8″. China. Qing dynasty. Cleveland Museum of Art

620. *One Hundred Horses at Pasture.*
By Lang Shi-ning (Giuseppe
Castiglione; Italian, act. in
Beijing A.D. 1715–1766).
Section of the handscroll, ink
and color on silk; height
37 1/4″, length 25′ 5″. China.
Qing dynasty. National
Palace Museum, Taibei

glione, called Lang Shi-ning by the Chinese. Castiglione, an emissary to the Chinese court, brought with him a fairly good French painting technique. Other artists and technicians came with him, but he became a special favorite of the court, painting many pictures for the emperor as well as influencing the decoration of porcelains. Some of his scrolls are in a mixed Western-Chinese manner; a very few others are thoroughly Chinese. The handscroll in the National Palace Museum, twenty or thirty feet long and representing a hundred horses, a subject that goes back to the Tang dynasty, is a characteristic mixture of Western realism in the shading and modeling of the horses and of Chinese idealism in the background, which reveals Chinese conventions in the painting of trees and mountains (*fig. 620*). The two manners have not, however, been successfully synthesized. Castiglione's works are competent, if curious and gaudy in color, but they cannot be taken as seriously as works either wholly Chinese or French in style. This mixture of two styles contrasts with European *chinoiserie,* in which European rococo style was brought to bear on Chinese subjects, with delightfully decorative results, particularly in porcelain and textiles.

Ceramics

It has become fashionable to underrate Chinese porcelains of the seventeenth and eighteenth centuries. They were the first love of the great collectors of the early twentieth century, including J. P. Morgan, Benjamin Altman, and P. A. B. Widener. One remembers mirror-back museum cases in which six ox-blood vases became six hundred ox-blood vases, inducing surfeit and stupefaction. But it is unfair to condemn the late works on these grounds, for their technical refinement represents one high point of many in the Chinese ceramic tradition. No finer porcelains have been made before or since from the standpoint of materials and technique. The wares acquired by the great collectors of the early century usually corresponded to French eighteenth century taste, like the rest of the decor in the great mansions where they were housed. The Chinese, and the Japanese as well, made porcelains expressly for eighteenth century French and English consumption. Black hawthorn vases, powder blue vases, jars with decoration in rose or green enamels, were desired by nearly all. Another type of porcelain, relatively unknown in the West until recently—porcelain in Chinese taste—now commands the attention of museums and collectors.

A simplified account of the Qing porcelain tradition, based on appearance and technique, is necessary before we consider the precious porcelains made solely for the Chinese court. Monochromes continue to be made with ever increasing technical skill in the Qing dynasty. The basic technique of monochrome glaze color is to be seen in the ox-blood, or *lang,* wares, of which vases are the most common shape (*colorplate 49, p. 465, left*). The glaze color, called also

by its French name, *sang de boeuf*, tends to be pale and slightly grayish at the top of the vessel, becoming a progressively deeper coppery red with crimson or red brown highlights, and it stops in a perfectly even line at the foot rim with no assistance other than the skill of the potter. Wares ground at the bottom in order to achieve the proper line are highly suspect as products of later declining technology. The brilliance of this glowing red color makes it one of the most boldly dramatic glazes, in high contrast with another copper oxide glaze of most delicate hue, appropriately known in the West as peach-bloom and to the Chinese as apple or bean red. While in ox-blood porcelains the color appears to lie deep under a brilliant, transparent surface, peach-bloom seems closer to the surface and soft in texture like the down of a peach—hence the appellation. Sometimes the rosy color is mottled with green, or is closer to ashes-of-roses than to peach color. Collectors delight in distinguishing nuances of color within each particular ware, sometimes creating extremes of minute classification. Where one separates ashes-of-roses from

peach-bloom is hardly a weighty matter. Eight prescribed shapes of peach-bloom porcelain were made for imperial contemplation, nearly all in the reign of the Kang Xi emperor. One of the eight shapes is called the lotus-petal or, less properly, chrysanthemum vase, represented here by a perfect specimen (*colorplate 49, p. 465, right*). Another of the rare and desirable monochromes is the *clair de lune,* or moonlight, glaze, its pale, shimmering cobalt blue suggesting the poetic name (*fig. 621*). Production of *clair de lune* porcelains—in a variety of shapes including those prescribed for peach-bloom—was also largely limited to the Kang Xi reign. The great monochromes come mostly from this early reign, the reigns of the Yong Zheng and Qian Long emperors being richer in decorated porcelains.

Another group of monochromes, usually of Yong Zheng or Qian Long date, used iron oxide to color the glaze. Of these the most famous is probably the tea-dust glaze, an opaque glaze of a greenish tea color with a slightly grainy texture (*colorplate 49, p. 465, below*). The shapes of the tea-dust wares are sim-

621. *Vase*. Porcelain with *clair de lune* glaze; height 6 1/4″. China. Qing dynasty, reign of Kang Xi (A.D. 1662–1722). Metropolitan Museum of Art, New York

622. *Bottle vase.* Soft-paste porcelain with decoration in underglaze Blue-and-White; height 11 1/4″. China. Qing dynasty, mark and reign of Yong Zheng (A.D. 1723–35). Cleveland Museum of Art

623. *Baluster vase.* Porcelain with *famille verte* panels on a *famille noire* ground; height 17 3/8″. China. Qing dynasty, reign of Kang Xi (A.D. 1662–1722). Cleveland Museum of Art

ple and oftentimes more agreeable to modern taste than the more elaborate monochrome and decorated porcelains. The famous apple-green glaze was actually an enamel applied over the surface of a glaze, producing a rich lime green.

Underglaze Blue-and-White was continued, not only in the standard Ming technique used to cold perfection by the Kang Xi potters but also in a rare type called soft-paste Blue-and-White porcelain (*fig. 622*). The body of this ware, produced largely in the Yong Zheng reign, is a buff gray clay, less homogeneous than the white body of the earlier Blue-and-White porcelains, and coated with a creamy white slip that makes it less hard and brilliant than the usual Blue-and-Whites. The soft body and slip cause the covering glaze to crackle slightly.

The greatest innovations in Qing porcelains are to be found in the enamel-decorated wares, whose French appellations—*famille verte, famille rose, famille noire*—are by now firmly ensconced in the language. Some use only one enamel, plus black, over a pure white glaze, in a taut but rich allover decoration of

peonies against a green ground. More colors and greater elaboration were a matter of technical refinement. *Famille verte* wares comprise large vases in green, rose, black, and brown enamels, sometimes including underglaze or overglaze blue, with green predominating. The decorations are floral motifs or narrative scenes from famous tales or novels, with the figures vigorously and boldly drawn (*fig. 623*). The *famille verte* technique was also used in combination with the black-ground enamel technique, where a black enamel ground gave a dramatic and somber appearance to the colors, in contrast with the transparent, clean white tonality customary in most Chinese porcelains of Ming and Qing. Again one can note how much the combination accorded with French eighteenth century taste.

The *famille rose,* the rose family of porcelains, is more characteristic of the later Yong Zheng and Qian Long reigns. In these porcelains, the white ground is almost always used, and the predominant enamels are rose or yellow, with green as a supporting note in foliage (*colorplate 50, p. 466, above*). The

rose enamels were sometimes used in large vases and plates with decorations of peaches and peonies, birthday presentations to the emperor, but they were at their most refined on smaller porcelains. Some larger pieces were exported, and it was these that first entered the great American collections. Not until the beginnings of Sir Percival David's collection in the late 1920s, and the London Exhibition of 1935, did the West realize that the *famille rose* technique had been used for Imperial porcelains of a quality surpassing anything known before or since. These enameled wares, beginning at the very end of the Kang Xi reign, are called by the Chinese "raised enamel" wares, or sometimes, after A.D. 1743, "foreign enamel" (*fa lang*) decoration. In the West they have been called *gu yue xuan* (moon pavilion ware), a misnomer derived from a group of late eighteenth and nineteenth century glass bottles made for private use, but we propose to return to the traditional Chinese appellations. A new and creative style begins at the very end of the Kang Xi reign, with delicately shaded decoration, perhaps revealing Western influence, on brilliant rose or yellow grounds (*colorplate 50, p. 466, below*). Nearly all examples of raised enamel ware have the mark of the reign on the base, not in the usual underglaze blue, but in Song style characters of raised blue or, less often, rose enamel. The height of the technique was achieved in the Yong Zheng reign and in the early years of the Qian Long reign, under Nian Xiyao and Tang Ying, directors of the Imperial factory. Works were produced such as the superb small vase in figure 624, which combines poetry in black enamel with floral or bird decoration in *famille rose* enamels in a delicate and refined, lyrical, and beautifully unified expression of painting and ceramic art. One may prefer Song porcelains, Tang pottery, or Neolithic earthenware, but one cannot deny the superb quality of these porcelains made in small numbers for the court. The bowl in figure 625 shows the influence of sophisticated, scholarly style painting in its use of monochrome black for a traditional prunus design on snow-white porcelain.

Other Decorative Arts

Other decorative arts are numerous, technically refined, and oftentimes interesting, even beautiful in an ornamental way. They display an unmatched technical virtuosity that often partakes more of patience than of inspiration: "My, what a lot of work went into that!" To which one adds, "To what end?" Still, the technical virtuosity that could produce a green jade dish so thin as to be translucent is to be admired and deserves mention in any history of Chinese decorative arts. The jewel jade *koro* in figure

624. *Bottle vase. Famille rose* porcelain, so-called *gu yue xuan* style; height 5 1/4". China. Qing dynasty, mark and reign of Qian Long (A.D. 1736–95). Percival David Foundation of Chinese Art, London

625. *Bowl. Famille rose* porcelain, so-called *gu yue xuan* style, with prunus decoration; diameter 4 1/2". China. Qing dynasty, mark and reign of Yong Zheng (A.D. 1723–35). Percival David Foundation of Chinese Art, London

626, its design worked in raised ridges giving an almost cloisonné effect to the surface, represents a degree of dexterity commanded only by artisans to the court. Naturally such bibelots as this, pleasing to early twentieth century taste and admirable to anyone for their unearthly technique, were much copied and are made to the present day. The ability to distinguish between a fine piece from the eighteenth century and a mechanically made twentieth century object comes with repeated handling and looking; once acquired, it shows us that dentist drills and machine tools are no substitute for endlessly patient hand abrasion.

The complex development of official costume and the ritual importance of different court ranks reached new heights under the Manchu emperors, resulting in magnificent robes of silk tapestry and embroidery, with the same rich, almost willfully bold and complicated decorative quality that is found in some of the porcelains and jades. From this to the repetitive inanities of the late Empire and the Republic was but a patient if agonized breath. Nothing, save for the work of a few individualists in painting and calligraphy, was worthy of the past; and China's present achievements are still in the process of assimilation and becoming.

626. *Koro*. Jade, height 6″. China. Qing dynasty,
reign of Qian Long (A.D. 1736–95). Cleveland
Museum of Art

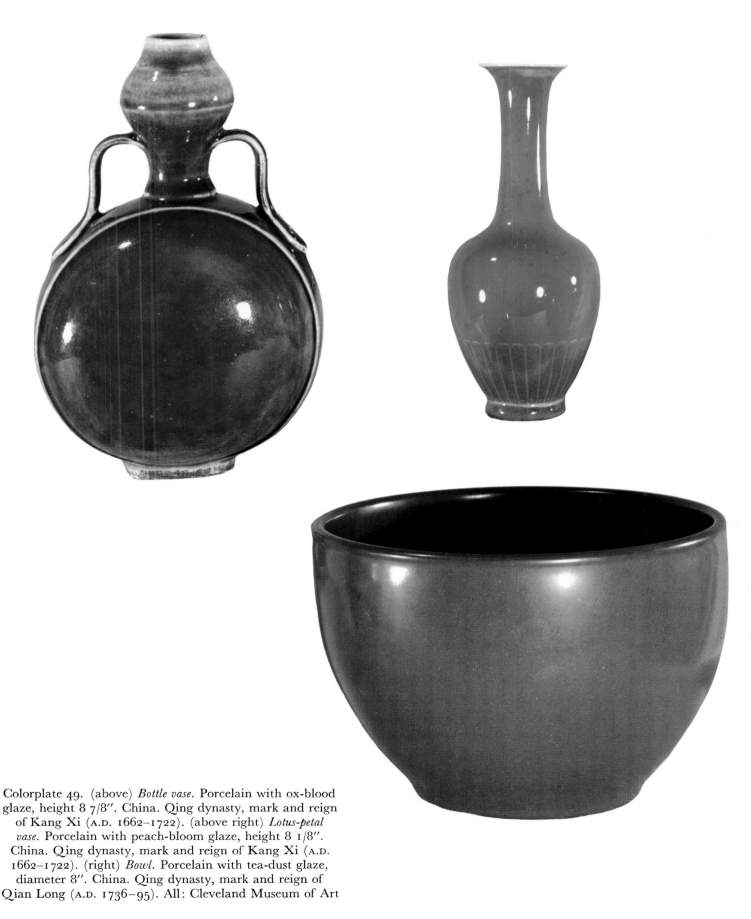

Colorplate 49. (above) *Bottle vase*. Porcelain with ox-blood glaze, height 8 7/8″. China. Qing dynasty, mark and reign of Kang Xi (A.D. 1662–1722). (above right) *Lotus-petal vase*. Porcelain with peach-bloom glaze, height 8 1/8″. China. Qing dynasty, mark and reign of Kang Xi (A.D. 1662–1722). (right) *Bowl*. Porcelain with tea-dust glaze, diameter 8″. China. Qing dynasty, mark and reign of Qian Long (A.D. 1736–95). All: Cleveland Museum of Art

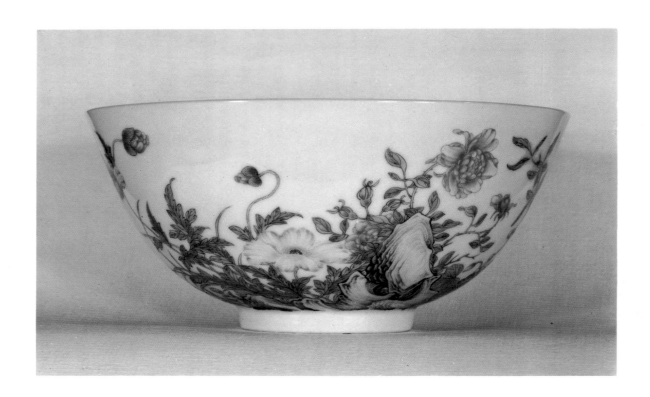

Colorplate 50. (above) *Bowl. Famille rose* porcelain, diameter 5 1/2″. China. Qing dynasty, mark
and reign of Yong Zheng (A.D. 1723–35). (below) *Bowl.* Porcelain, so-called *gu yue xuan* decoration
of raised enamel on yellow ground; diameter 4 7/8″. China. Qing dynasty, mark and reign of Kang
Xi (A.D. 1662–1722). Both: Mr. and Mrs. Severance A. Millikin Collection, Cleveland

Colorplate 51. *Garden of the Sambo-in of Daigo-ji*. Kyoto, Japan. Momoyama period,
completed A.D. 1615

Colorplate 52. *Tigers and Bamboo*. By Kano Tan'yu (A.D. 1602–1674). Two panels of a sliding screen, ink, color, and gold leaf on paper; height approx. 67″. Nanzen-ji, Kyoto, Japan. Tokugawa period

Colorplate 53. *White Prunus in the Spring*. By Ogata Korin (A.D. 1658–1716). One of a pair of two-fold screens, color and gold leaf on paper; height 62″. Japan. Tokugawa period. M. O. A. Museum of Art, Atami

Colorplate 54. *Cypress Tree*. Attrib. Kano Eitoku (A.D. 1543–1590). Eight-fold screen, color, gold leaf, and ink on paper; height 67″. Japan. Momoyama period. Tokyo National Museum

Colorplate 55. *The Pass Through the Mountains*. By Fukae Roshu (A.D. 1699–1757). Six-fold screen, color and gold leaf on paper; height 53 3/8″. Japan. Tokugawa period. Cleveland Museum of Art

Colorplate 56. *Irises*. By Ogata Korin (A.D. 1658–1716). Pair of six-fold screens, color and gold leaf on paper; height 59″. Japan. Tokugawa period. Nezu Institute of Fine Arts, Tokyo

18

Later Japanese Art: The Momoyama and Tokugawa Periods

The endemic warfare that afflicted Japan throughout the sixteenth century changed in the course of that century from a process of fragmentation to one of consolidation as the weaker contenders for power were progressively eliminated. This continuous struggle, which terminated by 1615 in the supremacy of one clan, the Tokugawa, changed the entire composition of the ruling class. Of the nearly three hundred great families that had dominated Japan before A.D. 1500, extinction or obscurity overtook all but about a dozen, while new families rose from insignificance to supplant the rest. The history of Japan during this time can in effect be summarized in the achievements of three uneasy allies whose drive to power effected the reunification of the country: Oda Nobunaga, Toyotomi Hideyoshi, and Tokugawa Ieyasu.

The names conventionally attached to their time accurately reflect their roles as historical agents. The Momoyama period, generally dated from A.D. 1573, when Nobunaga deposed the last Ashikaga shogun, to A.D. 1615, when Tokugawa Ieyasu attained sole mastery of Japan, is named, retrospectively, for the hill on which stood Hideyoshi's lavish castle in the district of Fushimi south of Kyoto. When Tokugawa Ieyasu demolished the castle in A.D. 1622, the hill was planted to peach trees, hence the name Momoyama—Peach Hill. The early phase of the Momoyama period is sometimes called Azuchi, after Nobunaga's similarly splendid castle on the southern shore of Lake Biwa, begun in A.D. 1576, decorated by one of the foremost painters of the age, and burned to the ground a scant seven

years later by the rebellious vassal who murdered Nobunaga. From Nobunaga's death in A.D. 1582 till his own in A.D. 1598 Hideyoshi ruled Japan. The Tokugawa period is said to begin in A.D. 1615, when Ieyasu, predictably, exterminated Hideyoshi's favorite son and successor along with all his family; it is also called the Edo period, after the old name for Tokyo, the Tokugawa capital, and it endured till A.D. 1868, when internal and foreign pressures combined to force the abolition of the shogunate and the restoration of power to the emperor.

In fact Momoyama and Tokugawa are a continuum, politically, socially, and artistically. They constitute a period of economic strength, feudal organization and military dictatorship, and—with the end of Hideyoshi's abortive invasions of Korea in A.D. 1598 and the expulsion of the last European traders and missionaries in 1638—nearly total isolation from the rest of the world. It was a period of artistic in-turning leading to the creation of a new native style, based in part upon Fujiwara and Kamakura revivals and in part on the emergence of strongly decorative tendencies reflecting the bold tastes of Japan's new aristocracy.

ARCHITECTURE

The most highly visible and striking expression of the expansive, ambitious temper of the times was the castle. Earlier military architecture had been largely utilitarian—defensive fortresses separate from the living-quarters of the daimyo, or lord. But the

473

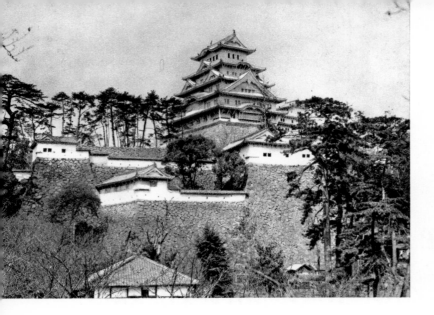

627. *Himeji Castle*. Hyogo Prefecture, Japan.
Momoyama period

Momoyama period saw the culmination of a trend, originating perhaps a century before, to combine keep and home into one massively fortified mansion, whose interior lavishness was designed to impress as much as its exterior strength was designed to protect. The walls of the compound, generally of earth faced with stone, encompassed all the buildings necessary to house the lord, his family, and his retainers; within, the principal, multistoried building commanded a strategic view of the surrounding countryside. The great Togukawa castle at Nagoya was unfortunately destroyed during World War II, but Himeji on the Inland Sea (called Castle of the White Herons for its soaring white walls), begun by Hideyoshi in A.D. 1581 and enlarged to its present state in A.D. 1609, remains as an outstanding example of the best castle architecture of its time (*fig. 627*). The exterior of the main building, for a third of its height, presented a forbidding military aspect: massive masonry construction, rising from a moat, towers some fifty or sixty feet above the surface of the water. Above this, however, tile roofs with upturned eaves (like those of Japanese temple architecture) top four soaring wooden stories, producing an almost pagoda-like effect and making Himeji at once watchtower, symbol of lordship, and spacious home. Within the walls, parks, gardens, and room interiors reflect not military but aesthetic and decorative requirements. The small exterior windows and the post-and-lintel construction characteristic of all East Asian architecture tended to make the great rooms rather dark, since light could enter only from the perimeter of the building; the far walls opposite the windows enjoyed a kind of perpetual glimmering twilight (*fig. 628*). This had considerable effect on the type and technique of decoration that was to develop. One of the few remaining castles is Nijo, built in A.D. 1603 by Ieyasu in Kyoto, whose clean lines and dominating roof are softened by the surrounding trees and open space. Here again the building exteriors give no hint of the palatial decoration to be found on the sliding and fixed panels of the interior walls (*fig. 629*). Even the gardens attached to aristocratic pavilions reflected something of the new

628. (above left) *Interior of Nijo Castle*. Kyoto, Japan. Tokugawa period, seventeenth century A.D.

629. (left) *Exterior of Nijo Castle*. Kyoto, Japan. Tokugawa period, seventeenth century A.D.

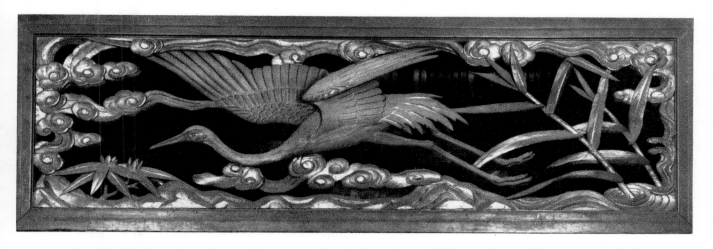

630. *Detail of carved wooden panel from the interior of Nishi Hongan-ji*. Kyoto, Japan. Momoyama period

sumptuousness of the age. The garden of the Sambo-in in Kyoto was designed for the great dictator Hideyoshi himself, and in contrast with the considerable restraint characteristic of the gardens of the Ashikaga period, such as the jewel-like garden of Daisen-in or the sand garden of Ginkaku-ji, the Sambo-in garden luxuriates in boldly shaped and landscaped man-made islands connected by subtly varied bridges (*colorplate 51, p. 467*). The building of the Sambo-in was brought in from the country by Hideyoshi and illustrates a continuation of that taste for peasant architecture which we have seen to be one aspect of the cult developed around the tea ceremony. But inside this apparently rustic structure the richness and brilliance of the colored panels belie the exterior.

In mediums other than painting this rich tradition of interior decoration is perhaps best seen in the openwork wooden panels of the interior of the great audience hall of Nishi Hongan-ji, elaborately pierced and carved into images of waves, flowers, and animals (*fig. 630*). The same decorative emphasis can be seen on a larger scale in the ornately carved panels of the gate at Nishi Hongan-ji (*fig. 631*). Here the realistic tradition of wood sculpture so strongly developed in the Kamakura period was modified for decorative ends; the result, while rich and overwhelming in its complexity, was a balanced blend of realism in detail with a decorative use of rhythmical repetition and bold color.

The comparatively restrained style of carved wood decoration characteristic of the Momoyama period becomes almost a jungle of profusion in the Tokugawa period. The Japanese buildings best known to Western tourists, and the type-site for Tokugawa gorgeousness in architecture, are the lavish shrines built by the Tokugawa shoguns at famous Nikko. The elaborately painted and lacquered interiors

certainly overwhelm the spectator, as does the Yomei gate, with its white base and pillars, elaborately carved and colored reliefs of peonies on the side panels, and profusion of copiously colored and gilded bracketing on the upper part of the gate (*fig. 632*). Yet this extreme expression of the decorative style is perhaps the least of the achievements of Japanese architecture. A real architectural contribution of this later military society is to be found, not in the overweening wooden decoration of the shrines, but in the stonework at Nikko (*fig. 633*). All of the great

631. *Kara gate (detail) of Nishi Hongan-ji*. Kyoto, Japan. Momoyama period

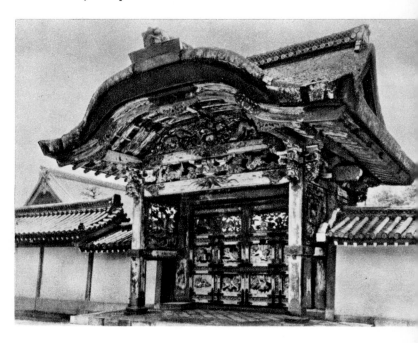

walks, stairs, and walls here are made of large blocks of granite, cut and fitted with the utmost precision, and so laid as to harmonize with the incredibly beautiful forest setting of great cryptomeria trees, some of them over a hundred feet high. The unornamented grandeur of this stonework seems the true measure of the men who by force and guile created the Momoyama and the early Tokugawa periods.

Notwithstanding the riotous extravagance of Nikko and the opulence of the castles, the already deeply rooted Japanese taste for simplicity in architecture was not displaced; rather, it was embraced

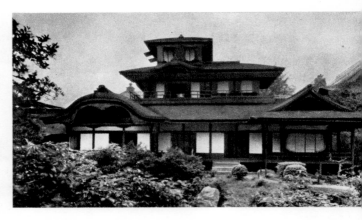

634. *Hiunkaku Pavilion of Nishi Hongan-ji*. Kyoto, Japan. Momoyama period.

632. *Yomei gate of Tosho-gu*. Nikko, Japan. Tokugawa period, seventeenth century A.D.

633. *Masonry from Tosho-gu*. Nikko, Japan. Tokugawa period, seventeenth century A.D.

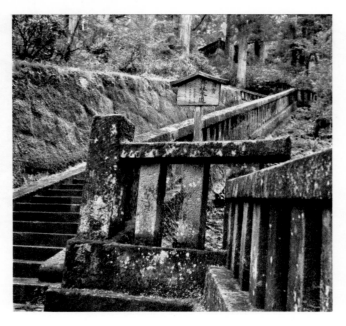

even more avidly, not only by the aristocracy and the military but by the new, wealthy upper-middle classes. The antithesis of Nikko is the calculated tea-ceremony taste embodied in the Katsura Detached Palace (A.D. 1625). Small tea pavilions continued to be built by all who could afford them, and these continue with more or less success the tea-ceremony architecture that had been established by the middle and late Ashikaga period. At Nishi Hongan-ji in Kyoto Hideyoshi had re-erected a pavilion, called the Hiunkaku (*fig. 634*), in the great tradition of such pleasure pavilions of the early Ashikaga shoguns as the Gold and Silver Pavilions in Kyoto. With its dark exterior woodwork, it seems even more asymmetrical and informal in general plan and arrangement than the earlier structures. Situated in a lush garden, perhaps even more decorative than that of the Sambo-in, the pavilion was a place where the new dictator and his military acquaintances could gather in an atmosphere suggestive of the Ashikaga tea house. But inside the Hiunkaku, though some rooms are decorated with monochrome paintings in the tea tradition, others boast colored *fusuma* in the rich painting style developed in the Momoyama period.

PAINTING

We shall consider Japanese painting of the Momoyama and Tokugawa periods, not according to the detailed genealogies of painter-families, but according to leading stylistic tendencies. As in any period, conservative styles persisted, but with few exceptions the numerous painters continuing in the Chinese-influenced style of the Ashikaga period, particularly in the Kano school, contributed little if anything new to Japanese painting. Among the

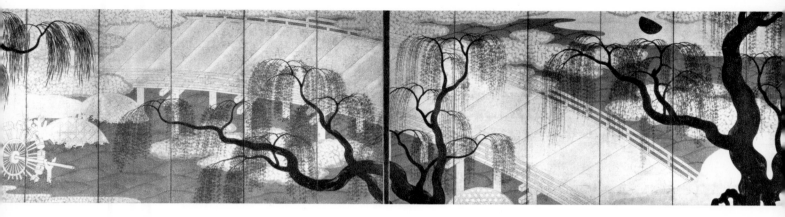

635. *Bridge at Uji*. Pair of six-fold screens, color, gold, and silver on paper; height 59″. Japan. Momoyama period. Nelson Gallery–Atkins Museum, Kansas City. Nelson Fund

creative trends we shall consider first the decorative style, perhaps Japan's most original and fruitful painting style. Second is a Chinese-influenced style, not based, like Ashikaga monochrome painting and its decadent Kano continuation, on Song and early Ming masters, but on the scholars' painting of the seventeenth and eighteenth centuries. This latter style, known as *nanga* or "southern" painting (according to Dong Qichang's terminology), boasted several artists of great importance and creative ability. The third trend is a naturalistic one, influenced in part by Western art and even more by a growing awareness of nature as seen, rather than as rendered in brush conventions. Finally the *ukiyo-e* tradition produced some very important paintings of mixed decorative and *ukiyo-e* subjects and styles in the seventeenth and eighteenth centuries and culminated in the great woodblock prints of the eighteenth and nineteenth centuries.

The native decorative style, which first appeared in Fujiwara and Kamakura painting, revives suddenly in the Momoyama period. The *Bridge at Uji*, though derived in subject from the *Ise monogatari* of the Fujiwara period, receives an almost totally new rendition (*fig. 635*). The silver moon recalls Fujiwara painting; the juxtaposition of undulating trees against the geometrically arched bridge recalls certain Fujiwara or Kamakura lacquers. But the overall richness and splendor of the composition, the copious use of gold in the background, the large and bold rhythms of the willow-tree trunks, the obvious delight in textures and rather crowded composition—these make a new and original statement, a Momoyama contribution, out of which most of the later decorative style develops. Earlier painting, whether iconic or Zen monochrome, had been primarily religious in tone and purpose; in Momoyama it tends increasingly to serve secular

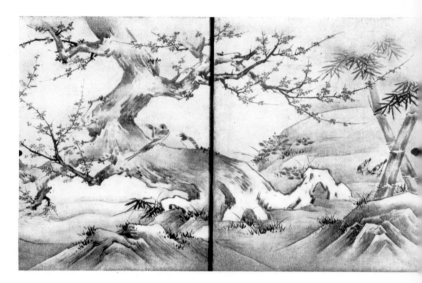

636. *Plum Tree by Water.* Attrib. Kano Eitoku (A.D. 1543–1590). One of a pair of sliding screens, ink and slight color washes on paper; height 69 1/8″. Juko-in, Kyoto, Japan. Momoyama period

requirements. The new style employed many formats, including sliding panels, single screens, folding screens, and decorative hanging scrolls. Gold leaf, because it reflects light, brightened the dark castle rooms; used as background, it also outlined painted forms dramatically. The new decorative art originated in the Chinese-influenced Kano school but soon advanced to extremes of pattern and color that belied the severe aims of the parent style.

This development can be traced from the first great master of the Momoyama period, Kano Eitoku (A.D. 1543–1590). As his name implies, he was in the main line of the Kano school, perhaps a pupil of Motonobu. But in the painting, attributed to him, on

477

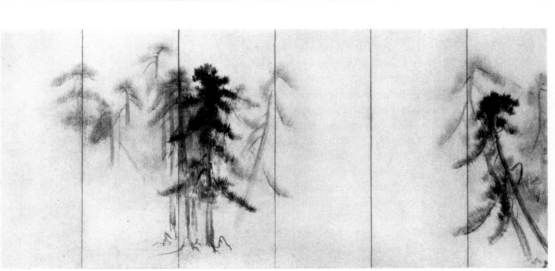

637. *Pine Wood.* By Hasegawa Tohaku (A.D. 1539–1610). Pair of six-fold screens, ink on paper; height 61″. Japan. Late Ashikaga or Momoyama period. Tokyo National Museum

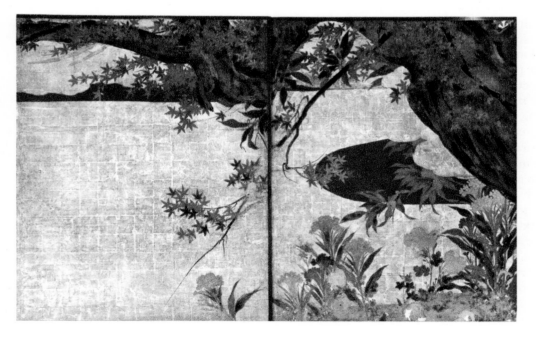

638. *Flowers and Maple Leaves.* Attrib. Hasegawa Tohaku (A.D. 1539–1610). Two panels of sliding screens, color and gold leaf on paper; height 70″, length 218 1/4″. Chishaku-in, Kyoto, Japan. Late Ashikaga or Momoyama period

the two sliding panels from the Juko-in in Kyoto, the ostensibly monochrome Kano style of representation of the blossoming tree, the birds, and the bamboo has been considerably transformed to a decorative style, with greater complexity of composition, fewer areas of open space left untouched by the brush, and a faint gold wash applied to the background sky (*fig. 636*). From this decoratively inclined but still relatively severe style of painting to Eitoku's main contribution is a considerable step, but it was made in one lifetime. It can best be seen in an eight-fold screen in the Tokyo National Museum (*colorplate 54, p. 471*). The large cypress tree is not an exercise in the use of ink, but a massive, even sculpturally modeled, form produced in color. Rich browns and reds model the general shapes, while the bark texture is applied in ink. Malachite green silhouettes the lithe boughs as well as creating their leaves. Rocks are now colored and placed against azurite blue areas indicating water. The background as well as the swirling clouds is indicated in gold leaf applied to the surface of the stretched paper. The result is very largely an art of silhouettes and of their careful placement against a background of gold. This ground, an abstract, unearthly realm in Byzantine art, becomes in the Momoyama decorative style a most palpable and solid ground of rich gold acting almost as a stage flat against which the clear silhouettes of natural forms stand out. Eitoku is still a shadowy figure and few works are surely by him, but tradition affirms and life span does not contradict his role as founder of the Momoyama decorative school.

His rival was Hasegawa Tohaku (A.D. 1539–1610), whom we know to have disliked the Kano tradition. Like Eitoku, he painted in both monochrome and colored decorative style, but his monochrome paintings, such as the famous *Monkeys and Pines* in the Ryusen-in, derive directly from the art of Mu-Qi, especially the famous triptych at Daitoku-ji, rather than secondhand through the late Ashikaga Kano school. If this were the only monochrome work by Tohaku, we would recognize him as a brilliant practitioner of late Southern Song monochrome style. But Tohaku also painted one of the supreme masterpieces of monochrome ink painting, *Pine Wood*, illustrated in figure 637. This pair of screens, executed solely in monochrome ink on paper, reveals the true originality and daring of Tohaku and his generation. Taking what would have been a detail in an earlier composition, he enlarged the pine trees and simply isolated them on the screens, providing no background of mountains, no foreground of scholars or rocks, suggesting space by means of graded ink tones implying swirling mist around the pine trees. These are painted boldly and

simply, with something of the dancing movement and rhythm of the trees in the screens by Shubun. Though implying the influences of Mu-Qi and Shubun, the screens exist as an original creation, one expressing something of the grandeur and scale of the Momoyama effort, even in such a usually nondecorative medium as monochrome ink.

Tohaku also attempted the more typically decorative Momoyama style in the numerous sliding panels now preserved at the Chishaku-in, Kyoto (*fig. 638*). These sliding panels, like those of Eitoku, have gold-leaf backgrounds, and are painted in opaque mineral and earth colors instead of monochrome ink. Indeed, there is little ink to be found in the originals except for occasional accents or underpainting guides to the application of color. The gold background has greatly increased in area and enhances the brilliance of the color and especially the importance of the profiles, which are not rendered in a single dark tone but vary from grays, pinks, and pale greens to the darkest azurite, malachite, and brown. The motifs of these screen paintings range from allover patterns of flowers and maple leaves to dominant, heavy tree trunks and boughs. The bold composition of the tree trunk reaching up and out of the panel at the top and then returning at the center demonstrates the decorative daring of the new approach, as do Tohaku's bold

639. *Hawks and Pines*. By Kano Sanraku (A.D. 1559–1635). Sliding screens, ink on paper; height approx. 70″. Daikaku-ji, Kyoto, Japan. Momoyama or Tokugawa period

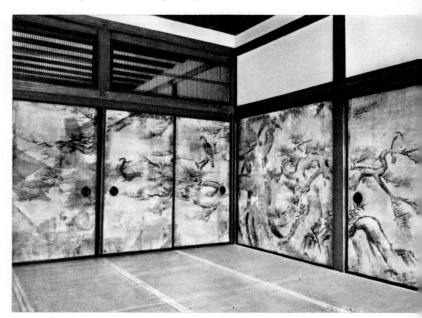

479

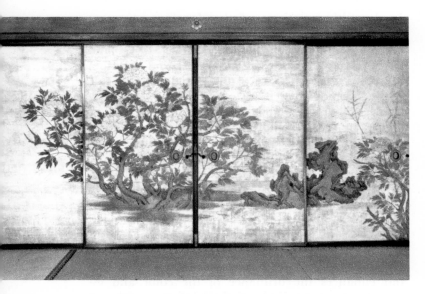

640. *Tree Peonies and Rocks*. By Kano Sanraku (A.D. 1559-1635). Four panels of eight-panel sliding screen, color, ink, and gold leaf on paper; height 72 3/4". Daitoku-ji, Kyoto, Japan

combinations of strong tree trunks with delicate foliage, blue water with green plants. Despite the decorative emphasis it is a powerful painting.

The third of the great Momoyama decorators is Kano Sanraku (A.D. 1559-1635). Like the others, he created both monochrome and colored paintings, which can be seen mainly at Daikaku-ji in Kyoto (*fig. 639*). There, in adjacent rooms, are superbly painted monochrome panels showing birds of prey on old pines and deciduous trees, and richly colored panels with gold backgrounds. The screens with Chinese peonies give some idea of the subtlety and restraint characteristic of Sanraku, in contrast with the bold and powerful styles of Eitoku and Tohaku (*fig. 640*). Some of Sanraku's panels at Daikaku-ji seem to combine the type of composition usually found in monochrome painting with the new colored decorative style. The delicate and refined tree-peony branches are balanced by the powerful tree trunk and rocks, but even these are more stylized than the massive forms depicted by the two earlier painters. Sanraku seems to anticipate something of the mode to be developed by Sotatsu and Korin in the seventeenth century.

Other Kano painters, famed in their day for monochrome painting, worked in the new decorative style. The best achievements of an artist such as Kano Tan'yu (A.D. 1602-1674), perhaps the most famous name in monochrome painting of the seventeenth century, are not in the old-fashioned and trite monochrome subjects, but in the new color-and-

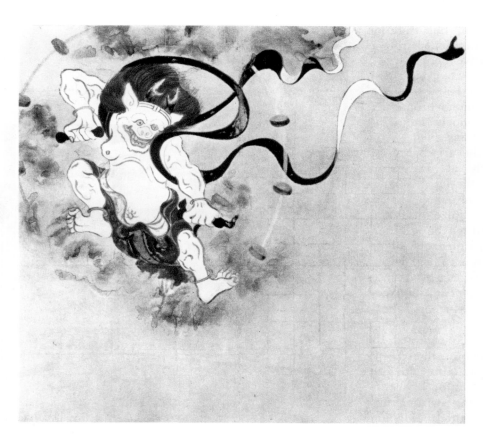

641. *Thunder God*. By Tawaraya Sotatsu (act. late sixteenth–early seventeenth century A.D.). Section of a pair of two-fold screens, color, gold leaf, and ink on paper; height 60". Kennin-ji, Kyoto, Japan. Tokugawa period

642. *Zen Priest Choka*. By Tawaraya Sotatsu (act. late sixteenth–early seventeenth century A.D.). Hanging scroll, ink on paper; height 37 3/4″. Japan. Tokugawa period. Cleveland Museum of Art

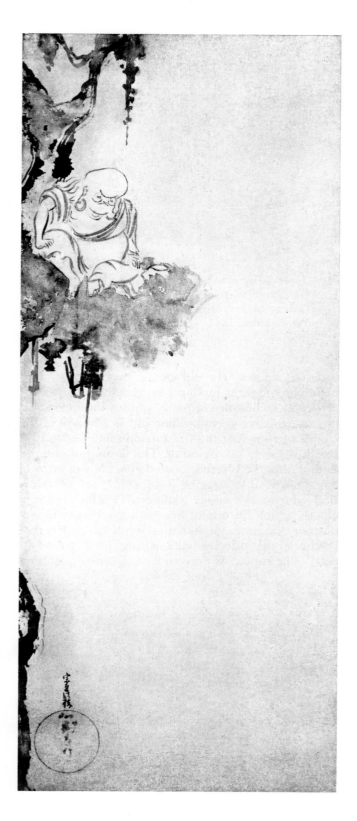

gold medium. The screens at Nanzen-ji, picturing tigers and bamboo, the favorite samurai emblems of strength and pliant resistance, utilize the gold ground to emphasize the silhouettes of the animals and complement their interior bulk (*colorplate 52, p. 468*). There is a trace in these panels of that sharpness of observation particularly important in works of the "realistic" school associated with the name of Okyo. Still, Tan'yu was a repetitive, if talented, late representative of the Kano school.

The Momoyama painters and their followers in the Tokugawa period established, boldly and at once, a rich, complex style difficult of further development. The statement was so complete and overwhelming—some four hundred-odd sliding panels were made for Nagoya Castle alone—that a new style became almost imperative. Changing tastes also dictated a different manner. The unabashed splendor of the Momoyama style, which might satisfy the first generation of the new ruling class, could not continue to please as their more refined descendants became increasingly aware of the contributions of older Japanese art. The Momoyama period may be considered a brilliant prelude to the culmination of later Japanese decorative style in the school established by Sotatsu (act. late sixteenth–early seventeenth century A.D.). Some thirty years ago Sotatsu was merely a name to be mentioned after Korin, but subsequent research and rediscovery of his paintings have led to his just evaluation as the most creative master of later decorative style and the founder of the great Sotatsu-Korin school.

A major work by Sotatsu, such as the pair of twofold screens representing the demons associated with thunder and wind, discloses a different decorative approach from that of such Momoyama painters as Eitoku, Tohaku, and Sanraku (*fig. 641*). In contrast with the overall patterning of these Momoyama painters, and their use of Chinese-derived motifs, Sotatsu's work seems bolder and more severe, with greater emphasis upon asymmetry of composition and simplicity of silhouette and a greater variety in the handling of color and ink. In subject matter too it differs from paintings of the earlier generation, being derived from pre-Ashikaga Japanese traditions, particularly from representations of deities, demons, and noble personages in scrolls of the Fujiwara and Kamakura periods. Tawaraya Sotatsu bypassed the Chinese style paintings of the Ashikaga period to find other sources more deeply

rooted in the Japanese tradition: the decorative style of the Fujiwara period, best seen in the *Genji* scrolls, and the narrative tradition of Kamakura handscroll painting with its emphasis upon action and carica-

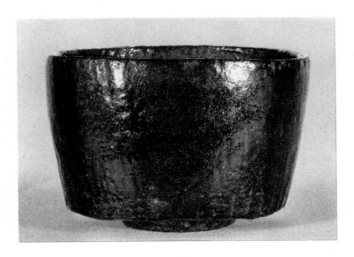

643. *Teabowl.* By Hon'ami Koetsu (A.D. 1558–1637). Raku stoneware, height 3 3/8″. Japan. Freer Gallery of Art, Smithsonian Institution, Washington, D.C.

ture-like figures. He did not, however, rely completely upon early Japanese sources for his style but used also techniques of paint application developed in the Ashikaga period. The bold brushwork of the clouds surrounding the wind demon shows a study of Sesshu's *haboku* ink painting. The fading off of color boundaries, the blurred, pooled effect of wet areas of color, with ink merging into color, are certainly derived from the *haboku* tradition. This inspiration is clearly visible in one of Sotatsu's important monochrome paintings, a hanging scroll of paper representing the priest Choka sitting in a tree (*fig. 642*). The subject is derived from Chinese paintings

as rendered in Chinese woodblock prints, and was used by such literary painters as Kun-Can. But Sotatsu transforms the original print, which shows the whole tree and clearly delineates the figure of the monk, into a daring asymmetrical composition. He leaves most of the tree outside the picture and deliberately deemphasizes the monk by using pale ink lines, thus creating a decorative composition while adhering to the *haboku* style. Of few pictures can it be more truly said that one's praises are for what is not there.

Sotatsu's style of painting is not wholly tradition-directed. Sotatsu's wife may have been related to Hon'ami Koetsu, and it is certain that Koetsu had some influence on Sotatsu's new painting style. Koetsu was known as a tea master who also made teabowls in the tradition of the tea masters of the late Ashikaga and the Momoyama periods (*fig. 643*). This famous example displays a beautiful control of the slightly asymmetrical bowl shape and an especially interesting and subtle use of orange and moss green, the colors of nature, in the glaze. Koetsu's training as a tea master undoubtedly reinforced his inclinations to aesthetic severity and to the deliberate roughness associated with the cult of tea. He was also a very important calligrapher, not in the Chinese but in the Japanese "running" style. He collaborated with Sotatsu on several scrolls of poems, writing the text over under-decoration by Sotatsu. On a long scroll bearing the signature of Koetsu and the seal of Sotatsu are herds of deer and poems from the *Ise monogatari* (*fig. 644*). The combination of bold and freely executed cursive calligraphy with the informal gold and silver representations of deer shows how Koetsu's tea inclinations and his accompanying

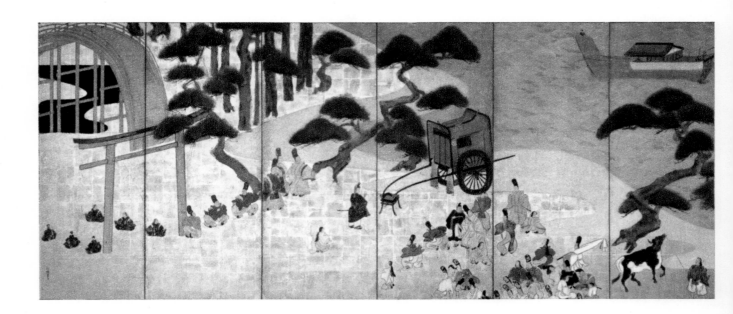

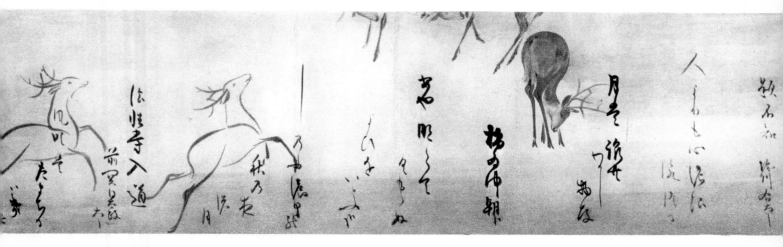

644. *Deer.* By Tawaraya Sotatsu (act. late sixteenth–early seventeenth century A.D.); calligraphy by Hon'ami Koetsu (A.D. 1558–1637). Section of the handscroll, gold and silver pigment and ink on paper; height 12 1/2", length 30' 3/4". Japan. Tokugawa period. Seattle Art Museum

asymmetry and slight roughness combined with Sotatsu's study of pre-Ashikaga Japanese art to transform—not merely develop—the Momoyama decorative style. The compositional device of allowing the herd of deer to run up and off the paper, with only the head and feet of one deer visible at the top of the scroll, is comparable with the barely visible tree in the monochrome representation of Priest Choka. This audacious combination of the handscroll format, the brilliant gold and silver of the Momoyama decorative style, and the asymmetry and

roughness of tea-ceremony taste will rightly always be associated with Sotatsu's name.

Perhaps the most important of Sotatsu's screen paintings are the pair belonging to the Seikado Foundation and representing a scene from *The Tale of Genji* (*fig. 645*). The episode is well though subtly developed in the novel, but its illustrative possibilities are played down by the artist. The representational elements are present—Genji, the two retinues, and the screened cart carrying the lady—but certainly these are not primarily narrative screens. The gold

645. *"Miyotsukushi" (opposite) and "Sekiya" (below) scenes from The Tale of Genji.* By Tawaraya Sotatsu (act. late sixteenth–early seventeenth century A.D.). Pair of six-fold screens, ink, color, and gold leaf on paper; height 59 1/2", length 139 1/2". Japan. Tokugawa period. Seikado Foundation, Tokyo

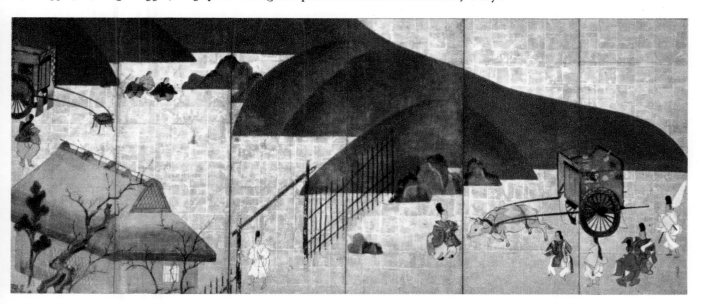

background, the brilliant use of green, blue, and brown, the bold silhouettes of the figures derived from Kamakura scroll painting, the construction of the landscape as a series of overlapping stage flats, probably under the influence of both Fujiwara lacquers and Kamakura handscrolls, are all elements derived from the past but fully assimilated and transformed into a new and original style. The placement of these silhouettes is crucial and has been exquisitely calculated, almost as if Sotatsu, like Matisse, had used a collage technique, moving cut-out figures against the gold background till the composition was perfect. The use of tilted perspective and of abstract water patterns at the top of the "Miyotsukushi" scene is also part of this silhouette style. We need not merely infer the influence of Fujiwara and Kamakura styles on Sotatsu, for we know that he was called upon to restore and redecorate some of the endpapers of the famous sutras at Itsukushima, which, you will remember, are key documents of the *yamato-e* style of the late Fujiwara period (*see p. 306 ff. and figs. 407, 408*), and free copies by Sotatsu after the mid-Kamakura scroll of *The Fast Bulls* are extant. His style reflects other sources as well, but Sotatsu's great contribution—unlike the merely eclectic Kano painters—was to fuse these influences into a new synthesis. The sense of humor apparent in his work seems in keeping with his Japanese artistic origins.

Of Sotatsu's contemporary followers—shadowy figures whose names we are only now becoming aware of—Fukae Roshu is one of the most significant and seems to have absorbed the lessons of his master's new and radical approach. *The Pass Through the Mountains*, a screen ostensibly illustrating a poem from the *Ise monogatari*, is an example of Sotatsu's art carried to further extremes, particularly in the treatment of the landscape as a series of stage flats and in the unusual color harmonies of blue and rust red (*colorplate 55, p. 471*).

Though Sotatsu undoubtedly influenced numerous painters, a direct line traditionally leads from him to Ogata Korin (A.D. 1658–1716) and Sakai Hoitsu (A.D. 1761–1828), each the leading decorative master of his generation. So important is Korin that in Japan his name and Sotatsu's are often used jointly to designate the later decorative school of painting. We know more of Korin's life than we do of Sotatsu's: He was descended from Koetsu's sister and came, not of the samurai class, but of an upper-middle-class merchant family, and he exemplifies the relationship between the new style and the new society of the Tokugawa period. He was officially reprimanded by the court for an overconspicuous display of wealth when at a party he wrote poems on gold leaf and floated them down a stream in emulation of the

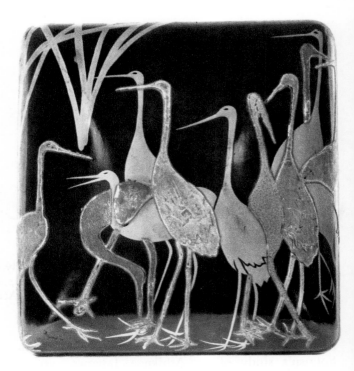

646. *Writing box with cranes*. Designed by Ogata Korin (A.D. 1658–1716). Black-lacquered wood with decoration of gold lacquer and pewter and lead inlay; length 9 1/8". Japan. Tokugawa period. Seattle Art Museum

legendary poets' gatherings in Tang China. His works were collected, however, not only by the new wealthy merchant class but also by the aristocracy. Genroku is the era-name for the fifteen-year period, from A.D. 1688 to 1703, in which the Japanese townsmen came into their own, supplanting the samurai, not in social status but in economic power, and giving rise to a distinctive culture. The Japanese decorative style, first appearing in Fujiwara and Kamakura art and suddenly revived during the Momoyama period, came to full flower during Genroku.

Korin's works are more carefully and less freely painted than Sotatsu's, with a greater emphasis upon precise outline and a relatively even application of color. Korin tempers Sotatsu's boldness to greater elegance and refinement, renders it more approachable; hence he was celebrated before the rediscovery and proper evaluation of Sotatsu. His two screens in the Tokyo National Museum, *White and Red Prunus in the Spring* (of which only the left-hand one is shown here), present an arresting contrast between Korin's native elegance, seen especially in the painting of the tree branches, and the daring inherited from Sotatsu, reflected in the strong shape and swirling surface of the stream (*colorplate 53, p. 469*).

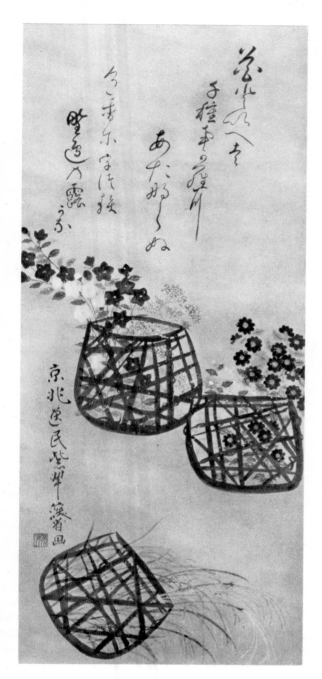

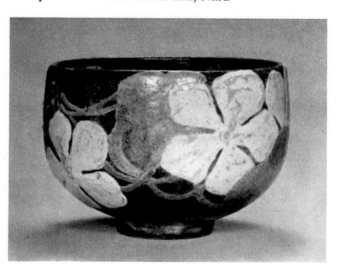

is only an allusion, or a suggested mood or flavor that can perhaps be sensed by the Japanese if not by us. The irises rising from a stream bed in Korin's screens are a fleeting image in one of the poems of the *Ise monogatari*, but Korin has taken this grace note and enlarged it into the sole motif of a great decorative composition, with the malachite green spikes of the leaves dancing across the screen in counterpoint to the iris blossoms in two shades of azurite blue. The effect from a distance is that of a silhouette modified by resonances of color within. As one approaches the screens, the color becomes ever more dominant until at last the vibration of the blue and green against the gold reaches its climax. The subject was painted again by Korin in a pair of screens in the Metropolitan Museum of Art, where the bridge mentioned in the poem is included. The iris screens of Korin, and those by his pupil Shiko, are among the most musical of all decorative style paintings.

Korin, like his predecessor Koetsu, worked in lacquer and ceramics as well as paint, and one of the lacquer boxes attributed to him represents cranes on a dark, blackish brown ground (*fig. 646*). The same subject was used by Korin in a screen recorded by Hoitsu, perhaps the one now in the Freer Gallery. In this the influence of the tea ceremony and of tea taste is more evident than in the screens. In addition to the gold defining some of the shapes, Korin composed the design not only of gold but of inlaid pewter and lead, whose different textures as well as colors lend to the presentation variety, complexity, and a note of roughness, of that *shibui* quality so important to the Japanese tea master. The shape of the box, with its slightly domed lid and rounded edges and corners,

648. *Teabowl with flowers.* By Ogata Kenzan (A.D. 1663–1743). Earthenware. Japan. Tokugawa period. Yamato Bunka-kan, Nara

647. *Baskets of Flowers and Weeds.* By Ogata Kenzan (A.D. 1663–1743). Hanging scroll, color on paper; height 44″. Japan. Tokugawa period. Matsunaga Collection, Tokyo

Korin's most famous paintings, and probably his masterpieces, are the pair of six-fold screens in the Nezu Institute of Fine Arts in Tokyo, representing irises, a subject derived from the *Ise monogatari* (*colorplate 56, p. 472*). It is characteristic of the Sotatsu-Korin school that its motifs can usually be traced to a literary source, although little, if any, effort is made to illustrate the scene literally; there

485

649. *Hozu River.* By Maruyama Okyo (A.D. 1733–1795). Pair of four-fold screens, ink and color on paper; length 15′ 8″. Japan. Tokugawa period. Nishimura Collection, Kyoto

650. *Nature studies.* By Maruyama Okyo (A.D. 1733–1795). One section of three handscrolls, ink and color on paper; height 12 3/8″. Japan. Tokugawa period. Nishimura Collection, Kyoto

is in this tea taste. Another box attributed to Korin, in the Tokyo National Museum, depicts the iris and bridge pattern already seen in his screens.

Korin's brother, Kenzan (A.D. 1663–1743), executed few paintings, but his famous masterpiece, *Baskets of Flowers and Weeds,* beautifully exemplifies the combination of tea taste and decorative style (*fig. 647*). The artful positioning of the baskets, the overlap of the two at the top, the tilt of the one at the bottom, the different color notes of the flowers in the three containers, the combination of calligraphy and decorative motifs, and the boldly

651. *Birds.* By Ogata Korin (A.D. 1658–1716). Detail of sketch sheets mounted as a handscroll, ink and color on paper; width 24″. Japan. Tokugawa period. Zenjuro Watanabe Collection, Tokyo

486

stylized representation of the wickerwork are in keeping with the flavor of the lacquer box by Korin or the joint works of Koetsu and Sotatsu. Kenzan also made ceramics, especially utensils for the tea ceremony—cake trays and teabowls. One of his teabowls fulfills the same intention as his hanging scroll of flowers and baskets (*fig. 648*). In a design of melon flowers on a black-glazed earthenware ground he combined large, bold decorative silhouettes with the roughness and the "naturalness" of a utensil in tea taste. Kenzan's influence on later Japanese ceramics is enormous, and even today his artistic lineage is continued by the ninth artist to take the name Kenzan.

The last great master of the Sotatsu-Korin school is Sakai Hoitsu (A.D. 1761–1828). That he was of the direct line is quite certain, for on the back of Korin's screens copying Sotatsu's depictions of the wind and thunder gods he painted wild flowers and vines by a river bank on a silver background (*colorplate 58, p. 490*). In this work Hoitsu carries even further Korin's tendencies toward elegance and a more flowing and refined composition than that used by Sotatsu. Here is something comparable to European rococo decoration—the bold silhouette shapes are gone. The stream is smaller now and swirls more gently and rhythmically. The color scheme is subtle, but

something of the old boldness and gorgeousness has been sacrificed to attain greater elegance and refinement on a small scale. Some realistic influence is to be seen in this as well, particularly in the depiction of the effect of wind blowing against the vines at the left; one or two of these autumn leaves swirl in the silvery air, revealing another facet of Japanese painting, to which we now turn.

The second main current in later Japanese painting, usually described as realistic, is perhaps more accurately termed naturalistic. It is seen at its highest level in the work of Maruyama Okyo (A.D. 1733–1795). The pair of screens representing the Hozu River illustrates his strange combination of a stylized Ashikaga monochrome manner with a degree of observation of nature that approaches Western objectivity (*fig. 649*). The topmost tree, with its slightly stunted trunk, is less an ideal tree than one observed from nature. The textures of the rocks are somewhere between the stylized *cun* of monochrome painting and the observed texture of volcanic rock. Even the rhythmical sweep of the water partakes of both stylization and naturalism. The general composition, however, is fairly arbitrary and bold, almost decorative. Okyo's interest in realism is more clearly divulged in other works, and most explicitly in one scroll (*fig. 650*). These realistic studies in ink and

652. *Westerners Playing Their Music.* Pair of six-fold screens, ink and color on paper. Japan. Tokugawa period, c. A.D. 1610. M. Hosokawa Collection, Tokyo

戊戌九月六日

本翁自題

六旬誕日寫傳神鷲
見蒼顏一老人烏帽
戴來雖似貴綿裘者
得竟應真紫名文苑
癯相頗游手黑池龜
有因無事散閒能到
七重逢無白盡中身

653. *Portrait of Ichikawa Beian.* By Watanabe Kazan
(A.D. 1793–1841). Hanging scroll, ink and color
on silk; height 50 7/8". Japan. Tokugawa period.
Goro Katakura Collection, Tokyo

color of leaves and insects show direct observation
translated into brushstrokes that follow observed
forms rather than East Asian conventions. The dif-
ference between this true naturalism and the stylized
or conventional naturalism of the decorative or
Kano style painters becomes apparent if one con-
trasts the Okyo scroll with a similar scroll painted by
Korin, in which brush conventions seem to dominate
(*fig. 651*).

Such realism in pictorial form was derived in part
from observation and in part from Western in-

fluence. The Portuguese missionaries and Dutch
traders in southern Japan introduced a style of
painting that impressed many Japanese painters,
some of whom set about picturing Europeans in
court costumes of the seventeenth and early eigh-
teenth centuries, with backgrounds in a strange and
naive, even comical, combination of Western and
Japanese techniques (*fig. 652*). The same curious,
unassimilated mixture of East and West has already
been seen in Castiglione (*see p. 458 and fig. 620*).
Pictorial modeling in light and shade to develop
the sculptural quality of figures impressed the
Japanese, and numerous works in this genre were
painted. It remained, however, for a painter of the
Japanese scholarly tradition of the early nineteenth
century, Watanabe Kazan (A.D. 1793–1841), to
produce perhaps the most striking and original works
under the influence of Western realism. Kazan, who
painted in Chinese style as well, was able to absorb
the mixed stylistic influences in the *namban* (Western

654. *Sketch for the Portrait of Ichikawa Beian.*
By Watanabe Kazan (A.D. 1793–1841). Hanging
scroll, ink and color on paper; height 15 1/2".
Japan. Tokugawa period. Goro Katakura
Collection, Tokyo

Colorplate 57. *Jar.* By Nonomura Ninsei (d. c. A. D. 1685). Porcelain with overglaze enamel decoration
of poppies; height 16 3/4″. Japan. Tokugawa period. Idemitsu Museum of Art, Tokyo

Colorplate 58. *Summer Rain and Autumn Wind.* By Sakai Hoitsu (A.D. 1779–
1828). Pair of two-fold screens, color on silver paper; height 61″. Japan.
Tokugawa period. National Commission for Protection of Cultural
Properties, Tokyo

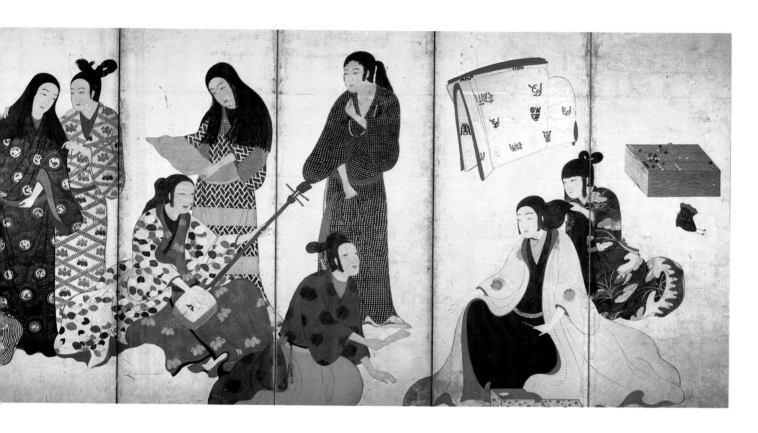

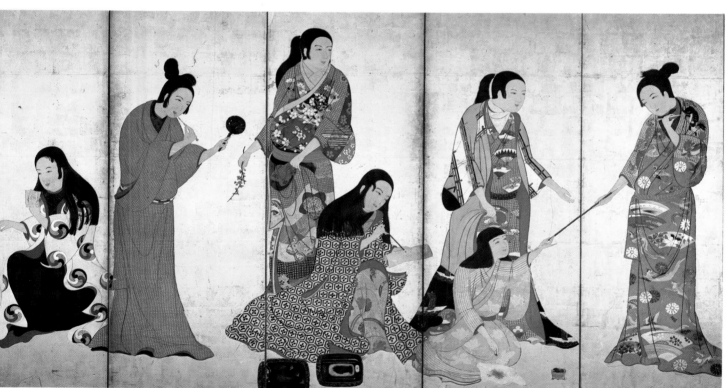

Colorplate 59. *Matsuura Byobu I and II (Screens with Women of Fashion at Leisure, owned by the Matsuura family)*. Pair of six-fold screens, color on gold paper; length 12'. Japan. Tokugawa period, first half of seventeenth century A.D. Yamato Bunka-kan, Nara

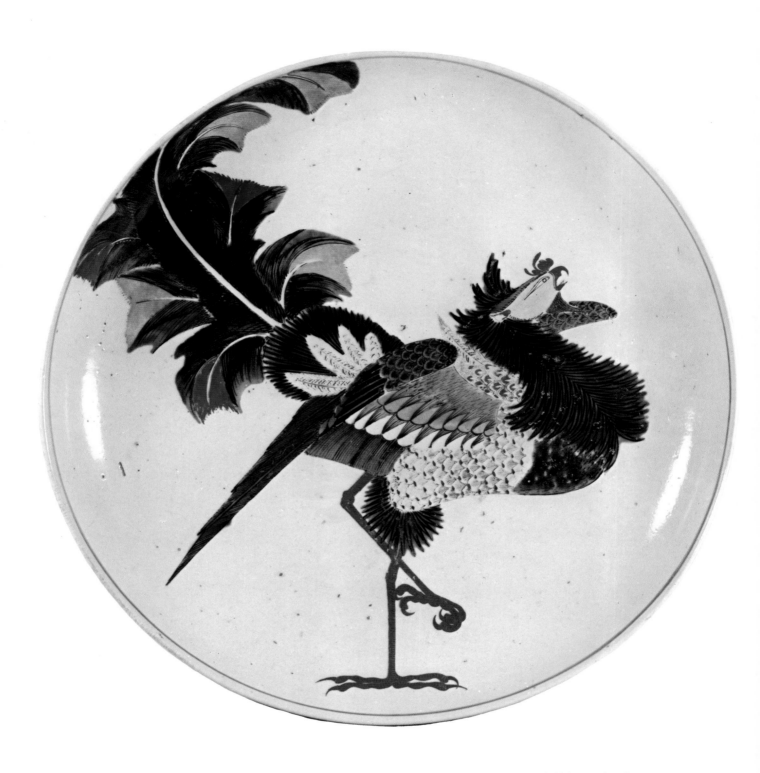

Colorplate 60. *Dish*. Kutani porcelain with overglaze enamel decoration of Chinese *feng-huang*; diameter 13 3/8″. Japan. Tokugawa period. S. Yamagami Collection, Ibaragi

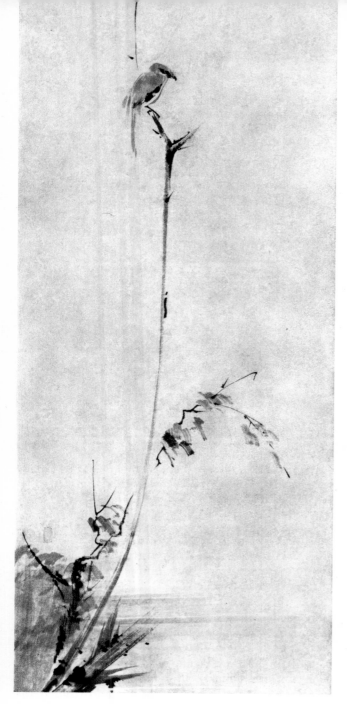

655. *Shrike on a Dead Branch*. By Miyamoto Niten
(A.D. 1584–1645). Hanging scroll, ink on paper;
height 59″. Japan. Tokugawa period. Formerly
K. Nagao Collection, Tokyo

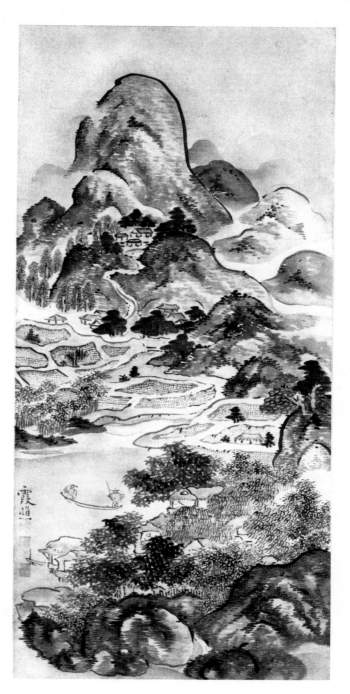

656. *Fishing in Springtime*. By Ikeno Taiga (A.D.
1723–1776). Hanging scroll, ink and color on
silk; height 48 1/8″. Japan. Tokugawa period.
Cleveland Museum of Art

subject) screens and to apply them with great
virtuosity of the brush. The realistic *Portrait of Beian*,
created by modeling in light and shade, seems a
unified work combining Chinese, Japanese, and
Western methods (*fig. 653*). We know that he pre-
pared portaits very carefully from preliminary
sketches, and in such a watercolor sketch for the
Portrait of Beian realism and the influence of Western
modeling are even more apparent than in the
finished work (*fig. 654*). Also apparent is the extent to
which Kazan modified these to harmonize with East

Asian brush style. Kazan, a political outcast and a
suicide, stands outside the mainstream of painting,
but he can be considered a culminating master of
the naturalistic style.

In the hands of certain individualists the mono-
chrome style of Sesshu and Tohaku could still
produce masterpieces such as *Shrike on a Dead Branch*
(*fig. 655*), by the samurai-painter Miyamoto Niten
(A.D. 1584–1645). Much has been written comparing
the "single" stroke of the branch with the cut of a
sword, since Niten was a samurai, but a careful

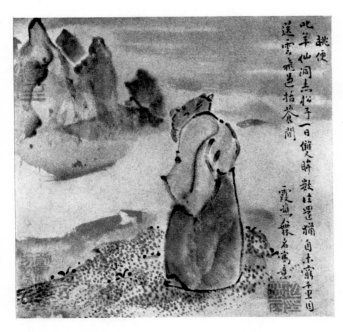

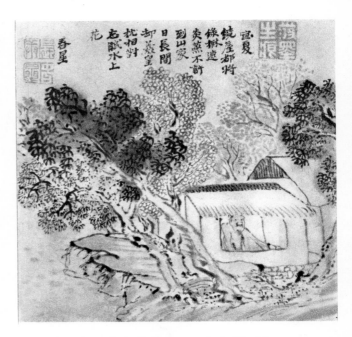

657. *Viewing Fine Scenery, from The Ten Conveniences and the Ten Enjoyments of Country Life.* By Ikeno Taiga (A.D. 1723-1776). Dated to A.D. 1771. Album leaves, ink and slight color on paper; height 7″. Japan. Tokugawa period. Formerly Yasunari Kawabata Collection, Kanagawa

658. *Enjoyment of Summer Scenery, from The Ten Conveniences and the Ten Enjoyments of Country Life.* By Yosa Buson (A.D. 1716-1783). Dated to A.D. 1771. Album leaves, ink and slight color on paper; height 7″. Japan. Tokugawa period. Formerly Yasunari Kawabata Collection, Kanagawa

examination of the painting, even in reproduction, reveals that the branch is composed of not one but at least three strokes. This in no way impugns the quality of the picture but merely indicates the degree of thought and care behind its apparent swiftness of execution. The boldness of the bird's silhouette and the elegance of the composition, with the shrike at upper left balancing the branch and leaves at the lower right, suggest a more decorative intention than would be found in a similar Chinese painting. The arbitrary fading off of the second stem at the lower left as it moves to the upper right is certainly not a naturalistic device but a decorative one. Niten's known works are in monochrome and of remarkably

consistent quality, but this painting towers above his others. His style is that of a great and gifted individual remote from the emptiness of the Chinese-influenced Kano school.

The third of the creative styles of later Japanese painting is called *nanga* (southern painting) by the Japanese. Among its numerous adherents are some of the most original and creative painters of the eighteenth and nineteenth centuries. The style is derived from Chinese literati painting. The *nanga* painters saw the Chinese paintings and studied the *wen ren* theories. Without the seventeenth and early eighteenth century Qing individualists, the *nanga* style is most unlikely to have arisen. Nevertheless, the

659. *Evening Snowfall.* By Yosa Buson (A.D. 1716-1783). Hanging scroll, ink and color on paper; length 50 5/8″. Japan. Tokugawa period. Formerly Kinta Muto Collection, Kobe

masters who created it, like the great Japanese ink painters of the early Ashikaga period, took an effective Chinese style and transformed it into a new and creative manner of such intense conviction that it transcends mere imitation. The *nanga* painters, like their early Ashikaga ancestors, tended to exaggerate the elements of Chinese *wen ren* painting, not only in composition but in brushwork, and added to them a strong sense of humor.

Two names in particular are closely associated in the *nanga* school: Ikeno Taiga (A.D. 1723–1776) and Yosa Buson (A.D. 1716–1783). Taiga is one of the wittiest and most daring of *nanga* painters. Most of his works in color have a summery, light, and cheerful tone (*fig. 656*). He emphasizes brush-dotted textures, and a rolling, rollicking rhythm runs through nearly all of his pictures, implying an extroverted good humor. In *The Ten Conveniences and the Ten Enjoyments of Country Life*, an album painted jointly with Buson, Taiga's pages seem to breathe this humorous and, at the same time, bold and creative air. Like the Chinese individualists of Anhui in the seventeenth century, Taiga, in the picture of an old scholar on a grassy knoll looking at the mountains, seems to be making a visual pun: The scholar and the mountain resemble each other (*fig. 657*). The homely old scholar with his bulbous nose is a latter-day version of the lohan or arhat: the unprepossessing exterior concealing an enlightened heart. The soft ink tones and brilliant simplification of the figure are the work of a master of the brush. Buson is less humorous but just as gay, with a springlike, pleasant, even disposition that surfaces in his pages from the album painted jointly with Taiga (*fig. 658*). This quality relates him closely to the Chinese individualists. His most fascinating scroll, a view of a village in the snow, seems to be a reinterpretation of Sesshu in *nanga* style (*fig. 659*). Even Sesshu would not have played with the ink tones in the sky so freely, even carelessly; and even Sesshu would have looked askance at the rather humorous and lilting hit-or-miss treatment of the roof lines; but perhaps only Sesshu could also have created the effect of the dampness and weight of wet snow achieved so playfully by Buson.

Another master of the *nanga* school, Uragami Gyokudo (A.D. 1745–1820), has recently grown to great esteem. In contrast with Taiga and Buson, he is

660. *Frozen Clouds Sieving Powdery Snow*. By Uragami Gyokudo (A.D. 1745–1820). Hanging scroll, ink and light color on paper; height 52 1/4″. Japan. Tokugawa period. Formerly Yasunari Kawabata Collection, Kanagawa

dramatic and somber. His compositions, with their feathery, high mountains, their tilted, circular planes that seem to be floating in different layers of space, and their sudden movements in the midst of the rich ink, reveal an arbitrariness related to the equally arbitrary compositions of the decorative style, but handled in the witty and flexible medium of the scholar-painter. His generally acknowledged masterpiece is the great composition *Frozen Clouds Sieving Powdery Snow*, where the texture, weight, even the feel of the snow are produced in his unique style (*fig. 660*). The fluttering rhythms, the swinging arcs indicating rocks, mountains, and movements, are Gyokudo's handwriting.

The fourth of these mainstreams of pictorial style is usually called *ukiyo-e*, pictures of the floating world, using "floating" in the Buddhist sense of transient or evanescent, the world of everyday life and especially of pleasure—theater, dancing, love, or festivals. The term *ukiyo-e* is particularly associated with the popular art of woodblock prints, but it really describes a style that begins with paintings of mixed heritage. The realistic, storytelling style of the *e-maki* (narrative picture scrolls) that originated in the Kamakura period, the decorative style brought to its peak by Sotatsu and Korin during the Momo-

661. *Street Scene in the Yoshiwara.* By Hishikawa Moronobu (c. A.D. 1625–c. 1695). Black-and-white woodblock print, width 16". Japan. Tokugawa period. Metropolitan Museum of Art, New York

yama and Tokugawa periods, Chinese elements of Kano painting, and something of both native and foreign realism were combined and adapted to the new and, in traditional eyes, vulgar demands of the merchant and plebeian classes of urban Japan after the seventeenth century. If even Hideyoshi delighted in gorgeous displays of "vulgar" art and decoration for the delight of the assembled masses on festival days, what was to prevent the adaptation of existing styles of painting to more popular consumption?

Some of the earliest *ukiyo-e* are screen paintings loosely associated with an almost folk-hero artist, Matabei. These actually do not reveal too similar an artistic "handwriting," but they all share a delight in gorgeously dressed large-scale figures engaged in commonplace pleasures or tasks (*color-plate 59, p. 491*). Often the figures are of low-class women, even prostitutes, dressed in gay everyday costume. Traces of other styles are readily visible; the subject matter may even be a plebeian version of the traditional Chinese-derived Kano "Four Accomplishments"—rendered in *ukiyo-e* as writing, music, dancing, and games. But the new interest in the floating world, in the latest hairdo and the most fashionable robe, dominates the screens. Their true subject is the pursuit of pleasure, whether visual, auditory, or tactile. Signed or not, and usually not, these screens are not the work of a mere artisan. The placement of the figures and their interrelations, psychological and aesthetic, show a calculation and subtlety worthy of the great decorative masters.

In addition to the painting traditions at hand, *ukiyo-e* artists exploited another, until then basically nonartistic, tradition—the woodblock print. The printing of books, even single prints, had been known in East Asia from the eighth century. But the technique had largely been used to produce cheap Buddhist icons or illustrated texts and many painting manuals and textbooks, the most famous of these being the Chinese *Mustard Seed Garden* and *Ten Bamboo* manuals. It had yet to be fully exploited, both technically and aesthetically. Despite the fantastic ability of the woodcutters to reproduce *paintings*, little had been done to produce *prints*, works of art in their own right with their own rules of form appropriate to the medium. The new interest in the urban everyday world and the new market among the moderately well-to-do and the not-so-fortunate motivated the swift development of numerous original *ukiyo-e* woodblock prints designed for mass consumption and reflecting popular urban interests and tastes with lightning rapidity.

Hundreds of thousands of prints were produced in the two hundred years between A.D. 1658, the year of Hishikawa Moronobu's first recognized illustrated book, and the death of Ando Hiroshige in A.D.

1858, when the first great tradition of woodblock artistry ended. These were usually despised by the upper-class artists and their patrons, and considered expendable amusements by the classes that consumed them. Thus Japan is relatively poor in fine old prints today. But in Europe, and by extension, America, fine Japanese print collections are legion, largely because of the enthusiastic approbation of the Post-Impressionists during the late nineteenth and early twentieth centuries. This patrimony has had one somewhat unfortunate result: Japanese art has often been judged by standards derived from the appreciation of woodblock prints, if indeed earlier Japanese art has been seen at all. If to many these prints are a culmination of Japanese traditions—and certainly the sheets combine some elements of nearly all earlier styles—to others they represent the last creative emergence of the great earlier traditions in a final popular expression before the sad decline of Japanese art in the late nineteenth and early twentieth centuries. This deterioration has only recently been arrested and turned by the rise of modern international art movements and by the shock effects of World War II.

Throughout its history the *ukiyo-e* woodblock print was the result of close collaboration between the artist-designer, the publisher, who often dictated or molded subject matter and style, the wood engraver, and the printer. The complex and specialized development, both technical and aesthetic, of the Japanese woodblock print can be but barely summarized here. Hishikawa Moronobu (c. A.D. 1625–c. 1695) is generally considered the first *ukiyo-e* print artist. His *Street Scene* is set in the red-light district of Edo (Tokyo) and, while it is indebted to traditional book illustration, it recalls sections of the earlier narrative handscrolls (*fig. 661*). The artist's line, though based on brush drawing, is adapted to the cut of knife on wood. The print is in black and white, and until the invention of color printing, about A.D. 1741, what restricted color was used was applied by hand. Print makers of this early period are called Primitives.

The leading master of the transition from single-block black-and-white prints to the printed two-color sheets, mostly pink and green, was Okumura Masanobu (A.D. 1686–1764), who is credited as well with the invention of a new shape—the extremely long and narrow "pillar" print. In contrast with the saturated hues of hand-applied colors, block printing permitted subtle, delicate, low-toned color combinations at the same time that the growing command of the artist produced more complex figure compositions. The *Parody on a Maple Viewing Party* combines the Tosa version of the narrative scroll tradition with the decorative development

662. *Parody on a Maple Viewing Party.* By Okumura Masanobu (A.D. 1686–1764). Dated to c. A.D. 1750. Two-color woodblock print, height 16 1/2". Japan. Tokugawa period. Metropolitan Museum of Art, New York

already seen in the costumes of the *Four Accomplishments* screens (*fig. 662*). The *Maple Viewing Party* is an early example of an increasingly popular kind of print, at once charming and parodistic, in which various sacred cows—secondary Buddhist deities, Confucian exemplars of virtue, aristocratic court nobles, and heroic samurai—are portrayed as pretty young girls. There could be no clearer expression than these parodies of the lighthearted exuberance and irreverence of the Japanese townsmen newly come into their own. The three beauties in Masa-

497

663. *Youth Representing Monju, God of Wisdom, on a Lion*. By Suzuki Harunobu (A.D. 1725–1770). Full-color woodblock print, height 11 1/2". Japan. Tokugawa period. Cleveland Museum of Art

nobu's print are attired cap-a-pie as members of the imperial guards.

In A.D. 1765 the two-color print technique was expanded, and polychrome prints using numerous color blocks took the market by storm. Prints were evidently popular, for the new technique was far more expensive and time-consuming than the old. The first artist to take full advantage of the new possibilities was Suzuki Harunobu (A.D. 1725–1770), whose lovely prints show the most refined and subtle taste achieved in the medium. Harunobu, like Sotatsu, knew the value of contrast between plain and complex areas, of purposeful juxtapositions such as flowering plant and beautiful woman, or of deliberate suppression. This last is particularly significant in the parodistic representation of the lion-vehicle of Monju (*fig. 663*). Not only is it aesthetically effective, but it serves to submerge the Buddhist content of the print into the image of a fashionable youth with elegantly elongated neck and almost unbelievably tiny hands and feet. Harunobu's style and mood were adapted by Kita-

gawa Utamaro (A.D. 1753–1806) with somewhat bolder draftsmanship and more monumental scale, his most remarkable works being the *Types of Physiognomic Beauty* of A.D. 1794, whose tinted mica backgrounds add to their daring decorative effect (*fig. 664*).

For the incredibly brief span of eight months in A.D. 1794–95 an artist-actor with noble connections, Toshusai Sharaku, poured out a spate of shockingly bold and harsh prints. His 159 caricatures and portraits of Kabuki actors combine decorative power with the long dormant satirical temper of Kamakura narrative scrolls (*fig. 665*). This aggressive style was often made more dramatic by dark mica back-

664. (above) *Bust of a Beautiful Lady Dressed in Kimono, from Types of Physiognomic Beauty*. By Kitagawa Utamaro (A.D. 1753–1806). Full-color woodblock print, height 15". Japan. Tokugawa period. Cleveland Museum of Art

665. (opposite) *Otani Onji III as Edohei*. By Toshusai Sharaku (act. A.D. 1794–1795, d. 1801). Dated to A.D. 1794. Full-color woodblock print, height 14 3/4". Japan. Tokugawa period. Art Institute of Chicago

666. *Mount Fuji Seen Below a Wave at Kanagawa, from Thirty-six Views of Mount Fuji.* By Katsushika Hokusai (A.D. 1760–1849). Full-color woodblock print, width 14 3/4″. Japan. Tokugawa period. Museum of Fine Arts, Boston

667. *Rain Shower on Ohashi Bridge.* By Ando Hiroshige (A.D. 1797–1858). Full-color woodblock print, height 13 7/8″. Japan. Tokugawa period. Cleveland Museum of Art

grounds which seem to throw the silhouettes of the posturing actors out at the spectator. We know that Sharaku's prints were not popular and, significantly, his output ceased abruptly. Such a frank record of the overacted, almost Grand Guignol realism of the Kabuki theater may well have startled or even repelled the pleasure-loving public, more attuned to lovely women and conventionally attractive theatrical portraits.

The heyday of the figure print ends with the eighteenth century. The most creative print makers of the first half of the following century, Katsushika Hokusai (A.D. 1760–1849) and Ando Hiroshige (A.D. 1797–1858), were primarily landscapists. Figures play a subdued if effective role in Hokusai's sturdy, energetic compositions, while in Hiroshige's prints they become sticklike *staffage* to the serene and poetic beauty of his famous views. Landscape series become most popular in the nineteenth century, and Hokusai exercised remarkable ingenuity in making his scenes transcend locality. The *Thirty-six Views of Mount Fuji* are universal landscapes, usually dramatic and capitalizing on unusual juxtapositions—Fuji and the fishermen dwarfed by the clawing wave, or Fuji enmeshed in a mackerel sky (*fig. 666*).

As the popular taste for figure prints became ever more garish, landscape became the only subject for the sensitive and original artist. Hiroshige put his technical virtuosity at the service of the "loveliness" of the Japanese landscape, which his prints render in velvety color and a more naturalistic, even Western-influenced style. His landscapes are nearly always idyllic, yet particular, with a local flavor as well as rec-

ognizable landmarks. His numerous series of views, including the *Fifty-three Stages of the Tokaido,* the *Sixty-nine Stages of the Kisokaido,* and the *Hundred Views of Edo,* maintain interest from print to print because of their particularity, while the subjects of Hokusai's landscapes seem far less important than their willful inventiveness and daring organization (*fig. 667*). Both artists, especially Hiroshige, whose paintings are singularly dull and pretty, are much indebted to the amazing skill of the engravers and printers who produced the prints from their designs. Traditional Japanese pictorial art ends in a consummate craft.

CERAMICS

The potter's art, which attained supreme excellence in East Asia, was an accurate reflection of artistic currents, both aristocratic and popular. The development of fine porcelain manufacture in seventeenth century Japan, under the stimulus of both Chinese and Korean influence, provided a new medium for the Japanese potter and stimulated a decorative development parallel to that seen in painting.

The Momoyama and early Tokugawa periods saw a continued demand for tea-ceremony ceramics, and the potters of the Seto region produced wares for subtle and aristocratic taste that maintained the

669. *Teapot.* Oribe stoneware, height 8 1/4". Japan. Early seventeenth century A.D. Cleveland Museum of Art

desired noble, rough, and warm qualities, notably in Shino and Oribe types (*figs. 668, 669*). By the middle of the seventeenth century quality began to decline, and later tea wares, save for the few by such individual masters as Kenzan and Koetsu, became mannered exercises in pseudo-amateurism. These inferior wares seem comparable to the monochrome mediocrities of the later Kano school of painting.

Individual potter's names become more prominent from the seventeenth century onward. The concept of the artist-potter, first embodied in painters or arbiters of taste who also made pottery, was in part the result of a genealogical pride paralleling that of the various painting schools, but it also grew out of a peculiarly Japanese respect for the craftsman as an artist in his own right. Most of the finest craft products, even such small and commonplace items as *netsuke* and *inro* (the *netsuke* is a carved toggle, often of wood or ivory, fastened to the end of the cord binding of an *inro,* which in turn is a small, compartmented, lacquered-wood container for carrying medicines at one's belt), were proudly signed. Perhaps the most famous of all the ceramic specialists was Nonomura Ninsei (d. c. A.D. 1685), who worked in Kyoto producing superbly finished jars and bowls painted in enamel with sophisticated decorative pictures that conform to the shape of the object (*colorplate 57, p. 489*). His art, certainly not for common use, is the equal in technical perfection of the most elegant lacquer work, and where it fails it does so because of a lacquer-like finish and overindulgence in gold or

668. *Flower basin. Nezumi* (mouse gray) Shino stoneware, length 9 1/8". Japan. Early seventeenth century A.D. Seattle Art Museum

670. *Plate*. Kakiemon porcelain with decoration in
colored enamels; height 2 1/2", diameter 12 1/8".
Japan. Tokugawa period, c. A.D. 1700. Mr. and
Mrs. Severance A. Millikin Collection, Cleveland

tions of paste and glaze exist but are not yet
thoroughly classified.

Kakiemon ware, named for the family traditionally
responsible for its development, is closest in tech-
nique to the Kang Xi *famille verte* enameled porce-
lains (*fig. 670*). Overglaze red, green, and blue
enamels were sparingly used on a soft, linen-white
ground in a restrained and hazily outlined decora-
tion with motifs that recall the screen painters'
decorative adaptations of Chinese academic paint-
ing style. The Kakiemon manner was known in
Europe from the wares exported to such royal
collections as that of Dresden and was much im-
itated by the European decorators of Meissen and
St.-Cloud. The Kakiemon flavor is sprightly, lyrical,
and elegant—hence its popularity in the period of
European rococo.

671. *Vase*. Imari porcelain with decoration of
Westerners; height 22". Japan. Tokugawa
period, eighteenth century A.D. Cleveland
Museum of Art

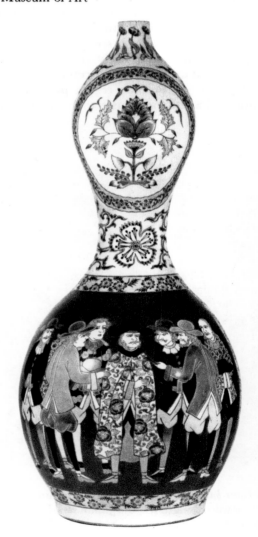

opaque color. His style and method were continued
at Kyoto by numerous artists and workshops in ever
increasing number and declining taste, particularly
in overly meticulous animal and bird figurines.

The discovery, in A.D. 1616, of porcelain clay
(kaolin) in the Kyushu province of Saga, combined
with the importation of Chinese techniques and the
immigration of Korean potters, led to a flowering of
porcelain manufacture. The starting point was rough
white porcelain with underglaze blue decoration in
the style of provincial Ming wares or the Yi dynasty
wares of Korea. By the last quarter of the century
the enameled porcelains of late Ming and the early
Kang Xi period had made their impact, and the
decorative means were at hand to cater to Japanese
pictorial tastes. The decorative style in its various
manifestations provided the principal motivation
for three most important porcelain types—Kakiemon
and Nabeshima, made in the Arita region of Kyushu,
and Kutani, produced in Kaga Province of central
Honshu on the Japan Sea. In the Arita region the
ascription of wares to a particular kiln is most un-
certain because of numerous but often unreliable
family traditions of manufacture and the overlapping
of decorative techniques from one kiln to another. The
various wares, including Kakiemon and Nabeshima,
must be thought of as styles, perhaps common to
several kilns of the same region. Minor differentia-

672. *Dish.* Nabeshima porcelain with brocade design; diameter 6″. Japan. Tokugawa period, c. A.D. 1700. Mr. and Mrs. Severance A. Millikin Collection, Cleveland

673. *Dish.* Kutani porcelain with decoration of footpaths between rice fields; length 9 1/8″. Japan. Tokugawa period, late seventeenth century A.D. Private collection, Japan

Another Arita porcelain, called Imari, was also exported (*fig. 671*). Much Imari ware shows European subjects, usually Portuguese and Dutch men and ships, drawn from hearsay or from observation at the trade port of Nagasaki. The dark underglaze blue gray and deep red enamel of Imari is distinctive and usually dominates the little white left uncovered by the opulent designs. Much Dutch and English porcelain reflects the influence of Imari decoration.

Nabeshima wares, on the other hand, seem to conform to a harder, colder, and more perfect taste. Red and green overglaze enamels were used with a clear underglaze blue in carefully calculated floral or formal designs that recall the decorative style of Korin's paintings or of contemporary lacquers and patterned robes (*fig. 672*). As Kakiemon seems comparable to Kang Xi decorated porcelains, Nabeshima can be compared with the more perfect ceramics of the Yong Zheng reign. It was not exported and hence had no influence abroad.

The most daring and original of these porcelains, the most purely Japanese in the best sense, was Kutani ware, especially Ko (Old) Kutani, traditionally produced before A.D. 1700 (*colorplate 60, p. 492*). The porcelain body of this ware is often rough, and the shapes are warped by imperfect firing, but the exclusively overglaze enamels of red,

green, aubergine, and mustard yellow are somberly powerful. The designs are free and extremely venturesome, combining the daring of Koetsu's vessels with the magnificence of the Momoyama screen paintings. Perhaps the relative isolation of the Kutani kilns in far-off Kaga helped to maintain their individuality. No other ware can show so striking a pictorial design as the bird's-eye view of paths between the rice fields on the square dish in figure 673. Ko Kutani combines the best qualities of such tea-ceremony wares as Shino and Oribe with those of the imported porcelain tradition.

Hundreds of other wares were made as time went on, including the infamous "brocaded gold" Satsuma ware produced for the worst Western taste of the Victorian era. Small wonder that flagging inspiration and consummate technique conspired to loose a flood of mediocre ceramics and that the most influential wares for the modern Japanese potter are the folk ceramics made for rural consumption. Only recently have the Japanese porcelain manufacturers begun to make well-designed, mass-produced wares for the modern international market. In Japan, as elsewhere in Asia, traditional styles seem meaningful only until the nineteenth century. The present and future of Eastern art is inextricably enmeshed with the modern international styles until now originating in Europe and America.

NOTES

1. (*p. 38*) Wen Fong, ed., *The Great Bronze Age of China* (New York: Metropolitan Museum of Art and Knopf, 1980), pp. 198, 205

2. (*p. 76*) F. Max Müller, ed., *Sacred Books of the East*, 60 vols. (Oxford: Oxford U. Pr., 1879–1910), vol. 11: *Buddhist Suttas*, trans. T. W. Rhys Davids, pp. 147–53, paraphrased from the *Dhamma-Kakka-Ppavattana-Sutta*

3. (*p. 163*) F. Max Müller, ed., *Sacred Books of the East*, 60 vols. (Oxford: Oxford U. Pr., 1879–1910), vol 49: *Buddhist Mahayana Texts*. Paragraphs 1–3 quoted from the *Amitayus-Dhyana-Sutra*, trans. J. Takakusu, part 2, pp. 178–79; paragraphs 4–5 quoted from *The Larger Sukhavati-Vyuha*, trans. F. Max Müller, part 2, pp. 40, 42–43

4. (*p. 173*) Stella Kramrisch, *The Hindu Temple*, vol. 1 (Calcutta: University of Calcutta, 1946), pp. 127–28

5. (*p. 190*) *Ibid.*, note 17

6. (*p. 219*) From Abu'l-Fazl, historian of the era of Akbar, quoted in Eric Schroeder, "The Troubled Image: An Essay Upon Mughal Painting," in *Art and Thought*, ed. K. Bharatha Iyer (London: Luzac, 1947), p. 78

7. (*p. 220*) *Ibid.*, p. 85

8. (*p. 222*) *Ibid.*, p. 79

9. (*p. 223*) Quoted in Ananda K. Coomaraswamy, *Catalogue of the Indian Collections in the Museum of Fine Arts, Boston*, part 6: *Mughal Painting* (Cambridge, Mass.: Museum of Fine Arts, Boston, 1930), p. 42

10. (*p. 226*) *Ibid.*, part 5: *Rajput Painting* (Cambridge, Mass.: Museum of Fine Arts, Boston, 1926), p. 42

11. (*p. 227*) Ananda K. Coomaraswamy, *Rajput Painting* (London: H. Milford, 1916), vol. 1, p. 44

12. (*p. 258*) From Cao Zhi (Cijian, A.D. 192–232), "The Goddess of River Lo," trans. Hsiao-yen Shih, "Poetry Illustration and the Works of Ku K'ai-chih," *Renditions*, no. 6 (Spring, 1976)

13. (*p. 307*) Lady Murasaki, *Tale of Genji*, trans. Edward Seidensticker (New York: Knopf, 1976), vol. 1, p. 63

14. (*p. 362*) Arthur Waley, *An Introduction to the Study of Chinese Painting* (London: Benn, 1923), p. 231

15. (*p. 363*) Daisetz T. Suzuki, *Essays in Zen Buddhism* (second series; London: Rider, for the Buddhist Society, 1950), pp. 84–85

16. (*p. 374*) *Pi ch'uang so yu*, trans. in G. R. Sayer, *Ching-Te-Chen T'ao-lu or The Potteries of China* (London: Routledge and K. Paul, 1951), pp. 97–98

17. (*p. 382*) R. H. Blyth, *Haiku*, 4 vols. (Tokyo: Kamakura Bunko, 1949–52), vol. 2, pp. 43, 54; vol. 4, pp. 205, 213

18. (*p. 414*) Osvald Sirén, "Shih-t'ao, Painter, Poet, and Theoretician," *Bulletin of the Museum of Far Eastern Antiquities*, no. 21 (Stockholm, 1949), p. 43

19. (*p. 414*) Ni Zan, *Ni Yunlin shiji* [Collected poetry of Ni Yunlin], *Si bu cong kan* edition (Shanghai, 1922–), vol. 3, appendix pp. 5.2a–b, trans. Susan Bush in *The Chinese Literati on Painting* (Cambridge, Mass.: Harvard U. Pr., 1971), p. 134

20. (*p. 445*) Quoted in Osvald Sirén, *Chinese Painting: Leading Masters and Principles*, 7 vols. (London and New York: Lund Humphries and Ronald Press, 1955–58), vol. 5, p. 10

21. (*p. 452*) Translated in Osvald Sirén, *A History of Later Chinese Painting* (London: Medici Society, 1938), vol. 2, p. 135

22. (*p. 452*) Dao-Ji, *Hua yu lu*, trans. Marilyn and Shen Fu in *Studies in Connoisseurship* (Princeton: Princeton U. Pr., 1973), p. 56

BIBLIOGRAPHY

Note: For works published in Chinese the *pinyin* romanization of Chinese authors' names and titles is given in brackets following the Wade-Giles romanization.

PERIODICALS

Ancient India, New Delhi
Annual Bibliography of Indian Art and Archaeology, Leiden
Archives of Asian Art, New York
Ars Buddhica, Tokyo
Artibus Asiae, Ascona
Arts Asiatiques, Paris
Bijutsu Kenkyu [The Journal of art studies], Tokyo
Bijutsushi [Journal of the Japan Art History Society], Kyoto
Bulletin of London University, The School of Oriental and African Studies, London
Bulletin of the Museum of Far Eastern Antiquities, Stockholm
Bulletin of the Museum of Fine Arts, Boston
Bulletin of the Prince of Wales Museum, Bombay
Bulletin of the State Museum of Baroda, Baroda
Burlington Magazine, London
Chanoyu (A Quarterly of Tea and the Arts of Japan), Kyoto
Chung-kuo hua [*Zhongguo hua*; Chinese painting], Beijing
Early China, Berkeley
Eastern Art, I–III, Philadelphia, 1928–31
Eurasia Septentrionalis Antiqua, Helsinki
Far Eastern Ceramic Bulletin, Ann Arbor
Harvard Journal of Asiatic Studies, Cambridge, Mass.
Indian Archaeology, New Delhi
Journal of Indian Museums, New Delhi
Journal of the American Oriental Society, Baltimore
Journal of the Indian Society of Oriental Art, London
K'ao-ku [*Kao gu*; Chinese archaeological reports], Beijing
K'ao-ku hsueh-pao [*Kao gu xue bao*; Chinese journal of archaeology], Beijing
K'ao-ku tung-hsin [*Kao gu dongxin*; Archaeological Society review], Beijing, 1955–58
Kokka, Tokyo
Ku-kung chi-k'an [*Gu gong jikan*; National Palace Museum quarterly], Taibei
Ku-kung po-wu-yuan yuan-k'an [*Gu gong bowuyuan yuankan*; Palace Museum bulletin], Beijing, 1958–
Kunst des Orients, Ernst Kühnel, ed., Wiesbaden
Lalit Kala [Journal of Oriental art], New Delhi
Marg [Magazine of architecture and art], Bombay
Mizue [Fine arts], monthly and special issues, Tokyo
Monumenta Serica, Beijing and Tokyo
Museum, National Museum, Tokyo
Nippon Toyo Kobijutsu Bunken Mokuroku [Bibliography of Japanese periodical articles on Asian art], Tokyo
Oriental Art, Oxford
Ostasiatische Zeitschrift (Publication of Gesellschaft für Ostasiatische Kunst), Berlin, 1912–
Revue des arts asiatiques, Paris, 1924–39
Roopa-Lekha, New Delhi

Sinologica, Basel
Tosetsu (Publication of the Japan Ceramic Society), Tokyo
T'oung Pao, Paris
Transactions of the Oriental Ceramic Society, London
Wen wu [Journal of Chinese culture], Beijing
Wen-wu ching-hua [*Wen wu jing hua*; Pictorial art], Beijing
Wen-wu tsan-k'ao tzu-liao [*Wen wu zan kao zi liao*; Reference material on Chinese culture], Beijing
Yamato Bunka (Quarterly journal of Eastern art, Museum Yamato Bunkakan), Osaka

GENERAL

denotes books of special interest

ACHARYA, Prasanna K. *An Encyclopedia of Hindu Architecture.* New York: Oxford U. Pr., 1946
AGRAWALA, Vasudeva S. *The Glorification of the Great Goddess.* Varanasi, India: All-India Kashi Raj Trust, Ramnagar, 1963
————. *India as Described by Manu.* Varanasi, India: Prithivi, 1970
————. *Indian Art.* Vol. 1: *A History of Indian Art from the Earliest Times up to the Third Century A.D.* Varanasi, India: Prithivi, 1965
————. *Studies in Indian Art.* Varanasi, India: Vishwavidyalaya, 1965
AKIYAMA, Terukazu. *Genshoku Nippon no Bijutsu* [Japanese art in color]. 20+ vols. Tokyo: Shogakkan, 1966–
————. *Japanese Painting.* James Emmons, trans. Geneva: Skira, 1961. Reprint. London: Macmillan, 1977
————; SUZUKI, Kei; and NAGAHIRO, Toshio, eds. *Chugoku Bijutsu* [Chinese art in Western collections]. 5+ vols. Tokyo: Kodansha, 1972–
Album of Japanese Sculpture. Tokyo, 1952
ALLAN, Sarah, and COHEN, Alvin P., eds. *Legend, Lore, and Religion in China.* San Francisco: Chinese Materials Ctr., 1979
Archaeological Survey of India. Memoirs, nos. 1–. Calcutta, 1919–
————. *New Imperial Series*
ARNESEN, Peter J. *The Medieval Japanese Daimyo: the Ouchi Family's Rule of Suo and Nagato.* New Haven: Yale U. Pr., 1979
Arts of China. 3 vols. Tokyo and Palo Alto: Kodansha, 1968–70. Vol. 1: *Neolithic Cultures to the T'ang Dynasty: Recent Discoveries*, by T. AKIYAMA et al.; vol. 2: *Buddhist Cave Temples: New Researches*, by T. AKIYAMA and S. MATSUBARA; vol. 3: *Paintings in Chinese Museums: New Collections*, by Y. YONEZAWA and M. KAWAKITA
The Arts of Korea. 6 vols. Seoul, 1974
*ASHTON, Sir Leigh, ed. *The Art of India and Pakistan.* Exhib. cat., Royal Academy of Arts, London. London: Faber, 1950
AUBOYER, Jeannine. *Arts et styles de l'Inde.* Paris: Larousse, 1951
————. *Rarities of the Musée Guimet.* Exhib. cat., Asia House

Gallery, New York. New York: Asia Society/Weatherhill, 1975

――――, and GROUSSET, René. *De l'Inde au Cambodge et à Java.* Monaco: Documents d'art, 1950

――――, et al. *Oriental Art: A Handbook of Styles and Forms.* Elizabeth and Richard Bartlett, trans. New York: Rizzoli, 1980

――――, et al. *La Vie publique et privée dans l'Inde ancienne.* 10 vols. Paris: P.U.F., 1955–

AYERS, John. *The Baur Collection, Geneva: Chinese Ceramics.* 5 vols. Geneva: Coll. Baur, 1968–76

*――――. *Far Eastern Ceramics in the Victoria and Albert Museum.* London: Sotheby's, 1980

BACHHOFER, Ludwig. *A Short History of Chinese Art.* New York: Pantheon, 1946

BAJPAI, K. D., ed. *The Geographical Encyclopaedia of Ancient and Mediaeval India.* Vol. 1. Varanasi, India: Indic Academy, 1967

BARNARD, Noel, ed., with FRASER, Douglas. *Early Chinese Art and Its Possible Influence in the Pacific Basin.* 3 vols. New York: Intercultural Arts, 1972

*BARRETT, Douglas, and GRAY, Basil. *Painting of India.* Geneva: Skira, 1963. Reprint. New York: Rizzoli, 1978

*BASHAM, Arthur L. *The Wonder That Was India.* London: Sidgwick and Jackson, 1954

*BERNET KEMPERS, A. J. *Ancient Indonesian Art.* Cambridge, Mass.: Harvard U. Pr., 1959

BHARAT KALA BHAVAN. *Chhavi: Golden Jubilee Volume 1920–70.* Varanasi, 1971

BHATTACHARYYA, D. C. *Tantric Buddhist Iconographic Sources.* New Delhi, 1974

BHAVNANI, Enakshi. *The Dance in India: the Origin* 2nd ed. Bombay: Taraporevala, 1970

BINGHAM, Woodbridge; CONROY, Hilary; and IKLÉ, Frank W. *A History of Asia.* 2 vols. 2nd ed. Boston: Allyn and Bacon, 1974

BIRD, Richard, comp. *General Index, Heibonsha Survey of Japanese Art.* New York: Weatherhill; Tokyo: Heibonsha, 1979

BLACKER, Carmen. *The Catalpa Bow: a Study of Shamanistic Practices in Japan.* London: Allen and Unwin, 1975

BLAIR, Dorothy. *A History of Glass in Japan.* Tokyo: Kodansha, 1973

BLASER, Werner. *Japanese Temples and Tea-Houses.* D. Q. Stephenson, trans. New York: Dodge, 1957

BODDE, Derk. *Festivals in Classical China.* Princeton: Princeton U. Pr., 1975

*BOISSELIER, J. *Le Cambodge.* Paris: Picard, 1966

BOSCH, Frederick D. K. *The Golden Germ: an Introduction to Indian Symbolism.* New York: Humanities Pr., 1960

――――. *Selected Studies in Indonesian Archaeology.* The Hague: Nijhoff, 1961

BOWIE, Theodore, ed. *The Sculpture of Thailand.* New York: Asia Society, distr. N.Y. Graphic Soc., 1972

BOYD, Andrew. *Chinese Architecture and Town Planning.* London: Tiranti; Chicago: U. of Chicago Pr., 1962

BRINKER, Helmut. *Die zen-buddhistische Bildmalerei in China und Japan von den Anfängen bis zum Ende des 16. Jahrhunderts.* Wiesbaden: Steiner, 1973

BROWN, Roxanna M. *The Ceramics of South-East Asia: Their Dating and Identification.* Kuala Lumpur and New York: Oxford U. Pr., 1977

*BUHOT, Jean. *Histoire des arts du Japon, dès origine à 1350.* Paris: Van Oest, 1949

Bunjin-ga Suihen [Essence of Chinese and Japanese literati paintings]. 20 vols. Tokyo: Chuo-koron, 1974–

BUSH, Susan. *The Chinese Literati on Painting: Su Shih (1037–1101) to Tung Ch'i-ch'ang (1555–1636).* Cambridge, Mass.: Harvard U. Pr., 1971

BUSSAGLI, Mario, and SIVARAMAMURTI, Calambur. *5000 Years of the Art of India.* (A. M. Brainerd, trans., chaps. 1–3, 5, 8, 9, 11, 12.) New York: Abrams, 1971

*CAHILL, James. *Chinese Painting.* New ed. Geneva: Skira; distr. New York: Crown, 1972

CAMERON, Nigel. *Barbarians and Mandarins: Thirteen Centuries of Western Travelers in China.* New York: Walker/Weatherhill, 1970

CAPON, Edmund. *Art and Archaeology in China.* South Melbourne: Macmillan Co. of Australia, 1977; distr. Cambridge, Mass.: MIT Pr.

CASTILE, Rand. *The Way of Tea.* New York and Tokyo: Weatherhill, 1971

CHANDRA, Moti. *Stone Sculpture in the Prince of Wales Museum.* Bombay: Prince of Wales Museum of Western India, 1974

CHANDRA, Pramod. *Stone Sculpture in the Allahabad Museum.* Poona, India: American Inst. Indian Studies, 1970

――――, ed. *Studies in Indian Temple Architecture.* New Delhi: American Inst. Indian Studies, 1975

*CHANG, Kwang-chih. *The Archaeology of Ancient China.* New Haven and London: Yale U. Pr., 1963

CHEN, Chao-ming, and STAMPS, Richard B. *An Index to Chinese Archaeological Works Published in the People's Republic of China, 1949–1965.* East Lansing: Asian Studies Ctr., Michigan State U., 1972

CHENG, Chen-to [Zheng, Zhenduo]. *Wei-ta ti i shu ch'uan t'ung t'u-lu* [*Wei da di yi shu chuan tong tulu*; The great heritage of Chinese art]. 2 vols. Shanghai, 1954

――――. *Yu wai so ts'ang chung-kuo ku hua chi* [*Youwai suo cang Zhongguo gu hua ji*; Chinese paintings in foreign collections]. 22 vols. Shanghai, 1947

*CHENG, Te-k'un. *An Introduction to Chinese Art and Archaeology: the Cambridge Outline and Reading Lists.* Cambridge, 1972

CHIANG, Yee. *Chinese Calligraphy.* London: Methuen, 1938

CHIBBETT, David G. *The History of Japanese Printing and Book Illustration.* New York, Tokyo, etc.: Kodansha, 1977

CH'IN Tsu-yung [Qin Zuyong]. *Im Schatten des Wu-T'ung-Baumes.* Roger Goepper, ed. and trans. Munich: Hirmer, 1959

CHINA, REPUBLIC OF. *Chinese Art Treasures: a Selected Group of Objects from the Chinese National Palace Museum and the Chinese National Central Museum, Taichung, Taiwan.* Exhib. cat., National Gallery of Art, Washington, D.C., and elsewhere. Geneva: Skira, 1961

The Chinese Exhibition: The Exhibition of Archaeological Finds of The People's Republic of China and *Illustrated Handlist of the Exhibition of Archaeological Finds of The People's Republic of China* (shown at the National Gallery of Art, Washington, D.C., and the Nelson Gallery–Atkins Museum, Kansas City, 1974–75). 2 vols. N.p., n.d.

Chinese Famous Painting. Series I. 9 vols. Tokyo, 1956–59. See individual author entries

Chinese Painters Series. 15 vols. Shanghai, 1958–59. See individual author entries

Ch'uan-kuo chi-pen chien-hsieh kung-cheng chung ch'u-t'u wen-wu chen-lan t'u-lu [*Chuan guo jiben jianxie gongzheng zhong chutu wenwu zhenlan tu-lu*; Exhibition of Chinese cultural objects excavated at construction sites since 1949]. 2 vols. Beijing, 1955

Chung-kuo ku-tai shih k'e-hua hsien-chi [*Zhongguo gu dai shi ke hua xianji*; Selections of earlier Chinese stone carving]. Beijing, 1957

Chung-kuo-ku-wen-wu [*Zhongguo gu wenwu*; Antiquities of China]. Beijing, 1962

Chung-kuo li-tai ming-hua-chi [*Zhongguo li dai ming hua ji*; Chinese paintings of all periods (from the collection of the Palace Museum)]. 5 vols. Beijing, 1964–65

Chung-kuo li-tai ming-hua chi [*Zhongguo li dai ming hua ji;* Collection of famous Chinese paintings]. 4 parts. Beijing, 1958

Chung-kuo ming-hua [*Zhongguo ming hua;* Famous Chinese paintings]. 40 vols. Shanghai, 1904–25

Chung-kuo shu-hua [*Zhongguo shu hua;* Chinese painting and calligraphy]. Committee of Painting and Calligraphy, ed. Nos. 1–. Taibei, 1969–

CLOUD, Frederick D. *Hangchow, the "City of Heaven."* Shanghai: Presbyterian Mission Pr., 1906

CODRINGTON, Kenneth de B. *Ancient India.* . . . London: Benn, 1926

COHN, William. *Asiatische Plastik: China, Japan, Vorder-Hinterindien, Java* (Coll. Baron Eduard von der Heydt). Berlin: Cassirer, 1932

———. *Chinese Painting.* 2nd rev. ed. London: Phaidon Pr., 1951

COMBAZ, Gisbert. *L'Évolution du stupa en Asie.* Bruges: Impr. Ste. Catherine, 1937

CONTAG, Victoria. "The Unique Characteristics of Chinese Landscape Pictures." *Archives of the Chinese Art Soc. of America* 6 (1952)

COOMARASWAMY, Ananda K. *Catalogue of the Indian Collection, Museum of Fine Arts, Boston.* 5 vols. Boston: Mus. of Fine Arts, 1923–24

———. *The Dance of Shiva.* Rev. ed. New Delhi: Sagar, 1968

———. *Elements of Buddhist Iconography.* Cambridge, Mass.: Harvard U. Pr., 1935

———. *History of Indian and Indonesian Art.* New York: Weyhe, 1927. Reprint. New Delhi: Munshiram Manoharlal, 1972

———. *Mediaeval Sinhalese Art.* Broad Campden, Eng.: Essex House, 1908

COOPER, Michael, et al. *The Southern Barbarians: the First Europeans in Japan.* Tokyo and Palo Alto: Kodansha, 1971

COWA (Council for Old World Archaeology) Surveys and Bibliographies. Series I, Far East, Area 17, no. 1, 1959; Series II, Far East, Area 17, no. 2, 1961

COX, Warren E. *The Book of Pottery and Porcelain.* 2 vols. New York: Crown, 1949

CREEL, Herrlee G. *The Origins of Statecraft in China.* Vol. 1: *The Western Chou Empire.* Chicago: U. of Chicago Pr., 1970

DANISH MUSEUM OF DECORATIVE ART. *Catalogue of Selected Objects of Chinese Art in the Museum.* Copenhagen, 1959

DAVID, Sir Percival, trans. *Chinese Connoisseurship: The Ko ku yao lun (by Ts'ao Chao): the Essential Criteria of Antiquities.* With facs. of the Chinese text of 1388. New York: Praeger, 1971

DE BARY, William T. "Self and Society in Ming Thought." *Studies in Oriental Culture* 4. New York, 1970

———, and BLOOM, Irene, eds. *Principle and Practicality: Essays in Neo-Confucianism and Practical Learning.* New York: Columbia U. Pr., 1979

DEGLURKAR, Gorakhnath B. *Temple Architecture and Sculpture of Maharashtra.* Nagpur, India: Nagpur U., 1974

DESAI, Madhuri. *Architectural and Sculptural Monuments of India (Bharat).* 4th ed. Bombay: Bhulabhai Mem. Inst., 1954. See map

DEVENDRA, D. T. *Classical Sinhalese Sculpture, c. 300 B.C. to A.D. 1000.* London: Tiranti, 1958

DIEZ, Ernst. *Die Kunst Indiens.* Wildpark-Potsdam: Akad. Verlagsges. Athenaion, 1925

DOWSON, John. *A Classical Dictionary of Hindu Mythology and Religion, Geography, History, and Literature.* 10th ed. London: Routledge, 1961

DRISCOLL, Lucy, and TODA, Kenji. *Chinese Calligraphy.* Chicago: U. of Chicago Pr., 1935

DUTT, Nalinaksha. *Mahayana Buddhism.* Calcutta: Mukhopadhyay, 1973

DWIVEDI, Vinod P. *Indian Ivories.* Delhi: Agam, 1976

ECKARDT, Andre. *A History of Korean Art.* J. M. Kindersley, trans. London: Goldston; Leipzig: Hiersemann, 1929

———. *Koreanische Keramik.* Bonn: Bouvier, 1970

ECKE, Tseng Yu-ho. *Chinese Calligraphy.* Exhib. cat., Philadelphia Museum of Art. Philadelphia: Phila. Mus. of Art; Boston: Boston Book, 1971

ELIOT, Sir Charles. *Japanese Buddhism.* London: Arnold, 1935

ELISSÉEFF, Serge, et al. *Arts Musulmans: Extrême-Orient.* . . . Paris: Colin, 1939

"Exhibition of Objects Excavated During the Cultural Revolution." *Jen min chung-kuo* [*Renmin Zhongguo*], Oct. 1971, pp. 29–49

FEDDERSEN, Martin. *Chinese Decorative Art: a Handbook for Collectors and Connoisseurs.* Arthur Lane, trans. 2nd ed., rev. and enl. London: Faber, 1961

———. *Japanese Decorative Art: a Handbook for Collectors and Connoisseurs.* Katherine Watson, trans. New York: Yoseloff, 1962

*FENG, Hsien-ming [Feng, Xianming]. "Important Finds of Ancient Chinese Ceramics Since 1949." *Wen wu,* 1965. 9. 25–56. Hin-cheung Lovell, trans. London: Oriental Ceramic Soc., 1967

FERGUSON, John C. *Chinese Painting.* Chicago: U. of Chicago Pr., 1927

———. *Li-tai chu-lu-hua-mu* [*Lidai zhu lu hua mu;* Index of recorded Chinese painting in all periods]. 6 vols. Nanjing, 1934

FIGGESS, John, and KOYAMA, Fujio. *Two Thousand Years of Oriental Ceramics.* New York: Abrams; London: Thames and Hudson, 1961

FISCHER, Klaus. *Schöpfungen Indischer Kunst.* Cologne: Schauberg, 1959

FITZGERALD, Charles P. *China: A Short Cultural History.* 4th ed., rev. N.p.: Barrie and Jenkins, 1976. Reprinted 1978

———. *The Southern Expansion of the Chinese People.* New York: Praeger, 1972

*FONG, Wen, ed. *The Great Bronze Age of China: An Exhibition from the People's Republic of China.* New York: Metropolitan Mus. of Art, 1980

———, and FU, Marilyn. *Sung and Yuan Painting.* New York: Metropolitan Mus. of Art, 1973

*FONTEIN, Jan, and HEMPEL, Rose. *China, Korea, Japan.* Berlin: Propyläen, 1968

*———, and WU, Tung. *Unearthing China's Past.* Exhib. cat., Museum of Fine Arts, Boston. Boston: Mus. of Fine Arts, 1973; distr. N.Y. Graphic Soc., Greenwich, Conn.

FREER GALLERY OF ART, Washington, D.C. *The Freer Gallery of Art.* 2 vols. Vol. 1: *China;* vol. 2: *Japan.* Tokyo: Kodansha, 1971

———. *Masterpieces of Chinese and Japanese Art: Freer Gallery of Art Handbook.* Washington, D.C., 1976

GARNER, Sir Harry. *Chinese and Japanese Cloisonné Enamels.* 2nd ed. London: Faber, 1970

———, and MEDLEY, Margaret. *Chinese Art in Three-Dimensional Colour.* 4 vols. New York: Asia Soc. for the Gruber Found., 1969

Gazetteer of Mainland China. 2nd ed. Washington, D.C., 1968

GEELAN, P. J. M., and TWITCHETT, Denis. *The Times Atlas of China.* New York: Quadrangle, 1974

GETTY, Alice. *The Gods of Northern Buddhism.* 2nd ed. Oxford: Oxford U. Pr., 1928

GLASER, Curt. *Die Kunst Ostasiens: der Umkreis ihres Denkens und Gestaltens.* Leipzig: Insel, 1922

GOEPPER, Roger. *Chinesische Malerei: die ältere Tradition.* Bern: Hallwag, 1960

GOETZ, Hermann. *India: Five Thousand Years of Indian Art.* New York: Crown, 1959

———. *Study in the History, Religion and Art of Classical and Mediaeval India.* Hermann Kulke, ed. Wiesbaden: Steiner, 1974

GOIDSENHOVEN, J. P. *La Céramique chinoise.* Brussels: Éditions de la connaissance, 1954

———. *Héros et divinités de la Chine.* Lochem: De Tijdstroom, 1971

*GOODRICH, L. Carrington. *A Short History of the Chinese People.* Rev. ed. New York: Harper, 1951

GRANET, Marcel. *Chinese Civilization.* Kathleen Innes and Mabel Brailsford, trans. New York: Barnes and Noble, 1957

GRISWOLD, Alexander B., et al. *The Art of Burma, Korea, Tibet.* New York: Crown, 1964

*GROUSSET, René. *La Chine et son art.* Paris: Plon, 1951

———. *The Civilizations of the East.* 4 vols. Vol. 2: *India;* vol. 3: *China;* vol. 4: *Japan.* Catherine A. Phillips, trans. New York and London: Knopf, 1931–34

———. *De la Grèce à la Chine.* Monaco: Documents d'art, 1948

*———. *Histoire de l'Extrême-Orient.* 2 vols. Paris: Geuthner, 1929

———. *In the Footsteps of the Buddha.* London: Routledge, 1932

GUEST, Grace D., and WENLEY, Archibald G. *Annotated Outlines of the History of Chinese Art.* Washington, D.C.: Freer Gallery, 1949

GULIK, Robert H. van. *Chinese Pictorial Art as Viewed by the Connoisseur.* Rome: Istituto Ital. per il Medio ed Estremo Oriente, 1958

GUNSAULUS, Helen C. *Japanese Textiles.* New York: Japan Soc., 1941

GUPTE, Ramesh S. *Iconography of the Hindus, Buddhists and Jains.* Bombay: Taraporevala, 1972

GYLLENSVÄRD, Bo. *Chinese Gold, Silver, and Porcelain: the Kempe Collection.* Exhib. cat., Asia House Gallery, New York. New York: Asia Soc., 1971

HACKIN, Joseph, et al. *Asiatic Mythology.* New York: Crowell, 1932

———. *Studies in Chinese Art and Some Indian Influences.* London: India Soc., 1938

HALL, John W. *Japan from Prehistory to Modern Times.* New York: Delacorte, 1970

HAMADA, Kosaku. *Ku-yü kai-shuo* [*Gu yu kai shuo;* Early Chinese jade]. Hu Zhaochun, trans. Shanghai, 1940

HANSFORD, S. Howard. *Chinese Carved Jades.* Greenwich, Conn.: N.Y. Graphic Soc., 1968

———: *Essence of Hills and Streams: the Von Oertzen Collection of Chinese and Indian Jades.* New York: American Elsevier, 1969

*———. *Glossary of Chinese Art and Archaeology.* 2nd ed., rev. London: China Soc., 1961

Han-T'ang pi-hua [*Han-Tang bi hua;* Murals from the Han to the Tang dynasty]. Beijing, 1974

HARADA, Jiro. *A Glimpse of Japanese Ideals.* Tokyo: Kokusai Bunka Shinkokai [Soc. for International Cultural Relations], 1937

HARADA, Kinjiro. *The Pageant of Chinese Painting.* Tokyo: Otsukakogeisha, 1936

HÄRTEL, Herbert. *Indische Skulpturen.* Part 1: *Die Werke der frühindischen, klassischen und frühmittelalterlichen Zeit.* Berlin: Museum für Völkerkunde, 1960

*———, and AUBOYER, Jeannine. *Indien und Sudostasien.* Berlin: Propyläen, 1971

HASEBE, Gakuji. *Chugoku Ko Toji* [Ancient Chinese ceramics]. Tokyo: Mainichi Shimbunsha, 1971

HASRAT, Bikrama J., ed. *History of Nepal as Told by Its Own and Contemporary Chroniclers.* Hoshiapur, 1970.

HAVELL, Ernest B. *The Ancient and Mediaeval Architecture of India.* London: Murray, 1915. Reprint. New Delhi, 1972

———. *The Himalayas in Indian Art.* London: Murray, 1924

HAYAKAWA, Masao. *The Garden Art of Japan.* Richard L. Gage, trans. New York: Weatherhill; Tokyo: Heibonsha, 1973

HENDERSON, Harold G., and MINAMOTO, Hoshu. *An Illustrated History of Japanese Art.* Kyoto: Hoshino, 1939

Hiho Nishi-Hongan-ji [Secret treasures in the Nishi-Hongan Temples]. Tokyo, 1973

HIRAI, Kiyoshi. *Feudal Architecture of Japan.* Hiroaki Sato and Jeannine Ciliotta, trans. New York: Weatherhill; Tokyo: Heibonsha, 1973

HISAMATSU, Hoseki S. *Zen to Bijutsu* [Zen and fine arts]. Tokyo, 1971

*HONEY, William B. *Ceramic Art of China and Other Countries of the Far East.* New York: Beechhurst Pr., 1954

HSIEH, Chih-liu [Xie, Zhiliu], ed. *T'ang Wu-tai Sung Yüan ming-chi* [*Tang Wu-dai Song Yuan ming ji;* Famous paintings of Tang, Five Dynasties, Song, and Yuan]. Shanghai, 1957

Hsin chung-kuo ch'u-t'u wen-wu [*Xin Zhongguo chutu wenwu;* Historical relics unearthed in New China]. Beijing: Foreign Lang. Pr., 1972

HUGHES, Sukey. *Washi: the World of Japanese Paper.* Tokyo: Kodansha, 1978

The I-li, or Book of Etiquette and Ceremonial. John Steele, trans. London: Probsthain, 1917. Reprint. Tabei: Ch'en-wen Pub. Co., 1966

IENAGA, Saburo. *Japanese Art: a Cultural Appreciation.* Richard L. Gage, trans. New York: Weatherhill; Tokyo: Heibonsha, 1979

Illustrated Catalog of Chinese Government Exhibits for the International Exhibition of Chinese Art in London, 1935. 4 vols. Shanghai, 1936

ITOH, Teiji. *Traditional Domestic Architecture of Japan.* Richard L. Gage, trans. New York: Weatherhill; Tokyo: Heibonsha, 1972

IYER, K. Bharatha. *Indian Art: a Short Introduction.* Bombay: Asia Pub. House, 1958

JAPAN. BUNKAZAI HOGO INKAI [Commission for the Protection of Cultural Properties]. *Catalogue of Art Objects Registered as National Treasures.* Tokyo?: Benrido, 1951–

———. *Nippon no bunkazai* [Cultural properties of Japan]. 2 vols. Tokyo, 1961

Japanese Famous Paintings. Series I. 13 vols. Tokyo, 1956–58. See individual author entries

Japanese Woodcut Book Illustrations. 4 vols. New York, 1979

JENYNS, R. Soame. *A Background to Chinese Painting.* London: Sidgwick and Jackson, 1935. Reprint. New York: Schocken Books, 1966

———. *Japanese Pottery.* London: Faber; New York: Praeger, 1971

Jingo-ji jiho tokubetsu kokai [Exhibition of the treasures of Jingo Temple]. Tokyo, 1973

JOLY, Henri L., and TOMITO, Kumasaku. *Japanese Art & Handicraft.* London: Yamanaka, 1916. Reprint. Rutland, Vt.: Tuttle, 1976

Jujo Bunkazai [Complete catalogue of appointed national treasures and important cultural objects]. 30 vols. Tokyo, 1972–

*KAGEYAMA, Haruki. *The Arts of Shinto.* Christine Guth, trans. New York and Tokyo: Weatherhill/Shibundo, 1973

———. *Kamigami no Bijutsu: Tokubetsu Tenrankai* [The Arts of the Shinto gods]. Exhib. cat. Kyoto: Kyoto Kokuritsu Hakubutsukan, 1974

———, and KANDA, Christine Guth. *Shinto Arts: Nature, Gods, and Man in Japan.* Exhib. cat., Japan House Gallery, New York. New York: Japan Soc., 1976

KAIL, Owen C. *Buddhist Cave Temples of India.* Bombay: Taraporevala, 1975

Kankoku Bijutsu Zenshu [Arts of Korea]. 15 vols. Seoul, 1974–75

KATO, Genchi. *A Historical Study of the Religious Development of Shinto.* Shoyu Hanayama, trans. Tokyo, 1973

KATO, Shuichi. *Form, Style, Tradition: Reflections on Japanese Art and Society.* John Bester, trans. Berkeley and Los Angeles: U. of Calif. Pr., 1971

KATO, Tokuro, ed. *Genshoku Toki Daijiten* [Great ceramic dictionary in color]. Kyoto, 1972

KATSURA, Matasaburo. *Jidai-betsu Ko Bizen Meihin Zuroku* [Illustrated catalogue of masterpiece ceramics of Old Bizen ware]. Tokyo, 1973

————. *Jidai-betsu Ko Shigaraki Meihin Zuroku* [Illustrated catalogue of masterpiece ceramics of Old Shigaraki ware]. Tokyo, 1974

KEIKAI. *Miraculous Stories from the Japanese Buddhist Tradition: the Nihon Ryoiki of the Monk Kyokai.* Kyoko M. Nakamura, trans. Cambridge, Mass.: Harvard U. Pr., 1973

KHAN, Mohammed A. W. *Stone Sculpture in the Alampur Museum.* Hyderabad, 1973

KIM, Chewon, ed. *Kankoku Bijutsu* [Arts of Korea]. Tokyo, 1970

————, and KIM, Won-yong. *Treasures of Korean Art: 2000 Years of Ceramics, Sculpture, and Jeweled Arts.* New York: Abrams, 1966

KOBAYASHI, Takeshi. *Nara Buddhist Art: Todai-ji.* New York: Weatherhill; Tokyo: Heibonsha, 1975

Kokuho [National treasures of Japan]. Tokyo: Mainichi Shimbunsha, 1963–

KOREA, NATIONAL MUSEUM OF. *5000 Years of Korean Art.* Exhib. cat. N.p.: Asian Art Mus. of San Francisco, 1979

KOREA, REPUBLIC OF. *Korean Arts.* 3 vols. Vol. 2 (C. Kim and G. St. G. M. Gompertz, eds.) also issued separately as *The Ceramic Art of Korea.* Seoul?: Ministry of Foreign Affairs, 1956–63

KOYAMA, Fujio. *Chinese Ceramics: One Hundred Selected Masterpieces from Collections in Japan, England, France and America.* Tokyo: Nihon Keizai, 1960

————, ed. *Toyo Ko Toji* [Early Oriental ceramics]. 7 vols. Tokyo, 1954–57

————, et al. *Kokyo Hakubutsu-in* [Catalogue of the Palace Museum]. Tokyo, 1975

*————, and ed. staff. *Sekai Toji Zenshu* [Catalogue of world's ceramics]. 16 vols. Tokyo, 1955–58

KOYANO, Masako. *Japanese Scroll Painting: a Handbook of Mounting Techniques.* Washington, D.C., 1979

Koyasan: Kobotaishi Goshotan Senniyakunen Kinen [Mount Koya on the twelve hundredth anniversary of the birth of Kobotaishi]. Tokyo, 1973

*KRAMRISCH, Stella. *The Art of India.* 3rd ed. London: Phaidon, 1965

————. *The Art of Nepal.* Exhib. cat., Asia House Gallery, New York. New York: Asia Soc., 1964; distr. Abrams, New York

*————. *The Hindu Temple.* Calcutta: U. of Calcutta, 1946

————. *Indian Sculpture.* Calcutta: Y.M.C.A. Publ. House; London and New York: Oxford U. Pr., 1933

Ku Kung [*Gu gong*] *Monthly.* 44 vols. Beijing, 1929–33

Ku Kung shu-hua-chi [*Gu gong shu hua ji;* Collection of calligraphy and painting in the Palace Museum]. 45 vols. Beijing, 1929–35

Ku Kung [*Gu gong*] *Weekly.* 21 vols. Beijing, 1930–34

Ku Kung [*Gu gong*] *Weekly Special Issues.* 5 vols. Beijing, 1930–34

KUNO, Takeshi. *Butsuzo jiten* [Dictionary of Japanese Buddhist images]. Tokyo: Tokyodo Shuppan, 1975

KYOTO NATIONAL MUSEUM. *Kyo no Shaji Meihoten: Tokubetsu Tenrankai* [Art treasures of shrines and temples in Kyoto: Special exhibition]. Kyoto, 1974

LACH, Donald F. *Asia in the Making of Europe.* 2 vols. Chicago: U. of Chicago Pr., 1965–70

*LAING, Ellen J. *Chinese Paintings in Chinese Publications, 1956–1968: An Annotated Bibliography and an Index to the Paintings.* Ann Arbor: U. of Michigan Pr., 1969

————. *Scholars and Sages: A Study in Chinese Figure Painting.* 2 vols. Ann Arbor: U. of Michigan Pr., 1967

LAUFER, Berthold. *Jade.* 2nd ed. South Pasadena: Perkins, 1946

LAWTON, Thomas. *Chinese Figure Painting.* Exhib. cat., Freer Gallery, Washington, D.C. Washington, D.C.: Smithsonian, 1973

LEE, Sammy Y. *Oriental Lacquer Art.* New York and Tokyo, 1972

LEE, Sherman E. *Chinese Landscape Painting.* 2nd ed., rev. Cleveland: Cleveland Mus. of Art; distr. Abrams, New York, 1962

————. *Japanese Decorative Style.* Cleveland: Cleveland Mus. of Art; distr. Abrams, New York, 1961. Paperback ed. New York and London: Harper and Row, 1972

*LI, Hsüeh-ch'in [Li, Xueqin]. *The Wonder of Chinese Bronzes.* Beijing, 1980

LIN, Yutang. *Imperial Peking: Seven Centuries of China.* With essay on art of Beijing by Peter C. SWANN. New York: Crown, 1961

LION-GOLDSCHMIDT, Daisy. *Les Poteries et porcelaines chinoises.* Paris: P.U.F., 1957

————, and MOREAU-GOBARD, Jean-Claude. *Chinese Art: Bronze, Jade, Sculpture, Ceramics.* Diana Imber, trans. 3rd Am. ed. New York: Universe, 1962

LIPPE, Aschwin. *Indian Mediaeval Sculpture.* Amsterdam, 1978

LOEHR, Max, assisted by Louisa G. F. HUBER. *Ancient Chinese Jades from the Grenville L. Winthrop Collection in the Fogg Art Museum, Harvard University.* Cambridge, Mass.: Fogg Art Mus., 1975

*————. *The Great Painters of China.* Oxford, 1980

LOUIS-FRÉDÉRIC, pseud. *The Art of Southeast Asia: Temples and Sculpture.* New York: Abrams, 1965

LOVELL, Hin-cheung. *Annotated Bibliography of Chinese Painting Catalogues and Related Texts.* Ann Arbor: U. of Michigan Pr., 1973

LUDOWYK, E. F. C. *The Footprint of the Buddha.* London: Allen and Unwin, 1958

*McCUNE, Evelyn. *The Arts of Korea.* Rutland, Vt., and Tokyo: Tuttle, 1962

MACHIDA, Koichi, et al. *Toyo Bijutsu-shi Yosetsu* [Outline history of Oriental art: Iran, India, China, Korea, and Japan]. 2 vols. Tokyo, 1957–59

McNEILL, William H., and SEDLAR, Jean W., eds. *China, India, and Japan: the Middle Period.* New York and London: Oxford U. Pr., 1971

————. *Classical China.* New York and London: Oxford U. Pr., 1970

MALLMAN, Marie-Thérèse de. *Introduction à l'iconographie du Tântrisme bouddhique.* Paris, 1975

*MARCH, Benjamin. *Some Technical Terms of Chinese Painting.* Baltimore: Waverly Pr., 1935

MARTIN, E. Osborn. *The Gods of India: a Brief Description of Their History, Character & Worship.* New York: Dutton, 1914. Reprint. Kennebunkport, Me.: Longwood Pr., 1977

MATSUBARA, Saburo, and TANABE, Saburosuke. *Sho-kondobutsu: Asuka kara Kamakura made* [Gilt bronze Buddha statuettes from the Asuka to the Kamakura period]. Tokyo, 1979

MAYUYAMA, Junkichi, ed. *Chinese Ceramics in the West: a Compendium of Chinese Ceramic Masterpieces in European and American Collections.* Tokyo: Mayuyama, 1960

MEDLEY, Margaret, ed. *Chinese Painting and the Decorative Style.* London: P. David Found. of Chinese Art, 1976

MEHTA, R. *Masterpieces of Indian Temples*. Bombay: Taraporevala, 1974

MIKAMI, Tsugio. *The Art of Japanese Ceramics*. Ann Herring, trans. New York: Weatherhill; Tokyo: Heibonsha, 1972

MINNEAPOLIS INSTITUTE OF ARTS. *Chinese Jades: Archaic and Modern from the Minneapolis Institute of Arts*. Rutland, Vt.: Tuttle, 1977

MINO, Yutaka, and WILSON, Patricia. *An Index to Chinese Ceramic Kiln Sites from the Six Dynasties to the Present*. Toronto: Royal Ontario Mus., 1974

MITRA, Rajendralala. *Buddha Gaya: The Great Buddhist Temple, the Hermitage of Sakya Muni*. Delhi: Indological Book House, 1972

MITSUMORI, Masashito, ed. *Amidabutsu Chozo* [Statues of Amida Buddha]. Tokyo, 1975

MITSUOKA, Tadanari. *Ceramic Art of Japan*. 5th ed. Tokyo: Japan Travel Bureau, 1960

MIZOGUCHI, Saburo. *Design Motifs*. Louise A. Cort, trans. New York and Tokyo: Weatherhill/Shibundo, 1973

*MIZUNO, Seiichi. *Bronze and Stone Sculpture of China from the Yin to the T'ang Dynasty*. Portions trans. by Yuichi Kajiyama and Burton Watson. Tokyo, 1960

MORRISON, Hedda, and EBERHARD, Wolfram. *Hua Shan: The Taoist Sacred Mountain in West China: Its Scenery, Monasteries, and Monks*. Hong Kong: Vetch and Lee, 1973

MUKERJEE, Radhakamal. *The Culture and Art of India*. New York: Praeger, 1959

MUNICH, HAUS DER KUNST. *1000 Jahre Chinesisches Malerei*. Exhib. cat. Munich, 1959

MURAKAMI, Hyoe, and SEIDENSTICKER, Edward G., eds. *Guides to Japanese Culture*. Tokyo: Kodansha, 1977

MURASE, Miyeko. *Japanese Art: Selections from the Mary and Jackson Burke Collection*. Exhib. cat. New York: Metropolitan Mus. of Art, 1975

*MURCK, Christian F., ed. *Artists and Traditions: Uses of the Past in Chinese Culture*. Princeton: Princeton U. Art Mus.; distr. Princeton U. Pr., 1976

NAKATA, Yujiro. *The Art of Japanese Calligraphy*. Alan Woodhull, trans. New York: Weatherhill; Tokyo: Heibonsha, 1973

NANKING [Nanjing] MUSEUM. *Nan-ching po-wu-yüan yüan-ts'ang hua-chi* [*Nanjing Bowu Yuan yuan cang hua ji*; Collection of famous paintings preserved by Nanjing Museum]. Beijing, 1966

———. *Nan-ching po-wu-yüan yüan-ts'ang ku-hua hsuan-chi* [*Nanjing Bowu Yuan yuan cang gu hua xuan ji*; Selected paintings from the Nanjing Museum]. Nanjing, n.d.

NARA IMPERIAL MUSEUM. *Nippon Shozoga Zuroku* [Illustrated catalogue of Japanese portrait painting]. By Mochizuki Nobunari et al. Exhib. cat. 2 vols. Kyoto, 1938

NARA MUSEUM. YAMATO BUNKAKAN. *Kannon no Kaiga: Sono bi to Rekishi* [Exhibition of Kannon paintings]. Nara, 1974

NARA NATIONAL MUSEUM. *Bukkyo Bijutsu Nyumon* [Introduction to Japanese Buddhist arts]. Nara, 1959

———. *Butsuzo to Zonai no Nyuhin ten* [Exhibition of Buddhist sculptures and objects preserved inside the sculptures]. Nara, 1974

———. *Kannon Bosatsu: Tokubetsuten* [Kannon: special exhibition]. Nara, 1977

Nara Rokudai-ji Taikan [Conspectus of the six great temples in Nara]. 14 vols. Tokyo, 1968–73

NEVEN, A. *Lamaistic Art*. S. Berresford, trans. Brussels, 1975

Nihon Bijutsu Taikei [Outline of Japanese arts]. Yukio Yashiro, ed. 11 vols. Tokyo, 1959–61

Nihon-ga Taisei [Great collection of Japanese paintings]. Tokyo, 1931–34

Nihon no Koten: Kaiga-hen [Japanese classic art: painting series].

6 vols. Tokyo, 1955–59. See individual author entries

Nippon Byobu-e Shusei [Complete collection of Japanese screen paintings]. 18 vols. Tokyo: Kodansha, 1977–

Nippon Emakimono Zenshu [Japanese scroll paintings]. 12 vols. Tokyo, 1958–59

Nippon no Tera [Buddhist Temples in Japan]. 12 vols. Tokyo: Bijutsu Shuppansha, 1958–61

Nippon Seikwa [Art treasures of Japan]. 5 vols. Nara, 1908–11

NOMA, Seiroku. *Artistry in Ink*. Edward Strong, trans. New York: Crown, 1957

OAKLAND ART MUSEUM. *Japanese Ceramics from Ancient to Modern Times, Selected from Collections in Japan and America*. Exhib. cat. Fujio Koyama, ed. Oakland, Calif., 1961

OKAZAKI, Takashi; HASEBE, Gaka; and SATO, Masahiko. *Chugoku no Toji: Shin Shutsudo no Meihin* [Chinese ceramics from recent discoveries and historical collections]. Tokyo, 1978

OLSEN, Eleanor. *Tantric Buddhist Art*. Exhib. cat., China House Gallery, New York. New York: China Inst. in America, 1974

OMURA, Seigai. *History of Chinese Art: Section of Sculpture*. 3 vols. Tokyo, 1915

———, ed. *Bunjinga-sen* [Selection of literati paintings]. 12 vols. Tokyo, 1921–22

OOKA, Minoru. *Temples of Nara and Their Art*. Dennis Lishka, trans. New York: Weatherhill; Tokyo: Heibonsha, 1973

Oriental Ceramics: the World's Great Collections. 12 vols. Tokyo, 1976–78

OSAKA FUJITA MUSEUM OF ART. *Fujita Bijutsukan Meihin Zuroku* [Masterpieces in the Fujita Museum of Art]. Tokyo, 1972

OSAKA MUNICIPAL MUSEUM. *Osaka Shiritsu Bijutsukan-zo Chugoku Kaiga* [Chinese paintings in the Osaka Municipal Museum of Art]. 2 vols. Tokyo, 1975

PAINE, Robert T. *Ten Japanese Paintings in the Museum of Fine Arts, Boston*. New York: Japan Soc., 1935

*———, and SOPER, Alexander C. *The Art and Architecture of Japan*. Rev. ed. New York: Penguin, 1974

PAL, Pratapaditya. *The Art of Tibet*. New York: Asia Soc.; distr. N.Y. Graphic Soc., Greenwich, Conn., 1969

*———. *The Arts of Nepal*. Vol. 1: *Sculpture*; vol. 2: *Painting*; vol. 3: *Architecture*. Leiden: Brill, 1974–

———, ed. *Aspects of Indian Art*. Leiden: Brill, 1972

PARIS. MUSÉE GUIMET. *Le Musée Guimet*. Vol. 1: *Inde, Khmer, Tchampa, Thaïlande, Java, Népal, Tibet, Afghanistan, Pakistan, Asie Centrale*, by Odette Monod. Paris: Réunion des musées nationaux, 1966

PARMENTIER, Henri. *L'Art du Laos*. 2 vols. Paris: Impr. nationale, 1954

PAUL-DAVID, Madeleine. *Arts et styles de la Chine*. Paris: Larousse, 1953

PEKING. KU KUNG PO-WU YÜAN. [Beijing. Gu gong bowu yuan; Palace Museum]. *Chung-kuo li-tai ming-hua chi* [*Zhongguo lidai ming hua ji*; Collection of famous Chinese paintings of all periods]. 2 vols. Beijing, 1959–60

———. *Ku-kung po-wu-yüan ts'ang hua* [*Gu gong bowu yuan cang hua*; Paintings from the collection of the Palace Museum, Beijing]. Beijing, 1964

———. *T'ao t'ze hsüan chi* [*Tao ce xuanji*; Pottery and porcelain selection]. 2 vols. Beijing, 1957–58

PETECH, Luciano. *Mediaeval History of Nepal (c. 750–1480)*. Rome: Istituto ital. per il Medio ed Estremo Oriente, 1958

A Pictorial Encyclopedia of the Oriental Arts: Korea. Kadokawa Shoten, ed. New York: Crown, 1969

*RAGUÉ, Beatrix von. *A History of Japanese Lacquerwork*. Annie R. de Wasserman, trans. Toronto and Buffalo: U. of Toronto Pr., 1976

RAMACANDRA, Kaulacara. *Silpa Prakasa*. Alice Boner and Sadasiva Rath Sarma, trans. and annot. Leiden: Brill, 1966

RAMBACH, Pierre, and GOLISH, Vitold de. *The Golden Age of Indian Art, Vth–XIIIth Century.* New York: Studio Publ., 1955

RAPSON, Edward J., et al., eds. *The Cambridge History of India.* 7 vols. Supplementary vol.: *The Indus Civilization,* Mortimer Wheeler, ed. Cambridge U. Pr., in assoc. with Crowell, New York, 1922–68

RAWLINSON, Hugh G. *India: a Short Cultural History.* 3rd ed. London: Cresset Pr., 1954

RAWSON, Philip S. *The Art of Tantra.* Delhi, 1973

———. *Erotic Art of the East: the Sexual Theme in Oriental Painting and Sculpture.* New York: Putnam, 1968

———. *Indian Sculpture.* London: Studio Vista; New York: Dutton, 1966

RAY, Nihar-Ranjan. *Idea and Image in Indian Art.* New Delhi, 1973

*REISCHAUER, Edwin O.; FAIRBANK, John K.; and CRAIG, Albert M. *A History of East Asian Civilization.* 2 vols. Boston: Houghton Mifflin, 1960–65

Republic of China: Official Standard Names. Washington, D.C., 1974

RIDELL, Sheila. *Dated Chinese Antiquities, 600–1650.* London, 1979

ROBERTS, Laurance P. *A Dictionary of Japanese Artists: Painting, Sculpture, Ceramics, Prints, Lacquer.* New York and Tokyo: Weatherhill, 1976

ROSENFIELD, John M.; CRANSTON, Fumiko E.; and CRANSTON, Edwin A. *The Courtly Tradition in Japanese Art and Literature: Selections from the Hofer and Hyde Collections.* Exhib. cat., Fogg Art Museum, Harvard University. Cambridge, Mass.: Fogg Art Mus., 1973

———, and GROTENHUIS, Elizabeth ten. *Journey of the Three Jewels: Japanese Buddhist Paintings from Western Collections.* Exhib. cat., Asia House Gallery, New York. New York: Asia Soc./Weatherhill, 1979

*———, and SHIMADA, Shujiro. *Traditions of Japanese Art.* Cambridge, Mass.: Fogg Art Mus., 1970

ROUSSET, Huguette. *Arts de la Corée.* Fribourg, 1977

*ROWLAND, Benjamin. *The Art and Architecture of India.* 3rd ed., rev. Baltimore: Penguin, 1967

———. *Art in East and West.* Cambridge, Mass.: Harvard U. Pr., 1954

———. *The Harvard Outline and Reading Lists for Oriental Art.* 3rd ed. Cambridge, Mass.: Harvard U. Pr., 1967

ROWLEY, George. *Principles of Chinese Painting.* 2nd ed. Princeton: Princeton U. Pr., 1959

ROYAL ONTARIO MUSEUM. *Chinese Art in the Royal Ontario Museum.* Toronto, 1972

SAHAI, Bhagwant. *Iconography of Minor Hindu and Buddhist Deities.* New Delhi: Abhinar Publ., 1975

SAHAY, Sachidanand. *Indian Costume, Coiffure, and Ornament.* New Delhi: Munshiram Manoharlal, 1975

SAKANISHI, Shio, trans. *The Spirit of the Brush.* London: J. Murray, 1939. Reprint. London: J. Murray, 1948

*SANSOM, George B. *Japan: A Short Cultural History.* Rev. ed. Englewood Cliffs, N.J.: Prentice-Hall, 1962

SARKAR, Amal. *Siva in Medieval Indian Literature.* Calcutta, 1974

*SAWA, Takaaki. *Art in Japanese Esoteric Buddhism.* Richard L. Gage, trans. New York: Weatherhill; Tokyo: Heibonsha, 1972

SEATTLE ART MUSEUM. *Ceramic Art of Japan: One Hundred Masterpieces from Japanese Collections.* Exhib. cat. Seattle, 1972

———. *International Symposium on Japanese Ceramics.* Seattle, 1973

Sekai Bijutsu Zenshu [World art series]. 38 vols. when completed. Tokyo: Kadokawa Shoten, 1959–

Sekai Bijutsu Zenshu [World art series]. 2 vols. Tokyo: Heibonsha, 1950–

Sekai Bunka-shi Taikei [Cultural history of the world]. 26 vols. Tokyo, 1958

Sekai Kokogaku Taikei [Archaeology of the world]. 16 vols. Tokyo, 1959–

SELIGMAN, Charles G. *The Seligman Collection of Oriental Art.* 2 vols. Vol. 1: *Chinese, Central Asian and Luristan Bronzes and Chinese Jades and Sculptures,* by S. Howard HANSFORD; vol. 2: *Chinese and Korean Pottery and Porcelain,* by John AYERS. London: L. Humphries for Arts Council of Great Britain, 1957–64

SEN, A. C. *Buddhist Remains in India.* New Delhi: Indian Council for Cult. Rel., 1956

SHANGHAI PO WU KUAN [Shanghai bowu guan; Shanghai Museum]. *Shanghai po-wu-kuan ts'ang-hua* [Shanghai bowu guan cang hua; Shanghai Museum collection of Chinese painting]. Shanghai, 1959

Shen-chou kuo-kuang-chi [Shen Zhou guo guang ji; Selected works of Chinese art]. 21 vols. Shanghai, 1908–12

Shen-chou-ta-kuan [Shen Zhou da guan; Selected works of Chinese art, cont.]. 16 vols. Shanghai, 1912–22

SHIMBO, Toru. *Butsuden-zu* [Scenes from the life of Buddha]. Tokyo, 1978

Shina Nanga Taisei [Chinese literati paintings]. 23 vols. 2nd ed. Tokyo, 1937

SICKMAN, Laurence, ed. *The University Prints: Oriental Art.* Series O, sec. II: *Early Chinese Art.* Newton, Mass., 1938

*———, and SOPER, Alexander C. *The Art and Architecture of China.* 3rd ed. Baltimore: Penguin, 1968

SIMPSON, Penny, and SODEOKA, Kanji. *The Japanese Pottery Handbook.* Tokyo: Kodansha, 1979

SINGH, Madanjeet. *Himalayan Art: Wall-Painting and Sculpture in Ladakh, Lahaul, and Spiti. . . .* Greenwich, Conn.: N.Y. Graphic Soc., 1968

*SIRÉN, Osvald. *The Chinese on the Art of Painting.* Beijing: Vetch, 1936

*———. *Chinese Painting: Leading Masters and Principles.* 7 vols. New York: Ronald Pr., 1956–58

———. *Chinese Paintings in American Collections.* 2 portfolios. Paris and Brussels: Van Oest, 1928

*———. *Chinese Sculpture from the Fifth to the Fourteenth Century.* New York: Scribner's, 1925

———. *A History of Early Chinese Art.* 4 vols. London: Benn, 1929–30

———. *Kinas konst under tre årtusenden.* 2 vols. Stockholm: Natur och kultur, 1942–43

SIVARAMAMURTI, Calambur. *An Album of Indian Sculpture.* New Delhi: Nat. Book Trust, 1975

———. *The Art of India.* New York: Abrams, 1977

———. *Sanskrit Literature and Art: Mirrors of Indian Culture.* Delhi: Mgr. of Publ., 1955

SMITH, Ralph B., and WATSON, W., eds. *Early South East Asia: Essays in Archaeology, History, and Historical Geography.* New York: Oxford U. Pr., 1979

SMITH, Vincent Arthur. *A History of Fine Art in India and Ceylon.* 2nd ed., rev. by K. de B. Codrington. Oxford U. Pr., 1930

So Gen Min Shin Meigwa Taikan [Collection of famous paintings of the Song, Yuan, Ming, and Qing dynasties]. Tokyo, 1931

SOPER, Alexander C. *The Evolution of Buddhist Architecture in Japan.* Princeton: Princeton U. Pr., 1942

SPEISER, Werner. *The Art of China: Spirit and Society.* George Lawrence, trans. New York: Crown, 1960

SPULER, Bertold, comp. *History of the Mongols: Based on Eastern and Western Accounts of the Thirteenth and Fourteenth Centuries.* Helga and Stuart Drummond, trans. Berkeley: U. of Calif. Pr., 1972

STAVISKII, Boris I. *Iskusstvo Srednei Azii: drevnii period VI v. do n.e.–VIII v. n.e.* [Art of Central Asia: early period, 6th century

B.C.–8th century A.D.]. Moscow: Iskusstvo, 1974

STERN, Harold P. *Birds, Beasts, Blossoms, and Bugs: the Nature of Japan*. Exhib. cat., U. of Calif., Los Angeles. New York: Abrams, 1976

STOCKHOLM NATIONALMUSEUM. *Kinesisk konst: en konstbok från Nationalmuseum*. Bo Gyllensvärd, ed. Stockholm: Rabén and Sjögren, 1959

SUGIMOTO, Masayoshi, and SWAIN, David L. *Science and Culture in Traditional Japan, A.D. 600–1854*. Cambridge, Mass.: MIT Pr., 1978

*SULLIVAN, Michael. *The Arts of China*. Rev. ed. Berkeley: U. of Calif. Pr., 1977

——. *Chinese and Japanese Art*. New York: Watts, 1965

——. *The Meeting of Eastern and Western Art: from the Sixteenth Century to the Present Day*. London: Thames and Hudson, 1973

*——. *Symbols of Eternity: the Art of Landscape Painting in China*. Stanford, Calif.: Stanford U. Pr., 1979

——. *The Three Perfections: Chinese Painting, Poetry and Calligraphy*. London, 1974

SUNDARAM, K. *Monumental Art and Architecture of India*. Bombay: Taraporevala, 1974

SUZUKI, Kei, ed. *Kaigai Shozai Chugoku Kaiga mo Uroku* [Catalogue of Chinese paintings in public and private collections abroad]. Tokyo, 1977

SWANN, Peter C. *Art of China, Korea and Japan*. New York: Praeger, 1963

——. *Chinese Painting*. New York: Universe, 1958

——. *A Concise History of Japanese Art*. (Rev. ed. of *An Introduction to the Arts of Japan*. New York: Praeger, 1958.) New York and Tokyo: Kodansha, 1979

SWARUP, Shanti. *The Arts and Crafts of India and Pakistan*. Bombay: Taraporevala, 1957

TAICHUNG. CHUNG YANG PO WU YÜAN. [Taizhong. Zhong yang bowu yuan; Taichung National Central Museum]. *Chung-hua ming-hua hsuan-chi* [*Zhong hua ming hua xuanji*; Selected famous Chinese paintings]. Taizhong, 1957

*TAICHUNG. KU KUNG PO WU YÜAN; CHUNG YANG PO WU YÜAN. [Taizhong. Gu gong bowu yuan; Zhong yang bowu yuan; Taichung National Palace Museum and National Central Museum]. *Chung-hua ts'ung shu wei yüan hui* [*Zhong hua congshu wei yuan hui*; Art of China]. 6 vols. Taibei: Chung Hwa Ts'ung-shu [Zhong hua Congshu] Committee: 1955–56

*——. *Ku kung ming hua san pai chung* [*Gu gong ming hua san bai zhong*; Three hundred masterpieces of Chinese painting in the National Palace Museum]. Taizhong, 1959

——. *Ku kung shu-hua lu* [*Gu gong shu hua lu*; Catalogue of calligraphies and paintings of the collection of the National Palace Museum]. 3 vols. Taibei, 1956

TAICHUNG. KUO LI KU KUNG CHUNG YANG PO-WU-YÜAN LIEN HO KUAN [Taizhong. Guo li gu gong zhong yang bowu yuan lian he guan]. *Chung-hua wen-wu chi ch'eng* (*Zhong hua wenwu jicheng*; Collections of Chinese paintings, calligraphy, and art objects in the collection of the National Central Museum, National Central Library, and National Palace Museum]. 5 vols. Taizhong, 1954

TAIPEI. KUO LI KU KUNG PO WU YÜAN [Taibei. Guo li gu gong bowu yuan; Taibei. National Palace Museum]. *Ku kung chen wan, fa lang chi, fa shu, ming hua, ts'e yeh, wen chü hsüan ts'ui* [*Gu gong zhen wan, fa lang ji, fa shu, ming hua, ce ye, wen ju xuan cui*; Masterpieces of Chinese miniature crafts, enamel ware, calligraphy, painting, album painting, and writing materials in the National Palace Museum]. 6 vols. Taibei, 1970–71

——. *Proceedings of the International Symposium on Chinese Painting, June, 1970*. Taibei, 1972

TAJIMA, Shiichi, et al., eds. *Toyo Bijutsu Taikan* [Masterpieces selected from the fine arts of the Far East]. Text by Seigai OMURA. 15 vols. Tokyo: Shimbi Shoin, 1909–20

TAKEJIMA, T. *Ryo Kin Jidai no Kenchiku to Butsuzo* [Buddhist architecture and sculpture of the Liao and Chin (Jin) dynasties]. Tokyo, 1944

TAKI, Seiichi. *Three Essays on Oriental Painting*. London: Quaritch, 1910

TANAKA, Ichimatsu. *Toyo Bijutsu* [Asiatic art in Japanese collections]. 6 vols. Tokyo: Asahi Shimbun, 1967–69

T'ang Sung Yüan Ming Ming-hua Ta-kuan [*Tang Song Yuan Ming ming hua da guan*; Collection of famous paintings: Tang, Song, Yuan, and Ming dynasties]. 2 vols. Taibei, 1976

TANGE, Kenzo, and GROPIUS, Walter. *Katsura: Tradition and Creation in Japanese Architecture*. New Haven: Yale U. Pr., 1960

TAZAWA, Yutaka, and OOKA, Minoru. *An Illustrated History of Japanese Art*. Tokyo: Iwanami, 1934

T'IEN-CHIN SHIH I SHU PO-WU-KUAN [Tianjin shi yi shu bowu guan; Tianjin Art Museum]. *I-yuan chi-chin* [*Yi-yuan ji jin*; Selection of fine paintings from the Tianjin Art Museum collection]. Tianjin, 1959

Toji-shi Meihin Zuroku [Japanese pottery and porcelain through the ages]. Tokyo: Japan Ceramic Soc., 1955?

Toki Zenshu [Ceramic series: collective catalogue of pottery and porcelain of different periods in Japan, China, and Korea]. 28 vols. Tokyo, 1957–. See individual author entries

TOKIWA, Daijo, and SEKINO, Tadashi. *Chugoku Bunka Shiseki* [Cultural monuments of China]. 15 vols. Kyoto, 1975–

TOKYO KOKURITSU HAKUBUTSUKAN [Tokyo National Museum]. *100 Masterpieces from the Collection of the Tokyo National Museum*. Tokyo, 1959

——. *Pageant of Japanese Art*. 6 vols. Tokyo: Toto Shuppan, 1957

——. *Tokyo Kokuritsu Hakubutsu-kan* [Catalogue of the Tokyo National Museum]. Tokyo: Kodansha, 1966

——. *Toyo no Toji: Toyo Toji ten Kinen Zuroku* [Oriental ceramics: Illustrated commemorative catalogue of the Exhibition of Oriental Ceramics, October 9–November 29, 1970]. Tokyo, 1971

TOMITA, Kojiro. *Portfolio of Chinese Paintings in the Museum (Han to Sung Periods)*. Cambridge, Mass.: Harvard U. Pr. for Mus. of Fine Arts, Boston, 1933

——, and TSENG, Hsien-Chi. *Portfolio of Chinese Paintings in the Museum, Yüan to Ch'ing*. Boston: Mus. of Fine Arts, 1961

Toyo Bijutsu [Asian art in Japanese collections]. 5 vols. Tokyo, 1967?

TOYO BIJUTSU KOKUSAI KENKYUKAI [Society of Friends of Eastern Art], comp. *Index of Japanese Painters*. 1940. Offset reprint. Tokyo and Rutland, Vt.: Tuttle, 1958

TREGEAR, Mary. *Guide to the Chinese Ceramics*. Oxford: Ashmolean Mus., 1966

TRUBNER, Henry; RATHBUN, William J.; and KAPUTA, Catherine A. *Asiatic Art in the Seattle Art Museum*. Seattle, 1973

TSUZUMI, Tsuneyoshi. *Die Kunst Japans*. Leipzig: Insel, 1929

*TWITCHETT, Denis, and FAIRBANK, John K., eds. *The Cambridge History of China*. Cambridge and New York: Cambridge U. Pr., 1978

UNESCO. *Japan: Ancient Buddhist Paintings*. Introduction by Takaaki MATSUSHITA. Greenwich, Conn.: N. Y. Graphic Soc., 1959

VAKIL, Kanaiyalal H. *Rock-cut Temples Around Bombay at Elephanta and Jogeshwari, Mandapeshwar and Kanheri*. Bombay: Taraporevala, 1932

*VALENSTEIN, Suzanne G. *A Handbook of Chinese Ceramics*. New York: Metropolitan Mus. of Art, 1975

VANDERSTAPPEN, Harrie A., ed. *The T. L. Yuan Bibliography of Western Writings on Chinese Art and Archaeology*. London:

Mansell, 1975

*VARLEY, H. Paul. *Japanese Culture: a Short History.* New York: Prager, 1973

VENICE. DUCAL PALACE. *Mostra d'arte cinese* [Exhibition of Chinese art]. Venice: Alfieri, 1954

VICTORIA AND ALBERT MUSEUM. *Tibetan Art.* Text by John Lowry. London, 1973

VILLA HÜGEL, ESSEN. *5000 Years of Art from India.* Exhib. cat., Villa Hügel. Essen, 1959

*VOGEL, Jean Ph. *Buddhist Art in India, Ceylon, and Java.* Oxford U. Pr., 1936

WAGNER, FRITS A. *Indonesia: the Art of an Island Group.* Ann E. Keep, trans. New York: Crown, 1959

WALEY, Arthur. *An Introduction to the Study of Chinese Painting.* New York: Scribner's, 1923

WANG, Shih-chieh [Wang, Shijie]. *I-chen pieh-chih* [*Yizhen biezhi*; Select Chinese paintings and calligraphy from Wang Shih-chieh's collections]. 3 vols. Taibei, 1971

————, et al., comps. *A Garland of Chinese Paintings.* 5 vols. Kowloon: Cafa, 1967

WANG, Shih-hsiang. "Chinese Ink Bamboo Painting." *Archives of the Chinese Art Society of America* 3 (1948–49)

WARNER, Langdon. *The Craft of the Japanese Sculptor.* New York: McFarlane, Warde, McFarlane/Japan Soc., 1936

*————. *The Enduring Art of Japan.* Cambridge, Mass.: Harvard U. Pr., 1952. Reprint. New York: Grove Pr., 1958

WATSON, William. "A Cycle of Cathay. China: The Civilization of a Single People." In *The Dawn of Civilization.* Stuart Piggott et al., eds. New York: McGraw-Hill, 1961

————. *Early Civilization in China.* London: Thames and Hudson, 1966; New York: McGraw-Hill, 1972

————, ed. *Artistic Personality and Decorative Style in Japanese Art.* London: P. David Found. of Chinese Art, 1977

————, et al. *Mahayanist Art After A.D. 900.* London: P. David Found. of Chinese Art, 1971

WATT, James C. Y., ed. *The Translation of Art: Essays on Chinese Painting and Poetry.* Hong Kong, 1976

WELLS, Wilfrid H. *Perspective in Early Chinese Painting.* London: Goldston, 1935

WENG, Wan-go. *Chinese Painting and Calligraphy: a Pictorial Survey.* New York: Dover, 1978

Wen-hua ta-ke-ming ch'u-t'u wen-wu, ti i chi [*Wen hua da ge ming chutu wenwu di yi ji*; Historical relics unearthed during the Cultural Revolution; first series]. Beijing, 1972

WHEELER, Sir R. E. Mortimer. *Early India and Pakistan to Ashoka.* New York: Praeger, 1959

————. *Five Thousand Years of Pakistan.* London: Johnson, 1950

WHITE, William C. *An Album of Chinese Bamboos.* Toronto: U. of Toronto Pr., 1939

WILHELM, Richard. *A Short History of Chinese Civilization.* Joan Joshua, trans. New York: Viking, 1929

WILKINS, William J. *Hindu Mythology, Vedic and Puranic.* 2nd ed. Calcutta: Thacker, Spink; London: W. Thacker, 1898. Reprint. Varanasi, 1972

*WILLETTS, William. *Chinese Art.* 2 vols. London: Penguin, 1958

WILLIAMS, Laurence F. R. *A Handbook for Travellers in India, Pakistan, Nepal, Bangladesh, and Sri Lanka.* 22nd ed. London, 1975

WINSTEDT, Sir Richard O., ed. *Indian Art.* New York: Philosophical Lib., 1948

Wu-shen ch'u-t'u chung-yao-wen-wu-chan-lan t'u-lu [*Wu shen chutu zhong yao wenwu zhan lan tulu*; Catalogue of the exhibition of important art objects excavated in five provinces]. Beijing, 1958

YAMATO BUNKAKAN MUSEUM, NARA. *Selected Catalogue of the Museum Yamato Bunkakan.* 1960

YASHIRO, Yukio. *2000 Years of Japanese Art.* Peter C. Swann, ed. New York: Abrams, 1958

*————, ed. *Art Treasures of Japan.* 2 vols. Tokyo: Kokusai Bunka Shinkokai, 1960

YONEZAWA, Kafu. *Beauty in Chinese Painting.* Tokyo, 1958

YOSHIDA, Tetsuro. *Japanische Architektur.* Tübingen: Wasmuth, 1952

*YOSHIKAWA, Itsuji. *Major Themes in Japanese Art.* Armin Nikovskis, trans. New York: Weatherhill; Tokyo: Heibonsha, 1976

YOSHINO, Tomio. *Japanese Lacquer Ware.* 2nd ed. Tokyo: Japan Travel Bureau, 1963

Zaigai Hiho [Japanese paintings in Western collections]. M. Narazaki and S. Shimada, eds. 6 vols. Tokyo: Gakken, 1969

*ZIMMER, Heinrich R. *The Art of Indian Asia.* 2 vols. Completed and edited by Joseph Campbell. New York: Pantheon, 1955

————. *Myths and Symbols in Indian Art and Civilization.* Joseph Campbell, ed. New York: Pantheon, 1946. Reprint. Princeton: Princeton U. Pr., 1971

Zusetsu Nippon Bunka-shi Taikei [Illustrated cultural history of Japan]. 14 vols. Kota Kodama, ed. Tokyo, 1956–58

PART ONE

EARLY CULTURE AND ART:
THE STONE AGE, THE BRONZE AGE, AND THE EARLY IRON AGE

I. URBAN CIVILIZATION AND THE INDUS VALLEY; NEOLITHIC AND PRE-SHANG CHINA

AGRAWAL, Dharma P., and GHOSH, A., eds. *Radiocarbon and Indian Archaeology.* Bombay: Tata Inst. of Fundamental Research, 1973

ANDERSSON, J. G. "Researches in the Pre-History of the Chinese." *Bull. of the Mus. of Far Eastern Antiq.* 15 (1943)

BROOKS, Robert R. R., and WAKANKAR, Vishnu S. *Stone Age Painting in India.* New Haven: Yale U. Pr., 1976

CHANDRA, Rai G. *Studies of Indus Valley Terracottas.* Varanasi:

Bharatiya, 1973

CHENG, Te-k'un. *Archaeological Studies in Szechwan.* Cambridge U. Pr., 1957

*————. *Archaeology in China.* Vol. 1: *Prehistoric China.* Toronto: U. of Toronto Pr., 1959

*CREEL, Herrlee G. *Studies in Early Chinese Culture.* . . . Baltimore: Waverly Pr., 1937

*FAIRSERVIS, Walter A., Jr. *The Roots of Ancient India: The Archaeology of Early Indian Civilization.* New York: Macmillan, 1971

GORDON, D. H. *The Pre-historic Background of Indian Culture.*

Bombay, 1958

Ho, Ping-ti. *The Cradle of the East*. Hong Kong: Chinese U. of Hong Kong; Chicago: U. of Chicago Pr., 1975

Hsia, Nai [Xia Nai]. "Our Neolithic Ancestors." *Archaeology* 10, no. 3 (September, 1957), pp. 181–87

Hsu, Shun-chan [Xu, Shunzhan]. "Kuan-yu Chung-yuan hsin-shih-ch'i-shih-tai wen-hua chi-ko wen-t'i" [Guan you Zhongyuan xinshi qishi dai wen hua jige wenti; Some problems concerning the Neolithic culture in the Chung-yuan]. *Wen wu* (May, 1960), pp. 36–39

Jouveau-Dubreuil, Gabriel. *Vedic Antiquities*. 2nd ed. Hyderabad, 1976

Kidder, Jonathan E., Jr. *Prehistoric Japanese Arts: Jomon Pottery*. Tokyo and Palo Alto, 1968

Li, Chi [Li Ji], ed., et al. *Ch'eng-tzu-yai: The Black Pottery Culture Site at Lung-shan-chen*. . . . Kenneth Starr, trans. New Haven and London, 1956

Loehr, Max. *Chinese Bronze Age Weapons*. Ann Arbor, 1956

Mackay, Ernest. *Chanhu-Daro Excavations, 1935–36*. New Haven, 1943

*———. *Early Indus Civilizations*. London, 1948

Marshall, Sir John. *Mohenjo-Daro and the Indus Civilization*. London, 1931

Mizuno, Seiichi. *Prehistoric China: Yang-shao and Pu-chao-chai*. Quezon City, Philippines, 1956

Mode, Heinz. *Das frühe Indien*. Stuttgart, 1959

*Piggott, S. *Prehistoric India*. London, 1950

Prufer, Olaf. "The Neolithic of Kansu Province, China." *Anthropology Tomorrow* 5, no. 2 (June, 1957), pp. 6–27

Rao, Shikaripur R. *Lothal and the Indus Civilization*. New York: Asia Publ. House, 1973

*Wheeler, Sir R. E. Mortimer. *Early India and Pakistan to Ashoka*. New York: Praeger, 1959

*———. *The Indus Civilization*. Cambridge, England, 1953

Yap, Yong, and Cotterell, Arthur. *The Early Civilization of China*. London, 1975

2. CHINESE ART FROM THE SHANG THROUGH THE MIDDLE ZHOU PERIOD

An, Chin-huai [An, Jinhuai]. "T'an-t'an Cheng-chou Shang-tai tz'u-ch'i te chi-ko wen-t'i" ["Tantan Zhengzhou Shang dai ci qi de jige wen ti"; On some problems concerning the Shang dynasty porcelain at Zhengzhou]. *Wen wu* (August–September, 1960), pp. 68–70

Barnard, Noel. *Bronze Casting and Bronze Alloys in Ancient China*. Canberra and Nagoya, 1961

———, and Sato, Tamotsu. *Metallurgical Remains of Ancient China*. Tokyo: Nichiosha, 1975

*Chang, Kwang-chih. *Shang Civilization*. New Haven and London: Yale U. Pr., 1980

Ch'en, Meng-chia [Chen, Mengjia], ed. *In Shu Seidoki Bunrui Zuroku* [A corpus of Chinese bronzes in American collections]. Michio Matsumaru, rev. Tokyo, 1977

*Cheng, Te-k'un. *Archaeology in China*. Vol. 2: *Shang China*. Cambridge: Heffer, 1961

Consten, Eleanor von Erdberg. *Das alte China*. 2nd ed. Stuttgart: Cotta, 1962

Creel, Herrlee G. *The Birth of China*. New York: Reynal, 1937. Reprint. New York: Ungar, 1954

Dexel, Thomas. *Les Bronzes chinois*. M. Maas-Auclert, trans. Paris: P.U.F., 1958

*Freer Gallery of Art. *The Freer Chinese Bronzes*. By John A. Pope et al. Vols. 1–20. Washington, D.C.: Smithsonian, 1967 and 1969

Heusden, Willem van. *Ancient Chinese Bronzes of the Shang and Chou Dynasties; an Illustrated Catalogue of the Van Heusden Collec-*

tion. Tokyo, 1952

Hsia, Nai [Xia, Nai]. "Wo-kuo chin-wu-nien-lai te Kao-ku shou-huo" [Wo guo jin wu nian lai de kao gu shou huo; Archaeological findings in the last five years in China]. *Kao-ku* [*Kao gu*] 10 (1964)

———. "Workshop of China's Oldest Civilization." *China Reconstructs* 6, no. 12 (December 1957), pp. 18–21

Hsu, Chin-hsiung. *Oracle Bones from the White and Other Collections*. Toronto, 1979

Institute of Archaeology, Chinese Academy of Science. *Hsin-Chung-kuo te Kao-ku shou-huo* [*Xin Zhongguo de kao gu shou huo*; Archaeology in the New China]. Beijing, 1962

Karlgren, Bernhard. *A Catalogue of the Chinese Bronzes in the Alfred F. Pillsbury Collection*. Minneapolis: U. of Minnesota Pr., 1952

*———. "New Studies on Chinese Bronzes." *Bull. of the Mus. of Far Eastern Antiq.* 9 (1937)

*———. "Yin and Chou in Chinese Bronzes." *Bull. of the Mus. of Far Eastern Antiq.* 8 (1936)

Kelley, Charles F., and Ch'en, Meng-chia [Chen, Mengjia]. *Chinese Bronzes from the Buckingham Collection*. Chicago: Art Inst. of Chicago, 1946

Kuo, Mo-jo [Guo, Moruo]. *Liang Chou chin-wen-tz'u ta-hsi t'u-lu k'ao-shih* [*Liang Zhou jin wen ci da xi tulu kao shi*; Illustrated catalogue, study, and explanation of inscriptions on bronzes of the Western and Eastern Zhou dynasties]. 8 vols. Beijing, 1957

Lefebvre d'Argencé, René-Yvon. *Bronze Vessels of Ancient China in the Avery Brundage Collection*. San Francisco: Diablo Pr., 1977

*Li, Chi. *Anyang*. Seattle: U. of Washington Pr., 1977

———. *The Beginnings of Chinese Civilization: Three Lectures Illustrated with Finds at Anyang*. Seattle: U. of Washington Pr., 1957

———. "Diverse Backgrounds of the Decorative Art of the Yin Dynasty." *Academia Sinica Annals* 2, part 1 (1955), pp. 119–29

———. "Examples of Pattern Dissolution from the Archaeological Specimens of Anyang." *Artibus Asiae* 22, nos. 1/2 (1958)

———. *Hsiao T'un (The Yin-Shang Site at Anyang, Honan)*. Vol. 3: *Artifacts*. Taibei, 1956

———. "Hunting Records, Faunistic Remains and Decorative Patterns from the Archaeological Site of Anyang." *Bull. of the Department of Archaeology and Anthropology, National Taiwan University* 9–10 (November 1957), pp. 10–16

Lodge, John E.; Wenley, Archibald G.; and Pope, John A. *A Descriptive and Illustrative Catalogue of Chinese Bronzes*. Washington, D.C.: Freer Gallery, 1946

Loehr, Max. "The Bronze Styles of the Anyang Period." *Archives of Chinese Art Society of America* 7 (1954)

*———. *Ritual Vessels of Bronze Age China*. Exhib. cat. New York: Asia Soc.; distr. N.Y. Graphic Society, Greenwich, Conn., 1968

*Mizuno, Seiichi. *Bronzes and Jades of Ancient China* [*In Shu Seidoki to Tama*]. J. O. Gauntlett, trans. Tokyo: Nihon Keizai, 1959

Palmgren, Nils. *Selected Chinese Antiquities from the Collection of Gustaf Adolph, Crown Prince of Sweden*. Stockholm, 1948

Salmony, Alfred. *Archaic Chinese Jades from the Edward and Louise B. Sonnenschein Collection*. Art Inst. of Chicago, 1952

*———. *Carved Jade of Ancient China*. Berkeley: Gillick Pr., 1938

Shanghai po-wu-kuan ts'ang ch'ing-t'ung-ch'i [*Shanghai bowu guan cang qing tong qi*; Chinese archaic bronzes in the Shanghai Museum]. 2 vols. Shanghai, 1965

Sumitomo, Baron Kichizaemon. *Sen-oku Sei-sho* [Catalogue of

the collection of Chinese bronzes owned by Baron Sumitomo]. 2 vols. Osaka, 1912

————. *Shin-shu Sen-oku Sei-sho* [Collection of old bronzes of Sumitomo]. S. Umehara, ed. 2 vols. Kyoto, 1971

TAIBEI, NATIONAL PALACE MUSEUM. *Ku-kung t'ung-ch'i t'u-lu* [*Gu gong tong qi tulu;* Illustrated catalogue of the bronzes of the Palace Museum]. Joint Administration Dept., National Palace Museum and Central Museum, ed. 2 vols. Taibei, 1958

UMEHARA, Sueji. *Sen-oku Sei-sho* [Collection of old bronzes of Baron Sumitomo]. Kyoto, 1934

————. *Shina-kodo Seikwa* [Selected relics of ancient Chinese bronzes from collections in Europe and America]. 5 vols. Osaka, 1933

————. *Shina Kogyoku Zuroku* [Selected specimens of Chinese archaic jade]. Kyoto, 1956

————, comp. *Nihon Shucho Shina Kodo Seikwa* [Selected relics of ancient Chinese bronzes from collections in Japan]. Osaka, 1959

WATSON, William. *Ancient Chinese Bronzes.* 2nd ed. London: Faber, 1977

————. *Archaeology in China.* London: Parrish, 1960

*————. *China Before the Han Dynasty.* New York: Praeger, 1962

WHITE, William C. *Bone Culture of Ancient China.* Toronto: U. of Toronto Pr., 1945

————. *Bronze Culture of Ancient China: an Archaeological Study of Bronze Objects from Northern Honan. . . .* Toronto: U. of Toronto Pr., 1956

*YETTS, W. Perceval. *The Cull Chinese Bronzes.* London: Courtauld Inst. of Art, U. of London, 1939

3. THE LATE ZHOU PERIOD

ANDERSSON, J. G. "The Goldsmith in Ancient China." *Bull. of the Mus. of Far Eastern Antiq.* 7 (1935)

————. "Hunting Magic in the Animal Style." *Bull. of the Mus. of Far Eastern Antiq.* 4 (1932)

*BOROVKA, Gregory. *Scythian Art.* V. Gordon Childe, trans. New York: Stokes, 1928. Reprint. New York: Paragon, 1960

BUNKER, Emma C.; CHATWIN, C. Bruce; FARKAS, Ann R. *Animal Style Art from East to West.* Exhib. cat., Asia House Gallery, New York. New York: Asia Soc., 1970; distr. N.Y. Graphic Soc., Greenwich, Conn.

CARTER, Dagny O. *The Symbol of the Beast.* New York: Ronald Pr., 1957

CHIANG, Yuen-yi [Jiang, Yuanyi]. *Ch'ang-sha: the Art of the Ch'u Tribes (I, Lacquer; II, Wood Sculpture).* Shanghai: Publ. of the Kunstarchäeologie Soc., 1949–50

Hui-hsien fa chueh pao-kao [*Hui Xian fa jue bao gao;* Report on the excavations at Hui Xian]. Beijing, 1956

*KARLGREN, Bernhard. "Huai and Han." *Bull. of the Mus. of Far Eastern Antiq.* 13 (1941), pp. 1–126

*MINNS, E. H. *The Art of the Northern Nomads.* London: Milford, 1944

*————. *Scythians and Greeks.* Cambridge U. Pr., 1913

*RICE, Tamara T. *The Scythians.* New York: Praeger, 1961

*ROSTOVTZEFF, Mikhail I. *The Animal Style in South Russia and China.* Princeton: Princeton U. Pr., 1929

SALMONY, Alfred. *Sino-Siberian Art in the Collection of C. T. Loo.* Paris: C. T. Loo, 1933

TROUSDALE, William. *The Long Sword and Scabbard Slide in Asia.* Washington, D.C.: Smithsonian, 1975

UMEHARA, Sueji. *Rakuyo Kinson Kobo Shuei* [Catalogue of selected relics from the ancient tombs of Chin-ts'un, Loyang (Jin Cun, Luoyang)]. Kyoto, 1937

WEBER, George W. *The Ornaments of Late Chou Bronzes; a Method of Analysis.* New Brunswick, N. J.: Rutgers U. Pr., 1973

WHITE, William C. *Tomb Tile Pictures of Ancient China.* Toronto: U. of Toronto Pr., 1939

————. *Tombs of Old Lo-yang.* Shanghai: Kelly and Walsh, 1934

4. THE GROWTH AND EXPANSION OF EARLY CHINESE CULTURE THROUGH THE HAN DYNASTY; KOREA AND JAPAN

BEARDSLEY, Richard K. "Japan Before History: a Survey of the Archaeological Record." *Far Eastern Quarterly* 14, no. 3 (November 1955), pp. 317–46

BEIJING CULTURAL OBJECTS PRESS, ed. *Hsi-Han ssu-hua* [*Xi Han si-hua;* Western Han painting on silk]. Beijing, 1972

BULLING, A. *The Decoration of Mirrors of the Han Period: a Chronology. Artibus Asiae,* Suppl. 20 (Ascona, 1960)

CHANGSHA PROVINCIAL MUSEUM AND INSTITUTE OF ARCHAEOLOGY. *Ch'ang-sha Ma-wang-tui i hao Han-mu* [*Changsha Mawangdui yi hao Han mu;* Han Tomb No. 1 at Mawangdui, Changsha]. Beijing, 1973

*CHAVANNES, Édouard. *Mission archéologique dans la Chine septentrionale.* 3 vols. Paris: Leroux, 1909–15

————. *La Sculpture en pierre en Chine au temps des deux dynasties Han.* Paris: Leroux, 1893

CHINESE ART SOCIETY OF AMERICA. *Arts of the Han Dynasty.* Exhib. cat. New York, 1961

EBERHARD, Alide, and EBERHARD, Wolfram. *Die Mode der Han- und Chin-Zeit.* Antwerp: De Sikkel, 1946

EGAMI, Namio. *The Beginnings of Japanese Art.* New York: Weatherhill; Tokyo: Heibonsha, 1973

FAIRBANK, Wilma. *Adventures in Retrieval: Han Murals and Shang Bronze Molds.* Cambridge, Mass.: Harvard U. Pr., 1972

HAMADA, Kosaku. *The Tomb of the Painted Basket of Lolang.* Seoul: Chôsens koseki-kenkyu-kwai [Society for Study of Korean Antiquities], 1934

I-nan ku-hua-hsiang-shih-mu fa-chueh pao-kao [*Yi-nan gu hua xiang shi mu fa jue baogao;* Report on the excavations of an ancient tomb at I-nan, Shandong]. Beijing, 1956

JAPAN ARCHAEOLOGISTS ASSOCIATION. *Toro* [Report on excavations of the Toro sites]. Tokyo, 1949

JANSE, Olov R. T. *Archaeological Research in Indo-China.* Cambridge: Harvard U. Pr., vol. 1, 1947; vol. 2, 1951

*KIDDER, Jonathan E., Jr. *Japan Before Buddhism.* 4th rev. ed. New York: Praeger, 1966

————. *The Jomon Pottery of Japan.* Ascona: Artibus Asiae, 1957

————. *Prehistoric Japanese Arts: Jomon Pottery.* Tokyo: Kodansha, 1968

KIM, Chewon, and KIM, Won-yong. *Excavation of Three Silla Tombs. Report of the Research of Antiquities of the National Museum of Korea.* Vol. 2. Seoul, 1955

KIM, Chong-hak. *The Prehistory of Korea.* Richard J. and Kozue Pearson, trans. Honolulu, 1978

KOBAYASHI, Yukio. "La culture préhistorique du Japon." *Cahiers d'histoire mondiale* 4, no. 1; pp. 161–82

————. *Haniwa* [Clay figures]. Tokyo, 1960

LEE, Sherman E. "Early Chinese Painted Shells with Hunting Scenes." *Archives of the Chinese Art Society in America* 11 (1957)

LUBO-LESNICHENKO, Evgenii I. *Ancient Chinese Textiles and Embroideries, V Century* B.C.*–III Century* A.D., *in the Collection of the State Hermitage.* Leningrad, 1961

MIKI, Fujio. *Haniwa.* Gina I. Barnes, trans. New York: Weatherhill, 1974

MIZUNO, Seiichi. *Painting of the Han Dynasty.* Tokyo, 1957

NOMA, Seiroku. *Tsuchi no Eijutsu* [The art of clay]. Tokyo: Bijutsu Shuppansha, 1954

————. "Haniwa." *Oriental Art,* new ser., no. 1 (Spring 1955)

———. *Haniwa*. New York: Asia Soc., 1960
OSAKA MUNICIPAL MUSEUM. *Kan Dai no Bijutsu* [Chinese art of the Han dynasty]. Osaka, 1974
PEARSON, Richard J. *Archaeology of the Ryukyu Islands: . . . 3000 B.C. to the Historic Period*. Honolulu, 1969
PHILIPPI, Donald L., trans. *Kojiki*. Princeton: Princeton U. Pr., 1969
RUDOLPH, Richard, with YU, Wen. *Han Tomb Art of West China*. Berkeley and Los Angeles: U. of Calif. Pr., 1951
SAITO, Tadashi. *Nippon Soshoku Kofun no Kenkyu* [Study of Japanese ancient tombs with mural paintings and ornamental paintings inside]. Tokyo, 1973
*SHUKAN, Asahi. *Chosa Danbo no Kiseki: Yomigaeru Taiko-Fujin no Sekai* [The miracle of a Han tomb excavated at Changsha;

the world of Marquise Dai]. Tokyo, 1972
TANAKA, Sakutaro. *Jodai no Tsubo* [Archaic jars]. Tokyo, 1959
TOKYO NATIONAL MUSEUM. *Nippon Koko-Ten* [Japanese archaeology exhibition documenting development during the past 25 years]. Tokyo, 1969
UMEHARA, Sueji. *Kokyo Zuroku* [Catalogue of ancient mirrors of Kohichi Kurokawa Collection]. Osaka, 1951
URUMCHI, XINJIANG UIGHUR AUTONOMOUS REGION MUSEUM. *Ssu-chou chih lu: Han-T'ang chih-wu* [*Sizhou zhi lu: Han-Tang zhi wu;* Silk Road: Chinese silks from the Han and Tang dynasties]. Beijing, 1972
*WATANABE, Yasutada. *Shinto Art: Ise and Izumo Shrines*. Robert Ricketts, trans. New York: Weatherhill; Tokyo: Heibonsha, 1974

PART TWO

INTERNATIONAL INFLUENCE OF BUDDHIST ART

5. EARLY BUDDHIST ART IN INDIA

ARCHAEOLOGICAL SURVEY OF INDIA. *Archaeological Remains, Monuments and Museums*. 2 vols. New Delhi: 26th Intern. Congr. of Orientalists, 1964
AUBOYER, Jeannine. *The Art of Afghanistan*. Peter Kneebone, trans. London: Feltham, Hamlyn, 1968
BARRETT, Douglas. *A Guide to the Karla Caves*. Bombay: Bhulabai Mem. Inst., 1957
———. *Sculpture from Amaravati in the British Museum*. London, 1954
BARTHOUX, Jules J. *Les Fouilles de Hadda*. Paris: Éditions d'art et d'histoire, 1930
BHATTACHARYYA, Benyotosh. *The Indian Buddhist Iconography, Mainly Based on the Sadhanamala and Cognate Tantric Texts of Rituals*. 2nd ed. Calcutta: Mukhopadhyay, 1958
BUCHTHAL, Hugo. "Foundations for a Chronology of Gandhara Sculpture." *Trans. of the Oriental Ceramic Soc.* (1942–43)
COOMARASWAMY, Ananda K. "The Origin of the Buddha Image." *Art Bull.* (June 1927)
DAVIDS, Caroline A. F. R. *Buddhist Birth-Stories (Jataka Tales)*. New York: Dutton, 1925. Rev. ed. Varanasi, 1973
DEHEJIA, Vidya. *Early Buddhist Rock Temples: a Chronological Study*. Ithaca, N.Y.: Cornell U. Pr., 1972
*DEYDIER, Henri. *Contribution à l'étude de l'art du Gandhâra*. Paris: Adrien-Maisonneuve, 1950
DHAVALIKAR, M. K. *Sanchi: A Cultural Study*. Poona: Deccan College Postgrad. and Research Inst., 1965
FOUCHER, Alfred C. *L'Art gréco-bouddhique du Gandhâra*. 2 vols. Paris: Leroux, 1905–18
———. *The Beginnings of Buddhist Art*. L. A. and F. W. Thomas, trans. Paris: Geuthner, 1918
GAJJAR, Irene N. *Ancient Indian Art and the West*. Bombay: Taraporevala, 1971
GANGOLY, Orun C. *Andra Sculptures*. Hyderabad, 1973
GODARD, A.; GODARD, Y.; and HACKIN, J. *Les Antiquités bouddhiques de Bāmiyān*. Paris and Brussels: Van Oest, 1928
HACKIN, Joseph, with HACKIN, Mme. J. R. *Recherches archéologiques à Begram*. 2 vols. Paris: Éditions d'art et d'histoire, 1939
———, with CARL, J. *Nouvelles Recherches archéologiques à Bamiyan*. Paris: Van Oest, 1933
JOSHI, Nilakanth P. *Mathura Sculptures: A Hand Book to Appre-

ciate Sculptures in the Archaeological Museum, Mathura*. Mathura: Archaeol. Mus., 1966
KAR, Chintamoni. *Classical Indian Sculpture, 300 B.C. to A.D. 500*. London: Tiranti, 1950
*KROM, Nicolaas J. *The Life of Buddha on the Stupa of Barabudar According to the Lalitavistara Text*. The Hague, 1926. Reprint. Varanasi, 1974
KUMAR, Baldev. *The Early Kusanas*. New Delhi: Sterling, 1973
LOHUIZEN-DE LEEUW, Johanna E. van. *The Scythian Period: An Approach to the History, Art, Epigraphy and Palaeography of Northern India from the 1st Century B.C. to the 3rd Century A.D.* Leiden: Brill, 1949
*MARSHALL, Sir John H. *The Buddhist Art of Gandhara*. Cambridge U. Pr., for the Dept. of Archaeology in Pakistan, 1960
*———. *Taxila*. 3 vols. Cambridge U. Pr., 1951
———, and FOUCHER, Alfred. *The Monuments of Sanchi*. 3 vols. London: Probsthain, 1940
MITRA, Debala. *Sanchi (Department of Archaeology, India)*. New Delhi: Dir. Gen. of Archaeology in India, 1958
NATH, Narinder, and SAXENA, J. P. *Archaeological Museum, Sanchi*. New Delhi, 1966
NATIONAL MUSEUM OF PAKISTAN. *Gandhara Sculpture*. Karachi: Dept. of Archaeology, 1956
PARANAVITANA, S. "The Significance of Sinhalese 'Moonstones'." *Artibus Asiae* 17, nos. 3–4 (1954)
RAY, Nihar-Ranjan. *Maurya and Sunga Art*. Calcutta: U. of Calcutta, 1945
REA, Alexander. *South Indian Buddhist Antiquities*. Varanasi: Indological Book House, 1969
*ROSENFIELD, John M. *The Dynastic Arts of the Kushans*. Berkeley and Los Angeles: U. of Calif. Pr., 1967
ROWLAND, Benjamin. *Art in Afghanistan: Objects from the Kabul Museum*. London: Allen Lane, 1971
———. "The Hellenistic Tradition in Northwestern India." *Art Bull.* 31, no. 1 (March 1959)
———. "A Revised Chronology of Gandhara Sculpture." *Art Bull.* 18, no. 3 (September 1936)
SINGH, Sarva D., and SINGH, Sheo B. *The Archaeology of the Lucknow Region*. Lucknow: Paritosh, 1972
SIVARAMAMURTI, Calambur. *Amaravati Sculpture in the Madras Government Museum*. Madras: Gov't. Press, 1942

SMITH, Vincent A. *The Jain Stupa and Other Antiquities of Mathura.* Allahabad: Gov't. Press, 1901

*SOPER, Alexander C. "Recent Studies Involving the Date of Kanishka." *Artibus Asiae* 33, no. 4 (1971) and 34, no. 1 (1972),

STERN, Philippe, and BÉNISTI, Mireille. *Évolution du style indien d'Amaravati.* Paris: P.U.F., 1961

SUBRAMANIAN, K. R. *Buddhist Remains in Andhra and the History of Andhra Between 225 and 610 A.D.* Madras, 1932

THOMAS, Edward J. *The Life of Buddha as Legend and History.* 3rd ed. New York: Barnes and Noble, 1960

6. THE INTERNATIONAL GUPTA STYLE

AGRAWALA, V. S. *Sarnath (Department of Archaeology, India).* 2nd ed. New Delhi, 1957

BANERJI, R. D. "Eastern Indian School of Mediaeval Sculpture." *Archaeological Survey of India,* new imperial ser. 47 (New Delhi, 1933)

BARRETT, Douglas. *A Guide to the Buddhist Caves of Aurangabad.* Bombay, 1957

BHATTACHARYYA, Tarapada. *The Bodhgaya Temple.* Calcutta, 1966

BOWIE, Theodore; DISKUL, M. C. S.; and GRISWOLD, A. B. *The Sculpture of Thailand.* Exhib. cat., Asia House Gallery, New York. New York: Asia Soc., distr. N.Y. Graphic Soc., Greenwich, Conn. 1972

BURGESS, James. *The Rock Temples of Ajanta.* 2nd ed. New York, 1970

CHAND, Emcee, and YIMSIRI, Khien. *Thai Monumental Bronzes.* Bangkok, n.d.

COEDES, George. "L'Art siamois de l'époque de Sukhodaya [13th–14th c.]: circonstances de son éclosion." *Arts asiatiques* 1, no. 4 (1954)

DAS GUPTA, Rajatananda. *Nepalese Miniatures.* Varanasi, 1968

DHAVALIKAR, Madhukar K. *Ajanta: A Cultural Study.* Poona: U. of Poona, 1973

GHOSH, A. *Nalanda (Department of Archaeology, India).* 4th ed. New Delhi, 1959

GRISWOLD, Alexander B. "The Buddhas of Sukhodaya." *Archives of the Chinese Art Soc. of America* 7 (1953)

————. *Dated Buddha Images of Northern Siam.* Ascona: Artibus Asiae, 1957

————. "A New Evidence for the Dating of Sukhodaya Art." *Artibus Asiae* 19, nos. 3–4 (1956)

*HARLE, James C. *Gupta Sculpture: Indian Sculpture of the Fourth to Sixth Centuries A.D.* Oxford U. Pr., 1974

HUNTINGTON, Susan L. *The Origin and Development of Sculpture in Bihar and Bengal, ca. Eighth–Twelfth Centuries.* Ann Arbor, 1972

*INDIANA UNIVERSITY, BLOOMINGTON. *The Arts of Thailand; a Handbook of the Architecture, Sculpture, and Painting of Thailand (Siam) and a Catalogue of the Exhibition in the United States in 1960–61–62.* Bloomington, c. 1960

KAK, Ram Ch. *Ancient Monuments of Kashmir.* London, 1933

KROM, Nicolaas J. *Barabudur: Archaeological Description.* The Hague, 1927

LE MAY, Reginald. *A Concise History of Buddhist Art in Siam.* Cambridge U. Pr., 1938. Reprint. Rutland, Vt., and Tokyo: Tuttle, 1962

————. "The Chronology of Northern Siamese Buddha Images." *Oriental Art* 1, no. 1 (Spring 1955)

LUCE, Gordon H. *Old Burma—Early Pagan. Artibus Asiae,* Suppl. 25, (Locust Valley, N.Y., 1969)

MALLERET, Louis. *L'Archéologie du Delta du Mékong.* Paris, 1962

MITRA, Debala. *Ajanta (Department of Archaeology, India).* 2nd ed. New Delhi, 1958

MODE, Heinz. *Die Skulptur Ceylons.* Basel, 1942

*MUS, Paul. *Barabudur.* Hanoi, 1935

PAL, Pratapaditya. *Bronzes of Kashmir.* New York: Hacker, 1975

————. *The Ideal Image: Gupta Sculptural Tradition and Its Influence.* Exhib. cat., Asia House Gallery, New York. New York: Asia Soc., 1978

————. *Nepal: Where the Gods Are Young.* Exhib. cat., Asia House Gallery, New York. New York: Asia Soc./Weatherhill, 1975

PALLIS, Marco. *Peaks and Lamas.* London and Toronto: Cassell, 1939

PARANAVITANA, S. *Art and Architecture of Ceylon, Polonnaruva Period.* Colombo(?), 1954

PHAYRE, Arthur P. *History of Burma.* 2nd ed. London, 1967

RAY, Amita. *Art of Nepal.* New Delhi: Indian Council for Cult. Rel., 1973

SAHNI, Daya R. *Guide to the Buddhist Ruins of Sarnath.* 3rd ed. Simla, 1923

SINGH, Madanjeet. *India: Paintings from Ajanta Caves.* New York: N.Y. Graphic Soc., 1954

*SPINK, Walter M. "Ajanta to Ellora." *Marg* 20, no. 2 (1967)

VICTORIA AND ALBERT MUSEUM. *Burmese Art.* By John Lowry. London: HMSO, 1974

*YAZDANI, Ghulam, et al. *Ajanta.* 4 vols. Oxford, 1931–55

7. THE EXPANSION OF BUDDHIST ART TO EAST ASIA

Ancient Buddhist Art in Central Asia and Tun-huang. Kyoto, 1962

ANESAKI, Masaharu. *Buddhist Art in Its Relation to Buddhist Ideals with Special Reference to Buddhism in Japan.* Boston: Houghton Mifflin, 1915

BEAL, Samuel. *Chinese Accounts of India,* trans. from the Chinese of Hiuen Tsiang. 4 vols. Calcutta: Susil Gupta, 1957–58

————, trans. *Travels of Fah-Hian and Sung-Yun: Buddhist Pilgrims from China to India.* London, 1869. Reprint. Trübner, 1964

BULLING, A. "Buddhist Temples in the T'ang Period." *Oriental Art* 2 (Summer 1955) and 3 (Autumn 1955)

CHENG, Chen-to [Zheng, Zhenduo]. *Mai-chi-shan shih-k'u [Maiji Shan shi ku;* The stone grottoes of Maiji Shan, "Wheatstack Hill"]. Beijing, 1954

DAVIDSON, LeRoy. *The Lotus Sutra in Chinese Art.* New Haven, 1954

DYAKONOVA, N. V., and SOROKIN, S. S. *Khotan Antiquities: Catalogue of Khotan Antiquities . . . in the Hermitage—Terracotta and Stucco.* Leningrad, 1960

GABBERT, Gunhild. *Die Masken des Bugaku: Profane japanische Tanzmasken der Heian und Kamakura Zeit.* 2 vols. Wiesbaden, 1972

GOODWIN, Janet R. *The Worship of Miroku in Japan.* Berkeley, 1977

GORDON, Antoinette K. *The Iconography of Tibetan Lamaism.* 2nd rev. ed. New York: Columbia U. Pr., 1959

*GRAY, Basil, and VINCENT, J. B. *Buddhist Cave-Paintings at Tun-huang.* London: Faber, 1959

HAKEDA, Yoshita S. *Kukai: Major Works.* New York: Columbia U. Pr., 1972

HENDERSON, Gregory, and HURVITZ, Leon. "The Buddha of Seiryo-ji—New Finds and New Theory." *Artibus Asiae* 19, no. 1 (1956)

HWANG, Su-young. *Kankoku butsuzo no kenkyu* [Studies of Korean Buddhist images]. Kyoto, 1978

KLEINSCHMIDT, Peter. *Die Masken der Gigaku, der ältesten Theaterform Japans.* Wiesbaden, 1966

KOBAYASHI, Takeshi. *Nara Buddhist Art, Todai-ji.* Richard L. Gage, trans. Tokyo: Heibonsha; New York: Weatherhill, 1975

KUMATANI, Norio. *Central Asian Painting*. Tokyo, 1957?

Kung-hsien shih-k'u-ssu [*Gong Xian shi ku si;* Buddhist cave-temple in Gong Xian]. Ed. Art and Archaeological Work Team, Henan Cultural Dept. Beijing, 1963

Lung-men shih-k'u [*Longmen shi ku;* Stone caves at Longmen]. Ed. Longmen Administration. Beijing, 1961

MATSUBARA, Saburo. *Chugoku Bukkyo Chokoku shi Kenkyu* [Chinese Buddhist sculpture]. 2nd rev. ed. Tokyo, 1966

MIZUNO, Seiichi. *Asuka Buddhist Art, Horyu-ji*. Richard L. Gage, trans. Tokyo: Heibonsha; New York: Weatherhill, 1974

*———. *Chinese Stone Sculpture*. Tokyo: Mayuyama, 1950

———, and NAGAHIRO, Toshio. *The Buddhist Cave Temples of Hsiang-t'ang-ssu*. Kyoto: Acad. Oriental Culture, 1937

———. *Ryumon Sekkutsu no Kenkyu* [A study of the Buddhist cave-temples at Longmen]. Tokyo: Zauho Pr., 1941

MUNSTERBERG, Hugo. "Buddhist Bronzes of the Six Dynasties Period." *Artibus Asiae* 9, no. 4 (1946), and 10, no. 1 (1947)

NAGAHIRO, Toshio. "Wei-ch'ih I-seng." *Oriental Art* 1, no. 2 (Summer 1955)

*NAITO, Toichiro. *The Wall Paintings of Horyu-ji*. William R. B. Acker and Benjamin Rowland, Jr., eds. Baltimore: Waverly Pr., 1943

NARA NATIONAL MUSEUM. *Asuka no Sembutsu to Sozo* [Baked clay reliefs and clay statues of the Asuka area]. Nara, 1976

NATORI, Younosuke. *Mai-chi-shan Sekkutsu* [Maiji Shan caves]. Tokyo: Iwanami 1957

PAN, Chieh-tze [Ban, Jieze]. *Tun-huang mo-kai-k'u i-shu* [*Dunhuang mo gai ku yi shu;* The art of the caves at Dunhuang]. Shanghai, 1957

PELLIOT, Paul. *Les Grottes de Touen-Houang*. 6 vols. Paris: Geuthner, 1914–24

PRIEST, Alan. *Chinese Sculpture in the Metropolitan Museum*. New York: Metropolitan Mus. of Art, 1944

*ROWLAND, Benjamin. *The Wall Paintings of India, Central Asia and Ceylon*. Boston: Merrymount Pr., 1938

———. "The Colossal Buddhas at Bamiyan." *Journal of Indian Soc. of Oriental Art* 15 (1947)

———. "Indian Images in Chinese Sculpture." *Artibus Asiae* 10, no. 1 (1947)

SEKINO, Tadashi, and TAKEJIMA, T. *Ryo Kin Jidai no Kenchiku to Butsuzo* [Buddhist architecture and sculpture of the Liao and Jin dynasties]. 2 vols. Tokyo, 1934

SIRÉN, Osvald. "Chinese Marble Sculptures of the Transition Period." *Bull. of Mus. of Far Eastern Antiq.* 12 (1940)

———, ed. *Chinese Sculpture in the Van der Heydt Collection*. Zurich, 1959

SOPER, Alexander C. *Literary Evidence for Early Buddhist Art in China*. Ascona: Artibus Asiae, 1959

———. "Northern Liang and Northern Wei in Kansu." *Artibus Asiae* 21, no. 2 (1958)

———. "Notes on Horyuji and the Sculpture of the Suiko Period." *Art Bull.* 33, no. 2 (June 1951)

*STEIN, Sir Mark Aurel. *Innermost Asia*. 3 vols. Oxford U. Pr., 1928

———. *Ruins of Desert Cathay*. 2 vols. London: Macmillan, 1912

*———. *Serindia*. 4 vols. Oxford U. Pr., 1921

*SULLIVAN, Michael. *The Cave Temples of Maichishan*. Berkeley: U. of Calif. Pr., 1969

TANAKA, Ichimatsu. *Horyuji Heki-gwa* [Wall paintings of Horyu-ji]. Tokyo, 1958

TOKIWA, Daijo, and SEKINO, Tadashi. *Shina Bukkyo Shiseki Tosaki* [Buddhist monuments in China]. 6 vols. Tokyo: Bukkyo-Shiseki Kenkyu-kwai, 1925–38

TOKYO NATIONAL MUSEUM. *Horyu-ji Kenno Homotsu* [Illus. cat.: Former imperial treasures from Horyu-ji]. Tokyo, 1975

———. *Horyu-ji Kenno Homotsu Mokuroku* [Treasures originally from Horyu-ji]. Tokyo, 1959

TSANG, Shu-hung [Zang, Shuhong]. *Wall Painting of Tun-huang*. Tokyo, 1958

TUCCI, Giuseppe. *The Religions of Tibet*. Geoffrey Samuel, trans. Berkeley: U. of Calif. Pr., 1980

Tun-huang i-shu hua-k'u [*Dunhuang yi shu hua ku;* Dunhuang art collection]. 13+ vols. Beijing, 1958–

Tun-huang pi-hua-chi [*Dunhuang bihua ji;* Wall paintings of Dunhuang]. Beijing, 1959

Tun-huang pi-hua hsüan [*Duahuang bihua xuan;* Wall paintings of Dunhuang]. 3 vols. Beijing, 1952–54

TUN-HUANG RESEARCH INSTITUTE. *Tun-huang ts'ai-su* [*Dunhuang cai su;* Polychrome sculptures at Dunhuang]. Beijing, 1960

UEHARA, Hotaro, ed. *Shin Seiiki-ki* [A new record of the western region and the countries bordering on western China. Otani Expedition]. 2 vols. Tokyo, 1937

WARNER, Langdon. *Japanese Sculpture of the Suiko Period*. New Haven: Yale U. Pr., 1923

———. *Japanese Sculpture of the Tempyo Period, Masterpieces of the Eighth Century*. James M. Plumer, ed. Cambridge, Mass.: Harvard U. Pr., 1964

WECHSLER, Howard J. *Mirror to the Son of Heaven: Wei Cheng at the Court of T'ang T'ai-tsung*. New Haven and London: Yale U. Pr., 1974

WEINSTEIN, Lucie R. *The Horyu-ji Canopies and Their Continental Antecedents*. New Haven, 1978

WHITE, William C. *Chinese Temple Frescoes*. Toronto, 1940

Yun-kang, the Buddhist Cave-Temples of the Fifth Century A.D. in North China; Report of . . . Survey . . . by Mission of Tohobunka Kenkyusho, 1938–45. Text by Seiichi Mizuno and Toshio Nagahiro. 16 vols. Kyoto, 1952–56

ZÜRCHER, E. *The Buddhist Conquest of China: The Spread and Adaptation of Buddhism in Early Medieval China*. 2 vols. Leiden: Brill, 1959

PART THREE

THE RISE OF NATIONAL INDIAN AND INDONESIAN STYLES

8. EARLY HINDU ART IN INDIA

*BANERJEA, Jitendra N. *The Development of Hindu Iconography*. 2nd ed. Calcutta: U. of Calcutta, 1956

BRUHN, Klaus. *The Jina-Images of Deogarh*. Leiden, 1969

CHANDRA, Pramod. *A Guide to the Elephanta Caves (Gharapuri)*. Bombay: Tripathi, 1964

DESAI, Madhuri. *The Gupta Temple at Deogarh*. Bombay: Bhulabhai Mem. Inst., 1958

GONDA, Jan. *Visnuism and Sivaism: a Comparison*. New Delhi, 1976. Distr. Intl. Pubns. Serv.

GUPTE, Ramesh S. *The Art and Architecture of Aihole; A Study of*

Early Chalukyan Art Through Temple Architecture and Sculpture. Bombay, 1967

*NEFF, Muriel. "Elephanta: Architecture, Sculpture." *Marg* 13 (September 1960)

*RAO GOPINATHA, T. A. *Elements of Hindu Iconography.* Madras: Law Printing House, 1914–16

RAWSON, Philip. "The Methods of Indian Sculpture." *Oriental Art* 4, no. 4 (Winter 1958)

SIVARAMAMURTI, Calambur. "Geographical and Chronological Factors in Indian Iconography." *Ancient India* 6 (January 1950)

TARTAKOV, Gary M. "The Beginning of Dravidian Temple Architecture in Stone." *Artibus Asiae* 42, no. 1 (1980)

9. EARLY MEDIEVAL HINDU ART: THE SOUTHERN STYLES

BALASUBRAHMANYAM, S. R. *Early Chola Art.* Part I. Bombay and New York: Asia Publ. House, 1966

——. *Early Chola Temples.* Part II. Bombay: Orient Longman, 1971

——. *Middle Chola Temples.* Part III. Faridabad: Thomson Pr., 1975

*BARRETT, Douglas. *Early Chola Architecture and Sculpture.* London: Faber, 1974

*——. *Early Chola Bronzes.* Bombay: Bhulabhai Mem. Inst., 1965

——. *Hemavati.* Bombay: Bhulabhai Mem. Inst., 1958

——. *Mukhalingam Temples.* Bombay: Tripathi, 1960

——. *The Temple of Virattanesvara at Tiruttani.* Bombay: Bhulabhai Mem. Inst., 1958

——. *Ter.* Bombay: Bhulabhai Mem. Inst., 1960

COOMARASWAMY, Ananda K. *Bronzes from Ceylon.* Ceylon: Colombo Mus., 1914

GANGOLY, Ordhendra C. *South Indian Bronzes.* London: Luzac, 1915

GOPALAKRISHNA MURTHY, Sreepada. *The Sculpture of the Kakatiyas.* Hyderabad, 1964

*GRAVELY, F. H., and RAMACHANDRAN, T. N. "Catalog of the South Indian Hindu Metal Images in the Madras Government Museum." *Madras Mus. Bull.* 2, no. 1 (1932)

HARI RAO, V. N. *The Srirangam Temple: Art and Architecture.* Tirupata: Sri Venkateswara Univ., 1967

JOUVEAU-DUBREUIL, Gabriel. *Archéologie du sud de l'Inde.* Paris: Geuthner, 1914

*——. *Iconography of Southern India.* A. C. Martin, trans. Paris: Geuthner, 1937

*KAR, Chintamoni. *Indian Metal Sculpture.* London: Tiranti, 1952

NAGASWAMI, R. *The Art of Tamilnadu.* Tamilnadu, 1972

NATARAMAN, B. *The City of the Cosmic Dance: Chidambaram.* New Delhi: Orient Longman, 1974

PATTABIRAMIN, P. Z. *Andhra.* Pondicherry: Inst. français d'indologie, 1971

PILLAY, K. K. *The Sucindram Temple.* Madras: Kalakshetra Publ., 1953

RAMA RAO, M. *Early Calukyan Temples of Andhra Desa.* Hyderabad: Gov't. of Andhra Pradesh, 1965

——. *Select Andhra Temples.* Hyderabad: Gov't. of Andhra Pradesh, 1970

REA, Alexander. *Chalukyan Architecture.* Madras, 1896. Reprint. New Delhi: Indological Book House, 1970

SHERWANI, Haroon K., and JOSHI, P. M., eds. *History of Medieval Deccan, 1295–1724.* 2 vols. Hyderabad: Gov't. of Andhra Pradesh, 1973

SIVARAMAMURTI, C. *Indian Bronzes.* Bombay: Marg Publ., 1962

——. *Kalugumalai and Early Pandyan Rock-cut Shrines.* Bombay: Tripathi, 1961

——. *Mahabalipuram [Mahamallapuram] (Dept. of Archaeology, India).* 2nd ed. New Delhi: Mgr. of Publ., 1955

——. *South Indian Paintings.* New Delhi: Nat. Mus., 1968

SRINIVASAN, K. R. *Cave Temples of the Pallavas.* New Delhi, 1964

THAPAR, D. R. *Icons in Bronze: An Introduction to Indian Metal Images.* New York: Asia Publ. House, 1961

10. LATER MEDIEVAL HINDU ART

ANDHARE, S. K. *Bundi Painting.* New Delhi, 1973

ARCHER, William G. *Central Indian Painting.* London: Faber, 1958

——. *Garhwal Painting.* London: Faber, 1954

——. *The Hill of Flutes; Life, Love, and Poetry in Tribal India: a Portrait of the Santals.* London: Allen and Unwin; Pittsburgh: U. of Pittsburgh Pr., 1974

*——. *Indian Miniatures.* Greenwich, Conn.: N.Y. Graphic Soc., 1960

——. *Indian Painting.* London: Batsford; New York: Oxford U. Pr., 1957

——. *Indian Painting in Bundi and Kotah.* London: HMSO, 1959

*——. *Indian Painting in the Punjab Hills.* London: HMSO, 1952

*——. *Indian Paintings from the Punjab Hills.* 2 vols. London and New York: Sotheby's, 1973

——. *Indian Paintings from Rajasthan.* London, 1957

——. *Kangra Painting.* 2nd ed. London: Faber, 1956

——. *The Loves of Krishna in Indian Painting and Poetry.* New York: Macmillan, 1957

*——. *Pahari Miniatures: A Concise History.* Bombay, 1975

——. *Visions of Courtly India: The Archer Coll. of Pahari Miniatures.* Washington, D.C.: Intern. Exhib. Found., 1976.

——, and RANDHAWA, M. S. "Some Nurpur Paintings." *Marg* 8 (1955)

ARTS COUNCIL OF GREAT BRITAIN. *Tantra.* Exhib. cat., Hayward Gallery. London, 1971

BABAR. *Memoirs of Babar, Emperor of India: First of the Great Moghuls.* Abbr. vers. London: Humphreys, 1909

BANERJI, Adris. *Archaeological History of Southeastern Rajasthan.* Varanasi: Prithivi, 1971

——. "Illustrations to the Rasikapriya from Bundi-Kotah." *Lalit Kala* (1956–57)

——. "Kishengarh Historical Portraits." *Roopa-Lekha* 25 (1954)

——. "Kishengarh Paintings." *Roopa-Lekha* 25 (1954)

——. "Malwa School of Paintings." *Roopa-Lekha* 26 (1955)

——. "Mewar Miniatures." *Roopa-Lekha* 30 (1959)

BANERJI, Rakhal D. *The Palas of Bengal.* New Delhi, 1973

BARRETT, Douglas. *Painting of the Deccan, XVI–XVII Century.* London: Faber, 1958

BHATTACHARYA, Asok K. *Technique of Indian Painting: a Study Chiefly Made on the Basis of the Silpa Texts.* Calcutta: Saraswat Lib., 1976

BHATTACHARYA, Bholanath. *Krishna in the Traditional Painting of Bengal.* Calcutta: Banerjee, 1972

BINNEY, Edwin, 3rd. *Indian Miniature Painting from the Collection of Edwin Binney, 3rd.* Portland (Oregon) Art Mus., 1973

BONER, Alice, trans. *New Light on the Sun Temple of Konarka.* Varanasi: Chowkhamba Sanskrit Series, 1972

BURGESS, James. *Report on the Elura Cave Temples and the Brahmanical and Jaina Caves in Western India . . . the Fifth, Sixth and Seventh Seasons . . . of the Archeol. Survey, 1877–80.* Varanasi: Indological Book House, 1970

——. *The Rock Temples of Elura or Verul.* Bombay: Thacker, 1977

*CHANDRA, Moti. *Mewar Painting*. New Delhi, 1957
———. *Mewar Painting: In the Seventeenth Century*. Lalit Kala, 1957
*———. *Studies in Early Indian Painting*. New York: Asia Publ. House, 1974
———. "Amaru-Sataka." *Bull. of the Prince of Wales Mus.* 1, no. 2
———. "The Paintings of Bundi." *Western Railway Annual*. Bombay, 1953
———, and SHAH, Umakant P. *Documents of Jaina Painting*. Bombay, 1975
CHANDRA, Pramod. *Bundi Painting*. New Delhi: Lalit Kala, 1959
*———. *The Cleveland Tuti-nama Manuscript and the Origins of Mughal Painting*. Cleveland Mus. of Art, 1976
———. "A Ragamala Set of the Mewar School in the National Museum of India." *Lalit Kala* (1956–57)
COOMARASWAMY, Ananda K. *Catalogue of the Indian Collections in the Museum of Fine Arts, Boston: Part V, Rajput Painting*. Cambridge, Mass., 1926
*———. *Rajput Painting*. London and New York: Oxford U. Pr., 1916
CROWE, Sylvia; HAYWOOD, Sheila; JELLICOE, Susan; et al. *Gardens of Mughal India*. London: Thames and Hudson, 1972
DAS, Sudhir R. *Archaeological Discoveries from Mursidabad Dist., West Bengal*. Vol. 1. Calcutta: Asiatic Soc., 1971–
DAS GUPTA, Rajatananda. *Eastern Indian Manuscript Painting*. Bombay: Taraporevala, 1972
DEVA, Krishna. *Khajuraho*. New Delhi: Archaeol. Surv. of India, 1967
DEVAKUNJARI, D. *Hampi*. New Delhi: Archaeol. Surv. of India, 1970
DICKINSON, Eric, and KHANDALAVALA, Karl. *Kishangarh Paintings*. New Delhi: Lalit Kala, 1959
EASTMAN, Alvan C. *The Nala-Damayanti Drawings: a Study of a Portfolio of Drawings Made for Raja Samsar Cand of Kangra (1774–1823) . . . now in the Museum of Fine Arts, Boston*. Boston: Mus. of Fine Arts, 1959
EBELING, Klaus. *Ragamala Painting*. Basel: Ravi Kumar, 1973
FABRI, Charles L. *History of the Art of Orissa*. Bombay: Orient Longmans, 1974
GANGOLY, Ordhendra C. *Critical Catalogue of Miniature Paintings in the Baroda Museum*. Baroda: Mankad, 1961
———. "Garhwal Painting." *Marg* 8 (1955)
GHOSE, Ajit. "The Basohli School of Rajput Painting." *Rupam* (January 1929)
GHOSH, A., ed. *Jaina Art and Architecture*. 3 vols. New Delhi: Bharatiya Jnanpith, 1974–75
GLÜCK, Heinrich. *Die Indischen Miniaturen des Haemzae-Romanes. . . .* Zurich, etc.: Amalthea, 1925
GOETZ, Hermann. "The First Golden Age of Udaipur: Rajput Art in Mewar During the Period of Mughal Supremacy." *Ars Orientalis* 2 (1957)
———. "The Kachhwaha School of Rajput Painting." *Bull. of Baroda State Mus.* 4 (1946–47)
———. "The Marwar School of Rajput Painting." *Bull. of Baroda State Mus.* 5 (1947–48)
GOSWAMY, B. N. *Painters in the Sikh Court*. Wiesbaden, 1975
*GRAY, Basil. "Painting." *The Art of India and Pakistan*. Exhib. cat., Royal Acad. of Arts, London. Leigh Ashton, ed. London: Faber, 1950
———. *Rajput Painting*. New York: Pitman, 1949
———. *Treasures of Indian Miniatures in the Bikaner Palace Collection*. 2nd ed. Oxford: Cassirer, 1955
HAMBLY, Gavin. *Cities of Mughal India*. New York: Putnam, 1968
Hamza-Nama. 3 vols. Graz, 1974–

HARLE, James C. *The Brahmapurisvara Temple at Pullamangai*. Bombay: Bhulabhai Mem. Inst., 1958
JOSHI, M. C. *Dig*. New Delhi, 1968
KAUFMANN, Walter. *The Ragas of North India*. Bloomington and London: Indian U. Pr. for Intern. Affairs Ctr., 1968
*KHANDALAVALA, Karl. J. "An Aniruddha-Usha Series from Chamba and the Painter Ram Lal." *Lalit Kala* (1955–56)
———. "Leaves from Rajasthan." *Marg* 4 (1951)
———. *Pahari Miniature Painting*. Bombay: New Book Co., 1958
———. "The Rasamanjari in Basohli Painting." *Lalit Kala* (1956–57)
———, and CHANDRA, Moti. *New Documents of Indian Painting: A Reappraisal*. Bombay: Prince of Wales Mus. of West. India, 1969
*———; GANGOLY, Ordhendra C.; CHANDRA, Pramod; GOETZ, Hermann: CHANDRA, Moti; DICKINSON, Eric; ARCHER, William G.; et al. "Problems of Rajasthani Painting" and "General Survey of Rajasthani Styles." *Marg* 11 (1958)
———, and STOOKE, H. *The Laud Ragamala Miniatures*. Oxford: Cassirer, 1953
KRAMRISCH, Stella. "The Image of Mahadeva in the Cave-Temple on Elephanta Island." *Ancient India* 2 (July 1946)
KRISHNA, Anand. *Malwa Painting*. Varanasi, Bharat Kala Bhavan: Banaras Hindu Univ., 1968
KRISHNADASA, Rai. *Mughal Miniatures*. New Delhi: Lalit Kala, 1955
KUHNEL, Ernst. *Moghul-malerei*. Berlin, 1955
KURAISHI, Mohammad Hamid. *Rajgir (Dept. of Archaeology, India)*. 5th ed. Rev. by A. Ghosh. New Delhi: Dir. Gen. of Archaeol. India, 1958
LAL, Kanwar. *Temples and Sculptures of Bhubaneswar*. Delhi: Arts and Letters, 1970
LEE, Sherman E. *Rajput Painting*. Exhib. cat., Asia House Gallery, New York. New York: Asia Soc., 1960
MAJUMDAR, Manjulal R. *Gujarat; Its Art Heritage*. Bombay: U. of Bombay, 1968
MAJUMDAR, Ramesh C., ed. *Hindu Period. The History of Bengal*. Vol. 1. Lohanipur, 1971
MITRA, Debala. *Bhubaneswar (Dept. of Archaeology, India)*. New Delhi: Dir. Gen. of Archaeol. India, 1958
———. *Konarak*. New Delhi: Archaeol. Surv. of India, 1968
MITTAL, Jagdish. "An Illustrated Manuscript of Madhu-Malati and Other Paintings from Kulu." *Lalit Kala* (1956–57)
MODE, H. A., ed. *Calcutta*. Bombay: Taraporevala, 1973
NAGASWAMI, R. *The Kailasanatha Temple: a Guide*. Tamilnadu: Madras State Dept. of Archaeol., 1969
PAL, Pratapaditya. *Krishna: the Cowherd King*. Los Angeles: L. A. County Mus. of Art, 1972
PATIL, D. R. *Mandu*. New Delhi: Archaeol. Surv. of India, 1971
PINDER-WILSON, Ralph H. *Paintings from the Muslim Courts of India*. London: World of Islam, 1976
PRASAD, Ishwari. *The Mughal Empire*. Allahabad: Chugh, 1974
*RANDHAWA, M[ohindar] S. *Basohli Painting*. New Delhi: Ministry of Information and Broadcasting, 1959
———. "Kangra Artists." *Roopa-Lekha* 27 (1956)
———. "Kangra Paintings Illustrating the Life of Shiva and Parvati." *Roopa-Lekha* 24 (1953)
———. "Kangra Ragamala Painting." *Roopa-Lekha* 29 (1958)
———. *Kangra Ragamala Paintings*. New Delhi, 1971
*———. *Kangra Valley Painting*. Rev. ed. Delhi: Ministry of Information and Broadcasting, 1972
———. *The Krishna Legend in Pahari Painting*. New Delhi: Lalit Kala, 1956

———. "Paintings from Nalagarh." *Lalit Kala* (1955–56)

———. "Some Inscribed Pahari Paintings with Names of Artists." *Roopa-Lekha* 30 (1959)

RAY, Nihar-Ranjan. *Mughal Court Painting: A Study in Social and Formal Analysis.* Calcutta: Indian Mus., 1975

REIFF, Robert. *Indian Miniatures: the Rajput Painters.* Tokyo and Rutland, Vt.: Tuttle, 1959

RIZVI, Saiyid A. A., and FLYNN, Vincent J. A. *Fathpur-Sikri.* Bombay, 1975

SARASVATI, Sarasi K. *Eighteenth Century North Indian Painting.* Calcutta: Pilgrim, 1969

SEN GUPTA, R. *A Guide to the Buddhist Caves of Elura.* Bombay: Bhulabhai Mem. Inst., 1958

SHAH, Umakant P. *Akota Bronzes.* Bombay: Dept. of Archaeol., 1959

SHARMA, Brijendra N. *Social and Cultural History of Northern India, c. 1000–1200 A.D.* New Delhi: Abhinav Publ., 1972

SHARMA, Y. D. *Delhi and Its Neighborhood.* 2nd ed. New Delhi: Archaeol. Surv. of India, 1974

SHIVESHWARKAR, Leela. *The Pictures of the Chaurapanchasika. A Sanskrit Love Lyric.* New Delhi: Nat. Mus., 1967

SINHA, Rajeshwar P. *Geeta Govind in Basohli School of Indian Painting.* New Delhi and Calcutta: Oxford Book, 1958

SKELTON, Robert. *Indian Miniatures from the XVth to XIXth Centuries.* Exhib. cat., San Giorgio Maggiore. Venice, 1961

———. "The Tod Collection of Rajasthani Paintings." *Roopa-Lekha* 30 (1959)

SMITH, Vincent A. *Akbar the Great Mogul, 1542–1605.* 3rd ed. rev. Oxford U. Pr., 1926

SPINK, Walter M. *The Quest for Krishna: Painting and Poetry of the Krishna Legend.* Ann Arbor, Mich., 1972

STAUDE, Wilhelm. "Les Artistes de la cour d'Akbar et les illustrations du Dastan i-Amir Hamzah." *Arts Asiatiques* 2, nos. 1/2 (1955)

UNIVERSITY OF MICHIGAN. *Krishnamandala: A Devotional Theme in Indian Art.* Text by Walter M. Spink. Exhib. cat. Ann Arbor, 1971

VICTORIA AND ALBERT MUSEUM. *Art & the East India Trade.* Exhib. cat. London, 1970

VIDYA, Prakash. *Khajuraho: A Study in the Cultural Conditions of Chandella Society.* Bombay: Taraporevala, 1967

WELCH, Stuart C. *The Art of Mughal India: Painting & Precious Objects.* Exhib. cat., Asia House Gallery, New York. New York: Asia Soc., 1963; distr. Abrams, New York

———. *A Flower from Every Meadow: Indian Paintings from American Collections.* New York: Asia Soc., 1973; distr. N.Y. Graphic Soc., Greenwich, Conn.

———. *Indian Drawings and Painted Sketches: 16th Through 19th Centuries.* Exhib. cat., Asia House Gallery, New York. New York: Asia Soc./Weatherhill, 1976

———, and BEACH, M. C. *Gods, Thrones, and Peacocks.* Exhib. cat., Asia House Gallery, New York. New York: Asia Soc., 1965; distr. Abrams, New York

ZANNAS, Eliky. *Khajuraho.* The Hague, 1960

11. THE MEDIEVAL ART OF SOUTHEAST ASIA AND INDONESIA

BAZACIER, Louis. *Le Viet-Nam. De la préhistoire à la fin de l'occupation chinoise.* Paris: Picard, 1972

BÉNISTI, Mireille. *Rapports entre le premier art khmer et l'art indien.* Paris: École fr. d'extrême Orient, 1970

*BRIGGS, Lawrence P. *The Ancient Khmer Empire.* Philadelphia: Am. Philos. Soc., 1951

CORAL RÉMUSAT, Gilberte de. *L'art khmer: les grandes étapes de son évolution.* Paris: Éditions d'art et d'histoire, 1940

DUMARÇAY, Jacques. *Borobudur.* Michael Smithies, trans. Kuala Lumpur: Oxford U. Pr., 1978

DUPONT, Pierre. *La statuaire pré-angkorienne.* Ascona: Artibus Asiae, 1955

FONTEIN, Jan; SOEKMONO, R; and SULEIMAN, Satyawati. *Ancient Indonesian Art of the Central and Eastern Javanese Periods.* New York: Asia Soc., 1971; distr. N.Y. Graphic Soc., Greewich, Conn.

*GITEAU, M. *Khmer Sculpture and the Angkor Civilization.* London: Thames and Hudson, 1965; New York: Abrams, 1966

GROSLIER, Bernard, and ARTHAUD, Jacques. *Angkor: Art and Civilization.* Rev. ed. New York: Praeger, 1966

LE BONHEUR, Albert. *La sculpture indonésienne au Musée Guimet.* Paris, 1971

LONG, Ly K. *An Outline of Cambodian Architecture.* Varanasi, 1976

O'CONNOR, Stanley J. *Hindu Gods of Peninsular Siam.* Artibus Asiae, Suppl. 27 (Ascona, 1972)

*STERN, Philippe. "Le Bayon d'Angkor et l'évolution de l'art khmèr." *Annales du Musée Guimet.* Paris: Geuthner, 1927

———. *Les monuments khmèrs du style du Bayon et Jayavarman VII.* Paris: P.U.F., 1965

PART FOUR

CHINESE AND JAPANESE NATIONAL STYLES AND THE INTERPLAY OF CHINESE AND JAPANESE ART

12. THE RISE OF THE ARTS OF PAINTING AND CERAMICS IN CHINA

*ACKER, William R. *Some T'ang and Pre-T'ang Texts on Chinese Painting.* Leiden: Brill, 1954

CHANG, Wan-li [Zhang, Wanli], ed. *T'ang san-ts'ai yu-t'ao* [*Tang san cai you tao;* Three-color pottery of the Tang dynasty]. Hong Kong, 1977

CH'EN, Wan-li [Chen, Wanli], and FENG, Hsien-ming [Feng, Xianming]. "Ku-kung-po-wu-yüan shih-nien-lai tui ku-yao-chih te t'iao-ch'a" [Gu gong bowu yuan shi nian lai dui gu yao zhi de tiao cha; Investigations of early ceramic kiln sites by the Palace Museum from 1949 to 1959]. *Ku-kung-po-wu-yüan yuan-k'an* [*Gu gong bowu yuan yuan kan*] 2 (1960)

CHIN, Tsu-ming. *Yueh Ware Kiln Sites in Chekiang.* London, 1976

Chuka Jimmin Kyowakoku Kan-To Hekiga ten [Exhibition of wall paintings of the Chinese Han through Tang dynasties]. Tokyo, 1975

FONTEIN, Jan, and WU, Tung. *Han and T'ang Murals Discovered in Tombs in the People's Republic of China and Copied by Contem-*

porary Chinese Painters. Boston, 1976

GOMPERTZ, G. St. G. M. "Some Notes on Yueh Ware." Oriental Art 2, no. 1 (Spring 1956) and no. 3 (Autumn 1956)

GRAY, Basil. Early Chinese Pottery and Porcelain. London: Faber, 1953

GYLLENSVÄRD, Bo. "T'ang Gold and Silver." Bull. of the Mus. of Far Eastern Antiq. 29 (1957)

*HARADA, Jiro. English Catalog of Treasures in the Imperial Repository Shosoin. Tokyo, 1932

HAYASHI, Ryoichi. The Silk Road and the Shoso-in. Robert Ricketts, trans. New York: Weatherhill; Tokyo: Heibonsha, 1975

HENTZE, Carl. Chinese Tomb Figures. London: Goldston, 1928

Ho, Lo-chih [He, Luozhi]. Wang Wei. Shanghai, 1959

JULIANO, Annette. Art of the Six Dynasties: Centuries of Change and Innovation. Exhib. cat., China House Gallery, New York. New York: China Inst. in Am., 1975

——. Teng-hsien: An Important Six Dynasties Tomb. Artibus Asiae, Suppl. 37 (Ascona, 1980)

KIUCHI, Takeo, et al. Shoso-in no Mokko [Woodwork objects in the Shoso-in]. Tokyo, 1978

KOBAYASHI, Taiichiro. Man in T'ang and Sung Painting. Tokyo, 1957

——. To So no Hakuji [White porcelain of Tang and Song dynasties]. Tokyo, 1959

LINDBERG, Gustaf. "Hsing-yao and Ting-yao." Bull. of the Mus. of Far Eastern Antiq. 25 (1953)

MA, Ts'ai [Ma, Cai]. Ku K'ai-chih yen-chiu [Gu Kaizhi yanjiu; A study of Gu Kaizhi]. Shanghai, 1958

MAHLER, Jane G. The Westerners Among the Figurines of the T'ang Dynasty of China. Rome: Istituto ital. per il Medio ed Estremo Oriente, 1959

MINO, Yutaka. Pre-Sung Dynasty Chinese Stonewares in the Royal Ontario Museum. Toronto, 1974

MIZUNO, Seiichi. To San-sai [Three-color glazed pottery of the Chinese Tang dynasty]. Tokyo, 1961

MORI, Hisashi, and HAYASHI, Kenzo. Shosoin no Gigakumen [Gigaku masks in the Shosoin]. Nara, 1972

NISHIKAWA, Kyotaro. Bugaku Masks. Monica Bethe, trans. Tokyo: Kodansha, 1978

OKADA, Jo; ARAKAWA, Hirokazu; and KIMURA, Homitsu. Shosoin no shikko [Lacquer works in the Shosoin]. Tokyo, 1975

ONO, Katsutoshi. Wall Painting of Kaokouli Tombs. Tokyo, 1959

OSHIMA, Yoshinaga. Shosoin Gyobutsu Zuroku [Catalogue of the imperial treasures in the Shosoin]. 18 vols. Tokyo, 1929

PAN, T'ien-shou [Ban, Tianshou]. Ku K'ai-chih [Gu Kaizhi]. Shanghai, 1958

ROWLAND, Benjamin. "A Note on Wu Tao-tzu." Art Quarterly 17, no. 2 (Summer 1944)

SATO, Masahiko. Kan Rokucho no Tsuchiningyo [Clay figures of the Chinese Han and Six Dynasties]. Tokyo, 1958

SHENSI [Shenxi] PROVINCIAL MUSEUM, SIAN [Xi-an]. T'ang Li Chung-jun mu pi-hua [Tang Li Zhongrun mu bihua; Mural paintings in the tomb of Tang prince Li Zhongrun]. Beijing, 1974

*SOPER, Alexander C. Kuo Jo-hsu's Experiences in Painting. Washington, D.C.: Am. Counc. of Learned Soc., 1951

*——. "Early Chinese Landscape Painting." Art Bull. 23 (June 1941)

——. "First Two Laws of Hsieh Ho." Far Eastern Quarterly 8 (August 1949)

*——. "Life-motion and the Sense of Space in Early Chinese Representational Art." Art Bull. 30 (September 1948)

——. "Some Technical Terms in the Early Literature of Chinese Painting." Harvard Journal of Asiatic Studies 11 (June 1948)

SULLIVAN, Michael. The Birth of Landscape Painting in China. London, Berkeley, and Los Angeles: U. of Calif. Pr., 1962

*——. Chinese Landscape Painting in the Sui and T'ang Dynasties. Berkeley: U. of Calif. Pr., 1980

——. "On Painting the Yun-t'ai-shan, a Reconsideration of the Essay Attributed to Ku K'ai-chih." Artibus Asiae 17, no. 2 (1954)

——. "On the Origin of Landscape Representation in Chinese Art." Archives of the Chinese Art Soc. of America 7 (1953)

——. "Pictorial Art and the Attitude toward Nature in Ancient China." Art Bull. 36 (March 1954)

T'ang-mu-pi-hua [Tang mu bihua; Mural paintings in the tombs of the Tang dynasty]. Shenxi Prov. Mus., ed. Shanghai, 1963

*T'ang Yung-tai kung-chu mu pi-hua-chi [Tang Yongtai gongzhu mu bihua ji; Collection of wall paintings of the tomb of Tang Princess Yongtai]. Beijing, 1963

TENG, Pai [Deng, Bai]. Hsü Hsi and Huang Ch'üan [Xu Xi and Huang Quan]. Shanghai, 1958

VANDIER-NICOLAS, Nicole. Bannières et peintures de Touen-Houang conservées au Musée Guimet. Paris: Mission Paul Pelliot, 1976

WANG, Pai-min [Wang, Baimin]. Chou Fang [Zhou Fang]. Shanghai, 1958

——. Wu Tao-tzu [Wu Daozi]. Shanghai, 1958

WATSON, William, ed. Pottery and Metalwork in T'ang China: Their Chronology and External Relation. London: U. of London, 1971

WRIGHT, Arthur F., and TWITCHETT, Denis, eds. Perspectives on the T'ang. New Haven: Yale U. Pr., 1973

13. THE BEGINNINGS OF DEVELOPED JAPANESE ART STYLES

BEAUJARD, A. Les notes de chevet de Sei Shonagon. Paris: Maisonneuve, 1934

BROWER, Robert H., and MINER, Earl. Japanese Court Poetry. Stanford U. Pr., 1961

CHANDRA, Lokesh. The Esoteric Iconography of Japanese Mandalas. New Delhi: Intern. Acad. of Indian Cult., 1971

Daigo-ji Mikkyo Bijutsu ten [Esoteric Buddhist arts from the Daigo Temple]. Kyoto, 1975

FUJISHIMA, Gaijiro, ed. Chuson-ji [Chuson Temple]. Tokyo, 1971

*FUKUYAMA, Toshio. Heian Temples: Byodo-in and Chuson-ji. Ronald K. Jones, trans. New York: Weatherhill; Tokyo: Heibonsha, 1976

HARUYAMA, Takematsu. Heiancho kaiga-shi [History of painting of the Heian period]. Tokyo, 1950

Hieizan: Tendai-no-hiho [Mount Hiei: the secret treasures of the Tendai sect]. Tokyo, 1971

*IENAGA, Saburo. Painting in the Yamato Style. John M. Shields, trans. New York: Weatherhill; Tokyo: Heibonsha, 1973

ISHIDA, Mosaku, et al. Onjo-ji: hiho [Secret treasures in the Onjo Temple, Otsu]. Tokyo, 1971

IZUMI, Shikibu. The Izumi Shikibu Diary: A Romance of the Heian Court. Edwin A. Cranston, trans. Cambridge, Mass.: Harvard U. Pr., 1969

KIDDER, Jonathan E., Jr. Early Buddhist Japan. London: Thames and Hudson, 1972

Koya-san [Mount Koya]. Asahi Shimbunsha, ed. Tokyo, 1957

KUNO, Takeshi. Heian-shoki Chokoku-shi no Kenkyu [Studies of the sculpture of the Heian period]. Tokyo, 1974

KYOTO NATIONAL MUSEUM. Heian Jidai no Bijutsu [Fine arts of the Heian period]. Kyoto, 1958

——. Jodokyo Kaiga; Tokubetsu Tenrankai [Buddhist paintings of the Jodo sect; special exhibition]. Kyoto, 1973

McCULLOUGH, Helen C. Okagami: the Great Mirror, Fujiwara Michinaga (966–1027) and His Times. Princeton: Princeton

U. Pr., 1980

——, ed. *Tales of Ise: Lyrical Episodes from Tenth-Century Japan*. Stanford: Stanford U. Pr., 1968

MARUO, Shozaburo. *Nihon Chokoku Shi Kiso Shiryo Shusei: Juyo Sakuhin hen* [Collection of the basic materials for Japanese sculpture history; Heian period: important works]. Vols. 1–8. Tokyo, 1973–77

MORRIS, Ivan. *The Tale of Genji Scroll*. Tokyo and New York: Kodansha, 1971

*MURASAKI, Shikibu. *The Tale of Genji*. Edward Seidensticker, trans. New York: Doubleday, 1977

*——. *The Tale of Genji*. Arthur Waley, trans. 6 vols. London: Allen and Unwin, 1926–33

NARA NATIONAL MUSEUM. *Hokkekyo no Bijutsu* [Arts of the Lotus Sutra]. Nara, 1979

——. *Kyozuka ihoten* [Exhibition of Buddhist relics excavated from sutra mounds]. Nara, 1973

OMORI, Annie S., and DOI, Kochi, trans. *Diaries of Court Ladies of Old Japan*. Boston: Houghton Mifflin, 1920

READ, Louisa M. *The Masculine and Feminine Modes of Heian Secular Painting and Their Relationship to Chinese Painting*. Stanford, 1976

*SAWA, Takaaki. *Art in Japanese Esoteric Buddhism*. New York: Weatherhill; Tokyo: Heibonsha, 1972

SAYRE, Charles F. *Illustrations of the* Ise Monogatari: *Survival and Revival of Heian Court Culture*. New Haven, 1978

SHIMBO, Toru. *Rokudo-e* [Pictures of Rokudo]. Tokyo, Osaka, Nagoya, 1977

SOPER, Alexander C. "Illustrative Method of the Tokugawa Genji Pictures." *Art Bull.* 37 (March 1955)

*——. "The Rise of Yamato-e." *Art Bull.* 24 (December 1942)

SUGIYAMA, Jiro. *Ganjin*. Tokyo, 1970

TAHARA, Mildred M., trans. *Tales of Yamato: a Tenth-Century Poem-Tale*. Honolulu: U. Pr. of Hawaii, 1980

TAKATA, O., ed. *Wall-Paintings in Daigo-ji Pagoda*. Tokyo, 1959

TANAKA, Ichimatsu, and YAMAGUCHI, Hoshun. *Shaka Kinkan Shutsugen-zu* [The awakening of Sakya]. Tokyo, 1959

TODA, Kenji. "Japanese Screen Paintings of the Ninth and Tenth Centuries." *Ars Orientalis* 3 (1959)

TOGANO, Shozui M. *Symbol System of Shingon Buddhism*. Ann Arbor, 1980

To-ji. Kyoto, 1970

To-ji and Its Cultural Treasures. Tokyo, 1958

TOKYO NATIONAL MUSEUM. *Exhibition of Japanese Buddhist Arts*. Tokyo, 1956

UEHARA, Kazu. *Shotoku-taishi*. Tokyo, 1970

YAMAMOTO, Koji. *Jodokyo Kaiga* [The painting of Pure Land Buddhism]. Tokyo, 1975

14. JAPANESE ART OF THE KAMAKURA PERIOD

AKAMATSU, Toshihide. *Kamakura Bukkyo no Kenkyu* [A study of Buddhism in the Kamakura period]. 2 vols. Kyoto, 1957–66

FOARD, James H. *Ippen Shonin and Popular Buddhism in Kamakura Japan*. Ann Arbor, 1977

GRILLI, Elise. *Japanese Picture Scrolls*. New York: Crown, 1958

Kamakura no Bijutsu [Fine arts of Kamakura]. Tokyo, 1958

KAMEDA, Tsutomu. *Bukkyo Setsuwa-e no Kenkyu* [Studies of Buddhist narrative paintings]. Tokyo, 1979

KAN, Tatto, ed. *Kamakura no Bijutsu* [Art of Kamakura]. Kamakura, 1978

*KITAGAWA, Hiroshi, and TSUCHIDA, Bruce T. *The Tale of the Heike*. Tokyo: U. of Tokyo Pr., 1975

*KOBAYASHI, Takeshi. *Study on the Life and Works of Unkei*. Okajima, 1954

KUNO, Takeshi. *Unkei no Chokoku* [The sculpture of Unkei].

Tokyo, 1974

KYOTO MUNICIPAL MUSEUM. *Kokuho Juniten Gazo: Kyoto Kokuritsu Hakubutsukan zu* [The paintings of the Twelve Devas: a history; from the coll. of the Kyoto Nat. Mus.]. 2 vols. Kyoto, 1977

——. *Narrative Paintings of Japan*. Exhib. cat. Kyoto, 1960

LA FLEUR, William R. *Saigyo the Priest and His Poetry of Reclusion*. Chicago: U. of Chicago Pr., 1973

MASON, Penelope E. *A Reconstruction of the Hōgen-Heiji Monogatari Emaki*. New York: Garland Pub., 1977

MASS, Jeffry P. *The Kamakura Bakufu: a Study in Documents*. Stanford: Stanford U. Pr., 1976

*MORI, Hisashi. *Sculpture of the Kamakura Period*. Katherine Eickmann, trans. New York: Weatherhill; Tokyo: Heibonsha, 1974

Nippon Emakimono Zensho [Japanese scroll painting]. Ichimatsu Tanaka, ed. 12+ vols. Tokyo: Kadokawa Shoten, 1958–

*OKUDAIRA, Hideo. *Narrative Picture Scrolls*. Elizabeth ten Grotenhuis, trans. New York: Weatherhill; Tokyo: Shibundo, 1973

——, and YAMAGUCHI, Hoshun. *Shigi-san Engi Emaki* [A picture-scroll story of Mount Shigi]. Tokyo, 1956

*SECKEL, Dietrich. *Emakimono, the Art of the Japanese Painted Hand-scroll*. Photographs and foreward by Akihisa Hase. New York: Pantheon, 1959

SHIMBO, Toru. *Jigoku-e* [Pictures of hells]. Tokyo, 1976

——. *Yokai Emaki* [Scroll paintings of apparitions]. Tokyo, Osaka, Nagoya, 1978

TODA, Kenji. *Japanese Scroll Painting*. Chicago: U. of Chicago Pr., 1935

*TOKYO NATIONAL MUSEUM. *Emaki: Tokubetsu ten* [Illustrated narrative handscrolls; special exhib.]. Tokyo, 1975

——. *Tokubetsu ten: Kamakura Jidai no Chokoku* [Special exhibition: Japanese sculpture of the Kamakura period]. Tokyo, 1975

——. *Tokubetsu ten: "Nippon no Buki, Bugu"* [Special exhibition: Japanese arms and armor]. Tokyo, 1976

UMEZU, Jiro. *Emakimono Zanketsu no fu* [Catalogue of fragments of Japanese scroll paintings]. Tokyo, 1970

15. CHINESE PAINTING AND CERAMICS OF THE SONG DYNASTY

BARNHART, Richard. *Marriage of the Lord of the River; a Lost Landscape by Tung Yüan*. Ascona: Artibus Asiae, 1970

BEIJING PALACE MUSEUM. *Ku-kung ts'ang-hua liao hua chi* [*Gu gong cang hua liao hua ji;* Flower and bird paintings in the Palace Museum]. Beijing, c. 1960

CAHILL, James. *The Art of Southern Sung China*. New York: Arno, 1962

——. *Chinese Paintings, XI–XIV Centuries*. New York, n.d.

CHANG, An-chih [Zhang, Anzhi]. *Kuo Hsi* [*Guo Xi*]. Shanghai, 1959

CHANG, Tse-tuan [Zhang, Zeduan]. *Ch'ing Ming shang ho tu* [*Qing Ming shang he tu;* Ch'ing Ming Festival Along the Bian River]. Beijing, 1958

CHAPIN, Helen B. *A Long Roll of Buddhist Images*. Rev. by Alexander C. Soper. Ascona: Artibus Asiae, 1972

CH'EN, Wan-li [Chen, Wanli]. *Chung-kuo ch'ing-tz'u shih-lueh* [*Zhongguo qing ci shi lue;* The history of Chinese celadon ware]. Hong Kong, 1972

CHENG, Chen-to [Zheng, Zhenduo], ed. *Sung Dynasty Album Paintings*. Beijing, 1957

CHOU, Wu [Zhou, Wu]. *Li Kung-lin* [*Li Gonglin*]. Shanghai, 1959

FONG, Wen. *The Lohans and a Bridge to Heaven*. Freer Gallery of Art Occasional Papers. Washington, D.C., 1958

GERNET, Jacques. *Daily Life in China on the Eve of the Mongol*

Invasion. Stanford: Stanford U. Pr., 1970

GOMPERTZ, G. St. G. M. *Chinese Celadon Wares*. London: Faber, 1959

———. "The Development of Koryo Wares." *Transactions of the Oriental Ceramic Soc.* 26 (1950–51)

———. *Korean Pottery and Porcelain of the Yi Period*. New York: Praeger, 1968

HASEBE, Gakuji. *Jishuyo* [Ci Zhou ware]. Tokyo, 1974

———. *So no Jishuyo* [Wares made by several kilns in the northern China of the Song dynasty]. Tokyo, 1958

KOYAMA, Fujio. *So Ji* [Song ceramics], *Sansai* [Three-color ware]. Tokyo, August, 1959

KURODA, Genji, and SUGIMURA, Yuzo. *Rio no Toji* [Pottery of the Liao dynasty]. Tokyo, 1958

LE COQ, Albert von. *Buried Treasures of Chinese Turkestan*. London, 1928

LEE, Sherman E., and FONG, Wen. *Streams and Mountains Without End*. Ascona: Artibus Asiae, 1955

Liang-sung ming-hua ts'e [Liang Song ming hua ce; Album paintings of the Northern and Southern Song dynasties]. Chang Heng [Zhang Heng], ed. Beijing, 1963

LOEHR, Max. *Chinese Landscape Woodcuts from an Imperial Commentary to the Tenth-Century Printed Edition of the Buddhist Canon*. Cambridge, Mass.: Harvard U. Pr., 1968

MAEDA, Robert J. *Two Twelfth Century Texts on Chinese Painting: Translations of the Shan-shui ch'un ch'üan chi by Han Cho and Chapters Nine and Ten of Hua-chi by Teng Ch'un*. Ann Arbor: U. of Michigan Ctr. for Chinese Studies, 1970

MATSUMOTO, Eiichi. "Caractère concordant de l'évolution de la peinture de Fleurs et d'Oiseaux et du développement de la peinture monochrome sous les T'ang et les Song." *Arts Asiatiques* 5, no. 1 (1958)

MEDCALF, C. J. B. "Han to Yuan—An Identification Table of Chinese Ceramics." *Oriental Art* 2, no. 4 (Winter 1956)

*MEDLEY, Margaret. *Korean and Chinese Ceramics from the Tenth to the Fourteenth Century*. Cambridge, 1975

MINO. Yutaka, *Ceramics in the Liao Dynasty North and South of the Great Wall*. New York: China Inst. in America, 1973

MUNAKATA, Kiyohiko. *Ching Hao's Pi-fa-chi: a Note on the Art of the Brush*. Ascona, 1974

MUSEUM OF FINE ARTS, BOSTON. *The Charles B. Hoyt Collection in the Museum of Fine Arts*. Vol. 2: *Liao, Sung, and Yuan Dynasties*. Boston, 1962–

———. *Han and T'ang Murals Discovered in Tombs in the PRC. . . .* By Jan Fontein and Tung Wu. Exhib. cat. Boston: Mus. of Fine Arts, 1976

NATIONAL PALACE MUSEUM, TAIZHONG. *Ju Ware of the Sung Dynasty*. Hong Kong, 1961

PLUMER, James M. *Temmoku: a Study of the Ware of Chien*. Tokyo, 1972

ROWLAND, Benjamin. "Hui Tsung and Huang Chüan." *Artibus Asiae* 17, no. 2 (1954)

———. "The Problem of Hui Tsung." *Archives of the Chinese Art Soc. of America* 5 (1951)

SHIMADA, Shujiro, and YONEZAWA, Yoshio. *Painting of the Sung and Yuan Dynasties*. Tokyo, 1952

So Gen Meiga: Kaben Reimo [Masterpieces of Song and Yuan paintings: flowers and animals]. Ryusho Matsushita and Kei Suzuki, eds. Ichikawa City, 1959

So Gen Meiga: Sansui [Masterpieces of Song and Yuan paintings: landscape]. Ryusho Matsushita and Kei Suzuki, eds. Ichikawa City, 1961

Sogen Meigwa-shu [Selected masterpieces of Song and Yuan dynasties from public and private collections in Japan]. 3 vols. Tokyo, 1930–39

SOUTHEAST ASIAN CERAMIC SOCIETY, SINGAPORE. *Ceramic Art of Southeast Asia*. Exhib. cat. Singapore, 1971

SUZUKI, Kei. *Li T'ang, Ma Yuan, Hsia Kuei. Suiboku Bijutsu Taikei* [Li Tang, Ma Yuan, Xia Gui. . .; Complete collection of ink monochrome painting]. Vol. 2. Tokyo, 1974

TAMURA, Jitsuzo. *Tomb and Mural Paintings of Ch'ing-ling: Liao Imperial Mausoleums of the 11th Century A.D. in Eastern Mongolia*. Kyoto, 1952–53

TANAKA, Toyotaro. *Mishima* [Mishima ware]. Tokyo, 1962

TENG, Pai, and WU, Fu-chih [Deng, Bai, and Wu, Fuzhi]. *Ma Yuan, Hsia Kuei* [Ma Yuan and Xia Gui]. Shanghai, 1958

TODA, Teisuke. *Mu-ch'i, Yü-chien. Suiboku Bijutsu Taikei* [Mu-Qi, Yu-Jian. Complete collection of their ink monochrome paintings]. Vol. 3. Tokyo, 1973

TOKYO NATIONAL MUSEUM. *Chinese Arts of the Sung and Yuan Periods*. Tokyo, 1961

YONEZAWA, Kafu. *Flower and Bird Painting of the Sung Dynasty*. Tokyo, 1956

16. JAPANESE ART OF THE ASHIKAGA PERIOD

ARAKAWA, Koichi. *Zen Painting*. John Bester, trans. Tokyo: Kodansha, 1970

ARAKAWA, Toyozo. *Shino* [Shino ware]. Tokyo, 1959

CORT, Louise A. *Shigaraki: Potters' Valley*. New York: Kodansha, 1979

COVELL, Jon. C. *Under the Seal of Sesshu*. New York, 1941. Reprint. New York: Hacker, 1974

*———, and YAMADA, Sobin. *Zen at Daitoku-ji*. Tokyo and New York: Kodansha, 1974

CUNNINGHAM, Michael. *Paintings of Unkoku Togan and Their Historical Setting*. Chicago, 1978

DOGEN. *A Primer of Soto Zen: a Translation of Dogen's Shobogenzo Zuimonki*. Reiho Masunaga, trans. London: Routledge, 1972

*FONTEIN, Jan, and HICKMAN, Money L. *Zen Painting and Calligraphy*. Boston: Mus. of Fine Arts, 1970; distr. N.Y. Graphic Soc., Greenwich, Conn.

FUJIOKA, Ryoichi. *Tea Ceremony Utensils*. Louise A. Cort, trans. New York: Weatherhill, 1973

HAKUIN, Zenji. *The Embossed Tea Kettle: Orategama and Other Works of Hakuin Zenji*. R. D. M. Shaw, trans. London: Allen and Unwin, 1963

HASUMI, Shigeyasu. *Sesshu Toyo Shinron* [The study of Sesshu Toyo: his humanity and works]. Rev. ed. Tokyo and Osaka, 1977

*HAYASHIYA, Tatsusaburo; NAKAMURA, Masao; and HAYASHIYA, Seizo. *Japanese Arts and the Tea Ceremony*. Joseph P. Macadam, trans. New York: Weatherhill; Tokyo: Heibonsha, 1974

Higashiyama Suiboku Gashu [Collection of monochrome ink paintings of the Higashiyama period]. Jurakusha, ed. 2 vols. Tokyo, 1936

HOLBORN, Mark. *The Ocean in the Sand: Japan—from Landscape to Garden*. London: Shambhala, 1978

KANAZAWA, Hiroshi. *Kao, Mincho*. Tokyo, 1977

KATSURA, Matsaburo, et al., eds. *Ko-Bizen Meihin Zufu* [Catalogue of ceramic masterpieces of Old Bizen]. Tokyo, 1961

KUMATANI, Norio. *Sesshu*. Tokyo, 1956

KYOTO NATIONAL MUSEUM. *Muromachi Jidai Shoga* [Painting and calligraphy of the Muromachi period]. Exhib. cat. Kyoto, 1961

LEE, Sherman E. *Tea Taste in Japanese Art*. Exhib. cat., Asia House Gallery, New York. New York: Asia Soc., 1963

McCULLOUGH, Helen C., trans. *Yoshitsune: a Fifteenth Century Japanese Chronicle*. Stanford: Stanford U. Pr., 1966

*MATSUSHITA, Takaaki. *Ink Painting*. Martin Collcutt, trans. New York: Weatherhill, 1974

———. *Josetsu, Shubun, San'ami*. Tokyo, 1974

———. *Muromachi Suibokuga* [Muromachi ink painting]. Tokyo, 1960

MINAMOTO, Hoshu. *Daitoku-ji*. Osaka, 1958

MITSUOKA, Tadanari. *Cha no Koyo* [Old kilns for tea ceramics]. Tokyo, 1972

NAKAMURA, Tanio. *Sesshu*. Tokyo, 1976

———. *Shokei*. Tokyo, 1970

NAKAMURA, Yasuo. *Noh: The Classical Theater*. Don Kenny, trans. New York: Walker/Weatherhill, 1971

NAKANISHI, Toru. *Ko-Tamba* [Old Tamba ware]. Tokyo, 1978

OSHITA, Masao, ed. *Sesshu. Mizue (Betsusatsu)* [Special issue of *Mizue*]. Tokyo, 1961

*SCHAARSCHMIDT-RICHTER, Irmtraud, and MORI, Osamu. *Japanese Gardens*. Janet Seligman, trans. New York: Morrow, 1979

SHIMIZU, Yoshiaki, and WHEELWRIGHT, Carolyn, eds. *Japanese Ink Paintings from American Collections: the Muromachi Period*. Princeton: Princeton U. Art Mus., 1976

STANLEY-BAKER, Patrick. *Mid-Muromachi Paintings of the Eight Views of the Hsiao and Hsiang*. Ann Arbor, 1980

TANAKA, Ichimatsu. *Kao, Mokuan, Mincho*. Tokyo, 1974

———. *Sesshu, Sesson*. Tokyo, 1973

TANAKA, Sen'o. *The Tea Ceremony*. Tokyo and New York: Kodansha, 1973

TANI, Shin'ichi; NAGAHIRO, Toshio; and OKADA, Jo. *Gyobutsu shusei* [Art collections from the households of Japanese shoguns]. 2 vols. Tokyo, 1976

TOKYO NATIONAL MUSEUM, ed. *Sesshu* [The masterpieces of Sesshu]. Text by Seiroku Noma. Tokyo: Benrido, 1956

WATANABE, Hajime. *Higashiyama Suiboku Ga no Kenkyu* [Monochrome ink paintings of the Higashiyama period]. Tokyo, 1948

YOSHIMURA, Teiji. *Ashikaga Yoshimitsu*. Tokyo, 1970

17. LATER CHINESE ART: THE YUAN, MING, AND QING DYNASTIES

ADAMS, Edward B. *Palaces of Seoul: Yi Dynasty Palaces in Korea's Capital City*. Seoul: Taewon, 1972

*ARTS COUNCIL OF GREAT BRITAIN. *The Arts of the Ming Dynasty*. Exhib. cat., Arts Counc. Gallery. London, 1958

ASAKAWA, Hakukyo. *Li-cho: Hakuji, Sometsuke, Tetsusa* [Korean Yi Dynasty: white celadon, Blue-and-White, and iron glaze wares]. Tokyo, 1960

BARTHOLOMEW, Terese T. *I-hsing Ware*. New York: China Inst. in America, 1977

BAUR, Alfred. *The Baur Collection, Geneva: Chinese Jades and Other Hardstones*. Geneva: Coll. Baur, 1976

BEURDELEY, Cecile, and BEURDELEY, Michel. *Giuseppe Castiglione: a Jesuit Painter at the Court of the Chinese Emperors*. Michael Bullock, trans. Rutland, Vt., and Tokyo: Tuttle, 1972

CAHILL, James. *Fantastics and Eccentrics in Chinese Paintings*. Exhib. cat., Asia House Gallery, New York. New York: Asia Soc., 1967. Reprint. New York: Arno, 1976

*———. *Hills Beyond a River: Chinese Paintings of the Yuan Dynasty, 1279–1368*. New York and Tokyo: Weatherhill, 1976

*———. *Parting at the Shore: Chinese Painting of the Early and Middle Ming Dynasty, 1368–1580*. New York and Tokyo: Weatherhill, 1978

*———, ed. *The Restless Landscape: Chinese Painting of the Late Ming Period*. Exhib. cat., Univ. Art Mus., Berkeley. Berkeley: U. of Calif. Art Mus., 1971

CH'ENG, Ping-shan [Cheng, Bingshan]. *Shen Shih-t'ien* [Shen Shitian]. Shanghai, 1958

CHENG, Te-k'un. *Painting as a Recreation in China: Some Hsi-pi Paintings in the Mu-fei Collection*. Hong Kong, 1973

CHIANG, Chao-shen [Jiang, Zhaoshen]. *Wen Cheng-ming hua hsi nien* [Wen Zhengming hua xi nian; Catalogue of Wen Zhengming's paintings. . . . from the coll. of the National Palace Mus., Taibei]. 2 vols. Tokyo, 1976

CHU, Tai, and JUNG, Doris. *T'ang Yin (1470–1524): the Man and His Art*. Pittsburgh, 1979

CLAPP, Anne de C. *Wen Cheng-ming: the Ming Artist and Antiquity*. Ascona: Artibus Asiae, 1975

*CONTAG, Victoria. *Die beiden Steine: Beitrag zum Verständnis des Wesens Chinesischer Landschaftsmalerei*. Brunswick: Klemm, 1950

———. *Chinese Masters of the 17th Century*. Michael Bullock, trans. Rutland, Vt., and Tokyo: Tuttle, 1970

*———. *Die sechs berühmten Maler der Ch'ing-Dynastie*. Leipzig: Seemann, 1940

———. "The Unique Characteristics of Chinese Landscape Pictures." *Archives of the Chinese Art Soc. of America* 6 (1952)

———, and WANG, Chi-ch'ien, comps. *Seals of Chinese Painters and Collectors of the Ming and Ch'ing Periods*. Rev. ed. Hong Kong: Hong Kong U. Pr., 1966

DUBOSC, Jean Pierre. *Great Chinese Painters of the Ming and Ch'ing Dynasties, XV to XVIII Centuries*. Exhib. cat. New York, 1949

ECKE, Tseng Yu-ho. *Chinese Folk Art in American Collections: Early 15th Through Early 20th Centuries*. New York: China Inst. in America, 1976

EDWARDS, Richard. *The Art of Wen Cheng-ming (1470–1559)*. Ann Arbor: U. of Michigan Pr., 1976

ELLSWORTH, Robert H. *Chinese Furniture: Hardwood Examples of the Ming and Early Ch'ing Dynasties*. New York: Random, 1971

Fa-hai-szu Ming-tai pi hua [Fa-hai Si Ming dai bihua; Wall paintings of the Ming dynasty at Fa-hai Buddhist Temple in Beijing]. Beijing, 1958

FRASCHÉ, Dean F. *Southeast Asian Ceramics: Ninth through Seventeenth Centuries*. Exhib. cat., Asia House Gallery, New York. New York: Asia Soc./Weatherhill, 1976

FU, Marilyn, and FU, Shen. *Studies in Connoisseurship: Chinese Paintings from the Arthur M. Sackler Collections*. Exhib. cat., Princeton U. Art Mus., 1974

FUJIOKA, Ryoichi. *Gen Min-cho no Sometsuke* [Blue-and-White porcelain of the Chinese Yuan dynasty and the beginning of the Ming dynasty]. Tokyo, 1960

———. *Min no Aka-e* [Ceramics with red glaze decoration of the Ming dynasty]. Tokyo, 1962

*GARNER, Harry. *Chinese Lacquer*. London: Faber, 1979

*———. *Oriental Blue and White*. 2nd ed. New York: Yoseloff, 1964

———. *Ryukyu lacquer*. London: U. of London, 1972

GEISS, James P. *Peking Under the Ming (1368–1644)*. Princeton, 1979

*GOODRICH, L. Carrington, ed., and FANG, Chaoying, assoc. ed. *Dictionary of Ming Biography, 1368–1644*. New York: Columbia U. Pr., 1976

HAYASHIYA, Seizo. *Korai chawan* [Korean teabowls]. Tokyo, 1958

HONG KONG CHINESE UNIVERSITY. *Landscape Paintings by Kwangtung Masters During the Ming and Ch'ing Periods*. Hong Kong: Inst. of Chinese Studies Art Gallery, 1973

HONG KONG CITY MUSEUM AND ART GALLERY. *Exhibition of Paintings of the Ming and Ch'ing Periods*. Hong Kong, 1970

HSIEH, Chih-liu [Xie, Zhiliu]. *Chu Ta* [Zhu Da]. Shanghai, 1958

HU, Pei-heng [Hu, Beiheng]. *Wang Shih-ku* [Wang Shigu; pseud. Wang Hui]. Shanghai, 1958

HUANG, Yung-chuan [Huang, Yongzhuan]. *Ch'en Hung-shou* [Chen Hongshou]. Shanghai, 1958

*JENYNS, Soame. "Chinese Lacquer." *Transactions of the Oriental Ceramic Soc.* 17 (1939–40)

*———. *Later Chinese Porcelain: the Ch'ing Dynasty.* London: Faber, 1971

*———. *Ming Pottery and Porcelain.* New York: Pitman, 1954

KATES, George N. *Chinese Household Furniture.* New York: Dover, 1948

KITANO, Masao. *Yang-chou School of Painters in the Ch'ien-lung Period, China.* Tokyo, 1957

KYOTO MUNICIPAL MUSEUM OF ART. *Chugoku Eiraku-kyu hekigwa-ten* [Wall paintings of the Yung-le Palace]. Kyoto, 1963

LAI, T. C. *Pa Ta Shan Jen: Chinese Monk-Painter.* Kowloon: Swindon Book, 1963

———. *T'ang Yin, Poet/Painter, 1470–1524.* Hong Kong, 1971

LEE, Sherman E., and Ho, Wai-kam. *Chinese Art Under the Mongols: The Yüan Dynasty (1279–1368).* Exhib. cat., Cleveland Mus. of Art. Cleveland, 1968

LI, Chu-tsing. *The Autumn Colors on the Ch'iao and Hua Mountains: A Landscape by Chao Meng-fu.* Ascona: Artibus Asiae, 1965

———. *A Thousand Peaks and Myriad Ravines: Chinese Paintings in the Charles A. Drenowatz Coll.* Ascona: Artibus Asiae, 1974

LIANG, Ch'i-ch'ao. *Intellectual Trends in the Ch'ing Period.* Immanuel E. Y. Hsü, trans. Cambridge, Mass.: Harvard U. Pr., 1970

LIPPE, Aschwin. "Kung Hsien and the Nanking School." *Oriental Art* 2, no. 1 (Spring 1956), and 4, no. 4 (Winter 1958)

*LOW-BEER, Fritz. "Chinese Lacquer of the Early 15th Century." *Bull. of the Mus. of Far Eastern Antiq.* 22 (1950)

———. "Chinese Lacquer of the Middle and Late Ming Period." *Bull. of the Mus. of Far Eastern Antiq.* 14 (1952)

MATSUSHITA, Takaaki, and CH'OI, Sun-u. *Richo no Suibokuga* [Ink monochrome painting of the Yi dynasty, Korea]. Tokyo, 1977

*MEDLEY, Margaret. *Yüan Porcelain and Stoneware.* London: Faber, 1974

Mei Ch'u-shan hua chi [*Mei Chushan hua ji*; Collection of paintings by Mei Qing]. Shanghai, 1960

MOSS, Hugh M. *By Imperial Command: An Introduction to Ch'ing Imperial Painted Enamels.* Hong Kong, 1976

MUSEUM YAMATO BUNKAKAN, NARA. *Chugoku no Min Shin Jidai no Hanga* [Chinese woodcuts and etchings of the Ming and Qing dynasties]. Nara, 1972

NAGAHARA, Oriji. *Shih-t'ao and Pa-ta Shan-jen.* Tokyo: Keibunkan, 1961

OZAKI, Ayamori. *Shin Cho no Kanyo* [Wares made in the official kilns of the Chinese Qing dynasty]. Tokyo, 1958

PAINE, Robert T. "The Ten Bamboo Studio." *Archives of the Chinese Art Soc. of America* 5 (1951)

PAN, T'ien-shou [Ban, Tianshou], and WANG, Po-min [Wang, Bomin]. *Huang Kung-wang yü Wang Meng* [*Huang Gongwang yu Wang Meng*]. Shanghai, 1958

Pa-ta-shan-jen shu-hua chi [*Ba-da-shan-ren shu hua ji*; Selected painting and calligraphy of Ba-da-shan-ren]. Chang, Wan-li [Zhang, Wanli] and Hu, Jên-mou [Hu, Renmou], comps. Kowloon, Hong Kong: Cafa, 1969

PICARD, René. *Les Peintres jésuites à la cour de Chine.* Grenoble: Éditions des quatre seigneurs, 1973

*POPE, John A. *Chinese Porcelains from Ardebil Shrine.* Washington, D.C.: Freer Gallery, Smithsonian, 1956

*———. *14th Century Blue and White: A Group of Chinese Porcelains in the Topkapu Sarayi Muzesi, Istanbul.* Washington, D.C.: Freer Gallery, 1952

SAITO, Kikutaro. *Kosometsuke* [Blue-and-White ware of the Chinese Ming Dynasty]. Tokyo, 1959

SAYER, Geoffrey R. *Ching-Te-Chen Tao-Lu* or *The Potteries of China.* London: Routledge, 1951

Sekito meiga-fu [A catalogue of Shi-Tao's (Sekito's) paintings]. Tokyo, 1937

SHANXI CULTURAL OBJECT ADMINISTRATION COMMITTEE. *Yunglo-kung* [*Yongle Gong*; Yongle Temple]. Beijing, 1964

Shih-ch'i hua chi [*Shi-Qi hua ji*; The selected painting of Shi-Qi]. Chang, Wan-li [Zhang, Wanli], and Hu, Jên-mou [Hu, Renmou], comps. Kowloon, Hong Kong: Cafa, 1969

SIRÉN, Osvald. *The Walls and Gates of Pekin[g].* London: John Lane, 1924

———. "Shih-t'ao, Painter, Poet and Theoretician." *Bull. of the Mus. of Far Eastern Antiq.* 21 (1949)

SUZUKI, Kei. *Yun Nan-t'ien.* Tokyo, 1957?

TAIBEI, NATIONAL PALACE MUSEUM. *Wu-p'ai-hua chiu-shih-nien* [*Wu pai hua jiu-shi nian*; Ninety years of Wu school painting]. Taibei, 1975

TOKYO NATIONAL MUSEUM. *Gendai Doshaku Jinbutsuga, Tokubetsu Tenkan* [Chinese paintings of the Yuan dynasty on Buddhist and Daoist figure subjects]. Tokyo, 1975

———. *Tokubetsu ten: Toyo no Shikko gei* [Special exhibition: Oriental lacquer arts]. Tokyo, 1977

TORONTO, ROYAL ONTARIO MUSEUM. *The Bishop White Gallery: Shansi Wall Paintings and Sculptures from the Chin and Yuan Dynasties.* Toronto, 1969

TSCHICHOLD, Jan. *Chinese Colour Prints from the Ten Bamboo Studio.* London, 1972

VAN OORT, H. A. *Chinese Porcelain of the 19th and 20th Centuries.* Lochem, 1977

VANDERSTAPPEN, Harrie. "Painters at the Early Ming Court (1368–1435) and the Problem of a Ming Academy." *Monumenta Serica* 15, no. 2 (1956), and 16, nos. 1/2 (1957)

VICTORIA AND ALBERT MUSEUM. *Chinese Porcelain of the Ch'ing Dynasty.* London, 1957

WANG, Kai. *The Mustard Seed Garden Manual of Painting (Chieh tzu yuan hua chuan* [*Jiezi yuan hua zhuan*]). Mai-mai Sze, trans. Princeton, 1977

WATSON, William, ed. *The Westward Influence of the Chinese Arts from the 14th to the 18th Century: A Colloquy on Art and Archaeology in Asia.* London: U. of London, 1972

WHITFIELD, Roderick. *In Pursuit of Antiquity: Chinese Paintings of the Ming and Ch'ing Dynasties from the Coll. of Mr. and Mrs. Earl Morse.* Addendum by Wen Fong. Princeton: Princeton U. Art Mus., 1969

WILSON, Marc, and WONG, Kwan S. *Friends of Wen Cheng-ming: A View from the Crawford Coll.* New York, 1974

Yang-chou pa-kuai shu-hua chi [*Yangzhou ba guai shu hua ji*; The selected painting and calligraphy of the Eight Eccentrics of Yangchou]. Chang, Wan-li [Zhang, Wanli], and Hu, Jên-mou [Hu, Renmou], comps. Hong Kong, 1970

YONEZAWA, Yoshiho. *Painting in the Ming Dynasty.* Tokyo: Mayuyama, 1956

Yung-lo-kung pi-hua hsuan-chi [*Yongle Gong bihua xuanji*; Wall paintings of Yongle Temple]. Beijing, 1958

18. LATER JAPANESE ART: THE MOMOYAMA AND TOKUGAWA PERIODS

ABRAMS, Leslie E. *Japanese Prints: a Bibliography of Monographs in English.* Chapel Hill, N.C., 1977

ADDISS, Stephen. *Nanga Paintings.* London: Sawyers, 1975

———. *Uragami Gyokudo: The Complete Literati Artist.* Vols. 1 and 2. Ann Arbor, Mich., 1977

AKABOSHI, Goro, and NAKAMURA, Heiichiro. *Five Centuries of Korean Ceramics: Pottery and Porcelain of the Yi Dynasty.* June Silla, trans. New York: Weatherhill, 1975

AKAI, Tatsuro. *Ogata Korin: Genroku Chonin no Zokei* [Art of a merchant in the Genroku era]. Tokyo, 1979

ARAKAWA, Yasuichi, ed. *Sengai Bokuseki* [Painting and calligraphy by Sengai]. Kyoto, 1976

ART INSTITUTE OF CHICAGO. *Masterpieces of Japanese Prints.* Chicago, 1955

ASAHI SHIMBUN-SHA. *Ichi Raku ni Hagi san Karatsu* [Raku, Hagi, and Karatsu wares]. Fukuoka, 1977

BAEKELAND, Frederick. *Imperial Japan: the Art of the Meiji Era, 1862–1912.* Exhib. cat., Johnson Mus. of Art, Cornell U. Ithaca, N.Y., 1980

BARKER, Richard, and SMITH, Lawrence. *Netsuke: the Miniature Sculpture of Japan.* London: British Mus., 1976

*BINYON, Laurence, and SEXTON, J. J. O'Brien. *Japanese Colour Prints.* B. Gray, ed. 2nd ed. London: Faber, 1960

BOXER, Charles R. *Jan Compagnie in Japan, 1600–1817: an Essay on the . . . Influence Exercised by the Hollanders in Japan. . . .* Tokyo, London, and New York, 1968

Bunjinga-sen [Selection of literati paintings]. Seigei Moura, ed. 12 vols. Tokyo, 1921–22

BUSHELL, Raymond. *The Inro Handbook: Studies of Netsuke, Inro, and Lacquer.* New York: Weatherhill, 1979

———. *Netsuke, Familiar and Unfamiliar: New Principles for Collecting.* New York: Weatherhill, 1975

*CAHILL, James. *Scholar Painters of Japan: the Nanga School.* Exhib. cat., Asia House Gallery, New York. New York: Asia Soc., 1972. Reprint. New York: Arno, 1976

CHISAWA, Teiji. *Korin.* Tokyo, 1957

COMPTON, Walter A., et al. *Nippon-to: Art Swords of Japan.* Exhib. cat., Japan House Gallery, New York. New York: Japan Soc., 1976

COULLERY, Marie-Therese, and NEWSTEAD, Martin S. *The Baur Collection: Netsuke.* Geneva, 1977

COVELL, Jon C. *Masterpieces of Japanese Screen Painting; the Momoyama Period.* New York: Crown, 1962

DOI, Tsugiyoshi. *Hasegawa Tohaku.* Tokyo, 1977

———. *Kano Sanraku, Sansetsu.* Tokyo, [1976]

*———. *Momoyama Decorative Painting.* Edna B. Crawford, trans. New York: Weatherhill; Tokyo: Heibonsha, 1977

———. *Sanraku to Sansetsu.* Kyoto, 1944

———. *Tohaku.* Tokyo, 1957?

DOMBRADY, Geza S. *Watanabe Kazan, ein Japanischer Gelehrter des 19. Jahrhunderts.* Hamburg, 1968

DOTZENKO, Grisha. F. *Enku: Master Carver.* Tokyo and New York: Kodansha, 1976

*FRENCH, Calvin L. *The Poet-Painters: Buson and His Followers.* Ann Arbor: U. of Michigan Mus. of Art, 1974

———. *Shiba Kokan: Artist, Innovator and Pioneer in the Westernization of Japan.* New York: Weatherhill, 1974

*———. *Through Closed Doors: Western Influence on Japanese Art 1639–1853.* Rochester, Mich., 1977

FURUTA, Shokin. *Sengai.* Tokyo, 1966

GRAY, Basil. *Japanese Screen Painting.* London: Faber, 1955

GRILLI, Elise. *The Art of the Japanese Screen.* New York and Tokyo: Walker/Weatherhill, 1970

———. *Golden Screen Paintings of Japan.* New York and London: Crown/Elek, 1959

———. *Sharaku.* New York, n.d.

GUNSAULUS, Helen C. *The Clarence Buckingham Collection of Japanese Prints: the Primitives.* Chicago: Art Inst. of Chicago, 1955

HARADA, Jiro. *Gardens of Japan.* London, 1928

*HAUGE, Victor, and HAUGE, Takako. *Folk Traditions in Japanese Art.* Exhib. cat. Washington, D.C.: Internatl. Exhib. Found., 1978

HILLIER, Jack R. *The Art of Hokusai in Book Illustration.* London: Sotheby's; Berkeley: U. of Calif. Pr., 1980

———. *The Harari Collection of Japanese Paintings and Drawings.* Boston, 1970

———. *Japanese Prints and Drawings from the Vever Collection.* New York: Rizzoli, 1976

———. *The Uninhibited Brush: Japanese Art in the Shijo Style.* London: Moss, 1974

———. *Utamaro: Colour Prints and Paintings.* Oxford, 1979

HONOLULU ACADEMY OF ARTS. *Exquisite Visions: Rimpa Paintings from Japan.* By Howard Link. Exhib. cat. Honolulu: Honolulu Academy of Arts, 1980

HOSONO, Masanobu. *Nagasaki Prints and Early Copperplates.* Lloyd R. Craighill, trans. Tokyo: Kodansha, 1978

IMAIZUMI, Motosuke. *Shoki Arita to Ko-Kutani* [Early Arita and Old Kutani wares]. Tokyo, 1974

ISONO, Nobutake. *Chojiro, Koetsu* [Wares by Chojiro and Koetsu]. Tokyo, 1960

ITOH, Teiji. *The Japanese Garden.* Tokyo, 1978

IVES, Colta F. *The Great Wave: The Influence of Japanese Woodcuts on French Prints.* 2nd ed. New York: Metropolitan Mus. of Art, 1980

JAPAN CERAMIC SOCIETY, OSAKA. *Ko-Kutani Meihin-ten* [Exhibition of Old Kutani ware]. Osaka, 1965

JAPAN CERAMIC SOCIETY, TOKYO. *Kakiemon, Imari, and Nabeshima.* Exhib. cat. Tokyo, 1959

Japanese Prints, Buncho to Utamaro, in the Coll. of Louis V. Ledoux. New York: Weyhe, 1948

Japanese Prints by Harunobu and Shunsho in the Coll. of Louis V. Ledoux. New York: Weyhe, 1945

Japanese Prints by Hokusai and Hiroshige in the Coll. of Louis V. Ledoux. Princeton: Princeton U. Pr., 1951

Japanese Prints of the Primitive Period in the Coll. of Louis V. Ledoux. New York: Weyhe, 1942

Japanese Prints, Sharaku to Toyokuni, in the Coll. of Louis V. Ledoux. Princeton: Princeton U. Pr., 1950

*JENYNS, Soame. *Japanese Porcelain.* London, 1965.

———. "The Wares of Kutani." *Transactions of the Oriental Ceramic Soc.* 21 (1945–46)

KATO, Hajime. *Oribe* [Oribe ware]. Tokyo, 1959

KAWAHARA, Masahiko, and MITSUOKA, Tadanari. *Ko-Kiyomizu* [Old Kiyomizu ceramics]. Kyoto, 1972

KAWAI, Masatomo. *Yusho, Togan.* Tokyo, 1978

KEYES, Roger S., and MIZUSHIMA, Keiko. *The Theatrical World of Osaka Prints: a Coll. of 18th and 19th Century Japanese Woodblock Prints in the Philadelphia Mus. of Art.* Philadelphia, 1973

KIKUCHI, Sadao. *Hokusai.* Tokyo, 1956

KIRBY, John B. *From Castle to Teahouse: Japanese Architecture of the Momoyama Period.* Rutland, Vt.: Tuttle, 1962

KOBAYASHI, Tadashi. *Harunobu.* Tokyo, 1970

Koetsu sho Sotatsu kingin deie [Koetsu and Sotatsu: Calligraphy on gold and silver paintings]. Tokyo, 1978

KONDO, Ichitaro. *Japanese Genre Painting, the Lively Art of Renaissance Japan.* Roy A. Miller, trans. Rutland, Vt., and Tokyo: Tuttle, 1961

———. *Kitagawa Utamaro.* Charles S. Terry, trans. Rutland, Vt., and Tokyo: Tuttle, 1956

———. *Sho-ki Hu-zoku-Gwa* [Genre painting of the 16th and 17th centuries]. Tokyo, 1957

KONO, Motoaki. *Ogata Korin.* Tokyo: Shueisha, 1976

Korin-ha gashu [Masterpieces selected from the Korin school]. 5 vols. Tokyo, 1903–6

Korin-ten [Korin exhib. cat. in commemoration of his 300th birthday]. Tokyo, 1958

KOYAMA, Kanji; AOKI, Shinsaburo; and KANEKO, Fusuri, eds. *Nikuhitsu Katsushika Hokusai* [Paintings by Hokusai]. Tokyo, 1975

KUMITA, Shohei; NAKAMURA, Tanio; and SHIRASAKI, Hideo. *Sakai Hoitsu Gashu* [Masterpieces of Sakai Hoitsu]. Tokyo, 1976

KYOTO NATIONAL MUSEUM. *Momoyama Jidai no Kogei* [Handicrafts of the Momoyama period]. Kyoto, 1977

LANE, Richard D. *Images from the Floating World: the Japanese Print.* New York: Putnam, 1978

LUNSINGH SCHEURLEER, D. F. *Japans porselein met blauwe decoraties uit de tweede helft van de zeventiende en de eerste helft van de achttiende eeuw.* The Hague, 1971

MICHENER, James A. *Japanese Prints from the Early Masters to the Modern.* Rutland, Vt.: Tuttle, 1960

MIKAMI, Tsugio. *Arita Tengudani Koyo: Shirakawa Tengudani Koyoshi Hakkutsu Chosa Hokokusho* [New light on early and eighteenth century wares: . . . excavations at the Tengudani kiln sites]. Tokyo, 1972

*MILLER, Roy A. *Japanese Ceramics.* Japanese text by Seiichi Okuda, Fujio Koyama, and Seizo Hayashiya. Rutland, Vt.: Tuttle; Tokyo: Toto Shuppan, 1960

MINAMOTO, Toyomune, and HASHIMOTO, Ayako. *Tawaraya Sotatsu.* Tokyo: Shueisha, 1976

MITCHELL, C. H., ed. *The Illustrated Books of the Nanga, Maruyama, Shijo and Other Related Schools of Japan: a Bibliography.* Los Angeles, 1972

MITSUOKA, Tadanari. *Kenzan* [Wares by Kenzan]. Tokyo, 1958

————. *Shigaraki, Iga, Bizen, Tamba* [Wares from Shigaraki, Iga, Bizen, Tamba]. Tokyo, 1961

MIZUMACHI, Wasaburo. *Shoki Imari* [Primitive Imari wares]. Tokyo, 1960

*MIZUO, Hiroshi. *Edo Painting: Sotatsu and Korin.* John M. Shields, trans. New York: Weatherhill; Tokyo: Heibonsha, 1972

Momoyama: Japanese Art in the Age of Grandeur. By Julia Meech-Pekarik. Exhib. cat., Metropolitan Mus. of Art. New York, 1975

Momoyama Ji-dai Konpeki Shohekiga [Colored screen paintings in the Momoyama period]. Bijutsu Kenkyusho [Institute of Art], ed. 2 vols. Tokyo, 1937

MORAOKA, Kageo, and OKAMURA, Kichiemon. *Folk Arts and Crafts of Japan.* Daphne D. Stegmaier, trans. New York: Weatherhill; Tokyo: Heibonsha, 1973

MURASE, Miyeko. *Byobu: Japanese Screens from New York Collections.* Exhib. cat., Asia House Gallery, New York. New York: Asia Soc., 1971

MURASHIGE, Yasushi. *Sotatsu.* Tokyo, 1970

MURAYAMA, Jungo, ed. *Nanga-shu* [Collection of Japanese Southern school paintings]. 3 vols. Tokyo, 1910

NABESHIMA HOUSE FACTORY RESEARCH COMMITTEE. *Nabeshima Colored Porcelains.* Kyoto, 1954

NAGAI, Shinichi, and MARUYAMA, Naokaza. *Enku to Mokujiki* [Enku and Mokujiki]. Tokyo, 1978

NAGATAKE, Takeshi. *Imari* [Imari ware]. Tokyo, 1973

NAITO, Akira. *Katsura: a Princely Retreat.* Charles S. Terry, trans. Tokyo: Kodansha, 1977

NAKAGAWA, Chisaku. *Ko Kutani* [Old Kutani ware]. Tokyo, 1958

NAKAMURA, Keidan. *Eitoku.* Tokyo, 1957?

NAKAMURA, Tanio. *Shokei.* Tokyo, 1970

NARAZAKI, Muneshige. *The Japanese Print: Its Evolution and Essence.* C. H. Mitchell, trans. Tokyo: Kodansha, 1966

————. *Masterworks of Ukiyo-e.* Vol. 1: *Early Paintings.* Charles A. Pomeroy, trans. Tokyo and Palo Alto: Kodansha, 1968

————. *Masterworks of Ukiyo-e.* Vol. 5: *Hiroshige: Famous Views.* Richard L. Gage, trans. Tokyo and Palo Alto: Kodansha, 1968

————. *Masterworks of Ukiyo-e.* Vol. 10: *Hiroshige: The 53 Stations of the Tokaido.* Tokyo: Kodansha, 1974

————. *Masterworks of Ukiyo-e.* Vol. 7: *Hokusai: Sketches and Paintings.* John Bester, trans. Tokyo and Palo Alto: Ko-

dansha, 1969

————. *Masterworks of Ukiyo-e.* Vol. 3: *Hokusai: "The Thirty-six views of Mount Fuji".* John Bester, trans. Tokyo and Palo Alto: Kodansha, 1972

————. *Masterworks of Ukiyo-e.* Vol. 9: *Kiyonaga.* John Bester, trans. Tokyo: Kodansha, 1970

————. *Masterworks of Ukiyo-e.* Vol 11: *Studies in Nature: Birds and Flowers by Hokusai and Hiroshige.* John Bester, trans. Tokyo: Kodansha, 1974

————, and KIKUCHI, Sadao. *Masterworks of Ukiyo-e.* Vol. 4: *Utamaro.* Tokyo and Palo Alto: Kodansha, 1968

————; TAKAHASHI, Seiichiro; KIKUCHI, Sadao; et al. *Kinsei Fuzoku Zukan* [Collection of genre painting scrolls of the Edo period]. Tokyo, 1973–74

NARUSE, Fujio. *Shiba Kokan.* Tokyo: Shueisha, 1977

NISHIMURA, Tei. *Namban Art, Christian Art in Japan, 1549–1639.* Tokyo: Kodansha, 1958

OKA, Isaburo. *Hiroshige.* Tokyo, 1957

OKAKURA, Kakuzo. *The Book of Tea.* London, 1932

*OKAMOTO, Yoshitomo. *The Namban Art of Japan.* Ronald K. Jones, trans. New York: Weatherhill; Tokyo: Heibonsha, 1972

————. *Namban Byobu-ko* [A study of folding screens depicting the Westerners coming to Japan through the southern islands]. Tokyo, 1955

————, and TUKAMIZAWA, Tadao. *Namban byobu* [Namban screens]. Tokyo, 1970

OKAWA, Naomi. *Edo Architecture: Katsura and Nikko.* Alan Woodhull and Akito Miyamoto, trans. New York: Weatherhill; Tokyo: Heibonsha, 1975

Okyo and the Maruyama-Shijo School of Japanese Painting. Exhib. cat., St. Louis Art Mus. St. Louis, 1980

PAINE, Robert T., Jr. *Japanese Screen Painting.* Boston: Mus. of Fine Arts, 1935

RANDALL, Doanda. *Korin.* New York: Crown, 1960

Rimpa Kaiga Zenshu [Selected paintings of the Korin school]. Kyoto, 1975

ROBINSON, Basil W. *The Arts of the Japanese Sword.* Rutland, Vt.: Tuttle, 1961

SASAKI, Kozo. *Chikuden.* Tokyo, 1970

————. *Mokubei, Chikuden.* Tokyo: Shueisha, 1977

SATO, Masahiko. *Kenzan.* Tokyo, 1970

————. *Kyoto Ceramics.* Anne O. Towle and Usher P. Coolidge, trans. New York: Weatherhill, 1973

SATO, Shinzo. *Hizen no Karatsuyaki* [Karatsu ware of Hizen]. Tokyo, 1958

SEN, Soshitsu; MURATA, Jiro; and KITAMURA, Denbe. *Chashitsu: the Original Drawings and Photographic Illustrations of the Typical Japanese Tea Architecture and Gardens.* Kyoto, 1959

SHONO, Masako. *Japanisches Aritaporzellan im sogenanntem "Kakiemonstil" als Vorbild für die Meissener Porzellanmanufaktur.* Munich, 1973

Sotatsu Ise-monogatari Zu-cho [Portfolio of color reproductions of Ise-monogatari by Sotatsu]. Tokyo, 1945

STERN, Harold P. *The Magnificent Three: Lacquer, Netsuke, and Tsuba: Selections from the Coll. of Charles A. Greenfield.* Exhib. cat., Japan House Gallery, New York. New York: Japan Soc., 1972

————. *Master Prints of Japan.* Exhib. cat., U.C.L.A. Art Galleries. New York: Abrams, 1969

————. *Rimpa: Masterworks of the Japanese Decorative School.* Exhib. cat., Japan House Gallery, New York. New York: Japan Soc., 1971

SUGASE, Tadashi. *Namban Bijutsu Tokubetsu Ten* [Namban art, special exhibition]. Kobe, 1973

SUZUKI, Juzo. *Masterworks of Ukiyo-e.* Vol. 2: *Sharaku.* John

Bester, trans. Tokyo and Palo Alto: Kodansha, 1968.

SUZUKI, Susumu. *Poet-Painter Buson*. Tokyo: Nihon Keizai Shimbun, 1958

————. *Kinsei Itan no Geijutsu: Jakuchu, Shohaku, Rosetsu* [Eccentric art of the modern era: Jakuchu, Shohaku, Rosetsu]. Tokyo, 1973

————, and OZAKI, Masaoki. *Watanabe Kazan*. Tokyo, Shueisha, 1977

————, et al. *Ike-no Taiga Sakuhin Shu* [The works of Ike-no Taiga]. 2 vols. Tokyo, 1960

SUZUKI, Takashi. *Hiroshige*. New York: Crown, c. 1958

TAKAHASHI, Seiichiro. *The Evolution of Ukiyo-e: the Artistic, Economic, and Social Significance of Japanese Wood-block Prints*. Yokohama: Yamagata, c. 1955

————. *Masterworks of Ukiyo-e*. Vol. 6: *Harunobu*. John Bester, trans. Tokyo and Palo Alto: Kodansha, 1976

————. *Traditional Woodblock Prints of Japan*. Richard Stanley-Baker, trans. New York: Weatherhill; Tokyo: Heibonsha, 1972

TAKASU, Toyoji. *Kakiemon, Nabeshima* [Kakiemon and Nabeshima wares]. Tokyo, 1961

TAKEDA, Tsuneo. *Kano Tanyu*. Tokyo: Shueisha, 1978

————. *Tohaku, Yusho*. Tokyo: Kodansha, 1973

TANAKA, Sakutaro. *Ninsei* [Wares by Ninsei]. Tokyo, 1960

TANI, Shin-ichi, and SUGASE, Tadashi. *Namban Art: A Loan Exhibition from Japanese Collections*. Washington, D.C.: Internatl. Exhib. Found., 1973

TOKYO NATIONAL MUSEUM. *Maruyama-Shijo-ha Kaiga Ten: Okyo to Rosetsu* [Okyo, Rosetsu, and the Maruyama-Shijo school of Japanese painting]. Tokyo, 1979

————. *Momoyama Edo no Bijutsu* [Japanese art from the Momoyama to the Edo period]. Tokyo, 1967

————. *Rimpa: Soritsu Hyakunen Kinen Tokubetsu Ten Zuroku* [Korin school: The special exhibition catalogue of the centennial]. Tokyo, 1973

TSUJI, Nobuo. *Kiso no Keifu: Matabei—Kuniyoshi* [Eccentric painters in the Edo period: Matabei—Kuniyoshi]. Tokyo: Bijutsushi Nihon, 1970

————; HICKMAN, Money L.; and KONO, Motoaki. *Jakuchu, Shohaku*. Tokyo: Shueisha, 1977

UCHIDA, Minoru. *Hiroshige, Life and Work*. Tokyo, 1932. Reprint. 1978

VLAM, Grace A. *Western-style Secular Painting in Momoyama Japan*. Ann Arbor, 1980

VOLKER, T. *The Japanese Porcelain Trade of the Dutch East India Company After 1683*. Leiden: Brill, 1959

WAKIDA, Hidetaro. *Uragami Gyokudo*. Tokyo: Shueisha, 1978

WAKISAKA, Atsushi. *Tohaku*. Tokyo, 1970

WATERHOUSE, David B. *Harunobu and His Age: the Development of Colour Printing in Japan*. London: British Mus., 1964

WEISBERG, Gabriel; CATE, P. Dennis, et al. *Japonisme: Japanese Influence on French Art 1854–1910*. Exhib. cat., Cleveland Museum of Art. Cleveland, 1975

*YAMADA, Chisaburoh F., ed. *Dialogue in Art: Japan and the West*. Tokyo: Kodansha, 1976

YAMAGUSHI, Keizaburo. *Hiroshige*. Tokyo, 1970

YAMAKAWA, Takeshi. *Okyo, Goshun*. Tokyo: Shueisha, 1977

YAMANE, Yuzo. *Koetsu, Sotatsu, Korin*. Tokyo: Kodansha, 1975

*————. *Momoyama Genre Painting*. John M. Shields, trans. New York: Weatherhill; Tokyo: Heibonsha, 1973

————. *Rimpa Kaiga Zenshu* [Complete collection of paintings by Sotatsu-Korin]. Tokyo, 1977

————, ed. *Sotatsu*. Tokyo: Nihon Keizai Shimbun, 1962

YAMASHITA, Sakuro. *Ko-Imari to Ko-Kutani* [Old Imari and Old Kutani wares]. Tokyo, 1968

————. *Shoki no Imari* [Early Imari wares]. Tokyo, 1972

YAMPOLSKY, Philip B., trans. *The Zen Master Hakuin: Selected Writings*. New York and London: Columbia U. Pr., 1971

YASHIRO, Yukio, and YAMAGUCHI, Hoshun. *Matsu-ura byobu* [The Matsu-ura screens]. Tokyo, 1959

YONEMURA, Ann. *Japanese Lacquer*. Exhib. cat., Freer Gallery. Washington, D.C.: Smithsonian, 1979

*YONEZAWA, Yoshiho, and YOSHIZAWA, Chu. *Japanese Painting in the Literati Style*. Betty I. Monroe, trans. New York: Weatherhill; Tokyo: Heibonsha, 1974

YOSHIZAWA, Chu. *Gyokudo, Mokubei*. Tokyo: Kodansha, 1975

————. *Nihon no Nanga* [Japanese Nanga]. Tokyo: Kodansha, 1976

————. *Taiga*. Tokyo, 1957

INDEX

Page numbers are in roman type. Figure numbers of black-and-white illustrations are in *italic* type. Colorplates are specifically so designated.

The Wade-Giles spelling of Chinese names and terms appears in parentheses directly after the *pinyin*. If the two transcriptions are identical, no parenthetic spelling appears.

PHOTOGRAPHIC CREDITS

Arranged alphabetically by source. Numbers refer to figure numbers.

Archaeological Survey of India: 96, 277. Archaeology Department of Indonesia: 324, 325, 329. Mr. William Archer and the Victoria and Albert Museum, London: 282–84, 294, 506. The Art Institute of Chicago: 124, 665. Éditions B. Arthaud, Grenoble: 217, 258, 302, 306, 316, 317. Asian Art Museum, San Francisco: 20. Asuka-en, Nara: 175, 176, 189, 192, 194, 209, 210, 328, 380, 381–86, 388, 411, 418, 420, 422, 423, 426, 430, 435, 437, 439, 451, 453. Banpo Museum: 8. Berlin Museum für Völkerkunde: 172, 173. Bharat Kala Bhavan, Hindu University, Varanasi: 216. Mr. Jean Boisselier and Mr. Pierre Dupont: 300. British Museum, London: 123, 149, 337–39, 376. The Brooklyn Museum: 542. Buffalo Society of Natural Sciences; photograph by C. E. Simmons: 10. Mr. James Cahill: 462, 464, 477, 478, 592. Mr. Frank Caro: 484. Mr. Pramod Chandra, Prince of Wales Museum of Western India: 218, 223. The Chinese Embassy, Washington, D.C.: 18, 48, 74, 77. The Cincinnati Art Museum: 547. The Cleveland Museum of Art: 7, 19, 20-B, 21, 35, 42, 50, 52, 55, 56, 70, 90, 126, 142–45, 152, 153, 179, 183, 198, 207, 215, 220, 280, 286, 287, 290, 291–93, 295, 296, 298, 299, 308, 309, 311, 321, 334, 336, 344, 350, 373, 374, 454, 460, 466, 468, 474, 486, 488, 489, 491, 494, 496, 500, 505, 507, 508, 511, 514, 522, 525, 537–41, 551, 553, 557, 563, 567, 568, 571, 573, 582–84, 593, 596–602, 605, 606, 609–12, 614–19, 622, 623, 626, 642, 656, 663, 664, 667, 669–72; colorplates 4, 5, 9, 16–21, 23, 36–39, 41–44, 48–50, 55. Mrs. Ananda K. Coomaraswamy: 171. A. C. Cooper, Ltd., London: 459, 461, 552, 607. Cultural Properties Commission, Tokyo: 195. Mr. Lance Dane, Madras: 279. Percival David Foundation of Chinese Art, London: 79, 504, 569, 570, 572, 624, 625. Mr. Leroy Davidson: 556. Professor K. Doi, Kyoto: 639. Eastfoto, New York: 565. Mr. Eliot Elisofon, New York: 109, 110, 133, 135, 136, 138, 140, 141, 166, 228, 231, 232, 236–38, 242, 245, 247, 254–56, 261, 263–66, 307, 313–15, 318, 320. Mr. Ernest Erickson, New York: 17, 45. Professor Wen Fong, Princeton University, Department of Art: 66, 560. Mr. G. M. Gompertz, England: 501. Government of India, Department of Archaeology: 1, 91, 96, 98–102, 104, 113, 116, 117, 120, 122, 129–32, 137, 170, 219, 224, 225, 227, 229, 230, 234, 240, 241, 244, 248, 250–52, 258–62, 267, 268, 270–72, 274–78. Dr. Alexander B. Griswold: 156, 157. Mr. Bernard P. Groslier, Paris: 310. Musée Guimet, Paris: 71, 75, 127, 128, 168, 169, 181, 235, 297, 300, 301, 303–5, 319, 322, 326, 335. Mr. T. Hara, Yokohama: 532, 533. Mr. Nasli M. Heeramaneck: 158. The Hermitage Museum, Leningrad: 38, 39, 80. Historical Museum, Beijing: 43. Mr. Walter Hochstadter, Zurich: 613. The Institute for Art Research, Tokyo: 359, 419, 431, 433, 434, 436, 438, 445, 449, 456, 457, 481, 483. Iwanami Shoten, Tokyo: 633. The Kern Institute, Leiden: 160–65, 323, 327, 330–33. Kochukyo Company, Tokyo: 499. Professor Stella Kramrisch: 103, 108, 249. Li Chi, Academia Sinica, Taiwan: 16, 25. Dr. J. E. van Lohuizen, Amsterdam: 159. Los Angeles County Museum of Art, Nasli and Alice Heeramaneck Collection: 146. Mr. Junkichi Mayuyama, Tokyo: 57, 64, 65, 85–88, 186–88, 196, 200–205, 208, 341, 352, 353, 360–72, 377–79, 390, 391, 395–400, 402–8, 410, 412–17, 421, 424, 425, 432, 441–43, 447, 471–73, 479, 482, 487, 492, 493, 495, 509, 510, 512, 516–18, 521, 523, 527, 529–31, 534, 536, 544–46, 575, 627–32, 634, , 638, 640, 645, 647, 648, 650–55, 657–59, 673. Mr. J. V. Mehta, Bombay: 120, 233, 269. The Metropolitan Museum of Art, New York: 355, 446, 497, 621, 661, 662; colorplate 27. The Metropolitan Museum of Art, New York, on loan from People's Republic of China, photograph by Seth Joel: 12, 60, 76. Mingei-kan (Folk Art Museum), Tokyo: 452. The Minneapolis Institute of Art: 31, 34, 41. Professor S. Mizuno, Kyoto, and Mr. Junkichi Mayuyama, Tokyo: 178. Museum of Eastern Art, Oxford: 51, 345. Museum of Fine Arts, Boston: 5, 47, 69, 125, 155, 180, 184, 285, 347, 393, 470, 490, 502, 587, 666; colorplates 12, 32, 35. Nara National Museum: 428. National Museum of India, New Delhi: 2–4, 6, 214. National Museum of Korea, Seoul: 81, 82, 185, 574. National Palace Museum, Taibei: 549, 550, 558, 559, 561, 586, 620. National Palace Museum, Taibei, and Mr. Henry Beville, Washington, D.C.: 354. Joint Administration, National Palace Museum and National Central Museum, Taibei: 555. Nelson Gallery–Atkins Museum, Kansas City: 11, 14, 29, 61, 197, 281, 342, 346, 463, 475, 476, 554, 588–91, 594, 595, 635; colorplates 14, 26, 46. Palace Museum, Beijing: 458; colorplate 34. People's Republic of China: 9, 13, 59, 62, 63, 73, 348; colorplates 6, 40. Mr. and Mrs. A. Dean Perry Collection, Cleveland: 603. Drawing after *Relics of Han and Pre-Han Dynasties*, Imperial Household Museum, Tokyo, 1932: 58. Professor John M. Rosenfield, Harvard University: 105, 121. Dr. Benjamin Rowland and the Fogg Art Museum, Harvard University: 93, 94, 97, 102, 107, 111, 114, 118, 134, 148, 154, 211, 222, 226, 239, 243, 253. The Royal Ontario Museum, Toronto: 343, 375, 576. St. Louis Art Museum: 485. Sakamoto: 190, 389, 465; colorplates 3, 11, 24, 25, 28–31, 33, 51–54, 56–60. The late Professor Alfred Salmony and the Institute of Fine Arts, New York University: 92, 95, 112, 115, 257, 273. Mr. John D. Schiff, New York: 577–81. Seattle Art Museum: 20-A, 27, 53, 356, 429, 480, 644, 646, 668; colorplate 1. Dr. P. C. Sestieri, Soprintendente all' Antichità, Salerno: 147, 150. Mr. Inosuke Setsu, Tokyo: 535. Mr. Laurence Sickman: 564. Skira and Mr. Henry Beville: colorplate 22. Smithsonian Institution, Freer Gallery of Art, Washington, D.C.: 15, 23, 28, 30, 32, 33, 36, 40, 44, 49, 78, 288, 289, 340, 450, 467, 498, 503,